T0212862

Lecture Notes in Computer Science 9445

Commenced Publication in 1973
Founding and Former Series Editors:
Gerhard Goos, Juris Hartmanis, and Jan van Leeuwen

Editorial Board

More information about this series at http://www.springer.com/series/7409

Henrik Schoenau-Fog · Luis Emilio Bruni
Sandy Louchart · Sarune Baceviciute (Eds.)

Interactive Storytelling

8th International Conference
on Interactive Digital Storytelling, ICIDS 2015
Copenhagen, Denmark, November 30 – December 4, 2015
Proceedings

 Springer

Editors

Henrik Schoenau-Fog
Aalborg University
Copenhagen
Denmark

Sandy Louchart
Glasgow School of Art
Glasgow
UK

Luis Emilio Bruni
Aalborg University
Copenhagen
Denmark

Sarune Baceviciute
Aalborg University
Copenhagen
Denmark

ISSN 0302-9743 ISSN 1611-3349 (electronic)
Lecture Notes in Computer Science
ISBN 978-3-319-27035-7 ISBN 978-3-319-27036-4 (eBook)
DOI 10.1007/978-3-319-27036-4

Library of Congress Control Number: 2015955377

LNCS Sublibrary: SL3 – Information Systems and Applications, incl. Internet/Web, and HCI

Printed on acid-free paper

Springer International Publishing AG Switzerland is part of Springer Science+Business Media
(www.springer.com)

Preface

This volume contains the proceedings of ICIDS 2015: The 8th International Conference on Interactive Digital Storytelling. ICIDS is the premier annual venue that gathers researchers, developers, practitioners, and theorists to present and share the latest innovations, insights, and techniques in the expanding field of interactive storytelling and the technologies that support it.

The field regroups a highly dynamic and interdisciplinary community, in which narrative studies, computer science, interactive and immersive technologies, the arts, and creativity converge to develop new expressive forms in a myriad of domains that include artistic projects, interactive documentaries, cinematic games, serious games, assistive technologies, edutainment, pedagogy, museum science, advertising, and entertainment, to mention a few. The conference has a long-standing tradition of bringing together academia, industry, designers, developers, and artists into an interdisciplinary dialogue through a mix of keynote lectures, long and short article presentations, posters, workshops, and very lively demo sessions. Additionally, since 2010, ICIDS has been hosting an international art exhibition open to the general public. In 2015, ICIDS took place in Copenhagen at Aalborg University in Copenhagen, marking the conference's return to Europe.

This year the review process was extremely selective and many good papers could not be accepted for the final program. Altogether, we received 80 submissions in all the categories. Out of the 48 full-paper submissions, the Program Committee selected only 18 submissions for presentation and publication as full papers, which corresponds to an acceptance rate of less than 38 % for full papers. In addition, we accepted 13 submissions as short papers, nine submissions as posters, and three submissions as demonstrations, including some long papers that qualified for participation in one of these categories. The ICIDS 2015 program featured contributions from 48 different institutions in 18 different countries worldwide.

The conference program also hosted two invited speakers: Chris Crawford, Game Design veteran, Interactive Storytelling pioneer and designer of Siboot; and Paul Mulholland from the Knowledge Media Institute (The Open University, UK), forerunner in the use and development of interactive narrative tools for enhancing learning and museum experience.

The titles of their talks were:

- Chris Crawford:
 "The Siren Song of Interactive Storytelling"
- Paul Mulholland:
 "Interactive Narrative and Museums"

In addition to paper and poster presentations, ICIDS 2015 featured a very rich pre-conference workshop day with 13 workshops: (1) Building IDS Research and Development Bridges, (2) The Ontology Project for Interactive Digital Narrative,

(3) Inspired Models for Interactive Narrative, (4) Managing the Stage: Challenges of Participatory Storytelling, (5) Storytelling Lighting Design, (6) The Overlap and Joint Potential Between Theater and IDS, (7) RPGs, Edularp and Blackbox: A Theoretical and Practical Primer on Role-Playing Games and Their Relevance for IDS, (8) When Our Destinies Meet: Design and Play a Blackbox Larp, (9) Storytelling, Digital Media, Museums and Beuys, (10) Creating Video Content for Oculus Rift - Scriptwriting for 360° Interactive Video Productions, (11) Wish Game Workshop, (12) Mobile Story-telling 3.0: How to Create Mobile and Digital Location-Based Stories, and finally (13) Social Media Fiction: Designing Stories for Social Media.

In conjunction with the academic conference, the interactive narratives art exhibition was held at the industrial era museum Diesel House in Copenhagen. The art exhibition featured a selection of 14 artworks selected from 30 submissions by an international jury.

We would like to express our gratitude and sincere appreciation to all the authors included in this volume for their effort in preparing their submissions and for their participation in the conference. Equally we want to heartily thank our Program Committee and art exhibition jurors for their accurateness and diligence in the review process, our invited speakers for their insightful and inspirational talks, and the workshops organizers for the dynamism and creativity that they brought into the conference. A special thank goes to the Danish Council for Independent Research for their financial support, to the Diesel House Museum, Copenhagen (Denmark), for hosting our International Art Exhibition, and to the ICIDS Steering Committee for granting us the opportunity to host ICIDS 2015 In Copenhagen. Thanks to you all!

November 2015

Henrik Schoenau-Fog
Luis Emilio Bruni
Sandy Louchart
Sarune Baceviciute

Organization

General Chairs

Luis Emilio Bruni Aalborg University, Copenhagen, Denmark
Henrik Schoenau-Fog Aalborg University, Copenhagen, Denmark

Program Chairs

Sandy Louchart The Glasgow School of Art, Digital Design Studio
Sarune Baceviciute Aalborg University, Copenhagen, Denmark

Art Exhibition Chair

Cumhur Erkut Aalborg University, Copenhagen, Denmark

Workshops Chair

Bjørn Flindt Temte Independent Scholar

Program Committee

Sarune Baceviciute	Aalborg University, Copenhagen, Denmark
Byung-Chull Bae	Hongik University, South Korea
Udi Ben-Arie	Tel Aviv University, Israel
Brunhild Bushoff	Sagasnet, Germany
Luis Emilio Bruni	Aalborg University, Copenhagen, Denmark
Marc Cavazza	University of Teesside, UK
Sharon Lynn Chu	Texas A&M University, USA
Patrick John Coppock	University of Modena and Reggio Emilia, Italy
Gabriele Ferri	Indiana University, USA
Michael Frantzis	Goldsmiths College, University of London, UK
Lisa Gjedde	Aalborg University, Copenhagen, Denmark
Andrew Gordon	University of Southern California, USA
Ian Horswill	Northwestern University, USA
Klaus Jantke	Fraunhofer IDMT, Germany
Noam Knoller	University of Amsterdam, The Netherlands
Hartmut Koenitz	University of Georgia, USA
Petri Lankoski	Södertörn University, Sweden
Sandy Louchart	The Glasgow School of Art, Digital Design Studio, UK
Brian Magerko	Georgia Institute of Technology, USA
Alex Mitchell	National University of Singapore, Singapore

Bradford Mott	North Carolina State University, USA
Frank Nack	University of Amsterdam, The Netherlands
Mark J. Nelson	Anadrome Research
Valentina Nisi	Carnegie Mellon Program, University of Madeira, Portugal
Paolo Petta	Austrian Research Institute for Artificial Intelligence, Austria
Stefan Rank	Drexel University, USA
Mark Riedl	Georgia Institute of Technology, USA
David Roberts	North Carolina State University, USA
Remi Ronfard	Inria, France
Henrik Schoenau-Fog	Aalborg University, Copenhagen, Denmark
Digdem Sezen	Istanbul University, Turkey
Tonguc Ibrahim Sezen	Istanbul Bilgi University, Turkey
Emily Short	Linden Lab, USA
Kaoru Sumi	Future University Hakodate, Japan
Nicolas Szilas	TECFA-FPSE, University of Geneva, Switzerland
Joshua Tanenbaum	University of California, Irvine, USA
Mariet Theune	University of Twente, The Netherlands
Nelson Zagalo	University of Minho, Portugal

Supporting Organizations

ICIDS 2015 was hosted by the Department of Architecture, Design and Media Technology, Aalborg University Copenhagen, in collaboration with the Center for Applied Game Research (CEAGAR), the Augmented Cognition Lab, and the ReCreate Center at Aalborg University.

The conference was kindly supported by the Danish Council for Independent Research (DFF) under the Humanities Council.

The International Art Exhibition was hosted with the collaboration of the Diesel House Museum, Copenhagen (Denmark).

Invited Talks

The Siren Song of Interactive Storytelling

Chris Crawford

Independent Researcher and Developer, Oregon, USA
www.erasmatazz.com

Abstract. Many a researcher has wasted years pursuing the siren song of interactive storytelling, and for all the efforts that have been spent, little has been accomplished. It would appear that interactive storytelling is like natural language processing: something that seemed easy at first, but is now recognized as immensely difficult. Five obstacles must be overcome in order to achieve genuine interactive storytelling: 1) emotionally significant facial displays; 2) a personality model appropriate to drama; 3) a narrative engine capable of processing dramatic interactions; 4) a development environment for controlling the technology; and 5) a language of dramatic interaction. This keynote will characterize these challenges and present the solutions to them that I have developed for the Siboot project.

Interactive Narrative and Museums

Paul Mulholland

Research Fellow, Knowledge Media Institute
The Open University, UK
paul.mulholland@open.ac.uk

Abstract. Museums often use stories to help visitors interpret their collections. For example, a story may help the visitor to interpret an artwork in the context of the life of the artist or the border social and political context in which the artwork was created. Visitors also tell their own stories, making connections between the artwork and their own concerns, knowledge and interests. There are ever expanding opportunities to use technology to enhance the museum experience. Online data sources can be used to provide additional information about artworks and artists discovered by the visitor. Mobile technology can be used augment physical museum visits in a way that is sensitive to context and location. Do these technologies work with or against the range of curatorial and visitor stories being shared within the museum environment? In this talk I will look at the nature of museum stories, from the larger stories that structure a museum exhibition to the smaller stories that may connect an artwork to a visitor's personal experience. I will then look at some examples of how the nature of stories, and museum stories in particular, can be used to inform the design of museum technologies and shed light on how visitors use them.

Contents

Analyses and Evaluation of Systems

Demonstrations

Workshops

Theoretical and Design Foundations

Touchscreen Poetry: Analyzing Gestural Digital Poems

Gabriele Ferri[✉]

Hogeschool van Amsterdam, Amsterdam, The Netherlands
g.ferri@hva.nl

Abstract. Interactive Poetry is a lively genre within E-Lit and interactive digital narrative that was made more accessible by the diffusion of tablets with "multitouch" screens allowing relatively complex gestural UIs on consumer-level hardware. This paper leverages pragmatist aesthetics to critically interrogate three exemplar pieces (Strange Rain, What They Speak When They Speak to Me? and Vniverse) that produce poetic effects by inviting gestural interactions. In conclusion, two critical concepts ("isomorphism" and "heteromorphism") are demonstrated for future design and research.

Keywords: Poetry · Gestural interfaces · Pragmatism · Aesthetics · Semiotics

1 Introduction

The relationship between poetry and digitally-mediated experiences has yielded evocative artistic projects, often running on ad-hoc hardware such as large capacitive screens. The introduction of personal, touchscreen-enabled devices such as tablets has made these experiences much more accessible, and "multitouch" devices popularized gestural UIs, creating new opportunities for design. This has paved the way for expanding interactive digital poetry (IDP) outside specialized and expensive hardware: for this reason, here I address design categories for tablet-based poetic gestural interactions. By curating and analyzing an ad-hoc corpus through structuralist narratology and pragmatist aesthetics, this work yields the categories of "isomorphism" and "heteromorphism" as practical insights for IDP researchers and designers to frame the relationship between gestures, interfaces and poetry.

2 Digital Poetry: A Theoretical Background

As a first step, a curated background on interactive digital poetry (IDP) and interactive digital narrative (IDN) is assembled, a selection of practical tools for teasing out different meaning-making strategies and for critically interrogating digital artifacts.

2.1 Between Interactive Narrative and Interactive Poetry

As synthesized by Koenitz et al. [1], IDN may be broadly understood as "narrative in digital media that changes according to user input". This programmatically open

© Springer International Publishing Switzerland 2015
H. Schoenau-Fog et al. (Eds.): ICIDS 2015, LNCS 9445, pp. 3–13, 2015.
DOI: 10.1007/978-3-319-27036-4_1

definition points at a vast and constantly expanding set of artifacts comprising– among others– computer games, story-generation systems and pervasive public interventions such as augmented-reality art installations. Kac popularized the specific term "media poetry" to describe poems that are readable only through digital means [2]. Searching for a definition of IDP, the relationship between IDN and IDP might at first be considered similar to the one between narrative prose and poetry. But, in reality, the situation seems to be much more nuanced: for this reason, I will first provide an overview of IDN and then I will turn to Jakobson's "poetic function" [3] for a pragmatic definition of poeticiy.

Murray [4] envisions interactive narratives as characterized by immersion, transformation and agency. In the same year, Hayles [5] implicitly describes electronic literature (E-Lit) as the artistic subset of IDN by pointing first at "digital object[s] created on a computer and (usually) meant to be read on a computer" and adding that they should be "work[s] with an important literary aspect that take advantage of the capabilities and contexts provided by the stand-alone or networked computer". The emphasis on the artistic qualities of E-Lit subsequently leads Grigar to synthesizing this genre as "as an emergent art form whose works cannot be experienced in any meaningful way without the mediation of an electronic device and which possess qualities sometimes associated with literary works" [6].

However, the recent developments in narratology [7] focus more on the emergent effects of human interpretation. And, indeed, this resonates with Roman Jakobson's understanding of a 'poetic function': "poeticity is present when the word is felt as a word and not a mere representation of the object being named or an outburst of emotion, when words and their composition, their meaning, their external and inner form acquire a weight and value of their own instead of referring indifferently to reality" [3]. In a surprisingly similar way to what is proposed by current definitions of narrativity as a cognitive construct [7], Jakobson's poeticity is an effect that is generated when an aesthetic text does not simply point to an external referent, but acquire further poetic value as they refer to other. In other words, extrapolating and paraphrasing Jakobson's early contribution, this specific perspective understands poeticity not as a given, but as an emerging interpretive effect.

2.2 Practical Approaches to Interactive Digital Poetry

IDP has emerged as an artistic and critical practice adopted by researchers and practitioners alike to explore the expressive capabilities of digital media: to provide context for this work, I will outline here four significant tendencies in this field.

IDP has clearly been often framed as an artistic/literary endeavor, and indeed several E-Lit pieces have explicitly been catalogued as interactive poems, with more than twenty high-quality, critically endorsed entries catalogued in the two volumes of the Electronic Literature Collection [8, 9].

Moreover, poetry has been successfully cross-pollinated with mixed-media art installations: for example, Fritsch et al. [10] report on a physical, tangible performance entitles Ink, an "interactive literary installation" focused on "performative writing and reading" [10]. Similarly, poetic video games exist – as famously exemplified by

Bogost's Slow Year [11] and Benmergui's Today I Die [12] – exploring the inter-
section of game mechanics (or their subversion), ludic expectations and a poetic
function.

Practitioners and educators have also addressed poetry with didactic IDN experi-
ments such as PoetryLab [13], described as "a close listening game [...] in which players
manipulate a virtual reel-to-reel tape machine. Gameplay teaches players about poetry
and recording media from both auditory and archival perspectives" [13]. Moreover,
other applications have been created to facilitate or support the creation of poetry –
either as part of a didactic practice, or simply as a means of self-expression: among
similar examples, we might point at Beat Haiku [14], or Super Atari Poetry [15].

Finally, researchers are beginning to adopt poetry also as an entry point to analyze
other digital forms: for instance, Digdem Sezen [16] proposed poetry as a novel ana-
lytical lens through which explore the overlap between IDN and video games from an
alternative perspective. She remarks that "looking at IDN through poetry's perspective
also liberates the IDN researcher from the necessity to align critical perspectives and
experiments in form with prose [and allows us to] reroute the patterns of thought in the
field and see even familiar IDN examples in a new light" [16].

2.3 Touching the Story: Tangible and Gestural IDNs

Tangible user interfaces were conceived as an alternative to standard graphical user
interfaces, and are based on physical devices, tangible objects to be grasped and
manipulated [17]. Hornecker writes: "it was proposed to represent digital content
through tangible objects [and] the core idea was to quite literally allow users to grasp
data with their hands" [18]. Differently from tangibles, gestural interfaces are not based
on direct manipulation but on recognizing gestures enacted by users. Saffer defines a
gesture as "any physical movement that a digital system can sense and respond to
without the aid of a [...] pointing device [...]. A wave, a head nod, a touch, a toe tap,
and even a raised eyebrow can be a gesture" [19].

Both approaches have been experimented with in IDN. Tangible devices for digital
storytelling exist both as commercial (e.g. Disney Infinity) and experimental products.
Tanenbaum and Tanenbaum developed the Reading Glove, "a wearable glove-based
interface and tabletop display surface that provides an interactive narrative experience
grounded in a set of physical objects" [20]. Chow and Harrell [21] experimented with
gestural interfaces for the Rainbus Ecstatic IDN, where "one can make the [...] pro-
tagonist express her view by running fingers on the touch screen; swiping up and down
causes [her] to nod, [...] pinching out inclines [her] toward an open and receptive
posture, while pinching in toward a closed and introverted one" [21].

Although there is a long tradition of larger-scale artistic installations making use of
digital technologies together with evocative props [10, 15, 22], there are still relatively
few personal, single-user, small-scale E-Lit and IDP artifacts that leverage them
expressly with the objective of producing a poetic effects. In other words, I point at an
opportunity space to be further explored: a space that is comprised within the
boundaries of Interactive Digital Storytelling, with artifacts that leverage Jakobson's
poetic function [3], that adopt gestural interfaces, and that are experienced individually,

not as part of public performances. In focusing on single-user interactions, this design space critically interrogates and remediates the intimate experience of reading poetry, also leveraging the affordances of tablets and other touch-enabled personal devices.

3 Collecting a Corpus

Having surveyed the current state of the art on the application of gestural interfaces to IDN and IDP, a mostly-overlooked opportunity space emerges. The rapid diffusion of multitouch tablets now allows the conversion of gestural poetic experiences that were previously available only on dedicated hardware. The following analysis aims at examining the design opportunities offered by these technological advances. For this reason, I collect and analyze a corpus curated following three heuristics, that identify the design space I aim at describing: (1) the desired artifacts should be expressly designed to run on personal touchscreen-enabled devices, (2) they should make use of gestural interfaces and (3) there should be a degree of coherence between the poetic effects evoked and the gestures required during interaction. Of the three heuristics considered, the first two are clearly structural whereas the third constitutes a critical, qualitative judgement from the researcher. Satisfying the third parameter has proven surprisingly more difficult than expected. In itself, the difficulty of finding high-quality, relevant software further underlines the urgent need for deeper reflections on these topics also from a practical perspective (Fig. 1).

Still, three artifacts are particularly significant: (1) Strange Rain [23], an interactive poetic experience associating tapping gestures on the screen with raindrops and text fragments, (2) What They Speak When They Speak to Me? [24], a kinetic poetry app where the user swipes and draws lines on the screen to make the verses of a poem materialize, (3) Vniverse [25], described by its authors as "a poetry instrument you can play", connecting groups of verses as if they were constellations on a star map (Figs. 2 and 3).

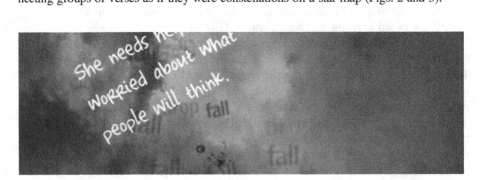

Fig. 1. Strange Rain [23]

3.1 Strange Rain

Strange Rain [23] is an iOS app that adopts the metaphor of rain as a poetic device, and presents the first person perspective of a character standing under a thunderstorm. The tablet may be tilted to rotate the point of view, and tapping, swiping and pinching

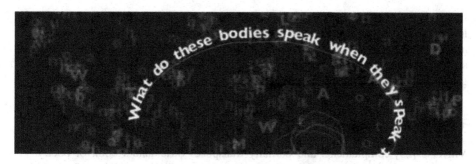

Fig. 2. What They Speak When They Speak to Me? [24]

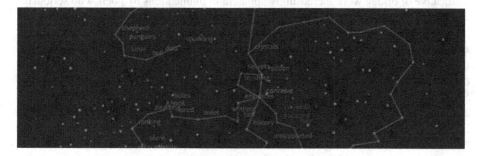

Fig. 3. Vniverse [25]

gestures cause raindrops to fall harder. Gestural interactions may also be modulated – for example, by tapping faster or slower – to alter the raindrops' behavior and to tweak the audio track. Strange Rain may be experienced in three different modes, selectable in the home screen: the "wordless" mode allows users to simply interact with the rain, whereas the "whispers" mode intertwines words – not composing a coherent narrative, but all related to water – between the falling droplets. Finally, in the "story" mode, every tap on the screen triggers a fragment of thought appearing on the screen – composing a loosely coherent narrative about a man standing under the rain to collect his thoughts, outside of an hospital where after his sister was admitted after a car crash.

3.2 What They Speak When They Speak to Me?

What They Speak When They Speak to Me? [24] (here called WTS for brevity) is part of the "Poetry for Excitable [Mobile] Media" project. P.O.E.M.M. comprises seven works by author and scholar Jason Edward Lewis, transposed into interactive poetry, publicly exhibited in Montreal, Canada, and later adapted as iOS apps. Specifically, WTS is based on a poem addressing differences, multilingualism, and the (im)possibility of understanding each other across spatial and cultural barriers.

Opening the app, users see a mass of floating white letters over a black background. Tapping one of them, it illuminates together with others forming a verse. If a user makes a swiping gesture, specific letters detach and align themselves. Drawing a longer

line causes the verse to flow after the user's moving finger, until an entire line is legible. By moving a finger right to left, or bottom to top, or in a circular motion, letters arrange themselves in reverse and make the sentence temporarily illegible. When the swiping is done, the characters are released and go resume their slow floating. More gestures assemble other verses, until the whole poem has been displayed.

3.3 Vniverse

Vniverse [25] complements and partially transposes Strickland's book of poetry V: WaveTercets/Losing L'una [26], which in turn is an updated new edition of a previous volume. Already in 2003, critic Chris Funkhouser praised Strickland's work as "indicative of bridge work increasingly apparent in publications by poets who seriously use computer technology to present writing in traditional and experimental formats" [27]. V:WaveTercets was, already in the print version, characterized by a numbering system that allowed readers to jump back and forth between tercets and to construct their own path. The 2014 digital version leverages the metaphor of a star map, positioning the lexias into a bidimensional space, like stars in a night sky. Similarly to Strange Rain, Vniverse may be used in different modes: selecting "constellation", the app automatically connects the verses following the connections established in the print book; "wavetercets" plays the entire sequence of verses from the beginning to the end; "draw" allows users to connect the stars/tercets and to create their own constellations/poems, and finally the "oracle" mode allows interactors to ask questions to the stars, receiving tercets as answers.

4 Analysis

In the following paragraphs, I address the poetic user experiences supported by Strange Rain, WTS and Vniverse. This analysis comprises a first part leveraging structuralist narratology [28–30] to address the anomalous schemata in these artifacts, and a second one drawing on pragmatist aesthetics [31, 32] to tease out how the emergence of poetic meaning is shaped through interaction.

4.1 Unstable Textuality and Plural Narrations

A fluid textuality is one of the defining characteristics of IDN, E-Lit and IDP [1, 2, 5, 6, 16]. Put another way, static, unilinear texts such as novels have inherently fixed and easily recognizable boundaries: readers can distinguish what is part of the text as a whole (e.g. a chapter of a book) from a broader paratext (e.g. a review of the same book). Moreover, text flow is governed by culturally-established conventions: for example, most Latin alphabets are read from left to right, from the top of a page to its bottom. In addition to these linguistic and morphological elements, formalist and structuralist narratology conceive meaning-making as a universal, linear progression, and consider flashbacks, loops and other similar plot devices as incidental qualities of the *syuzhet* [29]. This is not the place to re-discuss how IDNs differ from linear

narratives [1, 4, 7], but yet the artifacts examined here push the division even farther: a closer analysis, indeed, shows how Strange Rain, WTS and Vniverse escape from simple schematizations even more radically than common IDNs usually do. To do so, three related design strategies may be teased out from these artifacts: (1) a fragmented expression, (2) a dischronic structure, (3) an open interpretive trajectory.

Fragmented Expression. The output of Strange Rain is revealed little by little as users tap on the screen, and likewise the verses of WTS are presented one after the other, as the slowly assemble letter by letter as users swipe on the screen. Similarly, the star-map metaphor adopted in Vniverse is particularly effective at communicating such fragmentation, as each "star" is related to a single, autonomous stanza. Indeed, fragmented expression may be generalized as a design strategy that programmatically renounces to linear coherence when presenting an output to an interactor. Instead of fully-formed, coherent sentences or audio-video clips, the experience proposed by the three artifacts leverages textual fragments that become meaningful only in retrospect when considered in relation to the rest of the artifact.

Dischronic structure. The three artifacts expressly refuse a linear temporal order when presenting their audio-visual output to interactors. For instance, the graphic appearance of Strange Rains changes in specific moments, as the sky turns to an unnatural color and the flow of thinking presented on screen is disrupted – maybe by a daydream, or a flashback? Likewise, the order in which WTS and Vniverse arrange their outputs is arbitrary and sometimes apparently random – presenting to their users disjoined verses, arguably promoting free associations.

Indeed, openness to (re)interpretation and a plurality of configurations characterize all IDNs at large, but are particularly evident here. As written poetic forms favor linguistic experimentation, likewise it stands to reason that IDP adopts similarly experimental procedural conventions. Therefore, an **open interpretive trajectory** emerges as a consequence for the previous two design strategies and, at the same time, is in stark contrast with the structuralist narratological notion of a universal canonical schema: instead, the fuzzy narratives created with these interactive artifacts are programmatically open to interpretation, and renounce from standard elements such as a climax or closure in the end or a clear presentation of the setting in the beginning.

4.2 Interpretive Hypotheses and Temporal Pacing in an Aesthetic Experience

So far, the selected exemplars have underlined the excessive rigidity of a structuralist narratological legacy. In what follows, I turn to a different framework informed by pragmatist aesthetics to produce more fitting descriptions of how they support poetic experiences. Dewey's works have proven to be fundamental to a variety of current humanistic approaches to human-computer interaction [32–36]. Pragmatism characterizes aesthetic experiences for being creative, enlivening, and expressive, involving the senses and values in inclusive and fulfilling activity that is considered worth engaging in for its own sake [34], rather than for their material qualities or the social situations in which they take place. In this vein, Wright, Wallace and McCarthy [32]

propose an operational approach subdividing an aesthetic experience into four threads (Sensual, Emotional, Spatio-Temporal and Compositional). Even though experiences are holistic and should to be considered as a whole, one might turn to Wright et al.'s threads to interrogate specific experiential components. Here, I first leverage the Spatio-Temporal and Compositional threads to complement the three above-mentioned design strategies, before turning to the Sensual and Emotional ones to finally address the kinesthetic and gestural components of these poetic experiences.

"The **compositional thread** is concerned with the narrative structure of an experience, how we make sense of the relationships between the parts and the wholes of an encounter" [32]. In this analysis, the compositional thread addresses the interpretive challenge offered to interactors, who are invited to formulate interpretive hypotheses as they proceed through each experience. Our exemplars leave those questions partly open: the narrating voice of Strange Rain refers to a situation (a car accident), a place (outside a hospital, under a thunderstorm) and some characters (the victim in the accident, and the relatives of the protagonist). Likewise, WTS mentions places, languages and hints at specific situations and activities (walking down the road, being addressed by somebody), and Vniverse provides, for each star/tercet, titles that are both evocative and descriptive of the tercet associated with it. The balance they accomplish between what is made explicit and what is left ambiguous – enough for interactors to speculate, but not enough to formulate a definitive interpretation – is remarkable and likely contributes to their success.

"The **spatio-temporal thread** reminds us that experiences are particular [and] relate to a particular person in a particular situation at a particular time: no two experiences are identical" [32]. Indeed, temporality is relevant for Strange Rain, WTS and Vniverse as repeatability and looping. All the three exemplars follow loose patterns: for instance, the thoughts appearing on screen in Strange Rain seem to follow an overall progression even if they often repeat themselves, and the verses/tercets in WTS and Vniverse adopt similar behaviors. But what is different from the previous structuralist approach is that, in this framework, temporality is clearly controlled by interactors who influence – by tapping, swiping and pinching – the rhythm and the pacing of the experience.

4.3 Sensual and Emotional Threads for Gestural Experiences

"The **sensual thread** of experience is concerned with our sensory, bodily engagement with a situation, which orients us to the [...] visceral character of experience, [it] reminds us that we are embodied in the world through our senses" [32]. And this is, indeed, a crucial overlapping between IDP and linear, non-digital poetry, as they both make ample use of sensory, embodied components. Put another way, written or spoken poetry is recognized [3] not for the referential use of language, but for being *sensually* evocative through sound, rhythm, repetitions, alliteration and many other figures. Likewise, Strange Rain, WTS and Vniverse appear to produce similar effects not only through their textual or audiovisual components, but also through the embodied interaction they supports. The pointing and tapping gestures in Strange Rain produce a sense of connection between the interactor and the falling raindrops, as if he/she was

aiming them and causing them to hit the glass. The drawing and dragging motion supported by WTS may be understood as a type of gestural translation of the act of enunciating a verse: instead of speaking out loud, the interactor draws to cause the sentence to appear (and, like sounds cease to exist after having been spoken, also the electronic verses disappear at the end of the gesture). Likewise, moving a finger over the touchscreen in Vniverse further improves the embodied qualities of the "drawing constellations on a star map" act that constitutes its main interface metaphor.

"The **emotional thread** refers to judgments that ascribe to other people and things an importance with respect to our (or their) needs and desires" [32]. In relation to the analyzed artifacts, this thread refers to recognizing emotional components emerging from the embodied interaction: for example, the rainfall in Strange Rain evoking at the same time a sense of peace and timelessness, and thunders pointing at more negative emotions. Similarly, the drawing gestures in WTS and Vniverse may support a mood of calm, quiet exploration but, at the same time, some frustration at not being ever able to completely visualize the output.

5 Discussion and Design Insights

The analysis so far has moved from a critique of a linear and rigid model of interpretation based on structuralist narratology [32], to a more flexible analytical approach leveraging pragmatist aesthetics [31–33]. It has also suggested that – whereas written/spoken poetry makes use of the sensual qualities of rhythm and sound – IDP may also leverage analogous elements at the interface level. Finally, a closer look at the gestural interfaces of Strange Rain, WTS and Vniverse has underlined their ability to resonate with a poetic function [3].

In this concluding discussion, as contributions towards future works, I further elaborate on this last point and extrapolate design implications for researchers and IDP practitioners. To foreground the kinesthetic components of IDPs, I hypothesize two possible approaches – one based of isomorphism between gesture and poetic function, the other on heteromorphism. I clearly do not claim that these are the only two ways that should be pursued for advancing IDP design, but I offer them as insights that are explicitly supported by my analysis. **Isomorphic IDPs** aim at clear correspondences between the topic and the narrative addressed, the emotions evoked and the embodied qualities on the interaction. Strange Rain, WTS and Vniverse may be understood as weakly isomorphic, as the coherence between what interactors experience and what they are asked to physically do is not perfect. Future, more refined pieces may adopt more consciously the same approach, and aim at producing a sense of, for example, calm with both the interactive poem presented and the gestures required. For instance, a piece on slowness might require slow drawing gestures on the touchscreen. Vice versa, **heteromorphic IDPs** are complementary to the previous ones, and rely on the dissonance between that is evoked through words, images and sound and the gestural interactions proposed to users. If the number of poetic pieces that are consciously isomorphic is small, those leveraging heteromorphism is even lower – and this underlines the urgency for further research and design in this field. Indeed,

heteromorphic poetic interfaces could constitute an interesting and yet-understudied approach to engaging users in meaningful interaction that clearly requires further investigation.

There is clearly more work to be done for understanding the relationship between interface gestures and IDP, and the lenses of isomorphism/heteromorphism may provide us with productive insights for studying and producing artifacts in this field.

6 Conclusions

In the growing field of interactive digital narrative (IDN), Electronic Literature (E-Lit) and Interactive Poetry (IDP) are promising genres. Although some studies on IDP exist already, here I address the new, emerging space of opportunity delineated by overlapping IDNs, IDPs, and tangible and gestural interactions. A critical analysis of three IDPs for "multitouch" tablets – Strange Rain, WTS and Vniverse – demonstrates the usefulness of a pragmatist aesthetic model of analysis and, in conclusion, yields an operational distinction between isomorphic and heteromorphic IDPs as a practical contribution to be further explored by researchers, designers and poets.

References

1. Koenitz, H., Ferri, G., Haahr, M., Sezen, D., Sezen, T.I. (eds.): Interactive Digital Narrative: History, Theory and Practice. Routledge, New York (2015)
2. Kac, E.: Media Poetry: An International Anthology. Intellect Books, Bristol (2007)
3. Jakobson, R.: What is poetry? Lang. Lit. 368–378 (1976)
4. Murray, J.H.: Hamlet on the Holodeck: the Future of Narrative in Cyberspace. Free Press, New York (1997)
5. Hayles, K.: Electronic Literature: What is it? (1997). http://eliterature.org/pad/elp.html
6. Grigar, D.: The Present [Future] of electronic literature. In: Adams, R., Gibson, S., Arisona, S.M. (eds.) DAW/IF 2006/2007. CCIS, vol. 7, pp. 127–142. Springer, Heidelberg (2013)
7. Ryan, M.-L.: Narrative across Media: The Languages of Storytelling. University of Nebraska Press, Lincoln (2004)
8. Borràs, L., Memmott, T., Raley, R., Stefans, B. (eds.) Electronic Literature Collection 2. Electronic Literature Organization (2011)
9. Hayles, K., Montfort, N., Rettberg, S., Strickland, S. (eds.) Electronic Literature Collection 1. Electronic Literature Organization (2006)
10. Fritsch, J., Pold, S.B., Vestergaard, L.S., Lucas, M.: Ink: designing for performative literary interactions. Pers. Ubiquitous Comput. **18**, 1551–1565 (2014)
11. Bogost, I.: A Slow Year (2010). http://bogost.com/games/aslowyear/
12. Benmergui, D.: Today I Die (2009). http://www.ludomancy.com/games/today.php
13. Arawjo, I.A., Mitchell, C., Camlot, J.: PoetryLab: a close listening game for iOS. In: Proceedings of the First ACM SIGCHI Annual Symposium on Computer-Human Interaction in Play, pp. 311–314. ACM, New York (2014)
14. Helgason, I.: Beat haiku: interactive poetry application. In: Proceedings of the 7th Nordic Conference on Human-Computer Interaction: Making Sense Through Design, pp. 777–778. ACM, New York (2012)

15. Merhi, Y.: Super atari poetry. In: Proceedings of the 16th ACM International Conference on Multimedia, pp. 1137–1138. ACM, New York (2008)
16. Sezen, D.: Narrative explorations in videogame poetry. In: Koenitz, H., Ferri, G., Haahr, M., Sezen, D., Sezen, T.I. (eds.) Interactive Digital Narrative: History, Theory and Practice. Routledge, New York (2015)
17. Ishii, H., Ullmer, B.: Tangible bits: towards seamless interfaces between people, bits and atoms. In: Proceedings of the ACM SIGCHI Conference on Human Factors in Computing Systems, pp. 234–241. ACM, New York (1997)
18. Hornecker, E.: Tangible Interaction (2012). https://www.interaction-design.org
19. Saffer, D.: Designing Gestural Interfaces: Touchscreens and Interactive Devices. O'Reilly Media, Beijing; Cambridge (2008)
20. Tanenbaum, J., Tanenbaum, K.: The reading glove: a non-linear adaptive tangible narrative. In: Si, M., Thue, D., André, E., Lester, J., Tanenbaum, J., Zammitto, V. (eds.) ICIDS 2011. LNCS, vol. 7069, pp. 346–349. Springer, Heidelberg (2011)
21. Chow, K.K.N., Harrell, D.F.: Enduring interaction: an approach to analysis and design of animated gestural interfaces in creative computing systems. In: Proceedings of the 8th ACM Conference on Creativity and Cognition, pp. 95–104. ACM, New York (2011)
22. Arellano, D., Helzle, V.: The muses of poetry. In: CHI 2014 Extended Abstracts on Human Factors in Computing Systems, pp. 383–386. ACM, New York (2014)
23. Loyer, E.: Strange Rain (2010). http://opertoon.com/2010/11/strange-rain-for-ipad-iphone-ipod-touch/
24. Lewis, J.E., Nadeau, B.: What They Speak When They Speak to Me (2010). http://www.poemm.net/projects/speak.html
25. Strickland, S., Hatcher, I.: Vniverse (2014). http://vniverse.com/
26. Strickland, S.: V : WaveTercets/Losing L'una. SpringGun Press, Denver (2014)
27. Funkhouser, C.: Bridge Work (2003). http://electronicbookreview.com/thread/electropoetics/superdense
28. Greimas, A.J., Courtés, J.: Sémiotique: dictionnaire raisonné de la théorie du langage. Hachette, Paris (1979)
29. Budniakiewicz, T.: Fundamentals of Story Logic: Introduction to Greimassian Semiotics. John Benjamins Publishing, Amsterdam (1992)
30. Bertrand, D.: Précis de sémiotique littéraire. Nathan Université, Paris (2000)
31. Dewey, J.: Art as Experience. Perigee Books, New York (1934)
32. Wright, P., Wallace, J., McCarthy, J.: Aesthetics and experience-centered design. ACM Trans. Comput. Hum. Interact. **15**, 18:1–18:21 (2008)
33. McCarthy, J., Wright, P.: Technology as Experience. MIT Press, Cambridge (2004)
34. Boehner, K., Sengers, P., Warner, S.: Interfaces with the ineffable: meeting aesthetic experience on its own terms. ACM Trans. Comput. Hum. Interact. **15**, 12:1–12:29 (2008)
35. Karhulahti, V.-M.: Fiction puzzle: storiable challenge in pragmatist videogame aesthetics. Philos. Technol. **27**, 201–220 (2014)
36. Ferri, G.: Narrative structures in IDN authoring and analysis. In: Koenitz, H., Ferri, G., Haahr, M., Sezen, D., Sezen, T.I. (eds.) Interactive Digital Narrative: History, Theory and Practice. Routledge, New York (2015)

Open Design Challenges for Interactive Emergent Narrative

James Owen Ryan$^{(\boxtimes)}$, Michael Mateas, and Noah Wardrip-Fruin

Expressive Intelligence Studio, Center for Games and Playable Media,
University of California, Santa Cruz, USA
{jor,michaelm,nwf}@soe.ucsc.edu

Abstract. We introduce a research framework for the design of interactive experiences in the domain of *emergent narrative*, an application area of computational narrative in which stories emerge bottom-up from the behavior of autonomous characters in a simulated storyworld. Prior work in this area has largely concerned the development and tuning of the simulations themselves from which interesting stories may reliably emerge, but this approach will not necessarily improve system performance at its most crucial level—the actual interactive experience. Looking to completed experiences, namely simulation games like *Dwarf Fortress* and *The Sims*, we identify a series of shortcomings that yield four design challenges at the level of interaction: *modular content, compositional representational strategies, story recognition*, and *story support*. In this paper, we motivate and discuss each of these design challenges and, for each, summarize prior work and propose new approaches that future work might take.

Keywords: Emergent narrative · Content authoring · Story recognition

1 Introduction

Stories in *emergent narrative* arise bottom-up, usually from the interactions of autonomous characters in a simulated storyworld [77]. This approach to computational narrative is as old as the field itself. *Novel Writer* and *Tale-Spin*, the earliest known story generators, were emergent-narrative systems. In the former, a murder story forms from the simulated actions of a group of partygoers [40]; in *Tale-Spin*, characters in a storyworld autonomously carry out plans that may allow them to achieve their goals [56]. In recent decades, there have been a number of subsequent emergent-narrative systems, including other AI-research systems like *Virtual Storyteller* [78], *FearNot!* [13], and *Prom Week* [55], as well as commercial games like *The Sims* [54] and *Dwarf Fortress* [3]. Other character-based systems, such as the *Petz* series of digital games [28], the interactive-story system of Cavazza et al. [21], and Chris Crawford's *Storytron* [24], might also be called emergent-narrative systems.

Many of these systems, however, are not fundamentally *interactive*. *Novel Writer* and *Tale-Spin* are only interactive in that, in each, a user may specify

© Springer International Publishing Switzerland 2015
H. Schoenau-Fog et al. (Eds.): ICIDS 2015, LNCS 9445, pp. 14–26, 2015.
DOI: 10.1007/978-3-319-27036-4_2

the initial state of the storyworld. *Virtual Storyteller* is not interactive at all (it employs an embodied agent that tells emergent stories), though later extensions to it incorporated interactivity [33,73].

The *emergent narrative* research program, cultivated by Ruth Aylett, Sandy Louchart, and others, has typically concerned only interactive systems, most often *FearNot!*-like research systems. In this paper, we likewise limit our concerns to interactive systems, but we use the term 'emergent narrative' more broadly to include systems like the digital games listed above; this usage is not unprecedented [18,22,49,82]. We note that nondigital storytelling systems, such as tabletop role-playing games, should also be called emergent-narrative systems [45], but in this paper we do not consider these (as our concerns herein pertain only to digital systems). So, to be clear, by 'emergent narrative', we mean the application area characterized by digital, fundamentally interactive systems whose narratives emerge bottom-up, typically from the richness of underlying simulations that feature autonomous characters.

A basic appeal of emergent narrative is of course the very *emergence* that it yields, producing stories that even a system's designer might not have anticipated. Indeed, games with rich underlying simulations have often been lauded for their emergent qualities [4,38]—this is what got *Dwarf Fortress*, which we discuss in Sect. 4, into the Museum of Modern Art [87]. The fundamental advantage to this bottom-up approach, however, is that it defeats the sticky issue in top-down interactive narrative of accommodating player actions [9,64]. If the affordances given to a player are a subset of (or are coextensive with) the actions that non-player characters (NPCs) may themselves take in an underlying simulation, then an emergent-narrative system will be inherently reactive to player inputs. As such, the stories that emerge in these systems naturally incorporate player actions. Emergent narrative was articulated by Aylett as a solution to this problem of conciliating interactivity and narrativity [9], which has been called the *narrative paradox* [13,47] and the *interaction dilemma* [60].

Papers in this area have typically introduced new systems [6,13,16] or more generally concerned the engineering of systems [11,14,46,81,85], though others have discussed emergent narrative through the lens of narrative theory [47,48], creativity [10,42,62], and improvisation [76,77]. One class of contributions to the discipline has concerned the particular *design practices* that are employed in the domain [49,50,75]. Most prominent among these practices is the iterative design cycle of crafting a simulation from which certain kinds of stories may emerge, testing for whether those stories do emerge, hypothesizing why they do not, revising the simulation according to these hypotheses, and repeating these steps until the desired stories reliably emerge. To facilitate this procedure, Suttie et al. introduced the notion of *intelligent narrative feedback*, where a system gives real-time feedback about how well the simulation is satisfying authorial goals [75]; earlier, an authoring tool with a similar purpose was proposed [43].

We contend, however, that this iterative loop fails to capture system performance at its most crucial level—the actual interactive experience. It is only when a player is brought into the loop that an emergent-narrative system materializes

as a work of interactive storytelling. Iteratively tuning a simulation will certainly produce a better simulation, but a finely tuned simulation will not necessarily yield a well-crafted interactive experience. We subscribe to the stance articulated elsewhere that AI systems that are intended to support new types of interactive experiences cannot be truly appraised except through actual implemented experiences that get built atop them [41,52,74,84].

Let us look then to implemented interactive experiences in this domain, which have largely been games like *The Sims*, *Dwarf Fortress*, and *Prom Week*. We assert that these experiences, though wildly successful in many respects, exhibit a series of major shortcomings that, in turn, raise significant design challenges for emergent-narrative systems. First, systems from which narratives emerge tend to yield these by virtue of a complex underlying simulation, but often the richness of this simulation (and the very stories that emerge from it) is not made apparent to the player. This problem has prevailed since the earliest emergent-narrative systems and, fittingly, has been called the *Tale-Spin effect* [83]. We believe it will continue to persist until our first two design challenges are met: we must invent new authoring strategies for yielding *modular content* and we must develop new *compositional representational strategies*. Next, systems from which narratives emerge are typically unable to discern those narratives from the uninteresting event sequences that more commonly appear. When this happens, emergent stories may not get showcased by the system, and in turn they may go unnoticed by the player. This problem represents a nascent task area and our third challenge, *story recognition*, for which little work has yet been done. Lastly, even if a system is able to recognize some emergent story, how should it showcase it? We call this last challenge *story support*, and conceive of systems that could showcase (and support) emergent stories as they are unfolding.

In this paper, we introduce a research framework for the design of interactive experiences in the domain of emergent narrative. Specifically, we motivate and discuss each of the above design challenges and, for each, summarize relevant prior work and propose new approaches that future work might take. Because our concerns are at a level of system design (the player experience) above what has typically been discussed (simulation crafting) in prior work directly situated in this area, we more often refer to promising work in other domains. Likewise, because we are most interested in widely disseminated interactive experiences, we use systems like *Dwarf Fortress* and *The Sims*, rather than *FearNot!* and *Virtual Storyteller*, as examples. It is our hope that this paper will encourage new projects that may advance the medium of emergent narrative by taking on these difficult challenges.

2 Challenge 1: Modular Content

By *content*, we mean here the material used to express the underlying system state to the player, such as the animations and Simlish icons in *The Sims* or the textual dialogue in *Prom Week*. To the degree that such content is instantial (*i.e.*, non-procedural or 'canned'), authorial burden grows monotonically with a

system's state space. This is intuitive: the more states a system can get into, the more states that must be expressible by the system, and thus the more content that must be authored for it. So while, for instance, games with huge state spaces are often lauded for this very enormity [4,38,87], that same property yields a serious authoring challenge: when a system cannot express many or most of the states that its simulation yields, the latter will appear to the player much simpler than it in fact is—this is the *Tale-Spin* effect, mentioned above [83]. Because its systems often employ rich simulations that exhibit huge state spaces, this problem is endemic in emergent narrative. Note that there are other forms of authored material, such as the Edith scripts associated with objects in *The Sims* and volition rules in *Prom Week*, that already exhibit modularity and thus avoid this blow-up of authorial burden. But a player's experience of this authored procedural material (modularized simulation elements) is gated by the *expressive content*, which unfortunately tends to be instantial.

This issue is best alleviated by more content, but for games with particularly massive state spaces, it is not feasible to author by hand as much content as would be needed. Consider the case of *L.A. Noire*, a AAA game that does *not* have a massive state space, but for which a team of authors produced a script exceeding 2,000 pages [32]. This accumulation of dialogue is commensurate to that of ten full-length motion pictures—all this for an interactive experience that is very linear. The game, inasmuch as its narrative is concerned, cannot get into that many states—how else could it have a *script*? If this is the authorial burden commanded by *L.A. Noire*, imagine what is commanded by a system that can get into an essentially infinite number of states. The fact of the matter is that, in emergent narrative, standard authoring practice provides an author no hope for producing a base of content sufficient to give even marginal coverage to a massive state space.

2.1 Potential Approaches

We need to invent new, smarter authoring practices that are tailored to accommodate the massive state spaces and nonlinear properties that are characteristic of emergent narrative. We propose that such a scheme should exhibit two properties: first, with relatively little effort, a human should be able to produce many units of content that each express specific aspects of underlying state; second, these units of content should be largely independent of one another, but in a way that still affords sequencing and recombination.

Let us ground this out in an example. *Prom Week* [55] is a simulation game that features human-authored dialogue exchanges between NPCs. Each of these dialogue exchanges is composed of five to ten lines of dialogue and has on it a set of precondition rules that specify what must be true about the storyworld for the exchange to be enacted [70]. For instance, a precondition rule might enforce that a dialogue exchange only be enacted when the two characters who would carry it out are dating. But only some subset of the lines of dialogue that make up this exchange are likely to actually depend on the characters dating, which means that all the exchange's other lines (that do not have this dependency)

could have very well been used in cases where the characters were not dating. This represents misspent authoring effort, in that this content gets deployed less often than it could be. In [71], we worked to break down *Prom Week* dialogue exchanges into their constituent lines of dialogue (and then annotated the lines for their individual dependencies) in order to facilitate them getting deployed more often in a way that would increase coverage of the game's state space. An obstacle arose, however, in that many lines strictly depended on others (*e.g.*, due to anaphora) and thus could not be used independently of them.

From this exploration, we impart two general lessons that correspond to the content desiderata we outlined above: good content in emergent narrative should express one or few specific aspects of system state and should be as context-independent as possible, while still supporting content sequencing and recombination. This way, small units that each express individual things may be flexibly recombined into larger content units that express all those things simultaneously. Moreover, by being sequencable, content units may be used in a coordinated way that affords *emergent linear experiences* (*e.g.*, by having units reference earlier ones). Content should also be explicitly marked up for what it expresses about underlying state. When this is done, a system may be able to reason about its current state at any time in order to select content (or recombine content into a larger unit) that expresses that state. Currently, we are developing an authoring tool whose design is specifically informed by these two lessons [72].

3 Challenge 2: Compositional Representational Strategies

Related to the severe authorial burden endemic to emergent narrative is another challenge that pertains to the actual *deployment* of content. Rather than the makeup of individual content units, we are concerned here with how such units may be deployed simultaneously in a coordinated expression of underlying state. In systems underpinned by simulations whose primitives (and the procedures that operate on them to evolve state) are easily expressible, system state can be expressed *compositionally* by deploying content units that collectively express all active simulation primitives and procedures. This is classically the case in systems that simulate Newtonian physics. Let us consider *Angry Birds* [68], a game with a minor physics simulation whose primitives are the positions of game objects and whose procedures are the forces of classical mechanics. While *Angry Birds* can get into a lot of states, it has no trouble expressing any of them because these primitives and procedures happen to be easily expressible using *graphical logics*, which afford a particularly feasible *representational strategy*. By 'representational strategy', we mean a strategy for expressing internal processes at the surface (usually through the deployment of expressive content). Graphical logics are a brand of *operational logics* (abstract procedural tropes) by which a system may model things like movement and collision quite easily [53]. While graphical logics *can* be used rhetorically to make different kinds of meaning [79,80]—this has been done compellingly in games like *Passage* [67] and *Dys4ia* [7]—they really work best for expressing state in simulations of physical spaces.

So what representational strategy would afford compositional expression of state in a simulation that models, say, character internal state, as would be typical in emergent narrative? This is an open question, and it appears that until new (or currently immature) representational strategies are developed specifically for expressing things like this, experiences underpinned by simulations of such will not be able to express state compositionally. This means that, lacking such a strategy, designers of these experiences must author content units that essentially are each meant for big chunks of system state. But the better a content unit expresses a particular compound state, the more dependent it becomes on that state, and so the less generalizable it becomes to other states and the less often it can be deployed, as we discussed in the last section.

3.1 Potential Approaches

This is perhaps the hardest challenge we present in this paper, but we propose one potential compositional representational strategy that employs *generative dialogue* and *procedural animation*. A number of projects have explored using techniques from natural language generation to facilitate generative dialogue in interactive narrative systems [20,35,51,63,69]. A handful of other projects have explored expressive procedural character animation [36,57]. If each character in an underlying simulation could express her internal state at the surface through bespoke dialogue or animation, the system could express *its* underlying state compositionally by enacting all such procedures for all (on-screen) characters. Another compelling approach would be to utilize a modality that conventionally has *not* been used to express character internal states: sound. Indeed, Ian Horswill is currently exploring this in the experimental game *MKULTRA* [34].

4 Challenge 3: Story Recognition

Systems whose narratives emerge from simulations currently have no way of discerning the very stories they support. To illustrate this, let us consider perhaps the most lauded work of emergent narrative, *Dwarf Fortress* [3]. A roguelike set in procedurally generated fantasy worlds, *Dwarf Fortress* is best known for its rich underlying simulation. This game is often talked about in terms of the stories that emerge from this simulation (both by fans [1] and academics [39]) and its creator, Tarn Adams, has called *Dwarf Fortress* a "story generator" [86]. Undoubtedly, its simulation generates narratives—but does it know that it does?

There is typically no explicit narratological modeling whereby narratives in simulationist systems get composed; this would constitute a top-down approach to story generation, but simulations work bottom-up. As in other emergent-narrative systems with sufficiently complex underlying simulations, stories happen in *Dwarf Fortress* only incidentally; they are remarkable event sequences among a huge boiling stew of *things happening*. While humans who play experiences like *Dwarf Fortress* are capable of recognizing which event streams are storylike, the system itself is not. We call this challenge *story recognition*: how

does one make a system that can discern stories embedded in the morass of data that its simulation produces?[1]

4.1 Potential Approaches

Story recognition is related to *story understanding*, in which a system processes an event sequence and attempts to *understand* the story it represents by attributing explanations to the events that account for causal and temporal relations among them. Though related, story understanding is a different task than story recognition. Systems that do the former operate over storylike event sequences as a given, while systems doing the latter must *excavate* such sequences from larger accumulations of data. In this sense, story recognition may be thought of as a preliminary task to story understanding—a story's event sequence must first be recognized and compiled before it can be understood, though of course a system that does story recognition will probably have to operationalize a rudimentary notion of event temporality and causality, *i.e.*, *storiness*.[2] To further distinguish the tasks, work in story understanding has typically focused on artifacts like newswire stories [25], while in story recognition the central artifact is a simulation's event stream. Still, it is likely that techniques or insights from work on story understanding could inform the task of story recognition.

We are aware of preliminary work on story recognition outside the domain of interactive narrative. A handful of recent projects have explored recognizing storylike event sequences from structured representations of sports games (*e.g.*, baseball box scores) [5,15,44]. Pablo Gervás has been actively exploring the generation of stories from event-sequence data in chess [29]. In [31], event logs constituting the lives of characters in a social simulation are curated by the system to produce stories that interweave character biographies. (We build on lessons from this preliminary work in our proposal at the end of this section.)

One approach would be to assume that the trace of player actions in a system playthrough will typically represent a storylike sequence, since it may be expected that players will tend to interact with the storyworld in interesting or meaningful ways. In another project, however, we found that players of *Prom Week* cannot be relied upon to produce storylike gameplay, which works against this intuition [8]. However, by generalizing story recognition to mean making inferences about gameplay event-sequence data, prior work on both *goal recognition* and *gameplay summarization* becomes useful for resolving this problem.

In goal (and plan) recognition, a system attempts to infer a player's goals (and plans) from her playing behavior [23,30]. This is often done as part of a *player adaptation* scheme, wherein a system dynamically adapts gameplay to improve player satisfaction [88]. In gameplay summarization, a system curates the event sequence constituting a gameplay session in order to summarize it [8,26,61]. These tasks differ from that of story recognition in that they are

[1] We have adapted this term from that of an analogous task in computer vision, *object recognition*, in which discrete objects are identified in image data [37].

[2] What the most useful notion of storiness is will likely vary by system and application.

concerned with gameplay itself, not emergent stories that may be embedded in a gameplay session (or in parts of a simulation that are removed from player input). Still, we propose that they are similar enough to potentially inform our task here.

Finally, we propose a method whereby a human specifies interesting event sequences that the system will then attempt to match against sequences generated by its simulation. Indeed, a variant of this method has actually been employed in *The Sims 2*, as we discuss in the next section [17]. One concern here is that an author may not wish to specify precise event sequences, but rather higher-level patterns with major events that must remain constant and allowances for extraneous events that may be interspersed among those. For this, we believe *Playspecs*, a new formalism that supports regular expressions for play-trace data, could prove quite useful [58]. Relatedly, prior work in story understanding provides knowledge frameworks for expressing at higher levels of abstraction desired properties of storylike sequences. We are currently exploring this approach.

5 Challenge 4: Story Support

The last challenge that we will present is an extension of the previous one. Once a system has recognized a storylike event sequence that has emerged from its simulation, what should it do with it?

One thing the system could do is *retell* the story, either after gameplay or during it, perhaps by having NPCs conversationally relate stories about in-game events. This task would be quite related to prior work on gameplay summarization [8,26,61], but in this case the impetus is on summarizing a particularly interesting subset of gameplay events, not an entire gameplay sequence.

Perhaps more interestingly, a system could recognize partial event sequences *as they are happening* in order to influence the simulation or gameplay in a way that would support the emergence of interesting stories (*i.e.*, interesting completions of those partial event sequences). We will call this design challenge that of developing methods for *story support*. This problem may appear to be very similar to *narrative planning* [65], *drama management* [66], or *game mastering* [12,19,27,60]—these are certainly related notions (the latter might even be called an approach to story support), but we mean to encourage techniques that do not significantly compromise the integrity of the simulation, but rather gently nudge it toward the emergence of certain desirable event sequences. In other words, story support is not about enforcing some degree of narrativity on the simulation, but rather subtly manipulating it to facilitate and foreground emergent stories. Indeed, simulationist systems are appreciated for the emergent quality of their narratives [4,38,87], not necessarily the well-formedness of these stories according to narratological or dramatic concerns, and so we encourage the development of techniques that may promote emergence above other concerns.

5.1 Potential Approaches

One notable approach to story support was featured in *The Sims 2* [17]. In that game, characters have *fears* and *aspirations* that are expressed by tree data structures that specify event sequences by which certain fears or aspirations may be realized. For instance, a teen character may aspire to have her first kiss, and so the event sequence may include events like meeting, becoming romantically interested in, and eventually kissing another character. As gameplay proceeds, the system parses its event stream to check for partial completions of the sequences specified in characters' trees, and if a match is found, the system may nudge the simulation toward the event that would lead to that sequence's completion. Once a given sequence culminates, the system triggers content that will showcase the story it represents. We note that this particular aspect of the game was received favorably by critics [2,59].

6 Conclusion

We have introduced a research framework for the design of interactive experiences in the domain of *emergent narrative*, an application area of computational narrative in which stories emerge bottom-up from the behavior of autonomous characters in a simulated storyworld. Prior work in this area has largely concerned the development and tuning of the simulations themselves from which interesting stories may reliably emerge, but we have argued that this will not necessarily improve system performance at its most crucial level—the level of interactive experience. Looking to completed experiences in this area, namely games like *Dwarf Fortress* and *The Sims*, we assert a series of major shortcomings that yield four design challenges. First, the richness of underlying simulations (and the very stories that emerge from them) are often not made apparent to the player. We have argued that it will continue to persist until our first two design challenges are met: we must invent new authoring strategies for yielding *modular content* and we must develop new *compositional representational strategies*. Next, systems from which narratives emerge are typically unable to discern those narratives from the uninteresting event sequences that more commonly appear. When this happens, emergent stories may not get showcased by the system, and in turn they may go unnoticed by the player. This problem represents a nascent task area and our third challenge, *story recognition*, which we have outlined. Lastly, even if a system is able to recognize some emergent story, how should it showcase it? We have called this last design challenge *story support* and forecasted systems that may be capable of supporting and showcasing emergent stories as they are unfolding. It is our hope that this paper will spur new projects that may advance the medium of emergent narrative by taking on these difficult challenges.

References

1. Dwarf Fortress stories. http://dfstories.com/. Accessed 11 June 2015
2. Adams, D.: The Sims 2 review. IGN (2004)
3. Adams, T., Adams, Z.: Slaves to Armok: God of Blood Chapter II: Dwarf Fortress (2006)
4. Alexander, L.: Spector: Go emergent. Gamasutra (2013)
5. Allen, N.D., et al.: Statsmonkey: a data-driven sports narrative writer. In: Procedings of the CMN (2010)
6. Alvarez-Napagao, S., Gómez-Sebastià, I., Panagiotidi, S., Tejeda-Gómez, A., Oliva, L., Vázquez-Salceda, J.: Socially-aware emergent narrative. In: Beer, M., Brom, C., Dignum, F., Soo, V.-W. (eds.) AEGS 2011. LNCS, vol. 7471, pp. 139–150. Springer, Heidelberg (2012)
7. Anthropy, A.: Dys4ia (2012)
8. Antoun, C., Antoun, M., et al.: Generating natural language retellings from Prom Week play traces. In: Proceedings of the PCG in Games (2015)
9. Aylett, R.: Narrative in virtual environments-towards emergent narrative. In: Proceedings of the Narrative Intelligence Symposium (1999)
10. Aylett, R., Louchart, S.: I contain multitudes: creativity and emergent narrative. In: Proceedings of the Creativity & Cognition (2013)
11. Aylett, R., et al.: Unscripted narrative for affectively driven characters. Comput. Graph. Appl. **26**, 42–52 (2006)
12. Aylett, R., et al.: Managing emergent character-based narrative. In: Proceedings of the Intetain (2008)
13. Aylett, R.S., et al.: Fearnot! In: Proceedings of the IVA (2005)
14. Bevensee, S.H., Schoenau-Fog, H.: Conceptualizing Productive Interactivity in Emergent Narratives. In: Koenitz, H., Sezen, T.I., Ferri, G., Haahr, M., Sezen, D., Ç atak, G. (eds.) ICIDS 2013. LNCS, vol. 8230, pp. 61–64. Springer, Heidelberg (2013)
15. Bouayad-Agha, N., Casamayor, G., Wanner, L.: Content selection from an ontology-based knowledge base for the generation of football summaries. In: Proceedings of the ENLG (2011)
16. Brom, C., Bída, M., Gemrot, J., Kadlec, R., Plch, T.: Emohawk: searching for a "Good" emergent narrative. In: Iurgel, I.A., Zagalo, N., Petta, P. (eds.) ICIDS 2009. LNCS, vol. 5915, pp. 86–91. Springer, Heidelberg (2009)
17. Brown, M.: The power of projection and mass hallucination: practical AI in the sims 2 and beyond. In: Proceedings of the AIIDE [Invited Talk] (2006)
18. Cardoso, P., Carvalhais, M.: Breaking the game: The traversal of the emergent narrative in video games. Sci. Technol. Arts **5**, 25–31 (2013)
19. Carpentier, K., Lourdeaux, D.: Diegetization: an approach for narrative scaffolding in open-world simulations for training. In: Mitchell, A., Fernández-Vara, C., Thue, D. (eds.) ICIDS 2014. LNCS, vol. 8832, pp. 25–36. Springer, Heidelberg (2014)
20. Cavazza, M., Charles, F.: Dialogue generation in character-based interactive storytelling. In: Proceedings of the AIIDE (2005)
21. Cavazza, M., Charles, F., Mead, S.J.: Character-based interactive storytelling. Intell. Syst. **17**, 17–22 (2002)
22. Chauvin, S., et al.: An out of character approach to emergent game narratives. In: Proceedings of the FDG (2014)
23. Cheng, D.C., Thawonmas, R.: Case-based plan recognition for real-time strategy games. In: Proceedings of the Game-On (2004)

24. Crawford, C.: Storytron-interactive storytelling (2006)
25. DeJong, G.: An overview of the frump system. Strategies for NLP (1982)
26. Dominguez, M., Young, R.M., Roller, S.: Automatic identification and generation of highlight cinematics for 3D games. In: Proceedings of the FDG (2011)
27. Figueiredo, R., Brisson, A., Aylett, R.S., Paiva, A.C.R.: Emergent stories facilitated. In: Spierling, U., Szilas, N. (eds.) ICIDS 2008. LNCS, vol. 5334, pp. 218–229. Springer, Heidelberg (2008)
28. Frank, A., Stern, A., Resner, B.: Socially intelligent virtual Petz. In: Proceedings of the Socially Intelligent Agents (1997)
29. Gervás, P.: Composing narrative discourse for stories of many characters: a case study over a chess game. Literary Linguist. Comput. **29**, 511–531 (2014)
30. Ha, E., et al.: Goal recognition with markov logic networks for player-adaptive games. In: Proceedings of the AIIDE (2011)
31. Hassan, S., et al.: A computer model that generates biography-like narratives. In: Proceedings of the Computational Creativity (2007)
32. Helgeson, M.: L.A. Noire: Rockstar resets the bar with its upcoming crime thriller. Game Informer (2010)
33. Hoek, M., Theune, M., Linssen, J.: Generating game narratives with focalization and flashbacks (2014)
34. Horswill, I.: 4.4 Sonification of character reasoning. Artificial and Computational Intelligence in Games: Integration (2015)
35. Horswill, I.D.: Architectural issues for compositional dialog in games. In: Proceedings of the GAMNLP (2014)
36. Horswill, I.D.: Lightweight procedural animation with believable physical interactions. Comput. Intell. AI Games **1**, 39–49 (2009)
37. Jain, R., Kasturi, R., Schunck, B.G.: Machine Vision. McGraw-Hill, New York (1995)
38. Juul, J.: The open and the closed: Games of emergence and games of progression. In: Proceedings of the CGDC (2002)
39. Kelly, C.F.: Dwarf fortress: narratives of multiplicity and deconstruction. Bachelor's thesis, University of Amsterdam (2013)
40. Klein, S., et al.: Automatic novel writing: a status report. University of Wisconsin (1973)
41. Koenitz, H.: Five theses for interactive digital narrative. In: Mitchell, A., Fernández-Vara, C., Thue, D. (eds.) ICIDS 2014. LNCS, vol. 8832, pp. 134–139. Springer, Heidelberg (2014)
42. Kriegel, M., Aylett, R.S.: Emergent narrative as a novel framework for massively collaborative authoring. In: Prendinger, H., Lester, J.C., Ishizuka, M. (eds.) IVA 2008. LNCS (LNAI), vol. 5208, pp. 73–80. Springer, Heidelberg (2008)
43. Kriegel, M., et al.: An authoring tool for an emergent narrative storytelling system. In: Proceedings of the INT (2007)
44. Lareau, F., Dras, M., Dale, R.: Detecting interesting event sequences for sports reporting. In: Proceedings of the ENLG (2011)
45. Louchart, S., Aylett, R.S.: Solving the narrative paradox in VEs – lessons from RPGs. In: Rist, T., Aylett, R.S., Ballin, D., Rickel, J. (eds.) IVA 2003. LNCS (LNAI), vol. 2792, pp. 244–248. Springer, Heidelberg (2003)
46. Louchart, S., Aylett, R.: Emergent narrative, requirements and high-level architecture. In: Proceedings of the Hellenic Conference on Artificial Intelligence (2004)
47. Louchart, S., Aylett, R.: The emergent narrative theoretical investigation. In: Proceedings of the Narrative and Interactive Learning Environments (2004)

48. Louchart, S., Aylett, R.: Narrative theory and emergent interactive narrative. Continuing Eng. Educ. Life Long Learn. **14**, 506–518 (2004)
49. Louchart, S., et al.: Authoring emergent narrative-based games. Game Dev. **3**, 19–37 (2008)
50. Louchart, S., Swartjes, I., Kriegel, M., Aylett, R.S.: Purposeful authoring for emergent narrative. In: Spierling, U., Szilas, N. (eds.) ICIDS 2008. LNCS, vol. 5334, pp. 273–284. Springer, Heidelberg (2008)
51. Lukin, S.M., Ryan, J.O., Walker, M.A.: Automating direct speech variations in stories and games. In: Proceedings of the GAMNLP (2014)
52. Mateas, M.: Expressive AI: a hybrid art and science practice. Leonardo **34**, 147–153 (2001)
53. Mateas, M., Wardrip-Fruin, N.: Defining operational logics. In: Proceedings of the DiGRA (2009)
54. Maxis: The Sims. Electronic Arts (2000)
55. McCoy, J., et al.: Prom Week. In: Proceedings of the FDG (2013)
56. Meehan, J.R.: Tale-spin. In: IJCAI (1977)
57. Neff, M., Fiume, E.: Methods for exploring expressive stance. Graph. Models **68**, 133–157 (2006)
58. Osborn, J., et al.: Playspecs: Regular expressions for game play traces. In: Proceedings of the AIIDE (2015)
59. Park, A.: The Sims 2 review. GameSpot (2004)
60. Peinado, F., Gervás, P.: Transferring game mastering laws to interactive digital storytelling. In: Göbel, S., Spierling, U., Hoffmann, A., Iurgel, I., Schneider, O., Dechau, J., Feix, A. (eds.) TIDSE 2004. LNCS, vol. 3105, pp. 48–54. Springer, Heidelberg (2004)
61. Pizzi, D., et al.: Automatic generation of game level solutions as storyboards. Comput. Intell. AI Games **2**, 149–161 (2010)
62. Rank, S., et al.: Creativity in configuring affective agents for interactive storytelling. In: Proceedings of the ICCC (2012)
63. Reed, A.A., et al.: A step towards the future of role-playing games: The spyfeet mobile RPG project. In: Proceedings of the AIIDE (2011)
64. Riedl, M.O., Young, R.M.: From linear story generation to branching story graphs. Comput. Graph. Appl. **26**, 23–31 (2006)
65. Riedl, M.O., Young, R.M.: Narrative planning: Balancing plot and character. Artif. Intell. Res. **39**, 217–268 (2010)
66. Roberts, D.L., Isbell, C.L.: A survey and qualitative analysis of recent advances in drama management. Syst. Sci. Appl. **3**, 61–75 (2008)
67. Rohrer, J.: Passage (2007)
68. Rovio Entertainment: Angry Birds. Chillingo (2009)
69. Rowe, J.P., Ha, E.Y., Lester, J.C.: Archetype-driven character dialogue generation for interactive narrative. In: Prendinger, H., Lester, J.C., Ishizuka, M. (eds.) IVA 2008. LNCS (LNAI), vol. 5208, pp. 45–58. Springer, Heidelberg (2008)
70. Ryan, J., Walker, M.A., Wardrip-Fruin, N.: Toward recombinant dialogue in interactive narrative. In: Proceedings of the INT (2014)
71. Ryan, J.O., Barackman, C., Kontje, N., Owen-Milner, T., Walker, M.A., Mateas, M., Wardrip-Fruin, N.: Combinatorial dialogue authoring. In: Mitchell, A., Fernández-Vara, C., Thue, D. (eds.) ICIDS 2014. LNCS, vol. 8832, pp. 13–24. Springer, Heidelberg (2014)
72. Ryan, J.O., et al.: Toward natural language generation by humans. In: Proceedings of the INT (2015)

73. Silva, A., Raimundo, G., Paiva, A.C.R.: Tell me that bit again.. bringing interactivity to a virtual storyteller. In: Balet, O., Subsol, G., Torguet, P. (eds.) ICVS 2003. LNCS, vol. 2897, pp. 146–154. Springer, Heidelberg (2003)

74. Stern, A.: Embracing the combinatorial explosion: a brief prescription for interactive story R&D. In: Spierling, U., Szilas, N. (eds.) ICIDS 2008. LNCS, vol. 5334, pp. 1–5. Springer, Heidelberg (2008)

75. Suttie, N., Louchart, S., Aylett, R., Lim, T.: Theoretical considerations towards authoring emergent narrative. In: Koenitz, H., Sezen, T.I., Ferri, G., Haahr, M., Sezen, D., Ç atak, G. (eds.) ICIDS 2013. LNCS, vol. 8230, pp. 205–216. Springer, Heidelberg (2013)

76. Swartjes, I., Vromen, J.: Emergent story generation: Lessons from improvisational theater. In: Proceedings of the INT (2007)

77. Swartjes, I.M.T.: Whose story is it anyway?: how improv informs agency and authorship of emergent narrative. Ph.D. thesis (2010)

78. Theune, M., et al.: The virtual storyteller (2003)

79. Treanor, M., et al.: Proceduralist readings: How to find meaning in games with graphical logics. In: Proceedings of the FDG (2011)

80. Treanor, M., et al.: The micro-rhetorics of Game-O-Matic. In: Proceedings of the FDG (2012)

81. Truesdale, J., Louchart, S., Hastie, H., Aylett, R.: Suitability of modelling context for use within emergent narrative. In: Koenitz, H., Sezen, T.I., Ferri, G., Haahr, M., Sezen, D., Ç atak, G. (eds.) ICIDS 2013. LNCS, vol. 8230, pp. 65–70. Springer, Heidelberg (2013)

82. Walsh, R.: Emergent narrative in interactive media. Narrative **19**, 72–85 (2011)

83. Wardrip-Fruin, N.: Expressive Processing (2009)

84. Wardrip-Fruin, N., Mateas, M.: Envisioning the future of computational media: The final report of the media systems project (2014)

85. Weallans, A., Louchart, S., Aylett, R.: Distributed drama management: beyond double appraisal in emergent narrative. In: Oyarzun, D., Peinado, F., Young, R.M., Elizalde, A., Méndez, G. (eds.) ICIDS 2012. LNCS, vol. 7648, pp. 132–143. Springer, Heidelberg (2012)

86. Weiner, J.: Where do dwarf-eating carp come from. New York Times (2011)

87. Winslow-Yost, G.: SimCity's evil twin. The New Yorker (2013)

88. Yannakakis, G.N., Hallam, J.: Real-time game adaptation for optimizing player satisfaction. Comput. Intell. AI Games **1**, 121–133 (2009)

Reflective Rereading and the SimCity Effect in Interactive Stories

Alex Mitchell[✉]

Department of Communications and New Media,
National University of Singapore, Singapore, Singapore
alexm@nus.edu.sg

Abstract. Reflective rereading in print literature involves a critical or meditative re-examination of a work for deeper meanings. In this paper I argue that, in interactive stories, reflective rereading can involve examining the surface of an interactive work with the aim of gaining a deeper understanding of and appreciation for how the underlying computational system functions, and how this internal structure relates to the surface experience of the work as a story. I explore this through close readings of four interactive stories: *The Walking Dead (Season 1)*, *Façade*, *Prom Week*, and *Blood and Laurels*. Through this analysis, I make connections between this form of reflective rereading and Wardrip-Fruin's "SimCity Effect", suggesting a correspondence between works that afford reflective rereading and those that exhibit the SimCity effect. Further, I suggest that the abstractions used to represent the underlying system will impact whether or not an interactive story affords reflective rereading.

Keywords: Interactive storytelling · Reflective rereading · SimCity effect · Close readings

1 Introduction

One measure of the quality of a story is whether or not people want to go back and reread the story. With interactive stories, the process of rereading is complicated by the procedural, generative nature of the story - it is likely that on rereading, the reader will encounter a story that is subtly, or possibly drastically, different from what she encountered on previous readings. This raises the question of what form rereading takes in interactive stories.

In this paper, I focus on the problem of *reflective* rereading in interactive stories. Through a close reading of four interactive stories, I examine the relationship between reflective rereading and Wardrip-Fruin's "SimCity Effect" [2], which is manifest in systems where the audience's experience of the surface of the work enables the development of an understanding of the work's complex internal structure. I argue that reflective rereading depends on both the presence of the SimCity effect, and the use of appropriate narrative abstractions to foreground the underlying computational structure in the surface features of an

© Springer International Publishing Switzerland 2015
H. Schoenau-Fog et al. (Eds.): ICIDS 2015, LNCS 9445, pp. 27–39, 2015.
DOI: 10.1007/978-3-319-27036-4_3

interactive story in a way that encourages the player to pay attention to both the story and the underlying system.

Note that in this paper I am using the term "reading" to refer to the process of making choices and perceiving the outcome of those choices in an interactive story, and from those choices and outcomes constructing an understanding of the story, regardless of the medium used to convey the story. I use this term rather than "playing" or "interacting" to emphasize the importance of the experience of the story as part of the process of interacting with an interactive story.

The rest of this paper is structured as follows. I begin by briefly surveying previous work that has looked at rereading in interactive stories. I then propose the specific research problem I am investigating, and describe the close reading methodology used for my analysis. This is followed by a close reading of four interactive stories: *The Walking Dead (Season 1)* (TellTale Games, 2012), *Façade* (Mateas and Stern, 2005), *Prom Week* (Expressive Intelligence Studio, 2012), and *Blood and Laurels* (Emily Short, 2014). The paper ends with a discussion of the implications of my analysis, and some suggestions for future work.

2 Related Work

There has been some previous work to explore the repeat experience of interactive stories. Focusing on hypertext fiction, Bernstein et al. [3] describe rereading as opening up the possibility for multiple meanings to emerge as fragments of text are encountered in different contexts on subsequent readings, with readers motivated to reread to experience these variations. In contrast, researchers such as Harpold [4] and Douglas [5] argue that readers return to hypertext fiction, not to experience variation for its own sake, but rather to seek closure.

Bridging these two perspectives, Murray [6,7] has suggested that readers will want to repeatedly experience interactive stories to see different perspectives, and eventually achieve a form of second-order closure when they are able to perceive the larger system underlying the variations. Mitchell and McGee [8] expand upon this, suggesting that only after closure has been reached does a reader actually consider what she is doing to be rereading. After this, she will shift to something similar to Calinescu's [1] notion of simple or reflective rereading.

3 Research Problem

Previous work has suggested that readers of interactive stories initially reread for closure. There has not, however, been any work to explore what readers are doing when rereading after reaching closure.

Mitchell and McGee [8] suggest that rereading for closure is similar to Calinescu's [1] notion of *partial* rereading. Calinescu describes two other types of rereading: *simple* rereading, which involves an attempt to recapture the experience of the first reading, and *reflective* rereading, which involves stepping back and examining the text in a more analytical manner. Although Mitchell and McGee claim that after reaching closure, readers of interactive stories will engage

in either simple or reflective rereading, they do not explore in any detail what form these types of rereading may take in an interactive story.

According to Calinescu, reflective rereading in a non-interactive story involves looking analytically at a text in an attempt to find deeper meanings, to understand the process of reading, or to make sense of the way the text functions. In an interactive story, the meaning of a work often comes about, at least in part, through interaction. This suggests that one possible form of reflective rereading in an interactive story involves examining the surface of an interactive work that one has already read, with the aim of gaining a deeper understanding and appreciation of how the underlying system functions and how this internal structure relates to the surface experience of the work *as a story*.

In this paper, I explore the question of what it would take for an interactive story to successfully engage a reader in this type of reflective rereading.

4 Method: Close (Re)Readings

To explore the issue of reflective rereading in interactive stories, I conducted a series of close readings of interactive works that encourage or are positioned by the work's author(s) as intended to support rereading: *The Walking Dead (Season 1)*, *Façade*, *Prom Week*, and *Blood and Laurels*. I adopt Bizzocchi and Tanenbaum's [10] approach to close reading, where the critic explicitly formulates a set of "analytical lenses" through which to interrogate a work. In this case, I am specifically looking for ways that a text can be reread reflectively. This requires multiple readings, first to achieve closure, and then to continue rereading with the intent to look deeper into the work. I also bring to bear Wardrip-Fruin's three effects [2] – the Eliza, Tale-Spin and SimCity effects – as a means of examining the ways in which the surface and deep structure of the work interact, and how the resulting effect relates to the types of rereading afforded by the work.

5 *The Walking Dead* and the Eliza Effect

The Walking Dead (Season 1) is a graphical adventure game set in a post-apocalyptic world. You control the main character, Lee, as he and a young girl named Clementine try to survive the zombie apocalypse. In *The Walking Dead* an explicit attempt is made to show that your actions have an impact on the story. Early in my close readings, this emphasis on the importance of player choice gave me a sense that there is a complex system underlying the game, a belief that initially encouraged rereading to explore different endings. However, it quickly became evident that the game has a simple branching system, and that there is very little underlying complexity to this system. While this didn't reduce the satisfaction of rereading before the point where I achieved a sense of closure, it failed to encourage a more *reflective* rereading. I will now discuss this failure to encourage reflective rereading in more detail.

5.1 Creating the Expectation of a Complex System

From the very start, you are told that the game will be adapting to your choices. After the initial loading screen for each episode, the following text is displayed: "This game series adapts to the choices you make. The story is tailored by how you play." This immediately set up certain expectations, giving me a sense that there is a complex system underlying the game that is tracking my choices, and "tailoring" the story based on these choices.

The suggestion that there is a complex underlying system is repeated throughout the game. For example, after every "important" choice you make, the game indicates that the character you have just interacted with "will remember that." This reminds you that your actions will have consequences, suggesting that other characters will respond to Lee differently as the result of your choices.

The idea that there is a complex underlying system is further reinforced by the summary of the major choices you have made at the end of each episode, choices that presumably had an impact on the direction of the story, and that will be carried over to the next episode. There is even a comparison shown between the choices you made and choices made by other players. Finally, at the end of Season One, a detailed summary is provided of the choices you made and the related actions taken by the other characters.

5.2 Breaking the Illusion of Complexity

All of these examples show ways that the game makes an effort to convince you that there is a complex underlying system tracking the decisions you make, and altering the ways that the characters within the game world respond to you, with a corresponding impact on the direction of the story. And these choices do, on the whole, have an impact. The story goes down different branches and characters will react differently to Lee depending on choices you have made earlier in the story. However, on repeat readings, it quickly became evident that the game is very much like a branching "choose-your-own-adventure" story, with very little underlying complexity, and in fact very little deviation from the main storyline.

This can be seen by examining one of the choices that occurs early in the game. Soon after Lee met Clementine, I was faced with a seemingly important decision. Lee had just told Clementine that he will help look after her until her parents return, and she asked, "What should we do now?" I was given two choices: "Look for help, before it gets dark" or "Get out of here once the sun goes down". Choosing the first option led to an encounter with two men, Shawn Greene and Chet. Following an initial confrontation, they agreed to take Lee and Clementine to Shawn's father's farm. After escaping from a zombie attack, the group proceeded to the farm, and Chet headed home. When, on a subsequent reading, I instead chose to wait until nightfall, Lee and Clementine encountered Shawn and a policeman, and the group were attacked by a group of zombies that included Shawn's friend Chet (now a zombie). Again, after surviving the attack, the group proceeded to the farm, and the policeman drove off.

These two paths through the story provided a different experience, but quickly converged. The only long-term consequence was on Chet, who was safely at home in one branch, and became a zombie in the other branch. As Chet is a minor character who is never mentioned again, there was clearly no impact on the overall story. While this didn't detract from my immediate experience of the story, it did reduce rereading to a process of revealing the limitations of the system. As I explored alternative paths I came to see that, in the end, my choices had very little impact on what actually happened in the main story. This in turn suggested that, despite the repeated suggestions by the in-game text and my experience during an initial reading, there was no complex underlying computational system. Although I could enjoy re-experiencing the game, either as partial rereading or simple rereading, there was little opportunity for me to engage in reflective rereading.

5.3 The Eliza Effect: No Motivation for Reflective Rereading

What is happening here is an example of the "Eliza" effect. Named after Weizenbaum's [11] early chatbot, the Eliza effect describes how people's expectations of a system can (initially at least) make the system appear much more complex than it actually is. As Wardrip-Fruin [2] discusses, this illusion tends to break down during interaction, revealing the actual simplicity of the underlying system. In *The Walking Dead*, both the surface behaviour and the messages shown in the user interface suggest a complex underlying system. However, on repeated readings, it becomes clear that there is no such complexity - while there are a number of branches, and there is some intermixing of content based on player choice, the overall story is fixed. Branches eventually converge, and the differences in the story do not have a major impact on the player's experience. It is a testament to the craftsmanship put into *The Walking Dead* that the story remains engaging and enjoyable on repeated readings, despite the lack of complexity to the underlying system. However, once I had "got it", after 2 or 3 sessions, there was little reason to reread.

In *The Walking Dead*, an attempt is made to foreground the complexity of the system, a complexity that does not actually exist. This is something Wardrip-Fruin cautions against [12,13], suggesting that if the goal is to provide the interactor with a sense of dramatic agency within a coherent storyworld, it is more appropriate to create an actual complex computational system, and then enable players to develop an understanding of that system. The question then is how the presence of such a complex underlying system relates to the player's ability to engage in reflective rereading. To explore this, I will now examine a work that clearly does have a complex underlying system: *Façade*.

6 *Façade* and the Tale-Spin Effect

Façade is an interactive drama in which you take on the role of an old friend of a married couple, Trip and Grace, who becomes embroiled in a marital dispute

that you can nudge towards a number of possible resolutions. You interact with *Façade* by typing unstructured text, which is then translated into discourse acts [14]. These discourse acts trigger reactions from the system. The reactions consist of local responses from the characters and the initiation of new "beats" within the system's story model. The system also tracks the characters' perception of your affinity towards one or the other of the two main characters, and, in the second half of the experience, the degree to which the main characters have achieved some level of self-realization.

6.1 Lack of Surface Visibility of the System

Despite the presence of this underlying system, it is not directly visible to the player. Several layers of abstraction separate the surface layer and the underlying state, making it difficult to determine the impact of player actions on the system. In addition, as the authors explain, "the score is not directly communicated to the player via numbers or sliders, but rather via enriched, theatrically dramatic performance" [14, p. 5]. What is most visible is the triggering of story fragments (beats), and the changes of expression on the characters' faces. The multiple layers of abstraction between player action and change in underlying state, the lack of any direct feedback, and the wide range of possible player inputs can make it challenging for the player to develop an awareness of the system.

This challenge can be seen in an example from early in the story. Soon after my character arrived at the apartment, Trip mentioned a photo he took on a recent holiday in Italy. When I complimented Trip on the photo, Trip smiled and said, "Oh, ha ha, ha ha, yeah" somewhat nervously, while Grace frowned, and said, "Careful, too many compliments can go to Trip's head." There was clearly something happening here at the story level: Trip is proud of the photo but knows that Grace doesn't like it, whereas for Grace the photo is connected to deeper resentment on her part regarding issues within their marriage. This resentment is hinted at in the subsequent dialogue between Grace and Trip:

> Grace: [name], this is making you uncomfortable. See Trip, was it really worth flying all the way to Italy so you could take that inane picture?
> Trip: Grace!
> Grace: I'll take the picture down before I go to bed.
> Trip: [name], that trip was supposed to be our second honeymoon!
> Grace: Oh, is that what it was? Why am I always the last to know?

Although my actions were having an impact on the system's affinity model, an impact that becomes visible later in the story, there was no immediate feedback as to the relationship between my actions and the change in the underlying system state. This makes it unlikely that the average player will become aware of the underlying complexity of the system.

6.2 The Tale-Spin Effect: Lack of Visibility Impedes Rereading

Unlike *The Walking Dead*, in *Façade* there *is* indeed a well-documented, complex underlying system [14]. However, this complexity is not particularly evident on

the surface to the naive player. This lack of visibility of the underlying system can have a impact on how players read, and reread, the story.

On my first reading, I tended to focus on moving the story towards a satisfying conclusion, using the characters' reactions as a way to determine, to some extent, how my actions impact the story. On repeated readings, as an informed player who was already aware of the existence of the underlying system, I was able to engage in reflective rereading, exploring the relationship between discourse acts and the long-term behaviour of the characters. However, as observed by Knickmeyer et al. [9] and Milam et al. [15], naive players instead tend to switch to "playing with the system". This switch from engaging with the story to pushing the boundaries of the system is a result of the player's frustrated attempts to understand the system. It is easier, and more immediately gratifying, to see how fast you can be kicked out of the apartment for bad behaviour, rather than trying to make sense of the subtle relationships between your actions and the underlying social simulation. This behaviour is not something that can be equated with reflective rereading.

This failure to appreciate, or even notice, the presence of the complex underlying story system is similar to Wardrip-Fruin's [2] "Tale-Spin" effect. Named after Meehan's [16] story generation system, the Tale-Spin effect describes the situation where the interactor fails to see the underlying complexity of a system in the surface representation. In *Façade*, the presence of the Tale-Spin effect makes it unlikely that naive players will engage in reflective rereading.

I will now compare the lack of visibility of the underlying system in *Façade* with the ways that the system is exposed to the player in *Prom Week*, and consider how the resulting visibility of the system impacts reflective rereading.

7 *Prom Week*: Focusing on the System, Not the Story

Prom Week is a social simulation/puzzle game in which you manipulate the relationships between a group of high school students in the week leading up to the prom. In *Prom Week*, as with *Façade*, there is a well-documented, complex underlying system, in this case a form of "social physics" [17] simulating the web of relationships between the students. This system is meant to enable the player to experience "numerous playable stories" [18, p. 102]. Unlike *Façade*, in *Prom Week* the details of the system are explicitly brought to the surface in the user interface. However, as I discuss below, there are still some issues that made it difficult for me to engage in something that can truly be regarded as reflective rereading. In particular, my focus was very much on solving puzzles within the social simulation, with little attention given to the *story*, particularly when rereading.

7.1 Playing Social Games

In *Prom Week* you are controlling a group of characters, and can take action to determine how the characters interact with each other so as to achieve certain goals. For example, in the story "Zack: Your Next Prom King", you are

given three goals to complete: "Sweet Talk the Judge", "Sabotage the Competition", and "Smokin Date". Each of these goals requires specific manipulations of the relationships between the characters. The goal "Sweet Talk the Judge", for instance, requires that you "Make Zack and Naomi friends".

The first scene in the story is set in the school carpark, where Naomi (the judge), Zack, and Monica are hanging out. You can select any of the three characters and see the relationship between the selected character and the other characters in the scene. Each character has a rating showing how that character views the other characters in terms of "friendship", "romantic feeling", and "coolness". You can initiate social actions for the selected character to take towards another character, each of which will have consequences in terms of the relationships. For example, Zack can "confide" in Naomi, which will make Zack and Naomi friends. In this case, the action will also, by creating a friendship between the characters, satisfy Zack's goal of sweet-talking the judge.

7.2 SimCity Effect, but No Reflective Rereading

On my first reading, I focused on solving the puzzle of how to achieve the desired outcomes for the various characters. This involved exploring the relationships between the characters and figuring out which statistics need to be manipulated to achieve the best results. On repeat readings, the surface behaviour I observed began to reveal the underlying system, and I began to develop an understanding of this system through interaction. This is what Wardrip-Fruin refers to as the "SimCity" effect. This effect describes "systems that shape their surface experience to enable the audience to build up an understanding of a relatively complex internal structure" [2, p. 13].

Despite this, there was little focus on the *story* as part of this process. What I was beginning to understand was the correspondence between character actions and changes in character relationships within the social simulation, changes that lead towards achievement of the goals set by the system. There is, however, no modelling or representation here of any *story* structure. It is not clear, therefore, whether the type of repeat experience that I engaged in with *Prom Week* can be considered the type of reflective rereading I am examining, where the player is exploring the underlying computational system in the context of its relationship to the story, as opposed to focusing exclusively on the system.

To investigate this problem, I will now examine the experience of rereading *Blood and Laurels*, an interactive story that *does* afford reflective rereading.

8 *Blood and Laurels*: Visibility of the Story As System

Blood and Laurels is a choice-based interactive story set in Roman times. Built with the *Versu* storytelling system, it has a rich underlying model of character motivations and relationships that drives the narrative [19]. You control the main character, Marcus, by making choices from a list of options. The results are displayed as text and the occasional illustration.

As with *Prom Week*, the underlying system state in *Blood and Laurels* is explicitly represented to the player. In this case, the other characters present in the current scene are represented by a series of "portraits" at the bottom of the screen. These character portraits change subtly based on the current attitude of the characters, with facial expressions reflecting the character's mood. Selecting a portrait provides status information, often consisting of either details of the character's relationship with other characters in the story, or a comment on the current scene and the character's feelings as to how the scene may progress.

For example, in the first scene in the story Artus, a powerful politician and patron to the main character, is throwing a party. When a bad omen appears, Artus's status displays the following: "Artus looks annoyed. 'I don't want strange things happening at my dinner party.'" This status information represents both the current state of the character (annoyed), and a potential trajectory for the story (Artus's fears for what may transpire at his party). I will argue that this representation of both the current state of the character and the character's feelings about possible future events has an impact how players read, and reread, the work.

8.1 Understanding the System's Relationship to the Story

As I read and reread *Blood and Laurels* it gradually became clear how the system underlying the story works, as I observed the reactions of the various characters to my actions and compared those reactions to the same characters' reactions on previous readings. How this happens can be seen in a scene near the mid-point of the first part of the story.

Marcus has been ordered by Artus to visit the temple to ask the priestesses for a divination regarding Artus's desire to become Emperor. One of the priestesses is Gila, a woman Marcus knows from his time before coming to Rome. During this scene, in addition to negotiating with the priestesses to arrange for the divination, Marcus is given a number of opportunities to interact with Gila. Options range from the deliberately cold "Make some ritually appropriate response", to the carefully neutral "Comment on finally seeing the place where she was so determined to serve", and finally the more clearly suggestive "Compliment her on retaining her beauty".

My choices had an immediate impact on both Marcus's and Gila's attitudes, as reflected in the portraits at the bottom of the screen. For example, choosing the more flirtatious option led to Marcus's status displaying: "Marcus looks amused. 'I missed Gila.'" At the same time, Gila's status displayed: "Gila looks pleased. 'I've found a new flirt.'" These indicators, together with the pleased expressions on the faces in the portraits, provided immediate feedback as to the impact of my choices.

However, the impact was not only on the immediate state of the characters. As the story progressed, the actions available and the responses from the other characters clearly corresponded to the attitudes of the characters shown in the portraits and status display. The status displays also changed to reflect characters' thoughts about the events that had transpired in the story, and the

possible future direction of the story. For example, after Marcus hears from the Oracle that he, not Artus, is destined to be Emperor, his portrait changes from his earlier amused expression to a look of fear. Mirroring this, his status display now reads "Marcus looks worried. 'Whatever this means for me, it sounds dangerous.'"

After a second or third reading, I began to understand how the system works. Although I had not encountered all the possible variations of the story, it was possible to develop a sense of how my choices impacted the characters and the direction of the story. It was still difficult to predict the characters' responses at times, but this only made the experience more interesting, and contributed to my desire to continue to reread. What is being created here is a desire to reread to explore the *system*, and to deepen my understanding of the way the system works. At the same time, I was also paying attention to the *story*, and how the system of character relationships and plot points interacted with each other and influenced the progression of the story.

8.2 The SimCity Effect in Support of Reflective Rereading

As with *Prom Week*, the visibility of the underlying system enabled me to begin to grasp the relationship between my actions and the resulting surface details, and, more importantly, the ways that these surface details relate to the underlying system model. Both works seem to be exhibiting the SimCity effect. However, in *Blood and Laurels* I could focus on both the story *and* the underlying system at the same time. Whereas in *Prom Week* it was easy to become fixated on achieving the specified goals by manipulating the relationships between the characters, in *Blood and Laurels* my attention was fixed on the ways that the story could progress as the result of these changes in character relationships. I will explore this subtle difference in the next section.

9 Discussion: The Importance of Narrative Abstractions

The important question here is: *why* did I pay attention to both the story and the system simultaneously in *Blood and Laurels*, whereas in *Prom Week* I was more focused on the system at the expense of the story? One way to think about this is to examine what "system" it is that readers might be looking for as they reread traditional, non-interactive stories, and then consider what the equivalent system would be in an interactive story.

According to Janet Murray, "[o]ur story traditions make up an abstraction system for understanding ourselves and the world around us" [7, p. 19]. With this in mind, notice that a key difference between *Prom Week* and *Blood and Laurels* is the choice of abstraction used to represent the state of the underlying system.

Although the designers of *Prom Week* deliberately chose not to present "social state information in menus or an abstract information bar", instead presenting these details "as if they were the thoughts of the characters" [17, p. 100], the underlying system is a simulation of social interaction, not a story system. The state of the characters' relationships directly reflect the underlying simulation, and the actions available to the player are in the form of social moves. As Murray has observed, this focus on the details of social reality creates "a mismatch between computational abstraction and dramatic abstraction" [20], leading me to focus on the social system, but not the story. It is important to stress that this is despite the intention of the designers that each playthrough of *Prom Week* create "a possible world that is *narratively* significant [my emphasis]" [18, p. 98].

In contrast, although it also deals with social interaction and relationships between characters, *Blood and Laurels* does not present the player with abstractions based on a social simulation, but instead presents a narrative abstraction. The state displayed to the player includes not just the characters' feelings towards other characters, but also the characters' considerations of what may happen next. This provides a glimpse into the state of the story system, providing appropriate detail for the player to form a mental model of the *story* system without fixating on the details of the underlying *computational* system. By foregrounding and surfacing this narrative abstraction system, grounded in the reality of the storyworld, *Blood and Laurels* encouraged me to engage in reflective rereading to better understand the underlying story system.

10 Conclusion and Future Work

In the above discussion of *The Walking Dead*, *Façade*, *Prom Week* and *Blood and Laurels*, I have argued that there is a connection between the presence of the SimCity effect and the desire to engage in reflective rereading. However, I have suggested that it is not enough for a work to exhibit the SimCity effect for the work to afford reflective rereading. For reflective rereading to take place, the work must encourage the player to reread to simultaneously examine both the underlying system and its relationship to the player's experience of the story. For this to occur, the abstractions used to represent the underlying system at the surface of the work should be chosen carefully so as to convey this relationship.

In this paper, I have explored the problem of reflective rereading through close readings of four well-known interactive stories. This will help authors to create interactive stories that encourage players to engage in deeper, more reflective rereading. Future work will involve empirical studies of player response when rereading interactive stories to validate these initial findings, and the development of new interactive stories to explore design requirements for encouraging this type of reflective rereading. Work should also be done to investigate whether and how other forms of rereading found in non-interactive stories, such as simple rereading, manifest in interactive stories, and how rereading relates to other forms of repeat experience, such as replaying non-narrative games.

Acknowledgments. This work is funded under the Faculty of Arts and Social Sciences, National University of Singapore grant "Authoring Paradigms and Representation in Interactive Storytelling Tools".

References

1. Calinescu, M.: Rereading. Yale University Press, New Haven (1993)
2. Wardrip-Fruin, N.: Expressive Processing: Digital Fictions, Computer Games, and Software Studies. The MIT Press, Cambridge (2009)
3. Bernstein, M., Joyce, M., Levine, D.: Contours of constructive hypertexts. In: Proceedings of the Hypertext 1992, pp. 161–170. ACM (1992)
4. Harpold, T.: Links and their vicissitudes: Essays on hypertext. Ph.D. thesis, University of Pennsylvania (1994)
5. Douglas, J.Y.: The End of Books - or Books Without End? Reading Interactive Narratives. University of Michigan Press, Ann Arbor (2001)
6. Murray, J.H.: Hamlet on the Holodeck: The Future of Narrative in Cyberspace. The MIT Press, Cambridge (1998)
7. Murray, J.H.: Why paris needs hector and lancelot needs mordred: using traditional narrative roles and functions for dramatic compression in interactive narrative. In: Si, M., Thue, D., André, E., Lester, J., Tanenbaum, J., Zammitto, V. (eds.) ICIDS 2011. LNCS, vol. 7069, pp. 13–24. Springer, Heidelberg (2011)
8. Mitchell, A., McGee, K.: Reading again for the first time: a model of rereading in interactive stories. In: Oyarzun, D., Peinado, F., Young, R.M., Elizalde, A., Méndez, G. (eds.) ICIDS 2012. LNCS, vol. 7648, pp. 202–213. Springer, Heidelberg (2012)
9. Knickmeyer, R.L., Mateas, M.: Preliminary evaluation of the interactive drama Facade. In: CHI 2005 Extended Abstracts, pp. 1549–1552. ACM Press (2005)
10. Bizzocchi, J., Tanenbaum, J.: Well read: applying close reading techniques to gameplay experiences. In: Davidson, D. (ed.) Well Played 3.0, pp. 262–290. ETC Press, Pittsburgh (2011)
11. Weizenbaum, J.: Eliza-a computer program for the study of natural language communication between man and machine. CACM **9**(1), 36–45 (1966)
12. Wardrip-Fruin, N.: Beyond the complex surface. In: Schäfer, J., Gendolla, P. (eds.) Beyond the Screen: Transformations of Literary Structures, Interfaces and Genres, pp. 227–248. Transcript Verlag, Germany (2010)
13. Wardrip-Fruin, N.: Reading digital literature: Surface, data, interaction, and expressive processing. A Companion to Digital Literary Studies, pp. 163–82 (2013)
14. Mateas, M., Stern, A.: Procedural authorship: a case-study of the interactive drama Façade. In: Proceedings of Digital Arts and Culture (DAC) 2005 (2005)
15. Milam, D., Seif El-Nasr, M., Wakkary, R.: Looking at the interactive narrative experience through the eyes of the participants. In: Spierling, U., Szilas, N. (eds.) ICIDS 2008. LNCS, vol. 5334, pp. 96–107. Springer, Heidelberg (2008)
16. Meehan, J.R.: Tale-spin, an interactive program that writes stories. In: Proceedings of the 5th International Joint Conference on Artificial Intelligence, pp.91–98 (1977)
17. McCoy, J., Treanor, M., Samuel, B., Reed, A.A., Mateas, M., Wardrip-Fruin, N.: Prom week: Designing past the game/story dilemma. In: FDG, pp. 94–101 (2013)

18. Samuel, B., Lederle-Ensign, D., Treanor, M., Wardrip-Fruin, N., McCoy, J., Reed, A., Mateas, M.: Playing the worlds of prom week. In: Hatavara, M., Hyvärinen, M., Mäkelä, M., Mäyrä, F. (eds.) Narrative Theory, Literature, and New Media: Narrative Minds and Virtual Worlds, pp. 87–105. Routledge, New York (2015)
19. Evans, R., Short, E.: Versu-a simulationist storytelling system. IEEE Trans. Comput. Intell. AI Games **6**(2), 113–130 (2014)
20. Murray, J.H.: A tale of two boyfriends: A literary abstraction strategy for creating meaningful character variation. In: Koenitz, H., Ferri, G., Haahr, M., Sezen, D., Sezen, Tİ. (eds.) Interactive Digital Narrative: History, Theory and Practice, pp. 121–135. Routledge, New York (2015)

Tensions of Plot in Interactive Digital Storytelling

Colette Daiute[✉]

The Graduate Center, City University of New York,
New York, NY, USA
cdaiute@gc.cuny.edu

Abstract. This paper focuses on plot as a mediator of interactive digital storytelling (IDS). Drawing on a theory of narrative applied to IDS, the paper focuses on the manifestation of plot across three different IDS contexts. After defining plot, plot elements, and plot analysis, I explain the sampling of the three IDS types considered with plot analysis in this inquiry. The plot analyses of 116 IDS entries by youth and young adult participants within and across those IDS types revealed patterns of stability and variation of plot elements. The foundational nature of plot and its sensitivity to context outside as well as within the narrative scene are evident as participants in complex narrative systems used plot elements to communicate and to innovate. Future research can test and extend plot analysis for further application to IDS research and design.

Keywords: Interactive digital storytelling · IDS theory · Narrative analysis of IDS · Plot analysis · Implications for IDS design research and design

1 Plot - A Narrative Lens on Interactive Digital Storytelling

Interactive digital storytelling is a symbolic system of communication and imagination. As such, IDS requires conformity as well as creativity. This tension is prominent from the perspective of a narrative theory of use, positing that narrating is an interactive process of meaning making during story interpretation, generation, and transformation [1]. According to this theory, the implicit goal of narrating is to <u>do</u> something serving one's curiosity, pleasure, understanding, and participation in ways that connect with actual and imaged others and objects in the environment [2]. In this process, social motivations, such as to connect and to communicate are in tension with individual motivations to discover, to create, to play, and to contribute in original ways. The device at the center of such interactive narrating is plot – narrative structure and elements that are lenses in narrative discourse. As a cultural tool, narrative plot enables thinking and emotion but also constrains it so that shared meaning and symbolic journeys are possible [3, 4]. Given the extensive symbolic resources and processes of IDS, what can we learn about the tension between conformity and creativity from plot analysis of diverse IDS contexts? What do findings from plot analysis indicate for future IDS research and design?

© Springer International Publishing Switzerland 2015
H. Schoenau-Fog et al. (Eds.): ICIDS 2015, LNCS 9445, pp. 40–49, 2015.
DOI: 10.1007/978-3-319-27036-4_4

This paper offers a definition of plot and plot analysis applied to three types of IDS to examine the applicability of plot analysis and its contribution to understanding how participants engaging in complex narrative systems conform to a storyline yet also expand and change it. Researchers and practitioners applying IDS in educational and professional contexts mention creating storyboards in their guidelines to the development process [5], yet few discuss the intricacies of plot, such as tensions between its enabling and constraining features. To consider whether and how plot is a tool that participants in IDS systems use, this paper presents findings and implications of systematic plot analyses of 116 IDS entries by youth and young adult participants within and across diverse contexts.

2 Plot Theory

The appearance of life in the art of narrating comes, at least in part, from the cultural organization of events and characters in plots. Narratives apparently mirror life events, providing what people perceive as logical progressions of events, characters' feelings about events, and resolutions. Because the plot structure—*what happened*—is a human invention, with some remarkably common qualities across cultures as well as important differences, it's *how* the story unfolds in a certain way that indicates some of *why* the story is meaningful. Embedded in the cultural development of narrating is the concept of plot—the skeleton of meaning—*what happened* based on *what matters*. Consistent with these observations is the theoretical premise that plots are cultural tools organizing perception, action, and interpretation. The plot structure of a narrative imposes some order to imagined communication, reflection, and engagement, while allowing alteration for author/speaker/reader purposes and play.

The how and why to structure a story is learned early in life and develops across the life span. As we participate in culture(s) – such as home, school, gaming, and digital storytelling environments – we become socialized to the practices and meanings therein and guide our participation in ways that connect but also extend us via intrigue, surprise, and innovation. From readers' and authors' perspectives, story meaning – and a reason for interacting – comes in large part from their sense of the evolving plot as integrated with sub-plots, parallel plots, and so on as these relate to some personal or collective purpose. With familiarity of narrative plot, a reader's pulse might quicken, for example, in anticipation of a beloved character's plight as the story progresses. Allowing ourselves to play along emotionally and thoughtfully with the rising action of a plot is also pleasurable because we sense that the plot will resolve in some way that will relax us or, at least, offer closure. To create and make one's way through complex narratives, a participant uses plot structure. Because interactive digital storytelling compounds the complexity of the narrating process, understanding the role of plot is important for understanding IDS, that is to understand how people make their way through complex multi-dimensional symbolic environments.

3 Plot Analysis

Plot analysis is a tool for understanding how participants manage conformity and flexibility in storytelling. Plot analysis is, thus, focused on identifying the important dimensions of socio-cognitive functions of plot and plot elements. This focus on plot analysis is consistent with other contemporary studies: "First, one has to identify what are the "features" or "parameters" in an interactive narrative experience that could be of interest, for example narrative intelligibility, closure, surprise, suspense, etc. Second, one has to define what are the cognitive processes, faculties or tasks that relate to the narrative features or parameters that have been chosen as relevant...[6]".

3.1 Plot and Plot Elements

Literary theorists' debates about the nature and variation of plot have informed the present study. Applying plot theory to analysis of narratives by people in everyday life and diverse cultural practices, this study employs the following definitions of plot and plot elements. Plot is the skeleton of the story, typically imperceptible under the story's flesh and dressing, including, albeit with some of these elements in varying combinations: character(s) setting(s), an initiating action, rising and falling actions around a high point/turning point, or climax and, sometimes, a coda or moral/afterthought. Plot elements for the analyses discussed in this paper are defined in detail elsewhere [2] and briefly herein. Settings describe physical location (such as specific or general places) and symbolic locations (background information, memories, etc.). Initiating actions are events that launch and motivate the plot. Complicating actions build in relation (toward and/or away from) the initiating action and high point/turning point/climax, which is the point of the story, often involving the interaction of character and conflict around which the story turns. Like other elements, high points appear in different places in a narrative but always in relation to the other elements. Resolution strategies are attempts to rest the plot conflict, and because speakers, writers, and narrators using visual media in everyday life do not necessarily produce well-formed complete narratives that build toward an ultimate resolution, resolution strategies mark attempts to address issues raised in the high point and initiating action. Characters may invoke people, other animate beings, or other kinds of actors (such as a "magic spell"). The whole narrative is the unit of analysis, thus requiring understanding these elements as they function together. A coda is an explicit reflection on the story, complementing any implied moral. Character mentions are names, categories, pronouns referring to the story actors, and character enactments bringing those actors to life psychologically, such as with expressions of cognition and affect. Plot categories such author/reader interaction and genre are added to account for authors' exiting the flow of narrative events to interact with the story, with readers/listeners, or co-authors directly.

One example of an IDS activity, typical of digital and traditional progressive and collective story generation, was begun with a story seed – a brief scenario to be completed and shared by many authors [7]. The following story seed was introduced to young people who had agreed to participate in a range of online and offline activities in community centers for youth growing up during and after war.

"_____ and _____ (fill in characters' names, from two groups) met at a ground-breaking of the new town center building. Everyone at the event had the opportunity to break the earth for the foundation and to place a brick for the building. It was an exciting community event and everyone was pleased that the new building would mark a new future. As they were working to begin the foundation, they had a conversation about how they would like to make a difference in their town so their children could live happily together. All of a sudden, someone came with news that changed every-thing! What was the news? How did everyone involved think and feel? How did it all turn out?"

Participants contributed story completions, shared them across an interchange platform established for the project, and then selected entries to include in newsletters appropriate to each setting. The following story completion illustrates a response and, after that, a plot analysis of the story.

The news was that the main investor wasn't able to provide the money he had promised and that the building process would be postponed for an undetermined period of time. The citizens felt betrayed. They had the right to protest; they chose this government and now the government didn't want to give them the money that was essential for the town. The citizens decided to strike and the government was forced to give them the money.

Setting: Not explicitly stated (seems to assume the setting of the story seed).
Characters:
Character mention(s): *main investor, he, the citizens, they, them government*
Character enactment(s): *promised; chose, felt betrayed, decided; didn't want;*
Initiating action: *The news was that the main investor wasn't able to provide the money he had promised and that the building process would be postponed for an undetermined period of time.*
Complicating actions: *The citizens felt betrayed. They had the right to protest; they chose this government and now the government didn't want to give them the money that was essential for the town.*
High point/Turning point/Climax: *The citizens decided to strike*
Resolution strategies: *and the government was forced to give them the money.*
Coda: None stated

A typical variation on this story completion would, for example include additional complicating actions and/or additional resolution strategies, as well as a different specific initiating action and high point.

3.2 Plot Analysis Process

The plot analysis process requires reading each narrative several times to familiarize one's self with it. Narratives are formatted and entered into a digital database such as *Atlas ti* qualitative data analysis program, where each data set is organized as a "Hermeneutic Unit (HU)" for coding, compiling codes, and uploading to an Excel spreadsheet or standard statistical analysis programs. Plot elements (presented in

Sect. 3.1) are entered into the HU as "codes" that the researcher assigns via pull-down menus to relevant sentences within each narrative. After each IDS database is coded and checked for reliability achieving at least 85 % agreement, the researchers select an *Atlas* output for summaries by code and other relevant dimensions, such as for participants, narrating experiences, and so on.

3.3 IDS Sampling for Plot Analysis

IDS contexts for this paper were selected to vary IDS type, mode, and interactivity. The IDS types are consistent with some of the variety of IDS alternatives including online story completions, fan fiction, and video postings. The story completion IDS type presented above was introduced to participants interacting face-to-face and online in non-governmental organizations and sharing story completions digitally. The fan fiction type of IDS sampled for this study was generated from the popular Harry Potter book series in an online fan-judged contest for the best chapter following the end of the book series and related posts by fans [8, 9]. The home-made video stories were generated as assignments to share a story about experiences during foreign study and shared in relevant ways.

The IDS modes across these types varied from writing only to audiovisual and writing plus graphics, with plot analysis applied across the modes. Interactivity across the three sampled types range from solely online to combinations of offline and online among anonymous participants to a mix of known and anonymous interlocutors. This sampling is, thus, illustrative of different IDS alternatives, and while those features of mode and interactivity are not systematically varied for this study, plot analysis is applied consistently across these IDS contexts for inquiry into whether and how plot provides a means for our learning about stability and variation in research and design.

4 Results of Plot Analysis of Three Types of IDS

The sections that follow describe plot analyses within and across three types of interactive digital storytelling. I applied the same plot element categories, compilations of frequencies of plot elements (and percentages where relevant), and considerations of patterns of similarity and difference within and across the data sets.

Tables presenting the plot analysis results followed by a brief discussion of those results address questions about how the plot analysis accounted for the diverse IDS contexts.

4.1 Plot Analysis of IDS Story Completions by Youth of the Former Yugoslavia

Plot analyses of multi-modal interactive storytelling came from an activity coordinated with community centers across separated countries following the 1990s wars that shattered the former Yugoslavia. Story authors included 76 youth and young adults who had grown up during and after the wars. One of their digital activities was writing an ending to a story seed intended to be evocative and generative for participants who

Table 1. Number and percentages per plot element to total plot elements in story completions by youth across post-war former Yugoslavia

Plot element	In story completions from		
	Bosnia (21 entries) N/%	Croatia (37 entries) N/%	Serbia (18 entries) N/%
Setting	6/2.5	15/3.8	8/3.0
Character mention(s)	98/40.8	221/46.9	139/52.2
Character enactment(s)	51/21.2	89/18.9	37/13.9
Initiating action	22/9.2	36/7.6	18/6.8
Complicating action(s)	35/14.5	62/13.2	24/9
High point/Turning point/Climax	16/6.6	31/6.6	15/5.6
Resolution strategy(ies)	11/4.6	13/2.8	22/8.3
Ending/Coda	1/0.4	4/0.8	3/0.11
Total codes	240	471	266

had experienced oppressive war and post-war narratives. Table 1 presents the number and percentages of plot elements of story completions by participants across locations.

Analysis of participants' entries indicated a range of plot structures, conforming and differing in several ways. In spite of the diversity of plot elements participants used to extend the story seed, results indicate a striking similarity in organizing narratives around settings and high points. Although a setting had been established, participants tended to expand upon that in similar ways across the country settings, as they did by structuring their stories around a high point. Another similarity across the country settings was the relative lack of a coda, which in some other IDS contexts is prominent. Beyond these uses of common plot elements, which may be anchoring structures, differences in participants' uses of some plot elements indicate diverse creative engagements with the story. As shown in Table 1, participants in Bosnia tended to express character enactments (feelings, thoughts, etc.), initiating actions and complicating actions relatively more than their peers in Croatia and Serbia. Participants in Serbia, in contrast, tended to mention relatively more characters and resolution strategies than their peers in the other countries. Differences in those country settings, in particular the post-war political-economic circumstances, appear to resonate with the uses of plot elements, such as ongoing tensions in Bosnia reflected in multiple initiating actions, complicating actions, and character feelings, and a need in Serbia to atone for war aggressions committed by their country, as reflected in the relatively extensive resolution strategies. Most important for the present inquiry into the functionality of plot analysis is that it offers sensitivity to means of conforming to a story path while also expanding it diverse ways as relevant to conditions outside the story.

4.2 Analysis of Interactive Plots in an IDS Fan Fiction Context

The fan fiction database sampled relevant entries from "Mugglenet", including a prize winning post-series chapter by a fan, extensions of and commentaries about the chapter,

and YouTube posts about Hermoine, a protagonist of the Harry Potter book series. The fourteen related entries contribute to a narrative history of the protagonists as they lived on in fan fiction. Table 2 presents the frequency of plot element assignments to seven of the entries that conform to basic narrative and seven other entries involving interaction among the diverse participants around the fan fiction event of the new chapter. Because this IDS involved direct interaction among participants, plot categories including "participant direct interactions," "about genre," and "about one another" were added to the analysis.

As shown in Table 2, the favored plot elements by participants in this sample revolved around character development (character mentions and character enactments) and participant direct interactions.

Table 2. Number of plot elements across entries in post-Harry Potter fan fiction

Plot element	Frequency
Setting	7
Character mention(s)	42
Character enactments(s)	26
Initiating action	7
Complicating action(s)	17
High point/Turning point/Climax	6
Resolution strategy(ies)	7
Ending/Coda	0
Participant direct interactions	52
About genre	20
About one other	23

Plot analyses indicated that character enactments (affect and cognition in relationships) were central to this fan fiction context as was the direct interaction among participants about the text. Such direct interaction about the text more than through text may be characteristic of fan fiction where connecting directly appears to be as salient as connecting through story mediation.

4.3 Videolog Narratives of Foreign Students' Experiences in Italy

Study abroad experiences tend to be poignant and shared extensively via diverse media. A sample of narratives in a study by Alessio Surian and Christian Tarchi involves an audio-visual mode of narrating increasingly common via media like YouTube [10]. Data from a practice involving foreign students' sharing diverse experiences in 2-minute videologs provide another rich option for examining plot analysis. Student-made videologs about memorable incidents in Italy generally and in their education training practice were transcribed, entered into the *Atlas ti* database, and analyzed for plot. Video narratives by the education students offer two settings with potentially different issues to be addressed with plot. Table 3 presents results of plot analyses of 26 self-made videos.

Table 3. Number and percentages of plot elements in narrative videologs by foreign students studying education in Italy

Plot element	Frequency in videologs across task	
	Cultural incident videolog (13)	School setting videolog (13)
Character	N (%)	N (%)
Character mention(s)	414 (50.6)	350 (48.3)
Character enactment(s)	156 (19)	161 (22.2)
Initiating action	12 (1.5)	14 (1.9)
Complicating action(s)	107 (13.1)	74 (10.2)
Highpoint/Turning point/Climax	14 (1.7)	15 (2)
Resolution strategies	48 (5.9)	40 (5.5)
Ending/Coda	15 (1.8)	13 (1.8)

As shown in Table 3, the most notable (at least 3 %) differences in video stories across Italian experiences were in character enactments and complicating actions. The relatively greater engagement with others' psychological orientations (enactments) in the school setting video narratives is relevant to education students' focus on children in classrooms. The focus on complicating actions in the cultural incident narratives indicates the use of narrating to address novelty in Italian life more generally, which was less familiar to education students than the school setting. These findings also highlight the utility of plot in storytelling interaction.

4.4 Summary of Plot Analysis Across Three IDS Types

The inquiry discussed in this article posed questions about the nature and utility of plot as a mediator of complex symbolic resources and interactions in IDS, in particular in terms of the tension between participants' needing to play along with the story path yet also interact innovatively. Plot analysis across three types of IDS contexts indicate that plot elements act as anchors and allow for creativity. Story authors' consistent use of initiating actions and high points within and across contexts indicates an anchoring function of plot and certain plot elements, perhaps facilitating shared cognition and communication in the virtual story worlds. In contrast, story authors across the settings took liberties with some plot elements, offering evidence of the functionality of plot for novelty and context sensitivity.

This analysis highlights the implicitly powerful elements of story pointing to dimensions beyond the story – the real-life setting, theme, and purpose for participating in IDS – as well as for creating coherence within story. We also learn about the nature of plot, for example, that plots function for conformity while not being rigid scripts. That all the contexts sampled involve some sort of pivotal plot conflict (high point/turning point/climax), while also employing other plot elements to express individuality, in spite of major differences in language, narrative skill, and interest, offers a foundation for ongoing inquiry. More research is required to test, confirm, and

extend these observations, but should the tension between plot as a mediator of collective focus and innovation bear out, IDS research and design will have a productive tool in plot analysis.

5 Toward Plot Analysis in Future Research and Practice

Future research with these and other IDS types can further examine the nature of plot structural elements as anchors for collective engagement in IDS. A next step would be to sample increasingly broad and complex participant narratives, such as pathways through interactive story games. A question for future inquiry is whether and how story players anchor collectively in certain plot elements while using other elements to vary their journeys. Implications for IDS authoring guides are also intriguing. Designers of guides to IDS might, for example, provide certain plot elements, while leaving others open for expansion. Implications of plot analysis for authoring may also benefit from research that systematically varies features of the use context, such as the nature of interaction (timing and contingency), story generation and sharing mode (oral, written, graphic, video), the nature of the interactive space (completely online or a combination of online and offline etc.), and authoring guide (templates based on plot elements to maintain and vary pathways through a story). Plot analysis will not, of course, do the complete job of understanding meaning-making in media as complex as IDS, so ultimately plot analyses can be integrated with other approaches, such as semantic analyses.

In summary, this inquiry indicates that plot is a mediator of interactions in IDS as participants anchor their contributions to interactive stories, while also introducing variations and innovations to the IDS context. The tension between stability and variability suggests the potential importance of ongoing inquiry into plot to increase our understanding of how IDS participants enact narrative journeys in virtual environments and how those enactments with plot, in particular, play a role in the cognitive, social, and emotional aspects of IDS.

Acknowledgments. The author thanks Phoebe Lee for her assistance with the videolog plot analysis and Ralitsa S. Todorova for her assistance creating and preparing the fan fiction database for analysis and assistance with final preparation of the manuscript.

References

1. Bruner, J.: Acts of Meaning. Harvard University Press, Cambridge, MA (1986)
2. Daiute, C.: Narrative Inquiry: A Dynamic Approach. Sage, Los Angeles (2014)
3. Vygotsky, L.S.: Mind in Society: The Development of Higher Psychological Processes. Harvard University Press, Cambridge, MA (1978)
4. Rose, C.B., Granger, C.A.: Unexpected self-expression and the limits of narrative inquiry: exploring unconscious dynamics in a community-based digital storytelling workshop. Int. J. Qual. Stud. Educ. (QSE) **26**(2), 216–237 (2013)

5. Robin, B.R., McNeil, S.G.: What educators should know about teaching digital storytelling. Digit. Educ. Rev. **22**, 37–51 (2012)
6. Bruni, L.E., Baceviciute, S., Arief, M.: Narrative cognition in interactive systems: suspense-surprise and the P300 ERP component. In: Mitchell, A., Fernández-Vara, C., Thue, D. (eds.) ICIDS 2014. LNCS, vol. 8832, pp. 164–175. Springer, Heidelberg (2014)
7. Daiute, C.: Human Development and Political Violence. Cambridge University Press, New York (2010).
8. http://fanfiction.mugglenet.com/viewstory.php?sid=92870&chapter=1
9. Hermione Granger "Over Years": http://www.youtube.com/watch?v=Qa9ksCc3r6s
10. Surian, A., Tarchi, C., Daiute, C.: Assessing intercultural sensitivity: a plot analysis of study abroad students' Videologs. European Association Research on Learning and Instruction (EARLI) Biennial Conference, Cyprus, August 2015

Design Approaches for Interactive Digital Narrative

Hartmut Koenitz[(✉)]

Department of Telecommunications, University of Georgia,
120 Hooper Street, Athens, GA 30602-3018, USA
hkoenitz@uga.edu

Abstract. While authoring has long been a concern for researchers engaged in interactive narrative, generalized design approaches have been less of a focus. At the same time, the need for design conventions to aid in the creation of artifacts has long been recognized, starting with Murray's 1997 *Hamlet on the Holodeck*. However, unlike in the related field of game design, widely accepted, generalized conventions are still elusive. In this paper I investigate the state of affairs and identify several broad trajectories in the scholarly treatment of interactive narrative authoring. I propose a process and a set of design heuristics developed in my practice of teaching interactive digital narrative.

Keywords: Interactive narrative authoring · Interactive narrative design · Design heuristics · Design process · Design conventions · Interactive digital narrative

1 Introduction

Authors of traditional forms of narrative can rely on a rich body of design conventions for structuring and presenting narrative material – from Aristotelian material and formal causes to Freytag's structure for drama to the 20th century dramatic conceptions of Brecht and Boal. Even the comparatively young narrative medium of film has established a wealth of helpful conventions including continuity editing and rules for framing particular shots. In the evolving field of Interactive Digital Narrative (IDN), such design conventions are yet to be established. Indeed, in their summary of future entertainment media in 2012, Klimmt et al. [1] declare the field of interactive narrative to be still in flux and emphasize how the development of authoring will decide the shape of future artifacts.

The lack of generalized design conventions constitutes an important obstacle for authors from traditional narrative disciplines interested in the expressive potential of interactivity, and even more so for teaching interactive narrative to newcomers. However, the call for such expressive building blocks now has a history by itself, spanning the period from Janet Murray's *Hamlet on the Holodeck* [2] to a recent paper on IDN authorship [3]. This fact is especially surprising given the number of publications concerned with the related field of game design, which are built on the premise of generalizable conventions, for example Salen and Zimmermann [4], Fullerton et al. [5] and Schell [6].

© Springer International Publishing Switzerland 2015
H. Schoenau-Fog et al. (Eds.): ICIDS 2015, LNCS 9445, pp. 50–57, 2015.
DOI: 10.1007/978-3-319-27036-4_5

In this paper I cast a light on the discrepancy by investigating scholarly perspectives on authoring and design, before presenting a process and design heuristics developed in my practice of teaching interactive narrative for the past several years.

2 Existing Approaches

Authoring, the design and implementation of concrete artifacts, has been a focus for the research community for quite some time. Indeed the European IRIS project [7] identified authoring as a major concern for research. Perspectives on IDN design broadly exist in three different categories– high-level, abstract descriptions, which analyze the problem from a distance; dichotomic approaches, which take narrative as an antagonistic element to game design or interactive design; and descriptions of the design of particular works. In the first case, the high level of abstraction provides little concrete design advice. In the second case, the emphasis on bridging an assumed disciplinary gap forces a perspective on 'inclusion strategies' that prevents the consideration of a combined design space. In the third case, concrete design approaches are often described, however, the highly specific nature of particular projects often make it difficult to identify generalizable conventions.

An example for a high-level perspective is Murray's description of the "cyberbard" [2], the interactive narrative author whose difficult task it is to create a "multiform plot," [2], along with rules and events. In order to help aspiring cyberbards, Murray sees the main task in creating expressive building blocks – conventions for the interface, the use of language, gesture, but also themes like the murder mystery and generalized plot patterns. For Murray, oral storytelling traditions – especially how they are able to constantly adapt a core message to a given audience – provide inspiration for IDN design.

One example for the dichotomic approach is Bateman's edited collection [8] which does provide concrete design advice, but is focused on fitting narrative as an element within the confines of established game design workflows. Narrative here is relegated to the role of underlying support structure and justification for gameplay:

"[…] narrative strings together the events of the game, providing a framework and what can alternately be called a justification, a reason, or an excuse for the gameplay encounters" [8].

Another example in the same category is Bizzocchi and Woodbury's case study [9], which describes interactive narrative design as a compromise between two separate design domains – narrative and interactive. Narrative design is understood as a more holistic perspective, while interactive design is seen as privileging the granularity of individual puzzles. From this vantage point, the authors investigate the possibility of a shared design space, which they frame as difficult exercise of translating between deeply entrenched practices.

Design approaches for particular projects are featured in another set of papers. For example, Strohecker [10] describes a specific approach in which a fixed narrative structure is paired with interaction through character development and different perspectives. Strohecker describes IDN as related to video games, but with distinct qualities. In her paper, she provides a number of design recommendations, including

even pacing and sequencing, *continuous interaction*, and the ability for interactors to "navigate freely" [10] within the story structure. In describing their own practice for *Façade*, Mateas and Stern [11] explain the overall structure and detail many design decisions, for example the combination of an "Aristotelian tension arc" [11] with drama management, pre-authored dramatic elements and AI processing of natural language input. While certainly highly successful as a particular project, the specific nature of their approach towards AI make it difficult to deduce generalizable design advice. The most important aspect of their paper in this regard might be their call for deep procedural literacy – essentially the ability to use high-level programming languages – as a requirement for IDN authorship. Echoing these sentiments in a perspective focused on authoring tools, Spierling and Szilas [12] emphasize the need to educate authors in procedural literacy for a more productive dialogue with toolmakers.

The unfortunate lack of impact of Stephen Meadow's 2002 book [13] – which shares many of my sentiments regarding the need for new design perspectives – can also be explained in terms of my broad trajectories – his book combines a dichotomic approach with many singular project-based design strategies, and therefore also lacks in generalizable approaches.

3 A Design Approach for IDN

In my work, I start from a perspective on IDN as a novel from of expression in which narrative and interactivity are deeply intertwined, as "system narratives" in line with Roy Ascott's call for reactive "system art" in contrast to prior "object art." [14]. I am also inspired by Bernstein et al.'s understanding of "contours" [15] – narrative structures that allow for their re-shaping by the interactor. From this perspective, dichotomic approaches attempt to 'interactivize' traditionally static structures instead of exploring dynamic models – for example cybernetic feedback loops.

Although related to existing practices in video game design and interactive art, I understand my design work as specific to interactive narrative and as a critical reflection, inspired by critical practice [16] and reflective design [17] that provides vital clues for the continued development of my theoretical framework [18]. In this model, the IDN artifact is understood as a *protostory,* comprised of the four elements of *environment definitions, settings, assets,* and *narrative design.* This perspective expands the analytical reach beyond structural aspects (which are covered in the narrative design). The significance of protostory is in the recognition of the process of digital instantiation that connects the digital artifact and its many possible paths to a concrete output/product. If the output can be understood as a story, there must be an entity that describes the space of potential narrative, hence *protostory.* Within narrative design there are no preconceptions for any specific structure. The notion of *narrative vector* describes micro structures that define the boundaries and junctures of a given work.

The practical complement to this model is the authoring platform ASAPS [19], which I use in my practice and teaching for several years now. ASAPS reflects the four essential elements of the theoretical model and enables the creation of narrative designs from the combination of atomic narrative units with functions like 'dialog choice',

'inventory choice', and 'spatial selection,' but does not predicate particular structures. In addition, ASAPS combines branching with procedural elements like an inventory system, global variables, timers and general-purpose tracking functions.

I have earlier identified a tendency of students to create linear branching stories influenced by Choose Your Own Adventure books [19], which fail to capitalize on the procedural aspects and state memory. Once students start using the tracking functions, they often create strong antagonistic choices, which often lead to predictable outcomes. Another problematic outcome is in mechanistic pacing – choice after choice after choice – with no elements of surprise or narrative development. The most successful projects tend to either create big narrative spaces to explore, spanning 200–400 beats, or deliver well-focused smaller vignettes. Examples in the first category are *The Ship* by Charlie Stafford, where the interactor explores a mysterious cruise ship with a deadly destination, or Jay Hornyak's Beaver Project, which investigates the equally mysterious events surrounding a community of beavers and the adjacent dam. In the latter category are the timer-based interactive bank robbery *The Heist* by Jacob Harkey and *DeathJack* by Nathan Neufeld, which makes winning a card game the key to survival.

While based in this particular practice, both design process and heuristics are intended as a generalized approach toward the design of IDN artifacts. In my teaching, I refrain from advocating specific structural models and instead emphasize the need for experimentation. I do, however, provide guidance in the form of a design process and general design heuristics developed from my own practice and continuously evolved during several years of teaching interactive digital narrative.

3.1 Design Process: 4 Phases

On the surface, this design process might not appear to be much different from general game or application development. It differs however from other narrative media development, e.g. film production, in the focus on procedural elements, interaction flow and beta-testing. Authors of film scripts and books do not have to provide decision points and alternative paths or worry about the impact of participants on their work. The process includes four stages:

1. Paper phase (idea to treatment to flow diagram)
2. Prototype phase (check interaction and flow without (final) assets)
3. Production phase (create (final) assets, structure and interaction)
4. Testing phase (beta user testing, final adjustments)

During the *paper phase*, the project starts with a general outline of events, before filling in details. The next step is to move towards a flow diagram to visualize sequencing and choice points. Then, procedural aspects, like a character's changing level of anger, the time limit for robbing a bank, or the tools necessary for fixing the car are considered and noted in the flow diagram. As a final stage during this phase, the paper design moves to index cards, complementing the flow diagram as rough storyboard-like sketches for each visible element.

In the *prototype phase*, I leverage ASAPS's capacity as a prototyping tool to build an asset-less test version. This step is crucial to check interaction and narrative pacing and therefore improves on more traditional wireframing approaches (and there are many alternatives for this particular task that combine wireframing with interaction). At this stage, unnecessary narrative elements will be removed and missing ones added. To improve the understanding of visual aspects during this step, scans of the index cards from the prior phase or rough stand-in graphics are then used. These visualizations help in compiling a list of assets to be created in the next phase.

The *production phase* includes integration of final assets as well as adjustments to structure and interaction. Finally, in the *testing phase*, the prototype is being used by a group of beta testers and final adjustments are being made. A particular focus during this stage is on unexpected behavior, which can arise from procedural combinatorics or the application of artificial intelligence (AI).

3.2 Design Heuristics

For the present paper, I understand design heuristics in the sense of the term as used by Flanagan and Nissenbaum [20], who are concerned with showing alternatives to existing game design practices in order to support activist games. They propose specific principles as "design aspirations" [20] to guide the concrete development of an artifact. Similarly, I offer the following principles for interactive narrative as means to overcome the simplistic and uncritical interactivization of narrative design methods originally developed in non-interactive media.

The **cyberbardic principle** marks the contrast to traditional narrative authoring process and the role of the author. In contrast, the cyberbard tells little, shows a bit more, but most of all creates opportunities to explore and experience. Instead of readers/viewers, the cyberbard has interactors as her audience. In regards to the resulting work, the cyberbard says: 'I will sit back and watch with amazement what the audience will do with it.' Understanding the cyberbardic principle means to be a "narrative architect" [21], a system designer.

Initial interest and continued motivation are essential for works that require audience participation – the "non-trivial effort" Aarseth [22] has identified. This is another crucial aspect for IDN design, especially in comparison to video games, which have the advantage of clear reward structure oriented on continued measurable improvement and winning.

The **initial interest principle** casts the focus on strategies for initial engagement. Questions about narrative development create such interest, either in a holistic sense: 'Where can I take this?', in regards to particular characters: 'Who will this character turn into?' or in regards to particular perspectives: 'Is this the whole story? What other sides to it exist?' In more concrete terms that means to start from a challenge ('will you reach the summit?'), confusion ('what happened last night?','Is this the truth?') or an abundance of choices ('So many things to explore - where do I start?')

The principle of **continued motivation** has to do with careful management of interactor interest by offering just enough to keep her going without revealing all.

This key element warrants an extended look. A number of concrete strategies motivate continuous engagement, for example ambiguous choices, small narrative gaps that leaves space for the interactor to fill, and the temporary removal of control so that the interactor feels more special about being in control at other times. Surprises – if used sparingly – are another good strategy to keep the interactor motivated as long as they do not invalidate prior developments to such a measure that the interactor feels cheated. Equally, what should be avoided are design choices that can make progress exceedingly hard or boringly obvious for the interactor. An example of the latter strategy is a simplistic good/evil choice that puts the interactor on a predictable trajectory without further complications.

Delayed consequences are a particularly powerful strategy for continued motivation. Instead of providing the immediate feedback of many video games (if you go left, you are eaten by a grue, so next time go right), delayed consequences build up over time, as a result of the interactor's continued activity. For example, in an interactive version of Little Red Riding Hood, the interactor starts with Red as a blank character. Depending on the interactor's choices, Red develops into a timid, an aggressive, or a flirtatious girl over time. The consequences of these developments become apparent only much later, when faced with an attacking wolf, as the timid girl has no way to defend herself, while the aggressive girl can fight the wolf and the flirtatious girl can talk her way out of the situation. A key aspect of this strategy is to make the interactor aware that her current choice could matter in the future. Once aware of this mechanic today's interactors can sustain longer periods without feedback. They are well versed in the use of computers and therefore need immediate feedback to a much lesser degree than prior generations, but they are also trained to endure uncertainty. Other media forms like the printed detective story, the thriller film genre, and many episodic long-form TV series have been successful in withholding clear and immediate information without loosing their audience.

Yet another important aspect of continued motivation is the proper "scripting of the interactor" a strategy described by Janet Murray [2] in which the interactors is cast in a specific role and given sufficient information to perform well in it. A particular compelling example of this strategy is the way Weizenbaum's *Eliza* [23] (and recently Blast Theory's *Karen* [24]) put the interactor in the role of a patient consulting a therapist.

The principle of **opportunity magnitude** pertains to the amount of narrative material and opportunities for interaction. Providing choice means to always provide 'more,' which constitutes a challenge for tight production budgets and available project time. In general, cyberbardic authors should prioritize interactive opportunities over length of experience. While narrative does not always have to be fully specified, as users will fill in the blanks, the interactor should never feel that she only has one path to follow and alternatives are blocked. Ideally, an IDN artifact offers enough narrative material to cover all alternate paths offered. However, there is also the possibility of IDN stagecraft – at times, a convincing, yet non-existing, impression of alternatives might be good enough to create a compelling experience.

4 Conclusion

In this paper I have identified several broad trajectories in research concerning IDN authoring and found that between high-level perspectives, dichotomic approaches and specific project descriptions, little work has been done on developing and identifying generalizable design conventions, a conclusion already drawn (although with a focus on authoring tools) by Spierling and Szilias in 2009 [12], but unfortunately still true today.

Based on my practice in teaching interactive digital narrative as a design effort that combines narrative and interactivity, I have outlined a general design process, along with several overarching design heuristics as well as strategies for implementation. I hope to encourage further discussion on the topics of design conventions and teaching of interactive narrative with my contribution.

References

1. Klimmt, C., Roth, C., Vermeulen, I., Vorderer, P., Roth, F.S.: Forecasting the experience of future entertainment technology "Interactive Storytelling" and media enjoyment. Games Cult. **7**, 187–208 (2012)
2. Murray, J.H.: Hamlet on the Holodeck: the Future of Narrative in Cyberspace. Free Press, New York (1997)
3. Koenitz, H., Louchart, S.: Practicalities and ideologies, (Re)-considering the interactive digital narrative authoring paradigm. In: Li, B., Nelson, M. (eds.) Proceedings of the 10th International Conference on the Foundations of Digital Games (2015)
4. Salen, K., Zimmerman, E.: Rules of Play: Game Design Fundamentals. MIT Press, Cambridge (2003)
5. Fullerton, T., Swain, C., Hoffman, S.S.: Game Design Workshop. Morgan Kaufmann, Burlington (2008)
6. Schell, J.: The Art of Game Design: a Book of Lenses. Elsevier/Morgan Kaufmann, Amsterdam; Boston (2008)
7. Cavazza, M., et al.: The IRIS network of excellence: integrating research in interactive storytelling. In: Spierling, U., Szilas, N. (eds.) ICIDS 2008. LNCS, vol. 5334, pp. 14–19. Springer, Heidelberg (2008)
8. Bateman, C. (ed.): Game Writing: Narrative Skills for Videogames. Charles River Media, Boston (2007)
9. Bizzocchi, J., Woodbury, R.F.: A case study in the design of interactive narrative: the subversion of the interface. Simul. Gaming **34**, 550–568 (2003)
10. Strohecker, C.: A case study in interactive narrative design. In: Proceedings of the 2nd Conference on Designing Interactive Systems Processes, Practices, Methods, and Techniques, pp. 377–380. ACM, New York (1997)
11. Mateas, M., Stern, A.: Procedural authorship: a case-study of the interactive drama façade. In: Digital Arts and Culture (DAC) (2005)
12. Spierling, U., Szilas, N.: Authoring issues beyond tools. In: Iurgel, I.A., Zagalo, N., Petta, P. (eds.) ICIDS 2009. LNCS, vol. 5915, pp. 50–61. Springer, Heidelberg (2009)
13. Meadows, M.S.: Pause & Effect. New Riders Press, Indianapolis (2003)
14. Ascott, R.: The Construction of Change. Cambridge Opinion, Cambridge (1964)

15. Bernstein, M., Joyce, M., Levine, D.: Contours of constructive hypertexts. Presented at the ECHT 1992: Proceedings of the ACM Conference on Hypertext, New York, New York, USA December (1992)
16. Agre, P.: Computation and Human Experience. Cambridge University Press, Cambridge (1997)
17. Sengers, P., Boehner, K., David, S., Kaye, J.: Reflective design. In: Presented at the Proceedings of the 4th Decennial Conference on Critical Computing: Between Sense and Sensibility (2005)
18. Koenitz, H.: Towards a specific theory of interactive digital narrative. In: Koenitz, H., Ferri, G., Haahr, M., Sezen, D., Sezen, T.I. (eds.) Interactive Digital Narrative, pp. 91–105. Routledge, New York (2015)
19. Koenitz, H., Chen, K.-J.: Genres, structures and strategies in interactive digital narratives – analyzing a body of works created in ASAPS. In: Oyarzun, D., Peinado, F., Young, R., Elizalde, A., Méndez, G. (eds.) ICIDS 2012. LNCS, vol. 7648, pp. 84–95. Springer, Heidelberg (2012)
20. Flanagan, M., Nissenbaum, H.: Design heuristics for activist games. In: Kafai, Y.B., Heeter, C., Denner, J. (eds.) Beyond Barbie and Mortal Kombat. MIT Press, Cambridge (2008)
21. Jenkins, H.: Game design as narrative architecture. In: Wardrip-Fruin, N., Harrigan, P. (eds.) First Person: New Media as Story, Performance, and Game. MIT Press, Cambridge (2004)
22. Aarseth, E.J.: Cybertext. JHU Press, Baltimore (1997)
23. Weizenbaum, J.: Eliza — a computer program for the study of natural language communication between man and machine. Commun. ACM 9, 36–45 (1966)
24. Blast Theory: Karen [Video game] (2014). https://itunes.apple.com/us/app/karen-by-blast-theory/id945629374?mt=8

Adaptive Storyworlds

- Utilizing the Space-Time Continuum in Interactive Digital Storytelling

Henrik Schoenau-Fog[✉]

The Center for Applied Game Research, Department of Architecture,
Design and Media Technology, Section of Medialogy,
Aalborg University, Copenhagen, Denmark
hsf@create.aau.dk

Abstract. One of the challenges of interactive digital storytelling systems is to support the users' experience of being able to freely roam open sandbox-like storyworlds, while at the same time maintaining control over the distribution and order of events in the mediated narrative. However, although several investigations into how to address this challenge have been conducted, there seems to be a lack of focused research into the possibilities of using the concept of space-time continuum to organize the mediation of events. This paper will thus describe ideas, concepts and examples of how space-time may be used to organize events while maintaining narrative engagement, by introducing a suggestion for a framework, which exploits the possibilities of space-time.

Keywords: Narrative Paradox · Space-time · Engagement · Interactive digital storytelling · Storyworld · Emergent narratives · Environmental storytelling

1 Introduction

The design and development of storyworlds for Interactive Digital Storytelling systems (IDS) present many challenges due to the fact that stories conventionally are authored and experienced as linear chronological structures while interactivity gives users the agency and possibilities to perform various actions in a non-linear and unpredictable fashion. One of these well-known challenges is the Narrative Paradox [1], which occurs in more complex IDS systems. The Narrative Paradox can also be used to describe the problem of implementing an application with an open sandbox-like 3D storyworld, where the user may navigate "freely", while the application at the same time aims to maintain control over the order of events and mediate the story.

Numerous studies have attempted to solve such problems, for example by manipulating users [2], to use emergent narratives [e.g. 3], or simply by letting users enjoy a pre-scripted story, instead of influencing it [4]. Another approach for addressing the challenges of open storyworlds is to focus on creating narrative architecture and to use the concept of environmental storytelling introduced by Jenkins [5]. Environmental storytelling revolves around four types of narratives:

© Springer International Publishing Switzerland 2015
H. Schoenau-Fog et al. (Eds.): ICIDS 2015, LNCS 9445, pp. 58–65, 2015.
DOI: 10.1007/978-3-319-27036-4_6

- Evoked narratives (in which an existing narrative is enhanced through details in the design of the space)
- Enacted narratives (in which the narrative is character-driven)
- Embedded narratives (in which the world is a "memory palace" where the objects and the mise-en-scène reveal clues which may help players reconstruct the plot)
- Emergent narratives (in which players may construct personal stories inspired by encountered events in a storyworld).

In Jenkins' interpretation, "Emergent narratives are not pre-structured or pre-programmed, taking shape through the game play, yet they are not as unstructured, chaotic, and frustrating as life itself" [5, p. 128]. And further, on the construction of these types of narratives, Jenkins notes that: "game spaces are designed to be rich with narrative potential, enabling the story-constructing activity of players." [5, p. 129]. The current study uses Jenkins' understanding of an emergent narrative which may be described as a story which is not told, but instead constructed individually by the user and emerging from the interaction between user, the virtual environment and encounter with characters [5]. Several projects have experimented with the development of such interactive experiences e.g. "Dear Esther" [6], "Aporia" [7], and "First Person Victim" [8] and have demonstrated that there is potential in the emergent narrative approach.

Although several studies also investigated the temporal and spatial aspects in game narratives [e.g. 9], film [e.g. 10] and video [e.g. 11], there seems to be less detailed research into how the concept of space-time may be used as a parameter to manage events in interactive storyworlds while maintaining engagement and the desire to continue the experience.

This paper focuses on the potential of utilizing the fourth dimension – time – in addition to the first three dimensions of space in order to inspire the design of alternative interactive emergent narrative experiences, which are not merely founded on chronology or on cause and effect. This study will thus introduce a framework – the Space-Time Interactive Narrative Framework (SPATIN) – and the Space-Time Drama Manager (STDM), which exploit the potential of the space-time continuum within interactive digital storytelling. The framework is intended to inspire the creation of novel interactive experiences, which may be based on users' individual construction of associative narratives and/or chronology and causality.

2 The Storyworld Challenges: Events in Space and Time

In the current study, a "storyworld" is understood to be an interactive digital storytelling (IDS) experience, in an open sandbox-like virtual world, which mediates a sequence of events, in a temporal order so that the participant is able to navigate freely and to experience the events while constructing a meaningful narrative experience. The current use of the space-time continuum focuses only on simple navigation as an admittedly limited interaction, where users may witness events, and is thus not concerned with more complex interactions, which will be addressed in future work. In order to maintain engagement, the motivational driver in these kinds of experiences is the exploration of the world, experiencing the story and the experimentation with outcomes of the story based on navigation [12].

In order to explain the challenges of designing such storyworlds, imagine that we have designed a storyworld with several events, which may be discovered by simple navigation. However, in order to keep the user on track in the story, most interactive narrative experiences and games with narrative content use fixed structures, which lock events to a certain location, in order to ensure that the users experience events in the right order. In other words: the so-called "interactive" narratives are actually nothing more than a sequence of events "on rails", which are not influenced by the user's interactions. The problems with free roaming storyworlds, which lock events to locations, may thus be described as:

- Wrong order - The user may not encounter the events in the right order.
- Bad timing - The user may not encounter an event at a specific time when the event is active.
- Lost events - The user may not encounter a specific event that is needed to understand the story.

To illustrate these problems, Fig. 1a shows a free roaming world, where a user chooses a "wrong" path and encounters events (a) in the wrong order, (b) is at the right location, but at the wrong time and (c) is not encountering all of the events (1–4), because he or she does not follow the "right" path.

Fig. 1. (a) Problems in free roaming storyworlds, where events are locked to locations. (b) The space-time continuum with events locked to locations.

In order to address these challenges, the following concept proposes a way for the space-time continuum to be used for organizing events in space and time.

3 Interactive Stories in the Space-Time Continuum

The Space-Time Continuum is a model based on mathematics, which combines space (x, y, z) and time (t) into space-time world coordinates (x, y, z, t) [13]. One method of visualizing an interactive narrative as a space-time continuum is to imagine a three dimensional box, which represents space. In the box there is a number of points in space (x, y, z), which represent locations that the user may visit (e.g. an underwater world). However, if we add the fourth dimension – time (t) – we may imagine strings passing through all the (x, y, z) points. These strings represent time, and located on the strings are pearls of "event capsules". Event capsules represent the events which users

may encounter at that specific location at a specific time. For each location, the string with the events capsules may then move back or forth (in time), depending on which event is needed at that location at that time. Figure 1b illustrates this principle.

The principle is similar to the commonly used problematic method of organizing events in a spatial fashion where events are locked at a location. However, imagine if we discard the idea of locking events to a location, and use time in such a way that users may encounter events whenever they are "needed" regardless of the location.

Such events obviously need to be independent of the location, but with such a structure, it is possible to place events at locations at the "right time", when the user is exploring that exact area of the storyworld. Figure 2a illustrates a scenario, where the events are not locked at locations, but in time (the user's path is marked by a line, while the dotted line represents the string of time with sequential events). The event capsules are attached to the string of time like a sequence of pearls. The string can bend and stretch and thus be placed on the trajectory of the user's navigation. In this way the user will always encounter the events based on a sequential order or an order of dramatic intensity, as planned by the author, no matter how the user is exploring the storyworld. An extreme version of such storyworlds could "build" the world in front of the user on the fly by moving location-dependent events ahead of the projected path of the user, so that he/she may encounter them when needed. However, by following this approach there might be a risk that the user will encounter the events in the same order during a re-play of the experience and that the variability, emergence and influence of the narrative is lost. This method can therefore be combined with the organization of events so that their occurrence at specific locations are made conditional on which previous events the user has already encountered at other locations. With such an approach events can still be location-specific and thus support a meaningful construction of the emergent narrative.

Fig. 2. (a) The space-time continuum with events locked in time. (b) The space-time continuum with events that are not locked to locations or time.

Another example of how the space-time continuum may be used for organizing events is when there is a need for events that are not encountered in a chronological order (e.g. an abstract dream world).

Figure 2b illustrates a scenario, where the events are not bound by locations or time, but where the intersections in the grid represent event-capsules that can be moved to accommodate the user's desire to experience a specific event at any location (the user's path is marked by an arrow, while the intersections of the grid represent event capsules). This could for example be when the user did not encounter anything interesting for a while, and a dramatic event is needed.

Figure 3a shows another user in a free roaming world, who is following the same path as the first user (from Fig. 1a). However, this time he or she is encountering all events in the right order, because the events are not locked to spatial locations but in sequential order. These are some examples of how the space-time continuum may be used for addressing some of the problems associated with Fig. 1a.

4 The Space-Time Interactive Narrative Framework

Below, we will introduce the Space-Time Interactive Narrative framework (SPATIN), which describes how the concept of space-time may be used for organizing events in an open storyworld. The framework consists of event capsules, which describe the type and assets of each event, a temporal order, which explains the sequence of events, a Space-Time Drama Manager (STDM), which organizes the events, and finally the interaction manager, which controls the possible interactions. The framework may be useful for designing and developing novel IDS experiences.

4.1 Event Capsules

Event capsules are placeholders for the possible events that a user might encounter and describe the assets needed to create those specific events. There are various types of events, for example encounters with other entities, nature effects or immediate effects events caused by the user. Events may be positioned in any space-time storyworld according to four different categories:

- Events that are not locked in time and space – e.g. random events which may occur anytime and anywhere.
- Events that are locked in time but not in space – e.g. specific events which may occur anywhere, but only at a certain time. For example a lightning bolt strike.
- Events that are locked in space but not in time – e.g. a character, who always approaches the user at a certain location.
- Events that are locked in both time and space – e.g. an event which takes place at a certain place and at a certain time. For example a volcanic eruption.

These positions describe the possibilities of how the events may be placed in relation to a user's position in the space-time storyworld.

4.2 Temporal Order of Events – the Space-Time Drama Manager

As mentioned above, events are not necessarily locked in space or time. Events thus have the possibility to be placed in space, depending on when the user "needs" them (in time). The SPDM does therefore not only operate with "Box-colliders" where the 3D engine checks if the user is within a certain location in the storyworld, but also with "Time-colliders", which keeps track of the temporal aspects of the experience.

This way it is possible for the STDM to orchestrate events and keep track of upcoming events to be placed in the world in front of the current trajectory of the user.

If the user suddenly decides to change direction, the event can be moved to a new location in front of the user (e.g. hidden beyond a hill). These location shifts may be repeated until the user encounters the event, or the location may be generated in 3D space ahead of the user's path. Events may be planned by the author and experienced by the user in a variety of temporal orders:

- Chronological – as in a linear story. Events are encountered as a sequence one by one. The user may experience this as participating in a film, where the order of events is fixed.
- Causal – as in a cause-effect sequence of events. As an example, the user may experience the effect of an earlier event before experiencing the cause (e.g. a murder mystery revealed by a detective in an embedded narrative). Or vice-versa, where the event that caused the effect is encountered before experiencing the effect (e.g. witnessing a flood submerging a village).
- Associative – lyric structures, e.g. as in a dream. Events may be encountered based on associative relations between events. For example, the user may experience an event with a black cat, and the next possible events may include an event including darkness or tigers.
- Thematic – as in an episodic film. Here events have no immediate relation and order, however they all support the communication of a theme.
- Random – as in a chaotic world. Users may encounter events, which seemingly lack logical order. However through the user's own personal construction of the story, an emergent narrative may be experienced.
- Synchronous – as in a world where all events are happening in sync with the users' actions (e.g. a snowboarding experience which trigger an avalanche).
- A-synchronous – as when events are happening out of sync with the users' actions (e.g. a delayed effect such as a wildfire caused on the user forgetting to extinguish a bonfire).

The creator of a storyworld may thus design experiences by deciding on the order of events, and he or she can prioritize some events over others based on the various strategies mentioned above or in combination thereof.

4.3 Organization of Events

During run-time, the STDM uses a stack to keep track of which events have been encountered, and which events are the next possible ones to be placed in the space of the storyworld for the user to experience (see Fig. 3b where the STDM keeps track of events in a stack and distributes them in the world at the place and time required for the user to encounter them). In a simple storyworld, there is only one stack of events, which for example may orchestrate events that mediate a linear story. In more complicated storyworlds, there might be a need for more stacks to organize sub-stories or themes.

4.4 Interaction with Events

There are several ways to interact with the space-time storyworld. The navigation in the storyworld is essential as it moves the position of the user around in the space-time

Fig. 3. (a) A user in a free roaming world, following the same path as in Fig. 1 encountering all events in the right order. (b) Organizing events with the Space Time Drama Manager.

continuum. When events are encountered, a variety of interaction options may be possible, and it is up to the storyworld designer to decide how complex these interactions should be. Interactions may thus be anything from a Façade-like dialogue to simply watching events unfold.

The experiences in the space-time storyworld could also be enhanced by taking into account the different ways to interactively navigate in time, such as stopping completely, moving slowly or fast, or to jump forward or backward in time.

5 Discussion and Conclusion

In this paper, we have introduced the Space-Time Interactive Narrative Framework (SPATIN), which utilizes the space-time continuum in order to create novel interactive digital storytelling experiences. In such experiences, the events encountered by free roaming users in interactive 3D storyworlds are not necessarily fixed at certain locations, but may be shifted in their spatial and temporal position by the Space-Time Drama Manager (STDM). The STDM organizes events based on the current "need" of the user to experience a certain event, and not only on where the user is positioned in space.

However, a framework and a suggested system is not enough to guarantee an engaging experience. A question for future work is thus how to organize events in space-time, so that the users' engagement is sustained. The next step in the current project is thus to look into some essential drivers of users' engagement within 3D storyworlds such as: exploration, sensing the world, experiencing the narrative and entities, experimentation with outcomes, progression, completion and finally affect and feelings (e.g. curiosity, tenacity, suspense, surprise, an immersion) [12].

Since interactive space-time based 3D storyworlds have the possibility to go beyond causal and chronologically ordered narratives, future work may also draw on the studies by Oatley [14], who states that our minds are the optimal narrative engines, which only need to be fed with a few events to start constructing emergent narratives. Therefore we will conclude by proposing that interactive digital storytellers may begin to think of themselves as space-time architects. Such storytellers will be able to construct rich engaging interactive storyworld experiences based on the space-time

continuum. These experiences will not only be encountered in fixed causal chronological spaces, but also in free roaming open worlds, which exploit time to mediate events, so that encounters with these events will be different for every play-through.

This way, space-time architects may exploit the possibilities of the space-time continuum to engage users by constantly nudging them to ask themselves "What's around the next corner?".

References

1. Aylett, R.: Narrative in virtual environments – towards emergent narrative. In: Aylett, R. (ed.) AAAI Symposium on Narrative Intelligence, pp. 83–86. AAAI Press, Salford (1999)
2. Roberts, D.L., Isbell, C., Riedl, M.O., Bogost, I., Furst, M.L.: On the use of computational models of influence for managing interactive virtual experiences. In: Spierling, U., Szilas, N. (eds.) ICIDS 2008. LNCS, vol. 5334, pp. 268–272. Springer, Heidelberg (2008)
3. Louchart, S., Swartjes, I., Kriegel, M., Aylett, R.S.: Purposeful authoring for emergent narrative. In: Spierling, U., Szilas, N. (eds.) ICIDS 2008. LNCS, vol. 5334, pp. 273–284. Springer, Heidelberg (2008)
4. Tanenbaum, J.: Being in the story: readerly pleasure, acting theory, and performing a role. In: Si, M., Thue, D., André, E., Lester, J., Tanenbaum, J., Zammitto, V. (eds.) ICIDS 2011. LNCS, vol. 7069, pp. 55–66. Springer, Heidelberg (2011)
5. Jenkins, H.: Game design as narrative architecture. In: Wardrip-Fruin, N., Harrigan, P. (eds.) First Person: New Media as Story, Performance, and Game, pp 118–130. MIT Press, Cambridge (2004)
6. Pinchbeck, D.: Dear Esther: an interactive ghost story built using the source engine. In: Spierling, U., Szilas, N. (eds.) ICIDS 2008. LNCS, vol. 5334, pp. 51–54. Springer, Heidelberg (2008)
7. Bevensee, S.H., Dahlsgaard Boisen, K.A., Olsen, M.P., Schoenau-Fog, H., Bruni, L.E.: Project aporia – an exploration of narrative understanding of environmental storytelling in an open world scenario. In: Oyarzun, D., Peinado, F., Young, R., Elizalde, A., Méndez, G. (eds.) ICIDS 2012. LNCS, vol. 7648, pp. 96–101. Springer, Heidelberg (2012)
8. Schoenau-Fog, H., Bruni, L.E., Khalil, F.F., Faizi, J.: Authoring for engagement in plot-based interactive dramatic experiences for learning. In: Pan, Z., Cheok, A.D., Müller, W., Iurgel, I., Petta, P., Urban, B. (eds.) Transactions on Edutainment X. LNCS, vol. 7775, pp. 1–19. Springer, Heidelberg (2013)
9. Wei, H., Bizzocchi, J., Calvert, T.: Time and space in digital game storytelling. Int. J. Comput. Games Technol. 8 (2010)
10. Branigan, E.: Narrative Comprehension and Film. Routledge, London (2013)
11. Sawhney, N., Balcom, D., Smith, I.: Authoring and navigating video in space and time. IEEE Multimedia 4, 30–39 (1997)
12. Schoenau-Fog, H.: Hooked! – evaluating engagement as continuation desire in interactive narratives. In: Si, M., Thue, D., André, E., Lester, J., Tanenbaum, J., Zammitto, V. (eds.) ICIDS 2011. LNCS, vol. 7069, pp. 219–230. Springer, Heidelberg (2011)
13. Minkowski, H., Sommerfeld, A.: Raum und Eeit. Vieweg + Teubner Verlag, Wiesbaden (1923)
14. Oatley, K.: Such Stuff as Dreams: The Psychology of Fiction. Wiley, Chichester (2011)

Technical Advances

The Moody Mask Model

A Hybrid Model for Creating Dynamic Personal Interactions in an Interactive Setting

Bjarke Alexander Larsen, Kasper Ingdahl Andkjær[✉],
and Henrik Schoenau-Fog

Section of Medialogy, Department of Architecture, Design and Media Technology,
Aalborg University, Copenhagen, A.C. Meyers Vænge 15, 2450 Copenhagen, Denmark
{bala12,kandkj12}@student.aau.dk, hsf@create.aau.dk

Abstract. This paper proposes a new relation model, called "The Moody Mask model", for Interactive Digital Storytelling (IDS), based on Franceso Osborne's "Mask Model" from 2011. This, mixed with some elements from Chris Crawford's Personality Models, is a system designed for dynamic interaction between characters in an interactive setting. The system was evaluated with a quantitative study investigating the impact of interactivity, with some open-ended questions for qualitative analysis. Furthermore, it was compared with other IDS applications, using the common evaluation method "UxTool". We found that the Moody Mask model was not significantly improved by adding interactivity, except in a few logical areas. It also performed worse than other IDS applications in all areas. The participants reported issues with the lack of feedback from direct actions, repetitive actions, and problems with the story scenario and UI. With these issues solved, though, there are indications that this model might have potential.

Keywords: The Mask Model · Personality models · UxTool · Characters · Relations · Interactive Digital Storytelling · AI

1 Introduction

Interactive Digital Storytelling (IDS) is a topic with many challenges. An important one of these is creating realistic characters, considering their importance in stories [2,6]. The goal is to create believable characters that not only act as we expect them to in any situation, but also to create interactions that are meaningful enough to a perceiver that they can construe emergent, dynamic stories from them [6]. This has been attempted in many ways already [5,6,11,12,14,17,19], however, many of these have not undergone thorough evaluation. Therefore, in this paper one of these untested, yet promising, models have been implemented and tested with the purpose of evaluating it.

The model chosen for this was the "Mask Model" [14]. This is an interesting model because of its use of Goffman's theories [10], to define characters through

© Springer International Publishing Switzerland 2015
H. Schoenau-Fog et al. (Eds.): ICIDS 2015, LNCS 9445, pp. 69–80, 2015.
DOI: 10.1007/978-3-319-27036-4_7

"Masks", that can change depending on social contexts. This model was never developed beyond it's initial proof of concept. Therefore, in this paper, we implement it in an interactive system, and test if this added interactivity adds to the user-experience, as well as compare it to other models.

The paper is organized as follows: Section 2 describes the related work, Sect. 3 describes how this specific model was created, Sect. 4 shows how the method was used to evaluate the method, and Sect. 5 presents and analyse the findings from this evaluation. Section 6 concludes the paper.

2 Related Work

Several other IDS models have been created before. From the extensive IDS models proposed by Crawford [6], which deal with many different aspects of the problem, to the more socially focused models like "Versu" [9] and "Comme il faut" (CiF) [12], which powered the game "Prom Week" [12]. AI techniques such as "Belief-Desire-Intention" (BDI) [8] or planning techniques such as "Hierarchical Task Networks" (HTN) [5] have also been used. Another common path in IDS research is to develop a "Drama Manager" to help govern the story in a certain direction [11], sometimes adding additional techniques such as case-based reasoning [20] or reinforcement learning [13]. This is done to guide the story more surely than by having the characters interact freely, but it perhaps also limits some of the possible emergence.

In order to create a more natural interaction and storytelling, some have looked into other input methods, like voice recognition [5], and physical interactions [19]. This typically requires topics like "Natural Language Processing" [5,11] and language generation [4]; however, as these are still not fully researched areas, some have also tried avoiding them [7]. Some have researched interactivity itself, and how different interaction roles in the virtual environment changes the way a player interacts [17].

Other related work regarding IDS are research into: Comparison with branching-narrative game [15], replay value [16], perceived agency [22], player modelling [23], narrative engagement [18], authoring [21], narrative comprehension [1] and role differences [17].

The approach here is not to expand the possible ways of doing IDS, but instead to elaborate on a simple relation model to help evaluate what has already been designed.

3 The Moody Mask Model

Our "Moody Mask Model" was created as an interactive implementation of the Mask Model, as described by Osborne [14]. Certain aspects were left vague or unexplained, however. These were filled out with the "Personality Model" by Crawford [6]. We namely used the traits, moods, and opinion systems, as well as bounded numbers for variable calculations, and the addition of a "HistoryBook" which characters use as memory (See [6,14] for details on both of the models).

Finally, we added a "reaction system". This allowed characters to react to actions performed against them, through a sub-list of actions that served as possible reactions to the given action.

Traits and Moods. The Mask Model [14] includes an action-reaction system, but is vague about several factors we consider important to imitate conscious thought. As Crawford's models [6] includes these behavoiral influencers, we have added his traits and moods into the system at the person-level. Each person will this way have a full Crawford-set of moods and relations, and will be able to react, not only on hard-set values but also gradual influencers which can change their behaviour.

It should be noted that the traits and moods were never implemented into Orborne's formulas for action-selection. Instead a more indirect and manual approach was used. A Rule in the system contains a validation-system for when each action is validated for execution. This function is defined by the designers and can validate an action based on the character's moods and traits. The individual action's execution is then responsible for changing any traits and moods.

It is noteworthy that Crawford [6] critizises his own inclination-formulae as being too time-consuming and complex. Adding his system to the Mask Model [14] will arguably make everything even more complex and time-consuming to set up. It should be investigated which parts of Crawford's [6] and Osborne's [14] systems could be left out or optimized to reduce the designers' labour.

Reactions. As Osborne's model does not account for real-time reactions, we turn to Crawford's system.

We chose to use Crawford's "history-book" [6] as short-term memory. A character would be evaluating the actions of others towards themselves within $10\,s$ and limit the action-selection to appropriate responses to these actions. The $10\,s$ is an untested balance and the effects for believability when using other values should be tested, if not a more elegant solution can be found. Finding a way to calculate reactions to actions done towards a third party was beyond our resources, though it should be part of the model.

It could be considered to seperate traits into long and short-term memory at the cost of performance and memory, which would include a separate system of quickly changing opinions to simulate a character's reaction to immediate actions.

Change in Formula. Even if our design does not exclude anything described in Osborne's work [14], our resources did not allow us to implement the whole system. Notably we found no satisfactory solution for calculating visibility or success and the implementation therefore excludes this. Osborne's [14] ego calculation therefore becomes:

$$E = \alpha g + (1 - \alpha) \sum_{i=1}^{n} p_i g_i \qquad (1)$$

Where g is the *gain* a character would recieve from this action, n is the amount of reactions which can be predicted this action could result in, v_i is the percieved visibility of the the i'th reaction, p_i is the percieved probability of the i'th reaction, g_i is the gain of the i'th reaction toward's the character performing the initial action, and success as well as visibility has been removed.

In a complete "Moody Mask" model, no mathematical additions are made to any of Osborne's inclination-formulae as they seem sufficiently complete to calculate both a person's desire to act rationally and impulsely.

It should be noted that, even with these features, Moody Mask is still unfinished. The implementation was created as a real-time text application, where players could select actions through a menu and see what actions the characters performed through text.

3.1 The Bungaric Society

In order to evaluate our system, a small story scenario was created for people to experience.[1] This scenario consists of five people, one being controlled by a player. In the scenario, three peasants arrive at a nobleman's house, in order to hopefully put an end to the tension that has been in the society recently. To complicate things further, the player character realizes that his best friend might be sleeping with his girlfriend, both joining the player to the party.

These five people were given personalities, which were implemented through individual traits, opinions, moods [6], and mask influences needed for the Mask Model [14]. The masks where also created from the relations described in the scenario, which created ten masks: A culture mask for the Bungaric culture, a merchant culture mask, and three interpersonal masks (A Friendship, Romantic Relationship, and Rivalry Mask), as well as a self-mask for each of the five people. Within these were created all of the rules and actions that can happen.

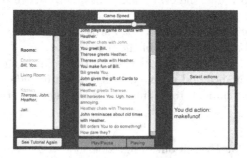

Fig. 1. A screenshot of playing "The Bungaric Society", the implementation of the Moody Mask Model.

[1] The current implementation of the Bungaric Society can be seen in Fig. 1, and can also be played through this link: http://chronologist.itch.io/bungaricsociety.

4 Methodology

The evaluation follows a Convergent Parallel Mixed Method [3] through experimental between-group analysis. Data was gathered through a questionnaire, as participants took the test online.

First, we investigated whether interactivity improves the experience, since the original Mask Model was not interactive. We proposed the following hypothesis: *Interactivity will improve the experience for the users.*

To measure user experience, we gathered data through a quantitative 5-point likert-scale questionnaire named the "UxTool" [24], extended with several open-ended questions for qualitative analysis, to support the quantitative findings. The UxTool has been widely used to measure user experience within IDS [15–17,22]. As the UxTool has already performed satisfyingly in reliability-tests [15,16], it must also be assumed that the UxTool proposes satisfying validity. Therefore this method fits well for our purpose.

To assess the quality of Moody Mask, we also compare the implementation to other interactive storytelling systems. Here, the common use of the UxTool [24] will be utilized. This is a secondary priority, though, and the reader should note that this evaluation is different from other studies through test-base and the medium Moody Mask communicates through. Therefore, these findings will only be indicatory of our model's performance compared to the others. We will not be providing a comparison of the qualitative data because of this, and because several of our qualitative questions were our additions to the UxTool and not shown in the data provided by other papers.

4.1 Procedure

Each session started when a participant chose to click the link to our system. Participants were taken to a page on "itch.io" from which they could download the system for either Windows or Mac. After opening the file, the system would choose which test-group to place the participant in, and the session would start. If the experimental group was chosen, the participant would play the interactive version of the system where they could choose actions, and if the control group was chosen, the non-interactive version of the system would be given, where they could only spectate and the fifth character would be controlled by an AI. After playing a session for 2 min, a button would appear at the top of the screen prompting the participant to fill out the online questionnaire, opened upon clicking the button. After filling out the questionnaire the session was complete.

4.2 Protocol

The questionnaire contains several additions besides the UxTool [24].

The UxTool already contains questions for demographics. We added a question about preference towards text-games, which was used to measure the difference between participants who liked, and did not like text-games.

Two open-ended questions were also introduced. First, we asked them to describe what happened in their story. With these stories we were able to categorize if the system managed to relay a meaningful set of events.

Secondly, we asked: *For how long did you play? Did you exit immediately when the button appeared?* If a player exited the game at once after the button appeared, it could indicate dissatisfaction with the system. It was also used to measure how many people had to play the game multiple times to get to the end.

4.3 Data Analysis

As the data consisted of both qualitative and quantitative data, several approaches were used in the analysis.

First, we calculated the p-values between the two test-groups for each question in the UxTool using an independent 1-tailed t-test, as we were looking for an increase, assuming the data was parametric. These raw results were later correlated with the same test where the two groups had been split further between participants who liked and did not like text-games.

Second, we compared means from the experimental group with other evaluations [15–17] using the UxTool [24], to understand how Moody Mask measures with other systems. The means were compared because the hyphotheses from the other evaluations were different, rendering p-values irrelevant. Facade [15] was the most useful reference as that study also tested interactivity.

4.4 Participants

Our target-group is people interested in narratives. The participants (n = 40, 33 male, 6 female, 1 other) were recruited over the internet through various game and interactive fiction forums, as well as facebook. Thus this was primarily a purposive sample, as the nature of the websites were chosen mainly for accessibility and likelyhood to return results.

Table 1. The results from the UxTool responses. The two groups are shown by means and standard deviations, and the p-value from the one-tailed t-test, the p-values from a similar test between the two groups where text game preference was reported as above 3 and the p-values presented in [15] are shown to the right (Note that [15] did not measure "Perceived Autonomy", and the "AffectPos" mean may be miscounted, as the scales in the UxTool goes from 1–5 and a mean of 5.07 should be impossible).

	Mean (I)	Std (I)	Mean (N)	Std (N)	P-values	P-values Text-pref	P-values (Facade)
Curiosity	2.9667	1.0246	2.6167	1.043	0.0331*	0.0062*	0.33
Suspense	2.5125	1.35	2.275	1.2826	0.1278	0.0784	0.32
Flow	2.4	1.3707	2.19	1.2202	0.1269	0.2426	0.89
AestheticPleasantness	1.7167	0.8654	1.5833	0.8294	0.1953	0.3562	0.67
Entertainment	2.525	1.0619	2.375	1.1916	0.277	0.033*	0.07
AffectPos	1.7	0.8694	1.7833	0.8045	0.7066	0.3069	0.032*
AffectNeg	2.1333	1.3712	2.2167	1.1658	0.6398	0.533	0.011*
RoleAdoption	1.8167	1.0969	1.3167	0.7009	0.0018*	0.071*	0.11
Usability	2.7833	1.4391	3.9833	1.2688	1	0.9978	0.53
Satisfaction	2.325	1.0715	2.25	1.0064	0.3739	0.2142	0.025*
CharacterBelievability	1.925	1.0473	2.35	1.231	0.9498	0.7797	0.32
Effectance	2.225	1.4049	1.575	1.0099	0.01*	0.0061*	0.001*
Presence	1.7833	1.075	1.5333	0.7471	0.0709	0.0305*	0.033*
PerceivedAutonomy	2.4875	1.501	1.825	1.4211	0.0024*	5.36E-04*	??

*Significant difference at $p < 0.05$, I = Interactive, N = Non-interactive

Participants were separated into the experimental group (n = 20, 18 male, 2 female), and the control group (n = 20, 15 male, 4 female, 1 other) through an automatic system in the test-program. In the experimental group, most were aged 25–31 (n = 12), while the remainder were either younger, 20–23 years (n = 5) or older, 37–44 years (n = 3). People in the control group were generally younger, the majority being 19–24 (n = 13), the remainder being 26–31 (n = 7). In the experimental group, all reported that they had experience with computer games (n = 20), For the control group, almost all had experience (n = 19). The test lasted 9 days, gathering as many results as possible. On the last day of test, we gathered results from 3 colleagues to pad the test-base to 40.

5 Findings

5.1 Experimental Analysis

Table 1 includes the results from the t-test performed on the two participant-groups (First P-values from the left), as the data showed to be parametric (This was false for a few; however, a Mann-Whitney test yielded the same results).

It can be seen that there is a significant difference in the means at "Curiosity", "Role Adoption", "Effectance", and "Perceived Autonomy".

The dimensions showing a significant difference, are nearly all "interactivity-focused", meaning dimensions that usually rely on some sort of interactivity from the user in order to be present. It is therefore not surprising that these dimensions show a significant difference. It can also be argued that "Role Adoption" is also more likely in an interactive scenario, since the player is acting as a character, allowing for easier adoption of a role.

The only dimension which shows a relevant significant change is "Curiosity". This might indicate the system felt like a unique experience, or interaction made the participants more curious about the effects of their actions. Neither the qualitative or quantitative responses reveal why, though.

The rest of the dimensions ("Suspense", "Aesthetic Pleasantness", "Entertainment", "Satisfaction", "Flow", and "Presence") show no significant difference and it can generally not be concluded that there is a statistically significant improvement from the non-interactive version to the interactive version.

Negative Results. Looking at the means, there were several results which showed a decrease from the control-group.

In "AffectPos" and "AffectNeg" (Positive and Negative Affect), this could indicate a more emotional experience for the non-interactive group, but since the difference is not substantial it can be excluded as a statistical inconsistency.

If we perform a t-test in the opposite direction, "Usability" shows a decrease with a p-value of 0.0000019442 (significant). This is not surprising, though, as many found the interaction design poor and confusing.

The final negative mean change is "Character Believability". The reason is indicated in the qualitative responses, in which several participants felt ignored when interacting.

In Table 1 it can also be seen that several of the mean values, especially "Aesthetic Pleasantness", "Role Adoption", and "Character Believability" are quite low. This indicates that the participants thought poorly of the system in these areas, which highlights that Moody Mask is an unfinished system.

There is, however, not much evidence to support that many participants' ratings of the experience were influenced by their story as they mainly focused on the frustrating implementation in their comments.

Text-Preference. Finally, Table 1, contains the results from a one tailed t-test that was calculated with only the participants who reported that they liked text games (scored > 3 on a scale from 1–5), since this was a text experience, which might discourage some people. This t-test shows 2 additional significant results. We argue that "Presence" is similar to the other interactive categories, but "Entertainment" showed an increase—meaning that people who didn't mind the text format found the interactive version more entertaining. A t-test was also performed on participants who did not like text games, and here, no dimensions showed a significant increase.

5.2 Ux-Tool Comparison

As [15] also tested interactivity vs. non-interactivity (in "Facade" [11]), our comparison with their findings will be the most reliable, and can be seen in Table 1.

The findings from Moody Mask show lower values in both groups, indicating that the current implementation of Moody Mask is not as effective as Facade [11]. They do share a similar trend in the significant change in Effectance, though. In contrast to these findings, [15] finds a significant difference in both "AffectPos" and "AffectNeg". They do this because they use a two-tailed t-test.

Other Comparisons. It is irrelevant to compare p-values with [16,17], as their hypotheses were different. However, Fig. 2 shows how all systems compare on means.

Again, it seems that Moody Mask is lower in nearly all categories, showing insufficiencies with the model. It does share some trends, though. Namely high Curiosity, low Aesthetic Pleasantness, and high Usability.

It should be mentioned that all these other models used an implementation which included graphics, making them more visually appealing (a frequent request by our participants). This most likely affected their participants' opinions about their experiences.

5.3 Qualitative Findings

Looking at the participants' responses, we can get a suggestion as to why they felt the experience was as it was.

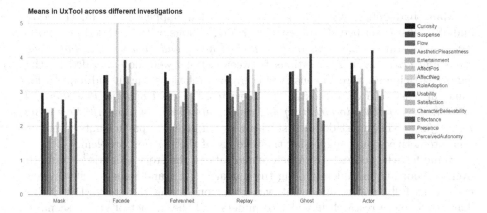

Fig. 2. Table showing the means of Moody Mask and each other researcher's use of the UxTool (all interactive groups and/or first exposures), laid out for each dimension. Facade & Fahrenheit = [15]. Replay = [16]. Ghost & Actor = [17]. Note that "Perceived Autonomy" was only tracked by Ghost/Actor and Moody Mask, not the others.

In both groups, some participants found it boring, repetitive, and random (I8[2] writes *"Unsure if the characters make decisions based on specific interests or if the game makes random decisions ..."*). Even the participants who liked the story had plenty of negative things to say about the experience too (like how there weren't any visuals (I2, I16, N12), or not enough detail (N11). A positive comment came from N8, who said *"I liked that I got to fill in all the blanks with my imagination"*, which suggests that the lack of information enabled some users to construe emergent narratives which could be enjoyable to some.

Some in the interactive group (I6, I13, I17) also found the interface confusing, which could have impacted their experience negatively. The feedback indicates a need for a visible timer on player actions, and an improved action selection interface where only possible actions and targets are shown, as future improvements to the UI.

Stories. When looking at what type of stories the participants wrote, many had experiences where they ended in jail, often because they killed someone.

According to our findings, this criminal behaviour was caused by the system seemingly ignoring good/neutral actions. I6 writes: *"...I engaged in very positive actions, but felt like nothing I did really mattered..."*. To combat this, participants would often perform bad/evil actions because those were more effective. It is not necessarily an error in the system that characters ignored players, however, it should be considered to change the design to be more agressively reactive to the player's actions.

[2] All participants are referred to as "I" or "N", signifying whether they belonged to the Interactive (experimental) or Non-interactive (control) group, followed by an identifying number.

Many had difficulty ascribing a story to what happened (I4, I5, I15, I17) and often just described characters performing actions, without describing motivation (I17 stated: *"... John tried to kiss Heather and then went to the living room and cried. ..."*). As relations between actions were not provided by the game, participants were to construct their own relations, and it did happen for some, at least to a certain extent (N17 writes: *"... So I imagine that this [...] party [...] escalated into bickering and arguments (probably about Heather being unfaithful)"*). The most detailed stories were all given by participants from the non-interactive group, suggesting the severity of the reaction problem.

Some felt the context given beforehand about the story scenario[3] was both overly important in understanding the narrative (I8), and some felt it was not enough to fully understand what was going on during the story (I10, N13). This needs more research in order to understand the impact of giving scenario information in IDS.

It is possible that the difference in responses was influenced by the participants' interest in answering questionnaires, some narratives being more interesting or coherent than others, or people's ability to use their imagination.

6 Conclusion

In this paper, The Moody Mask model, based on the Mask Model [14] and Crawford's personality models [6], was described, implemented, and evaluated with a Convergent Parallel Mixed Method, looking at the impact of interactivity and a comparison with other IDS models.

Limitations. As pointed out in Methodology 4, several concepts in the model still need definitive solutions, we proposed an alternative method for short-term memory, and visibility as well as success are still undefined.

Conclusions. Primarily, interactivity did not improve the experience significantly. There was a significant improvement in a few areas, namely the more interactively focused dimensions such as "Effectance". It was, however, worse in several others important to the experience, such as "Affect". Most showed no significant improvement. When we only analyze participants with a fondness for text-games, a significant difference in "Entertainment" is also present, however, the results are still mainly the same.

When compared with other IDS models through the UxTool [24], the Moody Mask model performs worse than all the other systems in all areas. However, Moody Mask does share some trends with the other models.

[3] A short description about the characters, initial motivations, etc. was given to players when they started playing. However, this was kept loose to allow players to interpret the characters as they wanted.

Improvements. When looking at the qualitative results, we can get an understanding of what needs improvement in the model, and by extension, other similar models. For example, participants in the interactive version need more direct feedback on why the other characters react (or choose not to react) to the player's actions. Furthermore, several problems with the implementation of this interactive experience have been reported, for instance problems with the interface, the explanation of the actions, repetition of actions, and the context for being in the story situation. This could have a negative influence on the results.

With significant improvement in these areas the Moody Mask model might show to be a reasonable alternative to other relation systems.

References

1. Anthony, M.N., Bae, B.-C., Cheong, Y.-G.: Comparison of narrative comprehension between players and spectators in a story-driven game. In: Mitchell, A., Fernández-Vara, C., Thue, D. (eds.) ICIDS 2014. LNCS, vol. 8832, pp. 208–211. Springer, Heidelberg (2014). http://dx.doi.org/10.1007/978-3-319-12337-0 22
2. Artistotle: Poetics. Web Atomics, Cleveland, OH, USA (350 BC). http://classics.mit.edu/Aristotle/poetics.html
3. Bjørner, T.: Qualitative Methods for Consumer Research: The Value of the Qualitative Approach in Theory and Practice, 1st edn. Hans Reitzels Forlag, Copenhagen (2015)
4. Cavazza, M., Charles, F.: Dialogue generation in character-based interactive storytelling. In: American Association for Artificial Intelligence (AAAI) (2005)
5. Cavazza, M., Charles, F., Mead, S.J.: Interacting with virtual characters in interactive storytelling. In: Proceedings of the First International Joint Conference on Autonomous Agents and Multiagent Systems: Part 1, pp. 318–325. AAMAS 2002, ACM, New York, NY, USA (2002). http://doi.acm.org.zorac.aub.aau.dk/10.1145/544741.544819
6. Crawford, C.: Chris Crawford on Interactive Storytelling, 2nd edn. New Riders, Indianapolis (2012)
7. Crawford, C., Bee, L., Conley, C., Dargin, L., Gonzalez, A., Kirk, J.: Siboot (2015)
8. Davies, N., Mehdi, Q., Gough, N.: Creating and visualising an intelligent npc using game engines and ai tools. In: Proceedings of the 19th European Conference on Modelling and Simulation, Riga, Latvia, pp. 721–726 (2005)
9. Evans, R., Short, E., Nelson, G.: Versu (2013)
10. Goffman, E.: The Presentation of Self in Everyday Life. Anchor, New York (1959)
11. Mateas, M., Stern, A.: Facade (2003). www.interactivestory.net
12. McCoy, J., Mateas, M., Wardrip-Fruin, N.: Comme il faut: a system for simulating social games between autonomous characters. In: Proceedings of the 8th Digital Art and Culture Conference (DAC). Irvine, CA, 12–15 December 2009
13. Nelson, M.J., Roberts, D.L., Isbell Jr., C.L., Mateas, M.: Reinforcement learning for declarative optimization-based drama management. In: Proceedings of the Fifth International Joint Conference on Autonomous Agents and Multiagent Systems, pp. 775–782. ACM (2006)
14. Osborne, F.: A new approach to social behavior simulation: the mask model. In: Si, M., Thue, D., André, E., Lester, J., Tanenbaum, J., Zammitto, V. (eds.) ICIDS 2011. LNCS, vol. 7069, pp. 97–108. Springer, Heidelberg (2011). http://dx.doi.org/10.1007/978-3-642-25289-1_11

15. Roth, C., Klimmt, C., Vermeulen, I.E., Vorderer, P.: The experience of interactive storytelling: comparing "Fahrenheit" with "Façade". In: Anacleto, J.C., Fels, S., Graham, N., Kapralos, B., Saif El-Nasr, M., Stanley, K. (eds.) ICEC 2011. LNCS, vol. 6972, pp. 13–21. Springer, Heidelberg (2011). http://dx.doi.org/10.1007/978-3-642-24500-8_2

16. Roth, C., Vermeulen, I., Vorderer, P., Klimmt, C.: Exploring replay value: shifts and continuities in user experiences between first and second exposure to an interactive story. Cyberpsychol. Behav. Soc. Netw. **15**(7), 378–381 (2012)

17. Roth, C., Vermeulen, I., Vorderer, P., Klimmt, C., Pizzi, D., Lugrin, J.L., Cavazza, M.: Playing in or out of character: user role differences in the experience of interactive storytelling. Cyberpsychol. Behav. Soc. Netw. **15**(11), 630–633 (2012)

18. Schoenau-Fog, H., Louchart, S., Lim, T., Soto-Sanfiel, M.T.: Narrative engagement in games-a continuation desire perspective. Found. Digital Game **8**, 384–387 (2013)

19. Shapiro, D.G., McCoy, J., Grow, A., Samuel, B., Stern, A., Swanson, R., Treanor, M., Mateas, M.: Creating playable social experiences through whole-body interaction with virtual characters. In: AIIDE (2013)

20. Sharma, M., Ontañón, S., Mehta, M., Ram, A.: Drama management and player modeling for interactive fiction games. Comput. Intell. **26**(2), 183–211 (2010)

21. Spierling, U.M.: Implicit Creation non-programmer conceptual models for authoring in interactive digital storytelling. Ph.D. thesis, University of Plymouth, September 2010

22. Thue, D., Bulitko, V., Spetch, M., Romanuik, T.: A computational model of perceived agency in video games. In: AIIDE (2011)

23. Thue, D., Bulitko, V., Spetch, M., Wasylishen, E.: Interactive storytelling: a player modelling approach. In: AIIDE, pp. 43–48 (2007)

24. Vermeulen, I.E., Roth, C., Vorderer, P., Klimmt, C.: Measuring user responses to interactive stories: towards a standardized assessment tool. In: Aylett, R., Lim, M.Y., Louchart, S., Petta, P., Riedl, M. (eds.) ICIDS 2010. LNCS, vol. 6432, pp. 38–43. Springer, Heidelberg (2010). http://dx.doi.org/10.1007/978-3-642-16638-9_7

Creative Help: A Story Writing Assistant

Melissa Roemmele[✉] and Andrew S. Gordon

Institute for Creative Technologies, University of Southern California,
Los Angeles, CA, USA
{roemmele,gordon}@ict.usc.edu

Abstract. We present Creative Help, an application that helps writers by generating suggestions for the next sentence in a story as it being written. Users can modify or delete suggestions according to their own vision of the unfolding narrative. The application tracks users' changes to suggestions in order to measure their perceived helpfulness to the story, with fewer edits indicating more helpful suggestions. We demonstrate how the edit distance between a suggestion and its resulting modification can be used to comparatively evaluate different models for generating suggestions. We describe a generation model that uses case-based reasoning to find relevant suggestions from a large corpus of stories. The application shows that this model generates suggestions that are more helpful than randomly selected suggestions at a level of marginal statistical significance. By giving users control over the generated content, Creative Help provides a new opportunity in open-domain interactive storytelling.

Keywords: Open-domain interactive narrative · Writing aids · Natural language generation

1 Introduction

The field of artificial intelligence has long conceived of using computers to write stories. The first known automated story generation system, *Novel Writer*, was developed in 1973 [7], followed by a steady line of work up to the present [8,13,15, e.g.]. These systems act as writing agents that generate narratives from hand-authored models of the characters, settings, and actions comprising the story-world domain. Similarly, there are works of fiction generated through user interaction, with these first of these systems, *Adventure*, emerging in 1975 [2]. Despite the apparent user-driven nature of interactive fiction systems, they are similar to the AI systems in their autonomy. They expect users' writing to adhere to a highly constrained syntax and vocabulary in order to continue the emerging narrative. They also similarly rely on hand-authored domain models that push users towards one of a limited number of predefined experiences. The current challenge for narrative AI is to provide interactivity that gives human authors control over writing, enabling them to write the stories they want to tell.

One of the barriers to advancing true interactivity is automatically understanding the author's intended meaning as the story is being written. Advances

© Springer International Publishing Switzerland 2015
H. Schoenau-Fog et al. (Eds.): ICIDS 2015, LNCS 9445, pp. 81–92, 2015.
DOI: 10.1007/978-3-319-27036-4_8

in the field of natural language processing are starting to break down this barrier. Many emerging language technologies can be seen as assistive tools that recognize users' intent and help them achieve it. Automated spelling and grammar correction, as commonplace as they seem, are examples of simple writing aids. We envision a new sort of writing aid, one that performs "narrative auto-completion": it analyzes a story as it is being written and then makes a suggestion for how to continue the story.

Recent work in open-domain interactive storytelling now supports this vision. The impracticality of authoring models for every possible story domain has motivated the effort to learn such models from data [1,11]. Swanson and Gordon [19] describe a case-based reasoning approach for generalizing knowledge from existing stories to new ones. They present this approach as Say Anything, a platform where the user and automated agent take turns writing sentences in a story. The success of this system in producing readable stories established a new path towards users having authorial control in interactive narrative experiences.

In this paper, we present Creative Help, a system that builds on Swanson and Gordon's story generation approach [19], but is unique in its role as an assistive tool that places the writer in control of the resulting narrative. Writers use Creative Help to generate ideas for what happens next in their story. In contrast to Say Anything, users both choose when to request a suggestion and what to do with the requested suggestion, enabling them to maintain the primary influence over the outcome of the story.

Previous systems have struggled to provide an objective evaluation of generated content, relying on questionnaire-based tasks where people read and rate the stories. In contrast to this, Creative Help has an inherent capacity to evaluate its own output by tracking users' revision of the generated suggestions. The application measures the similarity between the suggestions and users' modifications to them, providing a quantified score of users' interest in the suggestions. We use this functionality to compare different models for retrieving suggestions, which in turn enables us to draw conclusions about each model's relative helpfulness to writers. From these results we discuss how to move towards an automated story writing assistant that maximizes the potential of authors' storytelling creativity.

2 Creative Help

Creative Help is a web-based application for writing stories. Users request "help" from the application to automatically author a new sentence. The user interface (Fig. 1) is extremely simple: users see a text box where they can start typing a story. When the user wants to receive a suggestion for the next sentence in the story, she types "\help\". This initiates a Javascript function that sends a request to a CherryPy back-end server to generate a sentence. The server has a generation model that accesses a large corpus of stories in order to find a suggestion to fulfill the help request. The suggested sentence appears in the text in place of the "\help\" string. The user can modify this suggestion like any other text that already appears in the story. She can then continue writing, making

Creative Help USC Institute for
 Creative Technologies

Type \help\ when you need it.

I just returned from a particularly exotic vacation. We spent hours on flights and just to get to South America, and then from there had to make our way all the way to the mountains at the foot of the continent. Perhaps if I were more Sarah Palinesque I would make an ill thought out comment about being able to see Antartica from the mountain tops.
The best part of the trip was the hiking, one moment warm and sunny, and the next bitter cold with icy rain moving up the mountain. Irregardless the meteorological changes, we moved further up, further in.
I should explain our traveling party some. It began as just myself. I had hoped to make it a solitary venture. An opportunity to step back from the fast-paced life I normally lead and experience the awesome majesty of the most majestic mountain range on earth. That didn't last long. Word of my idea got out and very quickly two guys from work wanted to join in. Offering to split the costs it made sense financially, but at the same time frustrated my attempts at spiritual and physical rejuvenation.
Nothing could spoil the beauty of this wondrous place though. Not even their ridiculously awful driving along the bumpy, back country roads.
At night, the stars would light up the sky in a way which is far beyond the paltry attempts of humanity upon the advent of electricity. I watched the stars dance their way through the deep violet sky. \help\

Fig. 1. Creative help

additional requests for suggestions whenever she chooses. The application tracks the user's changes to suggested sentences in order to evaluate their quality as contributions to the story. We explain the details of this pipeline below.

2.1 Generating Suggestions

The mechanism by which Creative Help generates suggestions is similar to the generation component of SayAnything, a system that takes turns with a human user in writing sentences in a story [19]. In SayAnything, the approach was to search within a large corpus of stories to find the sentence that is most similar to the sentence the user wrote in his most recent turn. Once this sentence is located, the system retrieves the sentence that immediately follows it in the corresponding story. This is the sentence that is contributed as the system's turn. Analogously, in Creative Help, the sentence that appears directly before the help request is the sentence for which the system finds a most similar match. This technique follows the philosophy of case-based reasoning, which draws inferences about a new instance by comparing it to one that has been observed before. Here, the system infers that the generated sentence is a good continuation of the story because it appears in a story similar to the one that has been written so far.

In order to compute similarity between sentences, we use the software package Apache Lucene [5] to index all words in the corpus. An index stores the number of times a word occurs in a sentence (called *term frequency*) as well as all the sentences in which a word occurs (called *document frequency*). This information

enables Lucene to encode a sentence as a vector of words, with each word represented by its term frequency-inverse document frequency (tf-idf) weight. The tf-idf weight scheme assigns higher weight to words that occur more frequently in the sentence relative to their frequency overall in the corpus. This representation, called the Vector Space Model, enables efficient computation of similarity between sentences in terms of their vector similarity. Given the sentence the user wrote before making the help request, Lucene scores its similarity to all other sentences in the corpus using a formula based on cosine similarity. The sentence with the highest similarity score is selected as the most similar match. Along with the text of a sentence, we store the ID of the sentence that follows it. With this information, the system can easily retrieve the sentence that occurs after the most similar match and return it to the Creative Help user as the suggested continuation of their story.

2.2 Data

The suggestions for Creative Help are generated from a corpus of approximately twenty million English-language stories. These stories were identified using a story classification tool developed by Gordon and Swanson [4], which was used to specifically extract stories from a large set of public weblog posts authored between January 2010 and August 2014. We segmented each of these stories into sentences using the Stanford CoreNLP sentence tokenizer [12], which detects sentence boundaries at sentence-ending characters ("."", "!", or "?") that are not contained in a token such as an abbreviation. Using this tool, the 20,337,098 stories in the corpus were segmented into a total of 681,921,109 sentences.

2.3 Modifying Suggestions

As soon as the suggested sentence appears to the user, the application starts tracking any edits the user makes to the sentence. Specifically, the JavaScript component of the interface listens for any keystroke events occurring in the text area where the suggestion appears. If the majority of the text characters are removed from the suggestion (such that less than ten characters remain), the application considers the suggestion to have been deleted. Otherwise, the application continues to track edits to the suggestion. If a suggestion has remained unchanged for at least one minute, the tracking to that sentence "expires" and it is assumed that the user has made his final modifications to the sentence. As soon as a suggestion is given a deleted or expired status, it is logged to a SQLite database along with its original form before it was modified. For deleted suggestions, the modified sentence is just an empty string. In some cases, the suggestion might be "lost" in that the application is no longer able to find the tracked location where the suggestion first appeared. This might happen if the user suddenly cuts and pastes over all the text in the story, for instance. If this happens, the suggestion is assigned a lost status and logged accordingly in the database. As the next section explains, this tracking data directly shows the comparison between

Table 1. List of suggested first sentences, not included in any generation model

"Last night I had a crazy dream."
"A strange thing happened on my way home yesterday."
"I had the most awkward dinner of my life last night."
"I received a surprising phone call yesterday."
"Last week some old friends came in town for a visit."
"Last year I took a cross-country road trip."
"Last weekend I went to a party at a friend's house."
"I just returned from a particularly exotic vacation."
"I was sitting in my desk at work when I saw the news."
"I got in trouble a lot when I was younger."
"As a kid, I once made an unusual discovery."
"The scar on my leg has an interesting story."
"My first day of high school was unforgettable."
"Last night's performance was spectacular."
"On April Fools' Day, my co-workers played a prank on me."
"My friends planned a surprise party for my birthday."
"I rarely get angry, but yesterday was one of those days."
"I bumped into my ex a few weeks ago."
"I recently decided to make a big change."
"This morning I noticed a stranger staring at me."

a suggestion and its modification, revealing how helpful the user judged the suggestion to be.

2.4 Story Initialization

When a user first starts writing her story, there is no previous sentence from which to generate a suggestion. For help beginning a story, we wrote a list of twenty introductory sentences that could in turn generate a reasonable continuation. This list, shown in Table 1, illustrates the type of stories most highly represented in our corpus: personal experiences narrated in the first person. If the user types "\help\" before anything else, we randomly pick a sentence from our list as the suggested first sentence in her story. Users can edit these sentences like any other part of the story, but they are not evaluated in association with any generation model; we simply skip over these suggestions in our analysis.

3 Experiment

In allowing users to modify suggestions, Creative Help contains a built-in mechanism for evaluating the suggestion generation system. We assume that if users

consider suggestions to be good contributions to the story, they will edit them less frequently than suggestions they don't consider helpful to the story. Thus, variations in the quality of the model for generating suggestions should be revealed by differences in the rate of users' modifications. We designed an experiment to further explore this idea. In our experiment, users wrote stories with the Creative Help application and each time a user requested help, we randomly varied the model for retrieving the suggestion. We selected four models that we expected to differ based on the quality of suggestions they provided.

3.1 Models

We evaluated four models, which we refer to as the *full* model, the *reduced* model, the *diegetic* model, and the *random* model. The first three models all use the scheme described in the previous section: they consider the sentence the user wrote directly before typing "\help\" and search for the sentence in the corpus with the highest vector-based similarity. What distinguishes these models is the corpus from which they retrieve sentences. In the full model, a similarity match is found among the full corpus of approximately 20 million stories (680 million sentences). In the reduced model, sentences are retrieved from a reduced subset of the corpus containing one million stories, which was the size of the corpus used in Say Anything [19]. The purpose of comparing these two models is to observe if the amount of story data influences the quality of suggestions. We hypothesize that increasing the number of stories will yield more precise similarity matches, making it more likely that the generated suggestion fits the story.

In our third model, the diegetic model, we explore whether certain sentences of stories are better for generating suggestions than other sentences of the same story. In particular, each part of a story can refer to one of two narrative levels: the *diegetic* level on which the events in the story take place, or the *extradiegetic* level on which the narration of the story takes place. For example, consider the first two sentences in the following story. In the first, the writer is describing her experience as a character within the story at the time it occurred. In the second sentence, the writer is addressing the reader at the present moment (the time of writing).

> I walked to yesterday's party with my friend around 9 pm. *(diegetic)*
> Normally I try to stay away from big parties. *(extradiegetic)*

Rahimtoroghi et al. [16] proposed that because they focus on story-world events over evaluative commentary, diegetic sentences are more informative than extradiegetic sentences in continuing a story. We explored this possibility without having to manually annotate every sentence in the corpus. We used Sagae et al.'s tool [17], which automatically predicts a label of "diegetic" or "extradiegetic" for each sentence in a story based on linguistic features. Our diegetic model evaluates the hypothesis that specifically targeting the diegetic sentences in stories will yield more helpful suggestions. This model finds a similarity match among only the sentences labeled as diegetic in the full corpus of 20 million stories; the returned suggestion must also be labeled diegetic.

Finally, we compare these first three models to a fourth model, the random model, which just randomly selects a sentence from the corpus as the suggestion. Since the random model has no knowledge of the user's story, we expect users to judge these suggestions as poor relative to the models that take the most recent sentence of the user's story into account.

Based on the idea that better suggestions will receive fewer edits, we predict differences between each of these four models in terms of how much users modify the suggestions they generate. Obviously, we expect the random model to perform the worst. Because it considers the user's story, we expect the reduced model to outperform the random model, but perform worse than the full or diegetic model because it has fewer stories from which to generate suggestions. Finally, we predict that the full model will perform better than random and reduced models, but that the best suggestions will come from the diegetic model. Our reasoning is that compared to the full model, the diegetic model specifically targets the sentences in stories that are most relevant for generating suggestions. To summarize, we hypothesize the following ordering in the models' quality of suggestions: random < reduced < full < diegetic.

3.2 Task

We recruited 24 people to use Creative Help as part of our experiment. Users were all employees of our research organization who responded to an email inviting them to "try out a computer-assisted story writing tool". Users came to our lab to participate so that we could instruct them about the task in person and respond to any potential questions or issues they had while using the application. We deliberately gave participants only a few instructions: we told them to write a story about anything they wanted to write about, and to type "\help\" when they wanted to receive a suggestion for the next sentence in the story. We made it clear that they could choose to modify, add to, or delete the suggestion however they wished. We asked them to spend 20 min writing, but they were free to continue using the tool for longer. Each time a user requested help, the application randomly selected one of the four generation models, so users were equally likely to receive suggestions from any one of the models. Users were not aware of the method by which the suggestions were generated, other than by observing the suggestions themselves. At the end of the task users had the opportunity to provide feedback and ask questions about the purpose of the tool.

3.3 Evaluation

As discussed, by recording suggestions before and after they have been modified by users, Creative Help affords a means of evaluating the quality of suggestions. We presume an inverse relation between a user's edits to a suggestion and the quality attributed to it. In order to objectively determine if there were any differences between the models in terms of this relation, we needed a method for quantifying the difference between the original and modified form of a suggestion. In fact, there is a popular method in computer science for measuring the similarity between two strings: edit distance. Edit distance encodes the similarity

Table 2. Mean normalized edit distance and deletion rate of suggestions by model

Model	Edit distance	Deletion rate
random	0.760	0.628
reduced	0.729	0.573
full	**0.672**	**0.516**
diegetic	0.718	0.556

between two strings in terms of the number of operations required to transform one string into another, where an operation is an addition, deletion, or substitution of a single character. The more similar two strings are, the lower their edit distance will be; an edit distance of 0 indicates the strings are identical, while an edit distance equal to the length of the longer string indicates the strings share no common characters. There are a few algorithms for computing edit distance, but the traditional one is Levenshtein edit distance [10], which is what we used for computing the similarity between each original and modified suggestion. Because the length of a suggestion affects the edit distance score, we divided the Levenshtein distance by whichever sentence was longer, the original suggestion or its modification. This results in a normalized edit distance score between 0 and 1 [6], where 0 indicates that no edits were made to the suggestion and 1 indicates that the suggestion was entirely deleted or replaced. By computing the edit distance between a suggestion before and after the user has modified it, we can compute the mean edit distance of each model's suggestions as a way of scoring the quality of the model. A lower mean edit distance for a model means that users made fewer edits to that model's suggestions, presumably because they found those suggestions more helpful for continuing their story.

4 Results

There were a total of 378 suggestions requested across all 24 users, an average of about 16 suggestions per user, with each user receiving on average 4 suggestions from each model. The mean normalized Levenshtein distances for the suggestions generated by each model appear in Table 2. We also computed the proportion of suggestions that were deleted for each model, which shows how frequently users deleted suggestions. Even for the full model, where suggestions were edited the least, users deleted half (51.6 %) of the suggestions. The deletion rates and edit distances demonstrate the same pattern across the models. As we predicted, the random model has the highest mean normalized edit distance, meaning that its suggestions were edited more often than those of the other models. We used the compute-intensive randomized test with stratified shuffling [14] in order to evaluate the hypothesized differences between the models. The p-values computed by this method represent the probability of observing model differences at least as large as the ones shown in Table 2 if there were no actual differences. We found a marginally significant difference between the full model and the random model in terms of both normalized edit distance and deletion

(1) Once upon a time... In a galaxy far, far away... a donut shop on the planet Xantofar was experiencing a crisis. *Amber, the sweet but apathetic shop worker, had run out of flour to make the shop's delicious donuts.* **Suggestion (diegetic):** "After that we headed a few miles down the road to Davis Bayou National Park." **Modification:** "She tried going to a grocery store a few miles down the road near Davis Bayou National Park, but the manager said that due to a rare flour shortage the whole county was completely out."

(2) "I recently decided to make a big change. I decided to become a super hero. It all began when I spray painted a bunch of boxes black and put squares of yellow on them to look like buildings and then I used my boys superhero toys to help decorate. *I dressed up like Godzilla and started rampaging through this tiny, helpless box town.*" **Suggestion (diegetic):** "Vanessa made for great stories, but I related to-and sort of sided with-my mom." **Modification:** *(deleted)*

(3) "Last year I took a cross-country road trip. Bought a 15 day pass and (after visiting the Grand Canyon), caught the Southwest Chief in Flagstaff. *And then I met a prostitute.*" **Suggestion (full):** "He made me feel wonderful at first." **Modification:** *(no changes)*

(4) "This weekend my girlfriend and I took the train from Los Angeles to San Francisco. Our journey started out wonderfully, and we found the train ride to be particularly relaxing and picturesque. *Unfortunately, we hit a snag in Oxnard: the train broke down in the station.*" **Suggestion (full):** "Madi, can we go see the Palarie dogs?" **Modification:** "Mari, can we go see the prairie dogs?"

(5) *"Once upon a time there was a cabin in an island"* **Suggestion (random):** "Please keep reading my blog!" **Modification:** *(deleted)*

(6) "Once upon a time there was a young couple who met in a dream. *Each thought the other was a dream mate and not real, until*" **Suggestion (random):** "The location was also pretty good and we could easily walk to the main attractions in Foshan without having to use our tourist guide." **Modification:** "they landed in a dream location that was so pretty ugly that they wondered if they were actually dreaming or had been transported to another reality."

(7) "I received a surprising phone call yesterday. *It was my parole officer.*" **Suggestion (reduced):** 'We talked about work, how my anger was soothed, seduced by the dog." **Modification:** *(no changes)*

(8) "A girl becomes entranced by an inkling of an idea. *She starts to think about how we are all connected and how each interaction and passing we have with one another impacts all those around us.*" **Suggestion (reduced):** "It was a challenge like no other." **Modification:** *(deleted)*

Fig. 2. Examples of creative help suggestions

rate (p = .072 and p = .090, respectively), with the suggestions generated by the full model being modified less than the random suggestions. We take this as evidence that suggestions incorporating the content of the user's story are more helpful than generic suggestions. This may seem obvious, but it validates the use of Creative Help as an evaluation platform. By tracking users' changes to the

output of each generation model and quantifying those changes with a simple similarity metric (edit distance), our application revealed an objective difference in the quality of the models.

Our results did not show a significant impact of the size of the corpus on the generation model, given that the model with access to 20 million stories did not provide better suggestions than the model using only 1 million stories. However, given that the full model did perform the best, it's possible that such a difference would emerge with a larger set of users. Moreover, the hypothesis that diegetic sentences would be more helpful did not hold up. One interpretation is that filtering the corpus of extradiegetic sentences has the same effect as reducing the corpus size, merely limiting the number of examples from which to infer a fitting continuation of the user's story. It's also likely that users issued help requests upon contributing extradiegetic sentences, so the model was mismatching extradiegetic sentences with diegetic ones. An improved model would take the narrative level of the user's contribution into account and search for a similarity match of the same narrative level.

Figure 2 shows examples of suggestions originally generated by each model and their resulting form after being modified by the user. Each example shows the story written so far when the user made the help request, as well as the returned suggestion and how the user ultimately modified it. The sentence that preceded the help request (and thus generated the suggestion) is italicized. Even with the high number of deletions (e.g. examples 2, 5, and 8), some suggestions were retained without any editing (examples 3 and 7). Among the modified ones, users employed different strategies for rewriting these sentences. In some cases, they simply replaced the names of entities (example 4). In other cases, the modification had a related meaning to the original, with some extended or altered details (example 1). Other suggestions were completely transformed, expressing a new meaning even if retaining a few phrases from the original (example 6).

5 Discussion and Future Work

In this work, we defined a new paradigm of "narrative auto-completion", which assists users in writing the next sentence in a story. This functionality affords users more control over an emerging story than previous interactive narrative systems where system-generated content is entirely fixed. Moreover, by enabling users to modify generated content, Creative Help natively evaluates the quality of that content. We used this functionality to compare different generation models and showed that by modeling the domain of the emerging story, we can improve suggestions offered to users. We generated suggestions using case-based reasoning to find similarities between the user's ongoing story and stories in a massive corpus, but there are many alternative designs for generation models. Our goal is not to argue that the full model defined in this work is optimal, but to show that alternative models can be comparatively evaluated using Creative Help.

We compared models in terms of how much users edited their suggestions to incorporate them into the narrative, with the idea that more helpful suggestions receive fewer edits. The next step is to examine what makes a suggestion

more or less helpful to a story. In the case where the suggestion was deleted, there are many possible reasons this occurred. The suggestion could have been entirely incoherent with the story (e.g. example 5 in Fig. 2), or the user might have just disliked the suggestion despite it making sense within the story. On the other hand, we can assume that if a suggestion or some part of it was retained, the user found that part to be a helpful contribution to the story. We presented some characteristic examples in Fig. 2 of how users adapted these suggestions. As future work we plan to analyze what features promote a suggestion's adaptability to the story. In SayAnything [19], maximizing the local coherence between the generated sentence and the user's most recent contribution improved the acceptability of the system's contributions. We expect this to be true in Creative Help as well, but the modification data provides a new opportunity for insight.

This insight will help us refine our target for improving the full generation model used here, which will hopefully increase the rate at which suggestions are retained. One immediate plan is to allow users to request help for completing a sentence that is already partially written. In looking at the data, we noticed that many users expected this functionality, but the models were instead designed to return a new sentence. Another clear need to be addressed is incorporating the context of the full story into the generation model. The current model uses only the most recent sentence to generate the suggestion, which leads to weak global coherence between the generated sentence and the story as a whole. Swanson and Gordon [18] discuss this challenge, which lies in appropriately weighting the contextual information so that it does not compromise the local coherence of the suggestion. Looking farther forward, we want to take advantage of recent progress made in natural language processing on tasks like semantic role labeling [3], distributional word representations [20], and coreference resolution [9]. We expect that by annotating our story corpus with this linguistic information, we can represent stories at a more abstract level than the shallow word-based representation used in our current models. In doing so, we hope this will maximize the completeness and accuracy of the generation system's narrative knowledge. Creative Help can then use this knowledge to offer writers new and perhaps previously unimagined possibilities for storytelling.

Acknowledgments. The projects or efforts depicted were or are sponsored by the U. S. Army. The content or information presented does not necessarily reflect the position or the policy of the Government, and no official endorsement should be inferred.

References

1. Chambers, N., Jurafsky, D.: Unsupervised learning of narrative event chains. In: 46th Annual Meeting of the Association of Computational Linguistics, pp. 789–797 (2008)
2. Crowther, W., Woods, D., Black, K.: Colossal cave adventure (1976)
3. Gildea, D., Jurafsky, D.: Automatic labeling of semantic roles. Comput. Linguist. **28**(3), 245–288 (2002)

4. Gordon, A.S., Swanson, R.: Identifying Personal Stories in Millions of Weblog Entries. In: 3rd International Conference on Weblogs and Social Media, Data Challenge Workshop, pp. 16–23 (2009)
5. Hatcher, E., Gospodnetic, O., McCandless, M.: Lucene in action. Manning Publications, Shelter Island (2004)
6. Heeringa, W.J.: Measuring dialect pronunciation differences using Levenshtein distance. Ph.D. thesis, Rijksuniversiteit Groningen (2004)
7. Klein, S., Aeschlimann, J., Balsiger, D.: Automatic novel writing: a status report. Wisconsin University (1973)
8. Lebowitz, M.: Story-telling as planning and learning. Poetics **14**(6), 483–502 (1985)
9. Lee, H., Chang, A., Peirsman, Y., Chambers, N., Surdeanu, M., Jurafsky, D.: Deterministic coreference resolution based on entity-centric, precision-ranked rules. Comput. Linguist. **39**(4), 885–916 (2013)
10. Levenshtein, V.I.: Binary codes capable of correcting deletions, insertions, and reversals. Sov. Phys. Dokl. **10**, 707–710 (1966)
11. Li, B., Lee-Urban, S., Johnston, G., Riedl, M.: Story Generation with Crowdsourced Plot Graphs. In: 27th AAAI Conference on Artificial Intelligence (2013)
12. Manning, C., Surdeanu, M., Bauer, J., Finkel, J., Bethard, S., McClosky, D.: The stanford coreNLP natural language processing toolkit. In: 52nd Annual Meeting of the Association for Computational Linguistics, pp. 55–60 (2014)
13. Meehan, J.R.: TALE-SPIN, an interactive program that writes stories. In: 5th International Joint Conference on Artificial Intelligence, pp. 91–98 (1977)
14. Noreen, E.W.: Computer intensive methods for hypothesis testing: an introduction (1989)
15. Pérez, R.P., Sharples, M.: MEXICA: a computer model of a cognitive account of creative writing. J. Exp. Theor. Artif. Intell. **13**(2), 119–139 (2001)
16. Rahimtoroghi, E., Corcoran, T., Swanson, R., Walker, M.A., Sagae, K., Gordon, A.S.: Minimal narrative annotation schemes and their applications. In: 7th Intelligent Narrative Technologies Workshop (2014)
17. Sagae, K., Gordon, A.S., Dehghani, M., Metke, M., Kim, J.S., Gimbel, S.I., Tipper, C., Kaplan, J., Immordino-Yang, M.H.: A data-driven approach for classification of subjectivity in personal narratives. In: 2013 Workshop on Computational Models of Narrative, pp. 198–213 (2013)
18. Swanson, R., Gordon, A.S.: A comparison of retrieval models for open domain story generation. In: AAAI Spring Symposium on Intelligent Narrative Technologies II (2009)
19. Swanson, R., Gordon, A.S.: Say anything: using textual case-based reasoning to enable open-domain interactive storytelling. ACM Trans. Interact. Intell. Syst. **2**(3), 1–35 (2012)
20. Turian, J., Ratinov, L., Bengio, Y.: Word representations: a simple and general method for semi-supervised learning. In: 48th Annual Meeting of the Association for Computational Linguistics, pp. 384–394 (2010)

Remember That Time? Telling Interesting Stories from Past Interactions

Morteza Behrooz[1]([⊠]), Reid Swanson[2], and Arnav Jhala[1]

[1] University of California Santa Cruz, Santa Cruz, CA, USA
`morteza@ucsc.edu, jhala@soe.ucsc.edu`
[2] Institute for Creative Technologies,
University of Southern California, Los Angeles, USA
`rswanson@ict.usc.edu`

Abstract. Sociability is a human trait that plays a central part in relationships over time. Today, humans are increasingly in long-term interactions with intelligent agents, which have proven most useful when they are sociable. Such sociability requires the agent to remember and appropriately refer to past interactions. A common way in which humans refer to their past interactions and collaborations is through storytelling. Such stories, often abbreviated, include a small set of interesting and extraordinary events. We propose the design, development and preliminary evaluation of a generic computational architecture for finding and retelling such interesting event sequences. Our system mines interesting interaction episodes in a corpus of prior interactions. Initial evaluation of interactions selected by the system for retelling are encouraging. A future goal of the research is to support collaborative composition of stories about prior interactions between humans and agents in a mixed-initiative framework to produce interesting retellings.

Keywords: Social interaction · Storytelling · Story generation · Human-robot interaction · Narrative content selection

1 Introduction

In the rapidly growing category of interactive robots and virtual agents, sociability seems increasingly important in establishing and maintaining an effective interaction or long-term relationship. There is also an increasing amount of data of interactions that is being recorded on individual players within and across games. Importantly, the utility of a particular episode of such interaction is not limited to the conclusion of the tasks defined for it. We, as humans, reflect upon some such episodes in our daily interactions with each other as memorable points that can reshape a relationship's dynamics. This might be because the value of some social activities, such as "watching a sports game together", often goes beyond the main task itself, and so an interesting sub-sequence of it could be memorable and worthy of retelling.

© Springer International Publishing Switzerland 2015
H. Schoenau-Fog et al. (Eds.): ICIDS 2015, LNCS 9445, pp. 93–104, 2015.
DOI: 10.1007/978-3-319-27036-4_9

Similarly, the sociability of an agent plays a meaningful and often integral role in fulfilling the agent's tasks. For instance, the human-robot interaction community has been working on the notion of sociability for robots and virtual agents and has underlined its impact in numerous studies and in different contexts [7]. However, the memorable moments in interacting with these agents are not necessarily the tasks or sub-tasks themselves, but most often the interesting events that happen during them, which can relate or even be quite unrelated to the main context of interaction.

Hence, it can be very rewarding for an agent to be able to construct compelling retellings of personalized interaction episodes that are considered interesting. Such story retellings can potentially cause higher levels of user engagement through their emotional connection with a more sociable agent or game character [3].

From another point of view, the success of an interaction or collaboration with an agent in any context can be measured in various objective and subjective ways, and from different perspectives. For instance, context-based evaluations can assess the performance of the task in which the agent has been helping a user, or emotional analyses can estimate the levels of frustration, boredom or happiness and engagement. But intuitively, stories are our way of describing a fun, useful, healthy or otherwise negative and bothersome experience. Ideally, a good long-term interaction with a social agent, or a fun gameplay with a social game character, over time, should be interesting enough so that the user is compelled to tell or hear a story about some memorable episodes of it. For example, there are popular web-logs and social network pages dedicated to telling interesting stories that personal assistants currently shipped in smartphones trigger the users to retell.

Note that we are specifically talking about social agents, and it is perfectly normal, for example, if a utility robot (e.g., doing pizza delivery or house cleaning) does not trigger the users to say any stories; although interestingly enough, many users currently using such robots do have stories to tell about them through anthropomorphizing them and imagination (e.g. Roomba robots [8]).

This work focuses on the first aspect of the problem which is to find *interesting* events from past interactions. There is another aspect which is in the way any set of past events is *communicated*. With richer text generation toolkits, it is possible to make the agents recall even a mundane set of events but communicate them in an interesting way. The focus for this paper is a framework for representation of interactions and selection and annotation of interesting events. Future work will address richer natural language and visual composition of co-constructed stories from these selected events.

In this paper, we will first describe a software architecture and approach to annotate and record generalized gameplay interactions. We define and use the markup language notation AIL (Abstract Interaction Logs) and an algorithm that uses sequential rule mining to extract interesting events across multiple interactions in a game of *rummy*. Our current results are based on the choice of algorithm and a heuristic to find interesting events, but the methodology and

implementation is expandable to any set of interactions marked up in AIML and a generic or game-specific heuristic.

2 Related Work

Chess has been a particularly popular domain for exploring story generation possibilities among many researchers. The most recent and relevant works in this area include [5, 11]. Buchthal et al. suggest an interesting system capable of importing a chess game and applying its extracted features to one of their four available story "skins", to retell them based on the dramatic elements of the chess game. This work does not produce stories directly from the game interactions, but rather uses its extracted features to alter other skins.

Pablo Gervás takes a different approach to generating stories from chess games. Their work is more related to this paper, in that it tries to find interesting event sequences in a chess game. It does so by selecting and scoring the best "focalized" experiences within the game, which are the chosen as representatives of an overall story. Events are described relative to game pieces and their fields of vision. Moreover, each game piece is considered as a story character. Gervás' approach to finding compelling event sequences is geared toward better summarization. We focus on a general notion of interestingness rather than saliency. We also do not require recalling entire games but rather single events within past games.

Additionally, both works by Buchthal et al. and Gervás differ in a few fundamental ways from what we are considering. Not only they are limited to chess as a domain, they only consider the abstract game data as an input, and treat it as a series of isolated events that are separated from a possible interaction between the characters during which the game might have happened. In contrast, we are also interested in considering other types of events and actions that can occur inside a game of chess, or any other context of interaction.

Another category of the related research has focused on deriving narrative from sport games statistics [1, 4, 14]. Such efforts mostly target generating new reporting style narratives about sports games. Apart form the heavy stylistic conformity to the sports commentaries, they also have specifically annotated statistical data about the rules of the game. They include high level statistics about teams' performances, and not necessarily single actions performed by the team members.

3 A Generalized Framework

In this section, we introduce a framework for generating stories about interesting spans of events in a social interaction between a human and an intelligent agent. For this purpose, we have designed and developed a high-level architecture depicted in Fig. 1. It is important to note that this framework is generic, in that it has been designed to be used for new contexts, and create stories from new types of interactions, with minimal change.

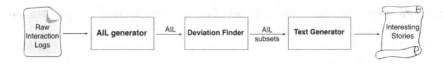

Fig. 1. The high level architecture of the framework.

We start with raw interaction logs that are output by external interaction systems. These logs contain information about the interaction events, in various non-standardized formats. Such external logs may contain different event types and encode them in different ways. In order to be able to standardize and automate our story generation process, we will define and use a notation for describing the interaction events (*AIL*). This notation allows us to perform analyses on the interaction events to find possible deviations from the ordinary event sequences. After which, using a simple natural language generator (SimpleNLG [10]), we produce readable stories about the interesting spans of events in the interaction.

3.1 Processing Input

As noted earlier, the goal in creating a new notation for describing the interaction events is to obtain a standardized format which makes it possible to analyze the event sequences statistically and also makes it easier to generate natural language based on them. We are inspired by simple relational logic which satisfies many of these criteria, while maintaining simplicity and readability. We refer to this notation as *Abstract Interaction Logs* (AIL).

AIL (Abstract Interaction Logs). AIL consist of a series of parameterized events annotated with *event type*. AIL events are categorized within two main groups: *generic* and *context-specific*. Generic events are the ones that can happen in different contexts of interaction, such as *speech* or *facial expression*. Context-specific events are defined for a specific context in which the interaction is occurring, allowing the AIL to capture and leverage such events most efficiently. Below, is the general format of an AIL event (*AILE*) for all types:

$$AILE \ (sub, \ obj, \ type, \ content, \ context, \ time)$$

An event is Context-Specific, if the *context* field of the AILE has a value. Furthermore, *type* parameter determines the event type which can be, for instance, a *speech* if the event is generic, or a *meld* in the context of a rummy game. Moreover, *sub* and *obj* denote the subject and the object for an event, who can be any of the characters involved in the interaction. If the *sub* field has a value, then the event is considered to be an *action*. Furthermore, the *content* field allows an event to have information specific to itself, such as an utterance for an speech

Table 1. The sub-types for the two built-in generic event types. The sub-types list is easily expandable.

Generic event type	Sub-types
Speech	Assertives, Directives, Commissives, Expressive, Declaratives
Facial expression	Smile, Laughter, Gaze, Nod, Eyebrows-up, Head-shake

event, or a card number for a card game move. Lastly, *time* contains the time-stamp for an event. This parameter can be very useful if the domain involves complex temporal sequence.

The more specific and fine-grained types that each event type can have are called *event sub-types*. The event sub-types for the two built-in generic event types that the framework currently supports, are shown in the Table 1 below.

In order to cover the speech sub-types most efficiently, we have adopted the illocutionary acts from Speech Act theory [16] and the taxonomy introduced in [17]. Below is a small description of the taxonomy.

- **Assertives**: speech acts that commit a speaker to the truth of the expressed proposition
- **Directives**: speech acts that are to cause the hearer to take a particular action
- **Commissives**: speech acts that commit a speaker to some future action
- **Expressive**: speech acts that express the speaker's attitudes and emotions towards the proposition
- **Declaratives**: speech acts that change the reality in accord with the proposition of the declaration

The optimal coverage of the interaction events depends on the sufficient addition of Context Specific events, which make it possible for the AIL to be compatible with interaction logs of different domains. In a robotic task of home cleaning, for example, perhaps moving the objects is a potentially important event that can lead to interesting event sequences, and in an interaction with a social virtual assistant (e.g., in a smartphone), asking for a phone call to be placed could be an informative event.

Characters and Meta-data: In addition to the list of AILEs, each AIL also contains a set of *Characters*. Each character includes at least a name and optionally a gender. The most important meta-data for an AIL is an *activity name*, which is used for creating Lead Sentences as explained later. Future work can bring more character specification and meta-data to AIL.

Converting Raw Logs to AIL. The conversion from raw interaction logs to AIL is different for various input logs, and is mainly performed by text processing. After extracting the events, the framework provides easy ways to create

AILE instances with various types and parameters. New AILE types and subtypes can easily be added to the system as mentioned before.

3.2 Detecting Interesting Events

We want to detect limited spans of a given AIL that can represent interesting event sequences in the original interaction. More specifically for this paper, we want to find sequences that are considered memorable and worth telling a story about.

Sequential Rule Mining Algorithm. In order to find the interesting event sequences in an AIL, we have taken a data mining approach, and perform sequential rule mining by treating every AIL in a training set as a sequence of events. Such approach yields a series of *sequential rules*, which, as depicted below, state what set of events (*itemset S or consequence*) are most likely to follow another set of events (*itemset P or antecedent*). Itemsets S and P are unordered and disjoint.

$$P = \{e_4, e_1, e_3\} \implies S = \{e_2, e_9\}$$

Training sets are often associated with a specific context. In order to find rare event sequences most efficiently and to capture the contextual information in doing so, we need to find sequential rules that are rare (or common) to several sequences (AILs). To satisfy this requirement, we use the *CMRules* sequential rule mining algorithm [9]. CMRules, which is based on Association Rule Mining, is specifically designed to find sequential rules common to several sequences (a detailed description of CMRules is outside the scope of this paper). The resulted sequential rules are presented with *support* and *confidence* numbers, as shown in the example below. Given an antecedent itemset, these rules could then be used to find least common (or anomalous) event sequences through either leveraging least probable consequence itemsets, or detecting the cases in which the most probable ones are violated.

$$P = \{e_4, e_1, e_3\} \implies S = \{e_2, e_9\}, \; sup: \; 0.5, \; conf: \; 0.8$$

The sequential rule above, for example, states that if events e_4, e_1 and e_3 are seen in any order, with a confidence of 0.8 (*conf*), they will be followed by an e_2, and an e_9 event, in some order. It also states that such rule has a support of 0.5 (*sup*), because it appears in half of the provided event sequences (i.e., half of the AILs).

Therefore, the general sequential rule for our system follows the format below, where P and S are disjoint unordered itemsets of events, and *sup* and *conf* denote *support* and *confidence* as more precisely defined below.

$$(P \implies S), \; sup, \; conf$$

- **Support**: the number of sequences that contain $P \cup S$ divided by the number of all sequences.

– **Confidence**: the number of sequences that contain $P \cup S$, divided by the number of sequences that contain P.

Using Sequential Rules to Find Rare Spans. After running the CMRules algorithm on a given set of AILs (as the training set), we obtain a series of sequential rules as described earlier. Our goal is to find rare spans of the interaction (event sequences) that have a higher chance of representing an interesting series of events. To do this, we first consider the sequential rules with a *sup* lower than a specific threshold, which filters our original rule list significantly. We then sort the resulting list by *conf*, and then the *sup* rates so that the rules with lower confidence appear higher in our list. We call this list *Rule List 1*. In a second list of rules, *Rule List 2*, we also extract and sort the most common rules (with highest *sup* and *conf*).

Afterwards, we explore the AILs in our test set and find matching event sequences for the *Rule List 1*, for which both S and P itemsets have occurred according to the rule. We also look for violation cases for rules in *Rule List 2*, for which the S itemset is occurring, but the P itemset is not. Sorted rules of both lists therefore result in a unified sorted list of extracted spans for every AIL and we consider that the spans that appear higher in this list, represent a more interesting sequence for every interaction.

3.3 Generating Natural Language Output

The next step in creating the story is to generate natural language based on the extracted spans of an AIL. In an initial attempt, we perform this by converting each AIL event (AILE) to a single sentence. In this process, we use SimpleNLG [10] which is capable of creating sentences from words and their assigned Part of Speech tags. SimpleNLG also supports changing the verb tense, and the addition of adjectives and propositional phrases.

Relating AILEs to Sentence Generation. In order to create a sentence from an AILE, we firstly need a verb. To yield one, for every AILE sub-type, we keep a verb stem that most closely describes the event or action. After which, we use the story characters that are assigned to each AILE as *sub* and *obj*, and since each character contains a name string, we can obtain name strings for subject and object, where applicable. Moreover, using the SimpleNLG's capability to change a verb's tense, we can use the *time* of each AILE to determine a verb tense, when compared to a given narration time (usually the present moment). Lastly, we use the AILE *content* parameter as a propositional phrases for our sentence generator, to add to the sentence type specific additions, such as quotations for a speech action.

To summarize, the conversion between an AILE's parameters and the tokens required to build a sentence is shown in Table 2.

Table 2. The mapping between AILE parameters and sentence tokens

AILE parameter	Sentence tokens
Sub-type (or *type*)	Verb
Sub character's name	Subject
Obj character's name	Object
Content	Propositional-phrase
Time	Verb tense

Adding Lead Sentences to Story Spans. In order to provide a context for the story spans, if it were to be presented to the reader separately, the framework builds a single "lead sentence" to appear before a story span, which plays a role similar to the role of an *Orientation* in Labov-Waletzky model [13]. Lead sentences briefly inform the listener about the type of activity in the interaction. For a context-specific set of events, we use the activity name variable of an AIL (e.g., *playing Rummy*), and for a generic set of events, if available, we use the time of the day in which the events have been happening (e.g., *In an afternoon*). In conjunction with character names, which are provided as meta-data in the AIL, lead sentences are shaped as a full sentence describing the interaction as an activity (e.g., *"During house cleaning by Jim and Karen"* or *"Once upon a time in an afternoon"*). If the none of the required meta-data are available, a leading phrase could simply be *"once upon a time"*.

4 Study

In order to evaluate our approach, we applied this framework to a specific context of social game-playing. As mentioned before, we had access to interaction logs from social gameplays between participants and a social virtual agent from a work by [2], with the related interface shown in Fig. 2. In the following sections, we will describe the specific interaction logs and context-specific events used for this study, explain our subjective evaluation, and provide and discuss our results.

Fig. 2. The interface of the system that generated the logs used in our study. Users played a social games of rummy with a virtual agent.

4.1 Raw Logs

The gameplay logs database contains 15 cases of interaction logs happening during rummy games with a social virtual agent capable of making verbal comments about the game and showing facial expressions that relate to the semantics in the game. The logs contain time-stamped records of the following events:

- User's game move (Draw, Discard, Layoff, Meld)
- Agent's game move (Draw, Discard, Layoff, Meld)
- User's smile and laughter
- User's comment on a move or response to an agent's comment
- Agent's comments on a move or response to a user's comment

Such events are translated into generic and context-specific AILEs seen in Table 3 below.

Table 3. Generic and context-specific AILEs in rummy logs. "FE" stands for Facial Expression. Sub-types, where applicable, are shown in parentheses.

Type	AILEs
Generic	Speech (expressive), FE (smile), FE (laughter)
Context-specific	Draw, Discard, Meld, Layoff

Table 4. A sample of a rummy AIL; Null values are used when a parameter is not applicable.

```
LayOffEventAILE(Karen, card, null, null , rummy, 11:15:50)
DiscardEventAILE(Karen, card, null, null , rummy, 11:15:56)
SpeechAILE(Karen, User, EXPRESSIVE, yes, i am finishing my cards, null, 11:16:03)
ResponseAILE(User, Karen, EXPRESSIVE, not so soon, rummy, 11:16:04)
MeldEventAILE(User, card, null, null , rummy, 11:16:17)
FacialExpressionAILE(User, null, SMILE, null , null, 11:16:19)
GameOverAILE(game, null, null, null , rummy, 11:16:27)
SpeechAILE(User, Karen, EXPRESSIVE, i finally win. good game., null, 11:16:27)
FacialExpressionAILE(User, null, LAUGHTER, null , null, 11:16:28)
FacialExpressionAILE(User, null, SMILE, null , null, 11:16:29)
FacialExpressionAILE(User, null, LAUGHTER, null , null, 11:16:29)
```

Table 5. A sample full story generated for a rummy interaction

There once was an agent named Karen who was playing rummy with a human named user. Karen melded card. Next, Karen discarded card. Karen told User how's your hand over there?. Afterwards, User responded to Karen good!. User discarded card. Subsequently, Karen told User i should say, you do play very well. User responded to Karen thank you, you do too. Karen discarded card. User laughed. Next, User smiled. After that, User laughed. After which, User discarded card. Karen discarded card. After that, User stopped laughing. User melded card. User laughed. User smiled. Afterwards, User discarded card. Karen laid off card. Karen discarded card. User told Karen nice. After which, User smiled. After which, User discarded card. Karen laid off card. Karen discarded card. User told Karen nice again. User laid off card. After that, User discarded card. User told Karen found a lay off, yes!. Karen responded to User. After that, Karen discarded card. After which, Karen told User i am in this to win. Afterwards, User responded to Karen well do your best. User discarded card. After that, Karen discarded card. User told Karen you do play very well. Karen responded to User good job. User discarded card. Karen told User humans are somewhat intelligent but robots are genius. User responded to Karen bragging won't get you to win madam agent. Afterwards, Karen melded card. Next, Karen discarded card. Afterwards, User responded to Karen good meld. Next, Karen responded to User such encouragement to hear that!. User melded card. Afterwards, User discarded card. User told Karen only few cards left for you. Afterwards, Karen responded to User yes, i just found noticed myself. Karen discarded card. Afterwards, Karen told User i am in this to win!. Next, User discarded card. User told Karen well do your best. User laid off card. Then, User discarded card. Then, Karen discarded card. Afterwards, User told Karen you do play very well. Afterwards, Karen responded to User i know, i am excited. Subsequently, User discarded card. User told Karen nice again. Karen discarded card. Next, Karen told User yes, i am finishing my cards. User responded to Karen not so soon. Subsequently, User melded card. Afterwards, User smiled. Game ended. Afterwards, User told Karen i finally win. good game. User laughed. User smiled. User laughed. Next, User smiled. After which, User laughed.

Table 6. Two interesting spans generated by our framework from the full story in Table 5.

> (1) During Karen and User's rummy game, this happened: Karen laid off card. Then, Karen discarded card. After which, User told Karen nice. Afterwards, User smiled. User discarded card. Afterwards, Karen laid off card. Karen discarded card. User told Karen nice again.
> (2) During Karen and User's rummy game, this happened: Karen laid off card. Then, Karen discarded card. Next, Karen told User yes, i am finishing my cards. Subsequently, User responded to Karen not so soon. User melded card. User smiled. Game ended. User told Karen I finally win. good game.

Table 7. Questionnaire results for every item, including a p-value from a binomial test.

Questions	Agreements out of 11	p-value
q1	2	0.03
q2	4	0.27
q3	10	< 0.006
q4	8	0.11
q5	11	< 0.001
q6	11	< 0.001
q7	7	0.27
q8	9	0.03

A sample of the AIL for a rummy game is shown in Table 4. Moreover, Table 5 shows a full rummy story, consisting of all the events in the interaction, while Table 6 shows the interesting spans of the same story, picked up by our framework. In the first interesting span, we see that the agent (Karen) seems to be on a streak of strong moves, and the user is complementing Karen. The second span covers the events of a surprising game ending, in which Karen first brags about finishing her cards after playing a layoff move. Afterwards, the user responds to that by saying "not so soon", and plays a finishing meld move to win the game. The user then reacts to the situation by smiling and talking about it.

4.2 Procedure

To evaluate our approach, we conducted a pilot study in which 11 participants were asked to choose the more interesting story span between two options. These two options consisted of an interesting story span generated by the framework, and a non-overlapping random span of the same story with an equal length, as a baseline. Each participant was presented with an identical set of 8 questions, while the ordering of the questions and their answers was randomized.

4.3 Results

Out of 88 choices made in 8 questions by 11 participants, in 62 cases, the system generated interesting story spans were favored by the participants, while in 26 cases, random spans were favored. Therefore, in 70 % of the cases, participants

identified the story spans generated by the system as more interesting than a random baseline.

Table 7 provides the detailed number of cases in which participants agreed or disagreed with the system in each of the 8 questions in our questionnaire, along with their respective p-values from a one-tailed binomial test.

We also calculated the inner-agreement of our participants, which yielded a Krippendorff's alpha [12] of 0.32.

5 Conclusions and Future Work

The results of the pilot study suggest that in almost 3 out of 4 cases, study participants prefer system generated output over randomly selected span of events for interestingness. Despite the limited number of participants, these results are statistically significant in 5 of our 8 questionnaire items. This is particularly promising when considering the fact that the raw interaction logs we used in this study had a very limited variety in terms of event types. We think that this pilot study provides initial validation of the framework.

An immediate future work for us would be to expand our mining algorithm to leverage information beyond just the event types, to include event parameters from each AILE. Not unrelated to such addition, would be to also consider a context-dependent multi-dimensional space that covers the semantics of an AIL's context, through a number of variables (such as "move strength" and "move novelty" in a game), in which every AILE is assigned a single point. Such covering of a context's event semantics can result in finding extraordinary event sequences that are not necessarily or merely rare, but are also semantically interesting.

It would also be interesting to see if adding a story representation system, such as SIG [6], would help to enrich the interaction dynamics that our system can support, and effectively add goals, affect and other interpretative artifacts to the AIL notation. It is also very important to choose the right moments and "trigger events" that motivate telling stories about prior interactions. Such semantic story representation for event sequences can also enable a search among interesting stories of prior interactions that are semantically analogous to a newly observed event sequence.

Additionally, we can change the *telling* of the story, which can be achieved using tools such as PERSONAGE [15] or new tools inspired by it. Moreover, we might benefit from leveraging information about users' emotional state to inform different stages of this process, such as the selection of interesting event sequences, telling of the story, or triggering of one.

Furthermore, we imagine a more sophisticated Natural Language Generation engine to be very advantageous, especially in the evaluation phase. Last but not least, a *collaborative retelling* of interesting stories will allow an even higher level of interactivity and completes a scenario in which an intelligent agent and its companion, collaboratively tell interesting stories about the experiences they have shared, to a third being.

References

1. Allen, N., Templon, J., McNally, P.: Statsmonkey: a data-driven sports narrative writer. In: AAAI Fall Symposium, pp. 2–3 (2010)
2. Behrooz, M., Rich, C., Sidner, C.: On the sociability of a game-playing agent: a software framework and empirical study. In: Bickmore, T., Marsella, S., Sidner, C. (eds.) IVA 2014. LNCS, vol. 8637, pp. 40–53. Springer, Heidelberg (2014)
3. Bickmore, T.W., Picard, R.W.: Establishing and maintaining long-term human-computer relationships. ACM Trans. Comput.-Hum. Interact. **12**(2), 293–327 (2005)
4. Bouayad-Agha, N., Casamayor, G., Wanner, L.: Content selection from an ontology-based knowledge base for the generation of football summaries. In: Proceedings of the 13th European Workshop on Natural Language Generation, pp. 72–81. Association for Computational Linguistics (2011)
5. Buckthal, E., Khosmood, F.: (Re)telling chess stories as game content. In: 9th International Conference on the Foundations of Digital Games (2014). http://fdg2014.org/papers/fdg2014_wip_03.pdf
6. Elson, D.K.: Detecting story analogies from annotations of time, action and agency. In: Proceedings of the Third Workshop on Computational Models of Narrative, vol. 1981, pp. 91–99 (2012)
7. Fong, T., Nourbakhsh, I., Dautenhahn, K.: A survey of socially interactive robots. Robot. Auton. Syst. **42**(3), 143–166 (2003)
8. Forlizzi, J., Disalvo, C.: Service robots in the domestic environment: a study of the roomba vacuum in the home. In: Design, pp. 258–265 (2006)
9. Fournier-Viger, P., Faghihi, U., Nkambou, R., Nguifo, E.M.: Cmrules: mining sequential rules common to several sequences. Knowl.-Based Syst. **25**(1), 63–76 (2012)
10. Gatt, A., Reiter, E.: Simplenlg: a realisation engine for practical applications. In: Proceedings of the 12th European Workshop on Natural Language Generation, pp. 90–93. Association for Computational Linguistics (2009)
11. Gervás, P., Díaz-Agudo, B., Peinado, F., Hervás, R.: Story plot generation based on cbr. Knowl.-Based Syst. **18**(4), 235–242 (2005)
12. Hayes, A.F., Krippendorff, K.: Answering the call for a standard reliability measure for coding data. Commun. Methods Measures **1**(1), 77–89 (2007)
13. Labov, W., Waletzky, J.: Narrative analysis: oral versions of personal experience (1997)
14. Lareau, F., Dras, M., Dale, R.: Detecting interesting event sequences for sports reporting. In: Proceedings of the 13th European Workshop on Natural Language Generation, pp. 200–205. Association for Computational Linguistics (2011)
15. Mairesse, F., Walker, M.: Personage: personality generation for dialogue. In: Annual Meeting-Association For Computational Linguistics, vol. 45, p. 496 (2007)
16. Pratt, M.L.: Toward a Speech Act Theory of Literary Discourse. Indiana University Press, Bloomington (1977)
17. Searle, J.R.: A taxonomy of illocutionary acts. In: Gunderson, K. (ed.) Language, Mind and Knowledge, pp. 344–369. University of Minnesota Press, Minneapolis (1975)

Hybrid Books for Interactive Digital Storytelling: Connecting Story Entities and Emotions to Smart Environments

Hajar Ghaem Sigarchian[✉], Ben De Meester, Frank Salliau, Wesley De Neve,
Sara Logghe, Ruben Verborgh, Erik Mannens, Rik Van de Walle,
and Dimitri Schuurman

Ghent University – iMinds, Gent, Belgium
{hajar.ghaemsigarchian,ben.demeester,frank.salliau,wesley.deneve,
sara.logghe,ruben.verborgh,erik.mannens,rik.vandewalle,
dimitri.schuurman}@ugent.be

Abstract. Nowadays, many people use e-books, having high expectations regarding their reading experience. In the case of digital storytelling, enhanced e-books can connect story entities and emotions to real-world elements. In this paper, we present the novel concept of a Hybrid Book, a generic Interactive Digital Narrative (IDN) artifact that requires seamless collaboration between content and smart devices. To that end, we extract data from a story and broadcast these data in RDF as Linked Data. Smart devices can then receive and process these data in order to execute corresponding actions. By following open standards, a Hybrid Book can also be seen as an interoperable and sustainable IDN artifact. Furthermore, according to our user-based evaluation, a Hybrid Book makes it possible to provide human sensible feedback while flipping pages, enabling a more enjoyable reading experience. Finally, the participants positive willingness to pay makes it possible to generate more revenue for publishers.

Keywords: e-Books · EPUB 3 · Interactive Digital Narrative · Semantic Web · Smart living environments

1 Introduction

Stories can be presented in several ways, for instance through the use of movies and e-books (that is, digital books). The definition of an e-book, as discussed by [28], contains both a static and a dynamic component: whereas the static component states that "an e-book is a digital object with textual and/or other types of content", the dynamic component expresses that "an e-book can have technology-dependent features that make it more interactive and dynamic than its paper counterpart". The rise of e-books brings opportunities for new reading experiences. One such reading experience may consist of having interaction with the physical environment when making use of a so-called "Hybrid Book".

© Springer International Publishing Switzerland 2015
H. Schoenau-Fog et al. (Eds.): ICIDS 2015, LNCS 9445, pp. 105–116, 2015.
DOI: 10.1007/978-3-319-27036-4_10

Anastasiades [2] defines the term "Hybrid Book" as "the best combination of use of traditional printed books and multiple potentials offered by a virtual educational environment". We propose to generalize the term "Hybrid Book" to a paper or digital book that extends into the "physical or digital realm". Specifically, we assume that a Hybrid Book can either take the form of an e-book that facilitates interaction with the physical and/or digital world, or that it can take the form of a paper book that has been enriched using digital content. In this context, we would like to point out that a Hybrid Book can also be seen as an interactive container that serves both heterogeneous physical and digital content, for instance through leveraging the Internet of Things paradigm.

In the above context, it is worth mentioning that EPUB 3 [14] is a powerful format for both representing and presenting e-books [10]. This format is based on HTML5, JavaScript, and CSS. Furthermore, this format supports the desired attributes of enhanced publications [32], for instance making it possible to integrate multimedia features and semantic annotations using RDFa [12] or microdata [13]. Moreover, EPUB 3 makes it possible to connect book content to networked services [11].

Nowadays, people can equip their living environments with smart devices, including smart lights and smart thermostats. Furthermore, people can control these smart devices either locally or remotely. We believe that reading stories is an activity that can be made more attractive in such smart living environments.

The contributions of this paper are as follows. Given that we see a Hybrid Book as an e-book that is able to facilitate interaction between story entities and emotions on the one hand, and smart living environments on the other hand, we document an approach to connect the entities and emotions of a fixed path narrative story to (1) relevant digital content that is open in nature and (2) to smart devices, taking advantage of Digital Publishing tools (e.g., EPUB 3) and Semantic Web technology (e.g., SPARQL and ontology reasoning). In this context, we see an author as the person (1) who acts as the designer of a story and (2) who decides what the desired interactions are. Furthermore, we investigate the way story entities (e.g., people, locations, and animals) and emotions can be represented within an e-book and how these entities and emotions can facilitate interaction with a smart living environment (e.g., light and sound changes). To that end, we explore the way a book can broadcast required data to smart devices and how these devices can interpret the data and perform the right actions. Finally, we present a prototype Hybrid Book that aims at giving its readers a more enjoyable reading experience, evaluating this prototype Hybrid Book by taking into account key aspects of Interactive Digital Narratives (IDNs) [17].

The remainder of this paper is organized as follows. In Sect. 2, we review related work. In Sect. 3, we discuss the proposed Hybrid Book concept in more detail, paying attention to the use of Hybrid Books as IDN artifacts and the development of a prototype Hybrid Book. We subsequently evaluate our prototype Hybrid Book in Sect. 4. Finally, we present our conclusions and a number of directions for future research in Sect. 5.

2 Related Work

In this section, we review a number of research efforts and best practices related to Interactive Digital Narratives. In particular, given the broadness and the nature of the proposed Hybrid Book concept, we first pay attention to interactive story books in smart environments. Next, we focus on semantic content representation and reasoning about entities and emotions in interactive stories.

2.1 Interactive Digital Narratives in Smart Environments

Koenitz [18] defined an Interactive Digital Narrative (IDN) as follows: an "expressive narrative form in digital media implemented as a computational system containing potential narratives and experienced through a participatory process that results in products representing instantiated narratives".

As an example of such narrative forms, we refer to two iPad applications: Philips Disney StoryLight[1] and Light Stories[2]. These applications take on the role of an e-book, enabling the reader to change the color of the Philips hue light[3] by touching screen elements. Besides the usage of lights for creating interactive stories, sound can be used as a complementary channel as well, given that the use of sound brings fantasy [20].

Furthermore, Nakevska et al. [21] proposed the concept of interactive storytelling in a mixed reality in which users do not directly use a computer and interaction devices. They provided three different stages, equipping all stages with sensory devices originating from a so-called ALICE installation [4], thus enriching these stages with different relevant sounds. The participants had to physically follow the aforementioned stages, having an exploratory experience during storytelling. In addition, the authors investigated immersiveness and user experience, finding that sound affects self-location in a storytelling environment.

The above discussed approaches, however, are proprietary in nature, while the Hybrid Book solution we propose is a generic approach that can be integrated in e-books using the standardized EPUB 3 format[4].

2.2 Semantic Representation and Reasoning

Semantic Web technologies aim to collect, structure, and recover linked data. In what follows, we describe a number of WC3 Semantic Web standards[5] that can be used to enrich story books, hereby creating interactive storytelling experiences.

Resource Description Framework (RDF) [16] is a general-purpose framework for representing Web information, expressing data in a machine-understandable

[1] http://disneystories.com/app/disney-storytime/.
[2] https://itunes.apple.com/us/app/light-stories/id692093472?mt=8.
[3] http://www2.meethue.com/en-us/.
[4] For the latest status on EPUB 3 support, please see http://epubtest.org/.
[5] http://www.w3.org/standards/.

format. RDF in attributes (RDFa) [12] adds a set of attribute-level extensions to (X)HTML documents, with the goal of including RDF data inside these documents. Terse RDF Triple Language (Turtle) [5] is a serialization format for RDF. An RDF query language such as SPARQL [24] is able to retrieve and manipulate data stored in RDF format. An ontology is "a specification of a representational vocabulary for a shared domain of discourse – definitions of classes, relations, functions, and other objects" [25]. The Web Ontology Language (OWL) [31] is a semantic markup language for publishing and sharing ontologies on the World Wide Web.

Enriching HTML pages of e-books by using RDFa and microdata makes story content machine-readable, thus facilitating the execution of queries against this content. Also, sets of vocabularies can be specified in ontologies. These sets of vocabularies can be used for extraction and reasoning purposes, with the aim of deriving new data. These new data can then be used for different goals, such as activating smart devices or finding relevant songs in an online sound repository. The Linked Data Fragments client and server [33] are two libraries for affordable and reliable querying of linked data with SPARQL.

Different stories often have similar themes, items, and characters. The Stories ontology[6] was developed in collaboration with the BBC, with the aim of linking items together in order to make stories navigable and discoverable. Onyx [27] is a linguistic Linked Data approach for representing emotions. In particular, Onyx is a semantic emotion vocabulary that focuses on lexical resources and emotion analysis services. The Onyx model includes EmotionML [3] vocabularies. EmotionML is a general-purpose emotion annotation and representation language using XML. As we use HTML files for representing story content, EmotionML is not suitable for supporting different emotions in EPUB 3-based e-books.

Considering the aforementioned related work, the proposed solution consists of a generic way to represent the content of interactive story books. In particular, we make use of RDF for broadcasting story entities and emotions. Furthermore, we created an ontology that allows describing the relationship between story entities and emotions on the one hand, and actions for activating smart devices on the other hand. In addition, our ontology allows mapping emotions to corresponding colors [22].

3 The Hybrid Book Concept

Our research focuses on a Hybrid Book, an e-book that facilitates interaction between the physical and the digital world, and where the interaction is enabled through the use of a generic data model. In this section, we first analyze the possibility of EPUB 3-based Hybrid Books to act as IDN artifacts. Next, we describe a prototype Hybrid Book that uses a generic data model to facilitate interaction with devices in a smart living environment[7].

[6] http://www.contextus.net/stories.
[7] http://multimedialab.elis.ugent.be/users/hghaemsi/DemoHybridBook.MP4.

3.1 Hybrid Books as IDN Artifacts

Considering the definition and characteristics of an IDN [18], we focus on a "fixed-path" narrative, as is commonly done for fiction books.

In the traditional way of creating fiction books, an author writes a story in the form of a text and a publisher distributes the text as is. Such fiction books are passive [19] in nature. However, these passive books can be converted to interactive e-books (e.g., Hybrid Books) by integrating interactivity and multimedia features. In advanced cases, the story entities and the emotions conveyed by these e-books can be connected to both the digital and the physical world.

IDN artifacts can be classified based on the presence of interactive features. For example, they can be mapped along the axes of exploration (story versus system) and control (user control versus system control). In addition, they can be mapped by taking into account criteria like *"agency (the variety of actions that a user can undertake)"*, *"narrative complexity (the quantity of concurrent narrative developments)"*, and *"dramatic agency (the degree of influence the user has on the course of the narrative)"* [19].

The usage of EPUB 3-based e-books in mobile environments [11] makes it possible to enhance these e-books with interactive features, including augmented reality and contextualization. Furthermore, connecting these e-books to the digital and physical world is key to making the storytelling more interactive.

Considering the above mentioned classification of IDN artifacts, a simple EPUB 3-based Hybrid Book that enhances a fiction book with limited narrative agency (e.g., just flipping pages) can already be seen as an IDN artifact. Moreover, the Hybrid Book concept allows for more substantial interactivity features, and where these features can be realized/defined by the author or the designer of the story.

3.2 A Prototype Hybrid Book

Facilitating real-world interaction requires seamless collaboration between different e-book elements (e.g., story entities and emotions) and devices in smart living environments (e.g., sounds and lights). To create a prototype Hybrid Book, we selected a children's book, namely "Red Riding Hood" from Project Gutenberg[8]. Project Gutenberg is an initiative that consists of freely available online e-books in different formats such as PDF and EPUB. Next, we enriched the book, taking on the role of a designer of interactive story books. We aimed at influencing the digital and physical reading environment by manifesting different story entities and emotions via different human senses.

Figure 1 demonstrates a high-level overview of the Hybrid Book setup. As can be seen in Fig. 1, the author annotates the story entities and emotions that are relevant to the desired interactions, before distributing the book as an EPUB 3 file. When the book is read, the annotated data are extracted and subsequently

[8] http://www.gutenberg.org.

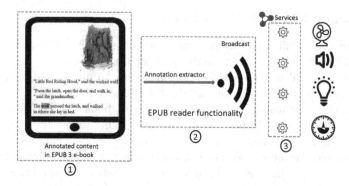

Fig. 1. High-level overview of the Hybrid Book setup: (1) story entities and emotions are annotated in the EPUB 3-based e-book; (2) the e-book reader extracts these annotations from the e-book and subsequently broadcasts these annotations; and (3) smart device services retrieve the broadcasted annotations, subsequently querying and reasoning about configuration data (i.e., data needed to activate the smart devices).

broadcasted (e.g., using socket.io[9]) to all the smart device services via an e-reader (that is, an application for reading e-books). The smart devices need to be installed in the network used by the Hybrid Book. If any of the smart devices are missing, then an alert can for instance be shown in the pages of the e-book. In addition, a specific service needs to be developed for each device. These services constitute a bridge between the Hybrid Book and the device. Furthermore, the data are interpreted by each device service, to determine the actions that need to be executed.

3.3 Representation of Story Entities and Emotions

We see the author of a story as the designer of the Hybrid Book. In particular, we see the author as the person who decides what actions need to be taken. In that regard, the desired interactions an author wants to invoke must be inserted in the e-book at the correct position. To that end, we use HTML annotations using RDFa. These annotations define which changes are intended, and possibly, which action(s) should be performed. Listing 1 shows a possible annotation for an entity. It shows how the word "wolf" is annotated with a "property" attribute, containing two customized items: "animal:wolf" and "emotion:afraid".

Listing 1. Example of annotation for an entity

```
<span property=''animal:wolf; emotion:afraid''> wolf </span>
```

3.4 Triggering Actions Using Story Entities and Emotions

The way we define different attributes is described below. These attributes are extensible if needed. Table 1 shows an example of matching entities to possible smart devices.

[9] http://socket.io/.

Table 1. Mapping story entities and emotions to possible devices.

Examples of story entities and emotions [23, 29]	Possible smart devices		
	Sound player	Lights	Thermostat
Emotion (e.g., afraid)		✓	
Animal (e.g., wolf)	✓	✓	
Event (e.g., earthquake)	✓		
Temperature (e.g., warm/cold)			✓

For this research, we work with the six basic emotion terms proposed by Paul Ekman [9]: "Angry", "Afraid", "Disgusted", "Sad", "Surprised", and "Happy". We can associate specific colors with a "mood" or an emotion [22]: e.g., "Sad" can be associated with the color "blue". By expanding the story entities (e.g., animal) to their sub-entities (e.g., bird and wolf), we create a so-called Hybrid Book dataset that takes on the form of an ontology[10]. This dataset consists of story entities, their corresponding data, and possible actions (e.g., "hasSound" as an action for a sound player and "hasColor" as an action for smart lights).

The e-reader extracts the annotations from any visible content (based on the size of the screen of the mobile devices used for reading). These extracted annotations (e.g., "animal:wolf") are then sent to services (e.g., over the Internet or a local network). Indeed, we assume that each smart device has a service that listens for incoming data. These services need to be implemented specifically for each device. It is necessary to have such services, because each device has its own functionality, and that functionality needs to be adapted to the proposed solution. For example, the Philips hue lights have the functionality of changing the color of lights. The proposed Hybrid Book needs to trigger the lights based on the annotated content. Thus, a service needs to bridge the gap between the Hybrid Book and the underlying APIs of smart devices. These services interpret the received data to derive desired actions, by executing queries against our dataset. For example, when a story entity such as "wolf" has been annotated in the text, the process executed is as follows:

1. The e-reader extracts the annotated entity "wolf" from the book.
2. The e-reader converts the data related to the annotated story entity in RDF format as ":Wolf :Emotion :Afraid". The data are subsequently broadcasted to all connected devices.
3. All connected devices receive the broadcasted data.
4. The services decide what actions to take, based on a set of rules (e.g., *(:Afraid rdf:type :Emotion, :hasColor :Orange)*, or *(:Wolf rdf:type :Animal, :hasSound :Wolf)*) stored in the dataset. In fact, the services query the received data against our dataset using the Linked Data Fragments [33] server and client software. To that end, the LDF[11] Server and Client are used for running SPARQL queries over Turtle data in our dataset. The resulting configuration

[10] http://uvdt.test.iminds.be/pub/hybrid/hybridbook.
[11] https://github.com/LinkedDataFragments.

data (data that are required to activate the smart devices) will for instance be formatted as ":Action :hasSound :Wolf" for the audio player and ":Action :hasColor :Orange" for the smart lights. Furthermore, to get the desired result (e.g., a relevant sound) from online resources such as Spotify[12], we need to have accurate search keywords. Based on the configuration data, the service of the sound player searches for a wolf sound on Spotify.

6. Finally, the light service sends the action to the hue lights to change the color of the lights, and at the same time, the sound service sends the action to the audio player to play the corresponding sound.

3.5 Authoring Hybrid Books

The creation of EPUB 3-based Hybrid Books should be cost-effective, thus requiring a user-friendly authoring environment. Ideally, creating a Hybrid Book is facilitated by an authoring environment that makes it possible for authors and publishers to indicate which elements of a story need to be annotated. Such an authoring environment is for instance discussed in [8], facilitating collaborative creation of enriched e-books using EPUB 3, also enabling authors and publishers to design and create EPUB 3-based story books with annotations.

4 Evaluation

In this section, we describe the evaluation of our prototype EPUB 3-based Hybrid Book as an IDN artifact. Koenitz [17] discusses five aspects of IDN artifacts that are important: "narrative analysis", "interoperability between different implementations", "sustainability of digital artifacts", "author-centered view", and "user-focused perspective". The author argues that these key aspects need to be addressed in ongoing and future work in order to have successful methods and artifacts in the field. In what follows, we evaluate our Hybrid Book concept, focusing on the aforementioned key aspects of IDN artifacts, with the exception of "narrative analysis", given that this aspect is not within our domain of expertise.

- **Interoperability between different implementations**: This aspect refers to the use of technical standards for, e.g., data exchange between different implementation platforms. As described in the Hybrid Book section, we use Turtle as our standard format for data exchange. In addition, the EPUB 3 format itself is an open standard for digital publications. Ghaem Sigarchian et al. [11] concluded that this open publication standard allows for interoperability between different mobile devices. In what follows, we list a number of relevant EPUB 3 capabilities: "sensor data utilization in mobile devices", "data transfer to servers", "connecting to local and networks", and "discoverable content".

[12] https://www.spotify.com/.

- **Sustainability of digital artifacts**: This is a key design aspect that can be achieved by following standards, making the artifacts sustainable. All technologies used in the implementation of our Hybrid Book are based on open standards, thus preventing "reinventing the wheel" in future research.
- **Author-centered view**: This key aspect refers to involving (multiple) authors of traditional narratives in IDNs, making it possible for these authors to easily design their own interactive digital story. They can thus apply their own preferences in terms of actions and emotions (that is, they can transfer their own vision to the audience).
- **User-focused perspective**: Given that this aspect is key to creating exciting narrative experiences, we organized a usability test in a lab environment at a research center, to quantify the level of reader enjoyment. This seemed the most appropriate method to have a profound evaluation of the proposed concept by both parents and children.

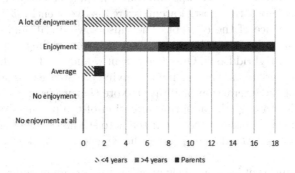

Fig. 2. Likert scale on the enjoyment of the book by children younger than 4 years, older than 4 years and parents (n = number of people).

A usability test is intended to determine the extent an interface facilitates the ability of a user to complete routine tasks. Typically the test is conducted with a group of potential users either in a usability lab, remotely (using e-meeting software and telephone connection), or on-site with portable equipment. Users are asked to complete a series of routine tasks. Sessions are recorded and analyzed to identify potential areas for improvement to innovation. This approach is based on usability evaluation methods [1,30]. When focusing on the testing of the usability of an innovation, it is recommended to do the test in a lab environment [15,34].

The test took place in June 2015. The purpose of the test was to have a user validation of the Hybrid Book concept and how a Hybrid Book can be connected to smart devices in a room while reading a story. As can be seen in Fig. 2, in total, 29 participants (13 parents and 16 children) took the test. They were colleagues or friends who were invited in an informal way. Some parents brought more than one child. Before the test started, the participants were given an explanation of the interface by the user researcher and they were asked to

read the story out loud from the laptop. During the test, the participants were allowed to choose who would read the story. The younger the children, the less willing they were to read out loud, something that can most likely be attributed reading skills that are not perfect yet. Every session took about half an hour. The story consisted of five pages. The first page was annotated with the animal "bird" and the emotion "love". The second and the fourth page did not come with annotations, thus offering no interaction. The third page was annotated with the animal "wolf" and the emotion "fear". The fifth page was annotated with the emotion "happy". Afterward, the children were asked to color a smiley matching their enjoyment and they were given an incentive. At the same time, the parents were interviewed.

The children were all highly enthusiast about the hybrid book, while parents were more critical. The scale we used to capture the opinion of the children is based on the Smileyometer [26], a discrete Likert Scale.

In general, the children liked reading the prototype Hybrid Book, as well as the interaction with the smart lamps and the audio player. The youngest children liked this type of book the most. Parents were also very enthusiastic about the enjoyment experience of the concept. They also saw educational opportunities for the book. The majority of the parents ($n = 13$) were willing to pay between 5 and 15 euros for a Hybrid Book. Only one parent would pay 1 euro for a story. All parents said they would use the technology, giving preference to reading a Hybrid Book because of the interaction facilitated. Note that we used a single intention question in order to map the adoption intention of the parents. We do have to be critical with this approach because it tends to stimulate overestimation [6,7]. All of the parents answered that at least the chance is high they would use this type of book.

The most important issue is a lack of willingness to adopt smart technologies. Because the technology is still in a concept phase, it was difficult for every parent to imagine all the future possibilities for interactions with smart technologies. This usability test gave us a first insight in the user evaluation of the concept. It is advisable to further test and adapt the concept with future users to get more in-depth insights. Also, future research should focus on taking better advantage of an interactive narrative.

5 Conclusions and Future Work

In this paper, we discussed the creation of interactive story books, using Digital Publishing and Semantic Web technologies. In particular, we investigated how semantic annotations can be used to author interactive story books, i.e. so-called Hybrid Books. Furthermore, we evaluated a prototype Hybrid Book by considering key aspects of IDN artifacts. We found that our Hybrid Book contributes to an enjoyable reading experience. In addition, our Hybrid Book is an interoperable and sustainable IDN artifact, making it possible for authors to apply their own preferences by inserting semantic annotations into Hybrid Books.

We can identify a number of directions for future research. First, to alleviate the burden of manual annotation, we could explore the use of an automatic story

entity and emotion recognition web service for already existing story books. Second, the current version of our Hybrid Book can be improved with more interactivity features, including read aloud and eye tracking functionality.

Acknowledgments. The research described in this paper was funded by Ghent University, iMinds, the Institute for Promotion of Innovation by Science and Technology in Flanders (IWT), the FWO-Flanders, and the European Union.

References

1. Smith, T.F., Waterman, M.S.: Identification of common molecular subsequences. J. Mol. Biol. **147**, 195–197 (1981)
2. Anastasiades, S.P.: The future of the book, the book of the future. In: Proceedings of Advanced Learning Technologies, pp. 246–247 (2003)
3. Baggia, P., Pelachaud, C., Peter, C., Zovato, E.: Emotion Markup Language (EmotionML) 1.0
4. Bartneck, C., Hu, J., Salem, B., Cristescu, R., Rauterberg, M.: Applying virtual and augmented reality in cultural computing. IJVR **7**(2), 11–18 (2008)
5. Beckett, D., Berners-Lee, T., Prud'hommeaux, E., Carothers, G.: RDF 1.1 Turtle Terse RDF Triple Language W3C Recommendation (2014)
6. De Marez, L.: Diffusie van ICT-Innovaties: Accurater Gebruikersinzicht voor BetereIntroductiestrategieën. Ph.D. thesis, Ghent University (2006)
7. De Marez, L., Verleye, G.: Innovation diffusion: the need for more accurate consumer insight. Illustration of the PSAP scale as a segmentation instrument. J. Target. Measur. Anal. Mark. **13**(1), 32–49 (2004)
8. De Meester, B., De Nies, T., Ghaem Sigarchian, H., Van der Sande, M., Van Campen, J., Van Impe, B., De Neve, W., Mannens, E., Van de Walle, R.: A digital-first authoring environment for enriched e-Books using EPUB 3. Inf. Serv. Use **34**(3–4), 259–268 (2014)
9. Eckman, P.: Universal and cultural differences in facial expression of emotion. In: Nebraska Symposium on Motivation, vol. 19, pp. 207–284. University of Nebraska Press Lincoln (1972)
10. Ghaem Sigarchian, H., De Meester, B., De Nies, T., Verborgh, R., De Neve, W., Mannens, E., Van de Walle, R.: EPUB3 for integrated and customizable representation of a scientific publication and its associated resources. In: Proceedings of the 4th Workshop on Linked Science (2014)
11. Ghaem Sigarchian, H., De Meester, B., De Nies, T., Verborgh, R., Salliau, F., De Neve, W., Mannens, E., Van de Walle, R.: Towards making EPUB 3-based e-TextBooks a first-class mobile learning environment. In: Proceedings of the 10th International Conference in e-Learning (2015)
12. Herman, I., Adida, B., Sporny, M., Birbeck, M.: RDFa 1.1 Primer - Third Edition Rich Structured Data Markup for Web Documents. Technical report, W3C (2015)
13. Hickson, I.: HTML Microdata. Technical report, W3C (2013)
14. IDPF: Electronic Publication, Version 3 (2013). http://idpf.org/epub/30
15. Kjeldskov, J., Skov, M.B., Als, B.S., Høegh, R.T.: Is it worth the hassle? Exploring the added value of evaluating the usability of context-aware mobile systems in the field. In: Brewster, S., Dunlop, M.D. (eds.) Mobile HCI 2004. LNCS, vol. 3160, pp. 61–73. Springer, Heidelberg (2004)

16. Klyne, G., Carroll, J., McBride, B.: RDF 1.1 Concepts and Abstract Syntax. Technical report, W3C (2014)
17. Koenitz, H.: Five theses for interactive digital narrative. In: Mitchell, A., Fernández-Vara, C., Thue, D. (eds.) ICIDS 2014. LNCS, vol. 8832, pp. 134–139. Springer, Heidelberg (2014)
18. Koenitz, H.: Towards a Specific Theory of Interactive Digital Narrative. Interactive Digital Narrative: History, Theory and Practice, p. 91 (2015)
19. Koenitz, H., Haahr, M., Ferri, G., Sezen, T.I., Sezen, D.: Mapping the evolving space of interactive digital narrative - from artifacts to categorizations. In: Koenitz, H., Sezen, T.I., Ferri, G., Haahr, M., Sezen, D., Çatak, G. (eds.) ICIDS 2013. LNCS, vol. 8230, pp. 55–60. Springer, Heidelberg (2013)
20. Liljedahl, M.: Sound for Fantasy and Freedom. Game Sound Technology and Player Interaction: Concepts and Developments, pp. 22–44 (2011)
21. Nakevska, M., Funk, M., Hu, J., Eggen, B., Rauterberg, M.: Interactive storytelling in a mixed reality environment: how does sound design and users' preknowledge of the background story influence the user experience? In: Mitchell, A., Fernández-Vara, C., Thue, D. (eds.) ICIDS 2014. LNCS, vol. 8832, pp. 188–195. Springer, Heidelberg (2014)
22. Nijdam, A.N.: Mapping Emotion to Color (2009). http://hmi.ewi.utwente.nl/verslagen/capita-selecta/CS-Nijdam-Niels.pdf at the University of Twente
23. Osondu, C., Wei, W.: Named Entity Classification. York University (2011)
24. Prud'Hommeaux, E., Seaborne, A.: SPARQL Query Language for RDF. W3C Recommendation (2008)
25. Gruber, T.R.: A translation approach to portable ontology specifications. Knowl. Acquisition 5(2), 199–220 (1993)
26. Read, J.C., MacFarlane, S.: Using the fun toolkit and other survey methods to gather opinions in child computer interaction. In: Proceedings of the 2006 Conference on Interaction Design and Children, pp. 81–88. ACM (2006)
27. Sánchez-Rada, J.F., Iglesias, C.A.: Onyx: a linked data approach to emotion representation. Inf. Process. Manage. 51, 83–113 (2015)
28. Seadle, M., Vassiliou, M., Rowley, J.: Progressing the definition of e-book. Library Hi Tech 26(3), 355–368 (2008)
29. Sekine, S., Sudo, K., Nobata, C.: Extended named entity hierarchy. In: LREC (2002)
30. Shaw, C., Ivens, J.: Building Great Customer Experiences. Palgrave Macmillan, Basingstoke (2002)
31. Smith, M.K., Welty, C., L. McGuinness, D.: OWL Web Ontology Language Guide: W3c Recommendation (2004)
32. Thoma, G.R., Ford, G., Chung, M., Vasudevan, K., Antani, S.: Interactive publications: creation and usage. In: Electronic Imaging 2006, pp. 603–607. International Society for Optics and Photonics (2006)
33. Verborgh, R., et al.: Querying datasets on the web with high availability. In: Mika, P., et al. (eds.) ISWC 2014, Part I. LNCS, vol. 8796, pp. 180–196. Springer, Heidelberg (2014)
34. Vermeeren, A.P., Law, E.L.C., Roto, V., Obrist, M., Hoonhout, J., Väänänen-Vainio-Mattila, K.: User experience evaluation methods: current state and development needs. In: Proceedings of the 6th Nordic Conference on Human-Computer Interaction: Extending Boundaries, pp. 521–530. ACM (2010)

Automatic Annotation of Characters' Emotions in Stories

Vincenzo Lombardo[1], Rossana Damiano[1(✉)], Cristina Battaglino[1],
and Antonio Pizzo[2]

[1] Department of Computer Science and CIRMA, University of Torino, Turin, Italy
{vincenzo,rossana,battagli}@di.unito.it
[2] Department of Humanities and CIRMA, University of Torino, Turin, Italy
antonio.pizzo@unito.it

Abstract. The emotional states of the characters allow the audience to understand their motivations and feel empathy for their reactions to the story incidents. Consequently, the annotation of characters' emotions in narratives is highly relevant for story indexing and retrieval but also editing and analysis. In this paper, we address the construction of tools for the annotation of characters' emotions in stories, opening the way to the construction of a corpus of narratives annotated with emotions.

Keywords: Emotion annotation · Narrative corpora · Emotion appraisal

1 Introduction

Despite the strong interest for affect in social media, tools for the annotation of emotions of narrative resources still lack. Stories, a pervasive feature of today's media - with narrative contents generated daily by amateurs and industry and made available on several platforms and devices - are a domain where affect is recognizably relevant, being intrinsic to the very notion of story (see for example [1]). In this paper, we address the annotation of characters' emotions in stories, with the goal of providing a resource that can support the development of emotional modules in story generators as well as in interactive narrative systems. With the paradigm of crowdsourcing annotation in mind, we propose a workflow for the annotation of characters' emotions that enforces a coherent emotion model in annotation through the use of rules.

In order to devise a set of annotation tags, we resort to cognitive theories of emotions. The core of such cognitive theories is the notion of appraisal [17]: emotions stem from how a character appraises a given situation with respect to its personal perspective. Basically, if the character appraises some event as beneficial, she/he feels positive emotions, such as happiness; if she/he appraises some event as deleterious, she/he is worried or disgusted.

A. Pizzo—The affiliations of the authors refer to the preparation of this work.

© Springer International Publishing Switzerland 2015
H. Schoenau-Fog et al. (Eds.): ICIDS 2015, LNCS 9445, pp. 117–129, 2015.
DOI: 10.1007/978-3-319-27036-4_11

The notion of emotional appraisal relies on the detection, and possibly annotation, of story incidents and how characters are engaged in those incidents, in terms of motivations. This requirement has brought to the integration of the cognitive theories of emotions into the computational systems that implement the characters through the well known BDI (Belief-Desire-Intention) model of intentional agency [4,5]. Virtual characters implemented through this model (1) rely on their knowledge (or Beliefs) about the world to achieve their goals (Desires) through plans of actions (Intentions), and (2) appraise the emotions triggered by the primitives of the BDI model.

The approach to the annotation of emotion pursued in this paper is semi–automatic: the annotators introduce schematic descriptions of the story incidents and of the goals of the characters that motivate the incidents, and a set of rules compute the characters' emotions, actually the emotion tags that describe the way characters react to the story incidents. The purpose of this rule–based approach is to enforce coherence in the implementation of the appraisal model and limit the intervention of the human annotation to the identification of the story incidents and characters' goals. Following the OCC theory of emotion appraisal [19], the rule set assumes that characters are driven by the achievement/failure of their goals and the respect/violation of their values, engaging in conflicts that are the input to their emotional states.

This paper is structured as follows. After reviewing the related work in story annotation in Sect. 2, we describe how the reference model of emotional appraisal has been translated in terms of a story representation formalism (Sect. 3) and discuss its use in story annotation. Section 4 contains the description of the rules for annotating the characters' emotions, illustrated through well known examples. Conclusion ends the paper.

2 The Annotation of Stories

The first attempts at describing the story content in a systematic way date back to the first half of the last century, prompted by availability of the large collections of narratives gathered by folklore studies. These attempts were mainly aimed at classifying stories into categories (see, e.g., Thompson's "motif index" of folk literature [27]) and distilling the basic structures that emerge from corpora (see, e.g., Propp's detailed account of the structure of Russian fairy tales [22]). However, such models were only partially encoded with the use of formal languages, a limitation they share with some notable today's resources for narrative content, such as, e.g., TvTropes[1].

Some recent projects have investigated the creation of story repositories with formal tools. Propp's work, in particular, has been the object of formalization with AI tools, thanks to the formal nature of linguistic structuralism. The adoption of the Proppian model has led to the creation of repositories for tasks that range from the creation of fictional story worlds [9] to narrative generation [11]. On the linguistic side, the DramaBank Project [8] is a repository of semantically annotated

[1] tvtropes.org.

narratives, oriented to the surface generation of different stories from shared nuclei [25]. Being concerned more with the encoding of plots rather than characters, the DramaBank annotation language has specific operators for causality and intentionality in stories, such as *Attempt to cause*. All these projects, however, do not account for the annotation of characters' emotions.

The Narrative Knowledge Representation Language (NKRL) proposed by [28] also provides highly developed tools for the annotation of the narrative content that account for the linguistic expression of stories. Mostly focused on the relation between the semantics of stories and their textual presentation, it opens to the application of sentiment analysis to the narrative text [29], a related topic of the affect annotation, but it does not acknowledge the role of the characters and the annotation of the emotions they feel.

The computational account (and, consequently, the annotation) of characters' emotions strongly relies on an explicit account of the characters' mental states in terms of what they believe and intend at any point of the story development. These character–centered description issues, not encompassed by the annotation languages above, are accounted for by the ontology–based story annotation in [14,15]. The ontology of drama called Drammar grounds the representation of characters upon the notion of agents' intention (realized through the notion of plan). A plan consists of the actions that are to be carried out in order to achieve some goal; plans are organized hierarchically, with high–level, longer term plans consisting of lower–level, shorter term plans (called subplans). Goals originate from the values of the agents, i.e., put at stake or balanced through the plan actions. The representation of dramatic characters is formalized through the rational agent paradigm, or Belief Desire Intention (BDI) paradigm [4] (which has already seen some applications in the computational storytelling community [18,20]). The dramatic scenes of the story are the places for the interplay of the actions that are carried out by the agents to achieve their goals. The scene is built in order to orchestrate the conflicts (or, alternatively, the support relations) over the goals and to induce into the agents the emotions sought after by the author of the drama, the dramatic qualities *par excellence*. A relevant feature of this ontology is that it was designed with the goal of being independent from specific genres of media, making it suitable for the annotation of heterogeneous narrative resources.

3 Rule-Based Annotation of Emotions

Given the representation of the story in terms of characters' goals, values and action plans, the emotion annotation rules add to the characters a set of emotional labels. The rules we propose are based on the cognitive theory of emotions proposed by Ortony, Clore and Collins in 1988 [19] (OCC). A number of computational models of emotions, since the pioneering work by [7], rely on the this theory [6,10,24] to model the emotional states of virtual agents, or on appraisal theories in general [16,23].

3.1 Background: The OCC Model of Emotions

In OCC theory, emotions are activated as a consequence of a person's (here, an agent's) subjective appraisal of a given situation. The *appraisal process* encompasses the following elements: the appraising *agent*, the appraised *situation*, the *dimension* of appraisal. Depending on the configuration of these elements, different emotion types are generated.

The OCC theory acknowledges three main dimensions of appraisal: the utilitarian dimension of *desirability* (or undesirability), mapped onto the achievement (or failure) of goals following an established tradition in computational models of emotions (e.g., Joy or Distress); the moral dimension of *praiseworthiness* (or blameworthiness), mapped onto the compliance (or conflict) with moral values (e.g., Pride or Shame), following the computational model of moral emotions in [3]; the *affection* for an entity involved in the situation. Notice that the utilitarian dimension can be also appraised by the agent from the point of view of another agent, thus generating emotions oriented to other agents (e.g. Happy–for or Reproach).

The *target* of the emotion, then, varies depending on the appraisal of the situation as a mere event or as an intentional act: in the former case, the target of the emotion is the event itself and the relevant dimension of appraisal is the desirability of the event; in the latter case, the target is the agent who intentionally performed the act and the relevant appraisal dimension is the praiseworthiness of the action. A third case is the appraisal of a specific entity (e.g., an object or a person) involved in the situation according to an affective, subjective inclination (e.g., Love and Hate): the affection towards the target cannot be computed, being intrinsic to the appraising agent. Notice that the same situation can be simultaneously appraised as an event, an action or an entity: so, for example, another agent's action may be appraised as an intentional act, as a mere event, or both, giving rise to different emotion types.

Finally, when a situation is appraised as event or act, its temporal dynamics becomes relevant: if the appraised situation is still ongoing, a *prospect-based* emotion will be generated based on the agent's expectation about its outcome (e.g., Hope or Fear). Otherwise, the generated emotion type depends on the actual outcome of the event with respect to the dimensions of desirability and praiseworthiness (e.g., Relief).

In OCC, emotions are grouped into emotion families depending on the appraisal dimensions. When the appraisal dimension is desirability, *Well–being* emotions are generated; these can be *Prospect–based* if the refer to the prospective accomplishment of events. The appraisal of actions according to the moral dimension gives rise to *Attribution* emotions. The appraisal of situations from the perspective of other agents gives rise to *Fortune–of–Others* emotions.

3.2 Mapping the OCC Model onto the Rules

In order to be compliant with the Semantic Web and the Linked Open Data initiatives, we have adopted the Semantic Web Rule Language (*SWRL*) to encode

the emotional appraisal process. This choice permits the possible use of the emotion appraisal process as a web service in a future of distributed resources in the web.

The SWRL rule language [12] augments an OWL ontology with a rule layer, adding the possibility to declare arbitrary Horn clauses expressed as *IF THEN* rules. A *SWRL* based system is therefore composed of ordinary *OWL* axioms plus a set of *SWRL* rules. The antecedent and consequent of the rules consist of lists of atoms, which may be *OWL* class expressions, property definitions, or built-ins. Most of the current available *DL* reasoners, such as *Pellet* or *Hermit*, support inferences based on *SWRL*. Encoding emotion generation using *SWRL* rules enables the automatic generation of the emotions of the characters in a scene that has been previously annotated in the Drammar ontology. However, notice that the rules may be easily translated into a different rule formalism in order to apply them to an annotation carried out with an equivalent formalism.

Translating the computational model of emotions into the rules for the generation of emotion labels involves a mapping of the elements of the appraisal process (appraising agent, situation and dimension of appraisal) onto the primitives of the Drammar ontology. In order to make the OCC theory compliant with the BDI agent approach incorporated in Drammar, we have adopted the operationalization of the theory provided by [2], which relies on the introduction of the notion of value for the appraisal of moral emotions. Basically, the rule antecedent represents a character's appraisal of a situation, and is based on the storyworld states determined by the character's goals achievement (e.g., killed an enemy of the country), the character's values put at stake or balanced (e.g., the freedom of the country), and the plans the character is committed to (e.g., ambushing the enemy during a street parade). The rule consequent asserts what emotions the character feels as a consequence of the appraisal and what is the target of the emotion. When the antecedent of the rule is true in the annotated story, the rule fires and, as a result, an emotion of the type prescribed by the rule is added to some character. For example, if a character's goal is not achieved in a given scene due to the occurrence of an (unpredictable) event, the rule derives that what happened in the scene is appraised by the character as undesirable and thus the consequent generates a Distress emotion for the character. Notice that, following the *componential view* of a computational model of emotions presented in [17], the *appraisal derivation* is encoded in the antecedent of the rules, while the *affect derivation* is encoded in the rule consequent.

The appraised situation is mapped onto a scene of the drama and the appraising agent is mapped onto a character featured in the scene. The content of the scene is represented as a set of variables that correspond to goals (`Goal` in Drammar), achieved by plans (`Plan` in Drammar), and values (`Value` in Drammar), engaged by the execution of plans. The support and conflict relations over goals determine the desirability/undesirability of the plans executed by the agents in the scene, seen as ongoing or accomplished processes; the way the plans affect the agents' values (putting them at stake or bringing them back to balance) determines the praiseworthiness/blameworthiness of the agent who executes them (self or other); finally, the affection toward other agents determine the emotions oriented to others.

3.3 Toward a Corpus of Emotionally Annotated Stories

The rules for assigning emotions to characters are deployed in a semi-automatic story annotation pipeline. The advantage of using a formally encoded set of rules for emotion assignment is that they allow the human annotator to check her/his assessment of the characters' emotional state against the emotion types returned by the rules. Here, we sketch a workflow that uses the rules set to construct a corpus of narratives annotated with characters' emotions, with the goal of fostering the creation of narrative corpora annotated with characters' emotions.

1. **Corpus selection.** A corpus of narrative works is selected by experts in drama and narrative theory, with the goal of providing a comprehensive corpus spanning through ages, genres and media.
2. **Segmentation.** Works are segmented by an expert before being fed to the parallel human and semi-automated annotation procedures, so as to provide a basic alignment. Notice that the segmentation is often explicitly marked in most media, from classic drama (with explicit acts, scenes, etc.) to Hollywood movies (with acts, sequence, scenes, etc.). However, in case the segmentation is not marked in the original work, the segmentation made by the annotators can still be considered reliable, as argued by [13] based on an empirical basis.
3. **Human annotation.** Each story is annotated by at least two different annotators, trained in dramatic narration and selected based on their familiarity with the work. The annotation follows the schema implied by the appraisal model, namely the set of incidents occurring in each story scene, together with the links to the characters' plans, goals and values and the conflict/support relations over them.
4. **Rule based computation of emotions.** A reliable version of the annotation is generated by accounting for the agreement between the annotators: this step requires the annotated elements (plans, goals and values) to be consistent not only from a logical perspective, but also from a narratological perspective, so the supervision of an expert may be required. The annotation is then fed to a reasoner[2] for the application of the *SWRL* emotion rules presented in Sect. 3.

Notice that the annotators may provide useful insights on the correctness of the rules, leading to minor changes and/or refinements of the rules.

4 Rules for the Automatic Annotation of Emotions

The rules for the automatic annotation of emotions can be classified according to the relations that holds over the primitives of the agent model.

The appraisal of an event as *desirable* (or *undesirable*) depends on the relation between a goal of the appraising agent and another agent's goal, achieved by the

[2] Such as Pellet, www.clarkparsia.com/pellet.

plan of the other agent in the scene. This relation is expressed through the properties inConflictWith or inSupportOf, respectively: an event is desirable if the goal it achieves is inSupportOf of the agent's goal, undesirable otherwise.

The appraisal of an action as *praiseworthy* (or *blameworthy*) depends on the relation between a character's value and a plan another agent is committed to (or by the agent itself) as a way to achieve some goal. This relation is expressed by the property atStake concerning one of the values of the character: if the value is put atStake as a consequence of the execution of a plan in the scene (in Drammar, this equates to saying that the value is a ValueEngaged in the effects of a plan), the plan is (or else, the actions contained in it are) blameworthy; otherwise, if a value is not at stake anymore after the execution of a plan, the plan is praiseworthy.

The temporal dynamics of the appraised situation, relevant for Prospect-based emotions, is grasped by a property describing the status of the execution of a plan in the agent's expectations. The status of a prospect event is expressed by the property accomplished of a plan, whose value is a string. A plan accomplishment can be *uncertain* (i.e., "uncertain") if the agent expects the plan to achieve its goal, *successful* (i.e., "true") if the plan has been successfully executed and has achieved its goal as expected, *failed* (i.e., "false") if the plan has not achieved its goal, differently from what expected. Notice that this is in line with the observations about prospect-based emotions made in [26].

Figure 1 illustrates the rules for emotion generation. The table is divided into three main sections, that correspond, respectively, to Well-being (and Prospect-based) emotions, Fortune-of-others emotions, and Attribution emotions, respectively. Compound emotions complete the table.

Well-being emotions, such as Distress and Joy, depend on the relation between a Goal $?G$ and a Goal $?G_{SA}$ owned by an Agent. An event is desirable if it encompasses a plan that achieves a goal $?G$ inSupportOf of the agent's goal $?G_{SA}$, undesirable if the goal $?G$ is inConflict with the agent's goal (notice that $?G$ and $?G_{SA}$ can be the same goal).

Fortune-of-others emotions, such as Happy-for another agent, depend on the agent's emotions *Love/Hate* for another agent encoded in the representation and on the (un)desirability of an event for an other agent's Goal $?G_{OA}$ (see Fig. 1). For example, if the Agent $?SA$ loves another Agent $?OA$ and the Goal $?G$ is inSupportOf the Goal $?G_{OA}$ of the other Agent $?OA$, $?SA$ feels *Happy-for* for the other agent $?OA$. Otherwise, the agent feels *Gloating* toward the other agent.

Attribution emotions arise when the agent appraises the consequences of an action with respect to its values. This happens when an Agent $?SA$ owns a Value $?V$ that is a *ValueEngaged* $?VE$ in the effects of the Plan $?P$. The Agent $?SA$ appraises the Plan $?P$ as *praiseworthy* if the value $?VE$ is re-balanced by the plan (i.e., the data property atStake of $?V$ is *false* as a consequence of the plan); the Plan $?P$ is blameworthy if $?VE$ is put at stake by the plan (i.e., the data property atStake of $?V$ is *true* as a consequence of the plan) (see Fig. 1). Attribution emotions can be self- or other-directed: if the Plan $?P$ that the Agent $?SA$ considers praiseworthy (or blameworthy) is a plan intended by the agent $?SA$ itself, the Agent $?SA$ feels Pride (or Shame). Otherwise, if the Plan $?P$ plan is intended by another Agent $?OA$ in the scene, $?SA$ feels Admiration or Reproach (see Fig. 1).

Event	A goal g_i is achieved by a Plan p_i in the scene	
Appraisal Variables		**Appraising Agent feels**
Well-being and Prospect-based emotions		
	Undesirable	
	Prospect of the event	
	No prospect	
	The appraising agent doesn't have a belief about the relation between the goal g_i and its goals	DISTRESS
	Uncertain	
Goal g_i is in conflict with appraising agent's goal	The appraising agent believes the relation between the goal g and one of its goals; the plan p_i is not still accomplished	FEAR
	Confirmed	
	The appraising agent believes the relation between the goal g and one of its goals; the plan p_i is accomplished	FEAR-CONFIRMED
	Disconfirmed	
	The appraising agent believes the relation between the goal g and one of its goals; the plan p_i is not accomplished	RELIEF
	Prospect of the event	
	No prospect	
	The appraising agent doesn't have a belief about the prospect of the event and the Plan p_i is accomplished	JOY
	Uncertain	
Goal g_i is in support of appraising agent's goal	The appraising agent believes the relation between the goal g and one of its goals; the plan is not still accomplished	HOPE
	Confirmed	
	The appraising agent believes the relation between the goal g and one of its goal; the plan is accomplished	SATISFACTION
	Disconfirmed	
	The appraising agent believes the relation between the goal g and one of its goals; the plan is not accomplished	DISAPPOINTMENT
Fortune-of-others Emotions		
	Undesirable	
	Relations	
	Love	
Goal g_i is in conflict with another agent's goal	The appraising agent loves the other agent	PITY
	Hate	
	The appraising agent hates the other agent	GLOATING
	Desirable	
	Relations	
	Love	
Goal g_i is in support of another agent's goal	The appraising agent loves the other agent	HAPPY-FOR
	Hate	
	The appraising agent hates the other agent	RESENTEMENT
Attribution Emotions		
	Praiseworthy	
	Agency	
	Self	
The plan p_i rebalances one of the values of the appraising agent	The appraising agent intends the plan p_i	PRIDE
	Other	
	Another agent intends the plan p_i	SHAME
	Blameworthy	
	Agency	
	Self	
The plan p_i puts at stake one of the values of the appraising agent	The appraising agent intends the plan p_i	ADMIRATION
	Other	
	Another agent intends the plan p_i	REPROACH
Compound Emotions		
	Desirable and Praiseworthy	
	Agency	
	Self	
Goal g_i is in support of another agent's goal and the plan p_i rebalances one of the values of the appraising agent	The appraising agent intends the plan p_i	GRATIFICATION
	Other	
	Another agent intends the plan p_i	GRATITUDE
	Undesirable and Blameworthy	
	Agency	
	Self	
Goal g_i is in conflict with another agent's goal and the plan p_i puts at stake one of the values of the appraising agent	The appraising agent intends the plan p_i	REMORSE
	Other	
	Another agent intends the plan p_i	ANGER

Fig. 1. SWRL Rules encoded in the Drammar Ontology

Compound emotions arise when the agent feels Well-being emotions and Attribution emotions at the same time. The Gratification (Remorse) rule fires if the `Agent` *?SA* feels *Joy (Distress)* and *Pride (Shame)* in the `Scene` *?S*. The Gratitude (Anger) rule fires if the `Agent` *?SA* feels *Joy (Distress)* and *Admiration (Reproach)* in the `Scene` *?S*.

4.1 Examples

In order to illustrates how the rules work on a story scene annotated with the narrative and dramatic elements, we resort to two examples taken from the movie "North by Northwest" by Alfred Hitchcock (1959), a tale of mistaken identity where the main character Roger tries to prove that he is not the 'double' George Kaplan. As a Hollywood classic, the characters' emotions in this movie can be identified unambiguously enough to provide straightforward examples for emotion assignment [21].

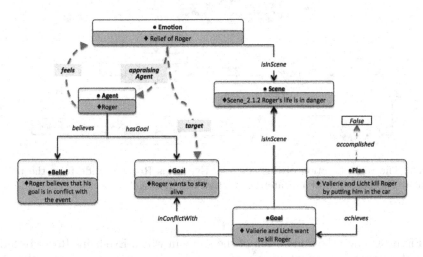

Fig. 2. The annotation of the scene used by the emotion rule module for the `Agent` *"Roger"*. The property `target`, `feels` and `appraisingAgent` are inferred by the rule for Relief emotion

Figure 2 describes the activation of the SWRL rule for Relief of the agent Roger in the scene in which two foreign spies, Valerie and Licht, believing that Roger is George Kaplan, try to kill him by forcing him to drink bourbon and putting him into a moving car. Roger eventually manages to exit from the car before it falls off a cliff. We only report the salient elements that are needed to illustrate the activation of the Relief SWRL rule. The `Scene` *"Scene_2.1.2 Roger's life is in danger"* has one `Agent`: the main character *"Roger"*. The emotional charge of the scene is usually described in the traditional *misè en scene* by focusing on the conflict between the two goals: Valerie and Licht want to kill Roger; Roger wants to stay alive. The application of the SWRL rules correctly outputs Roger's Relief as the emotion triggered in the scene. In Fig. 2,

the appraised event is represented by the `Plan` *"Valerie and Rick kill Roger by putting him in the car"* that achieves Valerie and Licht's `Goal` *"Valerie and Licht want to kill Roger"*. The plan has the data property `accomplished` set to *false*, meaning that the event is *discofirmed*. The `Agent` *Roger* has the `Goal` *"Roger wants to stay alive"* that is `inConflictWith` Valerie and Licht's goal and the agent believes that his goal is in conflict with the event. Thus, the `Agent` *Roger* appraises the event as an *undesirable disconfirmed* event that leads to the activation of the Relief SWRL rule (see Fig. 1). The Relief rule consequent asserts that the `Agent` *Roger* is the `appraisingAgent` that feels the `Emotion` *Relief of Roger*, with the `Goal` *"Roger wants to stay alive"* as target (property `target`).

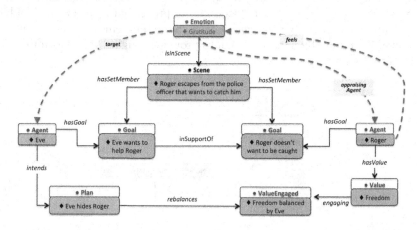

Fig. 3. The representation of the example: Eve helps Roger to hide from the police officers. The dotted lines indicate the emotion felt by Roger

Figure 3 shows the annotation of the scene in which Eve helps Roger to hide from the police officers who want to catch him, because they believe that he is an assassin. As a spy of the USA government, Eve knows that Roger is not an assassin, so she helps him. The incidents described above are contained in the `Scene` *"Roger escapes from the police officer that wants to catch him"*. The occurrence of the event (Roger's escape) featured in the scene is motivated by the following goals: Roger has the `Goal` of not being caught by the police officers (*Roger doesn't want to be caught*); Roger's goal is supported by Eve's `Goal` of helping Roger (*Eve wants to help Roger*). Roger `feels` an `Emotion` of Gratitude toward Eve, because her goal is `inSupportOf` of Roger's goal of not being caught and her plan brings back to balance Roger's `Value` of *Freedom* (`rebalances` arrow from Eve's `Plan` *Eve hides Roger* to Roger's value). The Gratitude rule asserts that the `Agent` *Roger* is the `appraisingAgent` who feels the `Emotion` *Gratitude*, with the `Agent` *Eve* as target (property `target`).

5 Conclusion

Since emotions are relevant for the comprehension and the fruition of stories by their public, they can be useful to implement innovative tools for search and editing of stories. Differently from sentiment detection in linguistic corpora, which mainly relies on lexical and semantic resources, the annotation of characters' emotions requires an understanding of how the characters' conflicting motivations in a story determine the generation of their emotions.

In this paper, we have described a system for the automatic generation of characters' emotions in stories, with the appraisal process encoded in a set of SWRL rules. A rule based system alleviates the task of manual annotation of characters' emotions by providing a coherent and founded model for character emotion generation through a variety of media. Based on the representation of story characters as BDI agents augmented with moral values provided by the Drammar ontology, the rules encode the OCC model of emotions, integrated with the notion of values into the BDI model.

In this paper, we have illustrated our approach through examples taken from a classic Hollywood movie. As a future work, we plan to use the rule set for a narrative annotation campaign, aimed at adding emotional labels to a comprehensive set of narrative works, spanning through media, ages and genres.

References

1. Quesenberry, K.A., Coolsen, M.K.: What makes a super bowl ad super? five-act dramatic form affects consumer super bowl advertising ratings. J. Mark. Theory Pract. **22**(4), 437–454 (2014)
2. Battaglino, C., Damiano, R.: Emotional appraisal of moral dilemma in characters. In: Oyarzun, D., Peinado, F., Young, R.M., Elizalde, A., Méndez, G. (eds.) Interactive Storytelling. Lecture Notes in Computer Science, vol. 7648, pp. 150–161. Springer, Heidelberg (2012)
3. Battaglino, C., Damiano, R., Lesmo, L.: Emotional range in value-sensitive deliberation. In: AAMAS, pp. 769–776 (2013)
4. Bratman, M.: Intention, Plans, and Practical Reason. Harvard University Press, Cambridge (1987)
5. Cohen, P.R., Levesque, H.J.: Intention is choice with commitment. Artif. Intell. **42**, 213–261 (1990)
6. Dias, J., Mascarenhas, S., Paiva, A.: Fatima modular: towards an agent architecture with a generic appraisal framework. In: Workshop on Standards in Emotion Modeling. Leiden (2011)
7. Elliott, C.D.: The Affective Reasoner: A Process Model of Emotions in a Multiagent System. Ph.D. thesis, Northwestern University, Evanston, IL, USA (1992). UMI Order No. GAX92-29901
8. Elson, D.: Dramabank: Annotating agency in narrative discourse. In: LREC, pp. 2813–2819 (2012)

9. Fairclough, C.R., Cunningham, P.: A multiplayer opiate. Int. J. Intell. Games Simul. **3**(2), 54–61 (2004)

10. Gebhard, P.: Alma: a layered model of affect. In: Proceedings of the Fourth International Joint Conference on Autonomous Agents and Multiagent Systems, pp. 29–36. ACM (2005)

11. Gervás, P.: Propp's morphology of the folk tale as a grammar for generation. In: CMN, p. 106–122 (2013)

12. Horrocks, I., Patel-Schneider, P.F., Boley, H., Tabet, S., Grosof, B., Dean, M., et al.: Swrl: A semantic web rule language combining owl and ruleml. W3C Member submission 21, 79 (2004)

13. Lombardo, V., Damiano, R.: Commonsense knowledge for the collection of ground truth data on semantic descriptors. In: Proceedings of the 2012 IEEE International Symposium on Multimedia (ISM 2012), pp. 78–83. IEEE Computer Society (2012)

14. Lombardo, V., Pizzo, A.: Multimedia tool suite for the visualization of drama heritage metadata. Multimedia Tools and Applications pp. 1–32 (2014)

15. Lombardo, V., Pizzo, A.: Ontology–based visualization of characters' intentions. In: Mitchell, A., Fernández-Vara, C., Thue, D. (eds.) Interactive Storytelling. Lecture Notes in Computer Science, vol. 8832, pp. 176–187. Springer, Heidelberg (2014)

16. Marsella, S.C., Gratch, J.: Ema: a process model of appraisal dynamics. Cogn. Syst. Res. **10**(1), 70–90 (2009)

17. Marsella, S.C., Gratch, J., Petta, P.: Computational models of emotion. In: Scherer, K.R., BÄnziger, T., Roesch (eds.) A Blueprint for an Affectively Competent Agent: Cross-Fertilization Between Emotion Psychology, Affective Neuroscience, and Affective Computing. Oxford University Press, Oxford (2010). http://ict.usc.edu/pubs/Computational%20Models%20of%20Emotion.pdf

18. Norling, E., Sonenberg, L.: Creating interactive characters with BDI agents. In: Proceedings of the Australian Workshop on Interactive Entertainment IE2004 (2004)

19. Ortony, A., Clore, G., Collins, A.: The Cognitive Structure of Emotions. Cambrigde University Press, Cambrigde (1988)

20. Peinado, F., Cavazza, M., Pizzi, D.: Revisiting character-based affective storytelling under a narrative BDI framework. In: Spierling, U., Szilas, N. (eds.) Interactive Storytelling. Lecture Notes in Computer Science, vol. 5334, pp. 83–88. Springer, Heidelberg (2008)

21. Plantinga, C.: Moving Viewers: American Film and the Spectator's Experience. Univ of California Press, Berkeley (2009)

22. Propp, V.: Morphology of the Folktale. University of Texas Press, Austin (1968)

23. Rank, S., Petta, P.: Appraisal for a character-based story-world. In: Panayiotopoulos, T., Gratch, J., Aylett, R.S., Ballin, D., Olivier, P., Rist, T. (eds.) Intelligent Virtual Agents. Lecture Notes in Computer Science (Lecture Notes in Artificial Intelligence), vol. 3661, pp. 495–496. Springer, Heidelberg (2005)

24. Reilly, W.S.: Believable social and emotional agents. Technical report, DTIC Document (1996)

25. Rishes, E., Lukin, S.M., Elson, D.K., Walker, M.A.: Generating different story tellings from semantic representations of narrative. In: Koenitz, H., Sezen, T.I., Ferri, G., Haahr, M., Sezen, D., Ç atak, G. (eds.) Interactive Storytelling. Lecture Notes in Computer Science, vol. 8230, pp. 192–204. Springer, Heidelberg (2013)

26. Steunebrink, B.R., Dastani, M., Meyer, J.J.C.: The occ model revisited. In: Proceedings of the 4th Workshop on Emotion and Computing (2009)

27. Thompson, S.: Myths and folktales. J. Am. Folklore **68**(270), 482–488 (1955)
28. Zarri, G.P.: Conceptual and content-based annotation of (multimedia) documents. Multimedia Tools Appl. **72**(3), 2359–2391 (2014)
29. Zarri, G.P.: Sentiments analysis at conceptual level making use of the narrative knowledge representation language. Neural Netw. **58**, 82–97 (2014)

Authoring Background Character Responses to Foreground Characters

Fernando Geraci and Mubbasir Kapadia[✉]

Computer Science Department, Rutgers University, New Brunswick, NJ, USA
{fgeraci,mk1353}@scarletmail.rutgers.edu

Abstract. This paper presents a flexible and intuitive authoring interface for specifying the behaviors of background characters and their reactions to user-controlled foreground characters. We use an event-centric behavior authoring paradigm and provide metaphors for altering the behavioral responses using conditions, modifiers, and contexts. The execution of an event (an interaction between multiple characters in the scene) is governed using authored conditions on the state of the participating characters, as well as the history of their past interactions. Our system monitors the ongoing simulation and the actions of foreground characters to trigger plausible reactions in the background characters as events, which satisfy user-authored conditions. Modifiers allow authors to vary how events are perceived by specific characters, to elicit unique responses. Contexts provide a simple mechanism to add behavior modifiers based on the current location of the characters. We demonstrate the benefits of our approach by authoring a virtual populace, and show the design of simple background activity, to more complex multi-agent interactions, that highlight the ease and flexibility of specification.

Keywords: Behavior trees · Behavior authoring · Background characters

1 Introduction

As virtual simulations technologies evolve in quality of graphics and animations complexity, users' expectations for a more immersive and realistic experience increases as well. The resulting user experience is mostly determined by two main factors: how the world is presented aesthetically, and how its inhabitants react to the user-controlled character's actions. The second is of critical importance when it comes to interactive virtual worlds, and the smallest details can determine how immersive its atmosphere is. Higher quality productions will pay special attention to background information which complements and completes the foreground scene. These, will also have higher and more complex development cycles which certainly benefit from the introduction of technologies which abstracts certain complexities providing simply a complete component. The availability, portability and licensing of third party quality components, proves to be a challenge for smaller scale developers finding themselves in need

© Springer International Publishing Switzerland 2015
H. Schoenau-Fog et al. (Eds.): ICIDS 2015, LNCS 9445, pp. 130–141, 2015.
DOI: 10.1007/978-3-319-27036-4_12

of creating their own non-mission critical elements, potentially compromising key aspects of the intended final product.

To alleviate these production cycles, we present ABAS, a tool which enables an author to easily design and modify character behaviors, and how these synthesize with their environment and other agents. ABAS provides a flexible event-centric model, which can simply be configured and tested anew, after modification in the next run, without the need of new builds or code modifications. An event is the cornerstone of the presented authoring model, which can be easily molded by utilizing *conditions, modifiers*, and *contexts*. Using our intuitive and flexible specification interface, end users can quickly specify and generate unique, heterogeneous background character behaviors in response to foreground (player-controlled) characters. These behaviors depend on user-authored conditions and modifiers, the spatial context in which the actions take place, and even the history of interactions between characters. We demonstrate ABAS by authoring different activities in a virtual populace in 15th century Plasenscia. Users may choose to take control over any character in the scene, thus promoting it to the role of the foreground character. Every character, remember past interactions, and elicit appropriate behavioral responses depending on the context of the situation, per user-authored conditions and modifiers using our specification interface.

2 Related Work

We refer the readers to surveys in behavior authoring [1,2] and provide a brief overview of prior work below.

Simulation-Centric Authoring. Commercial software such as Massive, Golaem, Alice, MayaCrowds, Houdini etc. are simulation-centric where designers author the responses of an autonomous agent to external stimuli and tweak simulation parameters to mold the emergent crowd behavior. This mode of authoring requires the animator to work within the limits imposed by simulation framework, which may be sufficient for generic crowds in the background of a shot (e.g. stadiums etc.). However, authoring precision is particularly important for crowd shots that mandate interactions with foreground characters, or when the behavior of a crowd must be carefully choreographed. As a result, designers resort to manual methods that provide precise control, at the expense of increasing the authoring burden.

Data-Centric Authoring. The work presented by [3], synthesizes synchronized multi-character motions and crowd animations, by performing editing and stitching operations on a library of motion capture data. However, the approach is limited to the database of pre-recorded clips as large deformations and time warping may yield unnatural results. Also, editing an individual motion may change the entire crowd animation, which is undesirable when orchestrating crowd activities with multiple constraints. Motion Patches [4] are environmental building blocks that are annotated with motion data, which informs what actions

are available for animated characters within the block. Motion patches can be edited and connected together [5], or precomputed by expanding a search tree of single character motions ([6]) to synthesize complex multi-character interactions.

The aforementioned contributions rely on pre-recorded motion building blocks which could synthesize animations of long duration, with many characters in complex environments. In comparison, this paper aims to generalize motion patches to represent logical behavioral constructs which can be stitched together with precise authorial control, while using simulation to automatically synthesize interaction instances that meet author constraints. In addition, this paper further refines the markup interface implementation presented by [7,8], in a more abstracted and intuitive way for a designer.

Parameterized Behavior Trees (PBT's) [9] provide a graphical authoring paradigm for specifying multi-actor behaviors and conform well to an event-centric authoring model which we use in our system. ADAPT [10,11] is an open-source platform for animating and directing virtual avatars using PBT's. Our authoring interface leverages the ADAPT platform to animate the avatars described in the results and shown in the video. Domain-independent planners [12–14] have recently gained prominence for automatically generating behavior-rich animations, at the expense of authorial control, and a promising research direction that complements this work.

3 Framework

3.1 Preliminaries

The following are the foundational blocks of our framework:

- **SmartObject**. An object or avatar that is able to interact with other smart objects using predefined affordances.
- **Affordance**. Affordances define the different possible ways in which smart objects can interact with each other.
- **Trait**. A specific characteristic of every agent, which has associated with it a real or boolean value, that defines the state of an agent.
- **State**. A collection of traits **T**, with unique values, initialized at the beginning of each simulation.
- **Behavior**. A logical interaction between two or more smart objects, defined as a PBT [9] which uses affordances as leaf nodes.
- **Condition**. A specific query on an agent's state, which must be satisfied in order to be considered valid.
- **Modifier**. Refers to a discrete value which will increase, neutralize or decrease, the effect of a behavior's impact in its surroundings.
- **Context**. Geographically delimited area within the simulation. This element, allows to further modify how behaviors are perceived, and can be added freely during the design phase.
- **Events**. Structure which encapsulates a particular behavior tree definition, conditions, modifiers, a type, and its priority.

3.2 Agent Model and Event-Centric Deliberation

The way the agent is designed in this implementation, allows for two type of characters. One is background, or non-controlled agents, and foreground user-controller characters. Ideally, the scene's plot will develop around a foreground agent, and this, allows the user to issue commands to interact with its environment and other surrounding agents. In return, and based on the authors' designs, non-controlled agents will react accordingly. Actions allowed to be performed by the user, will be represented as events at a system level. The entire authoring system, orbits around the idea that every behavior is encapsulated in an event. An *Event*, is a structure which carries all the required information for an agent to deliberate its viability and potentially execute its associated behavior, defined as a Parameterized Behavior Tree [9].

From the character's state perspective, each smart object has a generic set of **Traits**. A Trait is implemented a property with a real number assigned to it. These values are assigned randomly on instantiation which allows for a changing experience on each simulation. Some *Traits* could be: Friendliness, Courage and Hostility, among others. The viability of an *Event* is determined on whether all its conditions are met by the evaluating agent. These *Conditions* might test specific *Trait* levels. Besides traits, each agent keeps track of past interactions with other agents. This information will be taken into consideration during each deliberation cycle, allowing for changes on behaviors based on the **memory** of each agent. Figure 1 summarizes the behavior cycle for background characters in the scene.

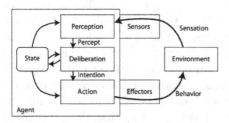

Fig. 1. General agent model and selection

Perception. This phase keeps track of other agents in the field of view (modeled as a foveal cone of 135 degrees up to a distance of 10 m), and the actions they may perform. These are categorized as: (a) global: which impacts all background characters that see it, (b) targeted: meant for a specific character, and (c) neutral. For example, an author could mark a 'Warning Shot' as global, which when executed, will update every perceiving agent's hostility level of the source character. This is provided as input to the deliberation module to elicit appropriate responses in the characters.

The perceived interactions are recorded in the agent's memory, then used in the deliberation phase to determine a reaction. The *conditions* that determine

these responses are defined using an XML interface (described below), and can also be tailored for unique agents, using *modifiers*. Additionally, every agent will be aware of its *context* its is currently in. Context is defined as a specific geographical place in the environment. The context can be used to enhance, reduce or neutralize behaviors' modifiers. As an example, an agent carrying a weapon in a combat training field would not increase perceived hostility levels on other characters. This should not hold true in a non-combat-controlled environment. This concepts are also available for design and are optional to every model, hence an author has no need to worry about the design complexity until is necessary.

Deliberation. All the perceived entities, and the current state of the agent, will be taken into consideration for selecting the next group of candidate events to be executed. The first step in this process is to filter all candidate events based on their conditions and modifiers. Conditions are evaluated against the state of the current agent, or the perceived character's state, and returns TRUE or FALSE. For example, let assume there exists an event 'GreetMainCharacter' with the following conditions: (1) `Target.IsForegroundPlayer`, (2) `Target.Friendliness` >0.5, (3) `Self.Idle`.

All *conditions* are created at design time and are not bound to any Event until the author assigns them to it. At code level, a condition is an *Attribute* which get associated with either a function or a property, for then to be evaluated against a target value during runtime. Once a condition has been instantiated, it can be reused in any defined event, hence the overhead of these are not significant as the number of available Events increase. Assuming the agent's current state satisfies all needed conditions, then 'GreetMainCharacter' becomes available as a candidate event. Now, assume there is also another event which has been satisfied, for instance, 'Wander'. This, will also be included in the candidate Events queue. At the time of taking a decision which event is to be executed, we must consider mainly four things: (1) Is this agent currently selected by the User? (2) Is the character currently executing an event? (3) Is the first candidate event of higher priority of the currently executed event? (4) Is the final chosen event the same one is being executed? Being a foreground character or taking part in a higher/equal priority than the top candidate one, can prohibit an agent to start executing a new event. Should two or more events share the same priority, the one with the higher number of constraints will be executed. Furthermore, if two or more share also the same number of constraints, then one will be picked randomly. Algorithm 1 is the highest-abstraction level routine for the event-deliberation system, to select potential candidates who satisfy its required conditions, based on their state. Every event may include modifiers that can persistently or non-persistently modify how its execution perceived by other agents. This enables a more flexible design which allows the author to further decide how a behavior will impact other agent's perceptive memory.

Act. Finally, the events that are chosen by the deliberation phase are used to invoke appropriate reactions in the background characters, implemented as PBT's.

Algorithm 1. Event Deliberation Process

```
Data: Predefined lexicon of Events e ∈ E
Data: Smart Objects s ∈ S
Data: Evaluating agent a_c
Output: Queue of valid events, E_v
E_v ← ∅;
e_t ← ∅;
foreach e ∈ E do
    P ← GetValidEventParticipants(S);
    foreach p ∈ P do
        if C(e_p) = true then
            if E_v = ∅ then
                E_v = E_v ∪ e_p
            else
                if p(e_p) > p(top(E_v)) then
                    E_v = E_v ∪ e_p
                else if p(e_p) = top(E_v) then
                    E_v = E_v ∪ ep;
                    if ResolvePriority(e_p, top(E_v)) = true then
                        E_v = E_v ∪ e_p
                else
                    InsertInOrder(e_p, E_v)
```

4 Authoring

This section describes the interface which will allow an author to design reactive background agents.

4.1 Event

Formally, an event $\mathbf{e} = \langle \varphi, \mathbf{C}, \mathbf{M}, \mathbf{t}, \mathbf{p} \rangle$ is a collection of a behavior, defined as a PBT φ, a set of conditions \mathbf{C}, modifiers \mathbf{M}, type \mathbf{t}, and priority \mathbf{p}. An event instance is represented by the event \mathbf{e} in addition to the set of smartobjects \mathbf{S} which will execute its behavior (Fig. 2).

The event's type (global, targeted, or neutral) will let a perceiving agent determine whether it should or not take its behavior's modifiers into account, for then updating its perception about the source agent. For example, a conversation

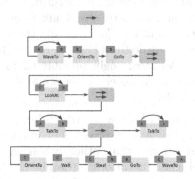

Fig. 2. Behavior tree

between agent A and B will probably not need to update how an unrelated agent C feels about this two characters. A global event such as a warning shot, however, will require that all surrounding agents respond. Once an *Event* takes place, it will change the state of all its participants. This change of state, might produce certain designed events to become eligible for execution on the next deliberation cycle. This creates *responsive* agents. Another feature taken into consideration when evaluating candidate behaviors, is the context the character finds itself, at that particular time, hence the deliberation process is also *context-sensitive*. Finally, enabled by each characters unique initialization of trait values, each reaction might be different for each agent. Events may have multiple participants. For example, `GoTo` would involve a single character, while `Converse` may involve two or more agents.

4.2 Conditions

The author can define reusable conditions which will be evaluated at the Deliberation phase. For an Event to be valid, all of its conditions must be true. A condition represents constraints on the state of the participating agent. Example conditions include: (1) `Self.Friendliness` >0.3, (2) `Target.IsForeground = true`.

This is the main way an author will specify how an event is validated at any given time. Still, a valid event does not guarantee it will be executed since there is more to it during deliberation that its validity. Conditions can be nested and marked as non-mandatory. A non-mandatory condition will not terminate the deliberation loop upon failure to be satisfied, allowing it to still be considered, but will not allow any character to be added to the candidate agents list until they satisfy a following non failing condition. The ability of nesting conditions can be useful in two ways. The first one, is reducing verbosity at design time. The second one, combined with the mandatory property, allows for multi-agent events to select candidate agents based on their traits. For example, assume a nested condition requires: `IsForegroundAndDistractedAndAttractive`, while another one is `IsThiefAndIsBored` and a third one as `IsThiefAndViolent`. Once a condition is satisfied, the complying agent is added to a candidates queue and the condition is not evaluated again. The deliberation cycle will continue with two possible outcomes: the other conditions are satisfied by two other characters, or not. Should the first option occurs, the event might be executed based on its priority level, allowing the event to take place and the foreground character to get robbed by a thief and a hostile third character. The *Act* module will discern among traits and assign roles accordingly, possibly having the thief with higher hostility to threaten the foreground character while the other one approaches from behind to take his wallet.

Event Priorities. All Events have a priority value determined at authoring time. This value will categorize each event. For example, Events of a social nature may have higher priority than other belonging to another group. At Deliberation time, the higher the priority, the higher an event's place in the candidates queue. We define four event priorities in ascending order: *Individual, Social, User Command* and *Self-Preservation*.

4.3 Modifiers

Each *Event* can have modifiers assigned to it by the author. A modifier is a simple structure which will increment, decrement, or neutralize the effect of a characters Trait at deliberation time. Each time a character interacts with another character, this behavior can have an impact in the way characters perceive each other. This impact, can be defined with Modifiers. A friendly behavior might increase the friendliness level in a single character, or a rude one might decrease it. This component, could be marked as *Persistent* or not, and will affect a character's memory with regard to other character. A non-persistent modifier will be forgotten as soon as the deliberation cycle is over, hence any action which might have impacted a character's perception will be obviated for next iterations.

4.4 Context

The author has the ability to mark in the simulation's geography and then have modifiers assigned to it. This allows emphasizing, decrementing or neutralizing the effects of any behavior's modifiers in a particular spatial location. Contexts use modifiers in the same manner as events, and provide an exocentric way of authoring background character responses. At runtime, should an agent is within the boundaries of a context while performing a behavior, if any modifiers were assigned to this context, they will be also be applied.

4.5 Authoring Interface

We provide a simple specification interface to easily author reactive behaviors in background characters. The following is a basic example of a simple reaction:

Listing 1.1. Simple authoring example

```
<behaviors>

  <conditions>
    <condition id="Friendliness">
      <name>Friendliness</name>
      <type>float</type>
      <trait>Friendliness</trait>
      <targetvalue>0.5</targetvalue>
      <targeted>true</targeted>
    </condition>
    <condition id="FriendlyForeground">
      <name>IsForeground</name>
      <type>bool</type>
      <targetvalue>true</targetvalue>
      <targeted>true</targeted>
      <condition>Friendliness</condition>
    </condition>
  </conditions>

  <modifiers>
    <modifier name="FriendlinessSpike">
      <trait>Friendliness</trait>
      <type>increment</type>
      <value>2</value>
      <persistent>false</persistent>
```

```
      </modifier>
    </modifiers>

  <context>
    <name>Market</name>
    <modifier>FriendlinessSpike</modifier>
  </context>

  <events>
    <event>
      <name>GreetAtTheDistance</name>
      <behavior>WaveTo</behavior>
      <priority>Social</priority>
      <type>Targeted</type>
      <condition>FriendlyForeground</condition>
    </event>
    <event>
      <name>USER-WaveTo</name>
      <behavior>WaveTo</behavior>
      <priority>UserCommand</priority>
      <modifier>FriendlinessSpike</modifier>
      <type>Targeted</type>
    </event>
  </events>

</behaviors>
```

This example shows how an Event called **SayHello** might be executed by an agent after deliberations time. From the deliberating agent's perspective, the conditions are: the perceived character is a foreground agent (selected by the user), his "friendliness" trait is greater than 0.5, and finally, he is the targeting (looking) at the agent. Should all these conditions be satisfied, this event will be included in a queue, with priority **Social**. If there are no other competing events, this event will be selected for execution, producing a modification in the way the foreground agent perceives this character, by increasing its friendliness of this character by 0.2.

5 Results

We use ADAPT [11] within the Unity 3D engine as the underlying platform to animate characters in an interactive virtual environment. ADAPT provides an implementation of Parameterized Behavior Trees (PBTs) [9] which are used to define events (multi-character interactions) in the scene. **ABAS** adds a specification layer to ADAPT and provides an intuitive means of creating rich background behaviors for interactive applications.

We demonstrate the effectiveness of **ABAS** b y authoring an active community around Plasencia, a town in 15th century Spain. Designing different behaviors and responses takes just a matter of minutes. Figure 4 illustrates how different agents, each with their own unique state, react to a foreground character's hostile gesture. The highlighted character is performing a gesture for which the other three agents have different reactions. This reaction is governed by how the background character may have previously interacted with the foreground one, along with any defined modifiers or context-specific reactions. Figure 3 illustrates an ongoing simulation showcasing different foreground character interactions, and the corresponding responses from background characters.

Fig. 3. Simulation Captures: (a) A foreground character walks by the town square. (b) He is spotted by two idle background NPCs. (c) One background agent calls for the foreground character's attention. (d) The foreground character responds to the call. (e) The second agent approaches the distracted foreground character, (f) and pickpockets the foreground character. (g) The thief returns to its original spot and calls its accomplice. (h) The distracting agent approaches the thief.

(a)

Fig. 4. Unique reactions - A foreground character tries to scare two agents. One gets surprised, while the other one gets scared.

Foreground Character Actions. Adding a new foreground character action is performed by adding a new event definition where the event priority is UserCommand. This allows the player to assume control of any character in the scene and issue a command to trigger the corresponding event definition. A foreground character event has no conditions associated with it.

Background Character Behaviors. We repeat the same process for background characters and the triggering of these events can be additionally controlled using conditions, modifiers, and contexts. For example, we can create an event for the Wandering behavior and create conditions where the character must be idle in order to participate in this event.

Adding Reactive Behaviors. Consider a new event WaveTo which is a user command for making a foreground character wave at another character. This has a modifier Friendliness which will add a persistent 0.3 friendliness level to the target's memory. We define a second event RespondToCall, which simply elicits a response from a character, causing him to approach another who might be calling for attention. For this, we specify the following conditions: the target is a foreground character, this agent is not currently in an event, his or her friendliness level is above 0.5, and finally, it is being targeted by the other character. Also, note that this has a Social event priority, which has higher priority than Individual, so a Social reaction might interrupt an Individual event that may be ongoing. Secondly, this is a Targeted event, which means it will only influence the character being targeted. The supplementary video showcases this example, along with more complex illustrations.

Listing 1.2. Figure 4 -Excerpt of a Reactive Behavior Exploiting Agents Traits

```
<event>
    <name>GetScared</name>
    <behavior>GetScared</behavior>
    <priority>SelfPreservation</priority>
    <type>Global</type>
    <condition>IsForeground</condition>
    <condition>Attractiveness</condition>
    <condition>Hostility</condition>
</event>

<event>
    <name>GetTerrified</name>
    <behavior>GetTerrified</behavior>
    <priority>SelfPreservation</priority>
    <type>Global</type>
    <condition>IsForeground</condition>
    <condition>Attractiveness</condition>
    <condition>Hostility</condition>
    <condition>LowCourage</condition>
</event>
```

6 Conclusion and Future Work

ABAS empowers content creators to easily author background character behaviors and responses in a centralized and intuitive way, while still producing unique and heterogeneous activity. Both the design process and mindset, are entirely approached from an intuitively event-centered perspective.Every authored block, can be easily tested and changed, without the need of performing a new build. By allowing the inclusion of perceptive memory, context and dynamic agent-specific traits' values, this implementation differentiates itself from others which only allow for customizing behavior trees hooks. This more general-purpose engines, do not offer, for instance, perceptive and interactive memory which might produce dynamic interactions. We would like to replace the current XML specification interface with a graphical platform that will ease the authoring process. We will expand the available portfolio of entities and affordances, which will translate into a more interactive environment. This includes, and is not limited

to, object manipulation, ownership, places of interest and influences. Allowing for more generic event definitions that operate at the crowd level.

References

1. Kapadia, M., Shoulson, A., Durupinar, F., Badler, N.: Authoring multi-actor behaviors in crowds with diverse personalities. In: Ali, S., Nishino, K., Manocha, D., Shah, M. (eds.) Modeling, Simulation and Visual Analysis of Crowds, vol. 11, pp. 147–180. Springer, New York (2013)
2. Kapadia, M., Shoulson, A., Boatright, C.D., Huang, P., Durupinar, F., Badler, N.I.: What's next? The new era of autonomous virtual humans. In: Kallmann, M., Bekris, K. (eds.) MIG 2012. LNCS, vol. 7660, pp. 170–181. Springer, Heidelberg (2012)
3. Kim, M., Hyun, K., Kim, J., Lee, J.: Synchronized multi-character motion editing. ACM TOG **28**(3), 79 (2009)
4. Lee, K.H., Choi, M.G., Lee, J.: Motion patches: building blocks for virtual environments annotated with motion data. ACM TOG **25**, 898–906 (2006)
5. Kim, M., Hwang, Y., Hyun, K., Lee, J.: Tiling motion patches. In: ACM SIGGRAPH/EG SCA, pp. 117–126 (2012)
6. Shum, H.P., Komura, T., Shiraishi, M., Yamazaki, S.: Interaction patches for multi-character animation. ACM TOG **27**, 114 (2008). ACM
7. Vilhjálmsson, H.H., et al.: The behavior markup language: recent developments and challenges. In: Pelachaud, C., Martin, J.-C., André, E., Chollet, G., Karpouzis, K., Pelé, D. (eds.) IVA 2007. LNCS (LNAI), vol. 4722, pp. 99–111. Springer, Heidelberg (2007)
8. Mateas, M., Stern, A.: A behavior language: joint action and behavioral idioms. In: Prendinger, H., Ishizuka, M. (eds.) Life-Like Characters, pp. 135–161. Springer, Heidelberg (2004)
9. Shoulson, A., Garcia, F.M., Jones, M., Mead, R., Badler, N.I.: Parameterizing behavior trees. In: Allbeck, J.M., Faloutsos, P. (eds.) MIG 2011. LNCS, vol. 7060, pp. 144–155. Springer, Heidelberg (2011)
10. Shoulson, A., Marshak, N., Kapadia, M., Badler, N.I.: Adapt: the agent development and prototyping testbed. In: ACM SIGGRAPH I3D, pp. 9–18 (2013)
11. Shoulson, A., Marshak, N., Kapadia, M., Badler, N.I.: Adapt: the agent developmentand prototyping testbed. IEEE TVCG **20**(7), 1035–1047 (2014)
12. Kapadia, M., Singh, S., Reinman, G., Faloutsos, P.: A behavior-authoring framework for multiactor simulations. IEEE CGA **31**(6), 45–55 (2011)
13. Kapadia, M., Falk, J., Zünd, F., Marti, M., Sumner, R.W., Gross, M.: Computer-assisted authoring of interactive narratives. In: ACM SIGGRAPH I3D, pp. 85–92 (2015)
14. Shoulson, A., Gilbert, M.L., Kapadia, M., Badler, N.I.: An event-centric planning approach for dynamic real-time narrative. In: ACM SIGGRAPH Motion on Games, 99:121–99:130 (2013)

Using a Controlled Natural Language for Specifying the Narratives of Serious Games

Frederik Van Broeckhoven[(✉)], Joachim Vlieghe, and Olga De Troyer

Vrije Universiteit Brussel, Pleinlaan 2, 1050 Brussel, Belgium
{frederik.van.broeckhoven,joachim.vlieghe,olga.detroyer}@vub.ac.be

Abstract. Creating serious games calls for a multidisciplinary design team, including game developers, subject-matter experts, pedagogical experts, and narrative designers. However, such multidisciplinary teams often experience communication and collaboration problems due to the different terminologies, backgrounds and concerns of the people involved. To overcome these problems, we propose the use of a Controlled Natural Language (CNL) in combination with a graphical notation for modeling game narratives. The use of a CNL provides an easy human-readable, yet flexible and expressive way to specify story-lines. In addition, a CNL provides the possibility for automatically processing story-lines and generating code. As such, incorporating CNL in the design process also contributes to shortening the development time.

Keywords: Domain specific modeling language · Controlled natural language · Game narrative

1 Introduction

The narrative of a video game is a powerful tool to convey knowledge and induce behavior change [3]. However, to come to well-grounded and effective serious games, the development should be a collaborative process involving experts from various fields [16]. Professional narrative designers contribute to the design process by creating compelling and emerging narratives, while pedagogical experts and subject-matter experts collaborate to integrate effective pedagogical methods. Game developers use their experience and expertise to turn all of this into a challenging game. However, narrative designers and pedagogical and subject-matter experts are often not trained or even familiar with the technical matters and jargon used by the game developers, and vice versa. In addition, each domain of expertise represents a different set of concerns [1]. This can seriously hinder communication and collaboration. As different experts usually communicate their requirements to the game developers in natural language, misunderstandings and ambiguities often arise. Furthermore, this form of collaboration and transfer bestows upon the game developers the task of translating the natural language specifications into formal specifications or code.

Suitable techniques and tools could support a more integral form of collaboration, as well as shorten the development process. In light of this observation,

© Springer International Publishing Switzerland 2015
H. Schoenau-Fog et al. (Eds.): ICIDS 2015, LNCS 9445, pp. 142–153, 2015.
DOI: 10.1007/978-3-319-27036-4_13

various authors [2,6,7,12,14] have presented arguments in favor of using a Domain Specific Modeling Language [10] (DSML) for specifying (i.e., modeling) (serious) games. A DSML is usually a small language dedicated and restricted to a particular domain [17]. It provides abstractions that make it easier and less time consuming to specify solutions for a particular class of problems. By building on the vocabulary of the problem domain, the DSML enables domain experts to understand, validate and often even develop specifications autonomously. In [10], DSMLs are shown to require less modeling work, that could often be carried out by persons with limited programming experience, resulting in a clear productivity increase. In general, a DSML is a graphical language. Graphical specifications are known to be easier for the communication with non-technical people, and allow people to grasp large amounts of information more quickly than large listings of textual specifications. Despite the use of a familiar vocabulary and a graphical notation, the language constructs in a DSML might still be too much oriented towards programming and therefore difficult to learn and use by people without programming experience. We believe that this problem could be resolved by creating a DSML that builds on a Controlled Natural Language (CNL). A CNL is a strict and controlled subset of natural language that avoids ambiguities. Using a CNL syntax provides an easy and human-readable, yet flexible and expressive way to specify the story-lines of the game, making it significantly easier for non-IT schooled domain experts to understand, and even create models. This way, a better communication and collaboration within multidisciplinary teams would be supported. Compared to the use of natural language, this approach provides the advantages that it allows for the automatic processing of the formally specified story models (i.e., generate code), which also helps to shorten the development time.

In previous publications, we introduced a graphical DSML for modeling (serious) games narrative, ATTAC-L, [14] and discussed the incorporation of educational aspects [15]. In this paper, the focus is on the use of a CNL to open the use of the DSML to a broader range of users. Our target audiences are the different stakeholders involved in the design and development of a narrative-based serious game. However, note that this does not imply that all types of users should be able to actually use the language for modeling narratives. For some users it suffices that they are able to read (i.e., understand) the models. Also note that such a DSML and its associated tool are not aimed to replace the creative contributions of narrative designers or game developers; they rather complement them. The paper is structured as follows: Sect. 2 we discusses the background and related work; Sect. 3 introduces the principles of ATTAC-L; Sect. 4 presents its CNL-based syntax; and Sect. 5 shows how this syntax can be supported by our original graphical language. Section 6 discusses tool support. Section 7 describes a pilot evaluation and Sect. 8 formulates conclusions and discusses future work.

2 Background and Related Work

The easiest way to specify the narrative of a game is through natural language (NL). However, plain NL is difficult to process by a computer. Therefore, usually

a strict subset of NL (a CNL) that avoids ambiguities is used. The formal use of a NL syntax has been studied extensively (see [8] for an overview) and various CNLs have been developed for a wide range of applications. The main challenge of using CNL is to deal with the trade-off between 'preciseness' (i.e., the degree to which the meaning can be directly retrieved from its textual form), 'expressiveness' (i.e., the range of propositions that the language can express), 'naturalness' (i.e., how much effort a person needs to do to interpret or understand the text), and 'simplicity' (i.e., the level of complexity of syntax and semantics) [8].

The CNL selected is Attempto Controlled English (ACE) [5]. ACE expressions are formulated much like plain English sentences. These sentences are written in the 3rd person, singular simple tense, and 'describe' logical terms, predicates, formulas and quantification statements. ACE-sentences are built based on the definition of two word classes: function words (determiners, quantifiers, negation words, ...) and content words (nouns, verbs, adverbs and prepositions). ACE defines a strict and finite set of unambiguous constructions and interpretation rules to create ACE sentences. We opted for ACE because it has a sound fundament (first order logic) and is well suited for our purpose.

The use of a CNL in relation to the modeling of narratives for video games is not new. The most notable works are *Inform* and *StoryBricks*.

The *StoryBricks*[1] framework is an interactive story design system. It provides a graphical editing language based on *Scratch* [11]. Without major programming skills a user can edit the characters in the game and the artificial intelligence that drives them. Through the use of so-called story bricks, users can place characters in a virtual environment and give them emotions and provide them with items. Story bricks are blocks containing words that read like NL sentences when placed together. The story bricks can also be used to define rules that specify what needs to be done under certain conditions during gameplay. In this way, the flow of an interactive story is modeled implicitly. Experiments have shown that people with limited programming knowledge and skills found it difficult to understand this form of implicit flow specification [13]. In our work, we adopted the bricks principle from StoryBricks, but not its rule-based approach. Instead, the story flow is explicitly specified.

Inform[2] is a toolset targeted toward professional narrators. It allows them to create interactive fiction (e.g., adventure games). Since version 7, *Inform* includes a DSML to define all aspects of an interactive fiction, including (scene) setting, character setup, and story flow. The DSML uses a CNL. Although not explicitly stated, *Inform* shares a lot of similarities with ACE. In contrast to *Inform*, we opted for a graphical language as most DSML's do. Also, our DSML also does not allow to define aspects such as environment settings and low-level implementation aspects. Instead, it focuses on the specification of the narrative, thereby reducing the complexity and increasing the understandability. Other tools can be used to specify other aspects.

[1] http://www.storybricks.com.

[2] http://inform7.com.

3 Principles of ATTAC-L

In this section we briefly explain the principles of ATTAC-L. A more elaborated explanation can be found in [14,15].

The principle of a 'game move', adopted from [9], represents an individual step in the game narrative performed either by the player (interaction) or by a non-playable character (NPC). Game moves are linked to each other according to their temporal order. By using flow-chart modeling principles, the overall flow of the story is defined. As such, ATTAC-L can express sequences (game moves following each other), choice (branching, defining alternative story flow paths), concurrency (story flow paths that are performed in parallel), and order independence (story flow paths that must all be performed, but in any order). Combinations of game moves that represented parts of the story can be defined as scenarios and re-used in other scenarios or stories. Scenarios help users to maintain an overview of large models.

The 'brick' principle, adopted from StoryBricks, represents a unit or building block used for composing story models and is used for the graphical representation of game moves. We discern between two types of bricks: *(Regular) bricks* and *Control-bricks*. Regular brick represents the smallest meaningful unit that exists in the context of a story: an act to be performed, a tangible object that can perform or undergo the act, or a state. These bricks are used to construct game moves by connecting bricks to each other according to a set of syntax rules (see Sect. 4). As we use a CNL syntax, the constructs created read as NL. Regular bricks are illustrated in Fig. 1a. Control bricks represent the control structures inside the story, i.e. these bricks are used to express the temporal relationships between game moves, composing the overall flow of the story. We decided to use the brick principle also to represent the control structures because our target users might not be familiar with the typical flow-chart notation used in modeling languages such a UML. Control bricks are shown in Fig. 1. Figure 2 shows how regular bricks are used to form game moves and how they are connected by control bricks.

4 ACE Based Syntax

As motivated in the introduction, we now use ACE for the syntax of game moves. This implies that game moves, i.e. sentences for events and actions (including

	(a)	(b)	(c)	(d)	(e)	(f)
	Regular	Value	Sequence	Choice	Order ind.	Concurrence

Fig. 1. Several types of bricks

(a) Two game moves in sequence (b) A choice between two game moves

Fig. 2. Connecting bricks to form story-lines

the players actions) are expressed in 3^{rd} person simple tense. In other words, narratives are modeled as if they were told from a narrator's point of view. In addition, and similar to ACE, we distinguish between function words and content words. Our set of content words consists of nouns, verbs, and adjectives, corresponding respectively to entities, acts, and states in the story-line. Our set of function words consists of determiners, negation words, pronouns, and the copula be. Unless otherwise specified, words are always expressed in lower case letters. Lastly, in accordance with ACE, the sentences are always composed of two main parts: a *subject*, followed by a *predicate*. The former describes the entity that invokes the action and is a *noun phrase*. The latter describes the action itself and is expressed as a *verb phrase*.

Noun Phrases. The simplest form of a noun phrase is a *proper noun* that refers to an entity by means of a name. Nouns always start with an upper case letter and may contain upper and lower case letters or digits (e.g., 'X1', 'John'). Spaces are not allowed, but hyphens can be used to form word-groups (e.g., 'Mr-Smith'). The proper noun 'Player' is reserved to refer to the player or the character that he or she is controlling.

A noun phrase can also refer to a game entity in an indirect way by means of a *countable common noun* which is a common noun preceded by a determiner or a quantifier. This type of noun phrase can be used to refer a single entity (e.g., 'the house', 'a door', 'some person', 'one key') or multiple entities (e.g., '2 doors', 'some persons', 'all keys'). This type of noun phrase is used to refer to one or more entities in a general way. This means that on different 'runs' of the story flow, different entities conforming to this noun phrase could be used. This allows narrative designers to create less predictable stories.

Adjectives. Adjectives can be used to make a countable common noun phrase more specific. As such, the group of entities to which the noun refers can be narrowed down. Adjectives can be positive, superlative or conjoined (e.g., 'the last person', 'two highest trees', 'a sad and angry person').

Variables. Variables are a way to assign a proper name to a countable common noun phrase. When a proper noun is appended to such a noun phrase, e.g., 'a person Mr-X', the proper noun can be used to refer to the same entity in subsequent game moves. This corresponds to an in-line and implicit declaration

of a variable. For people without programming knowledge or experience, this approach is likely to be more easily than the use of explicit variable declarations.

Genitives. Genetives are used to refer to nouns that have a possessive associa-tion with another noun. Genitives are constructed by appending the noun phrase of the possessor to the noun phrase of the possession using the preposition 'of' (e.g., 'the back-pack of Jack', 'two items of a person'). Note that in Standard English, the use of the preposition 'of' might sound odd in some cases (e.g., 'two apples of a tree' as opposed to 'two apples from a tree'). Nonetheless, we refrain from introducing extra prepositions in order to keep the syntax as simple as possible.

Values. Values (text, numbers, lists and associative maps) can be used as noun-phrases when their noun can be deduced from the context of the game move. For example, when the game move expresses a speech action, the action can only involve a text-value. The type of a value can be specified more directly by prepending a common noun (e.g., 'a message "Hello!"').

Verb Phrases. A verb phrase corresponds to the predicate of a sentence and describes the actual activity that is performed in a game move. Generally, a verb phrase starts with the conjugated verb. Depending on the type of verb that is used, direct and indirect passive objects can be included in the verb phrase. While an intransitive verb stands on its own (e.g., 'to wait'), a mono-transitive verb involves only one direct passive object (e.g., 'to see *something*'), whereas a ditransitive verb involves both a direct and indirect passive object (e.g., 'to give *something* to *somebody*'). Some verbs can also be associated with a particle. In this case, the combination verb-particle is considered as a whole and is written as a hyphenated combination (e.g., 'X walks-to Y', 'X looks-at Y').

It is possible to use an adjective phrase as part of a verb phrase. Similar to verbs, an adjective phrase can be intransitive (e.g., 'happy', 'sad') or tran-sitive (e.g., 'angry with *somebody*' or 'afraid of *something*'). In the latter case, the adjective is always associated with a preposition and must be written as hyphenated combination (e.g., 'angry-with X').

The verb 'to be' serves as a copular verb and thus represents a special case. Copular verbs establish a link between the meaning of a predicate of the sentence and its subject. This means that they can be used to set a state for the subject. In order to do so, the copular verb is suffixed by an adjective phrase (e.g., 'X is happy', 'X is angry-with Y').

Special Sentence Structures. Some special structures are added to provide the modeler with extra flexibility or expressive power. The phrases 'there is' and 'there are' are introduced to allow the modeler to *explicitly declare variables*. These phrases are followed by a noun phrase with a variable (e.g., 'there is a person Mr-X', 'there are two persons The-Johnson-Brothers').

Fig. 3. Noun and adjective phrases

Fig. 4. Verbs connecting noun and adjective phrases forming game moves

The modeler can express any sentence containing a transitive or ditransitive verb phrase in a *passive voice*. A passive voice sentence uses the copular verb to be in combination with the past participle tense of the verb from the original sentence. The placement of the subject and the direct passive object are then swapped (e.g., 'X steals an item of Player' becomes 'an item of Player is stolen by X'). This option increases flexibility by allowing the modeler to create sentences when the character that performs the action is not defined, i.e., when no subject would be present in the active equivalent of the sentence (e.g., 'an item of Player is stolen').

5 Mapping to a Graphical Language

In this section, we explain how the CNL syntax defined for ATTAC-L can be expressed by means of our graphical language constructs, i.e., bricks. We have mapped game moves to bricks by assigning words or phrases to regular bricks. These regular bricks can then be connected to each other in accordance with the syntax rules defined in Sect. 4.

A regular brick containing a noun phrase is called a noun-brick and refers to a tangible entity, i.e., an object, a NPC or a player (see Fig. 3a). Adjectives

Fig. 5. Example story-line model in the CNL-based DSML

Fig. 6. Example story-line model using the original syntax

used for noun-phrases are contained in the noun-brick because they are part of the noun-phrase (see Fig. 3c). Adjectives used as adjective phrases are placed in an adjective-brick followed by a noun-brick in case it is a transitive adjective phrase (see Fig. 3e). To introduce a variable, an extra noun brick containing the proper name of the variable is joined at the end of the noun brick (see Fig. 3b). This emphasizes the variable declaration and allows the variable to be used independently in subsequent game moves. Values are represented by the value-brick (see Fig. 3d) which can only be connected to the end of a regular brick.

A regular brick containing a verb is called a verb-brick and connects to noun phrases and/or adjective phrases to form a game move. In the case of a ditransitive verb, the associated preposition serves as an extra connecting point for

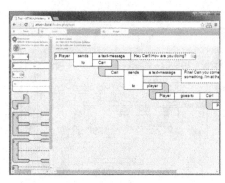

(a) Screen-shot of the modeling tool **(b)** Simulating the player sending a text message to Carl

Fig. 7. Modeling and simulating scenario's

the indirect passive object (see Fig. 4a, b, c, d and e for illustrations of the most common cases). As explained, game moves containing a transitive or ditransitive can also be expressed in a passive form (Fig. 4f represents the passive equivalent of Fig. 4e). In passive sentences, the placements of the indirect passive object and the direct passive object (i.e., the original subject) can be interchanged (Fig. 4f and g can be used interchangeably to represent the same game move). In some cases, the 'by'-part of the sentence can be omitted (see Fig. 4h). The subject of the game move is then assumed to be any NPC.

6 Tool Support

We developed a (web-based) toolset for ATTAC-L that consists of a graphical editor including an export module, and a simulator. The editor (see Fig. 7a) allows users to specify a story model by means of drag-and-drop. Extra assistance is provided by means of automatic layout management and an auto-complete suggestion mechanism for entering names. The export module generates a machine interpretable data structure (JSON) for the modeled story. This structure can be used by existing game engines as input for generating code or by an interpreter to execute the story. A code generator is currently under development.

The simulator is a separate module. The simulator is a kind of interpreter that executes the story directly. The execution is performed, however, in a simple and predefined 3D environment with predefined NPCs and behaviors. As such, the simulator provides a fast way to verify and test the modeled stories (Fig. 7b shows a screenshot from the simulation of the example from Fig. 7a) and therefore serves as a fast prototyping tool. The current simulator mainly targets scenarios for cyber-bulling, which was the focus of the project for which ATTAC-L was originally developed [4]. By providing other predefined NPCs and behaviors, the simulator can of course easily be adapted for use in other domains.

7 Evaluation and Discussion

Because of space restrictions it is not possible to provide here an elaborated comparison between the original ATTAC-L syntax and the ACE-based syntax. However, we will illustrate differences with an example. Figure 5 shows an example expressed with the new syntax, while Fig. 6 gives the same scenario expressed in the old syntax). We see that the model in the new syntax is more compact and allows a more dynamic story flow. First, it is not required to uniquely identify every entity as it was the case with the old syntax. Moreover, uniquely identified entities are now clearly distinguished by the use of proper nouns. Secondly, by using common nouns, actions can be specified more generally, which results in more flexibility for the story-line. For example, the character Boss will react in the same way regardless the player presents him with a hammer, a hacksaw or a non-woodcutting tool. This was not possible with the previous syntax without explicitly mentioning all the non- woodcutting tools. Similarly, the new syntax makes it possible for the player to grab woodcutting tools in places other than the workshop in order to successfully finish the scenario. Within the previous syntax, 'hacksaw' would refer to exactly one entity, i.e., the hacksaw positioned in the workshop. This example illustrates how the use of a CNL has increased the flexibility and expressive power of the DSML, whilst also enhancing its readability.

To investigate whether our CNL-based DSML satisfies our objectives, i.e., appropriate for people with and without programming knowledge and having the potential to enhance the collaboration in interdisciplinary design teams, we conducted a pilot evaluation. Four non-computer schooled people but with background in game narrative design participated. None of these people had prior experience in modeling stories with a DSML. First, the participants received a small introduction on the purpose of the DSML and how to use it. They also received an example (Fig. 5) and an outline of the syntax rules (in text). They were then asked to specify (i.e., model) a small prescribed story-line (given by means of text), namely a scenario about the player who has to escape from a locked house and having three possible ways of doing so. They were asked to first sketch the story flow on paper and then model the scenario with our modeling tool. The participants had a comprehensive list of actions and entities (nouns, pronouns, verbs, adjectives) at their disposal. When needed, they could ask for assistance. After finishing the exercise, the participants were invited to report on their experience and the difficulties they encountered.

The results of this evaluation were positive. The participants were able to understand the example given. They described this as very intuitive and easy. Similarly, all of the participants reported that they understood the modeling assignment and were able to model the scenario. Early during the exercise, some participants were inclined to model story flows that were too complex (introducing more game moves than actually needed) or created a solution that was very specific (e.g., using specific pronouns instead of the more general common nouns). When they were made aware of this, the participants quickly reflected on this and adapted their solution accordingly. In relation to the construction

of game moves, the participants reported that they had no difficulties in complying to the natural syntax specification. They found the (syntax) rules very intuitive and natural. The participants noted that (the use of) this language shows analogies with methods for interactive narrative design that they had encountered before, i.e., using small simple sentences in combination with a flow graph structure.

Although this was a small-scale evaluation, it provides us an indication that our graphical CNL-based DSML will be able to satisfy our aims. The models specified in this language were easy to understand for people without programming background. Furthermore, we have an indication that this kind of people will actually also be able to actively model narratives. This would imply that narratives designers could specify their stories in a formal way, which can directly be processed. This will not only save the time to elaborate the narrative on paper and transferring it to the technically people, but it will also avoid misunderstanding and eliminates ambiguities. Whether the language could improve communication was not investigated in this pilot evaluation.

The DSML and its toolset are currently used in an interdisciplinary project [4] aiming at developing serious games against cyber-bullying. The development team is composed of people from the social domain, from healthcare, computer science people, game developers, and also a narrative designer. The specification of story-lines is still an ongoing process, but the feedback on the language and its tool is promising.

8 Conclusions and Future Work

We presented a graphical Controlled Natural Language (CNL) based Domain Specific Modeling Language (DSML) for specifying (i.e., modeling) story-lines for serious games. Our aim was to enhance the communication and collaboration in the interdisciplinary design teams that are needed to arrive at well-grounded and effective serious games. We explained how a DSML for specifying narratives is based on a CNL. For this, we have based the syntax on Attempto Controlled English, a strict subset of plain English. In addition, we have shown how this domain-specific CNL can be mapped on the graphical brick representation used before. Using a CNL has increased the flexibility and the expressive power of the language, while also enhancing its 'naturalness' (human-readability). We also briefly presented the tools developed to support the use of the language. A first pilot evaluation was conducted. The results were promising. Furthermore, the language and its toolset are used in an interdisciplinary project [4] to specify the story-lines of a serious game against cyber-bullying. The feedback received from the collaborators of the project is promising.

Currently, a code generator for a specific game engine is under development. Future work will concentrate on extending the simulator to allow easy customization for different domains, and on mechanisms to specify other aspects of a serious games, needed for full code generation, on top of the story-lines. Also a large-scaled evaluation is planned.

References

1. De Troyer, O., Janssens, E.: Supporting the requirement analysis phase for the development of serious games for children. Int. J. Child-Comput. Interact. **2**(2), 76–84 (2014)
2. Dobbe, J.: A Domain-Specific Language for Computer Games. Master's thesis, TU Delft (2004)
3. Dondlinger, M.: Educational video game design: a review of the literature. J. Appl. Educ. Technol. **1**(4), 21–31 (2007)
4. Friendly ATTAC. http://www.friendlyattac.be/en/
5. Fuchs, N.E., Schwertel, U., Schwitter, R.: Attempto Controlled English – not just another logic specification language. In: Flener, P. (ed.) Logic-Based Program Synthesis and Transformation. Lecture Notes in Computer Science, vol. 1559, p. 1. Springer, Heidelberg (1999)
6. Furtado, A.W., Santos, A.L.: Using domain-specific modeling towards computer games development industrialization. In: The 6th OOPSLA Workshop on Domain-Specific Modeling (DSM06) (2006)
7. Guerreiro, R., Rosa, A., Sousa, V., Amaral, V., Correia, N.: Ubilang: towards a domain specific modeling language for specification of ubiquitous games. In: INForum, pp. 449–460 (2010)
8. Kuhn, T.: A survey and classification of controlled natural languages. Comput. Linguist. **40**(1), 121–170 (2014)
9. Lindley, C.A.: Story and narrative structures in computer games (2005)
10. Tolvanen, J.-P., Kelly, S.: Defining domain-specific modeling languages to automate product derivation: collected experiences. In: Obbink, H., Pohl, K. (eds.) Software Product Lines. Lecture Notes in Computer Science, vol. 3714, pp. 198–209. Springer, Heidelberg (2005)
11. Maloney, J., Burd, L., Kafai, Y., Rusk, N., Silverman, B., Resnick, M.: Scratch: a sneak preview. In: 2004 Proceedings of Second International Conference on Creating, Connecting and Collaborating through Computing, pp. 104–109. IEEE (2004)
12. Marchiori, E., Torrente, J., del Blanco, Á., Moreno-Ger, P., Fernández-Manjón, B.: A visual domain specific language for the creation of educational video games. IEEE Learn. Technol. Newslett. **12**(1), 36–39 (2010)
13. Van Broeckhoven, F., De Troyer, O.: ATTAC-L: A Domain Specific Modeling Language for Defining Virtual Experience Scenarios in the Context of Cyber-bullying Prevention - Version 2. Vrije Universiteit Brussel, technical report (2012)
14. Van Broeckhoven, F., De Troyer, O.: ATTAC-L: a modeling language for educational virtual scenarios in the context of preventing cyber bullying. In: 2nd International Conference on Serious Games and Applications for Health, pp. 1–8. IEEE, May 2013
15. Van Broeckhoven, F., De Troyer, O.: Specifying the pedagogical aspects of narrative-based digital learning games using annotations. In: Proceedings of the 9th International Conference on the Foundations of Digital Games. Society for the Advancement of the Science of Digital Games (2014)
16. Van Broeckhoven, F., Vlieghe, J., De Troyer, O.: Mapping between pedagogical design strategies and serious game narratives. In: Proceedings of the 7th International Conference on Games and Virtual Worlds for Serious Applications (VS-Games). IEEE (2015)
17. Van Deursen, A., Klint, P., Visser, J.: Domain-specific languages: an annotated bibliography. Sigplan Not. **35**(6), 26–36 (2000)

Tracery: An Author-Focused Generative Text Tool

Kate Compton[1]([⊠]), Ben Kybartas[2], and Michael Mateas[1]

[1] Department of Computational Media, UC Santa Cruz, Santa Cruz, USA
{kcompton,michaelm}@soe.ucsc.edu
[2] Department of Intelligent Systems, TU Delft, Delft, The Netherlands
b.a.kybartas@tudelft.nl

Abstract. New communities of generative text practitioners are flourishing in novel expressive mediums like Twitterbots and Twine as well as the existing practices of Interactive Fiction. However, there are not yet reusable and extensible generative text tools that work for the needs of these communities. Tracery is an author-focused generative text tool, intended to be used by novice and expert authors, and designed to support generative text creation in these growing communities, and future ones. We identify the design considerations necessary to serve these new generative text authors, like data portability, modular design, and additive authoring, and illustrate how these considerations informed the design of the Tracery language. We also present illustrative case studies of existing projects that use Tracery as part of the art creation process.

1 Introduction

What does it mean to make an 'author-focused' generative text tool? We consider the potential authors for such a generative tool to be creative persons who are interested in the expressivity of language and the aesthetics of prose. They may not self-identify as 'programmers' or want to write code, but they want to create generative text that is algorithmically combinatorial and surprising, while still seeing their authorial 'voice' in the finished text. With the success of NaNoGenMo, the text-generating twin of National Novel Writing Month [2], and the increasing popularity of Twitterbots [6], there is a coherent community of practice around generating text that has little relation to many previous academic approaches to narrative generation. Text generators are finding audience and community in new platforms like Twitter, Itch.io, and Twine. These platforms have lower barriers to entry and less structured expectations than traditionally game-oriented hosting spaces like Steam or publishers like Eastgate, so many text generators that could not stand alone as either games or literary experiences now have a chance to build a niche audience. These new works often embrace an aesthetic of nonsense and absurdity, and make use of unexpected, unplanned, yet insightful juxtapositions. Many of them use templates and grammars to create structured yet variable text, a technique used in the ELIZA system [11] but still powerful and popular.

© Springer International Publishing Switzerland 2015
H. Schoenau-Fog et al. (Eds.): ICIDS 2015, LNCS 9445, pp. 154–161, 2015.
DOI: 10.1007/978-3-319-27036-4_14

1.1 What Is Tracery

We designed Tracery as an open source tool to write text-generating grammars, for users who may be academics, IF authors, botmakers, or game-makers[1]. Grammars are written as JSON objects in a simple and readable syntax, and then recursively expanded by Tracery into finished text. The system has been kept as lightweight and syntactically simple as possible to encourage its use in other systems while maximizing accessibility for novice users, even non-programmers. Grammars have been dismissed as insufficient for analyzing and generating stories [1], and fallen out of fashion in interactive narrative. We show that, with a good interface and some small additional features, grammars can be rehabilitated in interactive narrative, and can be used by authors, even casual ones, to create a wide range of stories, poems, dialogue, and even images and code.

2 Related Work

Authors of Interactive Fiction have identified generative text tools as a missing or poorly developed feature of their practice. In Emily Short's survey of the IF community, she notes the desire for: 'the ability to have the computer describe complex world model states or story events without having to hand-author every possible variation,' and catalogs the useful generative text features that *have* appeared in existing IF authoring tools, such as pluralization, option selection, and slurred-speech filters, among many others [8]. Previous story generation systems commonly focus on story structure and the maintenance of narrative causality [7] with planning algorithms or agent-based simulations. The price of this causality, however, is a reliance on a carefully modeled database of world knowledge, provided either as part of the system [12] or authored by the user of the system [4]. The pleasures of writing, like creating dialogue and character, playing with language, writing expressively, take a backseat to performing laborious knowledge modeling. Several storytelling systems do, however, model poetic language use, like Zhu and Ontañon's Riu system [13], which creates analogy-based stories using force dynamics, and Harrell's GRIOT system [3], which uses conceptually-linked axioms to pick content to fill in phrase templates. GRIOT uses templating to create recognizable poetic structure, but requires the author to create an ontology of axioms in order to create a new polypoem with its own logic. Tracery takes a different approach by *not* explicitly modeling world knowledge or axiomatic relationships. The only knowledge of the world consists of the grammar of symbols and their rewrite rules provided by the author. Even with only this very shallow data structure, the case studies included in this paper show that authors can produce structured and interesting generative text with a unique literary voice, even though that text may lack the logic of GRIOT and Riu, or the narrative validity of MEXICA. As demonstrated in the MEXICA case study included in Sect. 5, causality can be handled by an external system which pipes a more rigorous story model into Tracery. To the large, diverse, and

[1] https://github.com/galaxykate/tracery.

mostly non-academic communities engaged in generative text practices outside of knowledge-modeling traditions, these limitations do not seem to matter as much as we might have expected from previous academic theory.

3 Design Considerations

Tracery was intentionally designed to be easy to author with. The content created by an author is a simple object (a formal grammar) written mostly in plaintext, and advanced syntax is kept as readable and minimal as possible (see Sect. 3.1 for details). In addition, we followed other design considerations that we knew would be important to our potential authors: **modularity, balancing generativity and control**, and **modifiability**. Tracery is a modular ecosystem of interworking parts: a parseable language, an expansion engine, and many visualization and integration tools for building larger works, each of which can be used independently (see Sect. 4). Modules can communicate through the data format of a *grammar*, a list of symbols and rewrite rules, which provides a lingua franca that can be understood by any tool in our set, even those not authored by us. Maintaining open data formats and good encapsulation is a standard practice in software industry, and it has many useful side effects, such as allowing an independent user to turn it into a Node.js library (Sect. 4), serving Tracery server-side to run Twitterbots. Seeing interesting and unintended juxtapositions is one of the great pleasures of generative text systems. Many users make satisfying generators using only the most basic syntax: hashtags to signal expandable symbols. At the same time, some authors also need control over some facets of generation, like maintaining a persistence of a character's name and pronouns. Advanced users can opt in to more control when they need it, by using higher-level features like push-pop actions and modifiers, or changing the random distribution, while still taking advantage of randomness when it suits them. JavaScript, conveniently the dominant language of the web, is well suited to this project by being highly mutable. If an author includes Tracery in a larger JS project, any exposed library variable or object can be modified and added to, at runtime. They can add new modifier functions, read or write rules, and add new symbols, as in 'Interruption Junction' [9]. No library can provide all features for all projects, so this modifiability allows authors to bend Tracery to their needs.

3.1 Syntax

Symbols and Rules. Tracery's main data structure is a formal grammar, a mapping of *symbols* to sets of *rewrite rules*, as in this example:

```
color: ["red", "green", "indigo", "ecru", "violet"],
animal : ["panda", "ocelot", "meerkat", "platypus"],
mood: ["joyful", "morose", "alert", "sleepy", "pensive"],
pet: ["puppy", "#mood# kitty", "#mood# #color# #animal#"],
tale: ["This is the story of a #pet#...", "Once there was a #pet#"]
```

Each rule can be written as plaintext or with Tracery's special syntax to specify recursively expandable symbols, as in a formal grammar. We use a hashtag syntax to signal recursion: #animal# tag in pet's rules can be replaced with the available rules for the animal symbol, and as shown in the rules for tale, rules can expand recursively to an arbitrary depth. This syntax defaults to allow the user to write in normal natural language, so an author can write: The hero walked into a bar, and then incrementally replace parts with symbols and alternative rules to add variability over time, until eventually #theHero# #walked# into #someBar# can expand to many different heroes, many bar names, and many ways of walking into them.

Modifiers. Capitalization, pluralization, a/an choice, and conjugation are common hassles of generative text, so Tracery provides functions that can be applied after a symbol is expanded. These built-in modifiers (.a, .ing, .ed, .pluralize and .capitalize) are provided as convenient though imperfect utilities. While we plan to improve the built-in modifiers, we also encourage advanced users to build their own modifiers for the languages and genres they work in: better pluralization, Spanish verb conjugations, or adding gender declensions for Icelandic nouns. Any function that can take text, modify it, and return it can be a modifier. Functions that work on full texts, such as a pirate-speak filter or a drunkenness filter, can be added, so that 'Aye', said the old sailor, '#longRamblingStory.piratize.drunkenize#' will produce a story with the necessary flavor, regardless of what longRamblingStory originally generates.

Push-Pop Stacks. Often, authors want to save and reuse some generated text, such as the main character's name, species, possessions, or appearance. To this end, Tracery allows rules to write to the grammar when they run, 'overwriting' symbols (or creating them if they don't exist). Each symbol, instead of just having one set of rules, actually has a *stack* of rule sets, only the topmost of which is used to select a rewrite rule. Because these actions affect only their current sub-tree, an author can create a recursive nested story-within-a-story. This technique uses the grammar itself as a sort of blackboard to store and read information over time, balancing random generation with control.

4 A Modular Architecture: One Format, Many Tools

Tracery's main component is a lightweight text-expansion library. A grammar is a key-value array matching symbols to arrays of expansion rules, written in the syntax in Sect. 3.1. This **grammar** is loaded into Tracery, which can then respond to requests to expand Tracery-syntax strings by using the grammar's rules to recursively generate text. Each generated **trace** represents one tree-shaped path through the possibility space of the grammar: each symbol encountered is a choice of available possible expansion rules. Thus the trace can be returned as either flattened plaintext, or as the original tree-shaped path. The **grammar** and the **traces** provide a data structure that can be used by other

independent modules, which may operate independently or alongside the expansion library, depending on the use case. In this section, we present the modules and apps that take these structures as input to create text, visualizations, Twitterbots, or hosted shareable generators. The intentional modularity of Tracery makes such an ecosystem possible.

Visualizations. Tracery grammars can become very deeply nested and interconnected for non-trivial works, but good visualizations can clarify even a complex grammar. We created several visualizations, for understanding connectivity and reuse of symbols in a grammar, and seeing the commonality and range between multiple traces (Fig. 1).

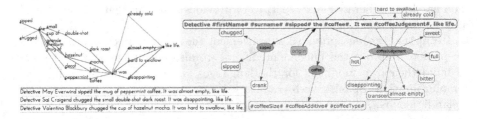

Fig. 1. Different ways to visualize the expansion of "Detective #firstName# #surname# #sipped# the #coffee#. It was #coffeeJudgement#, like life". Right: visualizing the grammar's connectivity shows how each symbol (in dark blue) can expand to many different options (pale blue). Left: visualizing five sample expansions demonstrates where each story varies or remains the same. Bottom-left: fully expanded text, as it would be read by the end reader (Color figure online).

CheapBotsDoneQuick and Twinecery. Tracery is being adopted by members of other established interactive fiction communities, some of whom have built tools to support the genres in which they write. Tracery's portability and common data format enabled these tools to be built with little or no additional support from us. Matthew Balousek, a student who had worked with Tracery, repackaged the expansion library to generate text inside of Twine[2]. The most successful Tracery tool so far was not created by us at all. George Buckenham, an independent game designer, created *Cheap Bots Done Quick!* (http://cheapbotsdonequick.com) independently for a bot-making workshop as a way for novice botmakers to quickly create and host expressive bots. Users sign in with Twitter, add a Tracery grammar, and can use it to preview generated tweets or set it to post automatically. This tool has encouraged both novice and very advanced IF authors (including Squinky, Emily Short, and Porpentine) to try Tracery and bot-making. At least 135 bots have been made so far, including some that generate orcish insults, fussy hipster cocktails and poetic space explorations (@orcish_insults, @HipsterCocktail, @DeepSpaceProbe), as well as non-prose like

[2] https://dl.dropboxusercontent.com/u/8790624/twinecery/twinecery.html.

valid query links for IFDB (@emily_testbot) and ASCII art (@infinitedeserts). Both Cheap Bots and Twinecery would not have been possible if we had not packaged and released Tracery for modification by others.

Hosting: Tracery.io. Though we are delighted by the success of Cheap Bots and new users it brought to Tracery, the bot authors lack a way to show the 'source code' of their grammars, or to learn from the grammars of others. We are building a hosting site (http://tracery.io/) where authors will be able to write and test grammars, browse the work of others, and examine and reuse elements of their grammars. This hosting provides templates hooking generated output to rogue-like RPGS, music generators, and image generators, as well as styling choices for dressing up plaintext Tracery output.

5 Evaluation: Case Studies

For a tool like Tracery, our evaluation metric is whether it has been successfully used to make works, by ourselves and others. Tracery has been developed while working on many of our own fully-implemented works (rather than just toy examples) and in conversation with authors writing real works. This kept our development grounded in the needs of the authors, leading us to the design considerations outlined in Sect. 3. Below are some of the works: several of our own, and one from independent designer Dietrich 'Squinky' Squinkifer, with the lessons we learned from them, and several pilot experiments showing new directions that Tracery may go in the future.

Eternal Night Vale. Eternal Night Vale was the first released stand-alone project using Tracery, and was created by us for ProcJam 2014, the procedural generation jam. It created possible episodes in the style of the podcast Welcome To Night Vale. A deeply nested grammar of about fifty symbols, each with many possible rewrite rules, was used to expand an '#episode#' rule recursively into the highly-structured segments of a Night Vale episode, filling in details with absurd generated vignettes that would be appropriate to the very idiosyncratic world of Night Vale. A review in Rock Paper Shotgun praised the work as 'a great little tool which condenses the tone and main elements of the show into just a few paragraph' [10]. By mimicking the distinctive structure and language of the show, we were able to capture the spirit of the show in a relatively short grammar, in the short time-frame of a one-week jam.

Interruption Junction. 'Interruption Junction' [9] by game artist Squinky is the first major game released using Tracery. In their words, it is 'a short one-button conversation game about being lonely in a group of people!' The player is in a conversation in which three other friends are discussing the activities of mutual acquaintances. The player can mash the space bar to interrupt and begin rambling about video games, but unilaterally dominating or retreating from the

conversation will cause people to fade from the conversation. The dialogue is generated by Tracery, using a grammar by Squinky, and is meaningless, absurd, and endless, a good fit for the theme of the game. Unlike Eternal Night Vale, Tracery dialogue is just one element of this game, which also has interactivity, animation, and sound. Interruption Junction showed that the encapsulation of Tracery works well in actual practice of professional game making.

Neverbar. Neverbar is a scifi dating sim that we are developing in parallel with Tracery to inform Tracery's development with the needs of a real game. Neverbar needs to maintain consistent world state, such as tracking the gender of the protagonist, their name, their current location in the bar, their drink, and the gender, name, and species of their love interest, and other story information. We found this to be a common need for users using Tracery in larger more interactive works like Interruption Junction, so we are developing an optional 'plumbing' layer on top of Tracery to automate the most common tasks we encounter. The 'plumbing' is able to generate options with display text, keep track of their potential values, and specify handlers to be called on activation or cancellation, like pushing the values into the game's world state. It can also move values from the world state back into the grammar to maintain synchronization.

MEXICA: Testing Integration with Other Narrative Systems. Many narrative generation systems focus on knowledge modeling, narrative, or simulation, features that Tracery lacks. Can we pair Tracery with these existing systems to create coherent stories augmented with expressive generative language? A recent paper on MEXICA included an XML output of the generator [5], which we translated into a JavaScript object, and then tasked Tracery with providing interesting and variable text interpretations for this skeleton story. Each concept in the MEXICA data is converted to a Tracery symbol and rules representing ways to describe it. The skeleton of the story remains the same, maintaining structure, but the language used creates very different stories. Although this test was done with exported XML data, any live narrative system that can communicate with JS will be able to use Tracery in the same way.

6 Future Work and Conclusions

We designed Tracery as an 'author-focused' generative text tool targeting the communities of practice around NaNoGenMo, Twine, and Twitterbots. We built a lightweight, modular, and easy-to-use library (and associated tools) using known best practices and design considerations drawn from those communities of practice. Our goal was seeing it adopted and used by a wide range of authors and toolmakers; it has been very successful by that metric. Our next steps will be launching Tracery.io and finishing and releasing the plumbing module and visualization tools. Intriguing recent experiments suggest that Tracery can generate syntax for HTML,[3] SVG, or even valid JavaScript, opening the door for

[3] https://twitter.com/ranjit/status/605149881200713728.

automatic code generation in the future. We look forward to seeing how Tracery continues to evolve as we add new authors and tools.

References

1. Black, J.B., Wilensky, R.: An evaluation of story grammars*. Cogn. Sci. **3**(3), 213–229 (1979)
2. Dzieza, J.: The strange world of computer-generated novels, November 2014. http://www.theverge.com/2014/11/25/7276157/nanogenmo-robot-author-novel
3. Harrell, D.F.: Walking blues changes undersea: imaginative narrative in interactive poetry generation with the GRIOT system. In: AAAI 2006 Workshop in Computational Aesthetics: Artificial Intelligence Approaches to Happiness and Beauty, pp. 61–69 (2006)
4. McCoy, J., Treanor, M., Samuel, B., Tearse, B., Mateas, M., Wardrip-Fruin, N.: Authoring game-based interactive narrative using social games and Comme Il Faut. In: Proceedings of the 4th International Conference & Festival of the Electronic Literature Organization: Archive & Innovate (2010)
5. Montfort, N., ý Pérez, R.P.: Integrating a plot generator and an automatic narrator to create and tell stories. In: On Computational Creativity (2008)
6. Neyfakh, L.: The botmaker who sees through the internet, January 2014. http://www.bostonglobe.com/ideas/2014/01/24/the-botmaker-who-sees-through-internet/V7Qn7HU8TPPl7MSM2TvbsJ/story.html
7. Riedl, M.O., Bulitko, V.: Interactive narrative: an intelligent systems approach. AI Mag. **34**(1), 67 (2012)
8. Short, E.: Procedural text generation in IF, November 2014. https://emshort.wordpress.com/2014/11/18/procedural-text-generation-in-if/
9. Squinkifer, D.S.: New game: interruption junction, January 2015. http://squinky.me/2015/01/19/new-game-interruption-junction/
10. Warr, P.: Welcome to eternal night vale, November 2014. http://www.rockpapershotgun.com/2014/11/19/eternal-night-vale/
11. Weizenbaum, J.: ELIZA: a computer program for the study of natural language communication between man and machine. Commun. ACM **9**(1), 36–45 (1966)
12. ý Pérez, R.P., Sharples, M.: MEXICA: a computer model of a cognitive account of creative writing. J. Exp. Theor. Artif. Intell. **13**(2), 119–139 (2001)
13. Zhu, J., Ontanón, S.: Story representation in analogy-based story generation in Riu. In: 2010 IEEE Symposium on Computational Intelligence and Games (CIG), pp. 435–442. IEEE (2010)

A Semantic Foundation for Mixed-Initiative Computational Storytelling

Ben Kybartas[✉] and Rafael Bidarra

Department of Intelligent Systems, Delft University of Technology,
Delft, Netherlands
{B.A.Kybartas,R.Bidarra}@tudelft.nl

Abstract. In mixed-initiative computational storytelling, stories are authored using a given vocabulary that must be understood by both author and computer. In practice, this vocabulary is manually authored ad-hoc, and prone to errors and consistency problems. What is missing is a generic, rich semantic vocabulary that is reusable in different applications and effectively supportive of advanced narrative reasoning and generation. We propose the integration of lexical semantics and commonsense knowledge and we present GLUNET, a flexible, open-source, and generic knowledge-base that seamlessly integrates a variety of lexical databases and facilitates commonsense reasoning. Advantages of this approach are illustrated by means of two prototype applications, which make extensive use of the GLUNET vocabulary to reason about and manipulate a coauthored narrative. GLUNET aims to promote interoperability of narrative generation systems and sharing corpus data between fields of computational narrative.

Keywords: Computational storytelling · Natural language · Semantics

1 Introduction

Mixed-initiative computational storytelling, in which the author and computer create a narrative by collaboratively building a story, requires a rich and detailed representation of narrative. This is often done by creating a model of narrative, and then providing the author a 'vocabulary', a set of building blocks that can be used to tell pieces of a story and of which the semantics are known to the computer. The 'words' in the vocabulary may take the form of text, images, or even actions, depending upon the application. This vocabulary is often built manually, which, in addition to being time consuming and costly, is also prone to human error and inconsistency and is typically only valid within each specific domain.

We propose the development of a rich, reusable semantic vocabulary in order to provide a solid foundation for computational storytelling applications. Since a mixed-initiative application requires the computer to *reason* about, and *create* pieces of a story, this vocabulary should provide the semantics for both

© Springer International Publishing Switzerland 2015
H. Schoenau-Fog et al. (Eds.): ICIDS 2015, LNCS 9445, pp. 162–169, 2015.
DOI: 10.1007/978-3-319-27036-4_15

the structure and use of each word, as well as more general commonsense knowledge that enables advanced reasoning about the relations between words in the vocabulary.

In this paper, we propose a flexible and generic knowledge-base, GLUNET, that seamlessly integrates a variety of lexical databases, facilitates commonsense knowledge consistency and is reusable in multiple domains. In addition, we show how using this rich vocabulary supports the kind of reasoning that is required both to analyze and to manipulate narratives.

To illustrate GLUNET's potential as a sound semantic foundation for computational storytelling applications, we present two mixed-initiative prototype applications which make extensive use of GLUNET to understand and manipulate narratives alongside one or more human authors.

Lastly, we discuss further directions for the development of semantic vocabularies, as well as the role vocabularies play in approaching open problems in computational storytelling, such as interoperability and the development of a shared narrative representation [10].

2 Related Work

We conducted a review of existing uses of lexical and commonsense resources in narrative or games for best determining which resources are suitable to lay this foundation. Story annotation tools [4,6] often annotate text with a vocabulary derived from WORDNET, a lexical database of words [5], and VERBNET, a lexical database of verb semantics and syntax [9].

Alternate forms of annotation have also sought to classify text according to its frame [3], by using FRAMENET, a lexical database of frame semantics [1]. Frame semantics has been proposed as a method for narrative generation [13], and FRAMENET has further been proposed to help create better natural language processing of questions in story-based games [8]. FRAMENET's frame semantics is also a good foundation for the description of events, in relation to structure and semantic roles.

It is also crucial for computational storytelling applications to have a significant amount of commonsense world knowledge to properly understand a narrative from the perspective of a human reader [15], as well as to drive generation or creativity-based applications. CONCEPTNET [11] is a popular commonsense knowledge-base which has been used in a variety of applications relating both to narratives and to games. Rodriguez et al. [16] created a procedural tool for generating game ideas that subverts CONCEPTNET's commonsense relations to create unusual and inspiring scenarios. Nelson and Mateas [14] explored the use of both CONCEPTNET and WORDNET to generate complete, thirty-second games where the vocabulary helped them to define game rules.

Previous efforts to unify lexical resources exist, largely intended for use within natural language processing applications. Shi and Mihalcea [17] explored the use of integrated resources for annotation, combining FRAMENET, VERBNET and WORDNET, which enabled them to exploit the data of each resource to extend

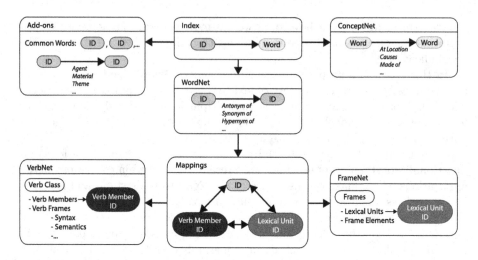

Fig. 1. The abstract structure of GLUNET showing the different components of the knowledge-base, the representation of knowledge in each component, and the way mappings are currently integrated.

the coverage of the other resources. Larger scale integration projects are typically intended for natural language processing, such as UBY [7] which integrates the aforementioned lexical resources along with crowdsourced resources, such as Wikipedia. We differ from the above research in that we integrate commonsense knowledge to derive essential semantic relations that are needed to generate meaningful and coherent content in mixed-initiative applications.

3 The GluNet Knowledge-Base

GLUNET is an SQLite database which provides a vocabulary of words as well as their syntax and semantics. It provides commonsense semantic relations between words, lexical information surrounding single words, the syntactic and semantic meanings of verbs, as well as the frame elements to which the words belong. This was achieved by using the list of words in WORDNET as a primary index, the remaining resources being integrated by either assigning the semantics to a single word, or as a semantic relation between two words. Integration was used to assign the semantics of each resource to a single word, to strengthen the existing resources [17] and to further allow for the creation of new semantic relations [14]. See Fig. 1 for a detailed structure of GLUNET.

The mapping was created using the WORDNET, VERBNET and FRAMENET mappings from the work by Shi and Mihalcea [17] and the similar mappings provided by the VERBNET project. This gives us an incomplete, but extensive, mapping between the three databases. The CONCEPTNET to WORDNET mapping is done at the word level, but lacks the sense key disambiguation of the other mappings which may lead to some inconsistent results when word semantics differ. Future work aims to find methods of bridging these gaps in the mapping, for example by using crowd-sourcing.

(a) SMART STORYBOOK. (b) IMPROV GAME

Fig. 2. Screenshots of each prototype. Figure 2a shows a sample story built in SMART STORYBOOK. Figure 2b shows the noun selection menu in IMPROV GAME.

The main feature of GLUNET is the ability to obtain a significant amount of semantic information for single words. Moreover, we are interested in the advantages of using GLUNET as a semantic foundation for mixed-initiative storytelling applications. To illustrate this, we developed two prototype applications, each requiring some form of narrative understanding and limited generation using GLUNET. The first application is a story-building tool primarily aimed at children, which uses GLUNET to reason and make suggestions about the story being built. The second application is a casual storytelling game that uses GLUNET for text and content generation. Screenshots of both prototypes may be seen in Fig. 2.

4 Smart Storybook

The first application, nicknamed SMART STORYBOOK, is a storytelling prototype designed specifically to allow children experience storytelling in a creative and exploratory way. From the perspective of validating GLUNET, the goal of the application was to be able to reason about narratives as they are dynamically being created. The application is inspired in part by the MY STORYMAKER application [2], in the sense that stories are built by having the child visually create a scene for the story, with the computer providing suggestions on story improvements using a question/answer system. Using the GLUNET vocabulary, however, gives us access to a significant set of WORDNET nouns for characters and props, as well as the semantic information needed to generate questions regarding the story.

A story in SMART STORYBOOK is defined as a linear sequence of scenes. Each scene is manually constructed by the author, by placing three kinds of entities, *characters*, *props* and *decor*, into the scene window. The WORDNET nouns are proposed candidate entities. We selected images for a large subset of WORDNET nouns from https://openclipart.org/.

The analysis and reasoning is largely performed from the event level. To add an event, the author enters the verb of the desired event in the top right box of the interface. The verbs available are the list of verbs available in VERBNET, and the application further checks if there exists a VERBNET-FRAMENET mapping for the particular verb. The application then retrieves the verb's thematic roles, leading to an understanding of the roles which need to be filled to complete the event. This generates questions such as 'What is the agent of the fight event?'. If the FRAMENET mapping is available, the application will then load the frame elements of the applicable frame. The frame elements allow the application to create further suggestions such as 'What was the style of the dance event?'. All these suggestions may be replied to by the author using the text box at the bottom of the interface. When answered, the response is stored in the event and a new line of text is added to the story. We further experimented with having certain questions, such as those relating to temporality (e.g. frequency and duration), be automatically applied to their corresponding events in the narrative.

Future development on this prototype aims to explore the possibilities of creating an educational tool to teach storytelling. The system currently introduces the author to event/frame-based reasoning and temporality, albeit to a very limited degree. Allowing the application to reason about entities, and even make creative suggestions based on commonsense knowledge, remain interesting avenues for future work.

5 Improv Game

IMPROV GAME is a prototype of a casual improvisational multi-player storytelling game, where players take turns in building segments of a story. Players are first asked to list several characters and props to serve as the starting entities of the story, all taken from the GLUNET vocabulary. Once all the entities have been chosen, the game procedurally generates two lines of text, a *starting line* and a *target line*. The current player's goal is to construct the story which connects the starting line to the target line within a set time. Once the player has finished their story, it is the next player's turn and the game generates a new target line. The previous target line now becomes the new starting line, and the new player has to link this starting line to the new target line. The game continues in this fashion until a set number of turns has passed, or when the players run out of time.

Both the procedural generation of lines, and the means by which players construct the story, strongly build upon the semantics provided by GLUNET. The procedural generation, in particular, makes heavy use of the WORDNET verb frames, as well as the CONCEPTNET database. First, the application selects the verbs from the most recent sentences in the story. The knowledge-base is then queried to find potential next events from these verbs, by obtaining the *causes*, *has first* or *last subevent* and *has prerequisite* relations to logical next events for the story. If no relations exist from any of the verbs, the application then checks

the characters and props in the story, and instead picks a verb based on the character's *capable of* relation. Once the verb has been selected, each piece of the verb frame is filled with a randomly selected character or prop. The players follow the same pattern for creating lines of the story, selecting a verb, followed by a sentence frame and then filling in each piece of the sentence frame using a set of possible values.

The prototype uses the rich semantics of the knowledge-base to link the high-level commonsense reasoning step with the syntactic construction of the sentence. As with SMART STORYBOOK, there is no world model nor consistency check, making it easy for players to 'cheat' or create nonsensical stories. Given the playful and experimental nature of both prototypes, this is not a concern. However, future work aims to examine how the GLUNET vocabulary could be used to support a world model, such that some level of story consistency is assured.

6 Discussion

Two areas of importance are: (i) the extensibility of GLUNET and (ii) the contribution of a rich semantic foundation towards encouraging interoperability.

Extensibility has been identified by previous integration research as an essential feature, given the growth and changing nature of language and knowledge [7]. We approached this by designing GLUNET with a common word index, and by using only open-source or freely available resources to allow for modification and community use. The common word index allows new semantics to be mapped to words in the database. Additionally, future work on GLUNET aims to improve and extend the existing mappings to create better coverage.

GLUNET was also designed as a first step in the development of a richer representation of story to promote interoperability. With a solid foundation, different applications can share semantics, which is important in interoperability projects where a number of systems generate unique content that must be merged into a final product. One such example is the SLANT [12] project, which generates narratives by having a variety of systems create different components of the narrative (plot, discourse, etc.). Without semantics, each system is largely confined to working in isolation, limiting their ability to collaborate, since their foundation knowledge is typically different, and at worst conflicting.

7 Conclusion

The more complex and detailed a mixed-initiative storytelling application needs to be, the more it requires a sound foundation, that will guarantee its generality, expressive power and consistency. For this, a rich vocabulary is needed, integrating lexical semantics and commonsense world knowledge, supporting the kind of advanced reasoning done by computational storytelling applications. We presented a flexible and generic open-source knowledge-base, GLUNET, that provides such a semantically rich vocabulary. It integrates several lexical databases

and facilitates commonsense knowledge consistency, establishing various mappings and semantic relations among them, in order to support reasoning over a variety of story elements, from different perspectives. The potential of this approach and its ease of integration with computational storytelling applications was demonstrated by means of two case studies, each involving a different mixed-initiative prototype. Both applications profited in different ways from the rich semantics provided by GluNet, which was expressive enough to reason about stories, and even generate narrative content for them.

Among the advantages of a semantically rich knowledge-base like GluNet to the computational storytelling community, we can point out both promoting interoperability of narrative generation systems and the sharing of corpus data between different fields of computational narrative. We expect that further development of better representations of narrative based on rich semantics will open up whole new possibilities for computational storytelling; the semantics-based foundation presented in this paper takes a first step towards this goal[1].

Acknowledgements. This research has been supported by the Netherlands Organisation for Scientific Research, under project no. 314-99-104.

References

1. Baker, C.F., Fillmore, C.J., Lowe, J.B.: The berkeley framenet project. In: COLING-ACL 1998: Proceedings of the Conference, Montréal, Canada, pp. 86–90 (1998)
2. Carnegie Mellon University Entertainment Technology Center: my StoryMaker (2007)
3. Das, D., Schneider, N., Chen, D., Smith, N.A.: Probabilistic frame-semantic parsing. In: Human Language Technologies: The 2010 Annual Conference of the North American Chapter of the Association for Computational Linguistics, HLT 2010, pp. 948–956. Association for Computational Linguistics, Stroudsburg (2010). http://dl.acm.org/citation.cfm?id=1857999.1858136
4. Elson, D.K.: Dramabank: annotating agency in narrative discourse. In: Calzolari, N., Choukri, K., Declerck, T., Doğan, M.U., Maegaard, B., Mariani, J., Moreno, A., Odijk, J., Piperidis, S. (eds.) Proceedings of the Eight International Conference on Language Resources and Evaluation. European Language Resources Association (ELRA), Istanbul, May 2012
5. Fellbaum, C. (ed.): WordNet: An Electronic Lexical Database. MIT Press, Cambridge (1998)
6. Finlayson, M.A.: The story workbench: an extensible semi-automatic text annotation tool. In: Intelligent Narrative Technologies IV Workshop, Stanford, California, USA, October 2011. http://aaai.org/ocs/index.php/AIIDE/AIIDE11WS/paper/view/4091
7. Gurevych, I., Eckle-Kohler, J., Hartmann, S., Matuschek, M., Meyer, C.M., Wirth, C.: UBY - a large-scale unified lexical-semantic resource based on LMF. In: Proceedings of the 13th Conference of the European Chapter of the Association for Computational Linguistics (EACL 2012), pp. 580–590, April 2012

[1] GluNet is available for download at https://graphics.tudelft.nl/glunet/.

8. Joseph, E.: Bot Colony. North Side Inc., Montreal (2014). https://www.botcolony.com/doc/BotColony_paper.pdf
9. Kipper, K., Korhonen, A., Ryant, N., Palmer, M.: A large-scale classification of english verbs. Lang. Resour. Eval. **42**(1), 21–40 (2008). http://dx.doi.org/10.1007/s10579-007-9048-2
10. Koenitz, H.: Five theses for interactive digital narrative. In: Mitchell, A., Fernández-Vara, C., Thue, D. (eds.) ICIDS 2014. LNCS, vol. 8832, pp. 134–139. Springer, Heidelberg (2014). http://dx.doi.org/10.1007/978-3-319-12337-0_13
11. Liu, H., Singh, P.: ConceptNet - a practical commonsense reasoning tool-kit. BT Technol. J. **22**(4), 211–226 (2004)
12. Montfort, N., Pérez, R.P., Harrell, D.F., Campana, A.: Slant: a blackboard system to generate plot, figuration, and narrative discourse aspects of stories. In: Maher, M.L., Veale, T., Saunders, R., Bown, O. (eds.) Proceedings of the Fourth International Conference on Computational Creativity, Sydney, Australia, pp. 168–175, June 2013. http://www.computationalcreativity.net/iccc2013/download/iccc2013-montfort-et-al.pdf
13. Murray, J.H.: Hamlet on the Holodeck: The Future of Narrative in Cyberspace. The Free Press, New York (1997)
14. Nelson, M.J., Mateas, M.: Towards automated game design. In: Basili, R., Pazienza, M.T. (eds.) AI*IA 2007. LNCS (LNAI), vol. 4733, pp. 626–637. Springer, Heidelberg (2007). http://dx.doi.org/10.1007/978-3-540-74782-6_54
15. Rodosthenous, C.T., Michael, L.: Gathering background knowledge for story understanding through crowdsourcing. In: Finlayson, M.A., Meister, J.C., Bruneau, E.G. (eds.) 2014 Workshop on Computational Models of Narrative, vol. 41, pp. 154–163. OpenAccess Series in Informatics (OASIcs) Schloss Dagstuhl-Leibniz-Zentrum für Informatik, Dagstuhl, Germany (2014). http://drops.dagstuhl.de/opus/volltexte/2014/4653
16. Rodriguez, M.T.L., Colton, S., Hepworth, R., Cook, M., Guckelsberger, C.: Towards the automatic generation of fictional ideas for games. In: AAAI Workshop on Experimental AI in Games (2014)
17. Shi, L., Mihalcea, R.F.: Putting pieces together: combining framenet, verbnet and wordnet for robust semantic parsing. In: Gelbukh, A. (ed.) CICLing 2005. LNCS, vol. 3406, pp. 100–111. Springer, Heidelberg (2005). http://dx.doi.org/10.1007/978-3-540-30586-6_9

Revisiting Computational Models of Creative Storytelling Based on Imaginative Recall

Sarah Harmon[✉] and Arnav Jhala

UC Santa Cruz, Santa Cruz, USA
smharmon@ucsc.edu, jhala@soe.ucsc.edu

Abstract. Certain story generation systems consider the processes of *imaginative recall* and *adaptation* as central to human creativity in storytelling. Researchers have recently compared the output of these systems through the lens of Boden's types of creativity [9]. This comparison highlights the contribution of *predefined structures* to story predictability, which influences perceived creativity. We revisit the connection between knowledge structures and story predictability, and compare Minstrel's use of knowledge structures versus the use of Story Intention Graphs (SIGs) as the underlying case frames. Semantic information encoded in the SIG produces coherent stories and retains the imaginative recall and generalization aspect of Minstrel's creative process. Mapping knowledge structures to SIGs enables the use of a common representation that is directly connected to surface realization. This opens up the performative aspect of creativity that does not come out in templated text outputs.

Keywords: Case-based reasoning · Computational creativity · Story generation

1 Introduction

Boden [1] has described two key types of creativity: *psychological* (novel with respect to the individual with the idea) and *historical* (novel with respect to all of human history). Pérez y Pérez and Sharples have argued that these two types are not appropriate for storytelling systems because they often use predefined structures, and, thus, the predictability of the resultant stories is high [9]. To provide a fair comparison of computational storytelling systems, they propose a third type of creativity: *computerized* creativity, which defines a creative storytelling system as one which generates context-appropriate knowledge outside of its pre-existing knowledge base.

If one reviewed the entire knowledge base of a narrative system, they might have a general idea of what stories might be produced. However, there should yet be inherent creativity and potential unpredictability in how the system chooses their words, sentence structures, and style to communicate the output. Thus, the connection of events in the knowledge base and semantic information can be used to create language that itself can be creative even when the aspects of coherence,

© Springer International Publishing Switzerland 2015
H. Schoenau-Fog et al. (Eds.): ICIDS 2015, LNCS 9445, pp. 170–178, 2015.
DOI: 10.1007/978-3-319-27036-4_16

flow, suspense, choice of content are the same [3]. Several modern systems have primarily targeted how coherent sequences of events might be generated at the plot level. While plot-level changes to stories influence language generation, the full expressive power of surface level linguistic changes, such as choice of sentence structures, verbosity, and choice of words is not fully utilized. The underlying knowledge structures are yet missing appropriate representations that will lead to expressive language generation output.

Minstrel, one of the earliest story generators, utilized a case-based reasoning approach to incorporate a model of computerized creativity [13] using imaginative recall. We revisit this mechanism through extension of a contemporary rational reconstruction of Minstrel called Skald [11]. We then present a mapping between the underlying story representation in Skald to the Story Intention Graph (SIG) formalism proposed recently by [4]. This mapping and extensions to Skald allow us to identify areas of research that are unexplored both in terms of storytelling and creative systems.

For example, a Minstrel-like system relies heavily on manually authored content, and quickly exhausts its library of reference stories. There is also no reliable bridge towards a natural language generation system for a generic Minstrel-like program. As such, current attempts to expand the creative power of Minstrel produce graphs, rather than text which reads like a natural story [11]. Further, it is difficult to compare storytelling systems like Minstrel with each other, because there is no definitive standard designed to assess the quality or scope of generated creative content. Here, we propose that a semantic representation system such as the SIG model [4] be used as a formalized standard of narrative meaning and comprehension. With the adoption of this standard, generated narrative content, such as that composed by Minstrel, can be more easily analyzed, transformed, and rewritten as natural text.

The primary contribution of this work is the connection between knowledge structures in Minstrel to the SIG formalism. The secondary contribution is the implementation of extensions to Minstrel in terms of event ordering, SIG node construction, and richer language generation. The focus of the current system is to explore the computational formalisms and the computational process of imaginative recall for storytelling. While results presented are for computer-generated stories, we note that similar reasoning processes and knowledge structures are necessary to serve as a model of interactors in interactive storytelling environments where they are directly manipulating the narrative through their actions. One way to look at the presented work here is to look at the process of co-creation of such narratives (akin to *exquisite corpse* style of turn-based interaction) by giving a human interactor the opportunity to select segments of the story.

2 Related Work

Minstrel is a LISP program that simulates the human creative process in order to produce stories [13]. In particular, Minstrel transforms memories of known events (case base) to formulate new scenarios via generalization and adaptation

(imaginative recall). Story elements are defined by schemas (case frames) and stored in a searchable database. Creating small changes in these schemas results in new stories.

To reconstruct old stories into new ones, Minstrel relies on twenty-five heuristics called TRAMs ("Transform-Recall-Adapt Methods"). As an example, Minstrel contains a default TRAM called "Standard-Problem-Solving" which simply looks for a pre-existing solution in memory. If no solution exists, the TRAM fails. The TRAM also fails if any found solutions have already been used, because such solutions are deemed "boring" by the Minstrel system. Whenever a given TRAM fails, the problem must be transformed and Minstrel must look for a case that best matches the newly transformed problem.

```
S:Amelia has Health of Injured. This motivates Amelia to
S:Amelia has Health of Injured. This motivates Amelia to
S:Amelia has Health of Healthy. This motivates Amelia to
G:Amelia wants to change the Health of Amelia to Healthy. This hassubgoal Amelia to
G:Amelia wants to change the Health of Amelia to Healthy. Amelia plans to
S:Amelia has Health of Healthy.Amelia's plan was successful.
G:Amelia wants to change the Health of Amelia to Healthy. Amelia plans to
A:Amelia Use Amelia with Heal. Amelia hopes to cause
A:Amelia Use Link with Amelia. Amelia hopes to cause
S:Amelia has Health of Healthy.Amelia's plan was successful.
S:Amelia has Health of Injured. This motivates Amelia to
G:Amelia wants to change the Health of Amelia to Healthy. This hassubgoal Amelia to
G:Amelia wants to change the Possess of PoisonedLamb to .(Amelia) Amelia plans to
A:Amelia PGive PoisonedLamb from Amelia to Amelia. Amelia hopes to cause
S:Amelia has Possess with PoisonedLamb.Amelia's plan was successful.
A:Amelia Ingest Amelia with PoisonedLamb. This precondition Amelia to
```

Fig. 1. An example of Skald's current natural language generation output. We will refer to this narrative as "Amelia's Story". Each line is an event in the story. The output indicates whether each event is a state ("S"), goal ("G"), or act ("A"). Each event may be connected to another. For example, some goal events contain subgoals, or some acts require preconditions before they can occur. However, events are not ordered, making the story difficult to read.

Skald was developed to make Turner's underlying system more robust and useful as a general-purpose story generator. Other modern storytelling systems have built upon the foundation of imaginative recall and annotated case-based reasoning, such as Riu and Mexica. Mexica [8] is a plot generation system that tells stories about the Aztec people, and considers a temporal progression of simple action-based events. Future events are decided by searching list, rather than graph, comparisons in a case-based approach. In contrast, Riu is an interactive system that examines human input in the course of telling a story about a robot named Ales. Unlike Mexica and Skald, Riu [7] relies on templates combined with a finite state machine to generate new linguistic variations in retellings. While not addressing generalization directly, the authors of Riu developed distance function measures to evaluate the quality of their system.

Mexica, then, advances beyond Skald by using an explicit event-ordering system, and Riu by considering language generation and a measure of evaluation. While outputs of these generators do qualify as being creative, it is difficult to

evaluate the systems together in terms of creativity due to the variety of underlying representations. We claim that some representational structure, similar to the SIG, has the potential to facilitate this process. SIGs can be learned from annotation, inherently have event-ordering properties, can be transformed, and can be connected to linguistic-level variation. Thus, by using a SIG-like structure, one can preserve the creative process in imaginative recall systems, and yet be able to influence and improve upon the creative outcome by modifying the underlying representation.

3 Research Foundation

3.1 Skald: Improving Minstrel

Skald was developed to make Turner's underlying system more robust and useful as a general-purpose story generator. Similar to Minstrel, Skald retrieves and executes author-level plans (ALPs) as part of the story generation process. Ultimately, the system constructs a connected graph with story frames as nodes. Most commonly, these frames are a trio consisting of a goal which *plans* an act, which, in turn, *intends* a state to occur, and wherein the state ultimately *achieves* the goal. Many of the narratives that Skald generates are formed by combining and connecting similar frame trios.

3.2 Generating Natural Language from CBR Systems

Translating case-based reasoning generations into text is challenging [2]. At present, there is no widely accepted architecture for translating between generated story content and natural language. Much research (e.g., [5]) has been devoted to generating natural language from ontologies. Virtual Storyteller relies on a "story world" ontology [12], which provides a basic semantic network for describing story concept, plot elements, and character models. This ontology, based on description logic, matches the level of representation that is closer to plan-based approaches and is useful for generation of coherent stories. However, stylistic variation at the surface realization level requires representation across multiple levels such as the fabula level, the interpretive level, and the affectual level. The ontologies used thus far have not been sufficient by themselves for generating a wide variety of narrative texts, because they lack a formal semantic representation for these fundamental units of story structure.

To address this issue, Rishes et al. have proposed an automatic method for converting between the SIG representation to a natural language generator such as PERSONAGE [10]. While Rishes et al.'s work is a step towards generating natural text from a standardized story representation, a bridge needs to exist between the narrative generator and the SIG model. We demonstrate how one may apply the SIG model to stories generated by an automated creative narrative system. The resulting SIG encodings may be used to generate natural language or produce transformed stories.

4 The Story Intention Graph as a Formalism for Imaginative Recall

4.1 Overview

Skald simulates the human authoring process using the same core ideas as Minstrel. Thus, Skald is a suitable creative narrative generator to formalize with SIGs because it represents a valid, open source model of computational creativity. We claim that SIGs are appropriate for three reasons, namely, they (1) provide a formal representation that can facilitate comparison between story generators beyond Skald, (2) are a bridge towards improved natural language generation in Skald and other generators, (3) expand the library of Skald without additional manual authoring.

4.2 Why Use the SIG Model?

Supporting Narrative Generator Comparisons. The SIG model provides formal, concise, and expressive representations for computer-generated narratives. A shared, growing corpus of encodings is currently available to describe and investigate narrative structures. By translating stories into SIG encodings, we have a means of expressing the diversity of structures and relationships that can be created by automated narrative generators.

Linking Plot Content and Language Generation. Skald generates bare plotlines rather than producing natural language in the expected format for a story. Many attempts have been made to implement text generation from case-based reasoning generations, yet there is no generally accepted formal representation to describe the authoring process. We propose that SIGs be used as the model of narrative meaning. Researchers are currently studying how to translate between SIGs and natural language [10]. This implies that translating computer-authored narratives into SIGs, in particular, would be a beneficial intermediary step prior to natural language generation.

Expanding the Creative Authoring Space. Thus far, SIGs have only been applied as an analytical tool on pre-written stories with simple plot structures and character attributes. However, SIGs have the potential to express a richer set of stories when combined with a sufficiently creative generator. Once a narrative is represented in terms of SIGs, we can then transform the story to result in creative retellings.

5 Translating Generated Plotlines into SIGs

5.1 Overview

We have developed a system that takes in Skald story data as input and produces SIG encodings. At present, our system outputs text that describes a graph

structure representing the SIG encodings. An example of how this graph would be represented using Elson's format is shown in Fig. 2. The following sections will describe each component of the system in detail. The process is described with a detailed example in [6].

5.2 System Procedure

Event Ordering. Skald generates a natural language story with events told out of order (see an example in Fig. 1). While not every narrative generation system may require event ordering, we included a module for this purpose so that any story generated by Skald will be told in the proper sequence. The Event-Ordering Module (EOM) uses knowledge of preconditions and consequences to reorder events in the timeline.

Node Construction. The Node Constructor (NC) unit categorizes each graph element as a Proposition (P), Goal (G), or Belief (B) node. Skald already labels frames as states, goals, and actions. This greatly simplifies the labeling process, as P nodes include states and actions that occur in the fabula timeline. Using these labels, every element of the output graph is then translated into a discourse relation and annotated with the correct agents, objects, and any other related entities. Because Beliefs and Goals are frames containing content, they are labeled and filled with one or more Interpretive Proposition (I) relations. In Skald, the affectual impact of a P node or actualized I node is merely implied with event-consequence pairings and whether goals are achieved. To create a proper SIG encoding, Affectual (A) nodes are created for each character of the story.

Chain Construction. Once all nodes are established, they must be linked to complete the SIG encoding process. This process is ensured by the Chain Constructor (CC) module, which reviews the given event-consequence pairings to make decisions about how P and I nodes (including Goals and Beliefs) are linked. Links are defined in accordance with Elson [4]. The system connects each I node to corresponding A nodes by considering the effects of that I on each agent's goals. If a goal is met for an agent when an I node is carried out, a *provides-for* link is established between an agent and that node. Conversely, a *damages* link is created when the current I node thwarts an agent's goal. If any A nodes contain no links by the end of the chain construction process, they are removed from the final graph.

Creative Retellings Using SIGs. By providing Skald with a SIG case library and specifying rules for SIG-based transformations, we can apply the TRAM procedure to the SIGs themselves. For instance, by following variations of "Ignore" TRAM templates, nodes and links may be removed from the more complex "Backfire" sub-encoding for Amelia's Story, resulting in different tellings (Fig. 3).

Fig. 2. A SIG encoding derived from Amelia's Story. Amelia's Story follows the "Backfire" pattern shown, coupled with an ultimate gain after a new "Desire to Aid Self" goal. In the story, a wizard named Amelia is injured. To make herself well, she tries eating some lamb, but the lamb is poisoned. Undaunted, she uses magic to restore herself to full health.

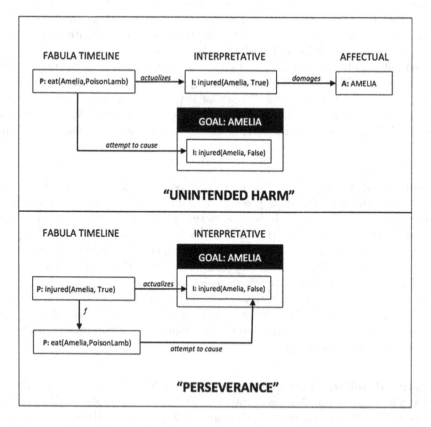

Fig. 3. Examples of alternate tellings for Amelia's story.

In the "Unintended Harm" telling, the storyteller emphasizes only how Amelia mistakenly came to harm herself by eating the lamb. In contrast, the "Perseverance" encoding tells the story of how Amelia continued to eat poisoned lamb in an attempt to make herself well.

6 Discussion

Analyses measuring the creative range of story generators reveal two aspects that significantly affect Boden's creativity measures. The first deals with the properties of the predefined structures in the knowledge base. These properties govern predictability and coherence in the types of plots and dramatic situations. The second deals with parameters of the system that *perform* the story (through text, visuals, or audio). This work suggests there is an aspect of creativity in the variations at the communicative layer even when the underlying plot structure is fixed. However, detailed analysis and comparison of creative storytelling systems must include both aspects. This is challenging because of the disparity and lack of formality in the underlying representations for different storytelling systems. To address this, we propose a mapping of predefined plot structures to SIG representations.

Regardless of whether SIGs are extended as a formal representation for creative narrative systems, they possess key properties that satisfy the provision of semantic plot information and a bridge towards linguistic generation. Most significantly, SIGs have inherent event-ordering properties and may be transformed, as we have shown. Any representation which provides this level of detail is useful for imaginative recall systems. SIGs also map well to plan-based and plot graph based story generation systems.

We have refined Skald's underlying representations to transform and improve its output, while preserving the creative process. Using a SIG-like representation leads to improved stories even with a predictable plot, because surface realization is expanded as an expressive medium for the same knowledge structures. Future research should work towards quantifying this improvement, as well as to further increase the creative capacity of narrative systems.

References

1. Boden, M.: The Creative Mind. Abacus, London (1992)
2. Callaway, C.B., Lester, J.C.: Narrative prose generation. Artif. Intell. **139**(2), 213–225 (2002)
3. Chen, S., Deunsing, A., Kong, P., Jhala, A., Wardrip-Fruin, N., Mateas, M.: Rolemodelvis: a visualization of logical story models. In: AIIDE (2012)
4. Elson, D.K.: Detecting story analogies from annotations of time, action and agency. In: Proceedings of the LREC 2012 Workshop on Computational Models of Narrative, Istanbul, Turkey (2012)
5. Galanis, D., Androutsopoulos, I.: Generating multilingual descriptions from linguistically annotated owl ontologies: the naturalowl system. In: Proceedings of the 11th European Workshop on Natural Language Generation, pp. 143–146. chloss Dagstuhl, Germany (2012)

6. Harmon, S., Jhala, A.: Imaginative recall with story intention graphs. In: Proceedings of the 6th Workshop on Computational Models of Narrative (CMN 2015), pp. 71–81 (2015)
7. Ontañon, S., Zhu, J.: Story representation in analogy-based story generation in riu. In: Proceedings of IEEE Computational Intelligence in Games (IEEE-CIG 2010), pp. 435–442. Vancouver, British Columbia (2010)
8. Pérez y Pérez, R., Sharples, M.: Mexica: a computational model of the process of creative writing. In: Proceedings of the AISB Symposium on Creative Language: Humour and Stories, pp. 46–51 (1999)
9. Pérez y Pérez, R., Sharples, M.: Three computer-based models of storytelling: BRUTUS, MINSTREL and MEXICA. Knowl.-Based Syst. 17(1), 15–29 (2004)
10. Rishes, E., Lukin, S.M., Elson, D.K., Walker, M.A.: Generating different story tellings from semantic representations of narrative. In: Koenitz, H., Sezen, T.I., Ferri, G., Haahr, M., Sezen, D., Çatak, G. (eds.) ICIDS 2013. LNCS, vol. 8230, pp. 192–204. Springer, Heidelberg (2013)
11. Tearse, B.R., Mawhorter, P.A., Mateas, M., Wardrip-Fruin, N.: Skald: minstrel reconstructed. IEEE Trans. Comput. Intell. AI Game. 6, 156–165 (2014)
12. Theune, M., Slabbers, N., Hielkema, F.: The automatic generation of narratives. In: Proceedings of the 17th Conference on Computational Linguistics in the Netherlands (CLIN-17), pp. 131–146. LOT Occasional Series 7, LOT, Utrecht (2007)
13. Turner, S.: Minstrel: a computer model of creativity and storytelling. Technical report CSD-920057, Ph.D. thesis, Computer Science Department, University of California, Los Angeles, CA (1992)

Narrative Review Process: Getting Useful Feedback on Your Story

Jonathan Dankoff[1]([⊠]) and Elizaveta Shkirando[2]

[1] Ubisoft Montreal, Montreal, Canada
jonathan.dankoff@ubisoft.com
[2] Ubisoft Massive, Malmö, Sweden
elizaveta.shkirando@massive.se

Abstract. Getting useful feedback on the narrative of a game can be notoriously difficult: by the time a playtester can experience the story in your game, it's usually already too late to make any significant changes. With this in mind, we developed a method which allows Ubisoft to apply a simple research methodology on a game's story, early enough for it to be valuable for the writers working on it. This paper defines common difficulties of properly testing narrative in games, and then explains the methodology developed and explains how it was successfully used on Ubisoft productions to generate actionable feedback.

Keywords: User research · Narrative · Review · User testing · Video games

1 Problem Definition

Narrative currently plays an extraordinarily important role in contemporary video games, as does user research. However, there is a disproportionately low amount of effective narrative research conducted in video games. One of the key problems leading to this issue is that narrative tends to be fully integrated quite late in the production of games. This is because narrative requires considerable work to be incorporated. You need finished scripts, voice over recordings, motion capture, etc. Once those milestones are reached, the game is nearing completion and the value of user feedback is informative at best, but certainly not actionable.

This creates several problems for game directors and narrative designers who must attempt to seamlessly merge a written story and game design into a cohesive whole. The research results from players experiencing the nearly finished game will be so late in development that they are unlikely to have time to act on the feedback to improve the quality of the story in any meaningful way. Changes at this point are impractical and expensive to implement, if not impossible, as games must adhere to strict release schedules, often planned years in advance.

Games user research has become increasingly common in game development as designers have learned the value of data-informed decision making and iteration. It is common for level and game designers to receive thirty rounds of scientifically collected feedback on their designs. Writers, on the other hand, tend to have a single table read before they send the script to production. EEDAR [1] recently presented data stating that nearly half of all text written in game reviews relates to story. Given the relative

© Springer International Publishing Switzerland 2015
H. Schoenau-Fog et al. (Eds.): ICIDS 2015, LNCS 9445, pp. 179–185, 2015.
DOI: 10.1007/978-3-319-27036-4_17

importance of narrative to the overall perception of quality of a game, it is only logical that research should support it with as much attention as game mechanics, level design, or overall aesthetics.

The average user is often ill-equipped to deliver interesting feedback at a critical level on storytelling and narrative. Their comments relating to story tend to be fairly vague, unclear, and lacking focus. Users are good at providing a broad appreciation, but have difficulty articulating complex narrative feedback as they are game players not literary critics. Unfortunately, this level of information is often insufficient for writers to make specific changes required to improve their stories.

Another issue that many writers face on a daily basis are frequent changes and unsolicited feedback from team members. This information, while potentially valuable, is unorganized, sporadic and generally difficult to parse. Writers must often using gut feeling and misguided orders from superiors to make changes to the narrative that are difficult to justify. They are unable to benefit from the data-informed decision making that their colleagues in other roles have the opportunity to use.

Additionally, narrative tends to be considered low priority by those outside the narrative team. Designers do not always consider the context of the story while working on their individual slice of the game. This can lead to a disconnect between gameplay actions and narrative. This problem is referred to as ludonarrative dissonance and has been described by many authors from a narrative and game design perspective. Numerous scholars claim that storytelling should be linear and created by writers, whereas an interactive experience such as video games depends entirely on the user's choice and motives [2]. Jenkins tries to unite the two camps by arguing that even though a game can exist without a narrative, a narrative can define game mechanics and rules [3].

These problems inspired the research teams of Ubisoft Montreal and Ubisoft Massive to create a research methodology that would allow them to gather actionable and useful feedback on game narrative earlier in the development process.

2 Developing the Method

The methodology is the result of several iterations, after which various takeaways were integrated to improve the overall process. The process was originally created as a practical response to the problems previously identified. A game in conception required structured clear feedback on the narrative before development could continue, and so representatives from the writing community and the research group attempted to work out a solution that drew from the best practices of each field of expertise. The original process created below is the result of that collaboration, that was further refined through iteration on other projects. As a practical tool for game developers, keeping the process lightweight, actionable, cost-effective and relatively quick were key considerations.

The basic structure of the narrative review consists of these steps:

- The review group reads and provides notes on a treatment, outline or script
- The feedback is synthesized into a report covering all of the notes provided by the reviewers
- A roundtable exercise is held that is part discussion and part brainstorm

2.1 Acquiring the Treatments and Recruiting the Participants

A treatment should be around a dozen pages in length. This should provide a thorough overview of the main storyline, challenges of the protagonist, and high level motivations of the player, without going into unnecessary detail or dialogue. This format tends to give an impression of the characterization and plot without burdening the review group with a full 300 page script to review, which would be unreasonable. This type of document also tends to be created very early in a project, as a guideline for creating the final script. Therefore, any recommendations for changes at this point are more likely to be integrated as they have a lower overall impact than later on in production. Another useful option is to include additional assets with the script to help the review group contextualize the text, such as concept or character art. This helps give a fuller experience and more closely resembles the audiovisual experience of playing a game.

Between six and twelve participants appears to be the optimal number for this exercise. Two types of reviewers are recruited: writers and game designers. The writers who are recruited should not be working on the game being studied. The second group is comprised of stakeholders of the narrative from the design team who are not directly implicated in the writing of the script. These include creative directors, game designers, level designers and other leads. This provides two very important and different points of view. Writers can give highly specific craft-oriented feedback that focuses on characterization, pacing, writing technique, etc. While game designers can give very contextualized feedback from a production perspective focusing on the stories' impact on the game, and its place within the broader scope of the entire production.

2.2 Reader-Friendly Process: Which Questions Should We Ask?

Participants are given 10 days to read the script and take notes. Every section of the script is linked to a short questionnaire with a box for taking notes, a short battery of rating questions followed by a small open ended justification section, and finally an area giving the reader the option to ask questions directly to the writer. At the end of the treatment there is a longer questionnaire covering more general topics. At Ubisoft, we use a digital survey solution (Fig. 1) that allows us to collect the results and quickly compile the qualitative data and tabulate the quantitative.

For the script notes portion of the questionnaire we attempt to mimic and accommodate a natural script note methodology used by many writers. They can take their notes in the margin, or use their text editor markup tool, and then transfer the notes to the questionnaire using a simple notation that specifies page, paragraph and line.

The next section is the battery. Questions are on a 5-point Likert scale, with a scale from "agree" to "disagree". The questions were formulated in collaboration with a writing team in order to understand the most important elements of a story:

- Appreciation: "I enjoyed this section of the script."
- Comprehension: "I understood what was happening in this section of the script."
- Interest: "I want to know what happens next in the story."

Fig. 1. Digital survey tool

- Character motivation: "I understand the protagonists motivations in this part of the story"
- Character progression: "I understand what the protagonist must do next."

These questions provide the fundamental answers required to understand how the readers are engaging with a narrative. Asking these identical questions on each section of the script allow us to easily track the key performance indicators of the story and identify weak areas. The questions themselves were developed with the writers to provide information on the elements that they considered to be of key importance for enjoyment of a narrative work. Players must enjoy the story, understand what is happening, remain interested, and understand and engage with the motivations and future actions of the protagonist.

The portion of the questionnaire that allows the reader to ask questions to the writer is valuable as it allows the group to question the intention of the writer and ask broader thought provoking questions, as opposed to the more formal and specific notes.

The final questionnaire is developed closely with the writing team in order to ensure that all important elements of the narrative structure are covered. The test objectives must reflect the current uncertainties of the writer, the areas in which they would like to receive constructive feedback, and the portions which they have already identified as problematic. This questionnaire covers such topics as:

- Overall likes and dislikes of the script
- Most memorable moments
- Elements that require more attention from the writing team
- Favorite and least favorite characters. Character related questions can also be included in each section depending how important is the feedback for the writing team.
- Resolution (ending) satisfaction
- Other specific questions based on the writer's key questions and concerns.

2.3 Analysis and Synthesis

Once all of the results have been collected, the researcher begins to synthesize and analyze the data into a preliminary report. The researcher may apply their preferred text coding method, such as mind mapping, grounded theory [4] or any other applicable process. There are several possible ways of coding in content analysis that have been widely described in the literature. For example Matthes and Kohring [5] who used this method for psychological narrative analysis, describe a well-structured method that can be applied to the entire text as well as to a smaller unit such as a paragraph. They define the clusters beforehand based on their previous knowledge of the topic while we are defining the topics based on the insights that we get from the readers' comments. However they also divide the data to negative and positive statements. Similar methods are used for film script analysis [6]. The authors mention its applicability to interactive storytelling systems such as video games. During the analysis it is important to look both for areas of consensus and areas of diverging opinions as both may provide valuable insight into the aggregate responses of the readers.

One problem that should be avoided is an overwhelmingly negative report. The note taking process tends to focus on areas that require improvement, thus the report become a long list of problem areas. Encourage the reading group to point out areas they feel are particularly good during the note taking process. It is important for the writer to understand which portions of the script are resonating, so that they are not lost in the iteration process. It is also important to remind the review group that the text is a work-in-progress and that it should not be perceived as a final document.

2.4 Round Table: Fruitful Discussion

Once the preliminary report has been delivered to the writer, the user researcher should develop a discussion guide with them. The round table should cover the most highly

weighted criticisms, the most divisive comments and the most interesting questions to writer. It is not necessary to invite the entire review group, as that many participants would be detrimental to the smooth operation of a discussion. Rather, choose the reviewers that had the most interesting and insightful notes. Ideally, the group should consist of approximately 6 of the readers, the writer as an observer, the researcher to act ask group moderator, and a note taker.

The format of the round table can move freely between discussion group where participants share and expand on their opinions of the script, and brainstorming session where the group attempts to solve difficult narrative conundrums together. The discussion guide must be completely anonymous only speaking generally about topics that are important, so that none of the reviewers feel singled out or put on the spot.

It is important to schedule the roundtable early in the process in order to ensure that the necessary participants will be able to attend. Waiting too long between the reading session and the roundtable may cause participants to lose interest and forget important material. Additionally, if the process is too time consuming the narrative will possibly have shifted, making the study results obsolete and less valuable and meaningful to the writer.

The results of this discussion group are added to the report.

3 Conclusion

This methodology allows a user research team to deliver actionable feedback on a narrative to a writer prior to the point where it is fully integrated in the game. This allows writers to iterate on the issues present in their story in a data-informed manner with constructive useful feedback. The review document combining the questionnaire results and the round table give a solid foundation for the writers to make better decisions and to quell some of the uncertainty in their craft. The quality of the feedback received from this peer group exceeds what you could obtain from a group of average gamers, as it is contextualized, direct, clear and solution oriented.

It is important to note that the review does not force the writer to incorporate any of the changes, no one is advocating design by committee. It simply provides writers with the information required to willfully choose their path, and then documents the decisions made based on that info, allowing them to get directorial sign-off, and keeping everyone involved accountable.

The process gives various stakeholders of the project a voice in the creation of the narrative, leading to greater investment in the narrative and greater consideration from the team when creating their own portion of the game.

Lastly, the process is easily customizable depending on the focus, the available assets, the available resources, the stage of development, and the specifics of each individual game. The process described above should be considered a widely adjustable framework for evaluating story that can be repurposed for a variety of circumstances. It is simple to set up, relatively cost-effective to run, and provides valuable much needed feedback to the writing staff of a game development project.

4 Further Research

The current narrative review process relies very heavily on a reading experience, which is a passive consumption of a potentially non-interactive linear story. It may be difficult for some readers to accurately relate the reading experience to a gaming one which normally incorporates various other media such as graphics, music, and interactivity. Research can continue to develop methods to include more media to create a close facsimile of the experience of playing a game. This would allow us to get feedback that more closely resembles the real environment of playing a game. It also includes the sense of control over the character which is an essential part of the interactivity in the game but is hard to represent in written text [5]. The greater is the sense of control in an interactive story, the more immersive will be the experience. This method would require further study to ascertain its validity and relative value.

Another area for further development is a methodology to test non-linear stories. Games increasingly incorporate player choice, but currently the method does not account for texts with branching paths and multiple possible outcomes. This could be achieved my using a more modular script delivery system, and allowing participants to read in a manner similar to a "choose-your-own-adventure" style book, progressing the story in the manner of their choosing.

The last part of the methodology development would be to adjust it in order to use the process with regular players who represent the target of the game. This would allow us to verify the adjustments made based on the expert feedback and add an additional dimension to the feedback. The regular playtesters could be used to conduct research with a much narrower scope, and iterate on the more contentious areas of the previous expert review. This would allow for better continued support of the narrative portion of our games.

References

1. Bernbeck, S.: What drives a review score? Gameindustry.biz. http://www.gamesindustry.biz/articles/2015-02-09-what-drives-a-review-score
2. Adams, E.: Three problems for interactive storytellers. Gamasutra http://www.gamasutra.com/view/feature/131821/the_designers_notebook_three_.php
3. Jenkins, H.: Game design as narrative architecture. In: Wardrip-Fruin, N., Pat, H. (eds.) First Person: New Media as Story, Performance, and Game, pp. 118–130. MIT Press, Cambridge (2004)
4. Strauss, A., Corbin, J.: Grounded theory methodology. In: Denzin, N.K., Lincoln, Y.S. (eds.) Handbook of Qualitative Research, pp. 217–285. Sage Publications, Thousand Oaks (1994)
5. Matthes, J., Kohring, M.: The content analysis of media frames: Toward improving reliability and validity. J. Commun. **58**(2), 258–279 (2008)
6. Murtagh, F., Ganz, A., McKie, S.: The structure of narrative: the case of film scripts. Pattern Recogn. **42**(2), 302–312 (2009)

Analyses and Evaluation of Systems

Connecting the Dots: Quantifying the Narrative Experience in Interactive Media

Hákon Jarl Hannesson[✉], Thorbjørn Reimann-Andersen, Paolo Burelli, and Luis Emilio Bruni

Aalborg University Copenhagen, 2450 Copenhagen, Denmark
{hakonjarl,thorbjorna}@gmail.com, {pabu,leb}@create.aau.dk

Abstract. In this paper we analyze narrative in interactive media with a special focus on emergent narrative. We detail the criteria for creation of an online questionnaire for the evaluation of emergent narrative as a subjective experience and present the result of a large scale survey in which it was applied. The survey was conducted during a three-week-period in May-June 2015, receiving answers from 14,259 people. Each participant answered based on one of the twenty games chosen for the investigation. The twenty games were chosen to meet one of three inclusion criteria's. Firstly on the usage of descriptive narrative in their communities, which indicates a strong emergent narrative experience, secondly their emergent narrative potential and thirdly for their potential to be used as comparative or baseline measurements. The results strongly indicate that the Emergent Narrative questionnaire is effective for measuring the occurrence of an emergent narrative, when compared to the test-subjects' self-reported experience.

Keywords: Emergent narrative · Interactive narrative · Computer games · Narrative research · Quantifying emergent narrative · Experienced narrative · Closure · Immersion · Narrative transport

1 Introduction

For the past 15–20 years the notion of emergent narrative has received great attention and many efforts have been made to theoretically define its fundamental characteristics. In this paper we attempt to improve the existing definitions in order to propose empirical instruments to assess and measure the degree in which a particular application enables the experience. The questions the present work means to answer are twofold: how to define emergent narrative in the context of video games, how it is experienced by the player and what design considerations or game mechanics are most likely to facilitate such experience.

Until now, no major attempts have been made to measure how an emergent narrative is experienced by players. Considering the apparent lack of consensus on a concrete definition, this article is seen as a step towards an operational definition that may enable a method for assessing and measuring the degree

© Springer International Publishing Switzerland 2015
H. Schoenau-Fog et al. (Eds.): ICIDS 2015, LNCS 9445, pp. 189–201, 2015.
DOI: 10.1007/978-3-319-27036-4_18

in which a subject experiences an emerging narrative. Furthermore, we see our contribution as an attempt to bridge the apparent gap between the research and the development communities.

With the objective of developing a methodology to measure how much a particular interactive application is prone to instantiate an emergent narrative, we designed a questionnaire composed of ten questions and we conducted a survey targeted to on-line players communities. For each of the participants, the questionnaire was followed by a second questionnaire, in which test subjects were asked to rate the individual game mechanics based on their perceived influence on the narrative experience, and to report whether they thought they had experienced an emergent narrative, based on a given definition of the concept. The participants in the study belong either to communities dedicated to video games that yield strong on-line accounts of storification processes and who use descriptive narrative in their retelling of their in-game experiences, or to communities dedicated to games that fit into our other inclusion criteria. Seven main communities were chosen, with thirteen additional games picked based on either their emergent narrative potential, or to be used as a contrasting comparative baseline.

From this group of potential participants, 13,547 people gave usable answers for the emergent narrative questionnaire, and 9438 for the game mechanic questionnaire.

The test was conducted on-line during a three week period in May-June 2015. The results strongly indicate that the emergent narrative questionnaire worked in measuring emergent narrative when compared to the self-reported emergent narrative experience with a strong correlation ($R = 0.947$, $p < 0.05$). It is therefore assumed that the survey succeeded in measuring the emergent narrative experience, based on the explanation given to the test subjects.

2 Background

Since introducing interactivity to the narrative process, the question has been raised about who holds authorial control during the experience. The "narrative paradigm" claims that human beings make sense of any series of events as ongoing narratives, and that most meaningful communication is done through storytelling [7]. Self-constructed narratives serve as a direct representation of a person's perceptual model of experience, sense of personal and cultural identity, and are involved in the creation and construction of memories and social relational patterns [3,17]. It is therefore possible to look at narrative as a cognitive act, ingrained in human experience: a mental construct we use to interpret and understand behaviors and people, and even interactive systems [19].

> "The greater our urge to tell stories about games, the stronger the suggestion that we experienced the game narratively. " - Ryan 2006 [19]

If asked, anybody could tell you a story about any game or any experience; Murray [15] argues that all games are narratives, no matter how abstract they are.

Ryan [19], on the other hand, argues that retell ability, at its base level, is not enough for a game to be considered a narrative, but rather she suggests a middle ground between stating that games can never offer a narrative experience and that all actions in games can be classifiable as narrative.

People will apply different levels of storification to games, as to their life experiences, depending on the impact it has on them. In games, it would depend on the nature of the particular system. Therefore games can also be defined or classified based on their narrative potential.

But how can this cognitive process of storification be measured? Once a personal narrative is written down, it is no longer in the ownership of the author, but becomes understood and interpreted by its audience based on their shared knowledge and experiences [12]. This is one of the main elements that makes storification a hard subject to measure. As soon as a story is told, written down or expressed in any other manner, it will change. On those lines, a story experienced and formed by a video game player through his experience of the game, will remain a story in the player's mind until he finds the need to discuss it or retell it. The actions and events encountered will be experienced, and its not until they are retold that they turn into narrative [1, 2, 18] One of the requirements for descriptive narrative is that the player actually has a story to tell. This can be related to narrative intelligibility and narrative closure, as proposed in [4]. In this perspective, intelligibility is the process by which an audience interprets the narrative in a way that is close to what the author intended. On the other hand, closure is a "process where the audience may construct its own meaning out of what is being mediated, independent of whether that meaning corresponds or gets close to what is intended by the author" [4]. Closure at the system level is usually experienced as meaningful interaction that may result from interactions that are independent of the author and the goal of the system. At the embedded narrative level, closure "entails a good sense of having experienced a narrative, which, however, does not necessarily coincide with the author's preferred or intended interpretation" [4]. This tells us that whether or not a system or narrative is created with the purpose of creating a highly didascalic or intelligible narrative, a user can still experience closure on either of these levels.

2.1 Emergent Narrative

The concept of emergent narrative has been discussed in the field of interactive narrative for around twenty years. In 1995, Tinsley Galyean offered what may be the first account of emergent narrative in connection with interactive media:

> "We all construct narratives out of our daily activities to help us remember, understand, categorize and share experiences. [...] We, by combining the elements of these spaces with our goals, allow a narrative to emerge. If any narrative structure emerges it is a product of our interactions and goals as we navigate the experience. I call this 'Emergent Narrative'." [9, 21]

In our paper, games are seen as a medium which has a great potential for narrative when designed with specific considerations in mind. But saying that all games are narrative and that all games can contain stories is counter-productive. What needs to be looked at, are the nuances and experiences that the player has, which makes him perceive and experience the game as narrative and how these experiences differ between games.

As mentioned by Ryan [19], games have the basic ingredients to create a narrative: characters, events, settings and beginning and end states. However, not all games will include all these ingredients as it will depend on the purpose and design of the specific game. Walsh [21] sums up a lot of the ongoing discussion. He argues that the seemingly straightforward notion of emergence gets more complicated in the context of digital media. He sees two different ways of how "emergent narrative" is being considered. The first one could be classified as the storification process, while the second is seen as a product the of interaction between the user and the digital agent (or bot) within the simulated environment.

The two ways or models of looking at emergent narrative are similar, but have different implications. Both look at interactivity as a prerequisite for emergence, but differ in where the creation of the narrative takes place during the interaction between the user and the system [21]. The storification process looks at emergent narrative as being created within the player himself, involving his cognitive processes, but affected by the feedback his interactions with the system offer.

The second model, a character based narrative system, is meant to account for the emergence of narrative through interaction, but within and from the system. We do not take sides in this here, since both accounts may contribute towards the design and creation of emergent narratives. Maybe the key point is not to so much to simulate narrative but to orchestrate the experiencing of it, and while character narrative systems are not fully developed, emergent narrative should still be pursued on a personal level, through the creation of systems which can facilitate its emergence within the player's cognitive processes.

As already mentioned, the term "emergent narrative" has been widely discussed and there are several different definitions [1,2,8–11,13,14,19,20]

Therefore it is pertinent to provide an operational definition for the purposes of this paper:

> *Emergent narrative is an intrinsic experience, which transpires as a mental process, through cognitive storification or alter biographing, as a player interacts with a systematic virtual environment. As the player navigates and interacts with the game environment and ludic system, the story emerges through that interaction, either during the play session, or post-facto, once the player has had time to reflect on the events experienced. The story that emerges is therefore a non-scripted, self-narrated player story that gives a sense of closure. It is a narrative that to the player feels unique.*

Or in other words:

> *Emergent narrative is created, internally by the player, as a non-scripted self-narrated player story that gives a sense of closure.*

In the survey, it is explained to the test subjects as:

> *An emergent narrative experience is something that happens to you as player, as you progress and interact with the game world. Under some circumstances the player might start experiencing events or "stories" that don't tie directly into the storyline of the game, but rather are events that you feel are unique stories happening to you just because you chose to act in a certain way (and might not happen again).*

3 Survey Design

3.1 Questionnaire

The purpose of the work detailed in this article is the development of methods to assess and quantify the potential for an emergent narrative experience in particular applications. In general, computer game narratives are inherently different from narratives presented in other traditional media. This is due to the interactivity afforded by the medium and in how the story is presented and how it evolves around the user. This is especially the case when dealing with emergent narrative games. Therefore, trying to use traditional measurements of narrative might present difficulties and ambiguities when measuring the occurrence of emerging narrative.

When trying to look at internalized narrative or emergent narrative, asking people to write or retell their descriptive narrative [16] might not necessarily gather the most usable data, as mentioned by both Calleja and Ryan [5,19]. Furthermore, as soon as a story is told or expressed in another manner, and as soon as you ask a person to tell you the story, the internalized aspects of it will change. This change can be caused by choice of language, storytelling skill or storytelling methods. Additionally, asking a person to tell a story might induce the player into creating a story, even if no such a process was triggered by the narrative experience.

The story could be analysed and conclusions drawn from it; however, this would not necessarily help in establishing whether the experience yielded an emergent narrative. For these reasons, the questionnaire needs to look for instances of storification and at what features can "cause" an emergent narrative. The questionnaire was designed using a five point Likert scale, with an additional N/A option.

Ten questions were designed to highlight the following aspects of the narrative experience:

- The player breaks out of the perceived game rules and structures, to make decisions of their own and experience their own story.
- The game offers enough narrative freedom for the player to experience the emergence of a personal narrative.

– The player feels ownership and/or emotional attachment of/to the narrative and the characters in it.
– The player has a need to describe or retell their experiences.

The following 10 questions composed the questionnaire:

1. While playing, I was more interested in creating my own goals than following the main objectives given by the game.
2. I was more interested in experiencing the game world and creating my own objectives, than following the main or side quests/objectives in the game
3. The main character had different objectives than those presented in the main story
4. If given the option, I would have made different choices than my main character
5. My story was somehow special. I think I experienced a story that not many other people have experienced
6. I found myself thinking about how the main character would react in situations not presented in the game
7. I found myself thinking about the main character's background story, even information not presented in game itself
8. On occasions I have found myself thinking about what I would do in the game, while not playing it
9. While playing, I felt like my in-game decisions had no effect on the story I experienced
10. I feel strongly about my experience and would consider writing it up or talking about it to other people (either online, offline or both)

The ratings given to the ten questions are combined in an emergent narrative score calculated as a normalised mean value of the each question's rating.

3.2 Games

The next step was finding released game products that already seem to facilitate the experience of emergent narrative. A few games already fall into that category, based on the fact that the designers were indeed trying to specifically create emergent narrative with their games. But in order to get a broader spectrum to analyse, this next section will talk about how a total of twenty games were chosen for the evaluation. An on-line search was conducted to find communities of gamers who have written detailed stories, covering their experiences in games. On Reddit.com and other on-line gaming forums, a great amount of player reported stories were found concerning certain games. From this, the assumption was made, that the players of those games were indeed experiencing some form of emergent narrative.

In her model of interactivity [19], Ryan defines four main types of interaction. The internal type of interactivity is when the player will project him or herself as a member of the virtual environment. This happens when the players starts identifying with an avatar, which can be shown both in the first and

third person perspective. In an external interactivity, the players point of view is situated outside or above the fictional world. The player then does not "physically partake in the happenings of the world, but rather participates through omnipotent observation. Exploratory interactivity allows players to navigate the game environment but does not allow altering of the plot, the player therefore becomes an observer rather than participant of the games event, and by contrast, in ontological interactivity, the decisions of the user will affect the story and story world in predictable or unpredictable manner giving a sense of agency or participation in the story.

According to Ryan's model of interactivity games that are internally ontological, or externally ontological are more likely to create emergent narrative than other types of games. The focus was therefore put on choosing games that would fall into those categories. For further analysis purposes, a wider range of games were also be included: both games that seemed to offer emergent narrative, but also games which could serve as comparisons; from other genres or design considerations and games that fall into the modes of interactivity. Lastly a few more basic, so called, "arcade" games were included. The reasoning for this is the assumption, that these types of games would have relatively rare instances of emergent narrative, and could therefore provide a baseline for the questionnaire. As part of including the widest range possible, games that offered either multiplayer or single player experiences were also included to see if the social aspect would influence the appearance of emergent narrative. [6]

Further inclusion criteria were the size of the on-line communities. Since the aim was to create an on-line survey, the bigger communities of gamers that fitted into our classification, should be reached. On Reddit.com, individual sub-reddits show the number of people that subscribe to it, so after classifying a list of possible games that met the requirements, in some instances the games with the bigger community would be chosen. The games chosen have all been released in the past five years (with the exception of the arcade games, and EVE Online, which has received continuous updates since its launch in 2003), and all have a relatively big and active online community.

Figure 1 shows the list of selected games categorised according to the type of interactivity organized along two conceptual pairs: internal / external and exploratory / ontological [19]. Among these games, the following are connected to an active community with a strong presence of online descriptive narrative, or to communities where players discuss and retell their experiences on forums and sub-reddits in a way that could strongly indicate an emergent narrative experience: *Civilization V, Crusader Kings 2, DayZ, Europa Universalis 4, EVE Online, Rimworld and Total War: Rome II.*

Additionally 13 other games were chosen, either based on their emergent narrative potential: *Far Cry 4, Minecraft, Mount & Blade: Warband, The Elder Scrolls V: Skyrim, The Sims 4* and *This War of Mine* or to be used for comparisons: *ARMA 3, Bioshock Inifite, Battlefield 4, Donkey Kong, Space Invaders, Spelunky* and *Super Mario Bros.*

	Internal	External
Exploratory	● Battlefield 4 ● Bioshock Infinite	● Super Mario ● Spellunky ● Space Invaders ● Donkey Kong
Ontological	● EVE online ● Skyrim ● Arma 3 (Multiplayer) ● Far Cry 4 ● Minecraft ● DayZ	● Mount & Blade: Warband ● RimWorld ● Europa Universalis 4 ● Total War: Rome II ● The Sims 4 ● Civilization 5 ● Crusader Kings 2 ● This War of Mine

Fig. 1. The games included in the survey classified according to Ryan's categorisation of interactivity, internal / external and exploratory / ontological [19]

4 Results

The demographics of the final sample was very much as expected; predominately male (67 %, female: 32 %, other 1 %), with most participants in the below 15 age group (0–15:62 %, 15–20:20 %, 21–25:11 % and the remaining 7 % spread out over higher age groups) and most participants from the United States of America. The age question on the demographics page had the age 15 and below preselected. Since not all test subjects filled out the demographics page, these numbers cannot be fully trusted.

In order to clean the collected data, four properties needed to be looked at before any meaningful analysis can be performed. Because the Likert scale questions were set up so that Neutral was preselected, all participants who had Neutral answers for all questions, were removed. Additionally duplicate answers had to be removed, due to the way the survey was implemented.

Since Likert scales are being created, each questionnaire had to receive at least four answers to be included. If a person had answered with N/A for more than the total number of questions - 4, those answers were excluded from that particular questionnaire's data. The last thing to check in the datasets, is whether there are any extremes (i.e. people who only answered, either, strongly disagree or strongly agree). These answers are most likely from participants who only wanted to participate for the chance to win one of the prizes. This could be checked in the Emergent Narrative questionnaire, since question nine was negatively worded (and reverse scored).

Table 1. Emergent narrative questionnaire mean scores compared to mean self-reported level of emergent narrative

Game	Questionnaire score	Self-reported emergent narrative
Crusader Kings 2	1,274	1,645
Europa Universalis 4	1,261	1,458
Eve Online	1,242	1,710
RimWorld	1,199	1,382
DayZ	1,161	1,625
Total war: Rome II	1,058	1,317
Minecraft	0,953	1,095
Civilization 5	0,933	1,237
The Sims 4	0,885	1,077
Mount & Blade Warband	0,883	1,295
Skyrim	0,721	0,999
Arma 3	0,641	1,145
Far Cry 4	0,404	0,796
Bioshock infinite	0,343	0,062
Spelunky	0,204	0,250
Battlefield 4	0,003	-0,159

Note that we have excluded the arcade games (*Donkey Kong, Super Mario Bros* and *Space Invaders*) and one of the modern games (*This War of Mine*), as their response rate was below our inclusion threshold. From, the initial 14259 questionnaires answered, approximately 5 % were removed in this process resulting in a total of 13547 valid data answers. The resulting Emergent Narrative score for each game can be seen in Table 1, sorted in a descending order.

4.1 Validation of the Questionnaire

To validate the results of the Emergent Narrative questionnaire we had included a question in the Game Mechanics questionnaire, that asked the participants to rate how much they thought they have experienced emergent narrative. In order to minimise the chance that the participants answered based on their own preconceptions, they were presented with the following description of emergent narrative:

> *An emergent narrative experience is something that happens to you as the player, as you progress and interact with the game world. Under some circumstances the player might start experiencing events or "stories" that do not tie directly into the storyline of the game, but rather are events that you feel are unique stories happening to you just because you chose to act in a certain way (and might not happen again).*

This description and question was presented to the participants *after* having answered the questions in the Emergent Narrative questionnaire, to avoid any potential biasing this might have introduced. Comparing this data with the results from the Emergent Narrative questionnaire reveals a strong and significant correlation with a Pearson's R value of 0.947 at an alpha level of 0.05. The validity of the questionnaire's score is further strengthened by the lack of significant difference between the Emergent Narrative and self reported scores revealed by a pairwise Mann-Whitney performed on each game.

Additionally, the results of the Emergent Narrative questionnaire match very well with the games that we selected because of their strong descriptive narrative communities and with the games we selected because of their emergent narrative potential. The games showing the strongest communities were: *Crusader Kings 2, Dayz, Europa Universalis 4, EVE Online, Civilization V, Rimworld* and *Total War: Rome II*. Five of these six games, make up the highest rated emergent narrative experiences. Furthermore the games perceived as having a strong emergent narrative potential line up most of the middle half of the scale with the exception of *Far Cry 4* being rated lower than expected.

From this we can conclude that what we tried to measure in the Emergent Narrative questionnaire, and the self-reported emergent narrative question of the Game Mechanics questionnaire (based on our explanation of it) in the survey are close to the same. We can therefore say that the Emergent Narrative questionnaire measures the almost same amount of emergent narrative as the self-reported answers.

4.2 Emergent Narrative and Game Mechanics

Looking at the game mechanics could give an indication of which systems are the strongest in the creation of emergent narrative. However this is debatable on many levels: the game mechanics where chosen and defined by us. All game mechanics might not have been included for a specific game or a particular game mechanic could have been omitted from the Game Mechanic questionnaire, because it is not present in the games we chose. What can be concluded is that the highest rated game mechanics seem to match with those seen in the highest rated Emergent Narrative games. This indicates that the systems of those games have been designed to include game mechanics that in a way facilitate emergent narrative. So investigating exactly what these interconnections are would be an interesting next step. Taking the top ranking game mechanics results in a list of likely game mechanics that can increase emergent narrative, if implemented properly. However as no analysis on the implementations of the game mechanics and their in-game relationship has been performed, no further conclusions will be made at this time. Further analysis into the design of these specific systems, and the considerations used in their creation could lead to interesting results.

5 Discussion

The results presented in the previous section confirm the validity of the proposed questionnaire across the games considered in the survey in relationship to the aforementioned definition of emergent narrative. It is therefore interesting to analyse the absolute scores that some of the games analysed have achieved. For instance, the games of *The Sims* franchise are in many ways an abstract simulation of human life, and are widely referenced in the research community. So why does it get only an average score on the emergent narrative questionnaire? It could be exactly because it is an abstract simulation of human life. There are not any goals built into the system of the game, it is just a simulation of life. There are no system actively working against you, trying to make you fail the game and this completely open and "unopposed" gameplay might not be giving the players the closure they need to experience emergent narrative.

Minecraft was expected to be higher on the emergent Narrative score; however, it is interesting to notice that the emergence in *Minecraft* happens within the games creation process, not as an experienced story for the player. The players discuss mostly their creations and their experience of constructing them, and do not talk about the stories they experienced in the game. While there are some stories about the adventures of *Minecraft* players, they are mostly anecdotal in nature.

The score achieved by *Mount and Blade: Warband* is most likely due to a lack in character interaction. The game system offers a great amount of re-playability, since its system will never play out the same way, but it has a low degree of closure; people rarely finish a full game, but frequently start up new games using new player created modifications.

Similarly to *The Sims*, the games *Skyrim* and *Far Cry 4* achieved an unexpected low score. Both games are strong in free exploration and player choices but also really strong in getting the player back on track by mixing it with linear narrative, and both score middling to low on the Emergent Narrative questionnaire. It would be interesting to take a closer look at these two games and investigate the exact nature of the narrative experience players are having in these games

Another aspect worth considering is the extents of the validity of the proposed questionnaire, as the base-line value measure used to validate it describes only a specific definition of emergent narrative. While it is our belief that the explanatory text presented to the test participants captures the emergent narrative experience well enough, and in a format understandable in layman's terms, a researcher interested in a different definition of emergent narrative would need to perform a validation of the questionnaire presented in this article.

As part of the questionnaire, the test subjects were asked how many hours they had put into the game, with the option to answer somewhere between 0 to 50+ hours. The reason nothing is being concluded from that data, is that it is seen as a missed opportunity. A more important question, could have accounted for re-playability, by asking how many times the test subjects have started a new game, or how many times they have created a new character, which could have

given an indication of the replay value of that title. That combined with the emergent narrative score would then have shown more definitely which games are offering strong emergent narrative experiences with re-playability. Another fact about that question is that we cut it off at 50+ hours. It is worth considering that people who go out of their way to subscribe to a specific subreddit where only a single game is discussed, are very likely to have put some hours into the game, making the question quite irrelevant. On top of that, we received number of the personal messages and on-line comments to the survey, criticizing that question as giving way to low values. Our original idea with this question was our assumption that in order to start experiencing emergent narrative, a player would need to have played a certain amount of hours (dependent on the game) in order to fully understand the game mechanics and therefore, becoming fluent enough in the "language" of the game to start experiencing his own emergent narrative, but we could have used this question to a much greater effect.

All in all, the Emergent Narrative questionnaire, shows that the emergent narrative experience can be quantified to certain extent, and that the research community could benefit from looking closer at what the industry is currently doing. The data set gathered in this research also shows great promise where further analysis could yield design frameworks or design considerations for designers and researchers alike.

6 Conclusion

In this paper, the first attempt to quantify emergent narrative has been outlined with the creation of an Emergent Narrative questionnaire. An on-line survey was designed and conducted of which one part was the Emergent Narrative questionnaire. The survey was presented to members of 20 different groups in the Reddit.com community, each concerning one of the twenty games chosen. The final tally of use-able answers was 13,547. When analyzing the results there was no significant difference measured between the emergent narrative questionnaire and the self-reported emergent experience ($P = 0.06 < 0.05$) with a strong correlation of $R(14) = 0.947$, $p < 0.05$. It is therefore assumed that the questionnaire created in this paper worked relatively well in classifying emergent narrative. There is still a great deal of work that needs to be done. The questionnaire itself needs further analysis and validation, before it can be considered complete. An interesting next step could be giving increased attention to the games that ranked the highest on the emergent narrative scale, and do qualitative analysis on how the systems within those games work and how they influence the player's experience of emergent narrative. It is our belief that useful design frameworks and considerations could be developed from this work, which could possibly make their mark on the research community and the video game industry alike.

References

1. Adams, E., Rollings, A.: Fundamentals of Game Design. New Riders, Berkeley (2010)
2. Aylett, R.: Narrative in virtual environments-towards emergent narrative (1999)
3. Bruner, J.S.: Acts of Meaning. Harvard University Press, London (1990)
4. Bruni, L.E., Baceviciute, S.: Narrative intelligibility and closure in interactive systems. In: Koenitz, H., Sezen, T.I., Ferri, G., Haahr, M., Sezen, D., Çatak, G. (eds.) ICIDS 2013. LNCS, vol. 8230, pp. 13–24. Springer, Heidelberg (2013)
5. Calleja, G.: Experiential narrative in game environments. In: DiGRA International Conference Proceedings. Digital Games Research Association (2009)
6. Calleja, G.: Narrative involvement in digital games. In: Conference proceedings from Foundations of Digital Games. Chania, Crete, Greece (2013)
7. Fisher, W.R.: Narration as a human communication paradigm: the case of public moral argument. Commun. Monogr. **51**(1), 1–22 (1984)
8. Fullerton, T., Swain, C., Hoffman, S.: Game Design Workshop. Elsevier Morgan Kaufmann, San Francisco (2008)
9. Galyean, T.A.: Narrative guidance of interactivity. Massachusetts Institute of Technology (1995)
10. Jenkins, H.: Game design as narrative architecture the game design reader. In: Tekinbas, K.S., Zimmerman, E. (eds.) The Game Design Reader: A Rules of Play Anthology. MIT Press, Cambridge (2006)
11. Kriegel, M., Aylett, R.S.: Emergent narrative as a novel framework for massively collaborative authoring. In: Prendinger, H., Lester, J.C., Ishizuka, M. (eds.) IVA 2008. LNCS (LNAI), vol. 5208, pp. 73–80. Springer, Heidelberg (2008)
12. Langellier, K.M.: Personal narratives: Perspectives on theory and research. Text Perform. Q. **9**(4), 243–276 (1989)
13. Louchart, S., Aylett, R.: Emergent narrative, requirements and high-level architecture. In: Proceedings of the 3rd hellenic conference on artificial intelligence (setn 2004), pp. 298–308 (2004)
14. Louchart, S., Swartjes, I., Kriegel, M., Aylett, R.S.: Purposeful authoring for emergent narrative. In: Spierling, U., Szilas, N. (eds.) ICIDS 2008. LNCS, vol. 5334, pp. 273–284. Springer, Heidelberg (2008)
15. Murray, J.: The last word on ludology v narratology in game studies. In: International DiGRA Conference, June 2005
16. Pearce, C.: First person: new media as story, performance, and game. First person: new media as story, performance, and game (Towards a game theory of game), 42–0713-42–0713 (2004)
17. Polkinghorne, D.: Narrative Knowing and the Human Sciences. State University of New York Press, Albany (1988)
18. Rackham, H.: Aristotle, The nicomachean ethics, vol. 19. CUP Archive (1926)
19. Ryan, M.L.: Avatars of Story. University of Minnesota Press, Minneapolis (2006)
20. Schoenau-Fog, H., Bruni, L.E., Khalil, F.F., Faizi, J.: Authoring for engagement in interactive dramatic experiences for learning. Trans. Edutainment **7775**(X), 1–19 (2013)
21. Walsh, R.: Emergent narrative in interactive media. Narrative **19**(1), 72–85 (2011)

Interaction in Surround Video: The Effect of Auditory Feedback on Enjoyment

Mirjam Vosmeer[1(✉)], Christian Roth[2], and Ben Schouten[1]

[1] Interaction & Games Lab, Amsterdam University of Applied Sciences,
Postbus 1025, 1000 BA Amsterdam, The Netherlands
{m.s.vosmeer,b.a.m.schouten}@hva.nl
[2] Department of Communication Science, VU University Amsterdam,
Amsterdam, Netherlands
roth@spieleforschung.de

Abstract. This study investigates whether an interactive surround video is perceived as more enjoyable when there is some auditory feedback on interactive moments. We constructed a questionnaire that measured presence, effectance, autonomy, flow, enjoyment, system usability, user satisfaction and identification, filled in by two groups of respondents who had either watched an interactive movie on Oculus Rift with feedback sounds, or a version without. Our results show that users rated presence significantly lower in the feedback condition. We rejected our hypothesis, that auditory feedback would increase the perception of effectance.

Keywords: Interactive cinema · Video games · Presence · Immersion · Enjoyment · Flow · Surround video · Oculus rift

1 Introduction

The introduction of a series of media systems that allow users to experience movies in 360° has opened up a whole new range of research questions into the field of Interactive Storytelling (IS). Surround video is the term that is often used for this type of video [1], that can be watched with for instance Oculus Rift, Samsung Gear Port VR or the - technologically less advanced but surprisingly effective - Google Cardboard. As implied by the term, with this kind of media the user is able to look all around - and often also above and underneath -, from a viewpoint that feels as if he or she is actually positioned in the middle of the movie. Some of the challenges that producers face, when aiming to capture this kind of real live video footage, have been pointed out by [2]. However, also media researchers are challenged by new issues that might require them to re-evaluate existing theoretical concepts and to investigate how media productions like this may be enjoyed by lay audiences. After all, only appreciation among a general public will eventually lead to market success. A defining quality of surround video is that it seems to merge characteristics of both movie and video game. The viewer is able to look all around and study elements that are displayed in the movie, such as actors and props, without his or her gaze being guided by the frames that have been decided upon by the director. This point of view reminds of playing an open

© Springer International Publishing Switzerland 2015
H. Schoenau-Fog et al. (Eds.): ICIDS 2015, LNCS 9445, pp. 202–210, 2015.
DOI: 10.1007/978-3-319-27036-4_19

world video game. To move the narrative forwards, interactive elements can be added to the video, which is also reminiscent of playing a game.

The difference in engagement style between the passive position of someone who is watching a movie and the active position of a person playing a video game has been referred to as *lean back* versus *lean forward* [3]. Vosmeer and Schouten [2] have proposed to use the term *lean in* for the engagement style with media such as surround video, in which the user position is neither fully lean-back nor completely lean forward. For these lean in media, concepts such as presence, flow, effectance and enjoyment may be related in different ways than previously discussed in the field of Interactive Storytelling. And since the impact of interaction on user engagement might take different forms as well, it is useful to study the user experience with IS from this new perspective. For the current research project, we have focused on the way that the perception of interaction in a surround video affects the user experience. The interactive drama *A Perfect Party* was specifically produced for this study. The video was presented in an experimental version and a control version during a special Oculus Rift-event that was held in January 2015 in Amsterdam. All the visitors who came to user the application were invited to fill in a questionnaire in which the concept enjoyment and seven other dimensions were measured. The application itself will be discussed in further detail in the method section of this paper.

2 Backgrounds

To allow for interaction in a surround video, small elements of code can be implemented in the application that allow the viewer to have some degree of agency over the events that happen on the screen. By looking towards one of these so-called hot-spots (which could be compared to clicking on a link in an HTML page), the user can activate the next part of the scene. In the field of Interactive Storytelling, research has often focused on the freedom that may be given to users, by letting them choose alternative outcomes for the narrative [4]. This kind of "branched" or "multiple pathway" story structure has for a long time been extremely prevalent within the multimedia industry, academia, and popular culture at large [5]. Murtaugh cites Genette [6] in his critique of such narrative structures, stating that "branch point" interactions are disruptive not only because they stop the story to wait for user input, but they also place the consequence of an action performed by the viewer within the diegesis. According to [5], interactivity should serve the narrative by focusing the viewer's attention on the story rather than on the discourse (to use Genette's terminology), or on the storyworld rather than on the medium.

Another more practical problem of branched story structures has been noted by [4], namely that narratives like that must contain vast amounts of story content. While for developers who create stories in VR, this may be an interesting challenge towards the field of automated story generation, for producers of live video content, it inevitably becomes a massive problem after already two or three branch points.

A second option for an interactive story structure is what has been referred to as 'string of pearls' [7]. This is essentially a linear structure, made up of a string of small episodes, in which the user may need to perform a specific action that will allow him to

advance to the next section of the story. With this kind of structure, users follow only one possible route through the storyline, with just one final outcome. Here, the story is no longer 'disrupted' by giving viewers authority over the outcome, but they still have impact on the temporality of the narrative.

When users move through an interactive story, there is a 'risk' that they will not even notice the fact that they had an impact on the events that happened on the screen - or in case of surround video, in the video scene that is displayed around him. When the technological part of the experience runs smoothly, users may not be aware of the fact that by gazing at a certain object, they started the next part of the scene, and might, in the case of a branched story structure, not even realize that alternative endings would have been possible. This signifies, in fact, an ideal kind of interactive experience as discussed by [5], as the users' attention is completely on the product, and not on the process of narrating. However, experiments with fake interactive stories have shown that when users feel that they have some kind of agency, they enjoy this experience, whether the agency is real or not [8]. So while it can be theoretically argued, on one side, that interactivity is 'disruptive' and might lower the enjoyment of an application, awareness of the autonomy, on the other side, might be an important factor in the overall enjoyment as well. In the current study, we therefore aimed to find out if users of interactive stories enjoy it more when they are given some feedback on interactive moments, or whether they prefer to move through the narrative without distraction. To establish this difference, we have measured the user experience of two groups of users, each group watching a different version of the same interactive movie – one in which some auditory feedback is given on successful interactive moments, and one in which this is not the case.

2.1 Measuring the User Experience

To generate empirical and conceptual knowledge about the specific ways that users evaluate interactive stories, a broad range of entertainment-related measures has been proposed. Roth et al. [9] conducted a theoretical analysis which resulted in a dimensional framework of the most important and most likely dimensions of the user experience in IS. For our current study, in which we wanted to focus on the effect that awareness of interactivity might have on the user experience while engaging in a surround video, we have selected the following list of eight measures from this framework:

Presence is the first concept that needs to be explored, when studying the reception of surround video. Presence has been a popular focus of research since the 1990 s with the development of the first virtual reality technologies [10]. The term is connected to immersion and relates to a sense of 'being in the story world'. This is exactly what happens when engaging in a 360° video experience, as the story world is literally displayed all around the user. The second concept that is often measured in IS studies is *effectance*. This measure considers whether the user is able to recognize when and how he has causally affected the story world, a notion that is directly related to our current research question. *Autonomy*, which refers to the freedom to determine one's own actions and behavior, is the third measure we have included in our study. *Flow* is the

fourth concept, and a term that is often discussed in relation to media enjoyment. Flow is described as the process of optimal experience, "the state in which individuals become so absorbed in an activity that nothing else seems to matter" [11]. *Enjoyment* itself was measured as well, as fifth concept on this list [12]. Verdugo et al. [13] have stated that one of the enormous challenges that creators of interactive narratives face is that both the aesthetic potential and the technical aspects must be considered, in order to come up with a media product that will effectively catch the audience's interest. In our current study, we therefore also included *system usability* and *user satisfaction* as our fifth and sixth concepts, investigating whether the technical aspects of the system were unobtrusive enough to allow the user to enjoy the aesthetic aspects of the experience, and feel satisfied about it. Finally, the eighth concept we wanted to investigate is *identification*, for instance to verify whether men and women would connect differently with the male character position and probably therefore also experience the interactivity in a different way.

From previous studies, we are able to formulate a tentative hypothesis. Effectance and presence are important for the enjoyment of interactive media, and people appreciate to hear or feel when they had an impact on the narrative. An agency study showed that feedback sounds increase the users' perception of influencing the course of a story [14]. We might therefore expect that the condition with auditory feedback will increase perception of having influence on the story (effectance) and will therefore be more enjoyed than the version of our Oculus Rift movie in which we expect no or limited awareness of interaction.

3 Method

In this section we will discuss the movie *A Perfect Party* and proceed with the design of the questionnaire and descriptions of the experimental setting and the group of participants that took part in our study.

3.1 Material

As stimulus we used the surround video *A Perfect Party*, produced by students of the MediaLab Amsterdam of the Amsterdam University of Applied Science. This short interactive drama can be experienced using a virtual reality display such as Oculus Rift. It was filmed using a special camera system, developed by the Dutch company WeMakeVR. This camera consists of a particular construction of lenses, supported by specialized software, which allows for recording live action 360° video footage. The movie was part of a research project for which a group of five students explored the narrative, production and design challenges that they would encounter while creating a video for Oculus Rift [15].

The movie narrative itself takes place at a party, which has just started when the user enters the experience. In the role of the main character, the user is made clear that he/she is hosting a get-together for the best friend who plans to propose to his girlfriend that night. The success of the party and therefore the proposal depends on user behavior. Interaction is established by gazing at the various hot-spots that are

implemented within the scene. The first interactive moment, for which the user is asked by one of the characters to locate her missing violin, serves as a tutorial to make the user comfortable with the system. Users are also suggested choices by a voice-over, which speaks to them in a second person, as if to verbalize one's own inner thoughts. The voice-over might, for instance, state that you would like to hear some music and therefore look at the DJ, whereupon the DJ steps up to the turntable and puts on a record. This then causes the other guests in the room to start dancing. Later in the movie, by making a choice whether to focus on the entrance door or not, the viewer can either evoke scene A in which an uninvited guest enters the room and starts a fight, or scene B in which the door will be locked by a friend and the fight does not happen. Other interactions include finding objects in time, as for instance, the engagement ring. In total, A Perfect Party features 5 interaction points, in a story structure that is partly branched, and partly linear. The narrative leads to four different outcomes and final scenes. In all of them, the prospective groom gets to propose to his girlfriend, but dependent on the previous user choices, the other guests have fled the room because of a smoke alarm that has gone off, or the proposal has to be conducted without the engagement ring.

An experimental version of the application was developed, featuring auditory feedback, a guitar riff, for successful interactions. The guitar riff sound was chosen to fit the scenery, which shows one party guest with a guitar, sitting on one side of the party room.

3.2 Design

Our experiment used a 2 × 8 between-subjects design to compare eight user experiences of interactive surround video between two conditions. For the experimental group, auditory feedback was implemented as a feedback for successful interactions. This independent variable was not present for the control group, which experienced the same interactions without auditory feedback. The dependent variables were eight user experience dimensions taken from the short-scale version of the measurement battery for Interactive Storytelling evaluation [9]: enjoyment (2 items); autonomy, presence, identification, system usability (3 items each); flow, effectance, and user satisfaction (with 5 items each). The questionnaire asked participants to rate how much they agree with statements regarding their user experience (e.g. "The experience was entertaining."). All dimensions were measured using a 5-point-Likert scale ranging from 1 (strongly disagree) over 3 (neutral) to 5 (strongly agree). Apart from the items that measured the user experience, we also inquired about age, gender and previous experience with video games and VR applications, in order to investigate whether any of these would significantly influence the overall experience as well.

3.3 Procedure

Upon entering the research lab, participants were randomly assigned to one of the two conditions and then waited for their turn, since only two (identical) VR systems were available. Then, participants were briefly instructed and helped into the head-mounted

Oculus displays and headphones, before the *A Perfect Party* application was started. The experience lasted for an average of 10 to 11 min and participants experienced the application while standing to fit the posture of their character in the story, who is also standing. Afterwards, participants were helped out of the VR system and instructed to fill out our paper-and-pencil evaluation questionnaire.

3.4 Participants

A sample of 287 guests of the *A Perfect Party* presentation event voluntarily participated in our study over the course of five days. 13 participants did not fill out the second page of the paper questionnaire and were excluded from further analysis. The final sample consisted of $N = 274$ participants; 144 males and 130 females between the ages of 9 and 72, with an average age of $M = 32.9$ years ($SD = 13.5$ years). Participants had a low degree of computer game literacy ($M = 2.22$, $SD = 1.06$) and a low degree of VR experience ($M = 1.65$, $SD = .81$), both on a scale from 1(no experience) to 5 (a lot of experience). We controlled for an equal distribution of gender to experimental and control group.

4 Results

In a first step, we ensured that experimental and control group were similar. We compared mean values with independent samples T-tests and found no significant differences regarding age, gender, video game and VR experience.

Reliability of the short-scales was satisfying. Only the recoded autonomy item 3 ("I felt strong limitations to my decisions on how the story should proceed.") was removed for a better reliability of the autonomy scale. See Table 1 for the reliability of each scale.

Multiple regression analysis was used to test if user experience dimensions significantly predicted participants' ratings of enjoyment. The results of the regression indicated that three predictors explained 58 % of the variance ($R^2 = .35$, $F(3, 265) = 46.9$, p < .001). It was found that presence significantly predicted enjoyment ($\beta = .33, p < .001$), as did autonomy ($\beta = .27, p < .001$) and usability ($\beta = .25, p < .001$).

Within-subject comparison by means of independent samples T-tests revealed that auditory feedback mainly affected the perception of presence (see Table 1 for results). Users rated presence significantly lower when getting the guitar riff sound as feedback for their actions. As a result, we have to reject our hypothesis, that auditory feedback will increase the perception of effectance.

Overall, participants enjoyed both versions of the application and gave the applications positive ratings (over 4) regarding system usability, perceived presence and user satisfaction. Albeit non-significant, we can see a trend of users liking the version without auditory feedback slightly better. Autonomy got the lowest rating from both groups; the score of ca. 3 equals a neutral user rating, which suggests that users perceived limited interaction possibilities.

Table 1. Comparison of user ratings between experimental and control group (*N* = 274)

	Reliability	No auditory feedback		Auditory feedback		
		M	SD	M	SD	P
System usability	α = .76	4.29	.51	4.19	.54	.10
Effectance	α = .89	3.51	.83	3.54	.88	.78
Autonomy	r = .54**	2.95	.94	3.08	.89	.23
Flow	α = .75	3.59	.63	3.58	.71	.92
Presence	α = .72	4.10	.65	3.93	.69	.034*
Identification	α = .77	3.37	.80	3.25	.82	.21
User satisfaction	α = .80	3.95	.63	3.89	.58	.39
Enjoyment	r = .47**	4.29	.53	4.18	.63	.13

Note: * significant difference at $p < .05$, ** significant difference at $p < .01$. Reliabilities of scales with only two items were assessed using Pearson's r correlations.

5 Conclusion

Our study aimed to investigate whether users of an interactive surround video prefer auditory feedback when they have successfully interacted with the narrative, or if they like it better when there is no feedback. Since users enjoy the sense of autonomy that interactive media give them, we had expected the experimental version in which a short sound was played when hot-spots in the movie were activated, to score higher on the user experience measures that we had included in our questionnaire. However, it turned out that the version without feedback was enjoyed more than the version with feedback. We learned from our results that presence, autonomy and usability drive the enjoyment of the immersive interactive application *A Perfect Party*. We expected auditory feedback to increase perceived effectance on story development but found that it did not increase effectance, but reduced the perception of being in a non-mediated environment (presence) and thus might lower suspension of disbelief. In other words: the small sound effects that were implemented in the movie lowered the sense of 'being in the story world' and might have indeed, as theoretically predicted by Genette [6] been perceived as being slightly disruptive.

Another more general but meaningful conclusion may be drawn from some of the background characteristics of our group of respondents. We observed that neither age nor gender had any significant effect on the overall experience of enjoyment that the surround video generated. Also, whether a respondent had a lot of experience playing video games or using other VR applications or not, did not make any difference in their appreciation of the movie and the system it was displayed with. Basically, all people of all ages scored high on system usability, which meant that they enjoyed wearing the Oculus Rift. User satisfaction was also quite high for all groups: most people were delighted to participate in the interactive movie that was displayed around them. This means that a shift towards *lean in* entertainment media is made just as easily

by *lean back* audiences as it is for people who are familiar with *lean forward* media. For producers of interactive 360° content, this finding may point towards promising possibilities of developing successful surround video projects for all kinds of audiences within a general public, without having to feel limited to the traditional (male) video game players' preferences considering themes and settings.

6 Discussion

However, both the experimental setting and the content of the application have confronted us with some limitations, which may have had influence on the final outcome of our research project. To start with, the story structure of our application itself does not allow for much autonomy, as most users mainly do what they are suggested to do (stop the unwanted guest, find the ring), either by the characters in the video, or by the voice-over that formulates the thoughts of the main character. The overall enjoyment of the application may therefore have been limited by this perceived lack of autonomy. Roth et al. [16] have found that replaying an IS application had positive effects on effectance. We might therefore expect that the perceived effectance in the current interactive movie would have been rated higher as well, when respondents would have been invited to watch it two or more times, and then to deliberately choose different alternatives. Also, the nature of the feedback sound itself may have influenced the perception, as people may have perceived the little musical sound as annoying or inappropriate. Therefore generalization towards all kinds of sounds or even all kinds of feedback may be premature at this point.

7 Future Research

With our current study, we have shown that among viewers of all ages, participation in an interactive surround video without feedback sounds was found more enjoyable than with feedback sounds. In our future research, we therefore intend to pursue our investigations into the ways that viewers can be guided through the narrative without disturbing their sense of presence. It will also be useful to investigate the effect of other kinds of feedback on interactive points, such as visual cues or different sound effects. As [17] suggested, the sense of participation in a scene may be just as important as the actual power to influence the outcome. In an ideal setting, a viewer would be given the possibility to linger in the scene and look around at people and objects that would attract his attention, while at the same time being gently invited by elements in the same scene to move forward in the narrative. We intend to focus on 'string of pearl' kind of story structures, instead of branched stories. The agency over the temporality of a scene that 'string of pearls' allows for is a drastic shift compared to traditional cinema, but is familiar to video gaming and it seems to fit the affordances of surround video in a way that exceeds the second point of critique towards interactive narratives as stated by Genette [6].

Another focus of future investigation will be the use of voice-over, and the possibility of heightening the users' sense of presence when they are guided through a narrative by a voice that is talking from a second person perspective, as if one's own

inner thoughts are being verbalized. This aspect is also quite new to cinema but well known to many gamers. Both topics promise to evoke intriguing new challenges to writers, producers and researchers of *lean in* experiences of interactive storytelling.

References

1. Nielsen, F.: Surround video: a multihead camera approach. Vis. Comput. **21**, 92–103 (2005)
2. Vosmeer, M., Schouten, B.: Interactive cinema: engagement and interaction. In: Mitchell, A., Fernandez-Vara, C., Thue, D. (eds.) ICIDS 2014. LNCS, vol. 8832, pp. 140–147. Springer, Heidelberg (2014)
3. Katz, H.: The media handbook: A Complete Guide to Advertising Media Selection, Planning, Research, and Buying. Routledge, New York (2010)
4. Stern, A.: Embracing the combinatorial explosion: a brief prescription for interactive story R&D. In: Spierling, U., Szilas, N. (eds.) ICIDS 2008. LNCS, vol. 5334, pp. 1–5. Springer, Heidelberg (2008)
5. Murtaugh, M.: The Automatist Storytelling System. Masters Thesis, MIT Media Lab (1996). http://xenia.media.mit.edu/ ~ murtaugh/thesis/
6. Genette, G.: Narrative Discourse. Cornell University Press, New York (1980)
7. Fitzpatrick, M.: Story Structure. Patterns in Narrative Structure for Interactive Media (2003). http://staff.jccc.net/mfitzpat/storystructures/index.htm
8. Fendt, M.W., Harrison, B., Ware, S.G., Cardona-Rivera, R.E., Roberts, D.L.: Achieving the illusion of agency. In: Oyarzun, D., Peinado, F., Young, R., Elizalde, A., Méndez, G. (eds.) ICIDS 2012. LNCS, vol. 7648, pp. 114–125. Springer, Heidelberg (2012)
9. Roth, C., Klimmt, C., Vermeulen, I.E., Vorderer, P.: The experience of interactive storytelling: comparing "Fahrenheit" with "Façade". In: Anacleto, J.C., Fels, S., Graham, N., Kapralos, B., Saif El-Nasr, M., Stanley, K. (eds.) ICEC 2011. LNCS, vol. 6972, pp. 13–21. Springer, Heidelberg (2011)
10. Jennett, C., Cox, A.L., Cairns, P., Dhoparee, S., Epps, A., Tijs, T.: Measuring and defining the experience of immersion in games. Int. J. Hum Comput Stud. **66**(9), 641–661 (2008)
11. Csikszentmihalyi, M.: Flow: The Psychology of Optimal Experience. Harper and Row, New York (1990)
12. Vorderer, P., Klimmt, C., Ritterfeld, U.: Enjoyment: at the heart of media entertainment. Commun. Theory **14**(4), 388–408 (2004)
13. Verdugo, R., Nussbaum, M., Corro, P., Nunnez, P., Navarrete, P.: Interactive films and coconstruction. ACM Trans. Multimedia Comput. Commun. Appl. **7** (4), 39:1–39:24 (2011)
14. Roth, C., Vermeulen, I.: Real story interaction: the role of global agency in interactive storytelling. In: Herrlich, M., Malaka, R., Masuch, M. (eds.) ICEC 2012. LNCS, vol. 7522, pp. 425–428. Springer, Heidelberg (2012)
15. Medialab Amsterdam (2015). http://medialab.hva.nl/interactivecinema/
16. Roth, C., Vermeulen, I., Vorderer, P., Klimmt, C.: Exploring replay value: shifts and continuities in user experiences between First and Second Exposure to an Interactive Story. Cyberpsychology, Behav. Soc. Netw. **15**(7), 378–381 (2012)
17. Tanenbaum, J.: Being in the story: readerly pleasure, acting theory, and performing a role. In: Si, M., Thue, D., André, E., Lester, J.C., Tanenbaum, J., Zammitto, V. (eds.) ICIDS 2011. LNCS, vol. 7069, pp. 55–66. Springer, Heidelberg (2011)

Mise-en-scène: Playful Interactive Mechanics to Enhance Children's Digital Books

Fatma Al Aamri[✉] and Stefan Greuter

Centre for Game Design Research, RMIT University, Melbourne, Australia
{fatma.alaamri,Stefan.greuter}@rmit.edu.au

Abstract. The inclusion of interactive content has become commonplace in many reading applications for children. Yet a growing body of research suggests that the inclusion of interactive content may distract children from the actual content of the story. Models are used to effectively integrate interactive content into reading applications to support a child's understanding of the story. This paper discusses the design of an interactive application for Omani children called *Trees of Tales,* including its use of a *mise-en-scène* inspired game mechanic to facilitate playful and meaningful engagement with the story. A trial of n = 18 Omani primary school students was used to determine the impact of the design on the intrinsic motivation and engagement in comparison with printed storybooks and e-books with limited interactivity. The findings suggest that *Trees of Tales* improves children's motivation to read. There was also evidence that the application enhances reading engagement of female children in particular.

Keywords: Interactive reading application · Trees of Tales · Children's e-books · Arabic children · Omani children · Intrinsic reading motivation · Reading for pleasure · Digital books · Mise-en-scène

1 Introduction

The number of children who access digital devices (e-books) to read is increasing [21]. Interactive digital books are particularly popular, yet evidence suggests that while they are more effective in attracting children than other digital book formats [29], most of their playful interactivity and engagement only relates to entertainment [27]. Interactive digital books have been found to distract a child from the actual content of the narrative [25]. Therefore, guidelines are needed to inform the design of interactive interactions in digital books, to not only motivate a child to pick up a book in the first place, but to also support the child's reading and understanding of the narrative.

This paper discusses the design of an interactive reading application that playfully engages children and supports their reading of the narrative. It provides background on the factors that affect children's reading motivation, and analyses the different types of digital books and their effects on motivation and engagement. The paper then reviews the design of the interactive techniques in the *Trees of Tales* reading app, including evaluating the intrinsic reading motivation and engagement in comparison with other digital and print reading applications.

© Springer International Publishing Switzerland 2015
H. Schoenau-Fog et al. (Eds.): ICIDS 2015, LNCS 9445, pp. 211–222, 2016.
DOI: 10.1007/978-3-319-27036-4_20

2 Motivation for Reading

Reading motivation is a multi-layered construct that includes aspects such as the person's reading goals, intrinsic and extrinsic motivation, self-efficiency, and other social motivations [37]. The intrinsic motivation for reading relates to curiosity and seeking a challenge; extrinsic motivation is the desire for recognition and academic achievements via reading [37]. Additionally, competence and efficacy beliefs refer to the individual's assessment of their ability to accomplish a task or activity, such as reading at least part of a book [37].

The type of motivation usually associated with reading for pleasure is called 'intrinsic reading motivation' [9, 33]. Intrinsic reading motivation can leverage long-term engagement; that is, interest and enjoyment are deemed more important than competitions and scores. Intrinsic reading motivation has been described as the curiosity about reading and a preference for challenge in reading [37]. Interactive e-books, particularly playful ones, often leverage intrinsic reading motivation [8].

According to Salen and Zimmerman, play is considered to be "free movement within a more rigid structure" [24]. Playful e-books are applications that use interactivity in the form of playful elements to support reading; they provide "a meaningful contribution to the text and reading remains the primary activity" [8]. In such a design that encourages reading for pleasure, three aspects of intrinsic motivation associated with leisure reading need to be addressed: curiosity; desire for challenge; and involvement [38]. Curiosity can be fostered by adding elements that allow exploratory behaviour, playfulness and interactivity [8]; challenge involves giving children the freedom to select opportunities suited to their different reading abilities; and involvement is when they lose track of the world around them and are fully immersed in the story.

There are three common factors used in literature to measure intrinsic reading motivation: enjoyment/interest; self-competence/self-awareness; and personal-importance/value [2, 10, 13, 23]. Interestingly, these are similar to the contextual factors that promote internalisation of the regulation of behaviour according to the Self-Determination Continuum [11]. This study used these three common factors to measure intrinsic reading motivation, with the results discussed in Sect. 6.

3 Interactive Digital Books

There are two types of digital books: e-books and book apps [25]. E-books are defined as "digital replicas of printed books" [25]; they usually only contain text, imagery and low levels of interactivity, such as hypermedia links to external data. Most book apps combine elements from printed picture books, game design and animated film; they "present a fusion of written text, visuals, audio and interaction design" [25].

Many recent studies have concentrated on the impact of digital books versus print books for motivating and improving children's reading habits. For example, a recent study by the National Literacy Trust revealed an increase in positive motivation towards reading among young people who mostly sourced e-books [22]. Another study by Maynard [19] examined the effects on the reading habits of 7–12-year-old children based

on the use of three devices: Kindle, iPod touch, and Nintendo DS-Lite. The inclusion of an iPad was also considered, but it was not available at that time. The study revealed a positive impact on the reading habits of children, especially when using e-reader devices like the Kindle. Yet other empirical studies have suggested there are no significant differences in children's reading motivation based on the format of the book [34]. In fact, lower motivation levels were reported in a study on fifth grade students when comparing their screen reading with traditional printed books [1].

Other studies examining how interactivity affects children's reading comprehension have also varied in their findings. A study by Labbo and Kuhn [15] found that e-books with contextual interactivity supporting the story's content elevated children's comprehension. Additionally, it was found that supportive elements such as narration, sound effects and animation can decrease reader effort to decode individual words, allowing them to focus on the meaning of the text [16, 18]. In contrast, a recent Meta study identified that elements such as hotspots, games and dictionaries can distract children from reading the text [31]. Yet none of these studies have concentrated on the specific features that support or weaken reader understanding, which suggests a simplistic relationship between e-books and comprehension has not yet been identified.

Studies that compare the effects of static and interactive digital books are limited. Chiong et al. [6] investigated the differences between basic and enhanced book apps. Comparing static digital books with print books, the findings showed that the interactivity of enhanced book apps can negatively affect children's story recall, yet it was more superior at engaging them in the reading activity. However, this study was limited in its data about the interactive elements used in the enhanced book apps, and did not specify the interactive features that negatively affect story recall. More research is therefore required to determine the impact of specific playful and interactive elements in digital books on children's reading experiences.

4 Designing Mise-en-scène in Trees of Tales

Mise-en-scène is a French term that refers to 'place on stage'. It traditionally describes the design and composition of all visual elements on a theatre stage that provide the visual theme for the play [3]. *Mise-en-scène* refers to the selection and placement of props, characters, lighting, etc. to set the mood and atmosphere in support of the narrative, aiming to deeply engage the audience. It is a powerful technique that is also used in many storytelling applications, such as where children act as the story's director, motivating them to create stories in an interactive and fun way. An example of an application that uses *mise-en-scène* is *Toontastic*[1] by Launchpad Toys, which allows children to choose a setting and drag and move characters while recording a dialogue. Some of the interactivity in *Toontastic,* such as creating the scene, can be used in reading applications to promote reading of the text.

Trees of Tales is an iPad app that was developed as part of this study to motivate Omani children to read more stories for pleasure. It contains six different stories inspired

[1] https://itunes.apple.com/au/app/toontastic/id404693282?mt=8.

by Omani folktales, with each page containing a menu with story characters, character emotions and other objects that can be placed and manipulated in a scene. To progress through a story, the child has to set the scene on each page in correspondence with the narrative. To accomplish this, the child needs to read the text on each page and examine it for clues on how to assemble the scene. At the very least, the child will choose and drag characters and objects mentioned in the text into the scene, positioning them in a meaningful way. For example, characters and plants should be located on the ground, and the sun in the sky. The application provides real-time feedback when the choice and placement of characters and objects is incorrect. For example, a character does not 'stick' on the canvas when incorrectly positioned, and the app will automatically return to the menu.

Once the scene has been set in accordance with the text, the 'next' button turns from red to green, indicating that the child can progress to the next page in the story. Although they can still continue to add to the scene before hitting 'next', using objects that do not alter the story's meaning, which provides an opportunity to playfully engage with the text. However, if the changing of a critical element contradicts the story, the green button reverts back to red to indicate something in the scene is incorrect, preventing reader progression. Figure 1 below contains three screenshots of a story page in *Trees of Tales* that illustrate the interaction required to advance in the application.

Fig. 1. Dragging correct objects into the scene to advance in the reading

5 Method

This study employed a within-subjects design as an experimental method; a design commonly used to investigate the use of technology and behavioural changes in children [26, 30]. This experimental design exposes the same participants in more than one treatment, and is based on a small number of participants [5]. To mitigate negative effects such as carryover or order in the repeated trials as identified by Foley [12], this study's participants were divided into smaller groups and given the treatments in different orders. This enabled an examination of individual behaviour changes in relation to exposure to different reading interventions [5].

Eighteen students from the fourth grade of Al Waha Primary School were selected from six classes. The students were aged between 9 and 10 years, and selected based on their academic performance. Only males were selected from the first three classes, and only females from the other three, to ensure an equal number of males and females in

the experiment. The three students from each class were considered a group, with six overall groups named according to their class number.

In an information session, the purpose and details of this study were explained to the young participants, and information sheets were sent to their parents, including consent forms.

Three reading interventions were used in the study:

- *Trees of Tales* application which contains six stories and was developed for this study on iPad2 (TT)
- Traditional print storybooks (PB) – a collection of six selected books from the school library based on librarian advice
- *Arabic Stories*[2], an iPad e-book (EB) – an application containing five Arabic children's e-books with limited interactivity, such as selecting one of five books, flipping the pages in the book, and turning audio narration on or off.

Resources available in the school library and the app store were used to find suitable storybooks. Although the content of the stories were different, both the Arabic language teachers and the librarian confirmed that all stories were of the same reading level. Throughout the experiment, the participants exchanged reading interventions across three separate reading sessions performed across three consecutive weeks. That is each child took home a different reading intervention to read each weekend. By the fourth week, all participants had completed the reading across the three reading interventions, both in school and at home.

6 Research Instruments

This study's data collection was based on two instruments: the Intrinsic Reading Motivation Scale (IRMS), and direct observations during the three school reading sessions.

6.1 Intrinsic Reading Motivation Scale (IRMS)

There are four common questionnaires that have been used in previous research to measure the motivation of participants related to reading; three of which have been used to measure children's reading motivation: *Motivation to Read Profile*; *Motivation for Reading Questionnaire*; and *Motivation for Reading Scale.*

The *Motivation for Reading Questionnaire* (MRQ) was designed by Wigfield and Guthrie [35], and measures 11 dimensions including reading efficacy, challenge, curiosity, reading involvement, importance, recognition, grades, social competition, compliance, and reading work avoidance.

The *Motivation to read Profile* (MRP) was designed by Gambrell et al. [13]. It measures two motivational dimensions: the self-concept as a reader and the value for reading. The MRP was designed specifically to scale reading motivation among elementary school students.

[2] https://itunes.apple.com/us/app/arabic-stories/id392531885?mt=8.

The *Motivation for Reading Scale* (MRS) was introduced by Baker and Scher [2], and was designed for school students, measuring enjoyment, value, perceived competence, and library-related dimensions.

All of these surveys contain subscales that measure a mix of intrinsic and extrinsic dimensions. The fourth questionnaire is the *Intrinsic Motivation Inventory* (IMI) by Ryan [23], which includes subscales concerning different aspects of intrinsic motivation such as enjoyment, importance, pressure and perceived competence.

The investigated questionnaires above share many elements, but there are inconsistencies in the use of terms and subscales. It was therefore necessary to identify common dimensions to assess the intrinsic motivation, as listed in Table 1 below.

Table 1. List of common subscales from the four questionnaires

Dimension	Questionnaire
Enjoyment/Interest/Involvement	IMI, MRS, MRQ
Curiosity	MRQ
Importance/Value	MRQ, MRP, IMI, MRS
Challenge/Pressure	MRQ, IMI
Self-Concept/Reading Efficacy/Perceived Competence	IMI, MRQ, MRP, MRS

The table shows that the most common subscales concerning intrinsic reading motivation across the four questionnaires are enjoyment, value, and self-concept. These three subscales and the following corresponding statements were therefore included in this study's IRMS:

Enjoyment
1. Reading is a very interesting thing to do
2. I like to read
3. I think reading is a boring way to spend time
Value
4. It is very important to me to be a good reader
5. I think people can learn new things from reading
6. I think reading could help me become a better student
Self-concept
1. I am a good reader
2. I know that I will do well in reading next year
3. Reading is hard for me

6.2 Direct Observations

In this study, six students (three males and three females) were selected for direct individual observations in the three sessions, to compare their level of engagement with the reading interventions. The six students consisted of two high-performing

students, two average-performing students, and two with a below-average academic performance. All six students attended every reading session and their facial expressions were clearly visible in the video. Every reading session occurred in the school's break time and was videorecorded for the full period of 20 min. The three recorded reading sessions were subsequently analysed, and reading behaviour was coded using the software NVivo.

To assess engagement with the reading material, the time each of the six children was engaged or disengaged was measured. Reading behaviour was defined as 'engaged' when the child was looking at the reading intervention, and as 'disengaged' when the child was looking or moving around the room, or talking to other kids [17]. The behaviour of each child was recorded from the fourth minute of the videorecording up to the eighth minute, for an interval of **five minutes**; with the data quantitatively analysed. During the five minutes of observation, a whole-interval sampling approach was used, where the children's behaviour was recorded every 12 s [4, 32].

Based on this approach, the reading behaviour was rated as 'engaged' if it was exhibited for the full duration of the 12-s interval. During the five-minute observation time, 25 separate records of each child's reading behaviour were recorded. This data provided a statistical measure of each child's reading engagement that is further discussed in the following section.

7 Results and Discussions

The participants were asked to complete the IRMS each time they returned one of the three reading interventions. In total, each participant completed the survey three times in three separate weeks after returning the printed books, the *Arabic Stories* e-book, and the *Trees of Tales* app. The survey scores were entered into SPSS for each participant to arrive at descriptive statistics for the sample population. The IRMS means and median values were very similar for the three reading interventions. Table 2 shows the means, medians, and standard deviations of the three measures.

Table 2. Mean, median and standard deviation values for IRMS

	n=	Range	Mean	Median	Std. deviation
Intrinsic motivation after reading printed books	18	5.00	34.50	35.0	1.65387
Intrinsic motivation after reading *Arabic Stories*	18	4.00	34.50	35.0	1.61791
Intrinsic motivation after reading *Trees of Tales*	18	4.00	**34.83**	**35.5**	**1.46528**

The results show that the children in the sample were highly intrinsically motivated to read for pleasure regardless of the medium they used. While no statistically significant difference in intrinsic reading motivation was found via a Friedman test, the box plot in Fig. 2 shows a slightly higher median and smaller standard deviation for *Trees of Tales*, while the results for the other interventions were practically identical.

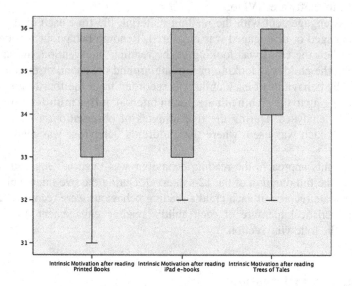

Fig. 2. Box plot chart for IRMS

As the maximum possible value for the IRMS score was 36 points, this highlights that the children observed at Al Waha Primary School in Oman were all highly intrinsically motivated to read at this young age regardless of their level of academic performance. However, the median for intrinsic motivation after reading from *Trees of Tales* was slightly higher than the median for *Arabic Stories* and traditional printed books.

Analysis of the results obtained in the three IRMS surveys, separated by gender, revealed higher intrinsic motivation scores for females after reading from *Trees of Tales*, while males were mostly concentrated around the same range across the three reading interventions (see Fig. 3 below). The noticeable difference was that the median score of intrinsic motivation after reading from printed books was 1 point higher than the median after reading from either of the iPad applications. Therefore, the format of the book had little influence on the intrinsic reading motivation for males; while it was noticeably higher for females after reading *Trees of Tales*. The male participants' intrinsic motivation was higher than their female counterparts when reading from the basic e-book and printed storybooks.

After analysing the observations, engagement rates for each child observed during the three reading sessions were recorded. Table 3 below presents the total number of intervals identified as 'engaged' for each of the six observed children during the three reading sessions.

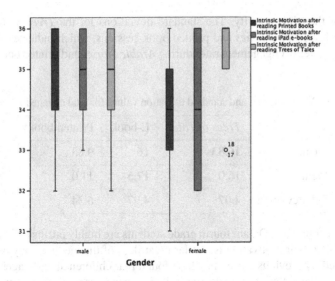

Fig. 3. Intrinsic reading motivation scores by gender

Table 3. Number of engaged intervals out of 25 observed intervals

	Trees of Tales	E-book	Printed books
Child 1	20	**22**	14
Child 2	14	**19**	8
Child 3	**17**	**17**	14
Child 4	**23**	18	17
Child 5	**15**	11	0
Child 6	**12**	9	6

These tabled results are separated by gender, with child 1 to child 3 representing male participants and child 4 to child 6 indicating female participants. They are also separated by the three reading interventions, with the highest number of engaged intervals for each child bolded.

Interestingly, males were more engaged when reading the *Arabic Stories* e-book, while females were more engaged in *Trees of Tales*. Quantitative analysis of the observation sessions further revealed that males engaged more with the basic digital reading material, while females engaged more with the interactive book using the *mise-en-scène* game mechanic.

In addition, the mean values for all six student participants' engaged intervals were slightly higher for *Trees of Tales* than *Arabic Stories*, but significantly higher than for printed books. In contrast, the median values for engaged intervals relating to *Arabic Stories* were higher than for both *Trees of Tales* and printed books. These results suggest that the engagement of participants was similar across the two digital book sessions

regardless of their interactivity. The standard deviations for the *Trees of Tales* were smaller than for *Arabic Stories* and printed book sessions, which indicates there were more discrepancies in engagement rates during *Arabic Stories* and printed book sessions (Table 4).

Table 4. Mean, median and standard deviation values for total engaged intervals

	Trees of Tales	E-book	Printed books
Mean	**16.83**	16	9.83
Median	16.0	**17.5**	11.0
Std. deviation	**4.07**	4.97	6.34

This study found that Omani fourth grade students are highly intrinsically motivated to read, and that their motivation is similar regardless of the medium they use. This is also supported by previous research, which found that children at early ages are motivated to read, which often starts to decline as their age increases [7]. However, this study found that the use of an interactive technique that supports reading can slightly increase general intrinsic reading motivation; particularly among females. This gender differentiation aligns with previous research that has identified females as having a higher level of reading motivation and more intrinsically motivated to read than males [20, 36].

The direct observations in this study also noted greater female engagement when reading from the *Trees of Tales* app, while males were more engaged with the more basic *Arabic Stories* e-book. In addition, both genders were observed as less engaged when reading from printed books. Hence, this study's findings indicate that the digital device plays a more significant role in regards to engaging children in reading than the *mise-en-scène* interactivity. However, this could change in the future when most books become digital and the novelty of the device declines.

8 Conclusion

This study found a difference in intrinsic motivation and engagement rates for interactive features based on gender. Among the 18 student participants, males were more engaged and motivated to read from the basic e-book app, while females were more engaged and motivated to read book apps like *Trees of Tales* with interactive content requiring them to think. The data indicated that female primary school children are more likely to benefit from interactive books using *mise-en-scène* game mechanics than their male counterparts. Understanding why the *mise-en-scène* format appeals more to females should be further researched, using a larger sample and a greater variety of interactive digital books.

The *mise-en-scène* design in *Trees of Tales* supported the reading of the stories and made it more playful and interactive. This study suggests this type of interactivity is stimulating, motivating and engaging for children, especially females. It is therefore surmised in this study that if *mise-en-scène* is implemented in digital books, it will help reduce reading distractions while potentially motivating children to read more.

References

1. Aydemir, Z., Ozturk, E.: The effects of reading from the screen on the reading motivation levels of elementary 5th graders. Turk. Online J. Educ. Technol.-TOJET **11**(3), 357–365 (2012)
2. Baker, L., Scher, D.: Beginning readers' motivation for reading in relation to parental belifs and home reading experiences. Read. Psychol. **23**(4), 239–269 (2002)
3. Bordwell, D., Thompson, K.: Film Art: an Introduction. McGraw-Hill Education, New York (2012)
4. Chapman, E.: Alternative approaches to assessing student engagement rates. Pract. Assess. Res. Eval. **13**(8) (2003)
5. Charness, G., Gneezy, U., Kuhn, M.: Experimental method: between-subject and within-subject design. J. Econ. Behav. Organ. **81**, 1–8 (2012)
6. Chiong, C., Ree, J., Takeuchi, L., Erickson, I.: Print Books vs. e-books: Comparing Parent-Child Co-reading on Print, Basic, and Enhanced e-book Platforms. The Joan Ganz Cooney Center (2012)
7. Clark, C., Foster, A.: Children's and Young People's Reading Habits and Preferences: The Who, What, Why, Where and When. National Literacy Trust (2005)
8. Colombo, L., Landoni, M.: Serious Games or Playful Books. Paper presented at the How Interactive eBooks can Better Support Leisure Reading. To be presented at IBOOC2014, 2nd Workshop on Interactive eBook for Children at IDC (2014)
9. Cox, K.E., Guthrie, J.T.: Motivational and cognitive contributions to students' amount of reading. Contemp. Educ. Psychol. **26**(1), 116–131 (2001)
10. De Naeghel, J., Van Keer, H., Vansteenkiste, M., Rosseel, Y.: The relation between elementary students' recreational and academic reading motivation, reading frequency, engagement, and comprehension: a self-determination theory perspective. J. Educ. Psychol. **104**(4), 1006–1021 (2012). doi:10.1037/a0027800
11. Deci, E.L., Ryan, R.M.: Overview of self-determination theory: an organismic dialectical perspective. Handb. Self-determination Res. 3–33 (2002)
12. Foley, H.: Counterbalancing. In: Lewis-Beck, M.S., Bryman, A., Liao, T.F. (eds.) The SAGE Encyclopedia of Social Science Research Methods, pp. 206–207. Sage Publications, Inc., Thousand Oaks, CA (2004). doi:http://dx.doi.org/10.4135/9781412950589.n180
13. Gambrell, L.B., Palmer, B.M., Codling, R.M., Mazzoni, S.A.: Assessing motivation to read. Read. Teach., 518–533 (1996)
14. Kellaghan, T., Madaus, G.F., Raczek, A.E.: The use of external examinations to improve student motivation. American Educational Research Association (1996)
15. Labbo, L.D., Kuhn, M.R.: Weaving chains of affect and cognition: a young child's understanding of CD-ROM talking books. J. Literacy Res. **32**(2), 187–210 (2000)
16. Lewin, C.: Exploring the effects of talking book software in UK primary classrooms. J. Res. Read. **23**(2), 149–157 (2000)
17. Marks, H.M.: Student engagement in instructional activity: patterns in the elementary, middle, and high school years. Am. Educ. Res. J. **37**(1), 153–184 (2000)
18. Matthew, K.: A comparison of the influence of interactive CD-ROM storybooks and traditional print storybooks on reading comprehension. J. Res. Comput. Educ. **29**(3), 263–275 (1997)
19. Maynard, S.: The Impact of e-books on young children's reading habits. Publishing Res. Q. **26**(4), 236–248 (2010). doi:10.1007/s12109-010-9180-5
20. McGeown, S.P., Norgate, R., Warhurst, A.: Exploring intrinsic and extrinsic reading motivation among very good and very poor readers. Educ. Res. **54**(3), 309–322 (2012)

21. McLean, K., Kulo, C.: The Children's Book Consumer in the Digital Age. Bowker, New York (2013)
22. Picton, I.: The Impact of ebooks on the Reading Motivation and Reading Skills of Children and Young People (2014)
23. Ryan, R.M.: Control and information in the intrapersonal sphere: an extension of cognitive evaluation theory. J. Pers. Soc. Psychol. **43**(3), 450 (1982)
24. Salen, K., Zimmerman, E.: Rules of Play. MIT Press, Cambridge (2004)
25. Sargeant, B.: What is an ebook? What is a book app? And why should we care? An analysis of contemporary digital picture books. Child. Lit. Educ., 1–13 (2015)
26. Sim, G., MacFarlane, S., Read, J.: All work and no play: measuring fun, usability, and learning in software for children. Comput. Educ. **46**, 235–248 (2006)
27. Smeets, D.: Storybook Apps as a Tool for Early Literacy Development (2012). https://openaccess.leidenuniv.nl/handle/1887/20363. Accessed 09 June 2015
28. Smeets, D., Bus, A.: Picture storybooks go digital: pros and cons. In: Neuman, S.B., Gambrell, L.B. (eds.) Quality Reading Instruction in the age of Common Core Standards, pp. 176–189. International Reading Association, Newark (2013)
29. Smeets, D., Bus, A.: The interactive animated e-book as a word learning device for kindergartens. In: Applied Psycholinguistics, pp. 1–22. Cambridge University Press, Cambridge (2014). doi:10.1017/S0142716413000556
30. Stoeckle, K.: Page Turning and Mouse Clicking: A Comparison of e-books and an Adult Reader on Comprehension Measures. Rising Tide, vol. 5, Department of Educational Studies. St Mary's College of Maryland (2012)
31. Takacs, Z.K., Swart, E.K., Bus, A.G.: Benefits and pitfalls of multimedia and interactive features in technology-enhanced storybooks a meta-analysis. Rev. Educ. Res. 0034654314566989 (2015)
32. Volpe, R.J., DiPerna, J.C., Hintze, J.M., Shapiro, E.S.: Observing students in classroom settings: a review of seven coding schemes. Sch. Psychol. Rev. **34**(4), 454 (2005)
33. Wang, J.H., Guthrie, J.T.: Modeling the effects of intrinsic motivation, extrinsic motivation, amount of reading, and past reading achievement on text comprehension between US and Chinese students. Read. Res. Q. **39**(2), 162–186 (2004)
34. Wells, C.L.: Do students using electronic books display different reading comprehension and motivation levels than students using traditional print books? Liberty University (2012)
35. Wigfield, A., Guthrie, J.T.: Dimensions of Children's Motivations for Reading: An Initial Study. Reading Research Report No. 34 (1995)
36. Wigfield, A., Guthrie, J.T.: Relations of children's motivation for reading to the amount and breadth or their reading. J. Educ. Psychol. **89**(3), 420 (1997)
37. Wigfield, A., Guthrie, J.T.: Engagement and motivation in reading. Handb. Read. Res. **3**, 403–422 (2000)
38. Wigfield, A., Guthrie, J.T., Tonks, S., Perencevich, K.: Children's motivation for reading: domain specificity and instructional influences. J. Educ. Res. **97**(6), 299–309 (2004)

Story Immersion in a Gesture-Based Audio-Only Game

Wenjie Wu and Stefan Rank[✉]

Drexel University, Philadelphia, PA, USA
stefan.rank@drexel.edu

Abstract. We report on the results of a study on immersion in an audio-only game with touch-less gesture interaction. A structured design approach to audio feedback that considers the story-context leads to different design approaches: explicit instructions on the one hand and diegetic environmental feedback on the other. Further, we distinguish audio feedback before, during, and after gestures as part of the approach. Two corresponding versions of a gesture-based audio-only story have been implemented and evaluated regarding immersion using a questionnaire study. The findings indicate that replacing explicit audio instructions for hand positions and movements with responsive audio feedback for suggesting interaction methods using environmental story-related audio cues leads to measurably higher story immersion.

Keywords: Immersion audio-only · Gesture interaction · Touchless motion control · Responsive feedback

1 Introduction

We report on a study on immersion in an audio-only game that uses gesture controls. In audio-only games, designers rely solely on auditory channels for delivering narratives and for providing feedback to players [12]. Recent developments in motion-tracking technologies allow audio-only game designers to employ motion control towards more immersive experiences. Immersion, although it has been studied in games in different forms for many years, is still not well understood in terms of the factors that influence the degree of immersion. Our study compares two different design principles for creating responsive audio feedback for hand gestures, one that focuses on explicit and easy-to-follow instructions, and one that relies on sounds and narration that relate to the story context or the virtual environment.

In this paper, after considering related work, we present our experimental approach, provide details on the design principles for environmental and diegetic audio cues, and summarize the results of our study.

2 Background and Related Work

Gesture interaction. Motion-based interaction has been described by many terms. Norman [7] sums everything under the plain term: gestural interaction.

© Springer International Publishing Switzerland 2015
H. Schoenau-Fog et al. (Eds.): ICIDS 2015, LNCS 9445, pp. 223–234, 2015.
DOI: 10.1007/978-3-319-27036-4_21

Hartson and Pardha [3] use the term embodied interaction for the possibility to use a physical body for interaction with technology. O'Hara et al. [8] speak about touch-less interaction referring to a controller-free way to interact with applications. Designers have to address the player's needs beyond mechanical presentation of the movement. The context of gestures is an important factor, as making a move or grabbing something needs to feel appropriate in that environment. As gesture control lacks in accuracy, making use of effective feedback, for example of sound effects that are closely responsive to the speed or angle of the movement, can help in maintaining positive participation.

Audio-Only Environments. Computer games often put their main focus on graphical contents. Sound and music are sometimes only used to keep up the atmosphere and strengthen the graphics. However, sound is a very capable element of game design. Papworth [9] indicated that audio provides information that triggers viewers' emotion and degrees of perceived realism that pure visuals cannot. For instance, we all determine values such as surface, friction, weight and impact from the audio elements in films rather than purely the visuals we are presented with. Audio's ability to manipulate and affect the emotion state of the user presents us with some new and unique opportunities in gameplay design [9]. Further, audio-only games offer a valuable opportunity to study what helps players to create an inner picture of the environment.

Audio-only games are a special case in that they rely purely on audio output to present the player with a game world. According to Liljedahl et al. [5], user investment plays a pivotal role: by making the players invest both time and imagination, as well as physical activity in the game experience, they are given space and opportunity to share in the creative process. Potentially, this creates a much more compelling game experience for the player, as personal imagination is far more dynamic and compelling than anything that a game designer can create without the players' help.

Of particular interest is the impact of audio feedback on the immersive qualities of the game experience. Audio feedback for natural gesture interaction needs to convey messages about appropriate gesture interaction to the player. Due to the lack of visual cues, it becomes a challenge for designers to structure the interaction so as to suggest when and how to interact in a gesture-based audio-only environment. Our question is how to convey gesture interaction messages to the player through auditory cues without interrupting the immersive experience in audio-only environments.

3 Experimental Approach

Our approach is to experimentally compare useful designs of audio feedback that are responsive to hand gestures to both encourage user participation and maintain immersion in gesture-controlled audio-only environments. For the experimental study, two designs for responsive audio feedback were implemented in

two game versions, as described below. We set up a between-subjects experimental design in order to compare the two game versions and their effect on the evaluation of the game, including its immersive qualities.

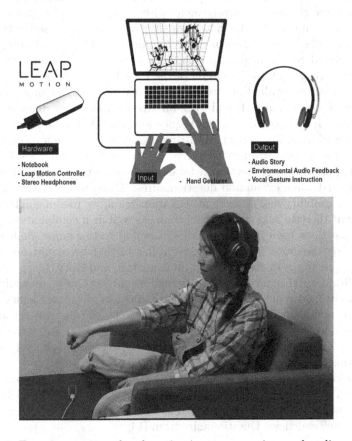

Fig. 1. Experiment setup: hand motion input, processing, and audio output

3.1 Hardware Setup

Figure 1 shows the hardware setup for the game which includes using a Leap Motion Controller for hand tracking and data input, a laptop for data recognition and processing of the game, and noise-cancelling stereo headphones for audio output.

3.2 Immersion

Immersion is a difficult to define concept. Murray gave her definition of immersion as the experience of being transported to an elaborately simulated place that

takes over our whole perceptual apparatus [6]. The concept of presence in the context of virtual reality research is defined as the "extent to which a person's cognitive and perceptual systems are tricked into believing they are somewhere other than their physical location" [10]. According to [2], immersion is usually used to describe the level of involvement with a game. For the context of this evaluation, story immersion, i.e. how strongly players felt immersed in the story-world, is particularly relevant, as is control immersion. This aspect of immersion has been related to the degree to which one can enter the game through its controls [11], going back to the notion of the invisibility of the tool [13].

For the practical evaluation, we adapted existing questionnaires, the Game Engagement Questionnaire [1] and work on directly measuring different aspects of immersion [4] and combined it with questions aimed at usability and enjoyment. This lead to an instrument consisting of 24 Likert-style questions rated on a 7-point scale (from "Strongly Disagree" to "Strongly Agree"). Usability and enjoyment questions were developed by us, specific to the game, but relate to previously used game evaluation questionnaires. Those result in two aggregate measures on usability and enjoyment. For immersion, we used a single-question measure that directly asks about immersion, as well as a combination measure based on questions used in above studies, adapted to this game. Following the model of those previous studies, immersion has further been split up into sub-components, in terms of control, environment, flow, and story.

In addition to this post-test questionnaire, subjects were partially video-taped and automatic metrics (participation indicators) of player behavior were recorded to complement manual video evaluation. The metrics reflect game progression and were used to further analyze usability and user participation. However, no significant differences were found between the game versions, and therefore this analysis is not included below.

This holds also true for data collected in a pre-test questionnaire. Data on physical and statistical properties of the subject as well as their experience levels with different technologies were recorded as well as immersive tendencies, based on Immersive Tendencies Questionnaire from [14].

4 Narrative Design Approach

An interactive audio story game was implemented as the setting for testing different designs from explicit vocal instructions about hand positions and movements to purely environmental story-related audio cues. The underlying hypothesis is that story-related environmental audio cues for hand gesture interaction will strengthen immersion in audio-only games.

Compared to explicit audio instructions on hand positions and movements, a combination of responsive audio feedback with narrative and environmental story related audio leads to higher immersion in gesture-controlled audio-only environments.

4.1 Story Setting for Game Testing

In order to test our hypothesis, we created game scenarios for players to perform hand gestures according to an audio story with the following synopsis:

A little boy called Dean wakes up on his boat. To his surprise, he finds out that his magic watch starts talking to him. He follows the watch's suggestions and embarks on a journey using his hands. He can throw stones, pinch petals, catch birds, row a boat, shake a tree, tie a rope, ride on a bike and more. By performing gestures differently, he can go faster or slower than his normal pace in time.

Figure 2 gives an overview of the gestures that players can perform during the course of the game. In addition to five main gestures that formed part of every playthrough, the game featured three 'reward' gestures that could be unlocked by doing well on preceding sequences in the game. To illustrate our designs for gestures and appropriate audio feedback, we will focus on the first sequence of gestures that represent grabbing and throwing of stones in the examples given below.

4.2 Audio Feedback Dimensions

In order to realize our design goals, we include different kinds of responsive audio feedback. For a principled approach towards the design of audio feedback for hand gesture interaction, we distinguish potential feedback along two dimensions:

1. vocal instructions vs. environmental audio cues
2. non-diegetic vs. diegetic (i.e. story-related) audio cues

We claim that the second variant of each dimension, respectively, can lead to a more immersive experience for the players. This directly leads to the design of two versions of the game for the experimental study.

4.3 Game Versions

Both implemented game versions were based on the above audio story told by a main character. The variants were played by two different groups of subjects in order to compare the designs and test which design can lead players to a higher immersion level.

See Fig. 3 for an illustration showing the approach to different implementations of audio feedback in the two game variants.

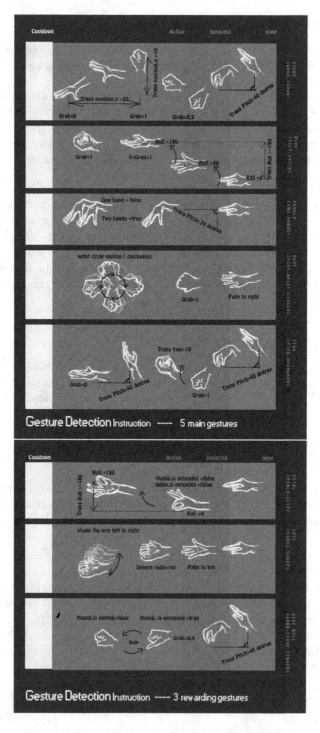

Fig. 2. Illustrations of the five main gesture sequences and the three reward gestures

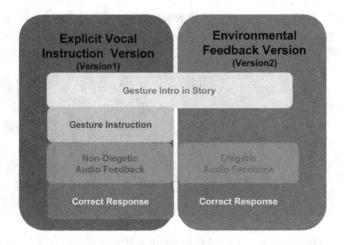

Fig. 3. Two different game variants

Explicit Vocal Instruction Version. When playing this version, apart from the audio story content, the player can hear explicit vocal instructions that are relevant to hand positions and movements from the magic watch (the main character in the story) as well. For example, after being prompted to row a boat back to the shore, players in this condition would hear: "Stretch your arms straight in front of you with your palm facing down, rotate your wrist 90 degrees downwards towards yourself and move it back and forth." During and after gestures, similar verbal feedback is used to inform players on how to successfully complete a gesture.

Environmental Feedback Version. No explicit instructions are given regarding hand positions, only the in-story cues (e.g. "row the boat"). Various other audio cues are used before, during and after gestures, that are responsive to gestures, caused by in-game objects and scenarios in the game environment and story.

5 Design Principles for Environmental Audio Cues

In order to improve the responsiveness of audio feedback for hand gesture interaction regarding immersion, we consider audio feedback not just as a result of gesture interaction, but as part of the interactive narrative and as an interactive signal that guides the player while going through a gesture sequence. Based on their temporal ordering, we therefore use the following categories for audio cues: pre-gesture, during-gesture and post-gesture feedback.

We use different design principles in order to create useful auditory feedback for the stages of a complex gesture sequence. See Fig. 4 for an illustration of how those principles map to the different stages of the gesture sequence of grabbing and throwing a stone at the beginning of the game's storyline.

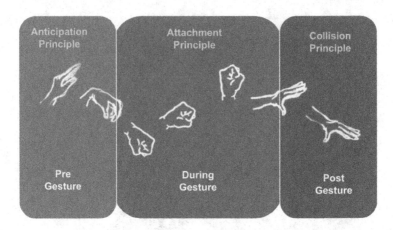

Fig. 4. Design principles for different stages of a gesture sequence: e.g. stone throwing

5.1 Anticipation Principles - Pre-gesture

Humans constantly use environmental signals or social cues given in advance by other humans or the surrounding environment to anticipate forthcoming events in part in order to know how to behave during the event. Ideally, effective audio design for games can leverage this understanding of anticipatory signaling.

1. Object-related audio for introducing the forthcoming gesture Sound derived directly from or related to the main object of the forthcoming gesture prepares the player. For example, the player can hear sounds of fish moving and swimming in water, combined with an ambient sound of a boat creaking before doing the grabbing gesture. Through the combination of these introductory sounds with the audio story told by the character, the player can get a better idea of the setting for performing the forthcoming gesture.
2. Movement of object-related audio positions for suggesting the direction and scale of the forthcoming gesture The movement of the sound source is proportional to the forthcoming gesture. In the bird-catching gesture, the position of the bird audio source moves around the player creating a circling effect. So before grabbing a bird in the air, the player can know where the starting point of the gesture is according to the bird's sound position relative to their location. If the player keeps listening to the moving effect, they can get an understanding of the scale of the forthcoming movement as well.
3. Volume changes for informing the player of the availability of the forthcoming gesture Relative volume changes corresponding to the distance of the gesture's main object to the player can indicate if a particular gesture is currently available or not.

5.2 Attachment Principles - During-Gesture

In real-world situations, hand gestures usually provide only minimal auditory feedback. Responsive audio feedback during a gesture sequence can only be

expected when performed by someone or something that produces constant movement sounds, such as someone with noisy clothing or a metal robot. In order to enable instant feedback from small hand movements of the player, we need to include suitable attachments on arms or wrists that generate sounds in the story-setting. For example, a bracelet with a ringing bell would be helpful for indicating the movement of the wrist. We employ this attachment idea for designing the during-gesture feedback. In the game, during-gesture feedback in particular plays the role of guiding players towards going through a complete gesture sequence. So in addition to conveying the message of the current ongoing movement, the design of during-gesture feedback should also be able to reflect positive or negative reinforcement that affects players' next movement.

1. Real-time mapping of hand movement to audio parameters for enhanced responsiveness For example, in the stone-throwing gesture sequence, we assume people will perform either an over-head throwing gesture or attempt to a gesture suitable for skipping stones after grabbing a stone. In order to suggest that the over-head throwing gesture is suited to scare away the fish and, thus, to move the game's story forward, we use a sound of the player's coat rubbing and creaking with increasing volume as feedback for the hand lifting movement.
2. Noticeable positive or negative feedback for guiding interaction Apart from enhancing immersion using story-related audio cues, we also provide positive or negative audio feedback during a gesture sequence to better affect the player's next step. In our game, players are told that main character is wearing a magic watch. We designed two types of sounds for the watch to convey movement feedback that have been subjected to playtesting: ticking and ringing. If the player performs a gesture sequence in the anticipated way, the ticking of time will remain at normal speed. If a player hears the time ticking getting faster, this is meant to suggest that they are wasting more time than they are supposed to use, or that they may be going in a wrong direction. The ringing sound uses a similar notion of suggesting correct vs. incorrect performance by a higher or lower pitch.

5.3 Collision Principles - Post-gesture

Blind people usually get a sense of surrounding environments by touch. Apart from the sense of touch, this can also provide sound feedback, e.g. when a stick collides with the environment. We posit that providing the player with audio feedback of collisions between their hands or extensions thereof and other objects in the game environment setting can be a way of informing them of hand movement messages needed for performing a complete gesture sequence.

1. Collision audio feedback for informing hand movement direction For example, we created a scenario that involves the player sitting in a boat being prompted to throw a stone to scare away a fish which is blocking his boat from going forward. When the player performs a grabbing gesture in the middle-front

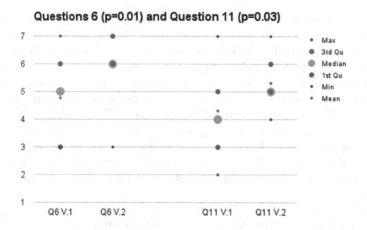

Fig. 5. Likert scores for questions 6 and 11 (p = 0.01 and p = 0.03 respectively)

section, he can hear an audio related to stone movement, suggesting he has grabbed a stone. If the player performs the grabbing gesture successfully in any other section, they can hear water splashing instead.

2. Setting of spatial surroundings to enable border collisions that indicate available moving space In addition, the surrounding spatial setting is designed to help reminding players of the height and width of the available moving space. For example, if players attempt over-head throwing after grabbing, they might lift their arm before letting go of the stone. In order to indicate that there is limited space for lifting arms, we create a cave setting for this gesture sequence, and provide hand-cave collision feedback when a player's hand position reaches that boundary.

6 Study Results

An evaluation of data collected from 26 subjects (13 per group) shows an overall positive evaluation of usability, enjoyment, and immersion for both game versions. The subjects' age ranges from 19 to 34, with a median age of 22. Among the subjects, 6 are females and 20 are males. Only 1 of the subjects is left-handed.

Across the board, the second game variant using environmental diegetic feedback is, on average, rated higher in all aspects. Regarding direct feedback for the design of the game, the distribution of the answers overall is particularly encouraging, as both game versions were rated positively in terms of usability and enjoyment.

Of particular note are statistically significant differences between the two game versions for single question items that were targeted at the audio feedback (Q6: Listening to sound hints for the gestures was helpful) as well as at the game's environmental realism (Q11: The game felt real). Both of those showed

Likert Scales

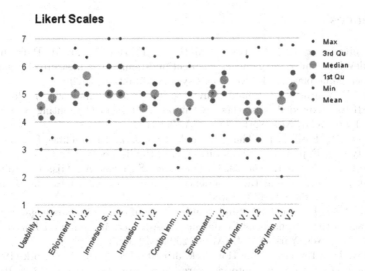

Fig. 6. Questionnaire evaluation of game versions 1 & 2 (for Story Immersion: p = 0.03)

significantly improved ratings for the second game variant (p = 0.01 and p = 0.03 respectively), see Fig. 5 for a summary of the data.

More valuable are the results for aggregate Likert items. See Fig. 6 for a summary of all aggregate Likert items for the main categories of our evaluation. While all means are higher for game version 2, only the result for story immersion is statistically significant (p=0.03) indicating that the presented design approach for environmental audio cues can potentially help in achieving higher immersion in the game's story.

7 Conclusion

In this paper, we presented an experimental evaluation of two design approaches to responsive audio feedback geared towards hand gestures in audio-only games. Regarding our narrative approach, we focus on suitable audio feedback pre-, during- and post-gesture that considers diegetic and environmental sounds related to the game's story. An experimental prototype served as the basis of an experimental evaluations of the designs and differences in terms of story immersion were found. In future work, we intend to relate the results regarding usability of our design approach for gesture-controlled audio-only games in particular to the accessibility of audio-only games for blind players. Finally, the design approach also has implications on Virtual Reality settings in which auditory feedback can improve the use of touch-less gesture input.

References

1. Brockmyer, J., Fox, C., Curtiss, K., McBroom, E., Burkhart, K.M., Pidruzny, J.N.: The development of the game engagement questionnaire: a measure of engagement in video game-playing. J. Exp. Soc. Psychol. **45**, 624–634 (2009)
2. Brown, E., Cairns, P.: A grounded investigation of game immersion. In: Proceedings of CHI '04 Extended Abstracts on Human Factors in Computing Systems, pp. 1297–1300. ACM, New York, NY, USA (2004)
3. Hartson, R., Pardha, P.: The UX Book: Process and Guidelines for Ensuring a Quality User Experience. Morgan Kaufmann Publishers Inc., San Francisco (2012)
4. Jennett, C., Cox, A.L., Cairns, P., Dhoparee, S., Epps, A., Tijs, T., Walton, A.: Measuring and defining the experience of immersion in games. Int. J. Human-Comput. Stud. **66**, 641–661 (2008)
5. Liljedahl, M., Papworth, N., Lindberg, S.: Beowulf - an audio mostly game. In: Proceedings of the International Conference on Advances in Computer Entertainment Technology, New York, NY, USA, pp. 200–203 (2007)
6. Murray, J.H.: Hamlet on the Holodeck, 3rd edn. Free press, New York (1997)
7. Norman, D.: Natural user interfaces are not natural. Interactions **17**, 6–10 (2010)
8. O'Hara, K., Harper, R., Mentis, H., Sellen, A., Taylor, A.: On the naturalness of touchless: putting the 'interaction' back into NUI. ACM Trans. Comput.-Hum. Interact **20** (2013)
9. Papworth, N.: iSpooks: an audio focused game design. In: Proceedings of the 5th Audio Mostly Conference, Pitea, Sweden, pp. 1–8 (2010)
10. Patrick, E., Cosgrove, D., Slavkovic, A., Rode, J.A., Verratti, T., Chiselko, G.: Using a large projection screen as an alternative to head-mounted displays for virtual environments. CHI Lett. **2**, 478–485 (2000)
11. Radford, A.: Games and learning about form in architecture. Autom. Constr. **9**, 379–385 (2000)
12. Roden, T.E., Parberry, I., Ducrest, D.: Toward mobile entertainment: a paradigm for narrative-based audio only games. Sci. Comput. Program. **67**, 76–90 (2007)
13. Winograd, T., Flores, F.: Understanding Computers and Cognition. Ablex, Norwood (1986)
14. Witmer, B., Singer, M.: Measuring presence in virtual environments: a presence questionnaire. Teleoperators Virtual Environ. **7**, 225–240 (1998)

Generating Side Quests from Building Blocks

Tomáš Hromada, Martin Černý[✉], Michal Bída, and Cyril Brom

Department of Software and Computer Science Education,
Charles University in Prague, Prague, Czech Republic
gyfis@seznam.cz, {cerny.m,michal.bida}@gmail.com

Abstract. Computer games are an important application area for interactive storytelling. In a large subset of games, quests — tasks that the player is assigned to complete — are the primary driving forces of the storyline. The main storyline is usually accompanied by a number of optional side-quests. We present a system for generating side-quests based on chaining simple building blocks, akin to the branching narrative approach to interactive storytelling. Our primary interest was how far can we get with such a simple approach. The simplicity of our system also lets game designers retain more control over the space of possible side-quests, making the system more suitable for mainstream computer games. We implemented the system in an experimental game and compared the quests generated by the system with hand-picked and random sequences of building blocks. We performed two rounds of player evaluation ($N_1 = 21$, $N_2 = 12$), which has shown promising results.

Keywords: Quests · Computer games · Role-playing games

1 Introduction

Open-world games (OWGs) form a large and popular subset of computer games. While there is not a universally accepted definition of OWGs, one of their defining properties is freedom: the actions of the player are relatively unconstrained, she may traverse the virtual world in a way she founds the most pleasant and has a (relatively) large pool of possible interactions with non-player characters (NPCs) and other entities inhabiting the game world. The high level of freedom has direct consequences for the way the game story is conveyed to the player. While some OWGs focus on sandbox-like experience with little or no story overarching the player's interaction with the game world, the typical solution is to structure the story into quests. Quest, in this context, is a task the player has to fulfill, usually assigned to the player by an NPC.

Structuring the main story into quests increases the feeling of agency as the player is free to choose when to attend to a specific quest and may spend a prolonged time exploring the world in between the quests. Most games have only one or very few possible main storylines. To make sure the game can be finished, the game does not usually let the player to reject most of the main quests and failure in any of the main quests makes the player lose the game.

H. Schoenau-Fog et al. (Eds.): ICIDS 2015, LNCS 9445, pp. 235–242, 2015.
DOI: 10.1007/978-3-319-27036-4_22

To balance the reduced freedom of the main storylines, OWGs usually feature a large amount of optional *side-quests*. Side-quests give the player purpose to explore the world beyond the main storyline and as they are optional, the player may choose the side-quests that best match her playing style.

Generating side-quests is an interesting challenge for interactive storytelling (IS) and also a practical consideration from game development perspective. Many games choose to generate side-quests simply to reduce the workload, as a large number of side-quests are often required. In all cases we are aware of, side-quest generation in commercial games is a form of template instantiation: a premade scene is placed on a chosen location in the game world, possibly with some assets replaced (e.g., differently looking NPCs taking part in the crime).

In a more complex template setup, as in the S.T.A.L.K.E.R. series [8], the whole game world is continuously simulated and filled with NPCs that make their own decisions and the quest templates are instantiated in response to events emerging in the simulation. While this increases the diversity of possible situations the quests are executed in, the quests themselves are still instances of very simple templates (e.g., help a friendly group in a fight against an enemy group).

Commercial games do not use any complex forms of quest generation (e.g., planning-based IS systems), partly because those decrease the control the designers have over the system and thus increase the probability that the generated side-quests will be inappropriate to their context or interfere with the main storyline. For this reason, our focus is on simplicity of the system.

In this paper we present a system based on composing side-quests from premade building blocks, akin to the branching narrative approach to IS. Each building block represents a short event that takes place in the quest, including all in-game assets needed to enact the event and conditions for the player to successfully progress through the event. We argue that our system is a possible improvement over simple template based systems of the contemporary OWGs by having greater expressive power than templates while keeping tight designer control over the side-quest space. We evaluate the system by letting players play side-quests generated by an implementation of the system in a simple role-playing game (RPG). Although our work is intended for side-quests, we will speak generally about quests in the remainder of the paper for the sake of brevity.

2 Related Work

Multiple automated quest generating systems were described in the literature. The GrailGM system [16] uses a forward chaining inference engine to recombine quest elements given by a designer to form quests with multiple solutions and to guide the player's progression through the game. Petri Nets have also been proposed as models for generating quests [10].

In [5], authors examine 3000 quests from commercial games and present a generative grammar that covers most of the analyzed quests. This system was later connected to the game Everquest [6], although no evaluation has been performed so far. Another approach connected to an actual game is *Charbitat* where simple key-lock quests are integrated into a procedurally generated landscape [2].

In [11] authors present a planning-based approach to quest generation. The system is shown to be able to generate quest variations for a 2D RPG, but it is evaluated only with respect to speed.

There are also works on creating interactive experiences that were not intended to be quests, but could be adapted to become quests of a specific kind. This includes generating murder mysteries [1] or adventure-game puzzles [4].

Our approach is simpler than all of the aforementioned works. We consider this to be an advantage for practical game development as simplicity promotes designer control and the system can be quickly implemented. We are also not aware of any other work that evaluated generated quests on actual players.

The building blocks in our system roughly correspond to scenes as discussed by Mateas and Stern [13], or the dramatic beats in Façade [14]. Multiple works have investigated representation of stories as plans, where each action in the plan corresponds to a scene or event being enacted (e.g., [12,15]). The blocks in our approach are similar to narrative actions in the plan-based approach to IS and our formalism could be reformulated as an extremely simple planning problem.

3 Building Blocks

One of our primary goals was to keep the system simple and controllable, while expanding the expressive power of template-based systems. To achieve both we decided to split quests into *blocks*. Each block represents a short section of a quest (e.g. killing a monster to obtain an item). The blocks are arranged into a directed acyclic graph (DAG) where edges connect each block to its possible successors. The DAG may be represented explicitly (as in our implementation) or it may be given implicitly by conditions. Blocks that have no incoming edges are called *start blocks* and those that have no outgoing edges are *end blocks*. Choosing blocks to form a quest is now simply the matter of choosing a random path from a start block to an end block. It is up to the designer to ensure that all paths in the DAG correspond to valid quests. Our experience however indicates that this is achievable with reasonable effort.

Once the blocks are chosen, the system lets the individual blocks to read data from other blocks in the sequence to make the quest coherent. For example a start block where an NPC asks the player to fetch a valuable item reads the name and location of the item from its successor block. The actual structure of the DAG has to ensure that for every possible path through the DAG, the necessary data are always present, but this can be easily checked automatically offline. To further increase variability, the individual blocks could be turned into templates (e.g., varying the specific type of a monster that protects the item).

Each block is also directly connected to assets in the game world, forming self-contained collections of in-game objects and behaviors they exhibit akin to smart objects [9] or smart areas [3]. This encapsulation further eases debugging as the blocks can be tested independently.

4 Our Implementation

To test the proposed approach we have created a simple first-person RPG in
the Unity game engine[1]. Screenshots of the game are presented in Fig. 1. Each
run of the game presents the user with a single quest generated by our method.
The game features some of the typical RPG mechanics: simple ranged combat,
picking up items and giving them to NPCs and dialogues.[2] We implemented a
total of 26 blocks, of those 9 are start blocks and 9 are end blocks. On average,
there are four outgoing edges from each block. The DAG is defined explicitly by
connecting each block to possible successors. Each block is also responsible for
instantiating the objects it needs for execution in the game.

Fig. 1. Screenshots of the game we used for evaluation.

In our implementation, the start blocks represent exposure to the quest —
there are multiple NPCs that give various motivations and context for the quests
(helping the world, personal enrichment, . . .) and a surprise attack by skeletons.
The end blocks represent conclusion of the quest (player returning an item to
an NPC, player being betrayed and ambushed, player meditating and reflecting
on the past experience, . . .). The blocks that are used in between represent the
core of the tasks assigned to the player (finding items, chasing an NPC, fighting
enemies, gathering information, . . .).

The blocks have several attributes (location, action, subject and object) that
can be accessed by other blocks in the quest. In our implementation, these
attributes serve only as strings that are inserted into the NPC's dialogue. Let us
show this on an example of a generated quest: the start block shows a priest that
has lost a valuable item and asks the player to bring it back to him. The successor
that was chosen is a block where the player is asked to find diamonds scattered
in a maple grove. In the chosen end block a mage asks the player to destroy an
item she has brought, because the mage discovers it is cursed. Now the first block
reads the object and location attributes of the second block ("diamonds" and
"maple grove") and inserts them into a sentence describing what did the priest

[1] https://unity3d.com.

[2] A playable version of the system can be downloaded at http://gyfis.itch.io/
side-quest-generating-system.

lost and where. It further reads the location and subject attributes of the last block ("mage Aaron" and "near the cemetery") and inserts them into a sentence describing where the player should deliver the items, once she finds them. The last block further reads the object attribute of the second block ("diamonds") and inserts it into a sentence thanking the player for bringing the item and into a sentence where the mage describes his discovery that it is cursed.

Our DAG represents 187 possible quests. A fully interconnected DAG with the same number of start, end and intermediate blocks would allow for 729 quests ($9 \times 8 \times 9$ of length three and 9×9 quests of length two), while combining the same amount of blocks into fixed quests would result in only 8 quests of length three or 13 quests of length two. This signals that the DAG structure does not overly limit the number of possible generated quests and that the system greatly increases the amount of quests over traditional methods. Since our blocks are not simple variants of a single concept, but truly different encounters for the player with different dialogues, game mechanics involved and motivations presented to the player, the template-based techniques for generating quests can be directly applied at block level to further increase variety.

5 Evaluation

We performed two rounds of evaluation. The first round engaged 21 high school students aged 15 — 22 (14 male, 7 female) in playing 8 quests in our game each. Five of those quests were generated (Gs), while three were hand-picked sequences of blocks (HPs) that were manually tweaked for maximal consistency. The Gs were different for each participant, while the HPs were the same.

After analyzing the first round, HPs showed to be a problematic baseline — they provided only an upper estimate of quality and did not let us asses the magnitude of the difference between HPs and Gs. So we performed a second round of evaluation with a random baseline. In the second round, 12 players aged 16 – 30 (7 male, 5 female) played 7 quests. Two of those were generated, two were HPs (randomly chosen from the three HPs from the first round) and three were randomly chosen sequences of a start block, an intermediate block and an end block that could not be generated by the system (Rs). The Gs and Rs were different for each participant.

For both rounds, the order of the quests was randomized. In total, 252 quest instances were played by the users. Due to bugs in the system, 7 invalid quest instances were removed from the results. In both rounds, players took 20 — 60 min to complete all quests.

After playing each quest, the participants were asked to evaluate the following statements on a 5-point Likert scale (strongly disagree to strongly agree): (Q1) "I liked this quest", (Q2) "The story was clear", (Q3) "I knew what to do all the time during this mission" and (Q4) "This quest was similar to another one I have already played" (during this session).

For all questions, the participants in the second round of evaluation viewed the system more positively — they were more likely to agree with the first 3

questions and disagree with question 4, but the differences were only slight. Thus for our analysis, we treat the two evaluation rounds as a single dataset, although the results for the random baseline should be interpreted with caution as they represent only 12 participants playing 3 quests each. The overall results for those questions are shown in Fig. 2.

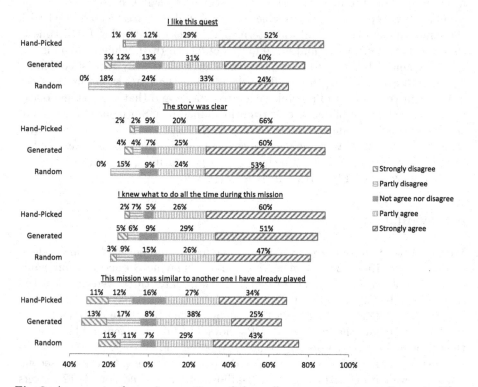

Fig. 2. Answers to the main questions of the poll, summarized over all quests. The percentages are rounded to nearest integer and thus do not always add up to 100%.

The answers to Q1 show a clear ordering. As expected, HPs were considered better than Gs (p = 0.04, Wilcoxon rank-sum test), while Rs were rated worse than Gs, although the difference is not significant (p = 0.1, Wilcoxon rank-sum test). The difference between HPs and Gs and between Gs and Rs is of approximately equal magnitude. For each player we further performed a pairwise comparison of ratings for Q1 for all quests she played. HPs were rated better or equal than Gs in 81% of the HP-G pairs and strictly better in 36% of the HP-G pairs, Gs were rated better or equal than Rs in 71% of the G-R pairs and strictly better in 44% of the G-R pairs. This indicates that HPs were indeed some of the best possible block combinations available, while Gs are slightly worse but still better than Rs. The differences are however small.

Answers to Q2 show that the differences in story coherence were even smaller (and not statistically significant), but retained the same ordering. Q3 lets us

estimate the amount of noise introduced by players having trouble with the specific game mechanics of the game. For all categories, less than 12 % of answers indicate some issues. The answers to Q4 (similarity to previous quests) are interesting, because the ratio of positive and negative answers is similar for Gs and HPs, but Gs have fewer neutral answers, although the link between the type of quest (HP or G) and the number of neutral answers is not statistically significant ($p = 0.09$, Pearson's χ^2). Further caution should be made when interpreting answers to Q4, as the participants initially reported low similarity, then their rating grows quickly and highest similarity was reported after completing the 4th quest and from then on, the players perceive the following quests as less and less similar. This could simply be noise — the correlation between answers to Q4 and the quest number is not significant, ($p = 0.06$, Pearson's χ^2). It is also possible that the perception of similarity evolves as players get familiar with the environment.

The answers to Q1 also evolve over time ($p = 0.049$, Pearson's χ^2). This is possibly related to quest similarity because participants' enjoyment of the game (Q1) was lowest when playing the first quest, possibly because some of the participants had problems understanding the mechanics, and peaked at 6th quest, which corresponds to the moment when, statistically, players start to see a lot of the content for the second time.

Further details on experiment design and source code can be found in the BSc. thesis of the first author [7]. Complete experimental results are also available.[3]

6 Conclusion and Future Work

We have presented a system for generating side-quests from premade building blocks. We have shown that although the system is simple, it can introduce a lot of variety to the input data and players rate the resulting side-quests positively and better than a random baseline but lower than a hand-picked baseline. Simplicity of the system is desirable as it promotes designer control and allows easy adoption for an existing game. We think that the accessibility of the system and the results presented in the paper show the system's potential to improve contemporary OWGs and pave the way for more massive usage of interactive storytelling techniques in the gaming industry. A shortcoming of our evaluation is that we did not evaluate how often a completely implausible quest is produced by the system, which is a very important metric in practice.

The system could be further improved by preferring blocks not yet seen by the player, or by using templates at the block level. Evaluating the system from the authoring perspective (e.g., comparing efficiency and quality of results authors achieve with our system and alternative quest generation paradigms) would make an interesting future work.

Acknowledgments. This research is partially supported by the student grant GA UK No. 559813/2013/A-INF/MFF and by SVV project number 260 224.

[3] http://popelka.ms.mff.cuni.cz/~cerny/papers/sidequests-evaluation.zip.

References

1. Arinbjarnar, M.: Dynamic plot generation engine. In: Proceedings of the Workshop on Integrating Technologies for Interactive Stories, pp. 1–5. ICST, Brussels (2008)
2. Ashmore, C., Nitsche, M.: The quest in a generated world. In: Proceedings of the Digital Games Research Association Conference, pp. 503–509 (2007)
3. Cerny, M., Plch, T., Marko, M., Ondracek, P., Brom, C.: Smart areas: A modular approach to simulation of daily life in an open world video game. In: Proceedings of ICAART 2014, pp. 703–708. SCITEPRESS, Portugal (2014)
4. Dart, I., Nelson, M.J.: Smart terrain causality chains for adventure-game puzzle generation. In: Computational Intelligence and Games, pp. 328–334. IEEE Press (2012)
5. Doran, J., Parberry, I.: A prototype quest generator based on a structural analysis of quests from four MMORPGs. In: Proceedings of the 2nd International Workshop on Procedural Content Generation in Games, pp. 1–8. ACM (2011)
6. Doran, J., Parberry, I.: A server-side framework for the execution of procedurally generated quests in an MMORPG. Technical report, Department of Computer Science and Engineering, University of North Texas, USA (2015). http://larc.unt.edu/techreports/LARC-2015-01.pdf. (Accessed 08 September 2015)
7. Hromada, T.: Generating side quests for RPG games from hand-crafted building blocks. BSc. Thesis, Charles University in Prague (2015)
8. Iassenev, D., Champandard, A.: A-Life, emergent AI and S.T.A.L.K.E.R. AIGameDev.com (2008). http://aigamedev.com/open/interviews/stalker-alife/. (Accessed 02 June 2015)
9. Kallmann, M., Thalmann, D.: Modeling behaviors of interactive objects for real-time virtual environments. J. Vis. Lang. Comput. **13**(2), 177–195 (2002)
10. Lee, Y.S., Cho, S.B.: Dynamic quest plot generation using Petri net planning. In: Proceedings of the Workshop at SIGGRAPH Asia, pp. 47–52. ACM (2012)
11. Soares de Lima, E., Feijó, B., Furtado, A.L.: Hierarchical generation of dynamic and nondeterministic quests in games. In: Proceedings of the 11th Conference on Advances in Computer Entertainment Technology, pp. 24–33. ACM (2014)
12. Magerko, B., Laird, J., Assanie, M., Kerfoot, A., Stokes, D.: AI characters and directors for interactive computer games. In: Proceedings of the 16th Conference on Innovative Applications of Artifical Intelligence, pp. 877–883. AAAI Press (2004)
13. Mateas, M., Stern, A.: Towards integrating plot and character for interactive drama. In: Dautenhahn, K., Bond, A., Cañamero, L., Edmonds, B. (eds.) Socially Intelligent Agents, pp. 221–228. Springer, Heidelberg (2002). http://dx.doi.org/10.1007/0-306-47373-9_27
14. Mateas, M., Stern, A.: Structuring content in the façade interactive drama architecture. In: Proceedings of the First Artificial Intelligence and Interactive Digital Entertainment Conference, pp. 93–98. AAAI Press (2005)
15. Riedl, M.O., Young, R.M.: Narrative planning: Balancing plot and character. J. Artif. Intel. Res. **39**(1), 217–268 (2010)
16. Sullivan, A., Mateas, M., Wardrip-Fruin, N.: Rules of engagement: moving beyond combat-based quests. In: Proceedings of the Intelligent Narrative Technologies III Workshop, pp. 11:1–11:8. ACM (2010)

Towards Measuring Consistency Across Transmedial Narratives

Jonathan Barbara[✉]

Saint Martin's Institute of Higher Education, Ħamrun Malta
jbarbara@stmartins.edu

Abstract. Interactive Digital Storytelling has a role to play in transmedial story-telling and yet there is no instrument to measure one of the critical success factors of such narratives: consistency. This short paper explores what is meant by consistency in this context and identifies it as being a subjective evaluation, part of the user experience. A consistency scale is hereby being proposed to measure user experience across media and invites feedback, suggestions, and discussion on its implementation. Its application will assist IDS designers in determining the success of their narrative game's role in a target transmedia production.

Keywords: Interactive digital storytelling · Transmedia storytelling · Consistency · User experience

1 Introduction

Interactive Digital Storytelling (IDS) lies on a continuum between interactivity and narrative, between Tetris and Shakespeare's Hamlet. However, today's narrative experiences are no longer tied to a single medium, but transcend platforms to convey the story to their audiences, like an orchestra performing a symphony [1]. Not only are narratives remediated to reach newer audiences, but narratives are being designed so that they are transmedial by nature: different parts of the story being experienced through different media, so that the sum of the parts leads to a greater whole – greater in terms of the resulting engagement and immersion in the target storyworld.

Like a composer choosing which orchestra instrument should play which part of the symphony, the multi-modal approach towards storytelling introduces a new tool to the writer: which medium will best convey the narration of which part of the story. In the ideal transmedial storytelling, each medium should do what it does best [2] and thus, while a game should focus on gameplay to convey its story, theatre should focus on its performative functions to tell its part of the story. Likewise IDS should identify its key unique features, such as the use of Artificial Intelligence (AI) to unravel the complex story structure in response to the user's actions [3], and employ them in delivering its part of the story as best as it can.

Just like the expectation of harmony from concurrent melodies in a symphony, such multimodal experiences are expected to convey a consistent narrative experience.

© Springer International Publishing Switzerland 2015
H. Schoenau-Fog et al. (Eds.): ICIDS 2015, LNCS 9445, pp. 243–250, 2016.
DOI: 10.1007/978-3-319-27036-4_23

This puts further load on the narrative design of IDS, which is already complex due to its accommodation of multiple possible storylines.

The various manifestations of the story in the different media make measuring such consistency across transmedial narratives a non-trivial task and its operationalization has not been attempted in the literature. This short paper introduces a proposal for measuring consistency and invites comments and suggestions on its implementation from experts and researchers in the area of IDS, due to the latter's attractive role in transmedia storytelling.

2 Literature Review

2.1 Transmedia Storytelling

Transmedia Storytelling is defined as the process of systematically distributing the core elements of a story [4], or multiple stories within the same storyworld [5], across different communication channels in order to create a "unified and coordinated entertainment experience" [4] where "each medium does what it does best" [2]. Such an arsenal of media may consist of the traditional non-participatory media such as books, comics, film and theatre but may also include media that provide agency for the pro-active reader, hereon referred to as the player, such as in games and IDS experiences.

Games may either concoct stories that give meaning to the rules of the game [6] or else employ gameplay that allows the player to experience the target storyworld. The latter is not a necessarily healthy affair, with the choice of game mechanics conflicting with the game's story being reported in the literature [7]. However, if effort is taken to match the game mechanics to the narrative fiction, they are no longer in conflict with each other but rather become one [8].

IDS employs mechanics that necessarily facilitate the narrative, because the aim of the provided agency is to fully immerse the player in the narrative's storyworld, and any counter-effective interaction is discarded. Moreover, every agency has to be understood by the game's AI, interpreted into an action within the storyworld, and cause the story's narration to react correspondingly and effectively change the course of the story in response [3].

2.2 Consistency

Such provision of agency to the players allows them to change the narrative outcome, over which IDS has to keep control to ensure that the resulting story remains consistent and coherent in order to maintain narrative presence [9, 10]. This demands the use of setting, plot, and characters that are consistent with the audience's set expectations, whilst coherence is attributed to the same order of events being maintained throughout the narration [11]. Emphasis is also made on the characters' actions being consistent with their psychology, especially where the narrative is character-driven as opposed to plot-driven [12, 13].

Consistency is also a criterion used in the design of multi-platform user interfaces (UI) for web services – relevant here due to the transmedial interest of this study - where

continuity of service is served by provision of a consistent UI in terms of visuals, labelling, terms, symbols, as well as operations [14]. Elsewhere internal consistency of the UI is contrasted with cross-device consistency, where keeping the same look and feel as well as functionality across devices is of utmost importance. The ultimate comparison to transmedial experience is achieved with the consideration of within-context consistency: the correlation of the UI with the task being modeled [15].

Consistency is thus also deemed to be a critical success factor in transmedial narratives [16–18]. Whilst each separate instalment of the grand story is expected to stand on its own, providing closure to the reader of the sole experience, each instalment should however add more depth to every previous exposure to the story [19], without causing any conflicting experience that may break the narrative presence [11]. Thus each instalment is to feature consistency with the rest of the story components [2, 20, 21].

Negligible research on how to operationalize and measure criteria relevant to consistency has been encountered in the literature. Harvey suggests consistency in character, plot, or scenario [22] whilst Dena [20] quotes Caldwell emphasizing consistent visuals and narrative texture [23]. Hochleitner et al. describe internal consistency as "making changes that last and predictable responses by the game" thus being about persistence and determinism [24]; and this paper subscribes to this definition while extending it across multiple experiences.

Consistency is not only at the mercy of the medium but also of the author. Apart from willful inconsistencies of the author, a different author may introduce their own inconsistencies in order to leave their imprint (such as Peter Jackson's visual feast take on *The Hobbit*). Inconsistency can also be willfully introduced to save the story brand when fans are dissatisfied with the storyline, most often resorting to corrective addenda that posthumously justify the misalignment [25, 26]. Inconsistencies multiply when the author lets go of their authorship by providing players with agency and thus the ability to co-author the story – as in the case of IDS and narrative games.

Rather than choosing between author-driven and fan-driven narrative outcomes, this paper suggests that, within the realm of IDS and games, the focus of consistency should be on the afforded agency and the narrative context within which they are provided, rather than the narrative outcomes of such actions.

2.3 Subjective Consistency

In the case of transmedia narratives, the main components of a narrative experience are the storyworld, with all its semiotics, geography, fauna, flora, demographics and lore, the characters, with their own personal traits, histories, arcs, and alignments, and the events, in terms of their temporal properties, outcomes, and repercussions. For players to remember all these details in order to inform their agency choices depends on their engagement with the storyworld, with hard-core fans being the most able to recall trivial details of particular experiences. Memory plays a big role in determining consistency [22] and in the reader's ability to support inconsistencies across media and give way to inconsistencies by changing the user's representation of the story [27]. All these variables place the determination of whether a story component is consistent or not with the other story instalments in the hands of the readers, themselves co-authors as players in the case of IDS and games, and their judgement is based upon the resulting user experience.

2.4 Measuring Consistency

Primarily applied to generic software systems, user experience (UX) research – as the domain within which consistency is being sought - has also focused on game studies and player experience since 2004 [28]. This took different forms borrowed from its use in software development, where the focus is on task completion, including the use of heuristics [29], questionnaires [30] and psychophysiological measurements [31]. However such UX research mostly focused on game mechanics and social presence aspects of single game or narrative experiences, even when these addressed cross-media presence [32], and are thus of no help in measuring user experience across multiple story instalments.

This study posits a separate measurement for consistency eliciting reactions from the players as a result of their encounter with storyworld artefacts, characters and events across multiple narrative media experiences, as well as context, agency, interaction, and outcome within participatory media experiences such as games and IDS.

3 Consistency Scale

This paper hereby suggests different levels of consistency as a means to compare experiences of the different components of a transmedial narrative. Different media experiences serve different roles, such as adaptations, spin-offs, and parodies, and are used here as exemplars. The five consistency levels being proposed are as follows:

Consistent. Such a rating would indicate properties that are always constant across experiences: symbols that mean the same; character behavior that always acts in the same way; events that are re-told free from variation or contradiction; artefacts that always provide the same interactions; player agency that always results in the same outcome. An adaptation would be expected to have such a level of consistency.

Cohesive. Such a rating would indicate a variation from the expected norm justified by some believable motive or cause: a symbol that has changed in meaning due to an important event; a character who becomes introverted due to a life-changing calamity; an event that is retold by a different character who gives a first-hand account that re-interprets the original tale; artefacts whose functionality has been augmented, or simply broken down; agency that results in a different outcome due to becoming better through training. Sequels and prequels would be typical experiences.

Irrelevant. Such a rating would indicate a new experience that was not noted in earlier experiences and has no impact on existing knowledge gained through prior experiences: a new symbol; an unexplored character trait; an untold event that has no impact on other events; an artefact's property such as weight; previously undocumented, or a new means of agency. This would be applicable to spinoffs, for example.

Inconsistent. Such a rating would be used with new information that doesn't follow expectations and yet it doesn't break the original knowledge: a different meaning to a given symbol that is unrelated to the original meaning; a character behaving differently to a situation, without any particular explanation as to the change; an event whose details

have changed, maybe a different sequence of events; an artefact's property that is reported differently, such as its color; an agency that is not always provided for the same interactive artefact. Such a level can be found in brand management exercises, called 'fanagement', when fans are unhappy with the story and changes come about in subsequent episodes to re-align the narrative with such expectations, such as in the TV series *Torchwood* [25].

Conflicting. Such a rating would be used when the new experience results in an outcome that is directly opposite to that originally experienced: a symbol that means exactly the opposite of the original meaning; a character who performs an out-of-character action, and that is not part of their character-arc, such as killing a hapless bystander rather than saving them from harm; an event whose outcome is totally different and opposite to the originally reported outcome, such as a loss instead of a victory in combat; an artefact which does exactly the opposite of what it should, like killing instead of restoring life; a provided agency that goes against that originally provided, like wearing a radiation suit that amplifies radiation levels rather than dampens them. Such a level can be attributed to either badly planned sequels or to parodies, which intentionally twist the story in order to make fun of the narrative.

4 Discussion

This short paper analyzed the role of consistency as a critical success factor for transmedial narratives and suggested a consistency scale with which to describe its measurement as part of the user experience in terms of both traditional narrative elements (storyworld, characters, events) as well as participatory characteristics of IDS and games.

Such a scale would be useful in providing a comparative measure of consistency between transmedia experiences which can be applied individually to the different elements of the narrative. Applications include the construction of user experience instruments with which to analyze existing games and IDS that share a transmedial world with other narrative experiences, such as film-based games and ARGs, as well as a game design tool to assess, at prototype stage, the suitability of the chosen narrative context and game mechanics to be employed in a game or IDS as part of a transmedial narrative.

Typically, transmedial experiences are not expected to be found at the extremes of the scale: since repurposing of narratives across media do not serve the transmedial augmented narrative outlook whilst breaking the immersion is surely not an objective of this phenomenon. Thus successful storylines are expected to be explored further in media experiences that are either cohesive – when expanding further on characters and events already introduced in earlier experiences - or irrelevant, when background story or parallel events and characters are explored in new experiences.

When the core story proves to be unpopular with a substantial portion of the target audience, new experiences might want to shift and alter core elements of the story by experiences that are inconsistent with the core experience in order to rectify character traits and events to appease the disgruntled fans.

Possible ways to operationalize this consistency scale include its use in scoring sheets as part of user experience questionnaires responded to after being exposed to multiple

experiences in the same transmedial narrative, having the participant consider and score each narrative element individually.

5 Conclusion

Being in its initial stages, there is little to conclude in this short paper except that trying to pin down what is meant by consistency across narratives should be a great step forward towards being able to quantify the success factor of a transmedial production employing both fully narrative as well as interactive digital storytelling components to narrate the story. Looking back at the Wachowski brothers' seminal transmedial experience *The Matrix*, appreciation of the separate instalments was not possible because, as Jenkins himself puts it, there were no adequate aesthetic criteria for evaluating multi-modal works [33]: this study is a step in the direction to start making it possible.

5.1 Future Work

The proposal is only the first step towards measuring consistency of interactive systems in a transmedial narrative. Further studies should explore at which granularity such a consistency scale should be applied: whether to the whole experience, or to each element of the transmedial narrative experience (storyworld, characters, events, and agency), or to each individual manifestation of such elements (each character each event, each motif, and each employed game mechanic). It is suggested to use grounded theory and to carry out a qualitative study, together with focus groups, in order to validate the use of such a consistency scale.

References

1. Future Studies: Transmedia narrative - Orchestra of multiple media platforms (2009). https://vimeo.com/12641234
2. Jenkins, H.: Transmedia Storytelling (2003). http://www.technologyreview.com/news/401760/transmedia-storytelling/
3. Spierling, U.: Interactive digital storytelling: towards a hybrid conceptual approach (2005)
4. Jenkins, H.: Transmedia Storytelling 101 (2007). http://henryjenkins.org/2007/03/transmedia_storytelling_101.html
5. Dena, C.: Do you have a big stick? Hand Made High Tech, 1–5 (2011)
6. Juul, J.: Half-real: video games between real rules and fictional worlds. MIT Press, Cambridge (2005)
7. Linderoth, J.: The effort of being in a fictional world: upkeyings and laminated frames in MMORPGs: the effort of being in a fictional world. Symb. Interact. **35**, 474–492 (2012)
8. Sheldon, L.: Character Development and Storytelling for Games. Cengage Learning, Crawfordsville (2014)
9. Young, R.M., Riedl, M.: Towards an architecture for intelligent control of narrative in interactive virtual worlds. In: Proceedings of the 8th International Conference on Intelligent User Interfaces, pp. 310–312. ACM (2003)

10. Roberts, D.L., Isbell, C.L.: A survey and qualitative analysis of recent advances in drama management. Int. Trans. Syst. Sci. Appl. Spec. Issue Agent Based Syst. Hum. Learn. **4**, 61–75 (2008)
11. Rowe, J.P., McQuiggan, S.W., Lester, J.C.: Narrative presence in intelligent learning environments. In: Working Notes of the 2007 AAAI Fall Symposium on Intelligent Narrative Technologies, pp. 126–133 (2007)
12. Pizzi, D., Cavazza, M.: From debugging to authoring: adapting productivity tools to narrative content description. In: Spierling, U., Szilas, N. (eds.) ICIDS 2008. LNCS, vol. 5334, pp. 285–296. Springer, Heidelberg (2008)
13. Riedl, M.: Actor conference: character-focused narrative planning (Technical report No. 03-000). Liq. Narrat. Group N. C. State Univ. (2002)
14. Wäljas, M., Segerståhl, K., Väänänen-Vainio-Mattila, K., Oinas-Kukkonen, H.: Cross-platform service user experience: a field study and an initial framework. In: Proceedings of the 12th International Conference on Human Computer Interaction with Mobile Devices and Services, pp. 219–228. ACM (2010)
15. Paternò, F., Santoro, C.: A logical framework for multi-device user interfaces. In: Proceedings of the 4th ACM SIGCHI Symposium on Engineering Interactive Computing Systems, pp. 45–50. ACM (2012)
16. Jenkins, H.: The Revenge of the Origami Unicorn: Seven Principles of Transmedia Storytelling (2009). http://henryjenkins.org/2009/12/the_revenge_of_the_origami_uni.html
17. Beddows, E.: Consuming transmedia: how audiences engage with narrative across multiple story modes (2012)
18. Breum, A.C., Midtgaard, H.S.: Story Bridges in Transmedia (2013)
19. Jenkins, H.: Searching for the Origami Unicorn. In: Convergence Culture, pp. 95–134. New York University Press, New York (2006)
20. Dena, C.: Transmedia practice: theorising the practice of expressing a fictional world across distinct media and environments (2010). http://elmcip.net/critical-writing/transmedia-practice-theorising-practice-expressing-fictional-world-across-distinct
21. Clarke, M.J.: Lost and mastermind narration. Telev. New Media **11**, 123–142 (2010)
22. Harvey, C.: A taxonomy of transmedia storytelling. In: Storyworlds Across Media' Conference. Johannes Gutenberg-University Mainz (2011)
23. Caldwell, J.T.: Production Culture: Industrial Reflexivity and Critical Practice in Film and Television. Duke University Press, Durham (2008)
24. Hochleitner, C., Hochleitner, W., Graf, C., Tscheligi, M.: A heuristic framework for evaluating user experience in games. In: Bernhaupt, R. (ed.) Game User Experience Evaluation, pp. 187–206. Springer, Heidelberg (2015)
25. Hills, M.: Torchwood's trans-transmedia: media tie-ins and brand "fanagement". Participations **9**, 409–428 (2012)
26. Harvey, C.: Fantastic Transmedia: Narrative, Play and Memory Across Science Fiction and Fantasy Storyworlds. Palgrave Macmillan, London (2015)
27. Lemke, J.: Transmedia traversals: marketing meaning and identity. In: Interdisciplinary Perspectives on Multimodality: Theory and Practice, Proceedings of the Third International Conference on Multimodality. Palladino, Campobasso (2010)
28. Ye, Z.: Genres as a tool for understanding and analyzing user experience in games. In: CHI 2004 Extended Abstracts on Human Factors in Computing Systems, Vienna, Austria, pp. 773–774 (2004)
29. Desurvire, H., Wiberg, C.: Game usability heuristics (PLAY) for evaluating and designing better games: the next iteration. In: Ozok, A., Zaphiris, P. (eds.) OCSC 2009. LNCS, vol. 5621, pp. 557–566. Springer, Heidelberg (2009)

30. IJsselsteijn, W., de Kort, Y., Poels, K., Jurgelionis, A., Bellotti, F.: Characterising and measuring user experiences in digital games. In: International Conference on Advances in Computer Entertainment Technology, Salzburg, Austria, p. 27 (2007)
31. Nacke, L.E., Grimshaw, M.N., Lindley, C.A.: More than a feeling: measurement of sonic user experience and psychophysiology in a first-person shooter game. Interact. Comput. **22**, 336–343 (2010)
32. Lassiter, J., Freeman, J., Davidoff, J., Keogh, E.: A Cross-Media Presence Questionnaire: The ITC-Sense of Presence Inventory (2001)
33. Jenkins, H.: Convergence Culture: Where Old and New Media Collide. NYU Press, New York (2006)

Evaluation of Yasmine's Adventures: Exploring the Socio-Cultural Potential of Location Aware Multimedia Stories

Mara Dionisio[1]([✉]), Mary Barreto[1], Valentina Nisi[1], Nuno Nunes[1], Julian Hanna[1], Bianca Herlo[2], and Jennifer Schubert[2]

[1] Madeira-ITI, University of Madeira, Campus da Penteada, 9020-105 Funchal, Portugal
{mara.dionisio,mary.barreto,julian.hanna}@m-iti.org,
{valentina,njn}@uma.pt
[2] Design Research Lab, Berlin University of the Arts, Berlin, Germany
{bianca.herlo,Jennifer.schubert}@udk-berlin.de

Abstract. This paper describes Yasmine's Adventures, a location aware multimedia story designed as a location based service for a museum. Yasmine's Adventures follows a young local girl (Yasmine) through a series of short animated adventures, tailored specifically to engage visitors in exploring the relatively neglected streets of the area in which the museum is situated. Yasmine's perceptions of the landmarks, identified by community members themselves, reflect the real concerns of the community. Results from the evaluation of the user's experience suggest location connection and perception changes when locative media narratives include learning, understanding and discovery elements.

Keywords: Location based services and experiences · Mobile socially driven storytelling · Interactive narrative · Digital storytelling · Location aware virtual reality · Urban computing

1 Introduction

This paper describes Yasmine's Adventures (YA), a location aware multimedia story (LAMS) that leverages on urban computing strategies to create an interactive trail across the landscape surrounding the Jewish Museum in Berlin. YA was created with the goal of challenging and engaging visitors of the museum to explore the adjacent and relatively neglected streets of the area in which it is situated. The motivation for this work is that the conscious layering of space and narrative provides a compelling, immersive experience with the power to reveal a community that is often overlooked.

Through the YA interactive story the audience follows the adventures of a free-spirited local girl named Yasmine as she sneaks away from her class field trip to the museum and attempts to walk home alone. The story is delivered through a mobile application that combines the finding and capturing of visual cues around the neighbourhood with the delivery of a sequence of short animations tailored specifically to the

© Springer International Publishing Switzerland 2015
H. Schoenau-Fog et al. (Eds.): ICIDS 2015, LNCS 9445, pp. 251–258, 2016.
DOI: 10.1007/978-3-319-27036-4_24

Mehringplatz area. The YA project was developed to investigate how a location aware narrative can impact the audience perception of a neighbourhood.

2 Related Work

We position our project in the Locative Media panorama and in particular as a Location Aware Multimedia Story (LAMS). LAMS refers to cinematically rendered narrative content related to specific locations and embedded in those real spaces through the use of location aware mobile technologies [1]. By designing and producing virtual layers of information that combine with existing material layers we can have a direct impact on how a location is perceived and experienced by visitors and residents. A number of past projects have explored the association of digital media to urban locations with the intention of providing entertaining and educational experiences [2, 3], while struggling with technological shortcomings such as GPS inaccuracy. Issues these projects focused on included empowering communities, highlighting local histories [1, 4, 5], counteracting media reports that damaged neighbourhood reputations [6], and connecting communities with visitors [7]. Such projects reported success in impacting audiences but remained experimental in evaluations and feedback.

Moreover, there is a bias in building and evaluating location aware services in laboratory settings [8] since it limits the understanding of design and use and the development of cumulative knowledge regarding the design of such systems. Only more recently have researchers begun to look at methods and techniques for staging these systems in the wild [9]. Current research within the evaluation of LAMS suggests that evaluation techniques could be further explored. This work proposes applying in the wild evaluation techniques to push forward the understanding of audience interactions within real spaces mediated by mobile interactive technologies and content.

3 Yasmine's Adventures Interactive Experience

3.1 Concept and Story

YA was conceived with the goal of sharing neighbourhood concerns and perspectives with visitors to Mehringplatz by presenting a community view of the area. The process originated with the 'Pinpointing Mehringplatz' workshops, in which community members expressed their opinions about features of the neighbourhood as pleasing, displeasing, or potentially transformational (see Fig. 1). Based on the issues raised by community members themselves we selected five anchor points in the area and created the story of Yasmine, an adventurous 7-year-old girl. Yasmine starts her adventure by escaping from a field trip to the Jewish Museum and walking home alone. On her journey she stops in various places, including: the KMA, a community centre where hip hop classes are offered; and a street mural, where she talks to an artist while he paints. Every journey has its challenges, and Yasmine also encounters some trouble on her walk. YA includes both positive and negative feelings about neighbourhood locations, reflecting the content generated in the community workshop.

Fig. 1. Connection between community content and Yasmine's story. Left to right: the first top and bottom pictures show the street mural and Yasmine talking to the artist. Second pair: the alley described by the community, where Yasmine meets a rat. Last pair: the construction site.

3.2 The Experience Design

The experience is designed as if it were a service provided by the Jewish Museum. If the participant wishes to experience YA they are given a YA enabled phone or instructed how to download and use the application on their own device. The participant then exits the museum to look for easily accessible visual markers located in strategic spots. The markers are A5 postcards depicting scenes from YA (see Fig. 2).

Fig. 2. Left: The experience points with content matched to the visual marker. Right: The visual markers placed in the real environment and participants interacting with them.

By pointing the phone's camera at the marker and capturing it, a 3D reconstruction of the surrounding environment is displayed on the screen and the user is prompted to scan the virtual environment looking for story content by moving the mobile phone around the physical space. Once found, the video animation is loaded and the user can watch it. The animation depicts an adventure of Yasmine in that specific location. When the video clip ends, the user returns to the 3D environment screen by clicking a back

button, and can scan the virtual environment for more stories. If no other stories are available, the user can go back to the 2D map and follow the indications of where to go next to view more adventures. The story fragments are sequential so the locations must be visited in the correct order. Yasmine's story ends with a concluding video after all five locations highlighted on the map have been visited. The walk lasts approximately 20 min; duration was a design consideration since the cold Berlin winter could lead to an unpleasant or unfinished experience.

3.3 Technical Description

The implementation of the mobile application that delivers YA was programmed in C# using the Unity[1] game engine. The main interface is composed of scrollable map, 'close' button, and 'capture the marker' button. To recognize and capture markers we used Vuforia[2], and for 360-degree interaction we used the Durovis Dive plugin[3].

For YA we recreated five three dimensional virtual locations in which to disseminate the animations. Once the target location in the virtual environment is found and users lock their scanning movement on it, the video loads and plays. When playback finishes Unity resumes, showing if there is more content to explore or not. All multimedia content is stored on the mobile device and no data connection is needed.

4 Methodology

4.1 Participants

A total of 20 users (55 % within the 25–34 age range) participated in the study (15 females). 50 % of the users had German as their native language and all users were pre-screened for their fluency in English. Participants were all currently living in Berlin. Participants were recruited using a snowball sampling methodology in order to gather both people familiar and unfamiliar with the area.

4.2 Evaluation Set Up

Participants were asked to experience the YA LAMS as described in Sect. 3.2 (see Fig. 3). The tour started at the entrance of the Jewish Museum where the researcher dispensed a mobile phone with the application and announced that they would be observed during the trials. On average each tour lasted approximately 20–25 min. Once the tour was complete, participants were asked to fill in a questionnaire consisting of demographic data and measures of narrative transportation, presence and flow.

[1] http://unity3d.com/.
[2] https://www.qualcomm.com/products/vuforia.
[3] http://www.durovis.com.

Fig. 3. Participants of the user evaluations in the different stages. Capturing visual clue (Left); scanning the 3D environment (Centre); enjoying video narrative (Right).

Afterwards, we conducted semi-structured interviews to probe for participants' impressions of the overall experience, using the application, location and spatial presence and finally, connection gained to the neighbourhood. The interview guide included a set of core questions from the questionnaire to be addressed more thoroughly. Each interview also included individual questions based specifically on that participant's tour shadowing/observation notes. Interviews lasted about 15-20 min. The questionnaire and interview data were then analysed using a grounded theory affinity analysis [10, 11] with the support of the *Nvivo* software tool [12]. Researchers conducted a bottom-up data analysis reviewing and iterative process in three stages: *open coding* (quotes and high-level categories), *affinity diagrams* (relationships between categories) and *theme organization* (most frequent themes and description).

4.3 Measures

The Narrative Transportation Scale (NTS) [13] was applied to assess participants' ability to be transported into the application's narrative. It evaluates immersion aspects, namely: emotional involvement, cognitive attention, feelings of suspense, lack of awareness of surroundings, and mental imagery ($\alpha = 0.47$). A principal component analysis (varimax rotation) revealed a two-factor structure of 8 ($\alpha = 0.49$) and 3 items ($\alpha = 0.37$). When asked if the experience helped users learn and if it changed their neighbourhood perception, participants indicated ratings with an average of 4.5 (on a 1 to 7 scale). This perspective modification correlated to transportation, a strong and positive correlation between the two variables ($[r = 0,702, n = 20, p = 0.001]$), with high levels of transportation associated with high levels of neighbourhood perspective.

The Flow Short Scale [14] evaluated the individual's ability to be absorbed by the activity and fluency while conducting it. Internal reliability of the scale was high ($\alpha = 0.71$). Emotional involvement (measured by NTS) was correlated with flow where results indicated a strong and positive correlation ($[r = 0.533, n = 20, p = 0.023]$) in which high levels of flow were associated with high levels of emotional involvement.

To assess presence in the story a single item was included in the questionnaire: 'In the video narrative I had *a sense of being there*.' Presence is defined as 'a psychological state in which virtual objects are experienced as actual objects in either sensory or non-sensory ways' [15]. The results suggest a strong, positive relationship ($[r = 0.505, n = 20, p < 0.05]$) between transportation and presence with high transportation levels

associated with high levels of presence. Preliminary analyses were performed to ensure no violation of assumptions of normality, linearity and homoscedasticity.

4.4 Evaluation Findings

In this section we will discuss the results to address the following question: How did our audience perceive the neighbourhood through this narrative? Change of perspective was supported by four elements that emerged from the qualitative data analysis (Sect. 4.2): **(1) Awareness of space, (2) Connection, (3) Empathy,** and **(4) Content**.

Concerning the first element, **awareness of space,** participants mentioned physical objects of which they were not aware, although they had visited and walked around the area before as stated by one participant: 'The fact that we actually stopped and looked around makes you notice other things' (U17 ref. 2); or, 'Through the application I saw something different – for example the playground' (U6 ref. 1).

The second element, **connection,** emerged whenever users referred to feeling connected to the neighbourhood, or whenever they wanted to interact directly with people from the neighbourhood. Participants stated that the connection they felt with the area was enhanced by the YA experience: 'I feel more connected. ... It is a geographically placed experience, I feel that they told me their perception of their home area' (U15 ref. 3). However, some participants suggested this connection would be improved if the application brought them even closer to the community: 'there could be teams from the neighbourhood developing the characters and the animations' (U4 ref. 2).

Regarding the third element, that supported a change of perspective on the neighbourhood, participants mentioned that their perspective was changed through **empathy,** feeling some kind of affinity, either towards people who live there or even the physical location. For example, feeling compassionate about local community issues: 'The construction is something I see more as an interference now and it was not something I really thought about before' (U10 ref. 1); or even, 'When we go to a place we do not know in this way, we can figure out the problems ... like the construction site and I would not reflect on why it has been there for so long' (U7 ref. 1).

Concerning the fourth theme, **content,** users thought it could be further expanded to add more complexity: 'I would make the story more complex and longer' (U13, ref. 1). Users suggested that the content could have been shaped around locals' anecdotes rather than a fictional story based on real events: 'I would have rather had the little stories of what happened here or there, to make me more curious' (U1, ref. 1).

Participants saw the application as an enjoyable gaming experience, comparing it to a **treasure hunt**: 'The fun part was finding the markers and the scavenger hunt' (U14 ref. 1). The markers in particular enhanced the sense of search and discovery: 'I like searching for something you need to look around for and observe' (U3 ref. 1).

5 Discussion

From the results and the analysis of the YA evaluation, similarly to [5, 16] we found YA to promote relatedness and exploration of the local neighbourhood. The results

indicate that participants did experience a sense of presence generated by the location aware multimedia story and this feeling allowed them to be immersed in the story. Participants revealed levels of immersion and transportation through the narrative, completed the task and felt absorbed by it, wishing to have extra visual markers and further information as they explored the space.

In addition, this sense of presence in the story enabled users to gain a greater awareness of the neighbourhood's physical space but also of the people living in it. This awareness expanded to feeling empathy and a shared understanding for community issues, since the story exposed issues identified by community members. Examples of participant engagement were the attention to and the awareness of the surrounding space throughout the experience, and the reported desire to add more complex content, visual clues and information, to learn more facts and expand the tour.

The level of connectedness and learning for users would have been greater if the application had included more facts, testimonials or even direct contact with locals. Learning and connecting for our participants meant talking to people who live in the area more than following a metaphorical story. Such a finding indicates that LAMS with a sociocultural intent should include more neighbourhood information to generate a stronger connection between the audience and the local neighbourhood. Nevertheless, participants did mention feeling concern for local issues. Such feelings might have been enhanced not only by the narrative, but also through the sense of presence in the story that was reported by several users.

In summary, the findings uncovered through the YA user study suggest that locative media associated with story content is a successful strategy for generating engagement and connection to local communities. However, these digitally mediated sociocultural efforts, such as YA, need to go beyond the individual engagement of a few people and perhaps even expand over longer periods of time. Beyond looking at individuals, users seem to suggest that having a community lens, looking at historical facts from a group perspective, and adding testimonials that allow others to understand the cultural and physical evolution of a particular location, would be welcome in LAMS with a sociocultural emphasis. The connection of audience and neighbourhood seems to increase when a treasure hunt experience is added to location aware multimedia stories. Such a result can be achieved by mixing content with search and discovery activities. Learning by being in the place, discovering and connecting factual elements with the real location, and ideally having direct contact with community members, seem to be key elements for the successful engagement of visitors in the discovery of socially marginalized, overlooked, or underprivileged neighbourhoods.

6 Conclusions

This work presented the design process and evaluation of the interactive location based YA. The experience was designed to better integrate visitors to the Jewish Museum Berlin with the surrounding Mehringplatz neighbourhood. The application contributed to changing perception of the neighbourhood by supporting empathy, awareness, and connection, and by capturing participants' attention with an engaging story.

Acknowledgements. We wish to acknowledge our fellow interns Rui Trindade, Paulo Bala and the support of the Associated Robotic Laboratories LARSyS (PEst-OE/EEI/LA0009/2013). The project has been developed as part of the Future Fabulators project (2013-1659/001-001 CU7 COOP7), funded by the EU Culture and Media program.

References

1. Nisi, V., Oakley, I., Haahr, M.: Location-aware multimedia stories: Bringing together real and virtual spaces. In: ARTECH Conference on Digital Arts, pp. 72–81 (2008)
2. Reid, J., Hull, R., Cater, K., Fleuriot, C.: Magic moments in situated mediascapes. In: Proceedings of the 2005 ACM SIGCHI ACE, pp. 290–293. ACM (2005)
3. Benford, S., Giannachi, G., Koleva, B., Rodden, T.: From interaction to trajectories: designing coherent journeys through user experiences. In: Proceedings of CHI2009, pp. 709–718. ACM (2009)
4. Nisi, V., Haahr, M.: Weird view: interactive multilinear narratives and real-life community stories. Crossings **2**, 27 (2006)
5. Christopoulou, E., Ringas, D., Stefanidakis, M.: Experiences from the urban computing impact on urban culture. In: 2012 16th Panhellenic Conference on Informatics (PCI), pp. 56–61. IEEE (2012)
6. Nisi, V., Oakley, I.: Locative narratives as experience: a new perspective on location—aware multimedia stories. Touchpoint J. **1** (2009)
7. Dionisio, M., Nisi, V., van Leeuwen, J.P.: iLand: a tangible location aware narrative experience. In: Proceedings of the Fifth International Conference on TEI, pp. 407–408. ACM (2011)
8. Kjeldskov, J., Graham, C.: A review of mobile HCI research methods. In: Chittaro, L. (ed.) Mobile HCI 2003. LNCS, vol. 2795. Springer, Heidelberg (2003)
9. ter Hofte, H., Jensen, K.L., Nurmi, P., Froehlich, J.: Mobile Living Labs 09: methods and tools for evaluation in the wild: http://mll09.novay.nl. In: Proceedings of the 11th MobileHCI, pp. 107:1–107:2. ACM, New York (2009)
10. Beyer, H., Holtzblatt, K.: Contextual Design: Defining Customer-Centered Systems. Elsevier, Amsterdam (1997)
11. Strauss, A., Corbin, J.: Grounded theory methodology. In: Handbook of Qualitative Research, pp. 273–285 (1994)
12. Nvivo Qualitative Research Software (2015)
13. Green, M.C., Brock, T.C.: The role of transportation in the persuasiveness of public narratives. J. Pers. Soc. Psychol. **79**, 701 (2000)
14. Magyaródi, T., Nagy, H., Soltész, P., Mózes, T., Oláh, A.: Psychometric properties of a newly established flow state questionnaire. Pszichológia **33**, 15–36 (2013)
15. Lee, K.M.: Presence, explicated. Commun. Theory **14**, 27–50 (2004)
16. Nisi, V., Oakley, I., Haahr, M.: Location-aware multimedia stories: turning spaces into places. Universidade Cátolica Portuguesa, pp. 72–93 (2008)

What Makes a Successful Emergent Narrative: The Case of Crusader Kings II

Bertrand Lucat[✉] and Mads Haahr

School of Computer Science and Statistics, Trinity College Dublin, College Green
Dublin 2, Ireland
{lucatb,haahrm}@scss.tcd.ie

Abstract. Though sometimes placed in opposition to digital games with authored narratives, simulation games and their primarily emergent narratives do not necessarily lack emotional depth and complexity, and can engage players in intellectually and emotionally engaging narratives. Through the close analysis of Paradox Development Studio's highly successful grand strategy game *Crusader Kings II*, we examine how the various layers that constitute that game's narrative as well as specific game mechanics assist in the creation of highly individualized narratives of play. By deploying hybrid narrative techniques that rely as much on the systems of the simulation as they do upon the actions of ambitious autonomous agents and scripted vignettes, *Crusader Kings II* provides a striking example of how a game can strive to accurately depict a historical period as well as the complexities of its social, cultural, and familial structures, and succeed in crafting engaging interactive stories out of this simulation.

Keywords: Emergent narrative · Digital games · Simulation · Emotion · Family

1 Introduction

In an essay published earlier this year in The Atlantic, Ian Bogost makes the bold claim that "Video Games Are Better Without Characters" [1]. Seizing upon the closure of Maxis Emeryville, the studio behind *SimCity* [2], Bogost decries what he perceives as the bias in recent digital games production towards making games that emphasize the representation of individuals and their stories, rather than of systems and their flaws, which he argues simulation games are best suited to convey and represent in potentially intellectually or ideologically challenging ways. Even as he contrasts simulation games with those he more readily associates with "identity politics", Bogost does not go so far as to state that greater popularity for such simulation games would prove entirely salutary for the games industry and the gaming public in general. However, his spirited defense of the simulation genre that was the hallmark of Maxis's output, with such titles as *SimCity* and *The Sims*, strikes a particular chord when he addresses the perceived opposition in certain sections of the digital games industry between the emergent narratives borne out of games like *The Sims* and the "emotional nuance" [3] that can, supposedly, only arise from authored digital narratives. This perception of opposition, be it qualitative or measured in terms of player engagement, between emergent narrative and

© Springer International Publishing Switzerland 2015
H. Schoenau-Fog et al. (Eds.): ICIDS 2015, LNCS 9445, pp. 259–266, 2016.
DOI: 10.1007/978-3-319-27036-4_25

authored content is nothing new in the field of interactive digital narratives, or of digital game studies [4]. Simulation games of the type that Maxis produced have been described as environments that create emergent narratives, with *The Sims* serving as the prime example behind, notably, Henry Jenkins's articulation of the concept [5]. Though Electronic Arts has turned a page of digital game history by closing down Maxis, simulation games that fully display the capacity these types of games have for creating emotional nuance through emergent play are still being made, and enjoying considerable popularity, despite Bogost's somewhat pessimistic stance. Indeed, some recent entries in the genre have displayed some of the ways that emergent narrative techniques, in conjunction with simulation systems, can produce engaging player experiences.

Through a close analysis of these systems at play in one such game, Paradox Development Studio's 2012 grand strategy game, *Crusader Kings II*, derived from extensive play of numerous game sessions, we will propose that this game has at its core hybrid narrative techniques which could be applied to other games of its genre, but which also prove relevant for interactive digital narratives in general. Through its reliance upon the concept of the family as both a mechanical and narrative cornerstone, *Crusader Kings II* creates a compelling historical sense of time as well as a jarring, entertaining, and emotionally potent representation of the medieval era and its politics. Furthermore, the use of scripted vignettes in conjunction with the largely emergent narrative arising from the experience of the game's simulation results in a strong sense of player engagement within the personal narrative of the dynasty they play through the ages.

2 Emergent Narratives and Emotional Actors

In "Game Design as Narrative Architecture", Henry Jenkins used Maxis's own *The Sims* to describe emergent narrative as one of numerous models for narrative possibilities in digital games: "Emergent narratives are not prestructured or preprogrammed, taking shape through the game play, yet they are not as unstructured, chaotic, and frustrating as life itself" [5]. The use of *The Sims* to illustrate this example of a narrative form in digital games is fitting, given the game and its successors' function as sandbox or "dollhouse" games. Yet Jenkins also highlights the narrative satisfaction that arises from playing the game, as well as the emotional satisfaction for players that arises from characters having "desires, urges, and needs" of their own [5]. Marie-Laure Ryan has argued, with reference in part to *The Sims*, that digital games have only so far tentatively approached dramatic narrative plots that "knot together several destinies into a dynamic network of human relations and then disentangles them to let characters go their own way" [4]. However, in *The Sims* and other simulation games, it is those drives and desires present in the characters that give them some measure of personality. In turn, this makes the emergent narrative resonate with players, depending on their level of control.

It has also been argued that, in certain interactive digital storytelling systems, the interaction between autonomous characters does not always lead to interesting stories, at least from a spectator viewpoint, if not from that of the interactor [6]. In connection with a game like *The Sims*, where the player is a disembodied puppet-master controlling his Sims, this may seem like quite a valid observation. However, the importance of such

independently motivated agents is not to be understated in the way that an emergent narrative as Jenkins described it can and should rely upon them to create a narrative that involves the player. A game like *Crusader Kings II* demonstrates that such emergent narrative techniques focused on character interaction, as found in dollhouse simulators like *The Sims*, can be successfully integrated within another genre of simulation game, otherwise not bearing the hallmarks of complex narrative ambitions. Indeed, *Crusader Kings II*'s lead designer, Henrik Fåhraeus names *The Sims* as one of the influences behind the game, and certain shared mechanics are quite self-evidently at play, such as systems for modelling interpersonal relationships [7]. This mechanic of balancing positive and negative relationships is fully realized through *Crusader Kings II*'s opinion system. Every autonomous agent in the game, as well as the player's current character, are characterized by a number of traits which carry opinion modifiers that affect a scale of −100 to 100 in characters' mutual opinions of one another. Complementary and opposing traits create tensions between the various agents and the player's character, which in turn drives a great deal of intrigue, betrayal, and conflict. This opinion system, by which every single individual in the game world is represented, is what creates the dynamic by which interpersonal relationships affect in meaningful ways the conduct of geopolitical actors, and in turn the player's narrative experience.

3 The Hybrid Storytelling Techniques of Crusader Kings II

Crusader Kings II relies largely on emergent narrative, part of which arises from the complexity of the simulation and the alternate histories that can be played through it. Due to this, but also to the emotional complexity of independently driven agents, *Crusader Kings II* deploys a layered, hybrid array of storytelling techniques. Through analysis of the different narrative layers present in the game, as well as the constituent mechanics that play a part in delivering or generating both scripted and emergent narrative content, we may begin to understand the game's success and popularity, which may be explained by its ability to create emotionally and intellectually engaging stories.

3.1 Narrative Layers

Crusader Kings II is an entry in the grand strategy genre of digital games, which most often involves highly complex political, military, and economic simulation, but rarely gives much consideration to the place of the individual. This is true of some of Paradox Studio's other grand strategy games in later historical periods, such as the *Europa Universalis* series and the *Victoria* series. The period covered by *Crusader Kings II* itself spans from as early as the year 769 to 1453, placing feudal politics and wars of religion at the heart of the game. The well-established importance of interpersonal relations in feudal politics [8, 9], however, resulted in the design necessity of modelling of individual actors who, from courtiers to lords, bishops, and kings, would interact with one another to demonstrate the volatility and constraints of medieval society. Fåhraeus himself remarks upon the comparative uniqueness of this type of interpersonal gameplay within the grand strategy genre [7]. We would argue, however, that the game is not, as Fåhraeus

puts it, *all* about the characters. Indeed, the characters and feudal politics in which they participate are but one of many overlapping narrative layers. These narrative layers instruct and feed into one another, and are primarily distinguished by the level of detail in their approach to the game world, from the broad, macro perspective of the narrative at the grand strategy level, to the much more detailed and complex dynamics of the interpersonal politics at the feudal and dynastic levels. The multiplication and diversity in their scopes and approaches to the simulated game world is what makes these layers responsible for the hybrid narrative techniques deployed by the game.

Grand Strategy. The grand strategy layer is the least detailed of the three at play in *Crusader Kings II*, and also the one most typical of the grand strategy genre, concerns itself with such key game modes as the player's management of his military, economy, religion, and other such systems that govern the provinces and territories that the player rules over, from a barony to an empire. The fact that actions in this layer affect territories and nations rather than individuals makes it comparatively less detailed than the other two. This layer is the one through which the player can most readily experiment with and experience alternate histories, as their influence in the game world expands far beyond historical realities. The ability to pause but also to advance time to experience years in the space of a few minutes of real-time further enables this realization of alternate histories over the game's lengthy timespan. The narratives at this layer are primarily depersonalized except where they intersect with the two other layers.

Feudal Politics. The second narrative layer found in the game is turned more inwards than the previous one, and is one degree more detailed. It is also where the opinion system truly starts to come into play. At this level, the player, through their character, must learn to deal with the disagreements, petty rivalries, or open rebellion that stem from agents with varying personalities and ambitions. The friction caused by the opinion system truly brings the fractious nature of feudal politics to life as it drives agents and player alike towards conflict or its suppression, in a constant state of flux and instability. However powerful a feudal lord can become, and even if they rise to become kings or emperors, the ambitions and desire for power of their vassals always creates an unstable matrix of relations that can easily be upset by interpersonal conflicts. This narrative layer adds further complexity to the geopolitics of the previous grand strategy level, as a feudal lord must balance expansion and conquest with internal politics.

Dynasty Politics. The third narrative layer is intricately connected to the first two, but is of even more direct concern to the player as it is the condition of their continued ability to play the game. Indeed, the player in *Crusader Kings II* is embodied through time as one member of a certain dynasty, and then as that character's heir when this first character dies. If this dynasty dies out, then the game ends for the player. Dynastic maneuvering designed to stop this from happening is therefore an important drive in the navigation of both the expansion of territory and the feudal politics this involves, as familial concerns take on considerable mechanical as well as narrative and emotional significance. This narrative layer is therefore concerned with familial matters, including marriage and the raising of children. As such, it is the layer in which most attention is given to the traits that inform the

opinion system. On this layer, interpersonal relations go beyond the purely political to enter into more intimate dynamics.

These different narrative layers allow for the player to have a variety of viewpoints on their character's place in the game world, on continual sliding scale of detail. This in turn participates in the creation of a layered narrative of play where the player's experience is a combination of grand strategy, feudal politics, and dynastic alliances.

3.2 The Opinion System

Primarily driving two of these narrative layers is the opinion system. Every character in *Crusader Kings II* is characterized through a number of ways: their name, portrait, culture, religion, attributes, and traits. A character's portrait changes and ages with time, and their culture and religion can also change. A character's attributes – in five categories: diplomacy, martial, stewardship, intrigue, and learning – broadly represents their base ability at certain types of action, and are in turn influenced by traits. These traits, which are acquired partly through inheritance and partly through the education that a character receives from their guardian, are, in conjunction with a character's culture and religion, some of the factors that most influence the opinion system. It is through guardianship that a character also acquires their education trait, which instructs the attributes most favored by the character, but which can also range from incompetence to great skill, depending in part on chance and in part on the quality of the guardian's own education trait. Chief among these traits are the seven cardinal sins and virtues of Christian doctrine, which provide advantages or disadvantages, and also importantly which mirror one another so that a character with a particular vice will be negatively disposed towards a character who possesses the corresponding virtue.

This acquisition through education, as well as the western and religious denomination of many of the most common traits, participate in an ideologically weighted characterization of the game's individual characters. This is the outcome of design choices made to emphasize the game's situation in a precise historical moment where the importance of family had a real bearing on not only feudal politics but succession matters, the application of justice, and more [8]. These traits, and in particular virtues and vices, play a double role. On the one hand, as the player comes to see these vices and virtues as little more than mechanical advantages or disadvantages, this deconstructs their potential moral significance, potentially serving as a critique of medieval Christian doctrine and its arbitrary moral categories. On the other hand, the terminology employed for these traits and their integration within the historical and cultural background of the period further encourages the player to engage with the narrative experience of the game. The oppositional nature of many of the traits reinforces a conflictual duality as a core concept of these medieval societies depicted, which accordingly instructs the player's reading of their experiences of play.

The depth, yet ultimate simplicity and transparency, of the trait system is essential to the player's engagement with the game's emergent narrative. However, this simplicity does not detract from the overall narrative experience of the game, or the player's engagement with it. On the contrary, it serves the depiction of a world were politics are not concerned with concealing its actors' vices, virtues, and ambitions, but rather with

what volatile and unpredictable consequences emerge when these collide. With all but a few violent actions, such as assassination, strictly limited by the parameters of the simulation and believable conduct in a feudal society, the player is often powerless to completely stop, alter, or even predict the outcome of interactions between his character and the agents, or between the agents among themselves. This powerlessness should not be conflated with a lack of agency, however. It is merely one of many narrative junctures that occur emergently, and which give all the more significance to the player's choices and actions to overcome the challenges posed by those situations.

3.3 Family Ties

Family and its representation is one of the key components of the narrative experience in *Crusader Kings II*, where these interpersonal and familial relationships are positioned with regards to the player in a way that renders them uncanny, in the Freudian sense of the unsettling juxtaposition of the familiar with the unfamiliar [10]. Indeed, these familial relationships are somewhat familiar, whether through more or less idealized popular representations of the middle-ages, but also through the simple presence of the base unit of the family. Simultaneously, however, the game's representation of the family is also thoroughly unfamiliar, particularly in the dehumanizing treatment of family members as little more than tokens of exchange in a patriarchal and largely homosocial system in which, for instance, female characters are primarily leveraged towards the formation of alliances or the acquisition of prestige, the game's point system. The dynastic layer of play encourages a certain type of familial politics where emotion is subordinate to pragmatism, and where familial affection often weighs very little compared to other concerns and the negative balance of opinion traits. These familial politics change depending on the culture, religion, and government type in play. The feudal ruler of a western kingdom will want to marry his children to form powerful alliances and potentially acquire new titles, while the leader of a republic will try to keep as many male relatives at court so that they may expand the family's trade empire further.

Family in *Crusader Kings II*, therefore, is at once a game system – the means by which the player ensures the survival of their dynasty, and through which they acquire even greater prestige –, a social system – one in which misogyny is the rule, and laws of succession determine your relatives' opinion of your character –, and a narrative system. This last is as much an output of the first two systems as it is a consequence of the player's relation to the uncanny family systems that they have to interact with in their experience of the narrative of play. Even as they exploit their family for political aims, they must also protect against the ambitions and betrayals of close relatives. The mechanical focus of the former does not, however, reduce the emotional impact of the latter. Indeed, the current player character's treacherous uncle can be the previous character's own brother, and one of the sons of the character before him. The attachments formed by the player with their character's progeny therefore have a high chance of being reversed as older bonds of familial affection and obligation grow weaker over time, and are steadily replaced in the agents' priorities by the pursuit of personal power.

3.4 Scripted Vignettes

Having addressed the primary emergent components of *Crusader Kings II*'s interactive narrative experience, we must look at how these interact with the scripted vignettes that punctuate the game over time. These vignettes have a certain predetermined chance of occurring if certain criteria are met. Some are linked directly to and affected by player choices, such as the process of educating a child. Others are far more arbitrary in their occurrence, such as the possibility of giving life to a suspected demon-spawned child, who wreaks havoc around him from the earliest points of his life, potentially even killing his siblings. Yet others are linked to a particular culture, religion, or government type. The player of a Venetian Patrician family, therefore, will at some stage have the opportunity to embark on a narrative chain surrounding an ongoing rivalry between their family and another Venetian ruling family, potentially featuring a remediation of the tragic outcome of *Romeo and Juliet*. Just as the demon-child is a remediation of *Rosemary's Baby*, these vignettes are often knowing, and occasionally participate in the grim gallows humor that occasionally appears in the game, though the parameters of the simulation themselves eschew humor in favor of rigorous pseudo-realism.

Whether their appearance is arbitrary or linked to player choices, however, these vignettes are at once enriching and disruptive for the narrative experience of play. They enrich the player's narrative experience by bringing additional opportunities for characterization and player choice. While a player may pick only optimal choices, they may also choose non-optimal, if dramatic choices, or be forced to choose between two equally unpleasant options, if they can choose at all. Though the repetitiveness of these vignettes hinders their narrative impact over time, they remain an important narrative element that contributes flavor to the game experience. Simultaneously, these vignettes are also disruptive, if not intrusive, within the flow of the game but they are so in a deliberate manner. Very often they arise and have the effect of disrupting, or interrupting the smooth progression of the simulation. Even taking into account the unpredictability involved in the simulation elements of the game, these scripted events further contribute to that unpredictability. The fact that they appear on written pop-ups in the center of the screen and address the player directly in the second person further emphasizes their marked difference from the rest of the emergent gameplay and narrative. These vignettes function as a break within the overall emergent narrative of the game, but also as a form of embellishment of the familial chronicle that a game of *Crusader Kings II* depicts. As a break, they almost serve as a type of punctuation that, in coordination with the emergent narrative, further engages the player with the game, their dynasty, and the events that surround them by creating additional memorable moments.

4 Conclusion

The close analysis of *Crusader Kings II* has revealed the potent effect of combining a complex simulation with ample allowance made in the game's design for the appearance of emergent narratives on a number of layers. This, in conjunction with scripted vignettes that serve to punctuate the experience of the emergent narrative creates a greater sense of personalization to the experience of the game. Returning to Ian Bogost's initial article,

it becomes apparent that the statement that simulation games without characters are "better" than games that do overlooks simulation games where characters feature prominently in both the game's systems and narrative potential. While the characterization in *Crusader Kings II* is unscripted and tied primarily to the opinion system, agent interactions can create and contribute to narratives of great emotional depth, primarily connected to the representation of family, in much the same way as scripted interactive digital narratives. Furthermore, this capacity for emotional depth does not negate the potential for ideological critique and reflection that a simulation game can offer. The misogynistic, patriarchal, religious and despotic cultures of the middle-ages are represented in *Crusader Kings II* warts and all, and the experience of the game's emergent narrative often invites the player to reflect upon the unconscionable actions they are led to undertake and the consequences of their acts. It is no doubt in large part due to its hybrid approach to interactive digital storytelling that a game like *Crusader Kings II* can have the best of all worlds in this regard, and invite all at once ideological reflection and the enjoyment of exciting narratives to play.

References

1. Bogost, I.: Video Games Are Better Without Characters. The Atlantic (2015)
2. Sarkar, S.: EA Shuts Down Maxis Emeryville, Studio Behind SimCity (update). Polygon (2015)
3. Khandaker-Kokoris, M.: Thinking About People: Designing Games for Social Simulation. Gamasutra (2015)
4. Ryan, M.-L.: From narrative games to playable stories: toward a poetics of interactive narrative. Storyworlds J. Narrative Stud. 1, 43–59 (2009)
5. Jenkins, H.: Game design as narrative architecture. In: Wardrip-Fruin, N., Harrigan, P. (eds.) First Person: New Media as Story, Performance, and Game. MIT Press, Cambridge (2004)
6. Louchart, S., Swartjes, I., Kriegel, M., Aylett, R.S.: Purposeful authoring for emergent narrative. In: Spierling, U., Szilas, N. (eds.) ICIDS 2008. LNCS, vol. 5334, pp. 273–284. Springer, Heidelberg (2008)
7. Kaiser, R.: The Surprising Design of Crusader Kings II. Gamasutra (2013)
8. Holt, J.C.: Presidential address: feudal society and the family in early medieval England: III. patronage and politics. Trans. R. Hist. Soc. 34, 1–25 (1984)
9. Gravdal, K.: Confessing incests: legal erasures and literary celebrations in medieval France. Comp. Lit. Stud. 32, 280–295 (1995)
10. Freud, S.: The Uncanny. Penguin, London (2003)

Current and Future Usage Scenarios and Applications

New Dimensions in Testimony: Digitally Preserving a Holocaust Survivor's Interactive Storytelling

David Traum[1]([⊠]), Andrew Jones[1], Kia Hays[2], Heather Maio[3],
Oleg Alexander[1], Ron Artstein[1]([⊠]), Paul Debevec[1], Alesia Gainer[1],
Kallirroi Georgila[1], Kathleen Haase[1], Karen Jungblut[2], Anton Leuski[1],
Stephen Smith[2], and William Swartout[1]

[1] USC Institute for Creative Technologies, 12015 Waterfront Drive,
Playa Vista, CA 90094-2536, USA
{traum,artstein}@ict.usc.edu
[2] USC Shoah Foundation, 650 West 35th Street, Suite 114,
Los Angeles, CA 90089-2571, USA
[3] Conscience Display, 7155 Oakwood Ave, Los Angeles, CA 90036, USA

> As survivors dwindle, what will this mean
> for memories of the Holocaust?
>
> The Independent [6].

Abstract. We describe a digital system that allows people to have an interactive conversation with a human storyteller (a Holocaust survivor) who has recorded a number of dialogue contributions, including many compelling narratives of his experiences and thoughts. The goal is to preserve as much as possible of the experience of face-to-face interaction. The survivor's stories, answers to common questions, and testimony are recorded in high fidelity, and then delivered interactively to an audience as responses to spoken questions. People can ask questions and receive answers on a broad range of topics including the survivor's experiences before, after and during the war, his attitudes and philosophy. Evaluation results show that most user questions can be addressed by the system, and that audiences are highly engaged with the resulting interaction.

Keywords: Video · Natural language dialogue · Holocaust survivor testimony

1 Introduction

The original method of interactive storytelling is still one of the most compelling: relaying of first-person experiences in face-to-face conversation. Analog and digital means have been used to preserve, and in some cases enhance, storytelling, but at the cost of the interactive aspect. Particularly with first person

© Springer International Publishing Switzerland 2015
H. Schoenau-Fog et al. (Eds.): ICIDS 2015, LNCS 9445, pp. 269–281, 2015.
DOI: 10.1007/978-3-319-27036-4_26

narratives, it can be especially compelling to look the narrator in the eye, ask questions, and make a personal connection with the narrator and thus the narrative.

This is especially true for Holocaust studies. Over the years, personal conversations between Holocaust survivors, the public, and students have shaped the way in which the next generation has experienced the Holocaust in a visceral way. One person's direct conversation with another is an intimate and powerful means to educate, connect and inspire. Currently, Holocaust survivors' in-person testimonies and 'Question and Answer' sessions form a major component of Holocaust education at museums and in classroom studies. For example, Bar-On [3] writes, "Story-telling also has an emotional component of connecting. When survivors come to the classroom and tell first hand their personal experiences during the Holocaust, children feel what the survivors are going through again and again by telling their stories, and they appreciate this and are willing to listen to learn about this period in history first hand. They ask questions and are willing to read more and thereby enrich their knowledge about an era that to them lies far back in history. Suddenly, the figures and dates became alive in front of them." Lieberman [14] writes, "The actual testimony of witnesses provides us with a three dimensional life-breathing force, from which we cannot escape and which we cannot deny. When this testimony is presented first-hand to our young people, it becomes a mind shattering and mind-altering experience."

However, in a few short years, Holocaust survivors will no longer be with us to share their experiences first hand through such personal encounters. Especially given the 70th anniversary of the end of the war this year, there have been many recent newspaper articles discussing the imminent change in Holocaust education, transitioning from live interaction to second-hand narratives and recorded testimonies (for example [6,16]).

We have created another alternative: live interaction with recordings of the survivor. Rather than hear the survivor's story in a linear way (as in a documentary film), future generations will be able to interact with the storytelling through conversation. Our hypothesis is that we can preserve much of the experience that students have with direct testimony and Q&A from survivors, using the following elements: a structured interview process to elicit answers to most of the questions visitors have, a high-quality recording process, immersive display of the recordings, and direct spoken language interaction to trigger contextually relevant recordings. What makes our project unique is the ability to connect on a personal level with a survivor, and the history, even when that survivor is not present.

In the next section, we review related work on computer systems that allow people to interact with and hear narratives with a historical or virtual character. In Sect. 3, we describe the elicitation and recording protocols designed to collect engaging and immersive narratives from a survivor that can be used to support digital interaction with an audience using speech. In Sect. 4, we describe the system architecture and functionalities. In Sect. 5, we give an example of use of the system and describe preliminary evaluation results. Finally, we conclude in Sect. 6.

2 Related Work

One of the first systems that allowed spoken interaction with a historical character was the August system [8]. This was a 3D "talking head" fashioned after August Strindberg, and could give tourist information about Stockholm, as well as deliver quotes from and information about Strindberg.

In the late 1990s Marinelli and Stevens came up with the idea of a "Synthetic Interview", where users can interact with a historical persona that was composed using clips of an actor playing that historical character and answering questions from the user [15]. "Ben Franklin's Ghost" is a system built on those ideas and it was deployed in Philadelphia in 2005–2007 [17]. The system used speech recognition and keyword-spotting to select the responses.

Sergeant Blackwell [10] was a full-bodied virtual human, shown full-sized on a transparent screen, who told stories in response to unrestricted user questions. The character was fictional.

All of the above systems utilized writers to create the narratives, and actors or artists to create the visuals. An early system to allow interaction with recordings of a real person was "Ask the President" at the Nixon presidential library in the early 1990s [5], but users were only allowed to choose from a set of predefined questions. As far as we know, the first system to enable conversational interaction with elicited recordings of a real person was [2]. This system had only a small amount of content, and showed that it could be interesting to an audience, but did not demonstrate whether it could work with real users and their own questions, which is necessary for the type of engagement that people have in face-to-face interactions.

3 Recording "Future-Proof" Stories

Our goal is to create a system that can carry on direct interaction with students and others far into the future. This means considering not just current technology and interests, but also trying to anticipate the requirements for interaction in the future. In this section, we describe the process for deciding on interview prompts that can lead to answers and stories that will work in an interactive situation with a diverse collection of users. We also describe the recording process, to generate high-quality video that can be used for future display technologies.

3.1 Preparing for the Interviews

The preparation consisted of several activities, including preparing a list of prompts needed and answers and stories expected, but also preparing the survivor and interviewer for this kind of experience.

Our initial material was generated from experiences with Holocaust survivors giving their testimonies and answering questions. An initial list was drafted and sent to experts in the fields of Holocaust testimony preservation, history, genocide studies, trauma specialists, Holocaust museum education staff, and representative target audiences. Questions were also gathered from audience members

who had seen a film about the survivor and experienced a live question-answer session.

In addition to the collected questions, we crafted a set of questions designed to elicit specific stories and other bits of information, based on our prior familiarity with the survivor. This was done in recognition that any collected set of questions will have some gaps, and that a good story can often serve as a response to a question that did not ask for it specifically. Both the collected and the devised questions were categorized according to themes and arranged into a set of interview scripts for recording.

In addition to the narratives regarding the survivor's experiences, we also devised a set of prompts to further the interaction, including short factual biographical information, opinions, and a variety of non-answers that could be used when there was no content answer available. We also solicited multiple versions of some stories, so that a questioner could receive different levels of detail. After an initial set of survivor statements were recorded, new questions were collected through conversational interaction with the recorded stories, and used to devise a second elicitation script [1]. Overall, we devised prompts for over 2000 survivor contributions.

3.2 Recording Process

In order to preserve testimony for the future, our project targeted a wide range of display types including new types of displays that may be developed over upcoming decades. In recent years there have been two major trends in video production. The first trend is that display resolution has increased from standard definition (640×480 pixels) to high definition (1920×1080) and 4k content. This trend was motivated by rapid advances in digital camera sensors and thin-panel LCD displays allowing smaller and denser pixels. The second trend is a resurgence of 3D stereo content. This includes both glasses-based 3D movies as well as new immersive virtual reality headsets. Other technologies are emerging that could enable 3D perception without the need for glasses or headware. To span all these areas we focused on three delivery form factors: traditional 2D displays, glasses-based 3D stereo displays, and glasses-free 3D displays (also referred to as automultiscopic displays).

During production, we looked to achieve the dual goals of high-resolution and multiview capture for 3D displays. Our hybrid approach combined a pair of top-of-the-line digital cinema cameras, to capture a central stereo view, with low-cost HD consumer cameras to record additional viewpoints. The digital cinema cameras were RED Epic cameras with a 6k dragon sensor. These two cameras were mounted as a stereo pair using a mirror box to position the cameras close together and approximate the distance between the human eyes. The consumer cameras were Panasonic X900MK cameras, spaced every 6 degrees over a 180 degree arc (Fig. 1). The cameras were chosen as they recorded HD footage with 3 sensors at 60fps. In addition, as the Panasonic cameras record data directly to SD cards with MPEG compression, we could record 12 h of footage on a single 128 GB card. The higher resolution RED cameras were limited to 60–75 min

continuous takes recorded on 512 GB flash drives. In practice, this was not a problem, as it provided natural breaks in the interview. Scene illumination was provided by a LED-dome with smooth white light over the upper-hemisphere (Fig. 2). This is a flattering neutral lighting environment that also avoids hard shadows.

Fig. 1. Panasonic cameras used to capture multiple views of the interview.

Fig. 2. Survivor in the lighting environment.

A key feature of natural conversation is eye-contact, as it helps communicate attention and subtle emotional cues. Ideally, future viewers will feel that the storyteller is addressing them directly. This could best be achieved if the survivor would maintain eye contact with the central stereo RED cameras. To create such eye contact, we placed the interviewer off to the side, so that their face was visible as a reflection in the stereo mirror box aligned with the central cameras. An opaque curtain, placed on the direct line of sight between the survivor and the interviewer, prevented the survivor from turning towards the interviewer directly.

A major consideration during the interviews was maintaining video and audio continuity. This is important as the interactive storytelling may jump back and forth between different takes and even different days of production. As much as possible, cameras were triggered remotely to avoid any unnecessary camera motion. We also prepared multiple identical outfits for the survivor to wear on successive days. Between interview sessions we would try to match body posture and costume. A video overlay was used to rapidly compare footage between sessions. Even with all these efforts, maintaining complete continuity was not possible. In particular, we noticed changes in how clothing would fold and hang as well as changes in the survivor's mood over the course of days. Both types of changes may be noticeable when transitioning between disparate contributions.

4 System Architecture

Figure 3 shows the architecture of the system. The user watches the survivor on a video monitor with speakers, and interacts by speaking into a microphone

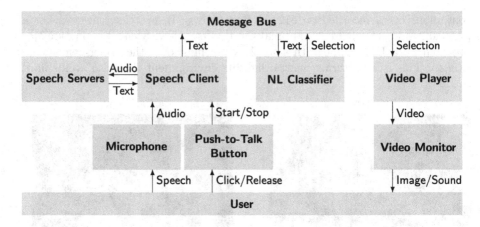

Fig. 3. System architecture

and clicking a push to talk button to tell the system when to listen. Software components include:

- a speech recognition system that converts user speech into text;
- a natural language classifier that selects an audio/visual recording as a response, given the user utterance text and prior context (Sect. 4.1);
- a video player that plays processed, high-quality videos, and manages transitions and idle behaviors between recordings (Sect. 4.2).

A message bus supports communication between the software components.

4.1 Natural Language Processing and Interactivity

For speech recognition, we use both freely available general purpose recognizers and a custom-built language model, trained on our domain. Our NL classifier is built using NPCEditor [12], which supports both answer classification and a custom dialogue management policy. Trained on questions and their associated answers, a statistical algorithm builds a model that predicts words that are likely to appear in the answer, given the words that are seen in the question. Responses are ranked based on how closely they match the predicted answer words. This approach is fairly robust to speech recognition errors and to variant phrasings.

NPCEditor's dialogue management logic is designed to avoid cases where the top choice of the classifier is still not good. During training, NPCEditor calculates a response threshold based on the classifier's confidence in the appropriateness of selected responses: this threshold finds an optimal balance between false positives (inappropriate responses above threshold) and false negatives (appropriate responses below threshold) on the training data. At runtime, if the confidence for a selected response falls below the predetermined threshold, that response is replaced with an "off-topic" utterance that asks the user to repeat the question or takes initiative and changes the topic [11]. Such failure to return a direct

response (also called non-understanding, [4]) is usually preferred over returning an inappropriate one (misunderstanding). The dialogue manager also seeks to avoid repetition, so if the top ranked answer has been said recently, a different response (if any more are above the threshold) is chosen. Further details about the classifier and dialogue policy are available in [18].

4.2 Visual Processing and Presentation

Primary post-production consisted of segmenting the interview into stand-alone video responses. The initial rough edit points are marked during the interview transcription process. These in/out points are refined by automatically detecting the nearest start and end of the speech where the audio levels rose above a threshold. Occasionally, the detected audio start and end points will not exactly match the natural video edit points. For example, if the survivor made silent hand-gestures prior to talking these should be included in the video clip. In these cases we manually clean up the audio and video edit points.

We developed a custom video player that can instantaneously transition between multiple video clips as triggered by the NL engine. The video player generates different resolutions and video formats based on the display type. We use video from a single RED camera for traditional 2D playback, and footage from both RED cameras for glasses-based stereo displays. The video player alternates between playing video responses to specific questions, and an idle mode where several passive listening videos are looped. We explored several different visual transitions to connect video clips. We found that direct jump cuts between clips could be distracting, so for most applications we applied a simple half-second dissolve timed to coincide with the survivor's initial motion.

New display types such as automultiscopic displays or virtual reality headsets will require more sophisticated processing. We use a technique called *light field rendering* to interpolate arbitrary views around the survivor [13]. A light field is defined as the set of all possible light rays leaving a scene. Each digital camera records a slightly different subset of these light rays. If there are enough cameras, any new viewpoint could be synthesized by sampling the nearest light rays based just on existing image pixels. The advantage of this technique is that it directly samples the original video without reconstruction of 3D geometry. Traditional light field capture requires dense arrays containing hundreds of cameras to create smooth view interpolation [19]. In order to handle more sparse setups such as our Panasonic camera rig, we utilize pair-wise optical flow correspondences to more accurately sample pixels between adjacent cameras [7]. Flow-based light field rendering allows users to move seamlessly around the survivor, while generating any view over the front 180 degrees.

A constant desire throughout post-production was to maintain the authenticity of the survivor. In any documentary film, editing can play a large role in how a story is perceived. We endeavored to present all answers in their entirety, including, for example, lengthy pauses where the survivor would gather his thoughts. Although it is theoretically possible to use 3D animation to adjust body posture, clothing, and even facial expression in post-production to create more seamless

transitions, we chose instead to use video dissolves for transitions. While video dissolves are more noticeable, it is also clear where each answer ends and that all presented video frames are taken directly from the original interview.

5 Examples of Use and Evaluation

We are currently evaluating the usability of the system and the learning and emotional connection with the storytelling that the system can effectively facilitate. Initial evaluation focused on training data collection and analysis of the coverage of the recorded answers and the performance of the NL components of the system, in terms of the coherence of the answers to user questions. We review these results in Sect. 5.1. We are also conducting extensive testing of the system at the Illinois Holocaust Museum and Education Center in Skokie, in a setting where a museum docent relays questions from a large school group audience to the system. A detailed evaluation of two docent-mediated sessions (one from Illinois and one local) is described in Sect. 5.2.

Figures 4 and 5 show an excerpt from a session in the museum. Audience members ask questions which are relayed (and possibly rephrased) by the docent to the system. Utterances 3, 6, and 9 show stories from the survivor delivered as interactive answers to audience questions.

5.1 Performance Evaluation of the System

We tested the system with individual museum visitors prior to the testing with docents and large classes described above. In both of these settings, 95 % of user questions could be answered by the set of over 1700 survivor utterances [1]. Currently, the system does not find all of these ideal answers, due to either poor speech recognition, lack of adequate classifier training data, or other issues with classification or dialogue management (such as insufficient tracking of context or deep understanding and inference). However, the system does return an answer deemed appropriate over 2/3rds of the time, with most of the remainder being non-understanding answers [18]. Even most of the "incorrect" answers are topically related to the question, often including stories that are interesting in their own right, even though telling them seems to indicate mishearing or misunderstanding of the original question. We expect this level of accuracy to improve as we gather more data from actual user interactions with the system. However, even at this level of accuracy, we are already seeing that the conversational approach to interaction with media can have a profound effect on users, as we describe in the next section.

5.2 Educational Impact of Stories

The interaction between audiences and the system has been the subject of an external evaluation [9]; here we report highlights from this effort. Two groups of students participated in the evaluation: high school students from the Camino

1 Audience	Are there any other surviving members of your family?
2 Docent	Did any members of your family survive?
3 Survivor	Unfortunately from my immediate family nobody survived. In other words my parents, my mother, my father, and my sister, my twin sister, they were murdered the same day when we arrived at the death camp and concentration camp Majdanek. But after the war I found that out of over a hundred and fifty family members, extended ones, four cousins remained alive.
4 Audience	In the first years after you were liberated, what did you really do?
5 Docent	What did you do immediately after you were liberated?
6 Survivor	Well there's a very interesting story that I can tell you about the day of liberation, how I started. When we woke up on the eighth, actually on the eighth of May, the last day of the war, uh, when we woke up we found that the gates were open, the Czech gendarmes and the SS had disappeared, and we could just go out. And I was healthy enough to be able to run out and see what was going on. And I saw all kinds of things, but how I started my life is a story: I saw a wagon with two horses with their reins spanned in, and with the with the with the baytsh, you know, the the um um they were standing there ready, but nobody was standing with them. I was very fond of horses because before the war my grandfather had a farm, my mother's father, in Wieluń, and I was very much attuned to horses. In Hasidic homes we don't like cats, we don't like dogs, but horses to me were something special. I loved them, I loved to caress them, to clean them, the smell of horses, it all everything appealed to me about horses. So I went nearer – nobody. I looked around – nobody. Eventually I got courage and I climbed up, and I sat on the seat, and I pulled the reins to the right and the horse went right, so obviously I know what's what i'm doing. Then I pulled the other rein and it went left. So i took the whip which was there and I said, didn't hit them, I just said "Vio!" and they started. So i went to Theresienstadt with the horses and the cart and the wagon...

Fig. 4. Dialogue fragment from museum interaction

Nuevo Charter Academy in Los Angeles interacted with the system at the USC campus; middle and high school students from the Boys and Girls Club of Chicago interacted with the system at the Illinois Holocaust Museum and Education Center. At both sites, students interacted with the system as a group, mediated by a docent as described above. Students also interacted with a live survivor: in Los Angeles, the students were split into two groups which differed in the order of interaction (one group experienced the system first, the other started with the live survivor); in Illinois, the students were split into two groups, and each had just one experience (system or live survivor).

The evaluation used a mixture of methods: pre/post surveys, participant observation, and focus group discussions after the interaction. In Los Angeles, pre/post surveys were taken before and after the first interaction, while the focus group discussion took place after the second interaction. The post-surveys

7 Audience	What did you eat in the camps?
8 Docent	What did you eat in the concentration camps?
9 Survivor	That's another good question, uh, what did we eat. We were given starvation diets, so let me explain to you. Like in Skarżysko-Kamienna, in a working camp where we worked twelve hours, when we woke up in the morning we were given what they called coffee, but the coffee was made from acorns, from leaves, it was almost like hot water, it wasn't even sweet, it was just a brown muck hot water, but you had to drink it because you had to have some sustenance. And then lunch time there was a break of a half an hour, where they brought from the kitchen people who were, that that that was their job, they brought big vessels, kind of you know, kitchen, huge vats, kitchen vats, and there was, they were kind of, a kind of soup. And if you were lucky and the policeman, the Jewish policeman that was serving it out would go either to the middle or to the bottom, then you got some rotten potatoes, some rotten meat, because it was made with all the dregs of food, you know, they didn't feed you properly, and then you had some kind of sustenance, some kind of, you know, real food. But if he didn't like you or if he was cross or anything like that and he gave you from the top, then all you got was like hot water from the soup. And then when you came back to the camp in the evening, you again, sometimes you got another bowl of soup of the same kind, or, and you got a piece of bread. And depending how the guards, the Ukrainian guards were the ones that brought the bread, and they would steal some of it on the way, sometimes they did not. So depending how many breads came into the camp it was either you got one, from one bread, one piece of divided by eight, sometimes divided by twelve, but that was your food for the whole day. It was very little and people were starving and dying from hunger.

Fig. 5. Dialogue fragment from museum interaction (Continued)

showed that the system gave students a connection to the survivor, kept their attention, and had a positive impact (Table 1; note that these data do not show whether there was a meaningful difference between the conditions).

Live observation of the system interactions provides insight into the dynamics between the students and the system. The observer in Illinois noted that a few students waved hello and goodbye, and that hands were still raised at the end of the 50-min session; these observations suggest that students felt a connection with the survivor and were engaged with the interaction. The same observer noted that questions got more detailed as time went on; this indicates a measure of depth to the storytelling, as each story generates additional interest. The observer also reports that students were impressed when the survivor responded to a request to say something in Polish by singing a Polish song, suggesting that the interactive abilities exceeded their expectations.

The Los Angeles focus groups allowed students to compare interaction with the system to interaction with a live survivor. In comparing the experiences, students tended to talk about the different survivors and their stories, rather

Table 1. Percent of students rating the statements as "Strongly agree" or "Agree"

	Live survivor ($N = 28$)	System ($N = 25$)
I felt that I could connect with the story of the survivor.	57	72
I felt that the activity kept my attention.	100	80
I think that my experience in this activity will have a positive impact on me.	86	92

than concentrate on the delivery methods. Students were aware, of course, of the difference; when probed about it specifically, one participant noted that sometimes the survivor in the system would answer a different question than he was asked (though he qualified this statement by noting that the response was still interesting); another student noted that this affected the way that they asked questions – they tried to ask less specific questions to the system.

6 Conclusions

We have presented an interactive system that allows first person audio-visual narratives to be presented to an audience in an interactive fashion, where people can engage in spoken, conversational interaction and ask questions to trigger narratives. The system has "new dimensions" including interactivity and high-fidelity recording, to allow an engaging and emotional experience somewhat comparable to direct interaction with a Holocaust survivor. Methodical recording preparations and processes and digital technology support this experience. Ongoing evaluation results suggest that the system can be accurate enough to support conversational interaction and timely delivery of narratives, and have the desired impact on the target learner population.

Acknowledgments. The New Dimensions in Testimony prototype was made possible by generous donations from private foundations and individuals. We are extremely grateful to The Pears Foundation, Louis F. Smith, and two anonymous donors for their support. We thank the Los Angeles Museum of the Holocaust, the Museum of Tolerance, New Roads School in Santa Monica, and the Illinois Holocaust Museum and Education Center for offering their facilities for data collection and testing. We owe special thanks to Pinchas Gutter for sharing his story, and for his tireless efforts to educate the world about the Holocaust.

This work was supported in part by the U.S. Army; statements and opinions expressed do not necessarily reflect the position or the policy of the United States Government, and no official endorsement should be inferred.

References

1. Artstein, R., Leuski, A., Maio, H., Mor-Barak, T., Gordon, C., Traum, D.: How many utterances are needed to support time-offset interaction? In: Proceedings of FLAIRS-28, pp. 144–149. AAAI Press, Hollywood, Florida, May 2015
2. Artstein, R., Traum, D., Alexander, O., Leuski, A., Jones, A., Georgila, K., Debevec, P., Swartout, W., Maio, H., Smith, S.: Time-offset interaction with a Holocaust survivor. In: Proceedings of IUI 2014, pp. 163–168. Haifa, Israel, February 2014
3. Bar-On, D.: Importance of testimonies in Holocaust education. Dimensions Online: A Journal of Holocaust Studies 17(1) (2003). http://archive.adl.org/education/dimensions_17/importance.html
4. Bohus, D., Rudnicky, A.I.: Sorry, I didn't catch that! - An investigation of non-understanding errors and recovery strategies. In: Proceedings of SIGDIAL, Lisbon, Portugal, pp. 128–143, September 2005
5. Chabot, L.: Nixon library technology lets visitors 'interview' him. Los Angeles Times, 21 July 1990. http://articles.latimes.com/1990-07-21/news/mn-346_1_richard-nixon
6. Dejevsky, M.: As survivors dwindle, what will this mean for memories of the Holocaust? The Independent, 5 January 2014
7. Einarsson, P., Chabert, C.F., Jones, A., Ma, W.C., Lamond, B., Hawkins, T., Bolas, M., Sylwan, S., Debevec, P.: Relighting human locomotion with flowed reflectance fields. In: Proceedings of the 17th Eurographics Symposium on Rendering, pp. 183–194 (2006). http://dx.doi.org/10.2312/EGWR/EGSR06/183-194
8. Gustafson, J., Lindberg, N., Lundeberg, M.: The August spoken dialogue system. In: Proceedings of Eurospeech 1999 (1999)
9. Kim, K.A.: New Dimensions in Testimony: Findings from student pilots. Internal report, USC Shoah Foundation, August 2015
10. Leuski, A., Pair, J., Traum, D., McNerney, P.J., Georgiou, P., Patel, R.: How to talk to a hologram. In: Proceedings of IUI 2006, pp. 360–362 (2006)
11. Leuski, A., Patel, R., Traum, D., Kennedy, B.: Building effective question answering characters. In: Proceedings of SIGDIAL, Sydney, Australia, July 2006
12. Leuski, A., Traum, D.: NPCEditor: Creating virtual human dialogue using information retrieval techniques. AI Mag. 32(2), 42–56 (2011)
13. Levoy, M., Hanrahan, P.: Light field rendering. In: Proceedings of SIGGRAPH 1996, pp. 31–42 (1996). http://doi.acm.org/10.1145/237170.237199
14. Lieberman, L.: Using testimony in the classroom. Dimensions Online: A Journal of Holocaust Studies 17(1) (2003). http://archive.adl.org/education/dimensions_17/using.html
15. Marinelli, D., Stevens, S.: Synthetic interviews: The art of creating a 'dyad' between humans and machine-based characters. In: Proceedings of MULTIMEDIA 1998, pp. 11–16 (1998). http://doi.acm.org/10.1145/306774.306780
16. Schechter, D.: After the survivors: Facing a future without Holocaust witnesses. Atlanta Jewish Times, 9 April 2015
17. Sloss, E., Watzman, A.: Carnegie Mellon's Entertainment Technology Center conjures up Benjamin Franklin's ghost. Press release, Carnegie Mellon Media Relations, 28 June 2005. http://www.cmu.edu/PR/releases05/050628_etc.html

18. Traum, D., Georgila, K., Artstein, R., Leuski, A.: Evaluating spoken dialogue processing for time-offset interaction. In: Proceedings of SIGDIAL, Prague, pp. 199–208, September 2015. http://www.aclweb.org/anthology/W/W15/W15-4629. pdf
19. Wilburn, B., Joshi, N., Vaish, V., Talvala, E.V., Antunez, E., Barth, A., Adams, A., Horowitz, M., Levoy, M.: High performance imaging using large camera arrays. ACM Trans. Graph. **24(3)**, 765–776 (2005). http://doi.acm.org/10.1145/1073204. 1073259

Urban Games and Storification

The "Being Grunberg" Case Study

Paul Schmidt[(✉)] and Frank Nack

Informatics Institute, University of Amsterdam, Amsterdam, The Netherlands
paul.schmidt@student.uva.nl, nack@uva.nl

Abstract. As it is the player who expands the urban game spatially, temporally, and socially, we hypothesize that it is also the player who can establish an expanded story space and provide the urban game with a narrative that suits its limitless nature and, simultaneously, the player's story needs and expectations. We developed and tested an urban game, *Being Grunberg*, to investigate the relation between interaction, storytelling, and story forming in real world environments. We outline the game design, describe the actual game play, and provide an analysis of the game. The major finding is that urban games facilitate and stimulate storification, but the design of the player role has a significant influence on this process, both during play as well as in post-play reflection.

Keywords: Urban games · Narrative · Interaction · Storytelling · Story creation · Storyfication

1 Introduction

Being Grunberg is an urban game inspired by narrative–driven urban games, such as *Pie' Veloce, Massive Multiplayer Soba* [6], *Zombies Run* [18], or *Corridor* [9], and Dutch writer Arnon Grunberg's writing paradigm that reality influences fiction and vice versa. Our aim was, besides the development of an entertaining story-driven game, to research the role of interaction in form of urban gaming in the future of literature. The game development process, the resulting game structure, and the gained experiences during play shed light on the question: What is the relation between interaction, storytelling, and story forming in real world environments?

In this article we focus on game description and the findings regarding the idiosyncratic storification [2] of players who played *Being Grunberg* and its influence on the design of narrative-based urban games. We outline the game design, describe the actual game play, and provide a short qualitative and quantitative analysis of the game.

2 Related Work

This study is influenced by research on urban and pervasive games, storytelling and storification, and social interaction and narrative.

Coppock et al. [6] define an urban game as a pervasive game "specifically designed for urban environments" [p. 123], while they describe pervasive games as "taking place

© Springer International Publishing Switzerland 2015
H. Schoenau-Fog et al. (Eds.): ICIDS 2015, LNCS 9445, pp. 282–296, 2015.
DOI: 10.1007/978-3-319-27036-4_27

in an expanded spatio-temporal and social situation" [p. 123]. Waern et al. [17] argue that urban games "blur the traditional boundaries of games" [p. 19], because they expand the realm of games in at least three ways: spatially, when they do not have a clearly defined game world; temporally, when the game's start and end points are not clearly defined; and socially, when there is no clear distinction between player and non-player. Therefore urban games are not limited to Huizinga's concept of the "magic circle" [13], in which games are set up in and limited to "a play-ground marked off beforehand either materially or ideally" [p. 10]. In this point they differ from live role-playing games, which also are a "dramatic and narrative game form that takes place in a physical environment, where players also assume character roles that they portray in person through action and interaction" [8, p. 128]. Urban games make use of urban spaces and combine physical and technological play [14], but are not necessarily bound to a certain location. Engl et al. [7] mention "location-free" urban games that can be set up practically everywhere. Most urban games are therefore mobile, which is realized by mobile devices the players carry around.

According to Chatman [5] any narrative can be understood as a communicational process which is organised around surface structures (expression) and deep structures (content). Both structures are composed out of substance and formal components, where substance represents the natural material for content and expression, but form represents the abstract structure of relationships which a particular media demands. In this framework an urban game can describe a story. However, Aylett and Louchart [2] showed for storytelling in virtual reality (which shares with urban games the aspect that a player is moving quite freely in an environment not restricted to what is physically there) that conventional theories of narratives do not apply, because the created reality establishes immediacy, which calls for real-time interactive storytelling, thus a dynamic and procedural narrative. Ryan [15] states that interactivity in general means that the player can interact and make choices with the system while it is running. Therefore storytelling has to be aimed at an active user instead of a passive spectator. Aylett and Louchart [3] argue that in interactive storytelling the storyline can emerge from the user's interactions with the game world. This "emergent narrative" [p. 2] is hardly an authorial artifact like conventional theories would treat any narrative, but rather an internal "storification" [p. 2] process constituted by the user's interaction with the game world and its elements.

One way to establish storification is making the players reflect on the game after playing [17]. Gentes and Jutant [10] show that narrative-driven games should inspire specific storylines in the way that players create a story out of the material provided by the game (see a similar approach by Nack et al. [14]). This can be achieved by the special relationship players of urban games have with their game world. While the game world consists of everyday scenes and objects the game adds a virtual layer through which the world's objects stand for something more than what can be seen. This ambiguity, which also holds for the temporal (are we playing right now?) and social aspects (who is a player, who just a passer-by?) can elicit a player state that Waern et al. [17] calls "apophenia", during which the expectation of meaningful connections between places, people, objects and actions create meaningful narratives where there is none prescripted by the game maker. Apophenia can be fostered by

giving the player goals without telling her how to achieve them, giving her useless information, and encouraging extrovert roleplay.

Scheible et al. [16] argue that it is the game's usability that fosters storification. The higher the overall usability of the game the easier it should be for the player to engage in story creation. Providing the player with a topic and clear game goals, giving feedback on the emerging storyline's quality, and creating high immersion should therefore help the player with her process of storification.

Waern et al. [17] states that it helps story creation if the player identifies with her player role, which can be facilitated by having the player engage in player-to-player interactions via communication or game mechanics. Likewise Aylett and Louchart [2] advise encouraging the player to engage in social interaction, because people's interactions is what creates narrative.

Aoki et al. [1] argue that a game that fosters story creation has to avoid having the player getting locked up in "experential bubbles" where she is so immersed in her private game experience that she is not available for possibilities of interaction with others anymore, e.g. when the game contains audio that fully occludes the environment's ambient sounds and speech from other people. It should be easy for the player to engage in social contact, therefore the effort to be made for interaction should be kept as low as possible.

Waern et al. [18] as well as Hansen et al. [11] state that instructed actors or bystanders can improve social interaction level. Especially if the player is expecting to meet non-players that were planted to improve her game experience she might enter a state of pronoia, where she deliberately searches for social interaction with bystanders in order to not miss part of the game. This works particularly well if, as Flanagan [9] suggests, the player is encouraged by the game instructions to seek social contact with others throughout the game.

Callaway et al. [4] propose to have the game build narrative tension that is not resolved in the progress. The player should then turn towards other players to seek for the anticipated relief. Overall the average player can be expected to have a welcoming attitude towards social interaction as the social aspect makes an experience more enjoyable for the participants.

We can conclude that Literature points to several design principles for how to encourage story creation: facilitate game reflection, invoke a state of apophenia, high game usability, player identification, avoid fear of embarrassment and motivate players to engage in social interaction. The question remains: Why does the player need to create a story, why should the urban game designer try to help the player's storification process?

While different kinds of structural paradigms exist, ranging from the simple fully pre-scripted one way-plot path the player follows along during play, to complex structures of plot graphs with numerous interconnected nodes that the player can potentially visit according to her decisions during the game [15], all of these storylines are predesigned authorial artifacts. In an urban game with its infinite number of possible game states, either the pre-authored storyline cannot keep up with the unpredictable number of game states the player evokes or it is limiting the player's choices and possible experience. As it is the player who expands the urban game spatially, temporally, and socially, we hypothesize that it is also the player who can establish an

expanded story space and provide the urban game with a narrative that suits its limitless nature and simultaneously the player's story needs and expectations. The remaining question is: How to facilitate through story concepts and presentation techniques a player's storification process while playing an urban game? In the design of *Being Grunberg* we mainly followed 5 hypotheses, based on our findings in the literature, to address this question:

H1. Story creation can be facilitated by having the player reflect on the game after playing.
H2. Story creation can be facilitated by high overall game usability.
H3. Story creation can be facilitated by high player identification.
H4. Story creation can be facilitated by having the players engage in social interactions.
H5. Leaving the player with narrative tension by not giving her all the information makes her engage in social interaction, which facilitates story creation.

3 Being Grunberg – An Urban Game Case

Starting at the point of Grunberg's notion on the relation between fiction and reality, namely that fiction and reality cannot be separated from each other, but some kind of interaction does take place, the game had to be set in a real environment and had to be designed around events that actually can happen in that environment. As the game should reflect aspects of his work, it was placed in Amsterdam. Additionally, the game should facilitate player-to-player interaction in the Waern et al. [17] and Aylett and Louchart [2] sense to stimulate story generation. The game design aimed for providing a fully functional urban game but also for evaluating the players' ingame storification processes in relation to the provided story concepts and presentation techniques.

3.1 Design

Being Grunberg was designed as a role-playing mystery game to be played in the Amsterdam red light district (de Wallen). It revolves around interactions between four different character types: the Human-trafficker, the Illegal Immigrant, the Marechaussee, and the Well-behaved Family Man. Players interacted with each other in order to achieve two different objectives: (1) to collect role-specific items and (2) to gather five hints that could solve the game's mystery. Players receive points both for the role-specific items they gather during game play and for solving the mystery. The player with most points wins the game.

The game was created by a group of 16 students and its design followed a rapid prototyping approach, where each new version was tested on usability as well as playability by changing groups of 15 people in average. The development process took from January to February 2015. The essential key concepts of the final game design are: location and meta-narrative, roles, props, interaction, system.

Location and Related Mystery. The red light district is a top tourist attraction, renowned for its entertainment, sex and drugs, and the feel of crime, and is hence of general interest. It is a lively place that offers a rich set of stereotypical characters that could be transferred into role descriptions. Due to its history it offered enough models for a mystery in which the game could be rooted in.

Following the approaches of Hansen et al. [11] and Waern et al. [17] we expanded the 'magic circle' by integrating real locations into the game. The players could enter several bars and tourist places, including a place that functioned in the game as a window similar to the prostitute cubicles. Some of these locations were safe and some unsafe, meaning that players had to watch out for other players in roles that could do ingame harm on their own player role. Furthermore all the locations were prepared with actors that the players could interact with to receive advice, parts of the mystery solution or other valuable game items.

In accordance with the environment a kidnapping mystery was created (none of its personage was ever visible during the game, which added to the sphere of the red light district – a place where crime cannot be witnessed but can only be sensed). None of the four main character types was directly involved in the kidnapping but each of them was influenced. The five hints the players could find during the game are:

1. On 23rd October there was a Syrian family smuggled into the Netherlands.
2. The family Aziz still has debts from their journey.
3. The kidnappers are Farid Aziz and his sons Hassan and Hakim.
4. Amira Aziz (17 years old) was recently forced into prostitution.
5. The kidnappers demand airtime on NOS to tell their story.

The 4 Player Roles. The design of the 4 roles was based on stereotypical characters associated with the location and Arnon Grunberg's work, but also aimed for practical playability issues. Each of the four characters had its own goals and means, represented in form of short snippets of personal history. The differences in goals and means establish a set of relationships (see Fig. 1) that should facilitate various types of interactions. However, since there was no controlling game authority virtually all interactions were possible between any player roles.

Well-behaved Family Man - Middle-aged father of two teenage daughters. The love in his marriage has vanished and he is in constant relationship struggles with his wife to whom his children turned to. He visits the red light district in search for feelings of power and therefore pursues to have paid sexual intercourse with its illegal prostitutes. The Family Man wants to help deliver the mystery's solution in order to regain his family's appreciation by being crowned "The Hero of de Wallen" by the grateful detectives.

Illegal Immigrant - Middle-aged mother of a son. They are refugees from a Middle-Eastern country and came to the Netherlands through illegal human trafficking. She has to sell her body in order to gather enough money for buying a fake ID and provide a safe future for her and her son. The kidnapping mystery is a personal problem for her, because in consequence the police planned a raid that will bring policemen asking for IDs and residence papers. She wants to solve the mystery to make a deal

with the police: the mystery solution in exchange for a chance to stay in the The Netherlands as a legal citizen.

Marechaussee - Ambitious and career-driven member of the border police who is currently stuck in a bottom-level field job. Following his conviction that he knows what is right and fair for the people – and himself – he strives to fine as many illegal activities as possible in order to quickly earn his well-deserved promotion to higher leagues of crime fighting. The kidnapping mystery is his chance to show his superiors what he is worth.

Human Trafficker - Knows everything that is going on in the red light district and does not miss a chance to enrich himself. While he exploits immigrants, uses family fathers'cravings, and fools around with the Marechaussee, his only worry is that he might lose grip and other scoundrel take what is rightfully his. The Trafficker is the police's first suspect in the kidnapping mystery. Therefore and because he wants to find out what is going on in his hunting grounds, he needs to gather the clues to the mystery's solution to whitewash his good name and make sure to retain the established order on de Wallen. The Trafficker earns points for money. Therefore he sells fake IDs, blackmails illegals and trades information to the police. He has to watch out to not get fined as this might decrease his influence.s

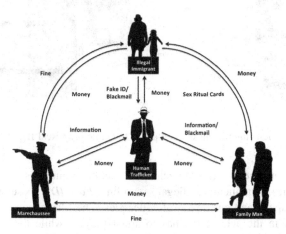

Fig. 1. Relationship between the 4 main character types based on their goals and means to achieve those.

Interactions and Related Props.

– *Character description card* – This card was handed out to players at the beginning of the game and it contained an extended role description, similar to the description provided above. It briefly summarized the characters' backstories, listed their goals and means, and provided the rules for interactions.
– *Coins* – This was the game's play money. The total amount was restricted on what was handed out to each player at the beginning of the game. The coins were designed in a way that they could not be easily reproduced, e.g. by copying.

- *Sexual interactions* - Sex in this game works as a universal currency that allows to bribe, to buy (e.g. a faked ID), or to get information. If two players engage in sexual interaction, they have to hug for a minute, ending with a nose kiss. The one who offers has to give the other a certificate of the sexual transaction (a playing card, see Fig. 2a). Under normal circumstances she would then receive something in return from the other player, such as money or information but she can be cheated. The design of the sex-certificates covered 18 different cards, each with the image of two silhouettes having sex in particular positions. Thus, although the sex was symbolic, the players were still confronted with the awkwardness of it related to the way it needed to be negotiated and finally performed in a public environment.
- *Fake ID* - The smuggler can sell IDs. The *Fake IDs* looked almost the same as *Real IDs*, with the exception of a code and a picture (see Fig. 2b). When an *ID* is sold, a picture has to be drawn in the blank space in order for it to become a *Real ID*. We designed both the *Fake* and *Real IDs* to look like real-life ID-cards, in order to make the game as realistic as possible. The rule of having to draw a picture on the *Fake IDs* was imposed to make the transaction last a little longer. This made it easier to catch the participants in the act.

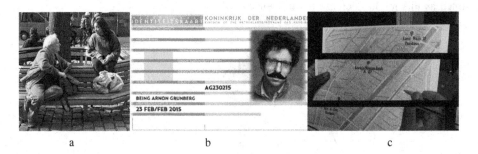

a b c

Fig. 2. a: A player (left) interacting with an actor, b: Game prop Real ID, c: Game world map

- *Fines* and *shame badge* - The Marechaussee can hand out fines to other players for illegal activities. That includes: illegal sex, selling *Fake IDs*, possession of *Fake ID*, not having papers, and corruption of colleagues. The Marechaussee needs to catch other players in the act, i.e. he has to arrest players while they are hugging or drawing images on IDs. When making an arrest, the Marechaussee writes down the name of the person who is arrested and sticks a shame badge with the fine reason on the actor. The offender was allowed to lie, run away, take the badge off, or do whatever necessary to avoid the fine (he was not told so, though).
- *Information trading* – The actual description of the kidnapping was available through five information cards. Each of the characters had access to one of these five hints. As information in the game was restricted to the amount of characters and actors represented (see Table 1), they had to trade the information with each other and the actors.
- *Map* – Showed several important locations the player should know about, as they provided spaces for information exchange or meeting relevant types of characters.

Maps were adapted to specific roles, as they also contained per role one place where special actors provided information in a real world setting for the particular role.

- *Actors* - Throughout the playing area actors were present to help the players and also to establish a feeling of authenticity and immersion, blurring the line between the real and the game world. There were two types of actors: The first were the home-base actors, whose main role was to provide the players with information on how to play and provide the first hint of the mystery. The second category were actors who were accessible to everyone. This included a few beggars who walked around the Oude Kerk, and the actors at the home-bases of the house father (a bunch of drunkards) and the human-trafficker (two pimps), who thus fell into both categories. The purpose of these actors was to not only give hints on playing tactics, but also to stimulate interaction by referring different players to each other.

Table 1. Distribution of props over roles and distributions of roles in a game session

	Huisvader	Immigrant	Marechaussee	People smuggler
Coins	10	0	5	5
Hints	1	0	0	0
Real ID	yes	no	yes	yes
Special items	–	8 sex ritual cards	Fine stickers and notepad	Fake IDs
Explicit advices at start to interact with other role members	1	2	1	2
Amount of players with this role in one session	35 %	35 %	15 %	15 %
Ratio helpful vs. harmful other players	77 %/ 23 %	62,5 %/ 37,5 %	86 %/14 %	85 %/15 %

The distribution of props to each character at the beginning of the game as well as the distribution of character types in each game is described in Table 1.

Location-Based Audio System. For increasing the pervasiveness of the game we provided a location-based audio track for each player. We made use of HearUsHear (http://www.hearushereapp.com/), a location-based nonlinear storytelling platform and app for iPhone (4 an higher) and Android (version 4 and higher). Through the use of GPS and iBeacon/Bluetooth devices one can align sounds on a location with an adjustable volume radius. In that we could facilitate every character type with additional information about his or her history and her surroundings to increase the identification of the player with the role in the game world. Those sound clips were provided by the game narrator, who also facilitated all characters with the context of the mystery at the beginning of the game. The exact positions of the virtual markers that triggered the play-back were hidden from the player's view, but the respective audio track started to fade-in on the player's headphones whenever she walked into the proximity of one of her role's audio markers. Hereby the player was unconsciously guided through the game world.

3.2 Play

On Monday 23rd of February 2015 the final game was played by 70 participants. Players had to register via the game website (http://beinggrunberg.nl/) to be assigned to different time slots. During this registration process they were also randomly assigned to a role.

In total there were three player groups of around 20 people and therefore three complete runs of the game. Each of the groups passed through the following six stages of the game:

1. *Pre-game Workshop* - After signing up and filling in a pre-game questionnaire, one group at a time took part in a pre-game workshop. The workshop was guided by two well-known Dutch actors, Halina Reijn and Pierre Bokma, and consisted in simple team-building assignments. It lasted for around 20 min and aimed at allowing the players to identify the people they play with and making them more open for social interaction between each other.
2. *Introduction Story and Walk to the Starting Position* - A guide took the group outside where everyone was asked to switch on their smartphone, set up the headphones, and start the first audio track on the *HearUsHere* application. This audio track introduced the players to de Wallen, and to the game's kidnapping mystery storyline: A person was abducted and the police is preparing a raid on de Wallen in order to solve the mystery. All people on de Wallen (so all the players) are asked to report what they know about the mystery at the *Detective's Office* in 90 min. Furthermore they heard about the four kinds of character types they were going to meet in the game world. While listening to this story introduction the players were walked to the starting location *Café de Dam*, a small bar at the edge of de Wallen.
3. *Role Assignment and Interaction Introduction* - At *Café de Dam* each player received her role-specific envelope, which contained the character description card, the map, and the props. Then the players listened to a speech given by one of the game guides and learned that from now on a roleplay is being played and that they better watch out who to trust and to keep their own role secret. The players were introduced to the game interactions, e.g. how to perform a sexual interaction, and advised to make use of those to gather as much information as possible to receive points when they have to report at the *Detective's Office*.
4. *Free Play* - Players were then released into free play. Most players first walked to their homebase, indicated on their respective map, to get some tips from actors there on how to play their game and obtain further information on the kidnapping mystery. Then the players explored the different game locations and engaged in the game mechanics' player interactions to get closer to the mystery solution and to obtain role-specific items (e.g. *Fake ID*). While the players in the beginning were introduced to the game interactions, player roles and different objectives, there was at no time any authority watching over the players' adherence to those rules. Therefore a great deal of unpredictable role-play behaviour was possible and expected and any adherence to game rules was merely by the players' self-regulation.

5. *Game's End (Detective's Office)* - After 60 min of game time players had to gather at the *Detective's Office*. There each player was asked individually to provide their name, role, and fill in the *Ingame Story* form. This form consisted in one open question, asking the players to give their version of the kidnapping mystery solution they pieced together from the collected clues (if they could provide all five mystery clues they would receive extra reward points). The players could choose to write a consistent story or simply line up the hints in a logical order, either on a provided laptop computer or by hand on a sheet of paper.

6. *Post-Game Reflection* - After the players reported at the *Detective's Office* they were told that the game is over and were sent back to the registration point. There all the props they amassed throughout the game (e.g. play money and sex ritual cards) were collected and counted. In the meanwhile the players of a group gathered in a separate room and held a post-game reflection. This reflection consisted in 10 min of free talk about the player's experience in the presence of Arnon Grunberg and afterwards 10 min of filling in a post-game reflection report. Finally the player who had collected the most points was announced as winner and was rewarded with a signed copy of Grunberg's newest Dutch book.

4 Analysis and Discussion

Evaluation and reflection of the game experience, as well as analysis of the storification process within players, was an essential part of the game design and play. The participants were asked to fill in a total of three different evaluation documents: an in-game story report (where players had to tell the story about the kidnapping based on the clues they collected during the game), a post-game reflection report (where players reflected on the happenings, events, and interactions they experienced during their play time) and finally a post-game evaluation form (intended to give us feedback on their play experience and the game's usability).

In addition we recorded the hints and items players acquired during the game, individual scores on playing success, and statements done during the post-game reflection. Demographic information about the players was collected during the game registration procedure.

In this article we concentrate only on those aspects of the collected data that support the main research question and implementation of the related five hypotheses as outlined at the end of the related work section.

4.1 Analysis

In total we received 70 result sets, thus each player contributed. However, as the different evaluation types happened at different moments in the game we eventually had to work with different set quantities. Below we outline the type of data gathering method per document and the amount of sets we worked with.

- *Ingame Story Report*: We used this data set to identify if the role-playing urban game stimulated storification. Based on Chatman's story component model we coded the ingame stories to find out which hints the players found, but also how many story elements they invented on top of the information supplied by the hints. For every of these newly invented story content elements we assigned one inventiveness point (IP) and categorized the *Ingame Stories* into five inventiveness levels (I0 with IP < 1: "none", I1 with 0 < IP < 14: "very low", I2 with 13 < IP < 19: "low", I3 with 18 < IP < 34: "high" and I4 with IP > 33), where I0 represent stories that describe the kidnapping story just in the provided terms. We also calculated the written words/newly invented words quota for each story. We received 70 units with 34 stories achieving IP > 0, meaning that 36 participants merely listed the hints in a logical order.
- *Reflection Report:* Five open questions concerning the player's experience during the game. Preceded by a 10-min free reflection talk on individual game experiences with all players of one group present. For the data analysis we counted the number of fully answered questionnaires and we counted the word numbers of the answer on question two ("Can you please tell us the story of your game?"). We also investigated if the player answered the questions as the role character or from their own personality reflection on the played role. We received in total 49 answered *Reflection Reports*.
- *Post-game Questionnaire:* Was filled in directly after the *Reflection Report* and investigated the usability and playability of the urban game. The questionnaire included Likert-scale, multiple choice, open and ranking questions where players were asked to rate the game's usability, importance of different game elements and their own enjoyment. We received in total 41 responses on the *Post-game Questionnaire*.

4.2 Discussion of Results

We found that the reflection phase created a 41 % higher story output, meaning that more players were able and willing to invent an at least partly new story after reflection. This does not indicate any effect on story quality though, as we only investigated if players reported a story. Thus, H1 proved effective in our game.

Players reported between 0 and 2 kinds of ingame problems. Interestingly, players of the group with the most problems (2) actually showed the biggest ratio of newly invented stories and the highest average new word quota in the *Ingame Stories*. This could indicate that more obstacles generated during play might have a positive influence on storification and that obstacles do not necessarily have to be in-character. Hence H2 did not prove directly effective in our game.

We did not find a correlation between behaving like a different person and writing the *Ingame Story* from the player role perspective. *Ingame Stories* written in-character do not significantly differ from the ones written out-of-character with respect to inventiveness and length. However, behaving like a different person during play seems to have an effect on story creation. Players who reported that they behaved like a

different character were more likely to invent a new story (or new story elements). Therefore H3 proved partly effective in our game.

Social interaction was one of the key aspects we identified as storification stimulator and hence invested various forms into *Being Grunberg*. The only social element we were able to measure, though, were the *Interaction Rituals*. The players reported via the game element ranking in the *Post*-game *Questionnaire* on how important the rituals were for their game experience. Therefore we can at most provide an indirect validation/falsification of this criterion. We found that players who stated social interactions as most important were much more likely to invent new story elements for the *Ingame Stories* and also had higher average word numbers on the story in the *Reflection Report*. Assuming that players who found interaction mechanics more important also engaged more often in social interaction we can say that H4 proved valid in our game. Furthermore *Interaction Rituals* were in average ranked as most important game element.

Players of *Being Grunberg* experienced different levels of narrative tension as all of them were informed that there are five hints hidden in the game, but most players only found an incomplete set of them. The players' new word quota decreased with an increasing amount of found hints. This is not surprising, though, as players with more found hints wrote down these hints in their *Ingame Stories*, which naturally made for lower new word/written word quotas. We found that highest inventiveness in *Ingame Stories* was shown by players with none or one found hint and players with all the hints had a low average IP-level. This also seems reasonable as a player who is asked to report a story, but has nothing at his hands, has to make up something. What is remarkable, though, is that players who lacked only one hint also showed a very high inventiveness. Assuming that narrative tension is highest when only a small part of the story is missing, the data recorded during our game would support the effectiveness of H5.

Apart from employing the five story creation criteria H1 – H5 we assigned the players four different player roles with different characteristics and different preconditions for game play. We recorded the player-specific data for each of the roles in order to establish which stereotypical roles best stimulate storification based on a set of parameters.

The *Human Trafficker* and the *Marechaussee* have better scores in most of the parameters than *Illegal Immigrant* and *Family Father*. Especially the *Family Father* scored rather low on most of the parameters. This holds for both: amount of written words in *Reflection Report* and *Ingame Story* and inventiveness in *Ingame Stories*.

None of the measured ingame parameters (e.g. final score, fun, ingame problems, etc.) seemed to be the reason for these differences in story creation; either because no significant differences among player roles showed for the parameters in question or because the differences were incoherent with the differences in story creation parameters.

Therefore we probed the game-mechanical differences between the roles as possible reasons: *Illegal Immigrant* and *Family Father* engaged predominantly in the sexual intercourse rituals and were the roles that had to be most afraid of the *Marechaussee* and hence punishment. Furthermore they by far formed the biggest group of players in the game (see Table 1), which sets interaction in a competition context.

The *Illegal Immigrant* might not have had an intrinsic motivation to solve the game's mystery as she would have only pursued to in order to obtain an ID, which she also could obtain by just buying it. Equally the *Family Father* was mainly interested in collecting as many *sex ritual cards* as possible. The mystery solution was only a bonus for him. On the other side the *Marechaussee* was directly motivated to solve the mystery as her main desire was a promotion, which she could only earn by solving the mystery. Also, if she acted in-character, she was most inclined by her player role to actually attempt to solve the mystery (as this is what a *Marechaussee* does). The *Human Trafficker* also had substantial motivation to have the mystery solved as the kidnapping took place in her scope of power in an area that is under her control.

We infer that roles that were more directly involved in the mystery and had less distractive other goals were more supportive to make up a long and good *Ingame Story*, as they received more source material through higher and more diverse interaction rates. So it can be assumed that giving the players (i.e. their respective player roles) intrinsic motivation to make up a good story facilitates story creation in urban games.

The *Human Trafficker* was by far the most successful role when it comes to storytelling. It seems natural that player roles in urban games with focus on storytelling should be designed with role sets that follow the *Human Trafficker* pattern, namely that a player is able to freely explore the game world, positively interact with every other player, and is not driven by the fear of losing the game. From our results formulated the following guidelines that a game character designer should use when creating roles for an urban game with focus on story creation:

1. Design the role so that its "narrative space" is not limited to a small set of themes and motives of the overall play narrative space.
2. Keep the goal space of the role small so that the character can focus, but synchronize it with narrative constraints to minimize potential obstacles (mainly existential) for the character.
3. Support player conflicts in the context of the narrative environment.
4. Synchronize the interaction means (props) so that a maximum of interaction moments with other characters can be achieved.
5. If the play has game elements, then synchronize the role goals with them so that an access maximum can be achieved.

5 Conclusion and Future Work

In this paper we presented the urban game *Being Grunberg* that explored the process of storification in the context of a story-based game in a real world context. We conclude that such an urban game enables players to create their own storyline while playing during the game and that it is hence the player who can establish an expanded story space and provide the urban game with a narrative that suits its limitless nature and simultaneously the player's story needs and expectations. The recorded storylines show, though, that this process of storification worked out in different degrees for different players.

We found that storification is fostered in urban games and resulting in players' willingness or ability to tell a story with parts they invented themselves, if players can reflect on the game, behave like a different person or role during gameplay, the game has the players value social interaction higher, and provide them with little pre-made storyline or high narrative tension.

Next to those criteria we can conclude that players with player roles that have an intrinsic and positive motivation in their backstory are more inventive and report longer stories than players who are just informed that they can earn points by engaging in storification.

Concerning the ideal player role that enables the best player storification, it is necessary to investigate further how to employ those characteristics in all player roles to make for ideal overall storification. The first step in future work is to test if the characteristics abstraction of the ideal player role was correct and if these character-istics alone facilitate good storification in this particular role or if it was rather the imbalance between one very free player role and three others that have a less com-fortable position in the game. Reruns of the game are necessary where also the other player roles are allowed more freedom, safety, and positive reinforcement. In those play reruns (either *Being Grunberg* or new settings) it has to be ensured that a particular role is not coincidentally played by players who happen to be more creative than other participants. As we are aware that our testing population was rather small, in particular the role we finally based the ideal type on was uderrepresented, the additional test runs should be played with more players.

References

1. Aoki, P., Grinter, R., Hurst, A., Szymanski, M., Thornton, J., Woodruff, A.: Sotto Voce: exploring the interplay of conversation and mobile audio spaces. In: Proceedings of ACM SIGCHI Conference on Human Factors in Computing Systems, pp. 431–438. ACM Press, Minneapolis, MN (2002)
2. Aylett, R., Louchart, S.: Towards a narrative theory of virtual reality. Virtual Reality 7, 2–9 (2003). Springer, London
3. Aylett, R., Louchart, S.: Being there: participants and spectators in interactive narrative. In: ICVS 2007 Proceedings of the 4th International Conference on Virtual Storytelling: Using Virtual Reality Technologies for Storytelling, pp. 117–128 (2007)
4. Callaway, C., Stock, O., Dekoven, E.: Mobile drama in an instrumented museum: inducing group conversation via coordinated narratives. New Rev. Hypermedia Multimedia Mobile Digit. Interact. Storytelling 18(1–2), 37–61 (2012)
5. Chatman, S.: Story and Discourse – Narrative Structure in Fiction and Film. Cornell University Press, Ithaca, London (1978)
6. Coppock, P., Ferri, G.: Serious urban games: from play in the city to play for the city. In: Tosini, S., Tarantino, M., Giacardi, C. (eds.) Media and the City: Urbanism, Technology, and Communication (Geography, Anthropology, Recreation), pp. 120–134. Cambridge Scholars Publishing, Cambridge (2013)
7. Engl, S., Nacke, L.E.: Contextual influences on mobile player experience – A game user experience model. Entertainment Comput. 4(1), 83–91 (2013)

8. Falk, J., Davenport, G.: Live role-playing games: implications for pervasive gaming. In: Rauterberg, M. (ed.) ICEC 2004. LNCS, vol. 3166, pp. 127–138. Springer, Heidelberg (2004)

9. Flanagan, M.: Critical Play – Radical Game Design. The MIT Press, Cambridge (2009)

10. Gentes, A., Jutant, C.: The game mechanics of pervasive applications: visiting the uncanny. New Rev. Hypermedia Multimedia **18**(1–2), 91–108 (2012)

11. Hansen, F.A., Kortbek, K.J., Grønbæk, K.: Mobile urban drama – setting the stage with location based technologies. In: Spierling, U., Szilas, N. (eds.) ICIDS 2008. LNCS, vol. 5334, pp. 20–31. Springer, Heidelberg (2008)

12. HearUsHere. http://www.hearushereapp.com/

13. Huizinga, J.: Homo Ludens: a Study of the Play- Element in Culture. The Beacon Press, Boston (1955)

14. Nack, F., El Ali, A., van Kemenade, P., Overgoor, J., van der Weij, B.: A story to go, please. In: The 3rd International Conference on Interactive Digital Storytelling (ICIDS), vol. 6432, pp. 74–85 (2010)

15. Ryan, M.-L.: Avatars of Story. University of Minnesota Press, Minneapolis, London (2006)

16. Scheible, J., Tuulos, V., Ojala, T.: Story mashup: design and evaluation of novel interactive storytelling game for mobile and web users. In: MUM 2007 Proceedings of the 6th International Conference on Mobile and Ubiquitous Multimedia, pp. 139–148 (2007)

17. Waern, A., Montola, M., Stenros, J.: Pervasive Games – Theory and Design. Morgan Kaufmann Publishers Inc., San Francisco (2009)

18. Zombies Run. https://zombiesrungame.com/

Novel Dramatic and Ludic Tensions Arising from Mixed Reality Performance as Exemplified in Better Than Life

Nicky Donald[✉] and Marco Gillies

Department of Computing/Institute for
Creative and Cultural Entrepreneurship,
Goldsmiths College, University of London, London, UK
{n.donald,m.gillies}@gold.ac.uk

Abstract. We observe that a Mixed Reality Performance called Better Than Life gave rise to novel dramaturgical and ludic possibilities that have not been observed elsewhere. Mixed Reality Performance is an emergent genre that takes many forms, in this case a live experience for a small group of physical participants (PP) and a larger group of online participants (OP). Both groups were offered individual and collective interactions that altered the narrative in real time. A mixed methodology approach to data generated during the performance has identified two key moments where both physical and online participant groups are split into many subgroups by ongoing live events. These events cause tensions that affect the trajectories of participants that make up their experience. Drawing on literary, theatre, cinema and digital game criticism we suggest that the possibilities for engagement in Mixed Reality Performance are exponentially greater than those available to previous media.

Keywords: Interactive storytelling · Mixed reality · Live streaming · Real-time interaction

1 Introduction

This paper is not concerned with the core research questions, findings, or user data, both quantitative and qualitative, gathered during the Better Than Life project. All this and more is contained in the official NESTA report which can be found here: artsdigitalrnd.org.uk/projects/coney. This paper is concerned with two particularly novel and complex moments that have no real equivalent elsewhere.

Mixed Reality Performance covers a small number of diverse experiments over the last decade, notably by Blast Theory, covering overlapping areas of game, performance and installation. Punchdrunk and MIT's collaboration on *Sleep No More*[1] also comes under this rubric. As a rule, participants navigate virtual spaces and content that

[1] Artsdigitalrnd.org.uk/wp-content/uploads/2013/07/Academic-report_Punchdrunk.pdf.

© Springer International Publishing Switzerland 2015
H. Schoenau-Fog et al. (Eds.): ICIDS 2015, LNCS 9445, pp. 297–308, 2015.
DOI: 10.1007/978-3-319-27036-4_28

coincide with physical spaces. This definition could well be applied to television programmes such as *The Adventure Game*[2] or *Knightmare*[3] or to performances using automation plotted in a 3-D model. Suffice to say that the genre is emergent.

Better Than Life was a series of 8 45-minute live Mixed Reality performances held in a Victorian glasshouse in New Cross in June 2014. It was funded by the NESTA Arts Digital R & D fund and devised by Coney in partnership with Goldsmiths College and Showcaster. Live broadcast production was by Spirit Digital, set design and construction by Pan Studios in collaboration with consultant magician Jon Armstrong. Coney are "interactive theatre-makers" with a long history of creating experiences for adults and children in settings from royal palaces to classrooms. Showcaster specialised in live streaming events for corporate customers and national media organisations. They have since transferred their activities to the Grabyo platform.

The premise was to host a live piece of immersive theatre, somewhere between a game show and a drama, live-streamed to an online audience and offering real-time interactions to both the physical participants on set and to the online participants at home. For the purposes of this paper I will refer to the audience who were present at the venue as the Physical Participants (PP) and those who took part online as the Online Participants (OP). This distinction is needed as the terminology remains unclear even among the most experienced practitioners of mixed reality and interactive television [14]. From the outset the intention was to provide complementary experiences, simultaneous but divergent, for PP and OP. At the end of the show the two groups would be able to engage directly with each other and compare their experiences.

2 The User Interface

Online Participants were presented with a live video feed and a chat box. It was possible to go full-screen but this removed the chat interface. Underneath the video were 5 buttons which would switch between:

(a) the video mix, a live edit of the camera streams which was much like a conventional broadcast, switching between various fixed and roaming cameras
(b) Camera 1, a roaming, handheld camera
(c) Camera 2, a second roaming, handheld camera
(d) the Commentary camera, a fixed view of the commentator
(e) the Audience Cam, a third roaming camera which moved closely to the PP groups and caught conversations

Hidden in the logo was a button enabling the Secret Camera, activated at certain key moments. Once activated, a Secret Camera button appeared alongside the others.

[2] *The Adventure Game* BBCTV, UK 1980.
[3] *Knightmare* ITV, UK 1987.

3 Scenario and Interactions

The scenario, briefly, was that a tiny cult were looking for new recruits. Their leader, the clairvoyant Gavin, knows that today he will solve all world problems and disappear to a higher plane. His followers, the idealist Tommy and the ambitious Shipra, canvass for new members and test them for psychic abilities. Initially, the Online Participants can chat only to each other and Big Dave, the fictional moderator. Once the tests are underway, the Online Participants follow the Physical Participants via various fixed and roaming cameras, switching between them at will. On a separate camera they find the Commentator, a fictional anthropologist who provides further insight into the unfolding events and their background. Following hints given by Tommy to camera and by Big Dave in the chat room, some Online Participants gain access to the Secret Camera, where Gavin appears and lets them know that the whole performance is something of a sham that he has allowed to get out of hand with the intention of embarrassing Shipra. At this stage, the fictional characters Gavin and Tommy are reading and responding in real time to chat messages from the Online Participants. Gavin lets the Online Participants choose his costume and give him lines to use in his entrance speech.

At the end of the show, having saved the world, Gavin magically disappears in front of everyone and a new leader is chosen by the Online Participants as the Physical Participants and fictional characters argue their case for taking over and continuing or abandoning the cult. Here individual Present Participants address the Online Participants directly and the Online Participants discuss their arguments.

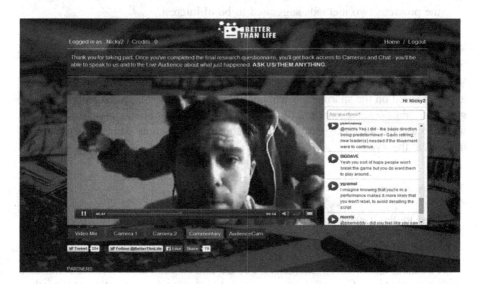

Fig. 1. The user interface

After the show, we encouraged groups of PP to talk directly to OP by means of a large screen which showed the video feed and the chat area. OP were able to chat directly to PP who replied to camera. Between them, they built up an overall picture of

the storyworld and shared their diverse experiences. This environment was known as the "bar".

4 Methodology- Capture and Analysis

All of the live stream video was recorded, from six different cameras. Over the course of the project, over 1000 h of video was generated. We also logged thousands of actions; every chat message and every time a user switched between camera views. Physical participants were given questionnaires before and after the show and online participants were given short questionnaires at three points during the show. The aftershow conversations between PP and OP were transcribed. Once all these were collated we were able to see how individuals felt about the experience and trace their trajectory through the show, punctuated by their own commentary. In this paper we are concerned with two key sequences that, having arisen from the process of data analysis, show the larger forces at that shape those experiences and trajectories. We arrived at these sequences by the following methods:

(1) visualising the user paths between the camera streams, revealing individual paths through the show, collective movements and numbers of OP that witnessed particular events
(2) coding the chat messages and transcriptions, looking for particular interactions such as direct address to actors, groups or individuals within PP and OP
(3) tracking down and closely analysing particular moments in the video footage that the previous two methods suggested to be of interest.

5 Theoretical Background

We suggest that beyond the theory of individual trajectories [3] there lies a language of tensions based on the sharing and withholding of information between individuals and groups within the sets comprised of online, physical, real and fictional participants. We will also use the lenses of metalepsis, metatheatre and framing from literary and dramaturgical theory.

5.1 Trajectories

"Mixed Reality Performance[s]… are constituted by a number of embedded and emergent trajectories through… a complex mixture of space, time, interfaces, and performance roles that are connected into a sophisticated structure using computing technologies" [3]

We cannot situate these sets (actors, PP, OP and subsets) along a linear continuum starting with physical participation at one end and virtual participation at the other. BTL employed fictional characters (actors, or NPCs in digital game parlance) in the physical performance space, in the virtual space of the Chat room and in the fictional space of the commentary room. Online Participants (OP) occupied all of these spaces and the Physical Participants (PP) became aware of them over time. Indeed several

Physical Participants returned as Online Participants. The theory of trajectories helps us to map these spaces in some way. If we trajectorise the experience of the actor playing Gavin alongside those of the physical and online participants, we begin to see distinct states of being, transitions, and intangible seams that hint at a complex structure that can only be revealed by further experimentation.

5.2 Weird Archaeology

"the documentation of unwritten happening, attested through material trace, is an archaeological project" [18].

If the interaction, chat and video data are the material traces of the performance, we are engaged in kind of Lovecraftian archaeology, uncovering a structure that is of unknown and quite possibly "inconceivable shape" [15]. By examining the material traces we begin to see edges, interstices and planes, *adjacencies* and *superimpositions* [3]. We send probes in the form of participants and track their progress, their recollections and reactions. The set of participants must also include those previously classed as actors and technicians, since they are very much part of the whole each time it is in motion. In BTL technicians were frequently on camera and on occasion dragged into the fictional world. For example, when a technician is addressed by a fictional character on camera, (s)he slides between the real, mediated and fictional worlds. This is doubly confounding when the technician is habitually invisible in the real world; several intangible, invisible boundaries are broken at once between conventions and cognitive states.. Mapping the structure in which these boundaries lie is surely an exercise in "weird ontography" [10].

5.3 Narrative and Dramatic Tensions

The wider picture can be glimpsed in terms of the narrative, dramatic, ludic and indeed technological devices BTL used to engage participants. Dramatic and narrative tensions arise from the author(s) withholding and gradually divulging information to the audience. Consider books, plays and films in the mystery genre where the author plays with the reader/spectator's expectations and the reader/spectator attempts to second-guess the author using the information available. This is linear, narrative tension and recently has given rise to a ludic approach to literature informed by Interactive Fiction [16, 19] and to film criticism informed by digital games [20].

The playwright David Edgar identifies *differential knowledge* as the key mechanism for generating tension and engagement in theatre:

"differential knowledge, the root of dramatic or proleptic irony (dramatic, when the audience knows something but a significant character doesn't; proleptic, when none of characters know what's going on [but the audience is aware that the play is a tragedy, a comedy etc.])...the difference between what we know and what the characters know is not just a mechanism for unfolding the plot but also the expression of the play's fundamental meaning." [7]

In Better Than Life, information was withheld and divulged by subsets of actors and participants alike. These transactions are analysed in detail in Sect. 7.

6 The Ludic Methodology: Losing Control

Over eight shows BTL gave rise to hundreds of questionnaire responses, thousands of chat messages, thousands of channel switches and hundreds of hours of video. All had to be scrutinised to find single revelatory moments that were not at all apparent to researchers on the scene. During a live show we were far too busy maintaining the interaction systems and live streams to follow dialogue, user activity or even narrative; we were simply a part of a frenzied whole.

However this is a powerful insight in itself; a Ludic methodology is a framework allowing sufficient play for moments of transcendence. Only when the authors, technicians and researchers lose control of participants can they play freely; it is only when rules are broken that we perceive their fragility and their validity, if any. Myers insists that "breaking gamerules is necessary to establish the presence and... function of rules" [17]. Ludic methodology consists not of establishing rules but testing the boundaries and breaking points of any given system. The philosophy of Myers' "bad" [17] or Spariosou's "destructive" [25] play supports our position, namely that Dionysian play in its transgression of social norms is the best way to inspect and maintain the structure of society, a game or a storyworld. As engineers or bricoleurs, we test things until they break and rebuild them in the light of that knowledge. In the two key sequences examined in this paper, an experienced player breaks the rules.

7 Metalepsis

It is only when Gavin breaks the rules of the story and of the game that we see the illusory boundaries within which we have been working. Thus far, we have two rich, revelatory transgressions in BTL. After weeks of analysis, linking chat messages with channel switching, 15 s of video were located. When Gavin attacks the Commentator he breaks the rules of the storyworld. Months later, the same analysis led to another 15-s sequence. When Gavin attacks the physical audience he breaks the rules of the spectacle as a whole.

Metalepsis was first identified by Gerard Genette in Homer, Diderot and Sterne: "taking hold of (telling) by changing level...the narrator pretends to enter (with or without the reader) into the diegetic universe" [9]. In Umberto Eco's *The Prague Cemetery*, the narrator gradually discovers that he is the protagonist [6]. It has since been applied to the metatheatre of Genet and Pirandello and to cinema classics such as *The Last Remake of Beau Geste*[4], where characters move between the diegetic world of a story and the extradiegetic world of its supposed telling. *The Last Remake of Beau Geste* contains two levels of metalepsis. In a café, Marty Feldman shares a joint with Gary Cooper who is playing his brother in a different (black and white) version of the film. At another point, Feldman appears alongside the spinning globe of the Universal logo, pulls the letters off and sticks his finger into the Sahara, creating a gigantic hole into which marching foreign legionaries fall.

[4] The Last Remake of Beau Geste. Marty Feldman, Universal Pictures, US (1977).

The first is a character moving between storyworlds. The second is a character breaking out into the real world of logos and production credits in which we, the audience, live. The former, to paraphrase Marie-Laure Ryan [22], is a rhetorical metalepsis and the latter an ontological one. Consider the parallels with the two attacks in Better Than Life:

Gavin moves from the world of the cult to that of the commentator, revealing him as both collocated and fictional. In the second instance, Gavin moves from the fictional world of the story to the "real" world of free, unscripted conversation between the PP and OP. This is the penultimate metalepsis; the ultimate would be Gavin appearing in your home, something hinted at when Gavin magically disappears (a Pepper's Ghost illusion characterised as metaleptic by Kukkonen and Klimek [13]).

There are ludic possibilities for metalepsis, allowing participants to move between diegetic levels. Astrid Ensslin has identified interactional metalepsis as an "underre-searched area" [8], but there are precedents in Live Action Role Play (LARP). Players meet at a location and play fictional characters, sometimes for days at a time. The Nordic tradition allows for the "meta-room", where a participant steps out of the storyworld to explore the inner workings of their character's emotions and motivations with directors or other players: "If a player needed a scene he or she could enter the black box and order the scene he or she wanted." [12] In this case, a character can choose to move from the ongoing storyworld to an adjacent one. In Better Than Life, the Secret Camera was used as a similar device, where Gavin, Tommy and Shipra gave voice to their inner feelings and misgivings while the main action proceeded on other cameras.

7.1 Gavin Attacks the Commentator: Rhetorical Metalepsis, Trajectory of Information

Like a sports commentator at a game, the Commentator appears to be watching at a remove. Once Gavin has crossed into this space (Fig. 1) it is revealed as part of the fiction and the spectacle is broken, expanded and ultimately reinforced. It is a rhetorical metalepsis, "a small window that allows a quick glance across levels, but the window closes … and the operation ends up reasserting the existence of the boundaries" [22] However, in doing so he splits the participants: a set (A) of Online Participants see the attack on Commentator Camera and are aware of Gavin's actions, and a set who are not (B), comprising Online, Physical and fictional participants along with the technical team. Set A is further split: some heard Gavin stating his intention on one camera and followed him to the other in order to see the action (A1); some were watching the Commentator and shared his surprise and shock at the attack (A2). Their trajectories and experiences are quite different: A1 are in-the-know and complicit, in as much as they do not warn anyone of the impending attack. A2 are surprised like the actor playing the Commentator, who genuinely didn't know it was going to happen. This is a revelatory mixed reality moment, where some of the online audience (A2) share in the surprise of an actor and some (A1) are complicit with another. This moment then plays out in interesting ways. To reveal the emergent structure, we have to follow the trajectory of the information itself rather than the actants.

Group A shares this information with other Online Participants by chat message and subsequently with several Physical Participants in aftershow conversation at the "bar", where PP talked to camera and viewed OP responses on a monitor. Some OP were watching on fullscreen and never saw the messages. Most of the PP never knew about it since they were not party to that "bar" conversation. Most of the technical team remain unaware of it to this day since the researchers only found it weeks later.

While the attack made an impression on those watching it, it had little narrative consequence. However, a *differential of information* [7] occurred that remains full of potential. The attack happened, and the way in which that scene's content was distributed, the way that information was divulged and withheld, the trajectory of the information, is a profound insight into possible dramatic and ludic tensions for future Mixed Reality performances (Fig. 2).

Fig. 2. Gavin, centre, threatens an unwitting physical participant (left) and his own author (right) while a camera operator (far left) watches. Two more physical participants are seated out of shot to the right.

7.2 When Gavin Attacks People After the Show: Ontological Metalepsis and the Transformation of the Participant

Our richest moment of insight, however is when Gavin threatens the Physical Participants. This is an ontological metalepsis, one of Hofstadter's strange loops in action:

> "there is a shift from one level of abstraction (or structure) to another, which feels like an upwards movement in a hierarchy, and yet somehow the successive "upward" shifts turn out to give rise to a closed cycle." [11]

In the film *Nightmare on Elm Street*[5], the killer Freddy Krueger moves from the characters' dreams to their waking world. In the video game *Alan Wake*[6] the writer is pursued by villains from his own oeuvre. Thankfully Freddy does not appear next to you in the cinema, nor do Alan Wake's villains appear in your living room. In Better Than Life, Gavin achieves a step in this direction.

In her analysis of metalepsis in drama, Marie-Laure Ryan examines the possibility of "metaleptic bleeding of the textual world into…the ground level of reality" [22] and concludes this is only possible if an actor uses a real knife during a show, superimposing a real murder on a scripted one. Luckily the actor playing Gavin is not inclined to murder, but there is a quite unprecedented leap between the fictional and real, the mediated and the live.

The show is finished. PP and OP are discussing the spectacle they have just experienced. People are no longer performing; they are discussing their experience with each other and one of the authors, Tom Bowtell. It is at this point that the fictional character Gavin reappears, provoking not only a fascinating mixed-reality interaction but causing completely unexpected rifts within the physical participants involved.

At a narrative, dramatic and ludic level the online participants (OP) suddenly have information that they desperately want to share with the physical participants (PP) on camera, namely that Gavin is behind them with a machete. However, the live stream is not entirely live; the events one sees on screen have happened up to a minute ago, dependent on server speed, ISP load, the equipment and local connection used to view. So, even though the OP send their warning message the moment Gavin appears, there is a fascinating 20 s before the physical participants receive the information, turn and see that he has gone, in best pantomime fashion[7]. The OP watch helplessly, which is doubly frustrating following a show in which they have been offered increasing levels of direct agency. There are innumerable ludic possibilities in exploiting this tension between immediacy and latency, between agency and passivity. It is a fascinating, exciting moment where the artistic process, the momentum of performance and our data capture and analysis come together to reveal an aspect of the future.

Just as fascinating is the reaction of the two PP who are seated off camera and have seen the whole thing. From transcription, we know that one of them recognizes Gavin from the show, the other does not. Both remain silent, prevented from acting by a perceived taboo. Were they at a bus stop they would presumably act quite differently. However both of them instantly perceive a tacit framework, namely that they are once more part of a show and that to intervene would somehow spoil the action. The first participant recognises Gavin and enters into a complicity with his joke. The second offscreen physical participant fails to recognize Gavin but recognises that aberrant behaviour is expected, that normal social responsibilities do not now apply. Unprompted, she transforms herself into a spectator. This is a brilliant and unplanned illustration of

[5] *A Nightmare on Elm St.* Wes Craven, New Line Cinema, US (1984).

[6] Alan Wake. Remedy Entertainment, Finland (2010).

[7] In the UK, a traditional Xmas panto is a theatre show invariably including a sequence where the villain appears behind the hero, prompting the audience to cry out "he's behind you!" The hero turns but the villain has hidden. The hero berates the audience for interrupting, then the sequence is repeated.

Ranciere's argument that there is no static opposition between acting and spectating, that the spectacle is subject to constant individual interpretation, where the viewer links the action before them with their own social and cultural experience, with every story they have been through and been told, and reacts accordingly [21].

Just as we do not expect a conventional theatre audience to intervene in dramatic events, it is likely most people would perceive the emergent rules of this situation and fail to intervene. Indeed a great deal of stage magic is based on this premise; perceived social pressure inhibits the audience member from contradicting the magician's version of events [26]. This is a human frailty; just as we instinctively, inevitably construct causality [24, 28], we construct rules for our behaviour on-the-fly.

8 Conclusion and Further Enquiry

Mixed Reality Performance demands a mixed approach, combining hard data with anecdote. Although Benson and Giannachi's trajectory-based analysis provides excellent results it is insufficient. Our participants are our probes; we track their progress, their recollections and reactions. But these trajectories are poor things in themselves. Like caterpillars in cabbages, we can see layers but not the shape of the leaf, still less the arrangement of the whole, its symmetries and situation. This is not to say that trajectorising the participant experience is not a crucial tool in understanding the mixed reality medium. In fact all of our current insights arise from this process. Only by following the movements of real and fictional, physical and virtual participants can we reach the waypoints that give rise to insight.

Nevertheless an understanding of narrative, dramatic and ludic structures and devices helps us to understand the forces at play across the whole experience, the tensions that influence the trajectories. As we examine the hard data, we can detect the influence of these tensions and improve our understanding of the whole. This in turn helps us to design experiences that take better advantage of these forces.

For example, Better Than Life allowed for infrequent communication between Physical and Online Participants. If both PP and OP were to use Twitter, communication would improve, but the live experience would be punctuated by PP consulting their phones. Furthermore, any information shared by the OP is immediately available to the PP, so differential information mechanics are unavailable. Improved communication has direct dramatic and ludic consequences, itself evidence of various tensions at work.

We do not attempt a universal list of possible tensions in a mixed reality environment Chris Salter identifies a mixed reality tension as early as 1924 in Erwin Piscator's *Trotz Allem*. Piscator himself recollects "the dramatic tension that live scene and film clip derived from one another" [23].

In The Emancipated Spectator Rancière proposes that we re-examine assumed "equivalences between theatrical audience and community, gaze and passivity, exteriority and separation, mediation and simulacrum; oppositions between the collective and the individual, the image and living reality, activity and passivity, self-ownership and alienation." [21] In Better Than Life, participants, actors and technicians alike moved elliptically between these states.

Maintaining tension sustains engagement. We admitted earlier that the technical team, researchers and authors were involved in frenzied activity throughout the shows, so there was no-one directing the action, controlling those tensions during the show. It is tempting to look to an Artificial Intelligence solution, and there are notable examples. Szilas and Richle have examined the control of dramatic tension in digital games: "Modelling tension… implies the construction of a computational model of the dramatic tension. This is different from tagging events with a tension level, as in the interactive drama *Façade*" [27].

The best known example of dynamic AI control of tension in digital games is the "AI Director" in Left4Dead (Valve 2008), which adapts the pressure on the players according to ability, creating crescendoes of action followed by periods of calm to great dramatic effect. Valve originally gave the AI some scenographic control in the sequel, adding to the tension of navigation: "the ability for the AI Director to change the path of the survivors… so they have to take a different path each time." This advance was mitigated, however, by user testing: "playtesters found the paths confusing…having all paths open led to a better experience" [5].

As Mixed Reality Performance offers increasing numbers of physical, online and virtual participants increasing control over scenic and narrative elements in real and virtual spaces, there will have to be increased automation. However we suggest that an AI approach to controlling mixed reality tensions will generate a tension of its own, namely that between a coherent experience and one that allows for transgression. In this we echo Weyrauch's 1997 proposal on AI drama management systems arising from the Oz project: "that the artist give up direct control of the sequence of events and instead define the interactive drama with a destiny" [29].

References

1. Allain, S., Szilas, N.: Exploration de la métalepse dans les "serious games" narratifs. Revue STICEF **19** (2012). http://sticef.org
2. Ayckbourn, A.: The Crafty Art of Playmaking. Faber & Faber, London (2002)
3. Benford, S., Giannachi, G.: Performing Mixed Reality. MIT Press, Cambridge (2011)
4. Boyd, F.: Immersive media: to the holodeck and beyond, knowledge transfer network blog post. www.ktn-uk.co.uk/immersive-media-to-the-holodeck-and-beyond/. Accessed 6 June 2015
5. Developer Commentary, Left 4 Dead 2, (2009 Video Game) Valve Software (2009). http://left4dead.wikia.com/wiki/Developer_Commentary_(Left_4_Dead_2)
6. Eco, U., Dixon, R. (trans.): The Prague Cemetery. Random House, London (2011)
7. Edgar, D.: How Plays Work. Nick Hern Books, London (2009)
8. Ensslin, A.: Diegetic exposure and cybernetic performance: towards interactional metalepsis. In: Plenary presented at Staging Illusion: Digital and Cultural Fantasy, University of Sussex 8–9 December 2011
9. Genette, G., Lewin, J. (trans.): Narrative Discourse: An Essay in Method. Cornell University Press, Ithaca (1983)
10. Harman, G.: Weird Realism: Lovecraft and Philosophy. Zero, Croydon (2012)
11. Hofstadter, D.: I Am a Strange Loop. Basic Books, New York (2007)

12. Hultman, A., Westerling, A., Wrigstad, T.: Behind the façade of a nice evening with the family. In: Playgrounds Worlds: Creating and evaluating Experiences of Role-Playing Games. Ropecon ry, Helsinki (2008)
13. Kukkonen, K., Klimek, S. (eds.): Metalepsis in Popular Culture. Walter de Gruyter, Berlin (2011)
14. Jenkes, C.: Presentation at NESTA Arts Digital R&D Learning Day, 11 June 2015
15. Lovecraft, H.P.: The Dreams in the Witch House and Other Weird Stories. Penguin, New York (2004)
16. Montfort, N.: Twisty Little Passages: An Approach to Interactive Fiction. The MIT Press, London (2003)
17. Myers, D.: What's good about bad play. In: Proceedings of the 2nd Australasian Conference on Interactive Entertainment, pp. 133–140. Creativity and Cognition Press, Sydney (2005)
18. Pearson, M., Shanks, M.: Theatre/Archaeology. Routledge, Padstow (2009)
19. Pereira, J.: A narrative at war with a crossword – an introduction to interactive fiction. In: Expectations Eclipsed in Foreign Language Education: Learners and Educators on an Ongoing Journey, pp. 87–97. Sabancı Üniversitesi, İstanbul (2011)
20. Perron, B.: Présentation. L'entre-jeux: médiations ludiques. Intermédialités: histoire et théorie des arts, des lettres et des techniques/Intermediality: History and Theory of the Arts, Literature and Technologies, 9, 9–13 (2007). http://id.erudit.org/iderudit/1005526ar
21. Ranciere, J.: The Emancipated Spectator. Verso, London (2009)
22. Ryan, M.-L.: Avatars of Story (Electronic Mediations). University of Minnesota Press, Minneapolis (2006)
23. Salter, C.: Entangled: Technology and the Transformation of Performance. MIT Press, Cambridge (2010)
24. Shermer, M.: The Believing Brain: From Spiritual Faiths to Political Convictions - How We Construct Beliefs and Reinforce Them as Truths. Robinson, London (2011)
25. Spariosou, M.: Dionysus Reborn: Play and the Aesthetic Dimension in Modern Philosophical and Scientific Discourse. Cornell University Press, Ithaca (1989)
26. Steinmeyer, J.: Hiding the Elephant: How Magicians Invented the Impossible. Arrow, London (2005)
27. Szilas, N., Richle, U.: Towards a computational model of dramatic tension. In: Finlayson, M.A., Fisseni, B., Löwe, B., Meister, J.C. (eds.) Proceedings of the 2013 Workshop on Computational Models of Narrative, vol. 32, 4–6 August 2013, Hamburg, Gernamy, OASICS (2013)
28. Wegner, D.: The Illusion of Conscious Will. MIT Press, London (2002)
29. Weyhrauch, P.: Guiding interactive drama. Ph.D. thesis, Carnegie Mellon University, Pittsburgh (1997)

Social Media Fiction

Designing Stories for Community Engagement

Francesca Piredda[(✉)], Mariana Ciancia, and Simona Venditti

Design Department, Politecnico di Milano, Milan, Italy
{francesca.piredda,mariana.ciancia,
simona.venditti}@polimi.it

Abstract. The current widespread use of digital videos, pictures, audio and text, and their distribution across social media leads to the rise of new consumption behaviours and the spread of new interactive narrative forms. These issues are considered with the analysis of the results of the workshop "Micro Narratives for Community Engagement", which is part of an ongoing research and educational programme about social media narratives and transmedia storytelling for community engagement. The aim of the workshop was to examine the structure of social media feeds as new ways of organising content based on storytelling and sense-making.

Keywords: Mobile storytelling · Social media storytelling · Interactive narrative · Design and new media · Community-centred design · Narratology

1 Introduction

In the contemporary media landscape, audience consumption is witnessing the rise of new behaviours and the spread of new interactive narrative forms, which rely not only on developments in technology but also on spontaneous practices of engagement. The remarkable acceleration in technological developments has been leading society to interact with a digital version of reality via several devices i.e. "the increased centrality of the mobilized and virtual gaze as a fundamental feature of everyday life" [14]. Nevertheless, it is cultural values that drive changes within media consumption behaviours. Thus, as noted by Jenkins, Ford and Green [18] "a media system is more than simply the technologies that support it". As a matter of fact, while historically user interaction was related mainly to technology, in recent decades it has depended much more on the time and space people are willing to devote to content.

Starting from the concept of Packer and Jordan [28], Castells [7] describes the communication scenario as being composed of five processes (*integration, interactivity, hypermedia, immersion* and *narrativity*). On the one hand, we are addressing the *integration* of languages and media to develop new expressive forms characterised by non-linear story structures (*narrativity*). On the other hand, we accept Jenkins' contribution to the concept proposed by Packer and Jordan, drawing a distinction between interactivity and participation. Jenkins defined interactivity as "the way that technologies have been designed to be more responsive to consumer feedback" [17].

© Springer International Publishing Switzerland 2015
H. Schoenau-Fog et al. (Eds.): ICIDS 2015, LNCS 9445, pp. 309–320, 2015.
DOI: 10.1007/978-3-319-27036-4_29

This means that interactivity has technological constraints that are shaped in the design phase. Participation, instead, is more open-ended, and refers to the cultural and social spheres. Participation and engagement become expressions of a scenario characterised by the audience's contribution in the meaning-making processes of the story worlds, thanks to the success of multi-channel structures based on storytelling, collaboration and engagement, such as cross media and transmedia systems.

In this scenario, audiences become "seekers" who are willing to move across platforms in order to follow stories and information. In our case, we refer to the audience as a specific local community, which has its own members, memories, places and imagery. By documenting and collecting this cultural repertoire, designers can build new stories, practising expressive languages and building relationships with the audience, as a result of the opportunities coming from instant editing, publishing and sharing. Furthermore, the aesthetic of "composition" [23, 24] and mash-up [22] is a diffuse expressive form, which emerges from everyday practices [9].

On the one hand, we consider the aesthetic and cultural dimensions of remix and mash-up as a contemporary socio-technical paradigm based on iconographic repertoires, footage and textual descriptions of narrative worlds. As this material is selected, used and enacted, new story lines can arise and be available for other users. On the other hand, we assume the engagement of local communities for meaning-making processes, as the experimentation field for interactive storytelling practices.

2 Social Media Storytelling

Within the realm of social media, interactivity cannot be considered as an internal feature of the medium: as a process-related variable [2], interactivity depends on the way the information is communicated through a specific medium, which cannot be seen as interactive or non-interactive itself. Social networks such as Facebook, Instagram or Twitter enable interaction between users and content, increasing the possibilities for active people to take part in conversational processes, but the content conveyed determines how and at what level people interact with the medium. Moreover, the concept of participation introduces the cultural and emotional spheres, taking into account motivations, values and desires that are deeply rooted in people's personal experiences and background knowledge. Thus, as social networks enable different kinds of interactions, the content, which is communicated on those platforms, is responsible for the audience participation, as it is able to evoke a specific reaction or response facilitating interaction.

Storytelling has been used for centuries to communicate in an engaging and effective way. The narrative form is commonly used in many communication fields, from advertising to marketing, social campaigns, entertainment and education. Specifically, story-creation processes have been conducted in the social domain with the aim of strengthening community engagement, identity and self-awareness [16, 21]. Narrative as a form of knowledge and communication has a long history, and Internet and Web 2.0 applications [27] have probably facilitated the development of interactive forms of storytelling, supported by media convergence. Digital technology itself is not enough: stories as a communication format have the potential to link interactivity,

intended here as the response in a communication process, and the emotional participation of the audience. If it is true that social media can be considered as those platforms that allow users to share a connection with other users [6] and to create and exchange User Generated Content [19], it is also true that a story told on social media cannot be considered interactive itself, as the platforms are not inherently interactive. For example, a brand's story told with a video and shared on a Facebook page can be shared and commented on by many users but cannot be seen as a form of interactive storytelling, rather as an expression of viral marketing.

What social media platforms can add to the practice of storytelling is that stories can be navigated by the users. This is much more effective within the mobile version of social media platforms, as one of the main features of storytelling through social media "is the embedded hapticality in the use of the touch-screen form, invoking a closeness and intimacy in which the content can literally be manipulated by the viewer's finger tips and physical movements" [3]. This approach to social media storytelling requires particular attention in the design phase, as stories are not only told but rather they are designed to harness the structure of social media feed as a narrative structure. A good example of this approach is the way the 'Toronto Silent Film Festival' communicated in the last three years on Instagram (i.e. @tsff_1, @tsff_2, @tsff_3, @tsff2015).

3 Workshop: Micro Narratives for Community Engagement

In this paper we introduce the results of a workshop held in May 2015 with a class of students of Communication Design at the School of Design (Politecnico di Milano, Italy). The aim of the workshop was to investigate the structure of social media feeds as new ways of organising content based on storytelling and sense-making. The workshop is related to the activities of an ongoing project, 'Plug Social TV', which is intended to investigate narratives, new media and transmedia strategies as opportunities for identity building and community engagement in a suburban area of Milan [1, 8].

The workshop aims to research new ways of telling stories and engaging people through mobile storytelling, thanks to the widespread use of portable devices and the audience's familiarity with the social media mechanisms. In this case, we refer to the audience as the members of the local community already involved in the project as well as those potentially reachable through social networks: many people of the community have personal profiles (on Facebook, Twitter or Instagram) and/or manage public pages to disseminate content of local interest (as associations or groups of active citizens).

3.1 Background

Since 2013, we have been conducting studies on digital storytelling and transmedia, in the domain of design practice, with the project 'Plug Social TV', which is part of a research and educational program. According to Ariel and Avidar [2] social media platforms "might be seen as *affordance technologies* that enable various levels of social involvement and participation". Specifically, our project makes use of social media to spread content at a local level, aiming to test and verify the ability of stories of local

interest to activate self-representation and self-narration processes, and to foster a dialogue among the inhabitants of the same neighbourhood.

During these two years, approximately one hundred students, in collaboration with thirty members of the local community, have produced content for the web channel 'Plug Social TV' testing the potential of transmedia systems oriented to community building activities and social innovation, and working out of the entertainment market and mainstream production. Over this period, we activated a process of engagement with the community that was developed through fieldwork: activities, interviews, participation in local events and workshops have been led primarily using audiovisual language as a listening tool[1]. Designers worked directly in contact with people of the community, both individually and in groups, not only in the "real world" but also in virtual spaces. The connection with citizens both offline and online represents a fundamental step for the collection of personal fragments[2] of stories. As a result we collected experiences, memories and short stories from citizens of the neighbourhood in the form of texts, photos and videos. These fragments represent the archive material upon which new narratives were built during the workshop, in which the participants were asked to work on existing story worlds.

3.2 Process and Tools

The workshop lasted five days and involved a group of fifty Communication Design students divided into ten teams. Each team had the goal of creating a digital storytelling project based on story elements coming from the different story worlds that were developed during the two years of the 'Plug Social TV' project. The workshop ended with the creation of nine stories that can be navigated through social media and the design of an exhibition for community public consumption on portable screen surfaces (i.e. smartphones and tablets). The following paragraphs describe the two phases (*Craftwork* and *Creation*) of the process we propose for the creation of social media fiction.

Craftwork: Building Stories. This phase consists of the development of fragments into more structured stories. Each team was supplied with a folder of digital material related to a specific story world, and students were asked to use this archive to create a new story. Archive material is selected, edited and re-elaborated (*craftwork*) in order to produce short individual stories about a specific character, preparing all the different elements for digital contents. Focusing on visuals and multimedia, craftwork also means creating semi-finished artefacts (i.e. mood board), which integrate different expressive languages and are able to immediately shape and visualise the character's

[1] We refer to the term "listening" as the action of building relations with the community: in this case, the audiovisual language represents a tool for collecting stories from users and shaping their expectations [15].

[2] The idea of collecting stories from fragments of the mainstream and weaving them together in a narration was one of the main topics discussed since 2013 within the *DESIS Philosophy Talks #Storytelling and Design for Social Innovation* (www.desis-philosophytalks.org; [4]) looking at the specific contribution of the German philosopher Hannah Arendt.

world, his/her values and his/her story. Connecting and referring to visual references and examples coming from different fields, such as cinema and visual arts, the craft-work edits archive material in order to achieve a specific atmosphere in terms of colours, photography and staging.

The first step focused on the identification of the main character (real or fictional) and the definition of the storyline (*fabula*), intended as the combination of the narrative elements in a logical and chronological order. To support this phase, we provided a set of tools: (1) the Character Wheel, (2) the Character Canvas and (3) the Character's Transformation Arc, in addition to more commonly used design tools such as mood boards and storyboards.

The Character Wheel identifies both the inner and external world of the character and refers to his/her actual features: age, gender, race, nationality, physical and mental skills, personality (inner world) and environment, social class, civil status, religion/beliefs, education, work experience, habits, physical appearance and activities (external world) (see Fig. 1a). The Character Canvas represents a narrative development of the previous tool. Starting from the field of narratology, the canvas provides a qualitative description based on seven variables: *Topos, Epos, Ethos, Telos, Logos, Genos, Chronos* [20, 30]. These elements incorporate the world in which the character moves and indicate his/her identity values: environment, background story, value system, life goals and objectives, language (forms of expression, personal terms, body language), system of relations (family and friends) and lastly, time, such as the historical period in which the character exists.

Afterwards, students worked on the storyline, defining it by combining together the archive digital fragments and brand new fictional elements. The Character's Trans-formation Arc is a tool, which merges together the Hero's Journey [32] and the Transformational Arc [25]. In this worksheet, students identified the main key points of the narrative structure and decided which of those they wanted to develop on social media.

Creation: Re-Framing Fragments. This phase is characterised by the creation of digital artefacts and their distribution on social media. Each team was assigned a specific form of social media (Facebook, Twitter or Instagram) and students were asked to analyse its limits and structures in order to develop a unique digital micro narrative, made up of different contents. In this way, "the intrinsic properties of the medium shape the form of narrative and affect the narrative experience" [31]. Students were able to define the genre (comedy, crime, fantasy, science fiction, romance) and the narrative format (web-doc, reality, web series, web comics, twitterature) according to the given archive material and the storyline previously created.

In this phase, the digital fragments are transformed into content for social media: it is defined how many posts, photos and/or videos are needed to tell the story and they are placed on a board following the reading order. The next step consists in the creation of a posting plan in which every single piece of the content is organised and scheduled according to the publication order: for example, if the story needs to be followed starting from the top to the bottom of the Facebook Timeline, the first post in the narrative order (the beginning of the story) is the last one to be published, as it appears at the top. This phase represents the definition of the plot (*intreccio*), such as the

Fig. 1. (a) On the left, the Character wheel, (b) on the right, fragments transformed into content for Twitter

narrative order of the single elements, which may be different from the actual storyline (see Fig. 1b).

In terms of storytelling, in this phase the narrative features are defined as well as the functional specifications. To help the students design all these elements, we guided them using a document called 'Social Fiction Format', in which we asked them to consider different diegetic strategies, using these questions: what is the narrative's point of view? Is the story told or enacted? What is the relationship between the time of the story depicted on the screen and the time of posting and consuming it? Who's telling the story? Is the main character telling the story or an external narrator? Who owns the social media profile/page? Are there any extra-diegetic elements such as events, places or secondary characters, which are external to the main story? Are there any elements referring to real life and the local community (people, places and events)? Does the main story mention external profiles/pages? What are the most useful hashtags for connecting the micro narratives with each other? What is the relationship between the visual part and the textual one (i.e. comments on Instagram)?

3.3 Outputs

Resulting from the workshop were nine narrative projects in which stories and interaction mechanisms work together to support each other. Students wrote the stories and designed the plot referring to the navigation of the assigned social media, as "navigation is to interactive what montage is to cinema" [29]. This means that within the realm of digital media, audience engagement depends also on the design of the "story space" (the digital space in which the story takes place) and its "navigation". The young designers built character-driven stories [12] and crafted their boundaries according to the channel's affordances. All the projects can be experienced on-line, but we would like to describe two of them.

The first example is the Instagram project called 'Adam Plug'. Adam Plug is a fictional character who tells his story on his Instagram profile. He is described as an intellectual and a story hunter, who started telling stories about the suburban area of

Milan, in which he lived. The story space is composed of two accounts: one for the main character (@Adam_Plug), and another one dedicated to moments of tender beauty, captured by Adam himself in the suburban area (@Frammenti_Plug). The personal profile starts from the bottom line and is organised in thematic triptychs that describe the character's world (his interest, hobbies, passions, values). The other profile organises the stories he gathered from the neighbourhood in narrative triptychs. These stories come from the digital archive material provided to the students. In this project the spatial organisation of the material uses the grid itself to guide the audience in the consumption of the single fragments. The personal diary of Adam Plug, his Instagram profile, doesn't have a daily editing program but rather a thematic one and uses the layout of Instagram interface to display the contents. A certain number of rows make a block of content: starting from the bottom, the first four lines are referred to the introduction of the character and his values. The following three rows describe Adam's hobbies and passions. The third block, made up of two lines, talks about his personal motivation to collect stories from the neighbourhood (*awakening*, [25]). The last row is made from three clips, which reflect the identity of 'Plug Social TV' channel as parts of an *ident*, remediating [5] the typical TV format of broadcast identity. The composition of the second profile, @Frammenti_Plug, is built according to a grid with three elements next to each other as a sequence, telling one story. We can say then that the 'Adam Plug' project uses Instagram as a dynamic storyboard, enhancing the opacity of the interface: the narrative structure becomes evident, the medium declares itself, and provides instructions for its use and access to the contents. The user is engaged by the promise of having a reflective action and not simply an immersive seamless experience: by moving in the digital narrative space, the user shifts his attention among different rhetorical levels (see Fig. 2a).

The second example is the Twitter project called 'I Guardiani della Nove'. This is a sci-fi adventure that tells the story of five heroes, sent back from the future in order to improve the environmental situation of a dystopian world, in which all the green areas are owned and enjoyed only by the rich. The story's genre is a modern form of the epistolary novel: the team built an instant message conversation on Twitter between the leader of the five heroes (@CORTO2115), who speaks from the present, and the assistant of the scientist who developed the mission (@XY2115), speaking from the future. In this example of twitterature there is no external narrator and the story is told in the first person as a dialogue between two characters. The two main characters are described through the manner in which they communicate: the hero's idiom is characterised by a corruption of various languages and the scientist's assistant uses simple, very short sentences, resembling those in a telegram. From a navigational point of view, the user reads the Twitter feed of each profile from the bottom to the top and can use the hashtag #gd9 to follow the whole conversation. Even though this is mainly a copywriting project, the team decided to create some brand new images in a form that imitates 8-bit style to match the story: coming from a future scenario characterised by low resources, the team hypothesised that the transmission between future and present time would have a low resolution (see Fig. 2b).

At the end of the workshop, the design students presented all the projects in an exhibition at the School of Design to other students and members of the community. The physical installation was composed of different stages, each one related to one of

Fig. 2. (a) On the left, Adam_Plug profile with thematic blocks and Frammenti_Plug with narrative sequences on Instagram, (b) on the right, the Twitter conversation between the two characters, mixing texts and 8-bit style images.

the nine projects, where people were able to experience the stories through their own mobile device, individually or in small groups. The public exhibition was an opportunity to collect feedback about the designed micro narratives, from the students themselves and from the people who visited the exhibition. We collected thirty responses to the questionnaire we provided, asking people to evaluate the narrative and interactive experience and to express their preference about which project they preferred. These questionnaires represent a first step in terms of qualitative evaluation for the design projects.

4 Discussion and Further Steps

The two projects we chose to describe in this paper were those most frequently selected by the audience, according to the feedback questionnaire (highest number of answers to the question "Which story most caught your attention?"). As designers, we can argue that those two projects were also the most coherent in terms of visual and narrative quality, as well as in terms of medium affordance. In order to improve the analysis of the work carried out by the design students, we are here defining the qualities based on the relationship between fiction and non-fiction. These qualities are: *content* (referring to narrative elements), *structure* (referring to medium affordance) and *representation* (referring to the visuals).

Content's main feature is *familiarity*: the possibility for the audience to recognise some of the narrative elements, such as locations and characters, as parts of the real environment and everyday life. In the 'Adam Plug' project, even if the main character is fictional, the stories come from the real world and the audience can recognise people and places from the neighbourhood. In the second example, 'I Guardiani della 9' project, the conversation between the two main characters is fictional, but there are some references in the text about real places, and well-known local landmarks and events appear in the visuals.

Considering the *structure*, the second feature of the designers' contribution is the *composition* of fictional and non-fictional elements being integrated in the images, or placed side by side in the layout grid. Designing the composition is about harnessing the potentialities and constraints of social media feeds for the organisation of contents (i.e. the grid for Instagram and the feed and hashtag system for Twitter). Every visual content has its own individual meaning and autonomy, which are further detailed by the textual comments, but it can also make sense because of the sequence of which it is a part. In the 'Adam Plug' project, for example, each story row of @Frammenti_Plug profile is composed of a first picture introducing the topic; a second clip developing the main content; and a third picture deepening the connection (geographical or relational) with the neighbourhood.

Finally, *representation* draws on visual culture and the capability of design to translate imagery and values of the community of users to shape and trigger the imagination of the audience. In the 'Adam Plug' project, the story sequences are enhanced by graphic frames, which make the Instagram square photos appear as though they are made from rectangular modules, reminiscent of the traditional storyboard and making the picture format far more similar to the 16:9 aspect ratio typical used by cinema as well as by some mobile screens. In 'Guardiani della 9', the 8-bit style of graphics and animated gifs bridges visual rhetoric from the past to a possible image of the future that everybody can recognise as both familiar and unexpected.

Reframing the fragments within a spatial-temporal [23, 29] organisation activates a dialectic meaning-making process, which is open to continuous interactions. Reassembling fragments according to social media structures requires the user to convert in further meanings what is there merely as potentiality. The outputs of the workshop demonstrate that this kind of interaction and relationship with the users does not require bringing out the authenticity of the materials. Both projects examined in this paper relate to profiles that are not pretending to be those of real people, even though they are named as the main characters and the point of view of the narration is delivered in the first person. It is not necessary to produce an impression of reality. Fictional stories are built from fragments of the real world (the neighbourhood and the local community involved in the very first phase of the fieldwork), but the imaginary narrative worlds developed through a participatory process have the power to trigger illusion [11] and magic [26] out of ordinary life. The workshop then, as already mentioned, developed the phases of craftwork and creation, shaping stories as parts of a whole shared vision. Young designers are authors of the stories building representations of others' life tales. They were not involved in the fieldwork phase with the citizens and members of local associations: other groups of students collected stories and images, and designed Plug Social TV channel and transmedia strategies. We documented those events in order to have them as part of the archive we provided to the people involved in the 'Micro Narratives' workshop. They practised meaning-making processes as tailor-made [11] stories, a custom produced mash-up which is community-centred, more than aiming at personalising the interaction experience.

Taking iconographic and video material and providing them to groups of young designers in order to build new stories from fragments, is intended as a way of socialising that archive, coming from a remix culture and practice. On the one hand, students produced brand new narrative sequences, editing footage and archive material

according to a specific plot that is orienting the transformative arc of the story itself. In this case, it is necessary to include or refer to specific characters, archetypes and narrative elements, which come from or belong to the story world. In other words, the footage archive is edited according to a narrative world that is already provided: there is the possibility to use a series of permanent features and quotes, to reinterpret the world as it is or to propose, extend or reflect upon it. On the other hand, they built a new semantic universe, which is made by a visual analysis of the footage material, giving it a formal flow and looking for a new rhythm. The process itself of using, re-using images and sharing contents can be considered as the main goal of a collaborative and expressive approach[3].

To conclude, these micro narratives on social media are designed as short formats, but they are constantly referring to a story world in order to let the audience follow the different stories (backstories, spin off, etc.) across media and in the real environment, discovering touchpoints with the fictional world. Many scholars have discussed the geography of narrative as typical of cyberspace: the model of the rhizome [10] avoids order and logics of stories typical of modern times [11, 33]. Multi-strand, series and episodic format offer alternative choices: the 'Adam Plug' project, for example, is based on the format of thematic sequences or blocks of contents; the epistolary novel on Twitter ('I Guardiani della 9') introduces a serial development. Nowadays narrative is based on different logics that don't make the plot proceed directly from the beginning to the end. Even though the set of tools we provided to the design students suggests the typical three act paradigm [13], the development of conflicts represents the very key element that enables designers to keep the story open and the audience to keep on following social media profiles and stories. It is not required that conflicts would be solved: social media fiction as a form of contemporary narrative is based on audience engagement rather than on the character's transformation and conflict resolution, enhancing the creation of a virtuous circle of actual needs and future perspectives of the community.

Thus far we have focused on the design aspect of micro narratives; a further step in our research is represented by the assessment of user engagement supporting the quantitative metrics from social media with the audience's response to qualities we previously described. All the projects were designed to be experienced regardless of position, because "the engagement with the text or the story progression has not been dependent on the viewer's geographic location" [3]. Accessing stories on social media and personal devices, on the one hand, enables users to go in and out of the narrative world and, on the other hand, makes the story world ubiquitous and pervasive. Social media then allows users to share the stories both online and offline, facilitating relationships within the local community and fostering partnerships among stakeholders. The design idea of the exhibition, which will provide the opportunity for the evaluation of the project, is meant to circulate the stories across the local area, having shops and cafés as locations and touch-points to the narrative world, and involving members of the community as partners considering participation as an open-ended process.

[3] Footage films have been based on these kinds of approaches, even before the opportunities introduced by digital technologies. See for example the film by Alberto Grifi and Gianfranco Baruchello "Verifica incerta" ("Disperse Exclamatory Phase", 35', color, 35 mm, Italy, 1965).

References

1. Anzoise, V., Piredda, F., Venditti, S.: Design narratives and social narratives for community empowerment. In: Coletta, C., Colombo, S., Magaudda, P., Mattozzi, A., Parolin, L.L., Rampino, L. (eds.) Proceedings of 5th STS Italia Conference. A Matter of Design: Making Society through Science and Technology, pp. 935–950. Politecnico di Milano, STS Italia Publishing, Milan (2014)
2. Ariel, Y., Avidar, R.: Information, interactivity, and social media. Atlantic J. Commun. **23** (1), 19–30 (2015)
3. Atkinson, S.: Beyond the Screen. Emerging Cinema and Engaging Audiences. Bloomsbury Academic, London (2014)
4. Bertolotti, E., Daam, H., Piredda, F., Tassinari, V.: The Pearl Diver: The Designer as Storyteller. DESIS Network, Milan (forthcoming)
5. Bolter, J.D., Grusin, R.: Remediation. Understanding New Media. The MIT Press, Cambridge (1998)
6. Boyd, D., Ellison, N.: Social network sites: definition, history, and scholarship. J. Comput. Mediated Commun. **13**(1), 210–230 (2008)
7. Castells, M.: The Internet Galaxy. Reflections on the Internet, Business, and Society. Oxford University Press, Oxford (2001)
8. Ciancia, M., Piredda, F., Venditti, S.: Shaping and sharing imagination: designers and the transformative power of stories. In: Moura, H., Sternberg, R., Cunha, R., Queiroz, C., Zeilinger, M. (eds.) Proceedings of the Interactive Narratives, New Media & Social Engagement International Conference, pp. 37–46. University of Toronto, Canada (2014)
9. De Certeau, M.: The Practice of Everyday Life. University of California Press, Berkeley (1984)
10. Deleuze, G., Guattari, F.: Anti-Oedipus. Athlone Press, London (1984)
11. Di Chio, F.: L'illusione difficile. Cinema e serie tv nell'età della disillusione. Bompiani, Milan (2011)
12. Dowd, T., Fry, M., Niederman, M., Steiff, J.: Storytelling Across Worlds. Focal Press/Taylor & Francis Group, New York/London (2013)
13. Field, S.: Screenplay: The Foundations of Screenwriting. Delta Trade Paperbacks, New York (2005)
14. Friedberg, A.: Window Shopping: Cinema and the Postmodern. University of California Press, Berkeley (1993)
15. Galbiati M., Piredda, F., Mattana, W., Bertolotti, E.: Envisioning the city: a design-oriented communication process for a sustainable urban transformation. In: Proceedings of ESA Research Network Sociology of Culture Midterm Conference: Culture and the Making of Worlds, Milan, Italy (2010). http://ssrn.com/abstract=1692118. Accessed September 2015
16. Hartley, J., McWilliam, K. (eds.): Story Circle: Digital Storytelling around the World. Wiley-Blackwell, Oxford (2009)
17. Jenkins, H.: Convergence Culture: Where Old and New Media Collide. New York University Press, New York (2006)
18. Jenkins, H., Ford, S., Green, J.: Spreadable Media: Creating Value and Meaning in a Networked Culture. New York University Press, New York (2013)
19. Kaplan, A.M., Haenlein, M.: Users of the world, unite! The challenges and opportunities of social media. Bus. Horiz. **53**(1), 59–68 (2009)
20. Klastrup, L., Tosca, S.: Transmedial worlds-rethinking cyberworld design. In: Proceedings of the 2004 International Conference on Cyberworlds. IEEEE Computer Society, Los Alamitos, CA (2004)

21. Lambert, J.: Digital Storytelling. Capturing Lives, Creating Community, 4th edn. Routledge, New York (2013)
22. Lessig, L.: Remix: Making Art and Commerce Thrive in the Hybrid Economy. Penguin Press, New York (2008)
23. Manovich, L.: The Language of New Media. MIT Press, Cambridge (2001)
24. Manovich, L.: Software Takes Command. Bloomsbury Academic, New York (2013)
25. Marks, D.: Inside Story: The Power of the Transformational Arc. Three Mountain Press, Los Angeles (2006)
26. Morin, E.: Il cinema o l'uomo immaginario. Feltrinelli, Milan (1982)
27. O'Reilly, T.: What Is Web 2.0. Design Patterns and Business Models for the Next Generation of Software (2005). http://www.oreilly.com/pub/a/web2/archive/what-is-web-20.html. Accessed September 2015
28. Packer, R., Jordan, K. (eds.): Multimedia: From Wagner to Virtual Reality. W. W. Norton, New York (2001)
29. Perlmutter, T.: The interactive documentary: a transformative art form (2014). http://policyoptions.irpp.org/issues/policyflix/perlmutter/. Accessed July 2015
30. Pinardi, D., De Angeli, P.: Il mondo narrativo. Come costruire e come presentare l'ambiente e i personaggi di una storia. Lindau, Turin (2006)
31. Ryan, M.L.: Narrative Across Media: The Language of Storytelling. University of Nebraska Press, Lincoln (2004)
32. Vogler, C.: The Writer's Journey: Mythic Structure For Writers, 3rd edn. Michael Wiese Productions, Studio City (2007)
33. Žižek, S.: Interrogating the Real. Continuum International Publishing Group, London (2005)

Film Education for Primary-School Students

Interactive Storytelling as an Educational Approach to Raise Awareness of Design Structures in Feature Films

Regina Friess[(⊠)], Anke Blessing, Johannes Winter, Meike Zöckler,
Felix Eckerle, Felix Prosch, and Philip Gondek

Department of Digital Media, University of Furtwangen, Furtwangen, Germany
{regina.friess,a.blessing,meike.zoeckler,
felix.eckerle,felix.prosch,
philip.gondek}@hs-furtwangen.de,
expdub@googlemail.com

Abstract. As students are consuming video content to a high degree without parental or other forms of guidance, we want to develop an interactive learning environment that supports media literacy with respect to video design. We argue that the reflection of design components and aesthetical structures are relevant also for younger students. In order to foster the perception of formal structures and raise awareness of different design qualities, we consider a pragmatic approach. This approach encourages experimental exploration and creative activities. We pursue a concept of gamification, which enables playful participation based on the freedom of exploration. It is assumed that a playful activity involving film design components as variable structures can enhance an aesthetic and therefore more abstract perception of the presented film plots. The core concept behind the educational application is built upon an interactive storytelling tool, which allows the creation of different variations of the same story.

Keywords: Gamification · Interactive storytelling · Pragmatic didactics · Aesthetic education · Film design

1 Media Literacy and Film Education in Primary Schools in Germany – The Current Situation

As an overview of the approaches to media literacy education in Germany [18] states, there has been a shift from a protectionist perspective to a more action-oriented didactics focusing on meaningful interaction with media. Nevertheless, the authors formulate the problem that children "do not reach self-selection and evaluation of media" and demand concepts that foster "a judicious and aesthetic literate recipient" [18]. Our project tries to take a step towards meeting this objective by means of interactive storytelling.

As a recent report on media integration in primary school states, the impact of media usage in everyday lives is not adequately reflected by school teachers in primary schools [10]. They do not have sufficient concepts to provide education for a responsible usage and reflection of media consumption. They often tend to establish

© Springer International Publishing Switzerland 2015
H. Schoenau-Fog et al. (Eds.): ICIDS 2015, LNCS 9445, pp. 321–328, 2015.
DOI: 10.1007/978-3-319-27036-4_30

schools as protected areas in which only little and if so, only so-called "valuable media" are presented and discussed [10].

Based on theoretical reflections on the interdependencies of media consumption and processes of identity construction, we assume that the competence of aesthetical reflection of media design can be a valuable component of media literacy even for younger students. Therefore, we focus in our project on the ability to differentiate basic structures of narrative composition in film design and reflect their influence on the story and its interpretation.

2 Theoretical Reflections

2.1 Media Consumption and Identity Construction – the Value of Aesthetic Education

In an increasingly media-driven society, processes of identity formation are increasingly related to an individual's media consumption and his or her social embedding. According to Mikos [11], from the 1950s up until now, mass media, especially television as a central player, gives us the platform to find our way into society. It presents us with a variety of possible life paths and role models, and helps us to reflect our attitudes to norms and values [11]. This in turn, results in the increase of media consumption which plays a central role in our social integration. Furthermore, mediated reality construction gets increasingly self-referential and builds a parallel layer of mediated reality, detached from unmediated interaction and perception processes [11]. A consequence of the increasing detachment and seclusion of mediated communication is that community is built less on common interests or qualities in real life but more on internal structures of the communication process itself (see also Krotz [9]). Aesthetic dimensions then build a crucial element of the shared media experiences and mediated lifestyle concepts [11]. Taking this into account seems necessary to foster aesthetic education within the field of media literacy. Aesthetic experience is understood, with reference to Hans Robert Jauß' aesthetic theory and John Dewey's pragmatic perspective, as a productive and creative process. The focus lies on qualitative aspects of the individual's interaction with the environment and implies a distanced perspective on situations (see Jauß [5]).

2.2 Pragmatic Didactics and Interactive Storytelling as a Pedagogical Concept

In pragmatic philosophy, as established by Dewey and George Herbert Mead (see Joas [6]), the capacity to make and reflect experiences plays a central role for social interaction and human cognition. Experiences (especially based on unexpected course of action processes) lead a person to reflect and anticipate future situations in order to be prepared for possible situations by developing models of possible actions. As Joas [6] states, action is not seen as a goal-driven process with a linear course in the first

place but as a process, which always includes some kind of ambiguity and therefore embeds the creativity of free choice.

Conveying these thoughts on didactic concepts, and especially conducted with e-Learning then means to focus on experiences in learning environments. As Kerres and Witt [7] reflect on pragmatic didactics, they claim that experience has to come before cognition as long as the experience is meaningful for the learners. They state three main components of a pragmatic approach for eLearning environments: a content component which lays ground for cognitive and also emotional activities in learning situations, a constructive component allowing the user to undergo learning activities leading to material results, and a communicative component which structures the communicative exchange between learners and learners, and learners and teachers [7].

2.3 Play and Playful Experiences in an Interactive Storytelling Environment as Basis for Structural Perception

As already stated, pragmatism focuses on the process of experience making within activities which are not mainly goal oriented. Joas [6] argues that the concept of assumed freedom allows for playful variations. Following this idea of play as a freedom of choice, we refer to the concept of play as a mental framework and not primary as an activity. Ohler and Nieding [12] discuss a theory of playful cognition, which in contrast to narrative concepts encourages human beings to develop variations. Whereas narrative frameworks focus on the one most probable causality, a playful modelling allows for flexible reactions in unpredictable situations (see Friess [3]). To be able to develop variations, people need to transfer phenomenological perception to more abstract models. According to Klaus [8] the ability to abstract from direct perception, and build models is one of the core components of play as well as the basis for human evolution. Sutton-Smith's [16] theory of play describes the process of developing variations and abstractions as fascinating and an involving component of play. Considering this, we assume an interaction between playful activities within a media environment and the possibility to foster the awareness for aesthetic structures.

Based on these thoughts, our concept of interactive story-tools allows a playful construction with many ways to tell the same story. We assume, that experimenting with film design components within a given situation, enhances the possibility to step beyond the primary story level and foster the cognition of design structures on a more abstract level. We have composed a two-fold environment consisting of an introductory learning segment and an experimental segment within the interactive story-module. Additionally, the pedagogical concept includes communicating, showing and reflecting the results together with the teacher and the students. The introductory segment provides an illustration of the core concepts of film design, which enables the student to make decisions (rather than random choices) in the experimental segment. As there are no concrete tasks to fulfill and no wrong decisions, these decisions aim at an experimental construction.

2.4 Educational Objective: Exemplary Teaching of Core Components of Film Design

Based on cognitive film theory of Branigan [2] and Bordwell [1] as well as the anthropological perspective of Smith [15] and Tan [17] we see three core components for film design: the character as human agent, the narration as structural link between story and recipient, and the audiovisual design of the movie as layer linking the narrative and aesthetic experience.

Within the small-scaled student project, we do not intend to reach an extensive teaching of film design, but to teach an exemplary awareness of the design possibilities by demonstrating opposing design options in each of the three basic design categories (explained below).

Human Agents. According to Smith and Bordwell, narrative perception is an anthropological pattern and not primarily a cultural convention, both intervene with each other. Bordwell [1] argues that film perception refers to a high degree on our schematic knowledge build in day-to-day perception. In addition, Smith [15] states that narrative perception is a general anthropological concept that constructs consequences and causalities and therefore helps us to understand social interactions. Furthermore, he states a reciprocal influence between narrative understanding in real-live perception and cultural knowledge, and schemes built by consuming narrative media. Smith therefore argues for a mimetic concept of film perception. In his view the human agent builds the core concept for an imaginative and empathetic comprehension of the represented situations and a simulative experience of social interaction (see also Tan [17]). The understanding of intentions and possible actions of human agents is a basic component of narrative perception in this perspective. He lays the ground for empathetic or simulative perceptions of narrated situations (see also Tan [17]). Therefore, the character and design of characters is a key concept for the design of film narration.

Narrative Comprehension. The construction of narrative continuity is to a large degree based on top-down cognition [2]. Also, it is interplay between declarative and procedural knowledge. Narrative perception is based on the analysis of what happens in the story itself and how the story is told. We do have a schematic knowledge of basic components of narrative structures, based on which we build expectations and try to analyze the form of narration as well as the narrated content [2]. Within this procedural perception of narration, knowledge restriction is a core concept of fiction films: for instance, the spectator does not necessarily know what the characters know and what the narrator knows, and in which way the narrator restricts knowledge [2]. The classical difference between suspense and surprise as explained by Alfred Hitchcock is exemplary for this concept and therefore integrated in our story-tool.

Artwork and Film Editing. The cognitive approach to film perception by Branigan and Bordwell assumes that film perception is to a high degree a procedural activity of formulating hypotheses on what might happen or why things happened. They argue for a top-down oriented process in which the audiovisual input gives us the access to use our schematic knowledge. Branigan [2] also points out the natural mapping of the third-person perspective. The observing camera corresponds to our mental image, that

we create of our actual situation and which seems natural and direct. Film perception therefore creates a direct physical experience of movement, space and physical expressions. Branigan refers to this quality of film perception as "salience" [2]. Grodal [4] also points out, watching films always contains a direct impulse of senso-motoric reaction to what we see.

Therefore, our third component refers to different ways of audiovisual representation of action and social situations. We oppose an editing design, which focuses on movement in space. We instead propose an editing, which stages the emotional involvement of the protagonists and concentrates on the mimetic expressions of the protagonists.

2.5 Empirical Research on the Reception of Interactive Film

There is little knowledge about the interdependency of interactive storytelling and aesthetic perception of audiovisual media and film especially. Roth et al. [14] developed a multidimensional model to explore the specific user experience of interactive storytelling, which includes aesthetic pleasantness. In a follow-up survey [13] comparing the experience of "Fahrenheit" with "Façade," the interactive versions showed little impact on aesthetic appreciation but without clear patterns. Also the scope of the survey was aiming at dimensions of enjoyment and pleasantness, and did not question the extent of aesthetic reflection.

Based on previous research on the reception of interactive film [3] we assume that already little interactivity can foster the reflection and discussion of the character's motivations and activities as well as the course of the story. The survey [3] showed that recipients of an interactive version (with only three decision points) were involved in the reflection of the story to a higher degree than those of the linear film.

3 Conceptual Approach for an Interactive Media Environment

As mentioned above, the learning environment consists of a learning module and an experimental module. The learning module provides exemplary knowledge on film design as the basis for an experimental module. The experimental module allows the students to combine different film design components within a given short movie. In order to provide situated learning, the subject of film design is presented in a narrative framework within the learning module. One example would be two friends discussing possible ways to stage a short film based on a given story. The narrative context is used to give the students necessary information on design possibilities, allowing them to make decisions in the later experimental segment.

The content component sets the basis for participation by cognitive comprehension and emotional involvement. It is mainly present in the learning module, and embedded in the narrative framework and the exemplification of design options.

The constructive component can be found in the experimental module to lay ground for an intrinsically motivated learning by experience. With the knowledge obtained in the

learning module, the students can choose between two different options at certain points of the experimental module, thus experiencing their influence on the movie's impact.

The communicative component is integrated into a blended learning situation during class. This means that a teacher introduces the informational portion, and more importantly, that the student can show and discuss their final versions of the short film within the class discussion.

The project is realized at Furtwangen University and supported by the Institute for Media and Communication of Baden-Württemberg. The prototype was finished in June 2015 and evaluated with primary-school students in July 2015.

The following chapters give a brief overview of the main contents of the prototype's two core modules based on the former discussed theoretical fundamentals and concepts.

3.1 The Propaedeutic Learning Module

The learning module consists of three separate chapters: character, audio-visual design, and dramaturgy. An introduction sequence establishes a conflict, in order to set up a situational context which confronts the students with a design problem: The young protagonists Emma and Paul want to shoot a film based on a fairy tale and are discussing different design options. Each of them prefers something different, e.g. the main character being gentle or really tough. The narrative context is used to give the students the necessary information on design possibilities, which allows them to make decisions in the later experimental segment. Based on the discussion of Emma and Paul, some fundamental terms of film design are taught. After that, the protagonists present each of their favored design options. These short film sequences are then presented in two extremes.

3.2 The Interactive Story Module in the Experimental Segment

The experimental segment enables students to make decisions between the three covered subjects: character development, suspense, and audio-visual design in a story. Students can choose between two design options in each of these subjects at certain points within the plot. The story focuses on the relations and friendship between the characters, which makes it attractive for both genders in the target group. Students using the educational application are able to empathize with the characters and to understand the situation.

In the experimental segment, the principle of experience is important, as well as the principle of motivated action which is caused by a problem in a situational context: Through a narrative framework – the educational application is guided by a boy and a girl, who have different opinions about the possibilities for structuring a film – our concept tries to embed this problem, as well as the accordingly guided explanations regarding the changes in structure.

The Story of the Short Film: The film tells the story of a group of girls who apply for a dance competition. It is mandatory for each participating dance group to include at

least one boy, and every group has to hand in their own dance video. One of the girls, Laura, finds out that Julian from her class is a good dancer, and successfully encourages him to join the group. Julian is new in class and the others do not know that he has serious money problems. Right before the group begins to shoot the necessary video, Julian steals Laura's bag. As she sees this happening, Laura chases after him, slips and falls. Julian, who sees that Laura is in pain, gets a bad conscience and comes to help her. The rest of the group is mad at Julian, but Laura tells the girls to calm down, since it should be appreciated that he eventually did the right thing and tried to help. Thus, the group can finally finish the video and succeeds in the contest.

The Interactive Part: At the beginning of the experimental segment, students decide between two main characters who are the complete opposite of each other: A cool guy who doesn't really care about other people, and a friendly boy who enjoys helping other people. Right before the climax, students decide whether they want to create a suspenseful or a surprising scene. The suspenseful version shows Julian observing Laura closely while she's opening and using her wallet, thus making the students assume that he's going to steal from her. The other version doesn't reveal this information and surprises the viewer with Julian's robbery. Before the chasing scene starts, the students are able to decide between different audio-visual designs. The same story is told, with variations in audio design and film editing. Whereas one version is dynamic and exciting, with fast cuts and exciting sounds, the other choice shows a comic version of the chase.

Embedded Learning: The learning environment is designed for an embedded use in the class. The teacher introduces the learning module and guides the students through the different sections. After that, the students can construct their own short film versions alone or in groups within the experimental module. They then present and discuss their results in class. It is expected, that the reflection on design components is fostered by comparing the different versions and discussing the impact on the appeal of the story.

4 Results and Conclusion

In summary, our project aims at teaching a basic understanding of film design components on the basis of gaining experiences within an experimental learning environment. We assume that experimental and therefore playful decisions enhance a more structural and aesthetic perception of a given narrative short film. This in turn, allows the students to reflect on design components.

The first prototype of the learning platform was finished in July and there was only little time left before school holidays. We conducted a brief evaluation focused on the usability and acceptance of the story-modules. There were some obvious changes necessary concerning the labeling and the guidance within the learning module. Also the fairy tale stories would need to be revised in order to convey the intended differences in film design, but within the project's means, that cannot be realized. The children's motivation to use the experimental module and discuss the results was quite high.

References

1. Bordwell, D.: Making Meaning: Inference and Rhetoric in the Interpretation of Cinema. Harvard University Press, Cambridge (1996)
2. Branigan, E.: Narrative Comprehension and Film. Routledge, London, New York (1998)
3. Friess, R.: Narrative Versus Spielerische Rezeption? Eine Fallstudie zum interaktiven Film. VS Verlag, Wiesbaden (2012)
4. Grodal, T.: Moving Pictures: a New Theory of Film Genres, Feelings and Cognition. Clarendon Press, Oxford (1997)
5. Jauß, H.: Ästhetische Erfahrung und literarische Hermeneutik. Suhrkamp, Frankfurt a.M (1997)
6. Joas, H.: Symbolischer Interaktionismus. Kölner Zeitschrift für Soziologie und Sozialpsychologie **49**, 417–446 (1988)
7. Kerres, M., Witt, C.: Quo vadis Mediendidaktik? Zur Theoretischen Fundierung von Mediendidaktik. MedienPädagogik **6**, 1–22 (2002)
8. Klaus, G.: Spieltheorie in Philosophischer Sicht. VEB Berlin, Berlin (1968)
9. Krotz, F.: Elektronisch mediatisierte Kommunikation: Überlegungen zur Konzeption einiger zukünftiger Forschungsfelder der Kommunikationswissenschaft. Rundfunk und Fernsehen **4**, 447–462 (1995)
10. Landesanstalt für Medien Nordrhein-Westfalen: Medienintegration in der Grundschule: Untersuchung zur Förderung von Medienkompetenz und der unterrichtlichen Mediennutzung in Grundschulen sowie ihrer Rahmenbedingungen in Nordrhein-Westfalen (2013). http://www.lfm-nrw.de/fileadmin/lfm-nrw/Forschung/Kurzfassung_Studie_73.pdf
11. Mikos, L., et al.: Im Auge der Kamera: Das Fernsehereignis Big Brother. Vistas, Berlin (2000)
12. Ohler, P., Nieding, G.: Antizipation und Spieltätigkeit bei der Rezeption narrativer Filme. Beiträge zur Film- und Fernsehwissenschaft **60**(42), 13–30 (2001)
13. Roth, C., et al.: The experience of interactive storytelling: comparing "Fahrenheit" with "Façade". In: 10th International Conference, ICEC 2011, Vancouver, Canada, Proceedings, 5–8 Oct 2011. http://www.researchgate.net/publication/220851315_The_Experience_of_Interactive_Storytelling_Comparing_Fahrenheit_with_Faade
14. Roth, C., Vorderer, P., Klimmt, C.: The motivational appeal of interactive storytelling. In: Iurgel, I.A., Zagalo, N., Petta, P. (eds.) Interactive Storytelling: Towards a Dimensional Model of the User Experience, pp. 38–43. Springer, Berlin (2009)
15. Smith, M.: Engaging Characters: Fiction, Emotion and the Cinema. Clarendon Press, Oxford (1995)
16. Sutton-Smith, B.: Die Dialektik des Spiels. Karl Hofmann Verlag, Schorndorf (1972)
17. Tan, E.: Emotion and the Structure of Narrative Nilm Nilm as an Emotion Machine. Lawrence Erlbaum Associates, New Jersey (1996)
18. Tulodziecki, G., Grafe, S.: Approaches to learning with media and media literacy education: trends and current situation in Germany. J. Media Literacy Educ. 44–60 (2012)
19. Zubayr, C., Gerhard, H.: Tendenzen im Zuschauerverhalten. Media Perspektiven **3**, 110–125 (2015). http://www.media-perspektiven.de

Enabling Instrumental Interaction Through Electronics Making: Effects on Children's Storytelling

Sharon Lynn Chu$^{(\boxtimes)}$, Francis Quek, Michael Saenz,
Sourabh Bhangaonkar, and Osazuwa Okundaye

Department of Visualization, Texas A&M University, College Station, TX, USA
{sharilyn,quek,michaelsaenz,
sourabh_bhangaonkar,awuzaso}@tamu.edu

Abstract. The electronics Making phenomenon, spearheaded by the introduction of open source microprocessors and 3D printers, has been quickly infiltrating into children's domains, but how Making interacts with storytelling has not been addressed. This paper achieves the following: it proposes the argument of instrumental interaction for Making-based storytelling, it details a custom Maker kit that integrates Making with storytelling, and it presents a study that investigates the effects of electronics Making-based storytelling on the semantics of children's puppet stories. Analysis results showed that the LED instrumental interaction contributes significantly to the children's story meanings.

Keywords: Storytelling · Making · Authoring · Children · Interactivity · Maker Theater

1 Introduction

Of concern to us in this paper is the role that interactivity achieved through physical Making may have on children's digital storytelling. Authoring tools proposed to support the process of children's story creation may be grounded in direct interaction with graphical user interfaces, pen-based interfaces, or embodied means. Recent research has resulted in the development of electronics-based physical Making kits, such as the LittleBits kit [1], that are may be used in children's workshops, camps and in the classroom. We explore how such Making may expand the vistas of authorial interactivity in children's storytelling. We focus on two gaps in current research: (i) Few of the existing Making kits for children intrinsically integrate storytelling as a purpose, and (ii) little is known about the specific impact of coupling storytelling and Making, e.g., whether and how Making-based methods may enrich children's stories. Specifically, (i) how may Making and storytelling be integrated in a kit design, and (ii) what effects would Making-based methods produce on children's storytelling?

In this paper we describe a custom Making kit, the *Maker Theater*, that integrates storytelling into its very structure by enabling children to create 'lighted stories', and we report on results about how such Making, centered on the expressive possibilities of the LED, affects elementary-school aged children's puppet storytelling using such an

© Springer International Publishing Switzerland 2015
H. Schoenau-Fog et al. (Eds.): ICIDS 2015, LNCS 9445, pp. 329–337, 2015.
DOI: 10.1007/978-3-319-27036-4_31

integrated kit. Following, we will discuss the Making movement, how it has been used with storytelling for children in prior research, and how and why Making may augment interactive potential in the story authoring process. We then present an overview of the Maker Theater, and describe its use in three cycles of workshop studies with children. The paper concludes by presenting results of analyses of how children used the LED to influence their stories, followed by a discussion of the findings.

2 Making-Based Storytelling for Children

2.1 The Making Phenomenon and Storytelling

The Maker or Making phenomenon can be defined as a "growing community of hob-byists and professionals dedicated to making their own functional devices, whether it be technological gadgets, open source hardware and software, fashion apparel, home decorating, or nearly any other aspect of physical life" [2]. We define Making in our research to be *the hands-on production of artifacts that are technologically-enhanced*. Technologies involved typically include electronics, 3D modeling and printing, robotics or sensor programming. Technological advancements have made it possible to develop kits that facilitate Making for novices, essentially enabling production by broader populations. Such popular physical Making kits are LittleBits [1], Circuit Stickers [3], the Arduino [4], and Makey Makey [5]. Some of these kits have been used as authoring tools to support storytelling-related activities. The Robot Diaries project [6] introduces middle school students to Making materials (e.g., motors, basic circuits, servos, the humming-bird microprocessor) to create a customizable robot. The level of control made possible in the design caused students to create backstories about their robots. The TOTA project [7] immerses children in a science fiction narrative of a dystopian world in which children must create their own toys and robots with homemade materials and electronics.

StoryClip [8] is an example of a project that integrates storytelling as a purpose of Making by allowing children to make interactive stories by turning drawings into a playback interface. Children create storyboard drawings, parts of which they can link to a microcontroller using conductive ink. They can then touch the conductive ink parts of the drawing to have recorded audio play back to them. In the Power Puppet project [9], 8th graders created origami and cloth puppets that can be embedded with an LED. However, the project focused on the creation of the puppets, and not on the narrative possibilities that may be created with them. In fact, the majority of Making research involving storytelling emphasize technology or kit design, and offer little insight from careful analysis of the effects of electronics Making on the stories told.

3 Authorial Interactivity Through Making

Approaches that utilize Making for children's storytelling stand in contrast to story authoring interfaces that are screen-bound, such as Wayang Authoring [10] and ToonTastic [11] that allow children to drag and drop story elements (characters,

settings, etc.) onto a 'stage-like' screen space for story recording. Making-based storytelling relates more closely to explicitly hands-on, embodied approaches like DiME (using full body enactment) [12] and the Reading Glove (through manipulation of various physical artifacts) [13], in which the user creates a story through performance.

We posit that the technology in Making methods may produce richer stories by augmenting the level of interactivity and expressivity over traditional performance-based storytelling such as puppetry. We define interactivity broadly as the *characteristic of offering a certain amount of control and freedom over the focus object*, which in our case is the story meaning or dynamic expression [14]. Research is needed to understand the appropriate level of interactivity that will scaffold the children's story creation process at their stage of cognitive development and empower them to feel engaged in the creative process and to enrich their stories.

Making adds a dimension to authorial interactivity over traditional forms of physical storytelling (e.g., puppetry) by allowing the child to (i) produce his or her own story artifacts, and to (ii) infuse it with a level expressivity through technology. Compared to traditional puppets, technologically-enhanced story artifacts produced using Making methods may enable story authoring through 'remote or distal control'. Beaudoin-Lafon [15] proposed a similar concept termed 'instrumental interaction for the design of user interfaces where a focus object is controlled through another instrument or tool. In Making, such interaction may be achieved by building a story artifact fitted with a vibrating motor that is triggered using a sensor, or a sound emitter controlled by a dial. We exclude both purely mechanically controlled storytelling, that are not enhanced through some sort of electronics or programming, and premade storytelling means (e.g., with toys) that do not necessitate any hands-on production.

4 The Maker Theater

We developed a custom Making kit that would allow us to investigate Making-based storytelling with elementary school-aged children through which children may tell a 'lighted story' through a recorded puppetry show. The kit makes use of a very basic level of electronics Making together with arts-and-craft to enable simple instrumental interaction of lighting up an LED through a switch. Children construct a basic circuit comprising a paper switch, a battery, a resistor, and an LED. They are able to create

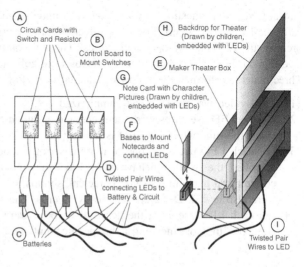

Fig. 1. General schematic of the Maker Theater kit

story elements (e.g., characters, backgrounds) adorned with distally controlled LEDs. Figure 1 illustrates the overall construction of the Maker Theater. More details about the functioning of the kit can be found in [16].

5 Workshop Studies

5.1 Study Description

We conducted a total of 6 workshops in 3 cycles over 2.5 years using versions of the Maker Theater kit with children aged 8 to 11. Although the design of the Maker Theater was improved for usability and manufacturability, the core concept and design centered on the LED electronic circuit remained constant. For cycles I and II, recruitment flyers were sent to university listservs. The workshops lasted around 3 to 4 h, and took place in large studio or lab spaces. Cycle III workshops took place over 5 days in an elementary school, in 3-h sessions each day. Recruitment was done by the coordinator at a local summer camp. Some children attended all the 5 days, while some came for fewer days. For all the workshops, parents who expressed interest to register their child received a study information sheet and a consent form to be signed and returned prior to the workshop. The children worked in teams of two or three. The protocol of the workshops was generally as follows: (i) The children were paired or grouped; (ii) They were introduced to the components of the Maker Theater; (iii) They created one or two lighted characters with assistance, and posed for a picture with their lighted characters; (iv) A 10-mins break time was given; (v) The children were given a story or a story prompt; (vi) They created a lighted story using the Maker Theater; (vii) The recorded stories were shown to the whole group on a large display.

5.2 Data Collection and Analysis

Our core research question in this paper is to understand how Making, more specifically the LED distal interaction, may affect children's storytelling. How did the children use the LEDs to augment their stories? The story output was in the form of videos (see Fig. 2). In total, 51 lighted story videos were collected across all the workshops. Three coders performed the following qualitative coding process on the videos:

(1) Each video was viewed, and summarized;
(2) All the LED use cases were identified and assigned a case ID – an LED use case spans the time when the LED is lighted;
(3) For each LED use case, one or more descriptive codes were assigned that characterized the explicit behaviors or ways that the LED lit up. Other types of co-temporal happenings (wrt characters, sounds, etc.) with the LED use episode were also coded. Descriptive codes were cross-checked among the 3 coders;
(4) For each LED use case, the descriptive codes were analyzed with regard to the context of the story meaning at the specific point of the plot, and an interpretive code

Fig. 2. Screenshots from the children's story videos

was assigned. For instance, a case tagged with a pair of 'Descriptive-Co-temporal happening' codes (Fast random blinking, Sound effects) could be assigned an interpretive code of 'Superpower' indicating the use of the LED to signify laser beams. If the LED was left on for the entirely story, the case was coded as 'unknown', as it was not possible to determine the exact significance of the light. These 'unknown' cases were discarded in later analyses. The 3 coders cross-checked each others' interpretive codes. When coding conflicts or disagreements arose, the case was either resolved through discussion, or discarded if no agreement could be reached. In total, 168 conflicts arose; 167 were resolved, and 1 case was discarded;

(5) All interpretive codes generated were analyzed to produce a set of categories. The 3 coders then conducted a third level of category coding to assigned a category to each LED use case. For example, an LED blink that was tagged with an interpretive code of 'Accessory' or as signifying 'Superpower' would categorized as being symbols. An LED blink that was interpreted as signifying an 'Object quality' would be coded as being a 'Qualifier'. Table 2 shows the codes that emerged;

(6) A final analysis was performed to see whether the LED instrumental control resulted in richer stories. For each LED use case, it was evaluated on how its interpretive code related to the semantic interpretation of any other co-temporal happening(s). Based on the evaluation, the LED use case was assigned one of these 3 labels: (*i*) *Complementary* – LED use conveys complementary but different meaning than other co-temporal happenings; (*ii*) *Reinforcing* – LED use has the same or similar meaning to one or more of the co-temporal happenings; (*iii*) *Distinctive* – LED use was not accompanied by any co-temporal happenings, and thus conveyed a unique meaning.

6 Results

A total of 1 h 20 min of video was analyzed in-depth (51 story videos averaging 1.75 min each). 696 of the 697 LED use cases identified were analysed after intercoder agreement. The list of descriptive, co-temporal happenings, interpretive and category codes obtained from the data are listed in Tables 1 and 2. Figure 3A – D show histograms of the frequency percentage occurrences of each LED use's codes, and co-temporal happenings.

A chi-square test showed a significant relationship between the Level 1 descriptive codes of the LED behaviors and the Level 2 interpretive codes in the story context, (X^2 (40, n = 762) = 151.02, p < .005). Through a close examination of the chi-square contingency tables, the interpretive codes to which each LED descriptive code was most likely to be associated were identified: 'Fast random blinking' & 'Slow random blinking' with 'Character speech' and 'Object quality'; 'Constantly on' and 'Single blink' with 'Spotlight'; and, 'Timed blinking' with 'Story point'. 49 % of the use cases were categorized as complementary, 37.7 % as reinforcing and 13.3 % as distinctive/unaccompanied.

7 Discussion

Our work is situated in the context of the Making phenomenon as applied to children's storytelling. We advanced the idea that electronics Making provides an additional level of interactivity to storytelling through instrumental interaction that may enable richer stories. Our results showed the prevalence of 'fast random blinking' and 'constantly on' LED behaviors. The LED was mostly used to signify characters' speech, character action and as a spotlight to highlight a particular area of the stage. At the highest level, the particular prominence of symbolic and focus uses of the LED were seen, echoing the distribution of the Level 2 codes. The significant chi-square test provides us with some confidence that the children used the LEDs with some degree of systematicity in meaning representation, even while portraying a wide range of expressions through the instrumental interaction. More than half of the LED use cases provided either added (coded as 'complementary') or new (coded as 'unaccompanied') meaning to the story, on top of story meaning from co-temporally occurring non-LED events. These results demonstrate the significance that instrumental interaction may take on in children's storytelling.

In traditional puppetry storytelling, ideas are embodied in the puppets through careful crafting at the point when the puppets are made [17]. Once made, the puppets and settings go onstage with a visual appearance that is immutable without some form of physical intervention. Instrumental interaction through Making not only allows ideas

Table 1. Level 1 descriptive codes generated

ID	LED Behavior	Pictorial Description	ID	Co-Temporal	Pictorial Description
1	Constantly on		A	Character movement	
2	Fast random blinking		B	Character tapping	
3	Slow random blinking				
4	Timed blinking		C	Character action	
5	Single blink		D	Voice	

Table 2. Level 2 and Level 3 codes generated

Level 2 Interpretive codes generated

ID	Interpretation	Description
i	Character's speech	Story characters conversing with each other
ii	Accessory	Any representation of an item or object on a character or in the background, e.g., hairband, star
iii	Story turning point	Indicates a major shift or change in the storyline
iv	Spotlight	Serves to draw the viewer's attention
v	Object quality	Signifies texture or quality of an object, e.g., a *shiny* crown
vi	Affect	Signifies affective state of a character, e.g., hungry, tired
vii	Thought/Thinking	Signifies thinking activity, like a comics book thought bubble
viii	Locomotion/Action	Accompanies or signifies a specific action, e.g., jumping
ix	Superpower	Signifies non-human capabilities, e.g., laser beams

Level 3 Category codes generated

ID	Category	Description
I	Symbol	LED use represents, signifies or stands in for something else
II	Focus	LED use emphasizes/highlights something specific in the story
III	Structure	LED use flags structural point \ in the story, e.g., climax, scene change
IV	Qualifier	LED use modulates, moderates or amplifies a certain quality in the story, performing a similar role to an adjective in verbal language

to be cast into concrete representations at the point of artifact creation, but also to have some degree of malleability during the telling of the story. The instrumental control of the LED allowed for 'on-the-fly' meaning creation. By integrating a simple instrumental interaction in the Maker Theater, we found that the LED control functioned essentially as *symbol* and *qualifier*, adding to the story content without the need for sophisticated language beyond the capacity of an 8-year-old, and as *focus* and *structure*, implicitly acting as a contextualizing channel for the story, similar to the functions typically attributed to non-verbal communication behaviors, such as gaze, gestures, proxemics, etc [18].

We suggest from our investigation that Making-based storytelling supports both the spontaneity of children's creativity, and the multidimensionality of meanings, beyond what speech and mechanical action can achieve. The major limitations of the work

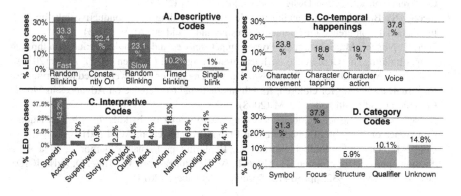

Fig. 3. Results charts and tables

presented are that first, we addressed only one illustrative case of instrumental control through the LED within the Maker Theater kit; and second, our analyses were done from a story viewer's perspective, and not from the child's perspective.

8 Conclusion

Our research provides a stepping-stone to the investigation of a new frontier of research in children's storytelling that involves electronics Making. We contribute to this area in at least four ways: we proposed the argument that Making-based storytelling may bring about the benefit of instrumental interaction in the story authoring process, we developed a custom Making kit that integrates storytelling in its very function, we explored the main uses enabled by instrumental interaction in children's stories, and we showed the significant role that instrumental interaction complemented, reinforced or added meaning to the children's stories.

References

1. Bdeir, A., Ullrich, T.: Electronics as material: littleBits. In: 5th International Conference on Tangible, Embedded, and Embodied Interaction. ACM (2011)
2. McCall, L.: What is Maker Culture? - DIY Roots, 10 March 2009. http://voices.yahoo.com/what-maker-culture-diy-roots-2810966.html?cat=46. Accessed May 2013
3. Hodges, S., et al.: Circuit stickers: peel-and-stick construction of interactive electronic prototypes. In: CHI. ACM (2014)
4. Arduino. LilyPad Arduino (2011). http://www.arduino.cc/en/Main/ArduinoBoardLilyPad. Accessed 14 Dec 2011
5. JoyLabz LLC. Makey Makey GO (2015). http://www.makeymakey.com. Accessed 17 June 2015
6. Hamner, E., et al.: Robot diaries: broadening participation in the computer science pipeline through social technical exploration. In: AAAI Spring Symposium: Using AI to Motivate Greater Participation in Computer Science (2008)
7. Rudolph, N.: TOTA: a construction set for the impending apocalypse. In: 12th International Conference on Interaction Design and Children. ACM (2013)
8. Jacoby, S., Buechley, L.: Drawing the electric: storytelling with conductive ink. In: 12th International Conference on Interaction Design and Children. ACM (2013)
9. Peer, F., Nitsche, M., Schaffer, L.: Power puppet: science and technology education through puppet building. In: Conference on Interaction Design and Children (IDC). ACM (2014)
10. Widjajanto, W.A., Lund, M., Schelhowe, H.: Wayang authoring: a web-based authoring tool for visual storytelling for children. In: 6th International Conference on Advances in Mobile Computing and Multimedia. ACM (2008)
11. Russell, A.: ToonTastic: a global storytelling network for kids, by kids. In: 4th International Conference on Tangible, Embedded, and Embodied Interaction. ACM (2010)
12. Chu, S.L., Quek, F., Sridharamurthy, K.: Exploring performative authoring as a story creation approach for children. In: Mitchell, A., Fernández-Vara, C., Thue, D. (eds.) ICIDS 2014. LNCS, vol. 8832, pp. 61–72. Springer, Heidelberg (2014)

13. Tanenbaum, J., Tanenbaum, K.: The reading glove: a non-linear adaptive tangible narrative. In: Si, M., Thue, D., André, E., Lester, J., Tanenbaum, J., Zammitto, V. (eds.) ICIDS 2011. LNCS, vol. 7069, pp. 346–349. Springer, Heidelberg (2011)
14. Chung, D.S., Yoo, C.Y.: Audience motivations for using interactive features: distinguishing use of different types of interactivity on an online newspaper. Mass Commun. Soc. **11**(4), 375–397 (2008)
15. Beaudouin-Lafon, M.: Instrumental interaction: an interaction model for designing post-WIMP user interfaces. In: CHI. ACM (2000)
16. Chu, S.L., et al.: Making the maker: a means-to-an-ends approach to nurturing the maker mindset in elementary-aged children. Int. J. Child-Comput. Interact. (2015)
17. Bernier, M., O'Hare, J.: Puppetry in Education and Therapy: Unlocking Doors to the Mind and Heart. AuthorHouse, Bloomington (2005)
18. McNeill, D.: Hand and Mind: What Gestures Reveal about thought. University of Chicago Press, Chicago (1992)

Posters

Students as Game Designers: Learning by Creating Game Narratives in the Classroom

Kristine Oygardslia[✉]

Department of Education, Norwegian University
of Science and Technology, 7491 Trondheim, Norway
kristine.oygardslia@svt.ntnu.no

Abstract. This paper explores the role of game narrative for learning when elementary school students design their own computer games in the classroom. The paper is based on data from a research project where one 6th grade class and one 7th grade class designed their own computer games in the classroom, related to concepts from their social studies curriculum. Data was collected through video observation, and analyzed using interaction analysis. In this short paper, selections of the initial findings are summarized, to show how the process of creating the game story, designing the game world and developing game characters might impact the students' learning outcomes.

Keywords: Game design · Learning · Storytelling

1 Learning from Designing Computer Games

While computer games have usually been seen as belonging to the sphere of home culture, it has impacted how children and youth learn, play, and work [6], and researchers have therefore argued that the learning potential of computer games should be considered in the modern educational system (e.g. [2, 9]). Narrative is a central factor for creating engagement when playing games [1], and previous research has established a link between narrative and interactive learning [1, 2]. But while most research on game-oriented learning has focused on learning through playing games, it should be remembered that children are not only consumers of digital media, but also producers of digital media content [3]. Is it possible that part of the key to providing an engaging learning environment might be to facilitate learning through game design, utilizing the narrative qualities of computer games?

According to Peppler and Kafai, computer game design has many benefits for learning, including learning how to collaborate with others, being part of a community based on similar interests, and develop sustained engagement [5, p. 375]. Research on game design in the classroom also emphasize that new projects are critical to understand how computer games can make us rethink the future of education [7]. However, there is still little research on creating computer games within a classroom setting [4]. This paper explores the role of narrative for learning when one 6th grade class and one 7th grade class design their own computer games in the classroom.

H. Schoenau-Fog et al. (Eds.): ICIDS 2015, LNCS 9445, pp. 341–344, 2015.
DOI: 10.1007/978-3-319-27036-4_32

2 Methods

Before the data collection started, a webpage was developed which included different challenges for the students to complete when working on designing computer games in the classroom, with a focus on creating the game story, the game world, game characters and dialogue. Each challenge included a brief introduction with game design advice, written to fit the target audience of 11 and 12 year olds, and a written tutorial and instruction videos on how to use the software *RPG Maker VX Ace*.

One 6th grade class and one 7th grade class were then video recorded and observed by the author in three different stages: (1) The teacher introducing a topic related to the social studies curriculum, (2) A two-day period where the students would learn to design computer games related to this topic, (3) A one-day game design session, occurring two months after the two-day game design period.

Video data was collected using three video cameras. Two of the cameras were stationary and recorded the screen and the interaction of a three-person focus group at all times, while one camera was used to more freely capture the classroom interaction. The video material encompassed a total of around 80 h, which was indexed and macrolevel coded using narrative summaries, before selected parts were transcribed and analyzed in depth using an interaction analysis approach. In addition, the students finished computer games were collected and used as a supplement for the analysis.

3 Designing the Story, Game World and Characters

Game narrative is seen as important both for engagement and learning when playing games [1, 2], which also seemed to be the case when designing the games. One example illustrating this is from the beginning of the game design stages. Here, three students are making a computer game for the first time, based on the topic The Medieval Ages. They have just watched an instruction video on how to create computer games, and are starting to make the game story. A large map is hanging on the wall beside their desk. The students have decided to design a game about the Crusades, and shape the game story in collaboration through pointing at the map and tracing the movement of the Crusaders, from Rome to Jerusalem, also including the challenges that the player character has to face – such as slaying crocodiles when trying to cross the river. Here, the element of storytelling is combined with using learning resources to situate the story in a historically correct setting.

Narrative in games is also tied to facilitating problem solving [2], which was also seen in the data material. One example of this is a group of three 7th grade students in the process of designing their game world, wanting it to resemble Florence in the Renaissance. As they are not sure what Florence in the Renaissance looked like, they quickly decide to use available resources to figure this out. They first use their school textbook, which shows an image of a church, *Santa Maria*. They then turn to Google image search to find more information. However, when they find two churches with the same name, they are not sure if it is the same church or two different churches. This is followed by a collaborative problem solving session where the students through dialogue and the use of online resources establish that there are two different churches in

Fig. 1. The Santa Maria church in the students' computer game

Florence called Santa Maria, before they quickly decide which one would be best suited for the game world, and add it to their game representation of Florence (Fig. 1).

Another example of collaborative problem solving which led to a deeper exploration of historical concepts occurred when this student group started making characters for their game world. The students had recently decided upon the story and the quest of their game character, Leonardo da Vinci: Painting the Mona Lisa. Using the game design software, they were now working on creating what would be one of the main characters in the story: Leonardo da Vinci's teacher. As they are prompted by the software to name their character, they realize that they do not know who da Vinci's teacher was. The students start the problem solving process by using Google and Wikipedia to find the answer, before asking their teacher, who is not able to give them an answer. In collaboration with their teacher, the students discover that da Vinci's teacher was called Andrea del Verrocchio. The students later add a quest for the main character, where del Verrocchio asks da Vinci to "Paint my daughter Mona Lisa".

4 Discussion

As the examples show, designing the game narrative facilitated the students' further exploration of concepts such as the Crusades and Florence in the Renaissance. However, it is interesting to note that the way the students worked with the game narrative also can have unintentional consequences for the learning outcomes, as it might make the students focus on narratives that are not historically correct. Simons noted that game narratives "allow the exploration of (or speculation about) what would or could have happened under even slightly different conditions" [8]. In the example of the students designing da Vinci's teacher, the students did indeed learn more about da Vinci's teacher from searching for information when they were designing this character. However, as the finished computer game showed, his role in the story was to give the main character a quest: "Can you paint my daughter, Mona Lisa?". While we cannot for sure know that del Verrocchio did not have a daughter named Mona Lisa, the Mona Lisa painting that da Vinci created is commonly thought to be a portrait of

Lisa del Giocondo. Thus, while the design of game narratives encourages the students to explore historical events, it is not a given that the students will make sure that what they create is historically correct.

Finally, it should be noted that the software used, RPG Maker VX Ace, is designed to make computer games within the genre role playing games (RPG), where storytelling is emphasized. This might therefore affect how the students worked with narrative in the game design process.

5 Conclusion

This paper has presented three short examples on how narrative might facilitate the students' learning outcomes when designing their own computer games related to curricular topics in the classroom. It is argued that while game design in the classroom can facilitate the students' collaborative problem solving and further exploration of curricular concepts, it can also have unintentional consequences in terms of the students mixing fiction with historical facts. These strengths and limitations should be researched further to establish how computer game design with a focus on narrative can best be used for learning in the classroom.

References

1. Dickey, M.D.: Game design narrative for learning: appropriating adventure game design narrative devices and techniques for the design of interactive learning environments. ETR&D **54**(3), 245–263 (2006)
2. Gee, J.P.: What Video Games Have to Teach us About Learning and Literacy. Palgrave McMillan, New York (2003)
3. Jenkins, H.: Confronting the Challenges of Participatory Culture: Media Education for the 21st Century. MIT Press, Cambridge (2009)
4. Kafai, Y.B.: Playing and making games for learning Instructionist and constructionist perspectives for game studies. Games Culture **1**(1), 36–40 (2006)
5. Peppler, K.A., Kafai, Y.B.: What videogame making can teach us about learning and literacy: alternative pathways into participatory culture. In: Baba, A. (ed.) Situated Play: Proceedings of the Third International Conference of the Digital Games Research Association (DiGRA), pp. 369–376. The University of Tokyo, Tokyo, Japan (2007)
6. Prensky, M.: Digital Game-Based Learning. McGraw-Hill, New York (2001)
7. Salen, K.: Gaming literacies: a game design study in action. J. Educ. Multimedia Hypermedia **16**(3), 301–322 (2007)
8. Simons, J.: Narrative, Games and Theory. Game Stud. **7**(1), 1–21 (2007)
9. Squire, K.: From content to context: videogames as designed experience. Educ. Researcher **35**(8), 19–29 (2006)

How Cognitive Niche Construction Shapes Storytelling?

An Investigation of e-picturebooks as Cognitive Artifacts

Thales Estefani, Pedro Atã, and João Queiroz[✉]

Institute of Arts and Design, Federal University of Juiz de Fora,
Juiz de Fora, Brazil
{thales.chaun,ata.pedro.1,queirozj}@gmail.com

Abstract. Here we introduce a theoretical framework for investigation of the cognitive and semiotic nature of digital storytelling. Our approach analyzes e-picturebooks (digital picturebooks) as cognitive artifacts and their impact on cognitive niche construction. Cognitive artifacts have the power both to create new problems and to create means for solving these problems. When both these aspects are taken into account, cognitive artifacts can be seen as shaping cognition itself: endowing it with both needs and capabilities, creating ever more specialized tools to deal with ever more specialized tasks. We investigate (i) how the problem space of storytelling is structured on cognitive artifacts, (ii) what are the specific semiotic features of e-picturebooks and how these features can alter storytelling production and interpretation, and (iii) how these alterations influence general cognitive abilities regarding storytelling tasks.

Keywords: e-picturebooks · Cognitive artifacts · Cognitive niche · Cognitive semiotics

This research project, which is still in its initial steps, introduces a theoretical framework for investigation of the cognitive and semiotic impacts of digital storytelling. Our approach is based on recent approaches in situated cognitive science and cognitive semiotics – distributed cognition and cognitive niche construction – that reconsider the relation between human cognition and the environment. The notion of distributed cognition has challenged the relevance of skin and skull as clear spatial boundaries of mental activity. Niche Construction Theory [1, 2] re-frames the discussion on evolution, moving the co-influence between organism and environment, from a peripheral position to the center of the evolutionary process. Finally, our approach is also highly influenced by Peirce's semiotic theory of mind [3, 4].

According to the distributed cognition thesis, various tools such as pen and paper, calculators, calendars, maps, notations, models, computers, shopping lists, traffic signals, measurement units, etc., are considered non-biological artifacts that allow cognitive operations external to the skull [5, 6]. In this sense, they are called cognitive artifacts. Their influence on cognitive capabilities can be described as possessing a dual identity. On the one hand, cognitive artifacts act on problem-solving efficiency: they may reduce the cognitive cost of an operation (such as when using a calculator to

H. Schoenau-Fog et al. (Eds.): ICIDS 2015, LNCS 9445, pp. 345–348, 2015.
DOI: 10.1007/978-3-319-27036-4_33

perform a division), increase its precision and efficiency (such as using a ruler to measure an object instead of just guessing its dimensions), or allow new capabilities that would be impossible to the brain alone (such as using a graphical diagram to represent the simultaneous relation between a large number of entities and infer specific visual patterns from it). On the other hand, cognitive artifacts are also responsible for the existence itself of certain tasks, i.e., they participate in the creation of new problems and problem-spaces. Language, for example, is a powerful cognitive artifact [7–9] which frames and transforms the problem-spaces of tasks related to memory, perception, navigation, forms of generalization and categorization, modes of inference, etc.

Cognitive artifacts have the power both to create new problems and to create means for solving these problems. When both these aspects are taken into account, cognitive artifacts can be seen as shaping cognition itself: endowing it with both needs and capabilities, creating ever more specialized tools to deal with ever more specialized tasks. Cognitive activity is seen as highly influenced by the historical development of artifacts made available for organisms in environments. This historical development is well-captured by the notion of cognitive niche construction.

The concept of a cognitive niche created and inhabited by humans has been proposed to explain our species' unique cognitive features [10, 11]. Cognitive niche construction can be characterized as evolution of cognitive abilities through a feedback cycle between problem spaces and cognitive artifacts [12]. Initial modifications in the artifacts available in the environment alter problem-spaces that pressure for further developments in the artifacts and so forth, specializing cognitive activities.

The activity of the fundamental components of cognitive niches can be generally described as semiotic processes. Our analysis is strongly influenced by Peirce's semiotic theory of mind. Peirce can be considered an important precursor of situated mind and distributed cognition thesis. But differently from the anti-cartesianism defended by some embodied-situated cognitive scientists, which is predominantly anti-representationalist, as recently explored in a Merleau-Pontyan [13], Heideggerian [14], or a Gibsonian [15] trend, for Peirce, mind is a semiotic process (semiosis) in a dialogical – hence communicational – materially embodied form, and cognition is the development of available semiotic material artifacts in which it is embodied as a power to produce interpretants. It takes the form of development of semiotic artifacts (similar to 'cognitive artifacts', as above), as stressed by Skagestad [3] with respect to the concept of intelligence augmentation.

Here we argue that the combination of cognitive niche construction, distributed cognition and mind as semiosis offers a good framework for approaching influence of new artifacts in cognition. This examination involves the following questions: (i) how the problem space in which the new artifacts act is structured? (ii) what new semiotic features does the new artifacts bring, and how these features change the structure of this problem space? (iii) how these changes might affect cognitive behavior?

We analyze e-picturebooks (digital picturebooks) as cognitive artifacts and their role in cognitive niche construction. As we are dealing with cognitive niche construction, our framework can be applied to cultural evolution in general, such as in other types of recent transformation in interactive media (computer games, audiobooks, digital photography, hyperliterature). Our choice to approach e-picturebooks is due to its being a recent phenomena related to the popularization of mobile devices, to the

transition between picturebooks and e-picturebooks being well-marked (paper vs. digital books) and to the ease of recognition of the specific semiotic features (see below) introduced by the digital media in comparison to the ones already present in the paper books. As our analysis is focused on the transition between non-digital and digital media, we decided to limit our scope to only one type of media and detail the changes in the semiotic artifacts (which we model as cognitive niche construction). With the advent of electronic reading devices, specifically tablets, picturebooks have developed into e-picturebooks, among which is the book-app: a new storytelling experience with multimedia resources and interactive tools, without which the experience is not complete. Applying the questions outlined in the previous paragraph to the domain of e-picturebooks, we investigate (i) how the problem space of storytelling is structured on cognitive artifacts, (ii) what are the specific semiotic features of e-picturebooks and how these features can alter storytelling production and interpretation, and (iii) how these alterations influence cognitive abilities regarding storytelling tasks. Answering question (i) requires an operational definition of storytelling as a problem space and identification of specific artifacts and semiotic features which produce effects that are observable and relevant for that problem space. Answering question (ii) requires analysis of examples and comparison between e-picturebooks and other forms of storytelling (digital or not). Answering question (iii) requires a model of the integration of the semiotic features identified in the answer (ii) and the inference of probable effects of these features in the storytelling niche. In the following paragraph we present an initial plan for the investigation on the cognitive-semiotic nature of e-picturebooks and some of its most salient features.

The task, or problem, that the term 'problem space' refers to in the first question (how the problem space of storytelling is structured on cognitive artifacts?) is that of story. How do people produce and interpret stories to make sense of the world? [16] The problem space (and the set of possible problem states) can be described as the possible causal links between semiotic entities and processes and high level structures (defined as boundary conditions or organizational principles) that influence these links. The "boundary conditions" have a downward effect on the spatiotemporal distribution of lower-level semiotic items [17]. Cognitive artifacts are the devices that allow navigation through the problem space (i.e., transition between problem states). What are the specific semiotic features of e-picturebooks and how these features can alter storytelling production and interpretation? Specific semiotic features of e-picturebooks include gestural repertoire, superposition of non-linear interactive elements, tendency of gamification, navigation conditioned to a specific interaction, multimodal textual forms, multimedia resources (video, animation, audio).

References

1. Laland, K., Kendal, J.R., Brown, G.R.: The niche construction perspective: implications for evolution and human behaviour. J. Evol. Psychol. 5(1–4), 51–66 (2007)
2. Sterelny, K.: Thought in a Hostile World: The Evolution of Human Cognition. Wiley-Blackwell, Oxford (2003)

3. Skagestad, P.: Peirce's semeiotic model of the mind. In: Misak, C. (ed.) The Cambridge Companion to Peirce, pp. 241–256. Cambridge University Press, Cambridge (2004)
4. Skagestad, P.: Thinking with machines: intelligence augmentation, evolutionary epistemology, and semiotic. J. Soc. Evol. Syst. **16**(2), 157–180 (1993)
5. Norman, D.: Things that Make us Smart. Perseus Books, Cambridge (1993)
6. Hutchins, E.: Cognition in the Wild. The MIT Press, Cambridge (1995)
7. Clark, A.: Language, Embodiment, and the Cognitive Niche. Trends Cogn. Sci. **10**(8), 370–374 (2006)
8. Clark, A.: Word, niche and super-niche: how language makes minds matter more. Theoria **20**, 255–268 (2005)
9. Clark, A.: Being There: Putting Brain, Body, and World Together Again. The MIT Press, Cambridge (1998)
10. Stotz, K.: Human nature and cognitive-developmental niche construction. Phenom. Cogn. Sci. **9**, 483–501 (2010)
11. Pinker, S.: The cognitive niche: coevolution of intelligence, sociality, and language. Proc. Nat. Acad. Sci. U.S. America **107**(2), 8993–8999 (2010)
12. Clark, A.: Supersizing the Mind: Embodiment, Action, and Cognitive Extension. Oxford University Press, New York (2008)
13. Dreyfus, H.L.: Intelligence without representation: merleau-ponty's critique of mental representation: the relevance of phenomenology to scientific explanation. Phenom. Cogn. Sci. **1**, 367–383 (2002)
14. Wheeler, M.: Reconstructing the Cognitive World: The Next Step. The MIT Press, Cambridge (2005)
15. Chemero, A.: Radical Embodied Cognitive Science. The MIT Press, Cambridge (2009)
16. Herman, D.: Storytelling and the Sciences of Mind. The MIT Press, Cambridge (2013)
17. Queiroz, J., El-Hani, C.: Downward determination in semiotic multi-level systems. Cybern. Hum. Knowing **19**(1–2), 123–136 (2012)

Target BACRIM: Blurring Fact and Fiction to Create an Interactive Documentary Game

Mathew Charles[1](✉), Brad Gyori[2], Sven Wolters[2], and Julián Andrés Urbina Peñuela[1]

[1] Universidad de La Sabana, Bogotá, Colombia
{mathew.hinson,juliamurpe}@unisabana.edu.co
[2] Bournemouth University, Bournemouth, UK
{brad.gyori,sven.wolters}@bournemouth.ac.uk

Abstract. Target: BACRIM is an immersive and interactive documentary game that exposes the atrocities of Colombia's paramilitary forces in one of its most violent regions. The producers combine both non-fiction and fiction to create a game that places the user at the heart of the story. Through this *docufiction*, which is anchored in augmented reality, the user or participant experiences danger first-hand. For the user, this violence is a game. For the people who live in this region, it is a reality. Target: BACRIM wants to blur that distinction. We therefore create a world, where fiction and non-fiction are interrelated, where genres merge and where individual disciplines escape the shackles of tradition to converge and create an interactive documentary that places user experience at its core.

Keywords: Interactive non-fiction · Interactive documentary · Augmented reality · Journalism · Games · Newsgames

1 Introduction

Target: BACRIM[1] is an immersive and interactive documentary game that exposes the atrocities of Colombia's neo-paramilitary forces in one of its most violent regions. The producers combine both non-fiction and fiction to create a game that places the user at the heart of the story. Through this *docufiction*, which is anchored in augmented reality, the user or participant experiences danger first-hand. As a reporter, it is he or she who must decide how far they are willing to go for the story. How much risk will they expose themselves to? Are they prepared to endanger their lives or those of their friends and family in pursuit of the truth?

Target: BACRIM is more than a game. It is a journalistic project that unmasks organised crime, terrorising communities across the Colombian sub-region of the *Bajo Cauca*. The user unearths tales of social cleansing, extortion and murder. They uncover modern day slavery and police corruption, and reveal criminal networks engaged in

[1] Target: BACRIM is a *Laborastory* production by Guerrilla Pictures with support from Bournemouth University and the Centre for Investigative Journalism in the UK and la Universidad de la Sabana and MIDBO in Colombia.

© Springer International Publishing Switzerland 2015
H. Schoenau-Fog et al. (Eds.): ICIDS 2015, LNCS 9445, pp. 349–352, 2016.
DOI: 10.1007/978-3-319-27036-4_34

illicit mining and trafficking. But only if they are brave enough to do so! For the user, this violence is a game. For the people who live in this region, it is a reality. Target: BACRIM wants to blur that distinction.

In essence, there are two interwoven stories and neither is the ultimate reality of the piece. One is a news story that gets to the hard truths about the actual conditions on the ground and the other is the fictional story that gets to truths about the human condition and what it is like to enter this world.

We therefore create a narrative, where fiction and non-fiction are interrelated, where genres merge and where individual disciplines escape the shackles of tradition to converge and create an interactive documentary that places user experience at its core. Indeed, as Aston and Gaudenzi note, 'the most interesting work in i-docs often arises when genre is transcended and boundaries are blurred' [1].

We intend to highlight some of the key challenges we continue to face in our production. Admittedly, the depth of analysis is somewhat limited within the confines of this poster. However, the aim is to provoke a discussion that can help contribute to ongoing debates about interactive storytelling and interactive documentary in particular, both in terms of theory and practice.

2 Changing Structures

Our principal intension is to transform the 'watcher' to 'user' and 'doer' [1]. This participation allows people to have a voice and to participate in the construction of reality [1, 4]. This is a reality the user can own. It involves an overhaul of both the 'three-act structure' and the 5Ws (who, what, where, why, when) of journalism. These give way to a narrative that lack the 'neat beginnings, middles and ends required by Aristotelian drama' [2]. The structure of Target: BACRIM builds on the nonlinear models defined by newsgame producer, Flaurent Maurin [3] and constructs a narrative that we describe as a 'thread of parallels'.

3 Competing Priorities: The Game vs the Journalism

Herein lies a central tension in constructing a nonlinear gaming narrative: is our project a game or is it a piece of journalism? Can it indeed be both, and if so, how? Games require users to look for content and rewards. Journalism seeks to include everyone, and so excluding users from particular content or stories could be seen as counter productive. However, this is still journalism, but 'with a different logic' [5]. It is no longer our story, but the user's. We hope the result is a more meaningful journalism. This is a journalism that people feel; that they experience and not just read, see or hear.

4 'Fictioning' Fact and 'Pulling the Character'

Our documentary is not character-driven, but 'character-pulled': because the user plays the role of the protagonist, this fictional character is invested with his or her own traits,

behaving in accord with that person's disposition, i.e. bold, meek, focused, erratic, etc. and so therefore, the protagonist does not actually 'drive' the story. Instead, this character is drawn into the story by compelling events and the actions of other supporting characters with more clearly defined traits. As Michael Mateas has noted, the characters in an interactive drama 'should be rich enough that the player can infer a consistent model of the character's thoughts. These thoughts become a material resource for player action' [6].

These characters can also provide anchors within the open story world of a 'mosaic narrative' [7]. That is to say that fictional characters can also be a useful guide for the user. This open world can be daunting and so characters can serve not only as a device to enhance the overall experience by strengthening the user's involvement, but also as a vehicle to help guide the user through the narrative with subtle hints, overt instructions or even to play tricks.

5 Augmented Reality: Interaction, Emergence and Personalization

The concept of augmented reality is central to our game. We want the user to feel threatened. We want them to live the story of the people they encounter. The aim is to immerse the user as much as we can in our storyline through the use of their personal email and telephone number. Augmented reality therefore allows us to take the user out of their comfort zone and place them directly in our story. For this to be effective, we must actually incorporate the user into the narrative. We must make their decisions impact on the story in front of them. Through 'completely open' interaction, we want the user and the documentary to constantly change and adapt to each other [7]. As Brenda Laurel notes, the player's agency 'must have real significance at the level of the plot' [8].

6 Conclusion

Target: BACRIM creates an open world of danger and risk. By combining fact and fiction through the use of augmented reality, we believe the user is able not only to see or witness this world, but is also able to experience it.

The notion of experience is undoubtedly central to interactive documentary. It can be achieved and has been achieved in various innovative ways. Indeed Target: BACRIM is by no means the only project that is attempting to break new ground in the field of interactive documentary. This poster is simply an attempt to share our particular construction of *docufiction* through game design. We hope the observations we have made go some way towards providing guidance for fellow producers of similar projects. We also hope we have identified not only practical dilemmas through our brief observations, but that we have also drawn attention to key theoretical tensions within this ever-evolving genre; tensions, which undoubtedly warrant much further analysis and debate.

References

1. Aston, J., Gaudenzi, S.: Interactive documentary: setting the field. Stud. Doc. Film **6**(2), 125–139 (2012)
2. Jennings, P.: Narrative structures for new media: Towards a new definition. Leonardo **29**(5), 345–350 (1996)
3. Maurin, F.: Constructing nonlinear narratives. MIDBO Colombia (2014)
4. Bruzzi, S.: New Documentary. Routledge, Abingdon (2006)
5. Gaudenzi, S.: The 3 Levels on the Spectrum of Interactive Storytelling. The Centre for Investigative Journalism Summer School, London (2015)
6. Mateas, M.: Interactive drama, art and artificial intelligence, Doctoral thesis, School of Computer Science, Carnegie Mellon University, Pittsburgh (2002). http://www.cs.cmu.edu/~dod/papers/CMU-CS-02-206.pdf
7. Gaudenzi, S.: The Living Documentary: from representing reality to co-creating reality in digital interactive documentary. Doctoral thesis, Goldsmiths, University of London (2013). http://research.gold.ac.uk/7997/
8. Laurel, B.: A response to a preliminary poetics for interactive drama and games. In: Wardrip-Fruin, N., Harrigan, P. (eds.) First Person: New Media as Story, Performance and Game, pp. 19–23. MIT Press, Boston (2004)

Connecting Cat - A Transmedia Learning Project

Patrícia Rodrigues[(✉)] and José Bidarra

Universidade Aberta, Lisboa, Portugal
1105075@estudante.uab.pt, jose.bidarra@uab.pt

Abstract. In this paper we present an overview of a transmedia learning project. As part of an ongoing research project, Connecting Cat provides glimpses of a story taking place in the material, physical world, and the imaginary world through image, sound and text. Specifically targeted to English as Second Language students, the project supports entry points for learning through immersion in an adventure story and engagement in multimodal learning activities.

Keywords: ESL · Language learning · Transmedia storytelling

1 Introduction

Transmedia storytelling as a process of "crafting stories that unfold across multiple media platforms, in which each piece interacts with others to deepen the whole - but is capable of standing on its own - giving the audience the choice as to how deep into the experience they go" [1] presents the potential to be used for educational purposes.

Transmedia learning environments allow to shift the balance of agency as learners "become hunters and gatherers pulling together information from multiple sources to form a new synthesis"; to become "active publishers of knowledge" [2]. They also allow to "broaden the mix of representational modes in which students express their knowledge and to build collaborative knowledge cultures" [3].

There is a lack of documented cases that may widen the understanding of the use of transmedia storytelling in educational context or to what extent it may add value to teaching or learning by enhancing the effectiveness of learning. As part of an ongoing research, the project Connecting Cat was created to provide a basis for assessment and reflection on the affordances of transmedia storytelling for learning in general and language learning in particular.

2 Narrative Features and Experience Design

The project is targeted to adolescent English as Second Language - ESL students and focusses on the exploration of contents and curricular goals of ESL, CEFR

© Springer International Publishing Switzerland 2015
H. Schoenau-Fog et al. (Eds.): ICIDS 2015, LNCS 9445, pp. 353–356, 2015.
DOI: 10.1007/978-3-319-27036-4_35

(Common European Framework of Reference for Languages) - level B1. Through this project, one intends to provide space for the development of communication skills and engagement in the topics: media culture, multiculturalism, linguistic diversity and use of technology. It is also aimed at developing media literacy and engaging students in multimodal learning experiences. Students are invited to unfold fragments of an adventure story of a teen girl seeking portal pieces in different locations to connect humans to a tribe of alien warriors via diversified media platforms.

The story is set both in a primary world, to unveil the heroine's journey, and a secondary world to allow for the exploration of a mystical dimension, in this case, an alien warriors' world. The segments of the story are presented through micronarratives - hierarchical, modular and accumulative "units of self-contained narrative coherence and flow that are critical to the formation of narrative meaning" [4]. They contribute to the overall experience of the narrative and encapsulate the required context to explore the topics. Participants of the storyworld are invited to shape and expand it through the creation of their representations and hypotheses about content and language.

The learning framework is embedded in the storyworld. Drawing from Kurek & Hauck's multiliteracy training approach [5], the interactions within the storyworld were designed to scaffold a process of reception, participation and contribution - "Similarly to what is happening in a language classroom, the learner is guided from observation of the desired acts, through their interpretation to the final performance" [5]. The gateways to the storyworld are set forth via a website. The navigation within the framework allows for a cumulative or complementary exploration of the elements, linear or non-linear.

3 Enhancing Learning Opportunities

The storyworld integrates platforms that provide learning inputs and platforms targeted to the creation of learning outputs. The goal was to create a meaningful experience that would allow for the progression from reception to contribution.

The first webisode establishes the setting for the story. The main character discovers her alien identity and mission - to seek pieces to assemble a portal and connect mankind to an alien tribe. "Who am I?" can be explored to raise awareness to diverse types of linguistic discourse and discursive practices in the L2. Students can critically evaluate discourse and develop conversation skills using the webisode as the setting.

Parallel to the events in the primary world, a different narrative thread is set to unfold the culture and life of an alien tribe through a motion book sequence. The events in "Allure" were crafted to provide learning inputs related to the topic linguistic diversity. Besides visual elements, the sequence is enhanced by audio elements to immerse the students in the topic. The sequence is available via the Madefire application. It adapts the graphic conventions of comic books - imaginative and supportive typography, strip panels, and speech bubbles to guide the act of reading. The progression in the narrative is dependant on interactions,

exchanges and movements of the readers. For ESL learning purposes, it presents the potential to explore receptive communication skills and reinforce meaning through different modes of representation. In terms of interpretation activities, students can identify biased or exploitative situations and report and rephrase information provided visually in the sequence or communicate about other modes on a metalevel.

The second webisode is an interactive video created via the Interlude platform. "Seek and you shall find" provides a multilayered video experience in which students can make choices within a set of narrative threads. It is set in London, where the protagonist is on a quest to find a portal piece. The setting and interactions with secondary characters were intentionally integrated to exploit the topics of linguistic diversity and multiculturalism. Besides authentic immersion in "World Englishes", the webisode depicts multicultural aspects of the city such as museums or world food markets. Different events provide learning inputs such as discourses representing various cultures, genres, intentions, communication modes and linguistic diversity.

In the location-based quest "AWOL", students aid the main character to solve the mystery of a missing portal piece and its guardian. The interactive elements seek to engage students in solving puzzles and clues through which they can develop reading and listening skills such as scanning or inferencing. The quest explores the topic media and is targeted to develop "reflective reception" [5], by accessing written and audiovisual information. To complete the quest, students need to express themselves through "thoughtful and purposeful online participation" [5] by interacting with Cat via her Facebook page. The story triggers are set via the mobile augmented reality application Aurasma. The primary goal is to make the story tangible to students by using a learner-centered and active participation approach.

Students can communicate with diegetic characters via Facebook pages. The posts reflect impressions related to the quests while expanding knowledge on the learning topics. By interacting with characters they are encouraged to develop accuracy on the linguistic level while using mechanisms of self-expression. The posts are also resources to exploit discourse issues such as argumentation and negotiation skills, pragmatic competence or even net-etiquette in L2 - "Learners are expected not only to interpret the meaning conveyed through input but also to articulate their own opinions by deliberately choosing and imitating a particular convention or type of discourse" [5].

Through the blog "Fluxus Log Archive", a file repository collected by humans to enlighten the tribe about human activities, students can become co-creators of the storyworld. The objective is to engage students in the topics, activate prior knowledge and skills, as well as develop media literacy skills. They can remix and recycle modes, genres and symbols to forge new interpretations or representations of the storyworld through the creation of digital artifacts such as podcasts, videos or wikis.

On the basis of enhancing learning via interactions on digital spaces, the project contemplates the construction of an online community of educators

Fig. 1. Screenshots of a scene of the motion book sequence and an interactive menu set in webisode 2

and students. Edmodo, given its affordances, allows for the creation of a space through which users can interact, share resources and discuss content correlated to the storyworld (Fig. 1).

4 Future Work

The primary purpose of this PhD research project is to deepen the understanding of the implementation of transmedia practices in ESL learning context. For the collection of data regarding the students' experiences of the storyworld, a set of observational tools will be used to analyze the participation in the social platforms and materials produced by students. The participants' experience will also be mapped by tracking predefined points of interaction within the storyworld. During the study case, interviews and questionnaires will be conducted to provide a body of data that can be scrutinized to interpret trends emerging from the participants' experiences. The goal is the systematic description and analysis of the implementation of the project, taking into account the subjective experiences of participants.

References

1. Weaver, T.: Comics for Film, Games, and Animation: Using Comics to Construct Your Transmedia Storyworld, p. 8. Focal Press, Burlington (2013)
2. Jenkins, H.: Confronting the challenges of participatory culture: Media education for the 21st century, p. 46. Mit Press, Cambridge (2009)
3. Kalantzis, M., Cope, B.: New learning: a charter for change in education 1. Crit. Stud. Edu. **53**(1), 83–94 (2012)
4. Bizzochi, J., Nixon, M., DiPaola, S., Funk, N.: The Role of Micronarrative in the Design and Experience of Digital Games. In: Proceedings of DiGRA 2013, pp. 161–197 (2013)
5. Kurek, M., Hauck, M.: Closing the "digital divide" - a framework for multiliteracy training. In: Digital Literacies in Foreign and Second Language Education. pp. 119–136. Calico Monograph Series 12, San Marcos (2014)

Collaborative Storytelling in Unity3D

Creating Scalable Long-Term Projects for Humanists

Lynn Ramey[1,2(✉)] and Rebecca Panter[1,2]

[1] Department of French and Italian, Center for Second Language Studies,
Vanderbilt University, Nashville, TN, USA
lynn.ramey@vanderbilt.edu
[2] Department of German Studies, Center for Second Language Studies,
Vanderbilt University, Nashville, TN, USA

Abstract. While storytelling and narratology have long been the domain of humanists, creating and exploring narratives using a video game platform poses unfamiliar challenges for team coordinators used to working alone with traditional media. Issues to overcome include training collaborators on technology, mutually accessible storage, prevention of data loss, and version control. This poster describes a process used to create a dynamic and scalable team for a long-term project using video games to explore medieval texts.

Keywords: Unity3D · Mixamo · Photoshop · Perforce · Collaboration · Training · Videogames · Storytelling · Teams · Project planning

1 Introduction

Humanists are not traditionally trained to work in groups, let alone on game design or computer graphics [1, 2]. From graduate courses that culminate in a typical 20-page research paper to dissertations, articles, and books, research in the humanities can be a solitary endeavor from start to finish. Co-authored books and articles are the exception, and good tools for collaboration in the humanities are only now being developed. Trends are changing, however, as the humanities embrace technologies that promise to open new ways of examining enduring questions.

With the advent of free and user-friendly game engines like Unity3D and the wide variety of 3D assets available for a nominal price, video game development is no longer confined to the realm of specialized artists and programmers. Games can be developed in the humanities classroom, allowing students and their instructors to create and control digital storytelling tools to explore cultures removed in time and place. These games almost always require a team of individuals to create a meaningful experience for the developers and the users; this teamwork creates new opportunities and benefits for the humanities at the same time that it introduces problems that humanists are poorly equipped to solve. As students come and go, sometimes in the space of a few weeks, how do we deal with a dynamic (high-turnover) roster of collaborators? How can we quickly train new project participants (students, faculty, or staff) so that the project can continue over time without losing momentum? With this diverse body of collaborators, how do we

H. Schoenau-Fog et al. (Eds.): ICIDS 2015, LNCS 9445, pp. 357–360, 2015.
DOI: 10.1007/978-3-319-27036-4_36

ensure that all the work produced is safely stored and easily integrate/dis-integrated into the main project? How do we prevent accidental and incidental data loss? While computer science has given us some models, working with students and faculty who are technologically less confident demands tweaking of these models, modifying them to make them appropriate to a team of humanists. We are experimenting with models to be used by project leaders working on storytelling and analysis in video games with variable-sized groups of collaborators located at various sites.

2 Materials and Methods

Humanists do not generally think in terms of business models when creating projects, but even a small classroom video game can benefit from advice directed at independent game makers. A game involves programming, design, art, sound, project management, quality control, and marketing. While one person may fill several of these roles, they should be clearly delineated, preferably before starting on the game [3]. In the initial stages of our game studio development, all of these roles were being performed by one or two people. For small teams consisting of novice designers, a balance needs to be struck between, on the one hand, the efficiency gain of being able to train multiple team members in the same skill (rather than teach each person a different skill), and, on the other hand, the need to have coverage of considerably different skill sets—for example, scripting versus graphic design.

In our recent eight-week summer session, our group composition varied weekly as students had other demands, but generally consisted of: five to seven game builders, each of whom focused on designing a different level in the game engine; one to two content specialists, who focused on writing text for the GUI and recording character dialog; and one artistically inclined person who designed the loading screens and Graphical User Interface (GUI) elements and did some customization of 3D models. This approximate ratio—roughly four to one to one of game builders, content specialists, and art asset creators—allowed the project to make progress at approximately the same rate in all of these areas, without any one noticeably outstripping the others. As students identified themselves as willing to take on a new role, like sound production, these key roles were transferred. In one case, after much struggle with his hardware, a student decided to specialize in dialogue.

The team members were not able to be physically present as the students were drawn from three universities and had typical summer demands of travel, coursework, and work. We felt it was essential to touch base daily, however, and did so using Skype with two different time slots to accommodate work schedules. Early on, the students required software training, which took up to an hour daily, but after a few weeks we were able to check in quickly to answer questions and monitor progress.

Due to anticipated turnover of student affiliates, the project manager needed to ensure that the software chosen to develop game assets (scripts, sound files, programming, objects, etc.) is openly available to the entire team. We settled on the following software, which we will evaluate in turn: Unity3D, Photoshop, QuickTime, Mixamo, P4Connect, and articy:draft.

Unity3D is freely available and rapidly becoming an industry standard, now shipped with the WiiU developer's kit [4]. Using Unity3D, teams have a powerful game engine that was designed for extreme flexibility to aid the independent developer. Key for our team was the Asset Store, which allows free market sales of models and characters that can be imported into games. For our group of students, previous experience with 3D modeling was very limited, and the ability to purchase a wide range of models inexpensively from the Asset Store was essential. Our game is set in the European Middle Ages, and the models for that period are plentiful. For other periods or specific needs, purchasing custom-made 3D models may still prove to be cost effective [3]. We had some success dealing with artists whose models we like on the Asset Store. As Unity3D constituted the central software in our design studio, training was required for novices.

Pre-made assets can also be modified using Photoshop (or GIMP) for minor changes. Photoshop is a program that many students already use and had installed on their computers. GIMP is a free alternative. Photoshop was also used to make logos and 2D assets such as a game map and title screen. Two students chose to work solely in this 2D area and due to their prior experience needed very little guidance.

Likewise, QuickTime is available on most computers and students had no trouble using it to record sound data. Music and other sounds were purchased or downloaded as .mp3 recordings.

Mixamo is a character creator (limited free version) that made excellent, modifiable models with no copyright problems. We encountered problems with other programs we tried, like MakeHuman (too difficult to add clothing) and DAZ3D (severe copyright issues). However, Mixamo has just been purchased by Adobe, and the future config-uration of the program is currently unclear.

Our biggest hurdle, yet to be resolved, lies in the important area of version control. With team members working at different times and in physically different places, keeping the project up-to-date is difficult and yet essential. Unity has several suggested methods of version control, none of which we found satisfactory. We settled on Per-force (P4Connect) because of its integration with Unity and the need to make version control software as user-friendly as possible for humanists. Perforce published videos that help greatly, but especially on the server end, we were unable to make a stable and reliable version control system. Ultimately we relied on Dropbox to exchange files. While this might work for a tiny team, Dropbox seems ill-suited for this kind of collaborative work and especially prone to duplication and data loss.

Finally, scriptwriting, which should be a familiar task for humanities students, was indeed rather easy for the team. Overall planning of the narrative could be better accomplished by software designed for game writing, and we tested articy:draft in this capacity. The software is only available for Windows OS, which not a single one of our humanities students was using. Most of their computers also did not have enough space to add a partition or Parallels. We will continue evaluating articy:draft due to its powerful interface, but we could not implement it in time to have an impact on this version of our program.

3 Conclusions

In a typical classroom setting, working on games requires training students on new skills. Unfortunately these students are often not available the following year or even semester. Creating a scalable training model for building classroom video games has a steep learning curve but will pay off in future team building. For a team of our size— that is, relatively small compared to most commercial game development teams [5, p. 13:16]—and, in addition, composed of non-specialist learners, it is important to use, wherever possible, readily-available software that is user-friendly and inexpensive, as well as pre-made game assets either purchased or downloaded for free [3]. Other- wise, ambitions can soon cause the project to exceed time and cost limitations, an issue that is indeed also frequently encountered by commercial teams [5].

Because students learn well from master teachers [2, 6] and we need to train students quickly to fill in new roles, we will record our next sessions of Unity instruction to make videos for the new team members to watch as they join the team.

This project is currently under development with some funding through the National Endowment for the Humanities Office of Digital Humanities via participation in a 2015 Advanced Challenges in Digital Humanities. In addition, Vanderbilt University has provided seed funding to set up a training program for humanities students in video game development.

References

1. MLA, Guidelines for Evaluating Work in Digital Humanities and Digital Media. Modern Language Association. https://www.mla.org/guidelines_evaluation_digital
2. Hobbs, R.: Digital and Media Literacy: A Plan of Action A White Paper on the Digital and Media Literacy. The Aspen Institute Communications and Society Program, Washington (2010)
3. Doulin, A.: Building a Strong Indie Game Development Team, Gamasutra: The Art and Business of Making Games. http://www.gamasutra.com/blogs/AlistairDoulin/20100107/86323/Building_A_Strong_Indie_Game_Development_Team.php
4. Takahashi, D.: Game developers, start your Unity 3D engines (interview), VentureBeat, 02 November 2012. http://venturebeat.com/2012/11/02/game-developers-start-your-unity-3d-engines-interview/
5. Petrillo, F., Pimenta, M., Trindade, F., Dietrich, C.: What went wrong? a survey of problems in game development. Comput. Entertainment 7(1), 13 (2009)
6. Kim, Y., Baylor, A.L.: Pedagogical agents as social models to influence learner attitudes. Educ. Technol. 47(1), 23–28 (2007)

Tell a Story About Anything

Mei Si[(⊠)]

Rensselaer Polytechnic Institute, Troy, NY 12180, USA
sim@rpi.edu

Abstract. With the fast development of internet technology, people can have easy access to a massive amount of information. The goal of this project is to provide a personal assistant for helping people explore large network of information by using narrative technologies. We propose an automated narration system that takes structured information and tailors the presentation to the user. It is aimed at presenting the information as an interesting and meaningful story by taking into consideration a combination of factors including topic consistency, novelty, user interests, and the user's preferences in exploration style. We present preliminary results of using this system for presenting information about the 2008 Summer Olympics Games, followed by discussion and future work.

Keywords: Data exploration · Novelty · User preferences

1 Introduction and Motivation

The development of internet technologies has enabled people to have access to a massive amount of information. For example, there are more than 4 million entries currently in the English Wikipedia. Unlike a traditional dictionary, these articles share many links among each other and form a huge network of information. Similarly, an incredible amount of information is being generated on Twitter and other social media at every moment. These posts are connected with each other by shared topics, user names, etc. A key difference between exploring such a large network of information and reading a book or an article is that there is not a clear thread for how the reading should proceed. Because the information is highly interconnected, a reader can be easily distracted by new topics. As a result, the structure in the data may become less obvious to the reader, and the reader may feel overwhelmed more easily.

To provide the user a more structured experience of information exploration while not restricting the user, we propose a narrative based agent with an integrated visualization tool as a personalized assistant. Visualization has been used widely for illustrating relationships in data. Similarly, narrative is a powerful tool for helping people understand and organize information [1,5,6]. In this work, an automated narrative agent is developed to take structured data and present them piece by piece to the user. It proactively constructs the narratives using information relevant to the user's interests, and also takes into consideration a combination of factors including topic consistency, novelty and the user's preferences for exploration style.

H. Schoenau-Fog et al. (Eds.): ICIDS 2015, LNCS 9445, pp. 361–365, 2015.
DOI: 10.1007/978-3-319-27036-4_37

2 Example Domain and User Interface

We will demonstrate the application of our systems by introducing information about the 2008 Summer Olympic Games in Beijing, China. We represent the network of information as topics and their relationships. Each topic is treated as a node in a graph, which has a description and links to other nodes. For example, the node "Table Tennis Competition" and the node "Peking University Gymnasium" are linked by the "happened" relationship. Currently, the example domain for this work includes about 200 nodes and 1400 links among the nodes, representing 27 types of relationships. This information is kept in an XML file.

Fig. 1. Interactive visualization interface

Figure 1 shows a snapshot of the end-user's interface. This interface is synchronized with the narrative agent. In the center of the screen, the current topic is displayed. All of the topics that are linked to the current topic are shown in a circle around it. The user can mouse over a topic to get detailed information about it. Without input from the user, the next topic is decided by the narrative agent. The user can click on any topic on the screen to make it the current topic, and the narrative agent will reconstruct its presentation accordingly. To help the user explore the knowledge base, on the right side of screen two lists of topics are suggested. One list contains the topics the narrative agent is most likely to talk about next based on the history of the interaction and the user's preferred information exploration style. The other list contains the topics that are considered as most novel to the user based on the history of the interaction. Using a set of slider bars, the user can indicate his/her preferred information exploration style by changing the relative weights of the factors that the narrative agent uses for picking the next topics, such as topic consistency and novelty. The algorithms of how the narrative agent works are described in Sect. 3. Finally, the interface allows the user to directly ask questions either by voice or text. Currently, we only support simple queries such as "Who is Michael Phelps?" by matching the user's input with predefined templates.

3 Storytelling by Balancing Objectives

Starting from any point in the knowledge base, the narrative agent can present the domain by introducing the topics one by one. The agent strives to go over

the topics in a meaningful order, while being attentive to the user's interests. The agent decides what to present next by balancing a number of objectives. For the domain of introducing the 2008 Olympics games, the agent has four objectives, which consist of maintaining hierarchical ordering consistency in the description, maintaining spatial ordering consistency in the description, adhering to the user's interests, and introducing more novel topics. These objectives may affect the narrative agent's behavior in different directions. For example, the system's current topic is introducing the Beijing National Aquatics Center. At the same time, there are novel topics the system can present, such as the US tennis players. Should the agent move its current topic to the tennis players or find a topic closely related to the Beijing National Aquatics Center? In our system, each objective is weighted with a relative importance. By default, we give high importance to those objectives that arrange the topics in a meaningful order. For our domain, that includes hierarchical ordering consistency and spatial ordering consistency. The user can change the weights at any time in the user interface. The agent picks its next topic by maximizing its achievement of these four objectives with their relative importance factored in. Next, we briefly describe how each of the objectives is evaluated.

First, for knowledge that is structured hierarchically, the agent prefers to talk about topics at the same hierarchical level together. For example, the 2008 Beijing Olympic Games have multiple venues, such as the Bird's Nest and the Water Cube, and within each venue there are several subtopics. For keeping hierarchical ordering consistency, the agent will not mix topics from different hierarchical levels, nor jump between subtopics that belong to different topics at a higher level.

Similarly, when describing a spatial environment, people typically follow an order, e.g. clockwise instead of randomly jumping around [4]. For keeping spatial ordering consistency, the agent ensures that the spatial relationship between the new topic and the current topic, and that between the current topic and the previous topic are the same.

For both maintaining hierarchical ordering consistency and spatial ordering consistency, a topic can receive a score of 1, 0 or -1. 1 means the ordering consistency is kept; -1 means the ordering consistency is violated; and 0 means the consistency check does not apply.

Thirdly, the agent wants to take the user's interest into consideration. Currently, we use a simple heuristics for estimating the user's interest – if the user has asked about a topic in the previous five steps, the user is interested in the topic and its closely related ones. The agent uses breadth first search for computing the distance between every topic in the knowledge base and the user's most recently queried topic. The shorter the distance is, the more coherent the topic is to the user's interest. If the user has not asked a question in the previous five steps, then 0 will be returned.

Finally, we want to keep the user engaged. In our previous work on creating digital storytellers, we found many users enjoyed the stories more when new topics were introduced from time to time, e.g. a new person or item [2]. We try

to do the same thing here by requesting the agent to pick novel topics to present to the user. This objective also serves the purpose of allowing the user to explore the knowledge base more efficiently because the agent will present a wider range of topics to the user. We evaluate the novelty of a topic by considering whether the topic has been presented before, what percentage of the topic's immediately related topics have been presented before, and the distance between the topic and the current topic.

An example is provided below. In this example, all of the four objectives have the same weight for the simplicity of the presentation. For computing novelty, the three factors we consider are weighted as -10, 1, and 1 respectively, i.e. if a topic has been presented before, it is usually not regarded as novel.

Node: 2008 Summer Olympic Games
Hierarchical Ordering Consistency: 0
Spatial Ordering Consistency: 0
Adhere to User's Interest: 0.8
Have been Presented Before: 1 (true)
Percentage of Related Topics Presented: 0.6
Distance from Current Topic: 0.2
Novelty (- 1*10 - 0.6*1 + 0.2*1): -10.4
Total Score (Hierarchical Ordering Consistency*1 + Spatial Ordering Consistency*1+ Adhere to User's Interest*1 + Novelty*1): -9.6

4 Discussion and Future Work

Narrative and dialogue are good ways for engaging people and helping people organize and memorize information. This project is aimed at helping people explore and consume a large network of information in a narrative form. A preliminary version of the system has been implemented and is presented in this paper.

For future work, we want to improve the algorithms for evaluating the objectives. In particular, we currently calculate the distance between two topics simply using breadth first search. This distance may not represent the distance of the two concepts in the user's mind. In the future, we will consider using a semantic tool such as concept net [3] to help us get a better estimation. Secondly, we want to explore how to automatically create the knowledge base by using existing data extracting tools such as DBpedia. This will allow us to have larger and richer domains for testing our algorithms. Having more domains encoded will also help us design a more general set of objectives for the narrative agent. Finally, we want to evaluate our system and test whether it can in fact help people explore information more effectively and whether people enjoy using it.

References

1. Abbott, H.P.: The Cambridge introduction to narrative. Cambridge University Press, Cambridge (2008)
2. Garber-Barron, M., Si, M.: Adaptive storytelling through user understanding. In: Ninth Artificial Intelligence and Interactive Digital Entertainment Conference (2013)
3. Liu, H., Singh, P.: ConceptNet-a practical commonsense reasoning tool-kit. BT Technol. J. **22**(4), 211–226 (2004)
4. Taylor, H.A., Tversky, B.: Perspective in spatial descriptions. J. Mem. Lang. **35**(3), 371–391 (1996)
5. Thorndyke, P.W.: Cognitive structures in comprehension and memory of narrative discourse. Cogn. Psychol. **9**(1), 77–110 (1977)
6. Wilkens, T., Hughes, A., Wildemuth, B.M., Marchionini, G.: The role of narrative in understanding digital video: an exploratory analysis. In: The Annual Meeting of the American Society for Information Science, pp. 323–329 (2003)

Investigating Narrative Modelling
for Digital Games

John Truesdale[1(✉)], Sandy Louchart[2], Neil Suttie[1], and Ruth Aylett[1]

[1] MACS, Heriot-Watt University, Edinburgh EH10 4AS, UK
{jtt5,ns251,r.s.aylett}@hw.ac.uk
[2] Digital Design Studio, Glasgow School of Art, Glasgow G3 6RQ, UK
s.louchart@gsa.ac.uk

Abstract. In this article, we discuss the notion of context from the perspective of narrative articulation or authorial trajectories in digital games. We conduct a survey of narrative contextual considerations in digital games and investigate the possibilities for Non-Player-Characters (NPCs) to react to players accordingly, particularly with respect to narrative situations, in both a consistent and coherent fashion. After which, we then discuss the foundations of a narrative context-based model for NPCs for digital games and interactive digital narratives (IDN).

Keywords: Interactive digital narratives · Digital games

1 Introduction

A popular notion in the modern digital games industry is for key player decisions to impact the direction of the story or support character development. Recent mainstream hit titles such as The Witcher 3: Wild Hunt, Bloodborne and Dragon Age: Inquisition highlight just how important a role storytelling plays in AAA productions [1]. Such franchises offer players increasingly complex and intertwined narrative structures that stress non-linear storylines [2], characterization [3], and environmental storytelling norms [4] and how much the role and importance of storytelling has increased in mainstream digital game productions in recent years. The Interactive Digital Narrative (IDN) domain has looked into exploring similar objectives and investigated mechanisms for effectively communicating a meaningful story whilst reciprocating player interactions in a significant way. In other terms, how can one provide a player control over aspects of a digital game, whilst ensuring the consistency of the story world (e.g. characters, plot, etc.) dynamically?

Yet, whilst offering a level of flexibility, the causality approach commonly taken by AAA productions often does not address key problems associated with IDN research such as character consistency and coherent narrative structures, both linked to the notion of narrative context (i.e. the narrative trajectory) [5]. Character consistency refers to character believability and its ability to make rational decisions and is essential in determining the nature and mindset of character interactions. Narrative coherence is the notion that whilst characters' actions match their innate personalities, these are

H. Schoenau-Fog et al. (Eds.): ICIDS 2015, LNCS 9445, pp. 366–369, 2015.
DOI: 10.1007/978-3-319-27036-4_38

seemingly motivated or affected by outside forces (story events) and provide the player with a coherent view of the game world.

The authoring of dynamic characters is a logical fundamental development of IDN [6] but is inherently complex. In this article, we discuss the potential impact of representing a narrative context or trajectory as an in-character mechanism to dynamically facilitate game narrative adaptation to player experiences. How can this be done within the boundaries of characterization and allow for greater NPC autonomy in acting responsibly as both actor and character in a story domain [7]?

2 Narrative Representation in Digital Games

Storytelling is an important component of modern digital games and recent successful franchises such as Fallout, Elder Scrolls, Bioshock, Halo, Assassin's Creed, and the Resident Evil series are just a few examples of productions with a clear narrative focus. From a historical perspective, recent story oriented franchises can be regarded as modern narrative games built upon the strong foundations of pre-dating series such as Final Fantasy, Legend of Zelda and Metal Gear Solid. These are all recognized for their emphasis on narratives and characters and sit in high positions on 'best games of all time' and 'favorite game characters of all time' charts [1].

Gradually, narrative designs have evolved and allowed for innovations through which a greater sense of narrative contextualization can be represented. One such example is Shadows of Mordor's 'Nemesis System' [8], an enemy generation system that creates personal player interactions with enemies through the use of dynamic histories. This approach exploits player to NPC interactions history in order to determine a representation of narrative context within the game world and motivate NPC actions. Conceptually, it presents contextual player actions and environmental awareness as exploitable gameplay mechanics. However, the Nemesis System approach does not model the player per say, and thus cannot determine the potential impact of contextual data on the player. We thus propose that the ability for a NPC to determine the desirability of an action from a player's perspective is key to the modelling of narrative contextual representations in both digital game and IDN research.

3 Contextual Application in Digital Games

Narrative information can be represented on multiple layers (e.g. authoring, characterization and environment design). A number of digital games have implemented mechanisms that allowed for characters or game worlds to display some level of awareness as to their role in the narrative experience.

The Sims, for instance, implemented behavior or mechanics where artificial intelligence (AI) controlled Sims exhibit a level of understanding of their roles as both Sims (actors) and characters in the world. Whereas the Sim characters carry out day-to-day activities (such as having jobs), the Sim actor generally often forfeits its plans in order to provide players with the possibility to develop their narratives and the context associated with them. Condemned, a survival horror first-person action series featured a

contextual AI approach that exploited and reinforced a suspenseful authorial direction, choosing to act or not with the aim to maintain a degree of tension. These examples show that, from a character perspective, the understanding of what an action means with regards to the narrative layer (i.e. desired authorial intent) could be potentially significant.

Additionally, traditional role-playing game (RPG) mechanics have demonstrated the potential and importance of a character layer where players invest in character development. Characterization [3] and player agency [9] have the potential to contextualize players' desirability for certain actions such that NPCs could consider a player's dislike for a particular action, and thus take the most relevant option based on that feedback. For instance, the Fallout series employs a traditional statistics-based character creation and leveling system, and items or dialog might require specific levels in order to be used, thus allowing limited player character development within the gameplay mechanics. Similarly, the morality system in the Fable series determines whether player-actions are 'good' or 'bad', and their effect on how a character is perceived by others. From a narrative perspective, character development is a mechanic through which contextual data can inform the direction of narrative trajectories.

The game environment plays an important role in that both narrative and character can and should be dynamically considered in order to achieve character consistency and narrative coherence. An environmental layer would traditionally be associated to environmental storytelling [4] and a way to communicate a desired narrative through non-explicit communication channels. However, from a narrative point of view, environmental contextual awareness would allow for characters to modify their action repertoires depending on their location. For instance, in Grand Theft Auto V players attempting to steal cars yield different outcomes depending on whether they steal from a rich or poor area, as NPCs will either run scared for their lives or decide to fight back to protect their property. Environment and location awareness could provide NPCs with important contextual information and aid characters in achieving consistent behavior along with the narrative and character layers discussed in this section.

4 Contextual Adaptation in Digital Games

Contextual narrative adaptation is conducted in games through narrative, character, and environment layers which targets players or player characters through implicit and/or explicit channels of communication. We have shown that there are a number of ways through which narrative context could be represented and exploited by both players and NPCs. Therefore, by understanding a player's desirability for an action, NPCs can make better decisions in relation to a player's experience. This can also lead to a better consideration of contextual information (in terms of overall game narrative) if NPCs had the means to understand the impact of their actions on players. Finally, providing NPCs with an understanding of their environment would lead to location awareness and add an environment-based contextual dimension to their action decision mechanisms. This would allow, in turn, for the consideration of desirability and undesirability of actions from an environmental perspective.

If such mechanisms were to be implemented, NPCs could display consistent character behaviors and carry responsibilities towards the coherence of the overall narrative within a dynamic system (e.g. digital games and IDN).

5 Conclusion

In this article, we investigated the nature and mechanisms of the narrative implications of context from the perspective of digital game productions. This discussion was motivated by the consideration of interactive storytelling in games and the impact player and NPC actions have on the overall narrative development of a gaming experience. We concluded that context plays an important role when communicating and interacting with narrative content and that it should be taken into consideration as part of a dynamic model that facilitates narrative adaptation. We proposed a triadic model of narrative layers (narrative, characters and environment layers) through which narrative elements could be communicated implicitly and/or explicitly to either the player or NPCs. Finally, we discussed the implication of contextual representation for the development of NPCs and game AI in general with regards to future development in both digital game and interactive digital narrative design.

References

1. Metacritic. www.metacritic.com/
2. Ryan, M.L.: Narrative as Virtual Reality: Immersion and Interactivity in Literature and Electronic Media. Johns Hopkins University Press, London (2001)
3. Sheldon, L.: Character Development and Storytelling for Games. Delmar Cengage Learning, Clifton Park (2013)
4. Bevensee, S.H., Dahlsgaard Boisen, K.A., Olsen, M.P., Schoenau-Fog, H., Bruni, L.E.: Project aporia – an exploration of narrative understanding of environmental storytelling in an open world scenario. In: Oyarzun, D., Peinado, F., Young, R., Elizalde, A., Méndez, G. (eds.) ICIDS 2012. LNCS, vol. 7648, pp. 96–101. Springer, Heidelberg (2012)
5. Louchart, S. Truesdale, J., Suttie, N., Aylett, R.: Emergent narrative: past, present, and future of an interactive storytelling approach. In: Koenitz, H., Ferri, G., Sezen, D., Sezen, T.I. (eds.) Interactive Digital Narrative: History, Theory and Practice, pp. 185–200. Routledge (2015)
6. Suttie, N., Louchart, S., Aylett, R., Lim, T.: Theoretical considerations towards authoring emergent narrative. In: Koenitz, H., Sezen, T.I., Ferri, G., Haahr, M., Sezen, D., Catak, G. (eds.) ICIDS 2013. LNCS, vol. 8230, pp. 205–216. Springer, Heidelberg (2013)
7. Aylett, R.S., Louchart, S.: Being there: participants and spectators in interactive narrative. In: Cavazza, M., Donikian, S. (eds.) ICVS-VirtStory 2007. LNCS, vol. 4871, pp. 117–128. Springer, Heidelberg (2007)
8. Walker, E.: Embracing your Narrative Nemesis – Cinematic Storytelling in Middle-earth: Shadow of Mordor. Game Developer Conference (GDC). https://archive.org/details/GDC2015Walker (2015)
9. Poremba, C.: Player as author: Digital games and agency. Doctoral dissertation, Simon Fraser University (2003)

Telling Non-linear Stories with Interval Temporal Logic

Matt Thompson[1]([✉]), Steve Battle[2], and Julian Padget[1]

[1] Department of Computer Science, University of Bath, Bath, UK
{m.r.thompson,j.a.padget}@bath.ac.uk
[2] Department of Computer Science and Creative Technologies,
University of the West of England, Bristol, UK
steve.battle@uwe.ac.uk

Abstract. Authoring a consistent interactive narrative is difficult without exhaustively specifying all possible deviations from the main path of a story. When automatically generating new story paths, it is important to be able to check these paths for consistency with the narrative world. We present a method of describing the structure of a story as a Kripke structure using Interval Temporal Logic. This allows the model checking of each possible telling of the narrative for consistency with the story world, as well as the ability to construct re-usable story components at different levels of abstraction. This is the first step towards building a fully checkable framework for building story components using modal logic.

Keywords: Interactive narrative · Model checking · Modal logic · Interval temporal logic · Kripke structures

1 Introduction

Agent-based approaches to interactive narrative generation must strike a balance between authorial control (writing a story structure), user agency and agent's actions (allowing characters to fill in the details of a story). One way to overcome this is to allow the author to describe the structure of a story in a way which constrains the available actions of the agents and user. This introduces a problem: if there are multiple paths through a narrative (chosen by user interaction), how can an author describe alternative scenarios without explicitly writing out every single branch of the story? Here we describe the use of Interval Temporal Logic to build narratives as Kripke structures, ensuring a logically consistent story.

1.1 Propp Example: Sausages and Crocodile Scene

As an example, take the classic British puppet show *Punch and Judy*, whose story is one of farcical violence. The common elements of Punch and Judy can be described in terms of Propp's story functions [1]. Here we pick one scene to use as an example: the scene where Punch battles a Crocodile in order to safeguard some sausages.

The corresponding story functions are:

© Springer International Publishing Switzerland 2015
H. Schoenau-Fog et al. (Eds.): ICIDS 2015, LNCS 9445, pp. 370–373, 2015.
DOI: 10.1007/978-3-319-27036-4_39

1. Joey tells Punch to look after the sausages (*interdiction*).
2. Joey gives the sausages to Punch (*provision or receipt of a magical agent*).
3. Joey leaves the stage (*absentation*).
4. A Crocodile enters the stage and eats the sausages (*violation*).
5. Punch fights with the Crocodile (*struggle*).
6. Joey returns to find that the sausages are gone (*return*).

2 Interval Temporal Logic

In order to model the story with modal logic, we employ Interval Temporal Logic (ITL), composed of the temporal intervals defined by Allen [2] and developed into modal operators by Halpern and Shoham [3]. This allows the expressiveness necessary to describe branching, parallel and nested paths through stories. The operators defined by Halpern and Shoham are (a bar over an operator denotes its inverse):

- $\langle L \rangle / \langle \overline{L} \rangle$ (Later): The interval occurs at some point after another interval.
- $\langle A \rangle / \langle \overline{A} \rangle$ (After): The interval occurs immediately after another interval.
- $\langle O \rangle / \langle \overline{O} \rangle$ (Overlaps): The interval occurs both during and before or after another interval.
- $\langle E \rangle / \langle \overline{E} \rangle$ (Ends): The interval ends at exactly the same time as another interval.
- $\langle D \rangle / \langle \overline{D} \rangle$ (During): The interval both starts and ends inside the duration of another interval.
- $\langle B \rangle / \langle \overline{B} \rangle$ (Begins): The interval begins at exactly the same time as another interval.

In our example, we combine Halpern and Shoham's temporal operators with the possibility (\Diamond) and necessity (\Box) operators of modal logic. We follow the convention of writing possibility operators inside angle brackets: $\langle \rangle$ and necessity operators within square brackets: $[\,]$.

$$S = \{S_0, S_1, S_2, S_{3a}, S_{3a_1}, S_4, S_{3b}, S_{3b_1}, S_4, S_5\} \tag{1}$$
$$P = \{\texttt{interdiction(A,B,C)}, \texttt{absentation(A)}, \texttt{struggle(A,B)},$$
$$\qquad \texttt{victory(A)}, \texttt{villainy(A,B)}, \texttt{violation(A,B)}, \texttt{return(A)}\} \tag{2}$$
$$T = \{D, \overline{D}, O, \overline{O}, A, \overline{A}, B, \overline{B}, L, \overline{L}, E, \overline{E}\} \tag{3}$$

Fig. 1. Modal operators

The example in Fig. 3 shows the "sausages" scene described in Sect. 1.1, consisting of a set of situations S, containing Propp story functions P. The interval temporal logic operators used in this example are the set T. Figure 1 shows the modal operators we use. A, B and C in formula 2 are variables that represent the characters and objects that appear in the story. We use hybrid logic to identify nodes using the *nominal* operator, shown as @. We can combine this with the Interval Temporal Logic to make statements such as "An absentation starts with state @S_1 and end with state @S_5." (formula 5).

$$S_0 \wedge interdiction(Joey, Punch, Sausages) \wedge$$
$$\langle B \rangle @S_1 \wedge \langle E \rangle @S_4 \wedge \langle A \rangle @S_5 \tag{4}$$
$$[@S_1] absentation(Joey) \wedge \langle A \rangle @S_2 \tag{5}$$
$$[@S_2] struggle(Punch, Crocodile) \wedge \langle E \rangle (@S_{3a} \vee @S_{3b}) \tag{6}$$
$$[@S_{3a}] victory(Crocodile) \wedge \langle A \rangle @S_{3a_1} \tag{7}$$
$$[@S_{3a_1}] villainy(Crocodile, Sausages) \wedge \langle E \rangle @S_4 \tag{8}$$
$$[@S_{3b}] victory(Punch) \wedge \langle A \rangle @S_{3b_1} \tag{9}$$
$$[@S_{3b_1}] villainy(Punch, Sausages) \wedge \langle E \rangle @S_4 \tag{10}$$
$$[@S_4] violation(Punch, Sausages) \tag{11}$$
$$[@S_5] return(Joey) \tag{12}$$

Fig. 2. Sausages scene with nominals and interval temporal logic

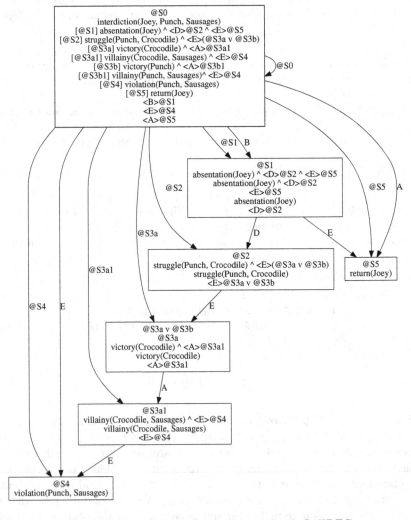

Fig. 3. One model from the sausages scene in LoTREC

3 Describing Punch and Judy with Kripke Structures

We use Kripke structures [4] as a method of interpreting the combination of modal logic with Interval Temporal Logic. In order to build and visualise the Kripke structures, we use LoTREC [5], a generic tableaux prover for modal and description logics. It allows the user to build up Kripke models using a domain specific language and display those models in the form of a graph diagram. Using the initial formulas from Fig. 2 as input, Fig. 3 shows the model for the case where Punch wins the fight with the Crocodile. One other model exists in this scenario, in which the Crocodile is instead the victor. The example in Fig. 3 describes a branching story, where either Punch or the Crocodile may win the fight for the sausages. This corresponds to the disjunction in Fig. 2, formula 6. This leads to the creation of two models: the one in which the Crocodile wins and then goes on to eat the sausages (situation $@S_{3a}$), and the one in which Punch wins (situation $@S_{3b}$).

4 Conclusions and Future Work

This paper demonstrates the use of Interval Temporal Logic for the construction of non-linear narratives. The advantages of this approach are that it enables an author to create re-usable story components at various levels of abstraction. It also allows for the model-checking of a proposed narrative of subset of a narrative to see if it fits with an author's model of a narrative world. From this point, we hope to explore alternative narrative formalisms outside of Propp. Though Propp works well for simple examples, modern media use story motifs that require some stretching of his story functions. We also intend to take our approach outside of the confines of the LoTREC software, into a live interactive storytelling program. In this way, we will be able to evaluate the effectiveness of our approach both in terms of story authoring and believability for the player.

References

1. Propp, V.: Morphology of the Folktale. 1928. Trans. Svatava Pirkova-Jakobson. 2nd edn. U of Texas P, Austin (1968)
2. Allen, J.F.: Maintaining knowledge about temporal intervals. Commun. ACM **26**(11), 832–843 (1983)
3. Halpern, J.Y., Shoham, Y.: A propositional modal logic of time intervals. J. ACM (JACM) **38**(4), 935–962 (1991)
4. Kripke, S.A.: Semantical analysis of modal logic in normal modal propositional calculi. Math. Logic Q. **9**(5–6), 67–96 (1963)
5. Del Cerro, L.F., Fauthoux, D., Gasquet, O., Herzig, A., Longin, D., Massacci, F.: Lotrec: the generic tableau prover for modal and description logics. In: Goré, R., Leitsch, A., Nipkow, T. (eds.) Automated Reasoning. LNCS, vol. 2083, pp. 453–458. Springer, Heidelberg (2001)

Opportunities for Integration in Interactive Storytelling

David Thue[✉] and Kári Halldórsson

School of Computer Science, Reykjavik University,
Menntavegur 1, 101 Reykjavik, Iceland
{davidthue,kaha}@ru.is

Abstract. While several Artificial Intelligence techniques have been applied fruitfully in the context of interactive storytelling, few projects to-date have attempted to integrate many of them into a single, cohesive system. Meanwhile, the call for better integration across related research groups has intensified in recent years, with the goal of crafting new systems that benefit from the advancements of diverse lines of AI research. In this paper, we identify several key technologies in this area and propose a high-level approach that may facilitate their integration.

1 Introduction

We envision an interactive, simulated world in which multiple stories occur at the same time, and where the actions of one or more players can influence each story's progression by changing the state of the world. We view interactive storytelling (IS) as the combined tasks of creating such a world and maintaining it at run-time. Over the past three decades, a variety of artificial intelligence (AI) techniques have been applied to address specific challenges in this context. With a few exceptions, many of the projects that have been undertaken in this area have each derived primarily from a single line of prior IS research. At the same time, multiple ICIDS workshops have called for integration [9]. We seek to extend and integrate key technologies from several prior lines of research, toward creating a new AI system for interactive storytelling that benefits from their contributions. In this paper, we summarize our first steps toward this goal.

2 Background and Key Technologies

In the context of our work, a simulated world is an environment that transitions between states in response to actions, and actions are performed by agents therein. These agents are characters in stories that occur in the world, and they might be controlled by players. Each story consists of events that might occur in parallel, and each event consists of actions that might also occur in parallel.

We have identified several technologies that grant useful abilities to either story designers (those who create IS artifacts) or players (those who experience them). We describe these technologies and the abilities they afford in the remainder of this section; we propose a way to integrate them in Sect. 3.

© Springer International Publishing Switzerland 2015
H. Schoenau-Fog et al. (Eds.): ICIDS 2015, LNCS 9445, pp. 374–377, 2015.
DOI: 10.1007/978-3-319-27036-4_40

Hierarchical Story Planning (i): AI Planning has become a dominant technology for story generation in IS research [1, 4–8, 12], and hierarchical approaches to planning offer a way to simplify each planning problem through either manual or automatic decomposition [1, 12]. Such decompositions can also be partially specified by hand and then completed automatically [12].

Guiding Planning with Constraints (ii): By placing extra constraints on an AI planner that are then enforced during planning, designers can guide the planning process to avoid the generation of unwanted plans. These constraints can be used to assert that specific predicates should become true either sometime in the plan in general, or sometime before a specific other predicate [4, 8].

Role Passing with Constraints (iii): The ability to dynamically assign characters to designer-defined roles while an experience is underway (i.e., *role passing* [2]) gives more flexibility to an interactive storytelling system as it maintains the simulated world. Each definition of a role includes a set of constraints that must be satisfied by a character before it can "fill" that role (e.g., "the villain must be the character that most strongly opposes the player"). Role passing can also be extended to include roles for objects and locations in the world [10].

Narrative Mediation (iv): To handle potentially disruptive player actions in a plan-based interactive story, such actions can be detected as they occur and used to trigger plan repair; this process is known as *narrative mediation* [6]. To identify disruptive actions automatically, an *exemplar plan* (which defines how the story should proceed) must be provided as input to the mediation process.

Optimization-Based Search (v): By treating the task of maintaining a simulated world as an optimization problem, designers can ensure that the AI system will adapt its behaviour as needed in pursuit of their goals [3, 5, 10, 11]. To allow the system to search for alternatives that are optimal, designers must provide an *evaluation function* that estimates the success of each option.

3 Proposed Approach

While previous systems have integrated different subsets of the technologies given in Sect. 2 (e.g., ii, iv, v [5]; i, ii, iv [8]; iii, v [10]), we propose that all five can be integrated using the approach that we sketch in this section. To save space, we focus on the challenge of integrating role passing (iii) with the technologies that focus on AI planning (i, ii, iv), since optimization-based search has already been integrated with technologies in both of these groups [5, 10]. More specifically, we aim to integrate two kinds of constraints: those that guide the planning process (tech. ii) and those that are used during role passing (tech. iii).

To begin, we envision an AI system where story content is represented at three levels of detail: actions, events, and stories. Each *action* defines a piece of content that can be performed directly by a character in the world (e.g., moving, manipulating objects, or expressing internal state) and is represented in the system as a planning operator. Each *event* defines a larger piece of story

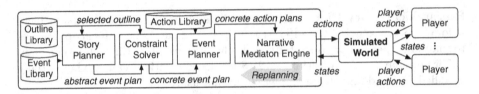

Fig. 1. Overview of our envisioned system and its interaction with a simulated world.

content (e.g., a bank robbery) and has a dual representation: as a partially-ordered plan of actions and as a planning operator. Each *story* defines an even larger piece of content (e.g., a heroic journey); it is represented by a partially-ordered plan of events and an *outline*. An outline is a proto-story construct that specifies both planning constraints and role-passing constraints.

Figure 1 gives an overview of the system that we envision. The designer creates a library of outlines and two libraries of planning operators: one for events and one for actions. Given access to these libraries, the AI system would perform the following steps. First, it would use optimization-based search (tech. v) to select an outline from the library; this outline would constrain the impending planning and role passing processes. Next, it would use an AI planner ("Story Planner" in the figure) to generate a partial-order plan of events that respect the outline's planning constraints (tech. ii). To integrate role passing into this process, the planner must be able to reason over each outline's roles as first-class entities (e.g., allowing the event "Villain captures Hero at Lair" to be generated). We propose that this can be done by generating and solving *abstract planning problems* where the roles that are defined in the outline (e.g., "Villain", "Hero", and "Lair") exist as entities for the planner to use. To add sufficient variety to each problem's domain, an abstract world could be made by collecting all of the roles and preconditions that are defined across the library of outlines. These roles and their properties could then be used to solve each planning problem.

After finding a plan of (abstract) events for the selected outline, the system would use a constraint solver to assign entities from the simulated world to each of the outline's roles (tech. iii; e.g., "Villain:Nero", "Hero:Bond", "Lair:Volcano"), instantiating new suitable entities if the solver failed to find any solutions. Each role in the story's events would then be mapped to the entity that was found for it by the constraint solver, resulting in a plan of fully concrete events. Given this plan, the system would invoke its AI planner again (forming a two-level hierarchy of story planning; tech. i) to plan each event as a partial-order plan of actions ("Event Planner" in Fig. 1). At run time, the partial-order plans in each story would be monitored by a narrative mediation engine (tech v.) to determine when each action therein was ready to occur. Ready actions would be sent to all involved characters for execution in the simulated world. To accommodate both disruptive player actions and conflicts between multiple simultaneous stories, the engine would re-plan using the mechanisms given above, along with optimization-based search (tech. v) whenever multiple plans were valid (like Ramirez & Bulitko [5]) or when multiple constraint solutions were found.

4 Conclusion and Future Work

We have proposed a high-level approach for integrating several key technologies from different lines of IS research, including hierarchical story planning, constraint-based planning, role passing, narrative mediation, and optimization-based search. Our work to implement it is now underway. Several broad challenges remain, such as finding useful evaluation functions to optimize, balancing long-term plan consistency with real-time flexibility, and developing a reliable way to evaluate our work. We particularly welcome discussions with the community with regard to these and related topics.

References

1. Cavazza, M., Charles, F., Mead, S.J.: Planning characters' behaviour in interactive storytelling. Vis. Comput. Anim. **13**(2), 121–131 (2002)
2. Mac Namee, B., Dobbyn, S., Cunningham, P., O'Sullivan, C.A.: Men behaving appropriately: integrating the role passing technique into the ALOHA system. In: Animating Expressive Characters for Social Interactions, pp. 59–62. AISB (2002)
3. Nelson, M.J., Mateas, M., Roberts, D.L., Isbell, C.L.: Declarative optimization-based drama management in interactive fiction. IEEE Comput. Graph. Appl. **26**(3), 33–41 (2006)
4. Porteous, J., Cavazza, M., Charles, F.: Applying planning to interactive storytelling: Narrative control using state constraints. ACM Trans. Intell. Syst. Technol. **1**(2), 111–130 (2010)
5. Ramirez, A.J., Bulitko, V.: Telling interactive player-specific stories and planning for it: ASD + PaSSAGE = PAST. In: 8th Artificial Intelligence and Interactive Digital Entertainment Conference, pp. 173–178. AAAI Press (2012)
6. Riedl, M.O., Saretto, C.J., Young, R.M.: Managing interaction between users and agents in a multi-agent storytelling environment. In: 2nd Joint Conference on Autonomous Agents and Multi-Agent Systems, pp. 741–748. ACM (2003)
7. Riedl, M.O., Stern, A.: Believable agents and intelligent story adaptation for interactive storytelling. In: Göbel, S., Malkewitz, R., Iurgel, I. (eds.) TIDSE 2006. LNCS, vol. 4326, pp. 1–12. Springer, Heidelberg (2006)
8. Riedl, M.O., Stern, A., Dini, D., Alderman, J.: Dynamic experience management in virtual worlds for entertainment, education, and training. In: Tianfield, H. (ed.) International Transactions on Systems Science and Applications, vol. 4, pp. 23–42. SWIN Press, Glasgow (2008)
9. Szilas, N., Rank, S., Petta, P., Mueller, W. (eds.): The ICIDS 2012 Workshop on Sharing Interactive Digital Storytelling Technologies (2012)
10. Thue, D., Bulitko, V., Spetch, M., Wasylishen, E.: Interactive storytelling: a player modelling approach. In: 3rd Artificial Intelligence and Interactive Digital Entertainment Conference, pp. 43–48. AAAI Press (2007)
11. Weyhrauch, P.: Guiding interactive drama. Ph.D. thesis, School of Computer Science, Carnegie Mellon University (1997)
12. Young, R.M., Pollack, M.E., Moore, J.D.: Decomposition and causality in partial-order planning. In: 2nd International Conference on Artificial Intelligence Planning Systems, pp. 188–194. AAAI Press (1994)

Demonstrations

The Quality System - An Attempt to Increase Cohesiveness Between Quest Givers and Quest Types

Daniel Brogaard Buss, Morten Vestergaard Eland, Rasmus Lystlund[✉],
and Paolo Burelli

Department of Architecture, Design and Media Technology,
Section of Medialogy, Aalborg University, Copenhagen, A.C. Meyers Vaenge 15,
2450 Copenhagen, Denmark
{dbuss12,meland12,rlystl12}@student.aau.dk, pabu@create.aau.dk

Abstract. In this article, we present our efforts to try to increase cohesiveness and connectivity between quests generated by a recreation of an existing procedural quest generation system, with an addition of a progressive tier system called Quality System. A study gave strong indications that the Quality System successfully produced a positive effect on the feeling of cohesiveness and connectivity between the generated quests amongst Role-playing- and Massively Multiplayer Online games players.

Keywords: Procedural content generation · Cohesiveness · Quests

1 Introduction

Quests are small narrative elements which the player uses to gradually unveil information about the story's context and content and forms the basic component of in-game story-telling. A quest within a Role-playing game (RPG) requires the player to complete a set of tasks given often by non-player character (NPC) and including some form of reward, such as items, experience, or money.

The study presented in this article investigates the process of procedural quest generation (i.e. automatic generation of quests by an algorithm) with the aim of creating a stronger cohesion within a series of generated quests. To do this a system to connect several quests together, based around NPCs motivations is introduced. The system, called the Quality System, aims at ensuring a sense of progression, by providing the players with a series of quests based on previous events. The Quality System is named as such to reflect the gradual ranking of objects and NPCs within the system.

This project was inspired by the work on procedural generation of quests performed by Sullivan et al. [1] and Lee et al. [2], which suggest cohesiveness as an important factor to consider when generating series of quests. In this article we will first present the logic driving the Quality System and then we will showcase an implementation and a user-evaluation of the system.

© Springer International Publishing Switzerland 2015
H. Schoenau-Fog et al. (Eds.): ICIDS 2015, LNCS 9445, pp. 381–384, 2015.
DOI: 10.1007/978-3-319-27036-4_41

2 Quality System and Structure

Based on the structural analysis of Role-playing games quests performed by
Doran and Parberry and on their quest generator [3], we designed a system
capable of generating coherent quest series linked by the context in which the
quests take place, ensuring a connection between the quest NPCs, the quest that
gets generated and the previously generated quests.

For this purpose, we have introduced the concept of *NPC profession* and *NPC
tier* which are used to allow the generator to guide the progression of the quest
and maintain coherence in the quest assignment. The first concept describes the
main role of the NPC responsible of providing a quest to the player, influencing
the types of quests that can be generated, while the second concept describes
the rank of the quests that can be generated in terms of influence and level of
responsibility of the NPC.

With the addition of these two concepts, instead of initiating the quest gener-
ation from an initial random motivation, the Quality System starts by randomly
generating an NPC with a profession which is responsible for providing the player
with randomly generated quests that fits their profession. For instance, a black-
smith NPC might ask the player to gather some iron ore or deliver a finished
suit of armour, whereas a king NPC might ask the player to go and rescue a
princess or kill a dragon.

Furthermore, to provide the player with a sense of progression, professions
are categorized into different tiers with an ascending quality (e.g. minor, major,
and epic) and each tier has categories containing NPC professions, motivations,
skills, and enemies/items, each fitting to the quality of the tier they are in. Table 1
shows an example of a profession categorized as "major" with its corresponding
motivations, items, skills and enemies.

Table 1. An example of Motivations, Items, Skills, and Enemies fitting the Priest
profession

Profession	Motivations	Items	Skills	Enemies
Priest	Knowledge All, Reputation All, Serenity 4, Protection 7, & Ability 3, 5, 6, 7.	Tome, Scripture, Holy relic, & Holy text/book.	Language, Holy rituals, Science, Use sanctified liquids, & Perform rituals.	Cultists, Infidels, Sinners, Undead

It is important to note that Table 1 only shows an example of NPC profession.
The name of the profession, the motivations, skills, and enemies/items can easily
be swapped, removed, or added, to fit any specific game in which the system can
be used.

Based on this arrangement of professions and NPCs in different tiers, the
system attempts to provide a sense of progression. The first quest generated
is always a minor quality quest; once that quest is completed, the system will
perform a calculation to determine if the next quest to be generated should be

another minor quality quest or if it should advance to the next tier, in this case, a major quality one.

A change in the quest tier corresponds also in a change of the NPC providing the next quest so, in case such progress happens, the system provides a connection text giving the player a reason why they should visit this other NPC to help out. As the player progresses through the quests in the different tiers, the chance for them to advance increases each time, meaning that the player always needs to complete one quest from a given tier before being able to move on. At each quest completion, the tier of the next quest is determined randomly with an increasing chance of progress dependent on the number of quests completed in the current tier. In the implementation tested in this article a 20 % progress chance was used for minor quests and a 33 % progress chance for major quests. With this configuration, the player can receive a minimum of three quests in a chain of quests and a maximum of 11.

3 Evaluation

A study has been conducted with a total of 38 participants (34 of them male) with the purpose of evaluating the quest generation mechanism described in this article. All of the participants were Role-playing game and/or Massively Multiplayer Online (MMO) players, with several different nationalities represented (Danish; English; Canadian; Korean; Bosnian; Vietnamese; Dutch; Romanian; Greek; Croatian; French) and ranging in age from 18 to 45.

Table 2. Average answers given by the participants expressed through a 5 points Likert scale defined between -2 and 2

Question	Set A	Set B	P-value
Between-quests connection	0.035	1.421	0.000
Internal coherence	0.289	1.316	0.000
Preference	0.158	0.737	0.002
Applicability	1.105	1.658	0.001

The evaluation was performed in the form of a within subject experiment in which each participant was asked to rate, through a 5-point Likert scale, four aspects of two sets of printed quests: one set generated through a recreated version of the generator proposed in [3] (set A) and one set generated through the Quality System (set B). As shown in Table 2, the questions focused on the participants' perception of the level of connection between the quests and of the coherence of each quest taken singularly, on their preference and on the perceived applicability to a computer game.

The resulting data revealed that, in every question, set B was rated significantly higher than set A. To evaluate the significance of this difference, we first performed a Kolmogorov Smirnov test to check for data normality. As the test

revealed that the answers to all the four questions for both sets were not normally distributed, we performed a non-parametric Wilcoxon Signed Rank test finding that the difference between the ratings given to the two sets is significant for all four aspects taken into consideration.

4 Conclusions and Future Work

The aim of this work was to find a way to increase the feeling of connectivity and cohesiveness between procedurally generated quests in an existing complex PCG quest system, as well as increase the appeal of said quests amongst RPG and MMO players. For this reason we designed and improved the version of the generator proposed by Doran and Parberry [3], which focuses on ensuring coherence between NPCs, quests and player progression. The data gathered in a comparative evaluation with the original generator shows a strong indication that the addition of the Quality System did have a positive impact on the players' perception of cohesiveness and was generally positively welcomed.

In its current version, the Quality System still has much space for potential improvements, such as additional content or new structural features. For instance, a better connection between the individual quests within the same tier of the Quality System could potentially improve further the perception of cohesiveness. Another possible improvement could consist of allowing the system to generate several different NPCs of the same tier with the same profession, creating greater diversity. Furthermore, to further evaluate the effects of the system and further understand potential improvements, we believe it is necessary to implement it into an RPG or an MMO.

References

1. Sullivan, A., Grow, A., Mateas, M., Wardrip-Fruin, N.: The design of Mismanor: creating a playable quest-based story game
2. Lee, Y.-S., Cho, S-B.: Context-aware petri net for dynamic procedural content generation in role-playing game. In: Computational Intelligence Magazine, pp. 16–25. IEEE (2011)
3. Doran, J., Parberry, I.: A Prototype Quest Generator Based on a Structural Analysis of Quests from Four MMORPGs. Technical report, LARC-2011-02 (2011)

No Reflection - An Interactive Narrative

Katharina B. Mortensen[✉]

Aalborg University, Copenhagen, Denmark
kbmo11@student.aau.dk

Abstract. No Reflection is an interactive, non-linear narrative based upon the short story *Uden Spejlbillede* (translated to *No Reflection*) written by Katharina B. Mortensen and published in the magazine Himmelskibet no. 28 in 2011 [1]. This paper demonstrates how the linear short story *Uden Spejlbillede* were made into an interactive, non-linear narrative. In order to do this, is the structure *the directed network* used, while maintaining the original linear storys format of a diary. The non-linear narrative was created using the game engine Unity3D and a plugin called Fungus.

Keywords: Interactive narrative · Non-linear · Short-story · Choices · Authoring · Didascalic narrative · No reflection · Uden Spejlbillede

1 Introduction

The focus when making this demo was on how one can mediate an already written story as an interactive narrative, where the user would still have a sense of having an impact on the story. The mediated story was based upon the short story *Uden Spejlbillede* - translated to *No Reflection* - written by Katharina Bregnhoved Mortensen and published in the magazine Himmelskibet no. 28 in 2011 [1].

The original short story is about a boy, called Benjamin, who does not have any reflection in the mirror. One day he discovers that he does not only have no reflection, but due to this he can actually go through mirrors and enter parallel worlds. These worlds are based on speculations upon what could have happened in this world; similarly is the new interactive parts based upon the *disnarrated*[1] in the story. The main plot of the short-story is for the protagonist - Benjamin - to find his way back home (the reader should therefore be experiencing Ryan's how-suspense [2, p. 144]).

The short-story is written in the format of a diary, which is a central thing; it creates believability. It was therefore decided to keep this format in the interactive narrative as well. This did, however, create a challenge, since the main parts of the interactive narrative did therefore not only have to be primarily text-based, the majority of the narrative also had to be written in a past tense.

[1] Disnarrated: what could have happened [6, p. 118].

© Springer International Publishing Switzerland 2015
H. Schoenau-Fog et al. (Eds.): ICIDS 2015, LNCS 9445, pp. 385–388, 2015.
DOI: 10.1007/978-3-319-27036-4_42

This obstacle is overcome by (1) sometimes making the protagonist either wonder about which choice he made, as if not remembering it correctly, (2) by letting the protagonist write about his worries before taking the decision, and (3) by letting the protagonists sentence hang in the air, in order for the user to finish it.

The goal of the system is to mediate the narrative, which should be *didascallic*[2], and the *author-audience distance*[3] should therefore be as minimal as possible.

2 The Structure

The main structure used for the interactive narrative is the *directed network,* as presented by Ryan [2, pp. 252–253], since it prevents the combinatorial explosion (see [2, pp. 248–252] for more about the combinatorial explosion). This structure makes it possible to use one main story due to its form and then evolve upon it. The drawback of the choices only being occurring in the middle of the structure (see about the directed network in [2, pp. 252–253]) are encountered by using a system where specific choices are stored, or in some cases are a point system used (see more in Sect. 3). This means that the ending the users experience, will differ depending of the choices they have made earlier.

In order to create an even stronger sense of having an impact on the narrative are elements from the structure *the maze,* as presented by Ryan [2, pp. 251–252], used: the addition of terminal nodes and circles. The circles, however, is somewhat limited, in order to guarantee a narrative coherence on both the global (overall structure) and on the local level (from node to node); this narrative coherence is also accomplished by said point system and remembering of previous choices. The full, used structure of the interactive narrative can be seen in Fig. 1.

Fig. 1. The full structure used for the interactive narrative *No Reflection.*

The new, interactive branches was developed by first applying the non-linear story to the structure, whereafter there was looked for disnarrated events. One of these events is e.g. what would have happened if the protagonist did not tell his newly found friend - Lene - about his missing reflection in mirrors - would he still go through the mirrors? Which type of objects would he then decide

[2] Didascallic: self-explanatory or having an obvious message [3, p. 16].

[3] The author-audience distance concerns with how large the interpretation gap between the sender and receiver is. The larger the interpretation gap is, the less of the narrative is self-explanatory and hence the more abstract is the story [3, pp. 15–16].

to bring with him? How would his relationship with this new friend be, if he did not tell her? And so on. Especially did the different parallel worlds that the protagonist visits give more freedom to create new branches to the original linear story: which world would he decide to go into first? Did he decide to explore said world, or rush back home or into the next one? Would he decide to stay there instead of trying to find back home?

3 Implementation

The interactive narrative was implemented using the game engine Unity3D [4] version 5 and the plugin Fungus [5], which is made for creating interactive narratives in either 2D or 3D. In this interactive narrative is 2D drawings used, as it was believed this were more true to the original medium and style of writing (diary-form). The drawings were made in Adobe Photoshop CS6 and created using a Wacom Intuous Pen and Touch Medium tablet. One of such images can be seen in Fig. 2 (in grayscale).

Fig. 2. One of the images used in the interactive narrative.

The plugin Fungus made it possible with its *Fungus Script* to create the interactive narrative with choices, variables to keep track of the different choices and to have a point system. This means that there is kept track on if the user chooses to tell the protagonist's newly found friend about him not having any reflection in the mirror or not. If he does tell her, this means that the user later on cannot choose what to bring into the parallel worlds that the protagonist (might decide to) enter, and that she will be mentioned in the majority of the end-nodes as well. If the user did not choose to tell her, he will instead be able to choose what to bring into these parallel worlds; if he e.g. chooses to bring food, he will not be hungry, if he brings the torchlight, he will not fall and hurt his foot. The point system is simply used to keep track on how much food and water the protagonist has left (or else he will complain about it) and it likewise keeps track on how much he lies to his friend; if he continues to lie to her, the user can encounter the ending, where the whole story has just been that - a story, made up by the protagonist himself.

4 Conclusion

This demo showed that it is in fact possible to create a non-linear narrative out of an established linear narrative, though the demo does not answer whether this will be possible to accomplish on all fictional narratives or not. It is very well possible that this transformation of the narrative from a linear narrative to a non-linear narrative could in some circumstances be made on the account of the author's intentions (in form, expression and message) of his/hers original linear narrative, while other linear narratives might actually benefit from it.

It is widely known in the book-industry that it is not only difficult for an unknown author to get a book published - it is even more difficult if it is a collection of short stories. It is therefore my belief that the making of these linear short stories into interactive narratives can in some circumstances not only give ground for new uses, users and create a basis for exploration of a specific theme - where it will be much more possible to explore the theme from different perspectives than with a linear narrative - it might also make it easier for new authors to get their story out, and perhaps later on to get their collection of short stories or novel published at a publisher as well.

References

1. Mortensen, K.B.: Uden Spejlbillede. Himmelskibet nr **28**, 10–17 (2011)
2. Ryan, M.-L.: Narrative as Virtual Reality. In: Nichols, S.G., Prince, G., Steiner, W. (eds.). The John Hopkins University Press (2001). ISBN: 0-8018-6487-9
3. Bruni, L.E., Baceviciute, S.: Narrative intelligibility and closure in interactive systems. In: Koenitz, H., Sezen, T.I., Ferri, G., Haahr, M., Sezen, D., Çatak, G. (eds.) ICIDS 2013. LNCS, vol. 8230, pp. 13–24. Springer, Heidelberg (2013)
4. Unity3D. http://unity3d.com/unity
5. Fungus. http://fungusgames.com/
6. Herman, D., Jahn, M., Ryan, M.L.: Routledge encyclopedia of narrative theory. Routledge, London (2005). http://books.google.com/books?isbn=1134458398

Bird Attack: Interactive Story with Variable Focalization

Irmelin Henriette C. Prehn[1], Byung-Chull Bae[2(✉)],
and Yun-Gyung Cheong[3]

[1] IT University of Copenhagen, Copenhagen, Denmark
irmelin.prehn@gmail.com
[2] School of Games, Hongik University, Sejong, South Korea
byuc@hongik.ac.kr
[3] Department of Computer Engineering,
Sungkyunkwan University, Suwon, South Korea
aimecca@skku.edu

Abstract. In this paper we present our working example of an interactive story using the notion of variable focalization. In our interactive story the readers can experience the change of PoV (Point of View) while reading. To ensure that changing PoV creates sufficient conflicts and dynamics among characters, Greimas's Actantial Model was applied to the story creation process. The final story was realized as a form of hypertext branching narrative using Inklewriter (Bird Attack story is accessible via https://writer.inklestudios.com/stories/f8pd).

Keywords: Interactive story variable focalization · Point of view · Inklewriter · Grei-mas's actantial model

1 Introduction

Genette [1] introduces the concept of focalization as a notion of "who sees the story" or "focus of narration", differentiated from the narrator's point of view (PoV)[1]. According to Genette, focalization can be either internal (i.e., everything is narrated or presented via the internal mind of story characters) or external (i.e., narrative is presented via a narrator outside of the story world). Specifically, the internal focalization can be among one of three cases – fixed, variable, and multiple. In fixed focalization there is only one focal character (i.e., the main character who sees/perceives/observes the story world). With variable focalization several focal characters tell a story in turn (e.g., Gustave Flaubert's Madam Bovary). In multiple focalization, story events occurring during a certain period of time are presented by multiple focal characters (e.g., John Fowles's *The Collector*, Kurosawa Akira's 1950 film *Rashomon*) [2]. In this paper we focus on variable internal focalization, particularly in interactive storytelling, as a new manner of creating reader agency.

[1] In this paper we employ the term focalization similar to PoV as they are often interchangeably used, although their meanings are not the same.

© Springer International Publishing Switzerland 2015
H. Schoenau-Fog et al. (Eds.): ICIDS 2015, LNCS 9445, pp. 389–392, 2015.
DOI: 10.1007/978-3-319-27036-4_43

To investigate variable internal focalization in interactive story, the first author of this paper created a short interactive fiction called *Bird Attack* using Inklewriter. The story was created drawing from Greimas's Actantial Model [3] where actants mean types of actors. His model consists of six actants: the *subject*, the *object*, the *sender*, the *receiver*, the *helper*, and the *opponent*, informed by a drama theory and Propp [4]. These six roles are interconnected via the notion of *object*, which represents desire of the character and are often manifested as quests. The subject is the protagonist of the story who attempts to obtain the object, which is provided by the sender. If the subject succeeds to achieve the goal and desire, the subject plays the role of the receiver as well. Otherwise, the receiver will be acted by another character that obtained the desire in the end. The notions of helper and opponent are marginal in this theory, representing the actors who assisted or hindered the subject (i.e., protagonist) to achieve the object. Therefore, one actor can perform several roles in a story while several characters can perform the same role.

Several IFs (Interactive Fictions) and text-based games have employed PoV as a narrative device [5, 6]. Eric Eve's *Shelter from the Storm* is a text-based game where you can change voice and tense freely during play, e.g. the first person, present tense (e.g. "I am empty-handed") or the third-person, past tense (e.g. "Jack was empty-handed") [5]. *First Draft of the Revolution*, written by Emily Short [6], is an example of how new types of IF stories show some resemblance to the idea of branching choices - though possibly with a much more complex structure. By playing different characters you revise the text of the letters they send to one another. It is a very interesting take on the IF both in a literary and in a gaming sense.

In this work we are looking into how new experience of interactive stories can be created by changing PoV (or focalization) in interactive story. Interactive stories and text-based games offer the player exploration of the world in which the player character (PC) is situated [7]. In *Bird Attack*, the story content remains the same but its discourse is altered by changing the focal character in the midst of the story – most often as the main character of the story as in the choice driven fictional stories best known from printed books such as Choose Your Own Adventure [8]. *Bird Attack* is written in the first person and allows the reader to switch between four different characters. By following different character inter-perspectives, different personalities and agendas are revealed. Thus, the variable internal focalization drives the story rather than the reader's choice of action, alone.

2 Bird Attack: Interactive Story with Variable Focalization

The story of Bird Attack takes place in the park, where a *boy* is walking his dog, a *bird* is sitting at a tree, and a *woman* goes to buy a sandwich from a *guy* working at the shop. The main plot is the event where the woman is attacked by the bird. These four characters, interconnected in a small story world and short story time frame, tell the story. Its narrative is told in the first person to follow the inter-perspective of changing multiple player characters (PCs). The open field of the park enables the characters to see one another at a distance or by direct interaction or conversation.

In order to create a story with tension (or conflict between characters), we have described the story as a set of interrelated objects, with each object being a character's desire or goal [9]. Gremais's Actantial model [3] is used operationally as a tool for exploring and analyzing the goal or object of each character, and we have distributed the roles as they appear from each character's PoV. The PoV is not merely a presentational choice (as a discourse variant) but a different way to tell a story, in which the relevance of certain facts will vary. Getting access to and following the inner perspectives of the characters reveal different personalities and agendas. One character may seem '*flat*' in the story as seen from one character's PoV but by switching to the side character's PoV their complicated '*roundness*' appears.

Each character in the story has his/her/its own goal and is interconnected, each functioning as secondary actants in the story of the other. In other words, the *subject* of one model may be the *opponent* of another model when different perspectives are taken. For instance, the goal of the Woman is to get a sandwich, but the opponent is the Bird attacking her, whereas the goal of the Bird is to collect nest material (from the Woman's hair). The goals and agendas of the characters are conflicting; however, as the first person narrative creates blinkers for the characters, being much entangled in their own thoughts, each protagonist is more or less unknowing of the other characters' motives.

As *Bird Attack* is entirely told in the first person, we do not distinguish between the eyes through which we perceive the story events and the voice of the narrator; the character experiencing the events is also the voice of the story. One exception occurs in the prologue of the story (Fig. 1), where the voice of the narrator is external though still told in the first person followed by selection of the narrative.

> *I, who am I? This I, I call myself, this tiny voice inside my head? Could this world be so small, my mind a limited landscape of observations through my eyes, this body walking, flying, running, standing, sleeping. Who am I? The loneliness exists in each body; belonging to a)! a woman b) a man c) a bird d) a boy.*

Fig. 1. Prologue of Bird Attack: underlined words provide options to the reader.

Who is talking here? It is an 'I' (the narrator) without identity. In the prologue we want to offer the player a choice of character, but still remain in the first person, to engage the reader. Therefore, in the prologue a more universal voice is chosen to present the concept of the story. But apart from this, the narrative of Bird Attack is kept to the first person PoV, although the protagonist is interchangeable.

The discourse layer concerns how events are presented with a branching story structure of character and action choice. The flashback narrative device is used to reveal new facts about the protagonist. Choice selection in IF usually relates to story development, however in *Bird Attack* the choice selection is more concerned about change of PoV, without necessarily changing the story development. The reader's choice changes the immediate future and the events converge again, with the event of the *bird attacking the woman* as the inevitable narrative point. Broadly, the story is the same throughout, and choices affect some future scenes and the narrative discourse.

3 Pilot Study and Discussion

As a pilot study to investigate how users appreciate the Bird Attack story, we recruited 6 participants with various backgrounds (age range: 23–38; two females). Each of them performed multiple playthroughs online (between 2–10 times) and answered open-ended questions regarding their story experiences, including how they perceived the character shifts and the interactivity of the story, which were collected via email. In general different perspective taking was perceived as coherent and positive, and the participants' replies can be summarized twofold: (1) changing interperspective can give insight into the thoughts and feelings of the characters; (2) it can envoke curiosity and eagerness to investigate and explore the story world.

The *Bird Attack* story can be developed to a fuller extent and can be more dynamic at certain points (e.g., love story between the woman and the sandwich guy). Some participants wanted more secrets, background stories to be revealed. Although the interaction works well, the participants felt that choice making would be difficult if there were multiple strong narrative lines. In addition, when playing the story more than a couple of times, the reader felt less engaged in the story particularly when the choices led to the plots previously experienced.

Technically the Inklewriter system has a simple if/else-true/false programming language structure. Although it's easy and convenient to write an interactive story, it has some inflexibility to create stories with variable internal focalization. Also, the system provides limited overview of the story as a whole. New authoring mechanisms would ease the development of these types of stories.

As future work we are updating our story based on the study participants' comments. We also plan to work on how this interactive storytelling with internal variable focalization can be applied in game design.

Acknowledgement. This work was in part supported by 2015 Hongik University Research Fund and the Hongik University new faculty research support fund.

References

1. Genette, G.: Narrative Discourse. Cornell University Press, Ithaca (1980)
2. Bae, B.-C., Cheong, Y.-G., Young, R.M.: Automated story generation with multiple internal focalization. In: Proceedings of Computational Intelligence and Games 2011. IEEE (2011)
3. Greimas, A.-J.: Reflections on actantial model. In: Onega, S., Landa, J.Á.G. (eds.) Narratology, pp. 76–89. Routledge, New York (1996)
4. Propp, V.: Morphology of the Folktale. University of Texas Press, Austin (1968)
5. http://ifdb.tads.org/viewgame?id=t6lk8c2wktxjnod6. Accessed 6 July 2015
6. http://lizadaly.com/first-draft/content/content/index.html. Accessed 6 July 2015
7. Montfort, N.: Curveship's automatic narrative style. In: Proceedings of International Conference on Foundations of Digital Games 2011, pp. 211–218. ACM, New York (2011)
8. Carabelli, J.: Genre history of the choose your own adventure book. http://www.jasoncarabelli.com/cyoa.html. Accessed 11 May 2014
9. Szilas, N.: IDtension: a narrative engine for interactive drama. In: Göbel, S., et al. (eds.) Proceedings of TIDSE 2003. Frauenhofer IRB Verlag (2003)

Workshops

Building Research and Development Bridges - Connecting Interactive Digital Storytelling Research with the Game Industry and Media Content Producers

Henrik Schoenau-Fog and Lars Reng

The Center for Applied Game Research,
Department of Architecture, Design and Media Technology,
Section of Medialogy, Aalborg University, Copenhagen, Denmark
{hsf,lre}@create.aau.dk

Abstract. This workshop aims at building bridges between the Interactive Digital Storytelling community, the game technology industry sector and interactive media content producers. The goal is to initiate collaborative projects and to create a foundation for an international community of researchers, industry and practitioners in the field of Interactive Digital Storytelling. The workshop will thus invite participants to present and discuss the challenges related to the research, design, development and evaluation of interactive digital storytelling artifacts, experiments and products.

Keywords: Collaboration · Game technology · Game industry · Interactive Digital storytelling · Networking · Community

1 Description of the Workshop

Most too often, academia and industry are two distinct worlds. We have attended numerous conferences and hosted and arranged several game jams and virtual reality jams, where we have realized that there is still an unfortunate gap between academics working with games and interactive digital storytelling and developers from the game and content producing industry.

With this workshop we will thus kickstart a stronger connection with the international community of interactive digital storytelling academics from ICIDS and companies and individuals from the game- and entertainment technology as well as the interactive media content producing industry in order to create a foundation for synergy, collaboration, entrepreneurship and business development.

1.1 Goals

The primary goal for this workshop is to initiate a community by creating a networking platform and thereby to initiate connections between academics from the interactive digital storytelling community and the digital game, entertainment and educational content producing industry.

© Springer International Publishing Switzerland 2015
H. Schoenau-Fog et al. (Eds.): ICIDS 2015, LNCS 9445, pp. 395–396, 2015.
DOI: 10.1007/978-3-319-27036-4

The secondary goal is to create a foundation for this community to become a creative hub for inspiring, concrete projects, which may become international research projects, commercial products or hopefully a combination thereof.

1.2 Topics

The main topics of the workshop will be formed by individual presentations by the participants who are invited to share stories about their own challenges in the IDS field. Each participant may thus prepare a short PechaKucha style presentation, where the last slide should contain a challenge to the other participants. This challenge could for example be a problem related to the "Narrative Paradox" or a user-test method, which is missing a concrete project to be used for experiments. It could also be a game company, which is looking for interactive digital storywriters.

1.3 Expected Outcomes

The expected outcome is the forming of a new community, which stands on three pillars:

- The interactive digital storytelling community
- The entertainment and game technology industry
- The content producing industry, i.e. the game industry, the interactive entertainment industry as well as the educational and communicative industries.

This community may then become the foundation for future collaborations aimed at designing, developing, producing and distributing interactive digital storytelling content. However, it is also the goal to initiate fruitful research and development (R&D) collaborations between academics and the industry in order to disseminate knowledge, methods and findings from academic research projects to the industry. Furthermore, the academic community may also benefit from learning about content production challenges from the industry.

The Ontology Project for Interactive Digital Narrative

Hartmut Koenitz[1], Mads Haahr[2], Gabriele Ferri[3],
Tonguc Ibrahim Sezen[4], and Digdem Sezen[5]

[1] Department of Entertainment Media Studies, University of Georgia,
120 Hooper Street, Athens, GA 30602-3018, USA
hkoenitz@uga.edu
[2] School of Computer Science and Statistics, Trinity College, Dublin 2, Ireland
Mads.Haahr@cs.tcd.ie
[3] School of Informatics and Computing, Indiana University,
919 E Tenth St., Bloomington, IN, USA
gabferri@indiana.edu
[4] Faculty of Communications, Istanbul Bilgi University,
santralIstanbul, Kazim Karabekir Cad. No: 2/13,
34060 Eyup – Istanbul, Turkey
tonguc.sezen@bilgi.edu.tr
[5] Faculty of Communications, Istanbul University,
Kaptani Derya Ibrahim Pasa Sk., 34452 Beyazit - Istanbul, Turkey
dsezen@istanbul.edu.tr

Abstract. Interactive Digital Narrative (IDN) is an interdisciplinary field in which long established perspectives (literature studies, narratology, oral storytelling practices) and newer views (computer science, communication and digital media studies, artificial intelligence) intersect. This variety of traditions creates difficulties for the exchange between researchers originating in different fields. A richer shared vocabulary would provide great benefits for the field. However, it is crucial for new vocabulary to be widely accepted. Consequently, we propose a community effort to develop an IDN ontology, inspired by similar efforts in game ontology [1, 2]

Keywords: Narrative ontologies · Interactive digital narrative · Interactive Digital storytelling · Narrative analysis · Narrative categories

1 Introduction

In the long tradition of analyzing narrative – from Aristotle's Poetics to the formalizations of structuralist and post structuralist narratology – a rich descriptive vocabulary has emerged. However, as Nitsche argues, "the range of interpretations of [narratological] terms has become so great as to be potentially confusing" [3] in the context of Interactive Digital Narrative (IDN). Simultaneously, existing terminology does not support the level of granularity required for deep analysis of procedural digital media artifacts. Consequently, researchers routinely face the need to redefine the vocabulary they adopt. Indeed, we observe the use of terminology that is in part borrowed from

© Springer International Publishing Switzerland 2015
H. Schoenau-Fog et al. (Eds.): ICIDS 2015, LNCS 9445, pp. 397–399, 2015.
DOI: 10.1007/978-3-319-27036-4

game journalism, in part reinterpreting legacy concepts, and in part invented anew. We engage in this discussion through an ongoing multidisciplinary research effort to develop categories and vocabulary for achieving an analytical understanding of IDN as the Games & Narrative group with workshops and publications [4]. We argue that turning to concrete exemplars is a highly effective way to produce new analytical terminology and, for this reason, we launch an effort for developing a bottom-up IDN descriptive ontology.

2 Developing an Ontology for IDN

Following previous work on videogame ontologies [1, 2, 5] and similar typologies [6] this workshop proposes to establish the grounding for a formal and explicit specification of IDN as a techno-cultural phenomena. The IDN Ontology Project intends to produce a precise classification of artifacts at a granular, descriptive level. Ludo-ontologies have identified important structural elements of games and their hierarchical relationships. This foundation also served as a starting point for defining the relationship between videogames and other cultural phenomena and as such, needs to be continuously criticized [7].

To understand IDNs, we have to start with questions. What are the elements that constitute an IDN? How are they related? How do they work together? Can they be found in other phenomena? What is the relationship between IDN and similar phenomena, which share these elements? And last but not least, how can we observe the transformation and development of IDN over time through these elements? In answering these questions we also have to study and discuss the methodologies and findings of ludo-ontologies due to the similarities of both forms.

3 Workshop Format

The half-day workshop kicks off with a wiki on the *Games & Narrative* website [8]. A Research-through-Workshop (RtW) approach (thematic introductions, brief directed discussions, collaborative sketching and reasoned comparisons), developed in the organizers' previous workshops, will be employed to produce insights through collective brainstorming at the conference and online. The process places emphasis on informal discussion, is programmatically open-ended, and will produce raw data, which will be accessible to the research community through the public wiki.

References

1. Zagal, J.P., Mateas, M., Fernández-Vara, C., Hochhalter, B., Lichti, N.: Towards an ontological language for game analysis. Presented at the DIGRA Conference 2005 (2005)
2. Zagal, J.P., Bruckman, A.: The game ontology project: supporting learning while contributing authentically to game studies. In: Proceedings of the 8th International Conference on International Conference for the Learning Sciences (2008)

3. Nitsche, M.: Video Game Spaces. MIT Press (2008)
4. Koenitz, H., Ferri, G., Haahr, M., Sezen, D., Sezen, T.I.: Interactive Digital Narrative: History, Theory, and Practice. Routledge, New York (2015)
5. Karhulahti, V.-M.: Fiction puzzle: storiable challenge in pragmatist videogame aesthetics. Philos. Technol. **27**, 201-220 (2014)
6. Elverdam, C., Aarseth, E.: Game classification and game design: construction through critical analysis. Games Cult. **2**, 3-22 (2007)
7. Grabarczyk, P., Gualeni, S., Juul, J., Karhulahti, V.M., Leino, O., Mosca, I., Sageng, J., Zagal, J.: Game and Videogame Ontologies: A Round Table Discussion at DIGRA 2015
8. gamesandnarrative.net

Narratologically-Inspired Models
for Interactive Narrative

Nicolas Szilas[1] and Fanfan Chen[2]

[1] TECFA, FPSE, University of Geneva, CH 1211 Genève 4, Switzerland
Nicolas.Szilas@unige.ch
[2] Department of English, Research Centre for Digital Games and Narrative
Design, National Dong Hwa University, Hualien County, Taiwan
ffchen@mail.ndhu.edu.tw

Abstract. Narratologically-Inspired Models for Interactive Narrative.

Keywords: Interactive digital storytelling · Interactive narrative · Narrative theories · Narratology

1 Narratology and Interactive Digital Storytelling (IDS)

Back in the early time of Interactive Digital Storytelling (IDS), at a time when artistic work on this new media remained a mere dream, researchers frequently referred to narrative or drama theorists: Laurel [1] as well as Sgouros [3] cited Aristotle, Machado and colleagues cited Propp [2], Szilas cited Bremond [4], Young cited Bal [5], etc. This was — and still is— a surprising encounter between two domains that were not supposed to interact: Artificial Intelligence and narrative theories. Note however that this encounter was not really an encounter: researchers in computing cited narratologist but we doubt the latter would have even imagined that the formers were interested in their field. Still today, conferences in the vast domain of narrative rarely take a look at AI and IDS. This comes as no surprise. Narrative theories study narratives, so why would narrative theory study IDS if hardly no artistic work has been produced? But if AI researchers cite narrative theories it is because to a certain extent they need them for constructing computational models suited to IDS or story generation.

Since the end of the last century, relation between narratology and IDS has changed a bit. From the narratology point of view, AI research is now slightly more visible[1], a phenomenon that has certainly something to do with the growth of the field of Digital Humanities. From the AI side however, we observe that the initial trend has not expanded as far it could have been expected. Instead of expanding their narrative horizon too quickly, AI researchers have sought to consolidate their initially narratively inspired computational approach. As a result, a few narrative theories, such as Propp's morphology of folktales, inspire many papers in IDS, while concepts such as metalepsis, hypotyposis or synecdoche (figure as fiction), analepsis, prolepsis or simultaneity; repetitive or singulative telling; ellipsis or expansion (narrative order,

[1] See the special session on "Computational Models of Narrative" at the 2014 International Conference on Narrative.

H. Schoenau-Fog et al. (Eds.): ICIDS 2015, LNCS 9445, pp. 400–401, 2015.
DOI: 10.1007/978-3-319-27036-4

frequency, pace), diegetic or hypodiegetic/embedded narrative (narrative levels), or five combinations of narrative voice and vision (heterodiegetic or homodiegetic narrator against zero, external or internal focalization) — to name a few — are rarely explored, despite their potential interest. Scientific research that ventured into the exploration of untouched (by IDS researchers) narrative concepts exists, but it is scarce and deserves more visibility.

Still incomplete, a rather accurate portrait of the relations between narrative theories and IDS can be found in a wiki build during a European project [6].

2 Reviving Narrative Theories for IDS

It is time now for what we call narratologically-inspired models —by analogy with the "biologically-inspired models" in cognitive science— to find a second wind. Sole computational principles (planning, logic, user modeling, case-based reasoning, etc.) may not suffice to achieve the ambitious goal of IDS. Still, some mistakes should not be repeated: 1) expecting that narrative theories provide off-the-shelf models for IDS; 2) forgetting that experiencing a linear narrative vs an interactive one are dissimilar experiences and therefore theories of the former cannot be blindly adapted to the latter; 3) working in isolation, that is reading narrative work but not enough meeting/working with narrative theorists.

A (series of) workshop(s) gathering computer scientists and narratologists is in consequence highly needed. We are confident that if researchers/theorists come to such a workshop with an explicit idea of how a given narrative concept/theory may be used in IDS, then the confrontation of these ideas will considerably open the horizon of research. For capturing these emerging ideas and for building exciting interdisciplinary research directions, the above-mentioned wiki [6] makes a well- suited platform, beyond the workshop's time.

References

1. Laurel, B.: Towards the design of a computer-based interactive fantasy system. Ohio State University (1986)
2. Machado, I., Martihno, C., Paiva, A.: Once upon a time. In: Mateas, M., Sengers, P. (eds.) Narrative Intelligence - Papers from the 1999 AAAI Fall Symposium - TR FS-99-01. AAAI Press, Menlo Park (1999)
3. Sgouros, N.: Dynamic generation, management and resolution of interactive plots. Artif. Intell. **107**(1), 29-62 (1999)
4. Szilas, N.: Interactive drama on computer: beyond linear narrative. In: Mateas, M., Sengers, P. (eds.) Narrative Intelligence - Papers from the 1999 AAAI Fall Symposium - TR FS-99-01, pp. 150-156. AAAI Press, Menlo Park (1999)
5. Young, R.M.: Notes on the use of plan structures in the creation of interactive plot. In: Mateas, M., Sengers, P. (eds.) Narrative Intelligence - Papers from the 1999 AAAI Fall Symposium - TR FS-99-01, pp. 164-167. AAAI Press, Menlo Park (1999)
6. Narrative IS Wiki. http://tecfalabs.unige.ch/narrative

Managing the Stage: Challenges
of Participatory Storytelling

Sabine Harrer[1] and Alina Constantin[2]

[1] University of Vienna, Vienna, Austria
`sabine.harrer@univie.ac.at`
[2] Tiny Red Camel, Copenhagen, Denmark
`alina@tinyredcamel.com`

Abstract. The proposed workshop explores the role of game story in the tension between design intent and audience participation. We use "stage managing" as a metaphor to describe our experiences with crafting compelling story moments in games. In the first part of the workshop, we will share some of the problems and challenges we have encountered in our work as game designers. This will open the discussion for limits and constraints of game-specific storytelling. The second part aims at arriving at a constructive consensus on well-played stage management: How can game designers facilitate meaningful play experiences? Using this workshop as think tank drawing on participants' encounters with the genre, we will be concerned with "best" and "worst" practice examples, encouraging a non-reductionist perspective on games and participatory storytelling.

Keywords: Participatory storytelling · Game design · Play

1 Background

Game designers have a difficult relationship with stories. They want to tell them, but through the agency of their players. They want to offer choice, but also to convey something specific. Game design is often measured according to whether or not a particular intention has been reached. But this is, conversely, at odds with the marketing of games as "open-ended" exploration space allowing players to experience a range of activities and stories.

How can game designers deal with this tension, wedged between a specific design vision, and the participatory affordances of the game medium? Are game elements detractive to story or are game and fiction intertwined? In this half-day workshop we are starting from the proposition that game design is the art of "managing the stage" from which a narrative is supposed to arise during play.

We have all experienced the effects of interesting or poor "stage management" as players - a useful resource to start with. However, we may experience the way games have impeded or facilitated story quite differently. We may disagree on what can count on "worst" or "best" practice examples of game elements enabling story. The idea is to

© Springer International Publishing Switzerland 2015
H. Schoenau-Fog et al. (Eds.): ICIDS 2015, LNCS 9445, pp. 402–403, 2015.
DOI: 10.1007/978-3-319-27036-4

use this tension in order to come up with a set of "basics" of successful stage management. It is intended as an exchange between both those who managed and those who participate on the stage of play.

2 Workshop Structure

The workshop will be conducted in two parts, focusing first on the problems and tensions, and then on possible solutions to the question of game-specific storytelling. The first half will be devoted to unpacking what can go wrong in game-specific storytelling. Particularly, we would like to shed light on the gap between design intent and game-specific tools used to realise this intent. An example-led introduction will highlight some of the organisers' attempts at crafting compelling playful storyworlds, going through some of the challenges. In the second part, we open the discussion on how to embrace the participation factor as strength, rather than a weakness of storytelling in games. In break-out groups, participants will explore a consensus on what good storytelling is, focusing their discussion on self-selected games and their particular "successful" narrative elements. These may be games either designed or played by the participants, but should be known to the rest of their group. In an ensuing wrap-up phase, participants will share their conclusions on what it means to participate in a "meaningful" play experience, what it was that made them care, and what this means for a well-crafted game story.

3 Goals and Outcomes

With this workshop we want to contribute to a deeper understanding of the player-narrative relationship and together produce a set of take-away methods to address it. In particular, we seek to:

- acknowledge challenges to the participatory nature of games as strength
- root discussions in real experience of participants and designers
- understand identification with/against game narratives
- negotiate the tension between design intent and player experience
- open up for multiple perspectives and polysemy of stories in games

Storytelling Lighting Design (ST-LiD)

Ellen Kathrine Hansen and Georgios Triantafyllidis

Lighting Design MSc, Aalborg University Copenhagen,
Copenhagen, Denmark
{eth, gt}@create.aau.dk

Abstract. Storytelling and light can have a bidirectional connection: Light can be used as a multidimensional design element, where light is communicating and telling a story. But also, the other way, stories can affect the multidimensional design of light. In this context, this workshop examines the use of lighting design in storytelling.

Keywords: Lighting design · Storytelling

1 Introduction

The workshop aims to increase awareness about storytelling lighting design and to bring together researchers and experts throughout the world into an interdisciplinary dialogue to exchange ideas on related topics.

1.1 Topics

Workshop's topics include (but are not limited to):

- Applications of lighting design in storytelling
- Psychological and physiological factors in storytelling lighting design
- Visual perception of lighting in storytelling
- Storytelling-based lighting design in education
- Interactive lighting design for storytelling
- Lighting design for storytelling in virtual environments
- User experience in storytelling lighting design

2 Description

This workshop is focusing on the Light as a multidimensional design element. There will be three parts in this workshop. In the two first parts of the workshop there will be a presentation of the works made in the Lighting Design MSc education in the context of two projects related to storytelling lighting design.

The first project is dealing with creating an interactive storytelling lighting design through media technology, as well as human/conceptual and functional considerations

© Springer International Publishing Switzerland 2015
H. Schoenau-Fog et al. (Eds.): ICIDS 2015, LNCS 9445, pp. 404–405, 2015.
DOI: 10.1007/978-3-319-27036-4

for cycle tunnels. The initial question posed was how to tell a story and also create a better biking environment, prioritizing commuters' and other users' needs, using interactive lighting and at the same time create a solution that is realizable/realistic in the longer term for the clients. The project was defined in collaboration with the CSC office, Cycle Super Highways (which is a joint office in the Capital Region of Copenhagen) [1], City of Copenhagen, City of Gladsaxe and ÅF Lighting.

The second project is on creating new narratives at the Royal Cast Collection [2]. The Royal Cast Collection was founded in 1895 as part of Statens Museum for Kunst. Today it consists of more than 2000 plaster casts of sculptures of the human form from across Europe, and which can reveal narratives of everything from pagan gods to Christian traditions. The sculptures are housed at "the West Indian Warehouse" at Copenhagen. Originally the warehouse was built to accommodate sugar and rum but in 1984 the Royal Cast Collection moved in and turned the warehouse into an exhibition space. In this context, some questions are arising: What is the point of all these sculptures in this space? How can this space and the stories the sculptures represent be explored through light? How can new stories be told? How can the possibilities of The Royal Cast Collection be extended? All these questions are synthesized in the overall question of the project: How can light create new narratives in The Royal Cast Collection?

The third and last part of the workshop will be a round table discussion, where all the participants of the workshop can actively participate and discuss the workshop's topics and future applications of storytelling lighting design.

Acknowledgements. The organizers of the workshop would like to thank all the students and supervisors of the Lighting Design MSc Education of Aalborg University Copenhagen that participated in the two aforementioned projects.

References

[1] Cycle Super Highway Office, Capital Region of Copenhagen. http://www.supercykelstier.dk/concept
[2] Royal Cast Collection, National Gallery of Denmark, Copenhagen. http://www.smk.dk/en/visit-the-museum/exhibitions/the-royal-cast-collection/

Creating Video Content for Oculus Rift

Scriptwriting for 360° Interactive Video Productions

Mirjam Vosmeer[1] and Christian Roth[2]

[1] Interaction & Games Lab, Amsterdam University of Applied Sciences,
Postbus 1025, 1000 BA Amsterdam, The Netherlands
m.s.vosmeer@hva.nl
[2] Department of Communication Science,
VU University Amsterdam, Amsterdam, The Netherlands
roth@spieleforschung.de

Abstract. In this workshop, we will discuss the participants' own previous experiences with producing and/or watching video content for Oculus Rift, or other 360° video devices. We will give a short presentation of our current research into the field, and some important concepts concerning this particular kind of storytelling will be discussed. After determining the challenges and possibilities that the medium implies, we will works towards developing concepts for settings and stories for surround video productions.

Keywords: Interactive narrative · Digital storytelling · Scriptwriting · Content development · Oculus Rift · Surround video

1 Introduction/Workshop Background

Oculus is awesome for games, but it's the future of movies, was the headline of an article that was published in January 2014 in technology and lifestyle magazine *Wired* (Watercutter, 2014). After Facebook paid 2 billion dollar to take over the company Oculus VR in March 2014 the headset Oculus Rift became world famous practically overnight. In the past year, researchers and developers who had gotten hold of the first series of developer kits have been presenting their latest findings on technology festivals and conferences all over the world, and discussing the challenges they encountered when producing 360 degrees content for this device. Especially developers who explore the possibilities of creating real life video content (instead of VR content), find themselves probing a new field of media production that offers characteristics of video games on one hand, but on the other hand feels like a movie in which the viewer is watching a scene that is displayed all around him or her.

While using Oculus Rift, the viewer has the sense of literally being in the center of the scene. Because the footage has been recorded in 360 degrees, the viewer has the strange sense of being present in the movie, almost as if he or she is playing a part in it, instead of watching from the outside.

In our first study, we have experimented with different voice over perspectives that would best suit the immersive qualities that 360° video content offers its users. It turned

© Springer International Publishing Switzerland 2015
H. Schoenau-Fog et al. (Eds.): ICIDS 2015, LNCS 9445, pp. 406–407, 2015.
DOI: 10.1007/978-3-319-27036-4

out that a second person perspective gave the audience the best sense of *presence*: of actually being a part of the narrative that was presented.

Our second study focused on creating an interactive story that could be produced for Oculus Rift. We developed a concept, explored different ways of interactive storytelling, and eventually produced a short interactive drama for Oculus Rift that was presented in Amsterdam in January 2015.

2 Workshop

In this workshop, we will first present a short overview of our previous studies into content creation for Oculus Rift, and explain the challenges and possibilities that we came across. Secondly, we will discuss the attendants' own earlier experiences with 360° video content, and invite them to reflect on the narrative aspects that they have encountered there. In the third part of the workshop, attendants will be asked to think of possible settings in which an Oculus Rift narrative could be placed, taking into account the production boundaries that were discussed earlier. During the fourth and last part of the workshop, we will discuss the settings, think of story concepts that might be written for these particular settings, and consider whether using a voice over could add useful extra information to the scene. Note that the focus will be on developing concepts and narratives, rather than on dealing with technical issues.

3 Workshop Outcomes

During this workshop, we hope to develop new concepts for settings and stories that can be produced for Oculus Rift. After attending the workshop, the participants will have gained new insights into the production challenges and narrative possibilities of producing 360° interactive stories.

The Wish Game Workshop

Ele Jansen[1] and Claire Marshall[2]

[1] Learn Do Share, Berlin, Germany
ele@learndoshare.net.au
[2] Story & Game Designer, London, UK
claire@learndoshare.net.au

Abstract. The Wish Game Workshop is a 90 minute collaborative authoring and problem solving experience which has been run with Google Labs, the UN and World Economic Forum and UNICEF in New York. The narrative design of the workshop is modelled after Joseph Campbell's Hero's Journey. Following a narrative, the Wish Game Workshop resembles a typical design process, which works because story and design draw on the same principles to create meaning. A story follows four steps: challenge, conquer, change and prevail. A design process follows four similar steps: analyze, ideate, develop, test. The Wish Game Workshop is unique as it brings these two ways of thinking together.

Keywords: Co-creation · Story-telling · Design thinking · Poesies · Analyze · Ideate · Develop · Test · Co-design

1 Introduction/Background

The Wish Game Workshop began as part of the research and exploration for Ele Jansen's PhD in Media/Design Anthropology. As part of her PhD, Ele co-founded a collective called Learn Do Share with Story-led innovator Lance Weiler. Learn Do Share operates to invent new ways of working and learning, using story and design principles at it's core. Claire Marshall joined the team as an experience story-teller and user experience designer and worked with Ele on the mechanics of The Wish Game Workshop for the last 3 years. The Wish Game Workshop has most recently been run at OUIShare Paris and Re:publica Berlin.

2 Goals of the Workshop

The Wish Game Workshop shows that story can be used to convey and simplify complex solutions but that it can also be used as a way to approach a life of poiesis. By enacting and shaping an incomplete narrative, players overcome fictitious separation and create for social innovation; reminding them of their own creative power to shape the world around them. One outcome will be a concept, which can be implemented by anyone, but the more important outcome is everyone's experience of empowerment created by leaving their comfort zone.

© Springer International Publishing Switzerland 2015
H. Schoenau-Fog et al. (Eds.): ICIDS 2015, LNCS 9445, pp. 408–409, 2015.
DOI: 10.1007/978-3-319-27036-4

3 Format of the Workshop

The Wish Game Workshop is played by participants divided into three groups, using two sets of cards, lots of brainstorming materials (pens, post its, paper) and a timer. The session always starts with a story that places everyone in a sci-fi world and encourages blue sky thinking.

Then three groups are formed: the "Designers" find a strategy to solve the design question; the "Storytellers" implement the designers' concept into a story that describes how the solution can work given the current context and opposing forces (e.g. antagonist or obstacles); the third group represents "The Future" who challenge and inform the other groups by providing futurist technologies and needs of certain stakeholders.

The groups cannot freely communicate with other groups, so the challenge is to synthesize design and story as best as possible, folding in the other groups' ideas to create something that features elements of each group's contribution.

At the end, the groups are prompted to record the outcome as a three-minute video pitch involving assets that have been created throughout the Wish Game Workshop.

4 Expected Outcomes of the Workshop

The enchanted ruckus of the Wish Game Workshop pushes participants to explore communication strategies, innovative pragmatism and to employ empathy with skill sets and world views different to their own. It is a valuable experience for everyone from students to professors, story-tellers to computer programmers and everyone in between. The Wish Game Workshop also generates insight on narrative design, hacking, and collaboration. We collect ethnographic data on the activation of subjectivity in society as well as the wishes, which flow into continuing academic research on how countercultures influence society.

Mobile Storytelling 3.0: How to Create Mobile and Digital Location-Based Stories

Ilse Rombout

7scenes, Amsterdam, The Netherlands
ilse@7scenes.com

Abstract. Stories are everywhere - and everything is a story. That is what we at 7scenes believe. Our platform for mobile storytelling is made for everyone to explore their stories at locations of their choosing. During our workshop, we'll explore how to create a mobile location-based story.

In small groups, we'll create our own mobile stories. We'll start with the scope, consider narratives, add media to locations and implement means of interactivity. We'll end with digitizing the tours into the 7scenes platform, and spend the last hour of the workshop walking your tours on your own mobile phones.

This way, we'll study mobile storytelling in a very practical way. At the end, you'll understand what the underlying principles of mobile storytelling are and what challenges have to be dealt with. Having created your own mobile story, you'll be ready once you start doing so professionally.

Keywords: 7scenes · Mobile · Storytelling · Apps · Location-based · Digital · Stories · Workshop

1 Introduction

Stories are everywhere - and everything is a story. That is what we at 7scenes believe. Our platform for mobile storytelling is made for everyone to explore their stories at locations of their choosing. During our workshop, we'll explore how to create a mobile location-based story.

2 Goals

- To study mobile and digital storytelling
- To understand what principles are important concerning mobile and digital storytelling
- To be able to understand and deal with the challenges concerning mobile and digital storytelling
- To successfully create an entire mobile story

© Springer International Publishing Switzerland 2015
H. Schoenau-Fog et al. (Eds.): ICIDS 2015, LNCS 9445, pp. 410–411, 2015.
DOI: 10.1007/978-3-319-27036-4

3 Topic

Mobile storytelling: how do you create mobile location-based and digital stories?

4 Expected Outcomes

Attendees are able to understand what mobile storytelling is and what the underlying principles and take into account what the challenges are. At the end of the workshop they will have created their own mobile stories in the 7scenes platform.

Social Media Fiction

Designing Stories for Social Media

Simona Venditti[1], Mariana Ciancia[1], Katia Goldoni[2],
and Francesca Piredda[1]

[1] Design Department, Politecnico di Milano, Milano, Italy
{simona.venditti,mariana.ciancia,
francesca.piredda}@polimi.it
[2] School of Design, Politecnico di Milano, Milano, Italy
katia.goldoni@gmail.com

Abstract. This full-day workshop presents a process for the design of fictional stories on social media, where the plot can guide the narrative and interactive experience. Activities and discussions build on the idea that the structure of the most renowned social media profiles - i.e. Facebook, Twitter, Instagram - can be considered as a narrative structure based on storytelling and sense-making, in which forms of micro narratives can be elaborated. Working with both professionals and academics, the main goal of the workshop is the research for new expressive, narrative and interactive ways to engage with the audience, harnessing potentialities and limits of social media storytelling.

Keywords: Mobile storytelling · Social media storytelling · Design research

1 Introduction

Storytelling practices represent both a spontaneous way for producing and sharing content and a design field to be explored further. Social networks such as Facebook, Instagram or Twitter enable interaction between users and content, and increase the possibilities for active people to take part in conversational processes, although the content conveyed determines how and at what level people interact with the medium. As stories can be navigated by the users, social media storytelling projects require a particular attention in the design phase for stories that are not only told but rather they are designed to harness the structure of social media profiles as narrative structures.

2 Description

The general topic of the workshop is social media storytelling, which is explored harnessing potentialities and limits of social networks, researching on new expressive, narrative and interactive ways to engage with the audience.

H. Schoenau-Fog et al. (Eds.): ICIDS 2015, LNCS 9445, pp. 412–413, 2015.
DOI: 10.1007/978-3-319-27036-4

The workshop examines a design process based on three main steps and a set of tools for the creation of digital interactive stories on social media, starting from digital archives stored in personal mobile devices (i.e. mobile phones, tablets, laptops).

The workshop's activities develop the three main design phases: 1) *Collecting fragments*, such as photos, videos, small text or notes that represent the archive material upon which new narratives are built; 2) *Crafting stories*, such as the development of fragments into more structured stories supported by the use of some design tools for the creation of the storyline (*fabula*), intended as the combination of the narrative elements in a logical and chronological order; and 3) *Re-framing fragments*, characterized by the creation of digital contents and their distribution on social media as digital stories, which can have different genres and narrative formats. This last phase represents the definition of the plot (*intreccio*), such as the narrative order of the single elements, which may be different from the storyline and which is conveyed using social media profiles as narrative structures.

Starting from personal archive material, participants work in groups in order to create a fictional story combining together different narrative elements. Each team is assigned a social network (Twitter or Instagram) and participants are asked to design the different contents (photos, videos, posts, tweets) as well as hashtags or mentions, which could guide the narrative experience. Eventually, each team activates a profile and uploads contents in order to create a *micro narrative*.

3 Goals and Expected Outcomes

Working with both professionals and academics, the main goal of this workshop is to examine the limits and structures of the most renowned social media and to develop micro narratives in which the plot can guide the narrative experience.

Expected outcomes of the workshop can be considered from three main perspectives: from the point of view of the content, the output is identified in a group of digital stories on different social media, which embed short narratives coming from personal experiences and digital archive material. By the end of the workshop, the profiles are activated and are accessible online on usual social networking platforms (Twitter, Instagram). From the point of view of the method, the aim is to implement and verify a set of tools and a design process for the creation of digital stories on social media, as part of our approach and research in the field of storytelling and media design. Eventually, a final aim is to develop a small network of people interested in this field of inquiry, giving feedbacks and exchanging skills and knowledge about new forms of interactive storytelling.

Author Index